MONET
IN THE 20TH CENTURY

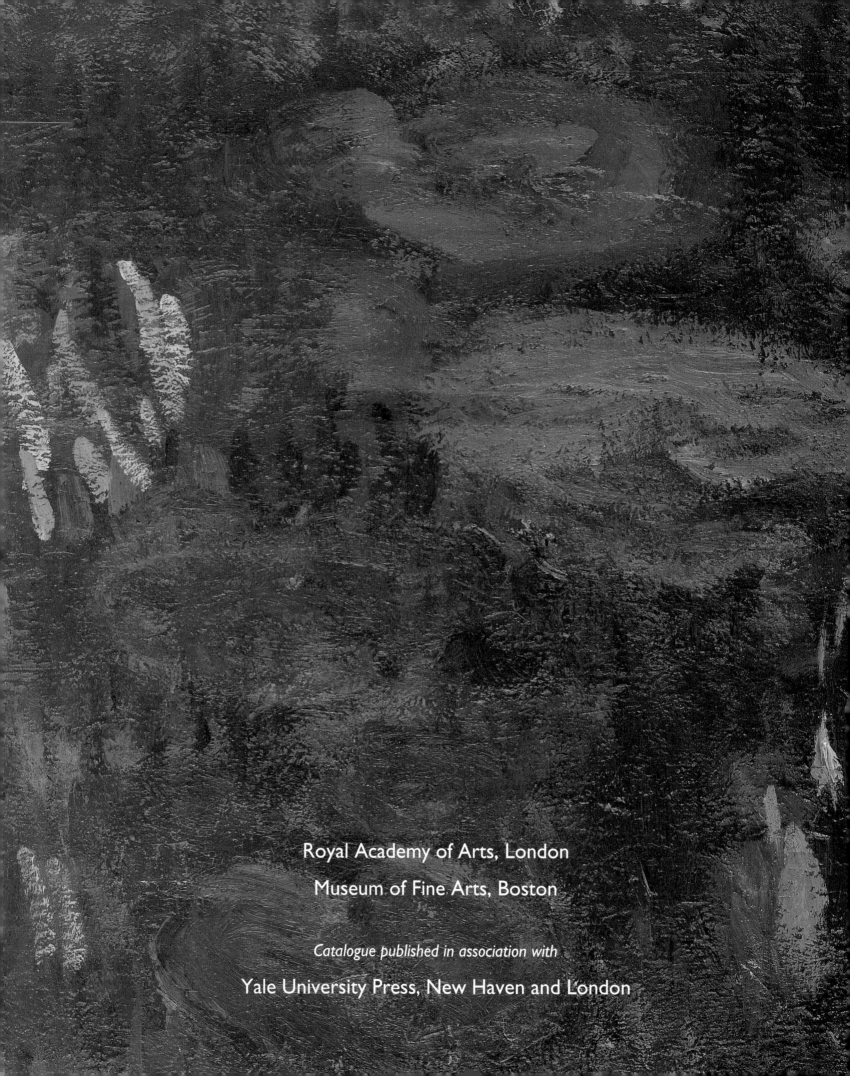

Royal Academy of Arts, London

Museum of Fine Arts, Boston

Catalogue published in association with

Yale University Press, New Haven and London

MONET
IN THE 20TH CENTURY

Paul Hayes Tucker

with George T.M. Shackelford and MaryAnne Stevens

Essays by

Romy Golan, John House, and Michael Leja

First published on the occasion of the exhibition
"Monet in the 20th Century"
Museum of Fine Arts, Boston, September 20 – December 27, 1998
Royal Academy of Arts, London, January 23 – April 18, 1999

The exhibition was organized by the Museum of Fine Arts, Boston
and the Royal Academy of Arts, London

In London the exhibition was sponsored by

 ERNST & YOUNG

The Royal Academy of Arts is grateful to Her Majesty's Government for
its help in agreeing to indemnify the exhibition under the National
Heritage Act 1980, and to the Museums and Galleries Commission for
their help in arranging this indemnity.

In Boston the exhibition was sponsored by Fleet Financial Group, Inc.
An indemnity was granted by the Federal Council on the Arts and
Humanities.

© Museum of Fine Arts, Boston and Royal Academy of Arts 1998

British Library Cataloguing-in-Publication Data
A catalogue record for this book is available from the British Library

ISBN: 0 300 07944 3 (paperback)

Published by Yale University Press, New Haven and London
Typeset in Gill Sans Regular and Sans Light by
SX Composing DTP, Rayleigh, Essex
Printed in Singapore by C.S. Graphics, PTE

Frontispiece: Claude Monet, *Water Lilies, Reflections of
Weeping Willows* (detail), 1916–19
The Metropolitan Museum of Art
Gift of Louise Reinhardt Smith, 1983 (cat. 65)

Cover illustration: Claude Monet, *Water Lilies* (detail), 1907,
Museum of Fine Arts, Boston
Bequest of Alexander Cochrane (cat. 33)

EXHIBITION ORGANIZATION

Guest Curator and Coeditor of Catalogue: Paul Hayes Tucker

For Museum of Fine Arts, Boston:

Curator: George T.M. Shackelford
Exhibition Organizer: Katie Getchell
Exhibition Assistants: Kate Priscilla Diamond, Deanna M. Griffin
Exhibition Registrar: Patricia Loiko

For Royal Academy of Arts, London:

Curator and Coeditor of Catalogue: MaryAnne Stevens
Exhibition Organizer: Emeline Max
Exhibition Assistants: Harriet James, Corinne Wellesley
Editorial Coordinator: Sophie Lawrence
Photographic and Copyright Coordinator: Miranda Bennion
Assistant Photographic and Copyright Coordinator: Roberta Stansfield
Picture Researcher: Annabel Ossel
Indexer: Helen Baz

For Yale University Press:

Editor, Designer, and Production Controller: Gillian Malpass
Copy-editor: Celia Jones
Editorial Assistant: Abby Waldman

Contents

Preface

The final year of the century is a good time for looking back as well as forward, and Monet's works from the first quarter of this century will surely provide inspiration well into the next. They have found almost universal appeal and have become some of the best known and most widely reproduced images of our time.

We have much enjoyed working with the team at the Royal Academy of Arts to bring *Monet in the 20th Century* to fruition. This is the largest exhibition that Ernst & Young has supported in a programme of arts sponsorship that in recent years has included the highly successful Picasso, Cézanne and Bonnard exhibitions at the Tate, for which we twice won ABSA awards. The Royal Academy of Arts has been at the forefront of corporate sponsorship since the late 1970s, and recognises the value of the additional publicity and wider audiences that our sponsorship can bring. For us, as a leading firm of advisers to businesses around the world, involvement in the arts allows us to make a rewarding contribution to the wider community.

However familiar you are with Monet's individual paintings, nothing quite prepares you for the experience of walking into a room filled with his wonderful canvases of water lilies. The blaze of colour and the intensity of the sensation will certainly remain with me for a long time. This magnificent exhibition will surely move and inspire every visitor in their own way.

Nick Land
Chairman
ƎlJ ERNST & YOUNG

Foreword

This exhibition demonstrates the genius of Claude Monet's late style: it shows the work created by an artist who was 60 years of age in 1900, who died in 1926, and who spent more than a third of his working life in our century.

Monet is possibly the most familiar and the most celebrated of nineteenth-century painters. A founder of Impressionism, he has been celebrated in important monographic exhibitions held in Europe, the United States, and Japan in recent decades – including the exhibition *Monet in the '90s*, which the Museum of Fine Arts and the Royal Academy of Arts presented with the Art Institute of Chicago in 1989–90. However, one aspect of the artist's accomplishment has until now remained underexamined: the more than 400 paintings, many on a significantly large scale, that Monet created during the first quarter of the twentieth century.

Our exhibition presents the legacy of Monet's nineteenth-century experience in his post-1900 work. It explores his reinventions of the aesthetic notion of series that he had first developed in the 1890s, in order to reveal the essence of place in, for example, his Venice scenes, or to pursue a sequence of variations on a theme – as in his composite Water Lily series begun in 1903 and ultimately exhibited in 1909 under the title, *Les Nymphéas: Séries de paysages d'eau*. Between 1900 and 1926 Monet consistently challenged his own artistic achievement and reassessed the relationships between work created within the privacy of his garden and studio for his personal satisfaction and that released into the public domain. The exhibition compares works that can be securely placed within the artist's development – above all those that were finished, exhibited, and almost immediately sold – with works with more complicated histories – those, for example, that were completed and exhibited but then returned to the studio to be released after reworking only at a very much later date.

Monet's late work raises questions about its relationship to that of the Fauves and the Cubists, or even the painters of the New York School after 1950. As the catalogue establishes, while such references may have been indirect, the increase in canvas scale from 1914, the resultant escalation in the breadth of brushwork, and the introduction of bolder colour suggest powerful affinities with his younger contemporaries, and with key developments in later twentieth-century painting.

Illuminating these themes has been a great challenge. The generosity of the many lenders to this exhibition has allowed us to bring together, for the first time since 1909, the largest number of Water Lily paintings – twenty-two in all – from the original *Nymphéas* exhibition of 1909, a remarkable group of "expressionist" garden paintings made after 1916, and seven of the great Water Lily panels – five compositions in all – from the group of more than forty canvases from which Monet selected his *Grandes Décorations,* ultimately installed in the Orangerie des Tuileries, Paris, in 1927. We are enormously grateful to museums and private collectors for their faith in the importance of our enterprise and their willingness to part with their works.

The exhibition has been curated by Professor Paul Hayes Tucker of the University of Massachusetts, Boston, with George T.M. Shackelford, the Mrs. Russell W. Baker Curator of European Paintings of the Museum of Fine Arts, Boston, and MaryAnne Stevens, Education Secretary and Chief Curator of the Royal Academy of Arts, with important additional advice from Professor John House of the Courtauld Institute of Art, London. The catalogue has drawn upon their scholarship as well as that of Professor Romy Golan, of the City University of New York, and Dr. Michael Leja, of the Massachusetts Institute of Technology.

No exhibition of this scope would be possible without our governments' indemnification or the support of our sponsors. Both institutions have been most fortunate in having enthusiastic and deeply committed sponsors: Fleet Financial Group has offered unprecedented underwriting to the Museum of Fine Arts, Boston, and Ernst & Young has provided exceptionally generous support to the Royal Academy of Arts. We thank them wholeheartedly for their involvement in the realisation of this exhibition.

A number of the paintings shown in this exhibition will probably be familiar to our visitors, others will surely surprise and astonish. All will be seen in a new light. We trust that visitors to the exhibition will confront and comprehend the challenges that Monet set himself after his 60th birthday, will marvel at the beauty, invention and scale of his achievement, and ponder his contribution to our century's art.

Malcolm Rogers
Ann and Graham Gund Director
Museum of Fine Arts, Boston

Sir Philip Dowson, CBE
President
Royal Academy of Arts, London

Acknowledgments

The curators of the exhibition, Paul Hayes Tucker, George T. M. Shackelford and MaryAnne Stevens, and the Museum of Fine Arts, Boston, and the Royal Academy of Arts, London, acknowledge with great thanks the following dedicated members of staff: Kate Priscilla Diamond, Katie Getchell, Deanna M. Griffin, and Patricia Loiko from the Museum of Fine Arts, Boston; Norman Rosenthal, with Miranda Bennion, Harriet James, Sophie Lawrence, Emeline Max, Roberta Stansfield, and Corinne Wellesley from the Royal Academy of Arts, London; and Celia Jones, Gillian Malpass, and Abby Waldman from Yale University Press, London. The curators also express their deep gratitude to all those whose names are given below. They have generously contributed their knowledge, advice, and support for the realization of *Monet in the 20th Century*.

William Acquavella; Yuji Akimoto; Sam Aldrich; Hortense Anda-Bührle; Alexander Apsis; Katherine Baetjer; Joseph Baillio; Felix Baumann; William Beadleston; Brent Benjamin; Ellen Bennett; James Berry-Hill; Paul Bessire; Ernst Beyeler; Irène Bizot; Robert J Boardingham; Michael Brenson; Christopher Brown; Sigfrid Buan; John Buchannan; Bill Burback; Rupert Burgess; Ray Burke; Christopher Burge; Ruth Butler; Françoise Cachin; Judy Chicago; Laura Church; Andy Cocito; Greg Coleman; Philip Consibee; Leane Coppola; Desmond Corcoran; Malcolm Cormack; David Curry; Patricia Curtis; Michael Dauberville; Barbara Davies; Sarah Davies; Jeffrey Deitch; Marianne Delafond; Suzanne Delay; Kathryn Delmez; Douglas Druick; Elizabeth Easton; Stuart Feld; Karen Fielder; Michael Findlay; Peter Findlay; Edwin Firestone; Stephen Frankel; Eric Frasier; Carol Fredian; Judi Freeman; Marianne Frisch; Anne-Brigitte Fronsmark; Katsunori Fukaua; Barbara Dayer Gallati; Elaine Gans; David Geldart; Tamsen George; Pierre Georgel; Franck Giraud; Kelly Gifford; Mark Glimscher; Robert Gordon; Dawn Griffin; Gloria Groom; Louise M. Haddleton; Andrew Haines; Tokushishi and Chieko Hasegawa; Masaaki Hasegawa; Arnaud d'Hauterives; Gregory Hedberg; Robert Herbert; Erica E. Hirshler; Yoshio Hitokoto; Peggy Hogan; Jenny Holland; Mariko Ito; Patricia B. Jacoby; David Joseph; Betra Katz; Jamie Kaufmann; Christian Klemm; Katie Klitgaard; Stephan Koja; Irene Konefal; John-Paul Kozicki; Heidi Kucker; Tom Lang; Marc Larock; Pierre Larock; Jean-Pierre Larrieu; Philippe Laydeker; Jean-Claude LeBlond-Zola; John Leighton; Henri Loyrette; Dr. Christoph Löw; Michael Luck; Libby Lumpkin; Rhona MacBeth; Neil MacGregor; Julia McCarthy; Anne McCauley; Kathleen McDonald; Valerie McGregor; Daniel Malingue; Paul Manning; Barbara Martin; Evan Maurer; Maureen Melton; Katsumi Miyazaki; Charles Moffett; Professor Owen Morgan; Professor David Moss; Dr. Edward B. Murphy Jr.; Halley Nahmad; David Nash; John Nicoll; Larry Nichols; Patrick Noon; Janet O'Donoghue; Lynn Federle Orr; Karen Otis; Cynthia Palmer; Michäle Paret; Chantal Park; Tracy Phillips; Ted Pillsbury; Joachim Pissarro; Lionel Pissarro; Linda Powell; Irving Rabb; Maria Reinshagen; Christopher Riopelle; Joseph Rishel; Pierre Rosenberg; James Roundell; William Rubin; Dennis Russo; Gary Ruuska; Elizabeth Sackler; Sabine Sandquist; Jinichi Sasaki; Marjorie Saul; Susan Scott; Katharina Schmidt; Barbara S. Shapiro; Tetsuji Shibayama; Kenneth Silver; Mrs. Sylvia Slifka; Mary Sluskonis; David Solkin; Richard Solomon; Janice Sorkow; John Stanley; Theodore Stebbins; David Strauss; Michel Strauss; Jeremy Strick; Wallace Stuart; Charles Stuckey; David Sturtevant; Peter Sutton; Erika Swanson; John Tancock; Gary Tinterow; Susan Tomasian; Carol Troyen; Jennie Tucker; Jonathan Tucker; Maggie Moss Tucker; Mary Elizabeth Tucker; William Tucker; Richard Upton; Lydia Vagts; Kirk Varnedoe; Kim Vick; Roland Waspe; Mikael Wivel; Jeannie Waldinger; Roger Ward; Daniel Wildenstein; Jürg Wille; Ully Wille; Barbara Bruce Williams; Ealan Wingate; Gilian Wohlauer; Ernie Wolfe III; William Wondriska; Susan Wong; Jean Woodward; John Woolf; Jim Wright; Eric Zafran; Taryn Zarillo.

Lenders to the Exhibition

AUSTRIA
Vienna, Neue Galerie of the Kunsthistorisches Museum,
 Österreichische Galerie

CANADA
Hamilton, McMaster Museum of Art
Ottawa, National Gallery of Canada

DENMARK
Copenhagen, Ordrupgaard Museum

FRANCE
Grenoble, Musée de Grenoble
Lyon, Musée des Beaux-Arts
Nantes, Musée des Beaux-Arts de Nantes
Paris, Galerie Larock-Granoff
Paris, Musée d'Orsay
Paris, Musée d'Orsay, deposited at Musée des Beaux-
 Arts, Caen
Paris, Musée Marmottan-Claude Monet
Saint-Etienne, Musée d'Art Moderne de Saint-Etienne
Vernon, Musée Municipal Alphonse-Georges Poulain

GREAT BRITAIN
Cardiff, National Museum of Wales
London, The National Gallery
London, Private Collection courtesy of Helly Nahmad
 Gallery

IRELAND
Dublin, Hugh Lane Municipal Gallery of Modern Art

JAPAN
Aichi, Maspro Denkoh Corporation
Kitakyushu, Municipal Museum of Art
Okayama, Benesse Corporation
Tokyo, Asahi Breweries, Ltd.
Tokyo, Bridgestone Museum of Art
Yamagata, Yoshino Gypsum Co. Ltd., deposited at
 Yamagata Museum of Art

NETHERLANDS
The Hague, Gemeentemuseum

RUSSIA
Moscow, Pushkin State Museum of Fine Arts

SWEDEN
Göteborg, Göteborg Museum of Art

SWITZERLAND
Basel, Kunstmuseum Basel, Öffentliche Kunstsammlungen
Sankt Gallen, Kunstmuseum
Zurich, Kunsthaus

USA
Baltimore, The Baltimore Museum of Art
Boston, Museum of Fine Arts, Boston
Brooklyn, The Brooklyn Museum of Art
Mr. G. Callimanopulos
Cambridge, Harvard University Art Museums, Fogg Art
 Museum
Chicago, The Art Institute of Chicago
Columbus, Columbus Museum of Art
Dallas, Dallas Museum of Art
Dayton, The Dayton Art Institute
Denver, Denver Art Museum
Fort Worth, Kimbell Art Museum
Honolulu, Academy of Arts
Houston, The Museum of Fine Arts, Houston
Mr. and Mrs. Herbert Klapper
Milwaukee, Milwaukee Museum of Art
Minneapolis, The Minneapolis Institute of Arts
New York, Private Collection (Courtesy of Hirschl &
 Adler Galleries, New York)
New York, The Metropolitan Museum of Art
New York, The Museum of Modern Art
Oberlin, Allen Memorial Art Museum, Oberlin College
Philadelphia, Philadelphia Museum of Art
Richmond, Virginia Museum of Fine Arts
San Francisco, The Fine Arts Museums of San Francisco
Saint Louis, The Saint Louis Art Museum
Ralph T. Coe
Toledo, The Toledo Museum of Art
Washington, National Gallery of Art
Worcester, Worcester Art Museum

and those lenders who wish to remain anonymous

Editorial Note

All works are listed in the Exhibition Checklist (pp. 280–84). Titles are given in English and in French; they follow those given in Daniel Wildenstein, *Claude Monet: Biographie et catalogue raisonné* (Lausanne, Vol. I, 1974; Vol. II, 1979; Vol. III, 1979; Vol. IV, 1985; Vol. V, 1991; reprinted in four volumes, Paris, 1996). Medium and support are recorded, and dimensions are given in centimeters, height before width. All works are identified by a number preceded by "W" (e.g., W.1697), which denotes their number in the aforementioned Wildenstein catalogue raisonné; where relevant, a number following the credit line refers to the work's institutional inventory number. Presence of signature and date are indicated, their location being given as follows: u. = upper; l. = lower; c. = center; r. = right; and l. = left.

From the 1880s, Monet would work simultaneously on several paintings of the same motif, often bringing these related paintings to completion over an extended period of time. This practice was continued after 1900: a certain number would be worked up for exhibition, others were left in the studio to be completed, exhibited, and/or sold at a later date, while a relatively high proportion was neither exhibited nor sold during the artist's life and remained in the artist's studio on his death in 1926. This poses certain specific and sometimes intractable problems for scholars who seek to ascribe a specific date to a painting.

In this catalogue, a date appended to a painting by Monet is in all cases recorded in the Exhibition Checklist. However, in certain cases where documentary or stylistic evidence suggests that the work may have been either finished at a later date or even started after the given date, a second date, or date range is proposed. Thus, for example, for a painting started in a specific campaign, such as that of London, but neither exhibited at the 1904 Galerie Durand-Ruel exhibition nor dated, but sold out of the studio at a considerably later date, a second date or a date range is given, encompassing the earliest possible date of inception and the final exit of the painting from the studio (see pp. 128 and 130). In other cases, our knowledge of Monet's studio practice may lead us to question the date inscribed by the artist on the canvas – as in catalogue number 71, where, although the painting is dated "1917," documentary evidence indicates that it could not have been started until 1918 and was probably not brought to completion until 1922 (see p. 218). Finally, in the case of the forty-four late, large Water Lily panels from which Monet was ultimately to select the twenty-two that formed the *Grandes Décorations* in the Orangerie des Tuileries, consideration of the variations in the widths of the panels and external documentary evidence suggest that some were possibly started as early as 1915 (see cats. 88–9), while others would probably not have been embarked upon until the completion, toward the end of 1915, of Monet's new, 276 square meter studio (see cats. 90–92, and p. 252).

All details of paintings by Monet reproduced in the catalogue are reproduced on a scale of 1:1, with the exception of the following: frontispiece (cat. 65), page 1 (cat. 8), page 81 (cat. 83), page 84 (cat. 88), page 87 (cat. 92), pages 116–17 (cat. 91), page 142 (cat. 20), page 149 (cat. 39), page 158 (cat. 32), page 231 (cat. 73), and page 233 (cat. 75).

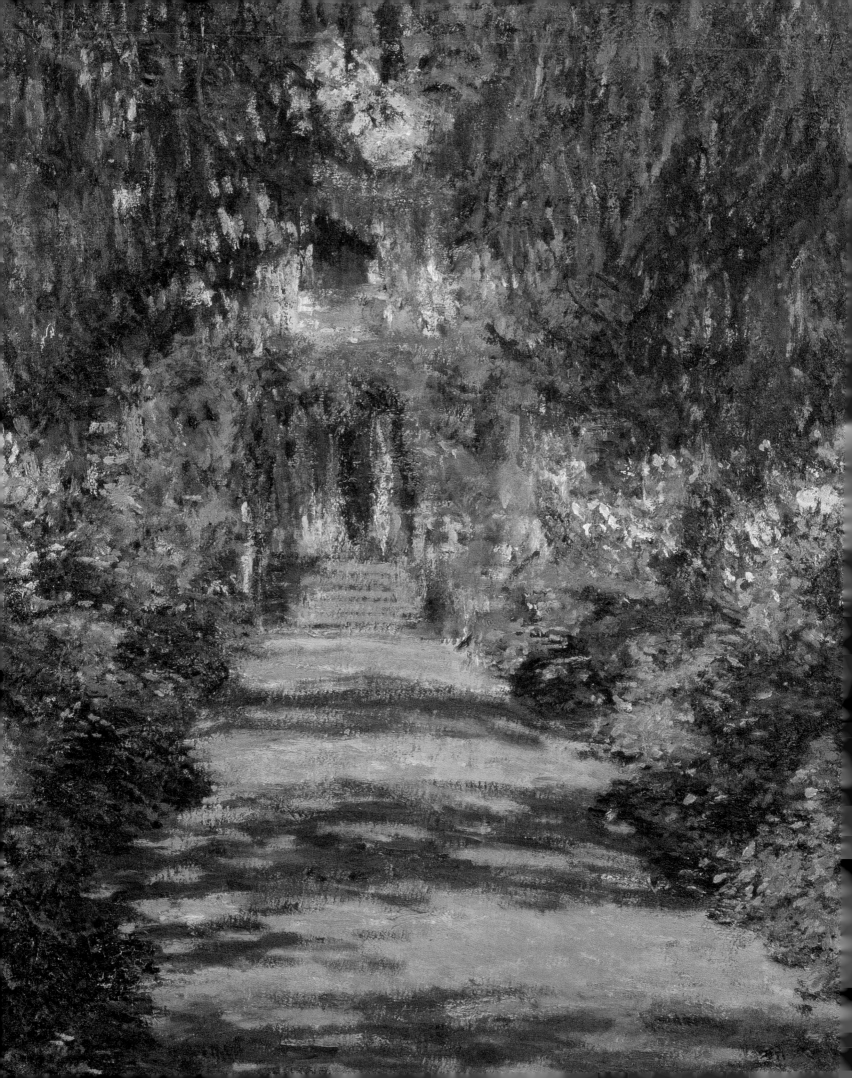

MONET: THE LAST IMPRESSIONIST?

John House

facing page Detail of cat. 26.

At first sight, Monet's late *Grandes Décorations* are a far cry from the landscapes of his "high Impressionist" period of the 1870s, painted around fifty years earlier. In *The Railway Bridge at Argenteuil* of 1873 (fig. 1), the whole picture is built up of a series of contrasts: land and water; steam and sail; natural and man-made; warm and cool color; broad sweeps of paint and crisp little brush-marks. Two trains pass each other on the monumental metal railway bridge, newly rebuilt after the Franco-Prussian War, and we watch two men on the riverbank as they survey this quintessentially modern scene. In works like these, the art of landscape painting was dragged into the modern age. In place of the rural villages and forest refuges so common in the art of the period, we are face to face with modernization and technological change, seemingly able to celebrate the transformation that this was imposing on the landscapes around the fringes of Paris.

By contrast, in the *Grandes Décorations* we are presented with a single, unbroken visual field; occasionally panels are framed by willow trees, but in most of them we see no more than a vast expanse of water surface, without trace of human presence or man-made elements. As we explore these canvases, the contrasts are still there: contrasts of color and touch, and of near and far, between the pond surface and the reflected trees and sky, but the overall effect is one of integration and harmony, with nothing to disturb the viewer's solitary immersion in the private experience of viewing.

These paintings from the opposite ends of Monet's career seem to belong to different worlds. Their contexts, too, were very different. Monet's artistic position changed from the rebel of the 1870s to the grand old man of French painting, and by 1910 Impressionist landscape had come to be seen as the latest link in the great chain of the French artistic tradition. Both works emerged in the aftermath of catastrophic wars, but they present totally different types of response to the worlds around them.

Despite the evident transformation of his art, Monet's declared aims as a painter were consistent throughout his career. In 1868 he wrote to his friend and fellow painter Frédéric Bazille that his latest work would simply be "the expression of my own personal experience [*l'expression de ce que j'aurai ressenti, moi personnellement*]."[1] In 1912, writing to his future biographer Gustave Geffroy, he commented, "I know only that I do what I think best to express what I experience in front of nature [*pour rendre ce que j'éprouve devant la nature*] . . . I allow plenty of faults to show in order to fix my *sensations*."[2] And shortly before his death he wrote to Evan Charteris, the biographer of John Singer Sargent, "I have always had a horror of theories . . . My only virtue is to have painted directly in front of nature, while trying to render the impressions made on me by the most fleeting effects [*en cherchant à rendre mes impressions devant les effets les plus fugitifs*]."[3]

In all of these comments, as in the pronouncements of the other members of the Impressionist group, there is a consistent emphasis on the personal experience of nature. Central to the whole Impressionist aesthetic was an insistence on the fundamental subjectivity of each individual's *sensation* – of his or her experiences of the external world.[4] The Impressionist painter was seeking ways of translating this unique personal vision into paint. Yet, as we have seen, both Monet's subjects and the means by which he conveyed them changed radically. This essay will look across the whole of Monet's long career, seeking to isolate key points of change. These could well be described in terms of his changing material circumstances, or in relation to the wider historical and social changes during his long life. However, the focus here will be more self-contained; we shall ask whether the turning-points in his art involved a wholesale abandonment of his aims and principles of the "high Impressionist" years of the 1870s, or rather a process of gradual redefinition that remained, to the end, faithful to the basic tenets of the Impressionist vision.

Fig. 1 *The Railway Bridge at Argenteuil*, 1873 (W.279), courtesy of Helly Nahmad Gallery, London.

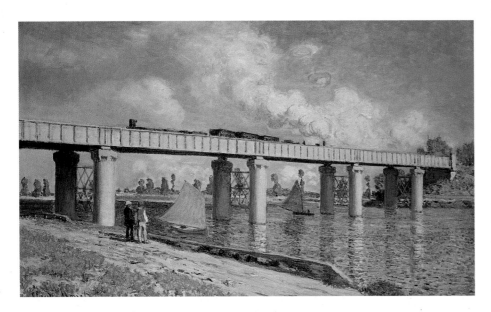

Paintings such as *The Railway Bridge at Argenteuil* (fig. 1) present every element in the scene as something distinctive, differentiated by brushwork and color, rather than absorbed into an overall effect. The painter's eye registers everything as potentially of equal interest, rather than focusing on any key point. Such indiscriminate vision presented a particular view of the essence of modernity; this was not simply a matter of the presence of contemporary items such as railway bridges and trains. Rather, it involved the juxtaposition of varied and potentially discordant elements without attributing any clear hierarchy of significance to them. At the time, a fascination with effects like these was often characterized as *curiosité*; this sort of viewing was championed by such critics as Baudelaire, but was heavily criticized by moralists for its failure to register any system of values.[5]

By the mid-1870s Monet's treatment of his subjects began to change. In place of the crisp painterly shorthand that stressed the diversity of the objects in the scene, he began to adopt a smaller and more fragmented touch, introducing more complex nuances of color. The tonal contrasts that helped to differentiate between objects in earlier paintings now gave way to a concentration on colour relationships. Separate elements increasingly became absorbed into an overall effect, as in *Vétheuil in Summer* of 1879 (fig. 2), in which the forms of buildings and foliage seem to dissolve into a play of soft colored touches. This development marks a significant shift in his way of viewing his subjects; now the emphasis is more on the act of seeing than on the objects seen.

Fig. 2 *Vétheuil in Summer*, 1879 (W.534), Art Gallery of Ontario, Toronto, Purchase 1929.

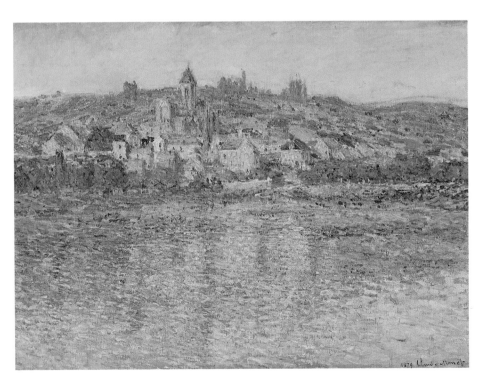

Monet himself did not leave any indication of the way in which he viewed these changes in his art. However, a letter from Camille Pissarro in 1890 about the development of his own career gives a valuable clue to their significance: "When I was about forty [i.e. around 1870], I began to understand my *sensations*, to know what I was seeking, but only vaguely; when I was fifty, that is in 1880, I formulated the idea of unity, but without being able to render it; now, at sixty, I am beginning to see how to render it."[6] This notion of unity as the painter's goal marks a significant shift in focus. No longer was the *sensation* an end in itself; now a further stage was necessary in order to bring these *sensations* together into a coherent work of art.

Hindsight from the critical perspective of post-Second World War modernism has viewed this in terms of an increasing emphasis on purely pictorial qualities — the painted mark on the two-dimensional canvas. Yet, in the late nineteenth-century context, the way in which Monet conceived the act of seeing was crucial, as well as the ways in which he transformed his *sensations* into paint — or, in Cézanne's terminology, "realized" his *sensations* in paint. These concerns, with the *sensation*, and with the ideas of realization and unity, remained central to Monet's art throughout the remainder of his career. The unity of the moment of vision is recreated by the harmonies and rhymes of color and touch that bind the picture together.

In the mid-1870s Monet continued to treat explicitly contemporary subjects in this more fragmented manner, but in 1878 he moved his base away from the Paris region to Vétheuil, a small and largely unchanged village on a remote loop of the Seine. His subjects here — rural river banks, meadows, and old villages (for example, fig. 2) — were close to those chosen by many more conventional painters who exhibited at the Paris Salon, and differed from them only in their treatment.[7] In the same years, several of Monet's Impressionist colleagues also turned their backs on the imagery of modernity. Not until his London series of 1899–1904 did Monet again tackle overtly modern themes.

These changes in Monet's technique and subject matter in the mid- to late 1870s raise fundamental questions about the definition of "modern" painting. In the 1860s and early 1870s the watch-cry of artists seeking to challenge academic conventions had been "One must be of one's time"; being "of one's time" was generally agreed to involve an engagement with the novel aspects of the imagery of the contemporary world. Yet by 1880 Monet was pursuing a notion of the "modern" through his treatment of his subjects alone, irrespective of the subject treated. In the debates around the issue of *curiosité* in the 1860s, a key concern had been with the dangers of choosing to view things that were morally or aesthetically inappropriate; but the central underlying concern was that the eye might float free of ethical concerns altogether — that

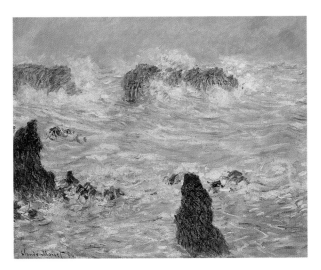

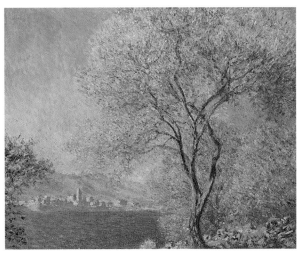

the pleasures of sight were absolutely independent of any value attributed to the object seen. On this argument, Monet's modernity lay in the extraordinary acuity of his vision, stripped bare of prejudices and preconceptions, a vision that allowed him to explore the pictorial potential of any and every scene.[8]

Yet it would be wrong to disregard his choice of subjects. Throughout the 1880s, too, Monet explored another theme favoured by Salon painters, the scenery of the coasts of France. In his pictures of the coasts of Normandy, Brittany and the Mediterranean, he often painted motifs very similar to those chosen by Salon painters or recommended by the tourist guides of the period.[9] However, his primary focus in these paintings was the most extreme effects of light and weather, ranging from the Atlantic storms pounding the granite coasts of Belle-Ile to the intense luminosity and color of the southern light (see figs. 3 and 4). To evoke these effects in paint, he deployed an extraordinary variety and virtuosity of technique, capturing a breaking wave with a flurry of dynamic hooks and flecks of paint, or the play of light across foliage by the most delicate gradations of hue and touch.

In these paintings from his travels Monet was seeking to bring out what he saw as the most distinctive characteristics of each site, and commented in letters on what it was about a place that he was seeking to capture. Occasionally he mentioned the physical structure of the landscape and the local flora, but his prime concern was with the dominant tone or mood of a place; as he wrote from Antibes, on the Mediterranean, in 1888, "After terrifying Belle-Ile, this will be something tender. Everything here is blue, pink, and gold, but my God, how difficult it is."[10] There is a fascinating slippage in his language here between mood and color – between the emotive and the optical. It is the scene in front of him – and especially the weather and light – that makes the emotional impact on the painter, and it is this impact that the painter seeks to transmit to the viewer.

The landscape is not the vehicle for the transmission of private psychic anxiety, as it was to be in the landscapes of Munch. Monet's paintings from his travels of the 1880s at the same time represent his struggle to capture nature's most extreme elemental forces and are a demonstration of the painter's genius, in his mastery of this astonishing range of effects.

In the exhibitions of the Impressionist group and the other exhibitions in which he showed his work between 1872 and 1886, Monet emphasized the diversity of his art, in subject and treatment. Since the 1860s he had on occasion painted more than one canvas of the same view in different conditions, but he made nothing of these groupings in his exhibitions, wishing to present the widest range of his art, presumably in order to stress his versatility and to attract buyers. During his travels of the 1880s he began to paint larger numbers of canvases of some motifs, viewing the identical subject in different conditions of light and weather, but he did not exhibit these together as distinct entities, preferring to display the range of subjects he had found at a particular place. Of the ten views of Antibes that he exhibited in 1888, only two, as far as we can see, were of a single subject; five canvases of a single subject from the valley of the Creuse were shown together in 1889, but these were only a small part of a major retrospective of his work. In part, the diversity of his exhibits may have been the result of pressure from the dealers who were buying and displaying his paintings. It was during the 1880s that his art first found a regular market through art dealers, initially through Paul Durand-Ruel. Later in the decade other dealers began to buy, too; the Antibes exhibition in 1888 was organized by Theo van Gogh, brother of the painter and manager of a branch of the leading dealers Boussod et Valadon; the 1889 retrospective was mounted by another dealer, Georges Petit.[11]

However, it was Durand-Ruel who launched Monet's public career in a new direction in 1891, by presenting an

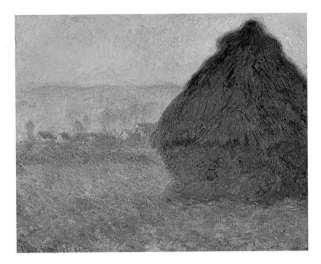

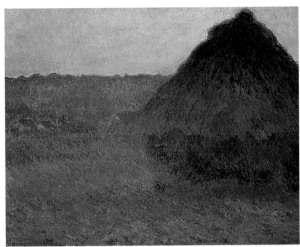

Fig. 5 *Grainstack at Sunset*, 1891 (W.1289), Museum of Fine Arts, Boston, Juliana Cheney Edwards Collection.

Fig. 6 Grainstack in the Sunlight, 1891 (W.1290), Courtesy of Helly Nahmad Gallery, London.

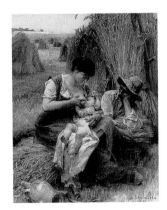

Fig. 7 Léon Lhermitte, *Rest*, Salon of 1888, present whereabouts unknown.

exhibition of Monet's recent work whose centrepiece was a series of fifteen canvases of a single subject – of grainstacks in a field (figs. 5 and 6). Arguably, this exhibition was the most crucial turning-point of Monet's whole career. In their subjects and their treatment, and in the way in which they were exhibited, the Grainstacks marked out a path that Monet was to follow for the rest of his life.[12]

In contrast to the spectacular scenery that he had painted on his travels in the 1880s, the stacks of grain were, in conventional terms, a wholly unpicturesque subject: simple monolithic shapes on a flat field, backed by cottages, trees, and a line of hills. Certainly, images of stacks of grain were a commonplace in the landscape imagery of the period, in the images of harvest and agricultural plenty that were the staple diet of every year's Salon exhibition, as for instance in Léon Lhermitte's *Rest*, shown in the 1888 Salon (fig. 7). However, the thematic resonance of Monet's stacks is minimized by the way in which they are presented. There is no direct reference to agricultural labor – to the making of the stacks or to their use in the community; only the cottages hint at a human presence. The dominant theme of the paintings is not the stacks but the effects of light that play across them, transforming their simple shapes into rich and endlessly varied harmonies of color.[13]

The viewer's attention is distracted from the subject still further by the technique of the paintings, whose surfaces are built up from dense superimposed layers of paint. At times, broader strokes, laid on quite early in the process of execution, remain visible; but the final surfaces are largely made up of a complex and variegated skin of colored touches. In the paintings from his travels of the 1880s, the elaborate brushwork had consistently sought to draw out the distinctive physical characteristics of the subjects as well as their mood. By contrast, in the Grainstacks there are no obvious representational points of reference in the shapes and textures of the paint-marks that Monet added

in the later stages of the execution of the paintings. Instead, they serve to accentuate the complex color harmonies of the paintings themselves.

This increasingly complex paint-handling involved a crucial paradox that was to dog Monet for the rest of his career. As his vision became more attuned to the smallest changes in lighting, the execution of his pictures became increasingly protracted; the most transitory effects had to be recreated over a period of time after the initial effect had passed. In the 1880s it had been his practice to retouch the paintings from his travels in his studio after his return home; but with the Grainstacks these problems were exacerbated, both by the ephemerality of the effects he was seeking to capture, and by the complex effects of touch and color that he saw as necessary to a fully resolved painting. He explained the problems he faced in a letter to Gustave Geffroy while he was working on the Grainstacks:

I'm working away at a series of different effects [of grainstacks], but at this time of year the sun sets so quickly that I can't keep up with it . . . I'm becoming so slow in my work that it makes me despair, but the further I go, the better I see that it takes a great deal of work to succeed in rendering what I want to render: "instantaneity," above all the enveloping atmosphere [*enveloppe*], the same light diffused over everything, and I'm more than ever disgusted with things that come easily, at the first attempt. In short, I'm more and more consumed by the need to render my experiences [*de rendre ce que j'éprouve*] . . .[14]

The final surfaces of the paintings must effectively have been produced in the studio, and elaborated to their finished state in relation to the other paintings of the series, far from the initial light effects that were their starting points.

The role of studio reworking became ever more central in his later series, especially those whose subjects were

Fig. 8 *Poplars on the Banks of the River Epte*, 1891 (dated 1890) (W.1300), Tate Gallery, London (4183; on loan to National Gallery, London).

Fig. 9 *Poplars on the Banks of the River Epte*, 1891 (W.1298), Philadelphia Museum of Art: Bequest of Anne Thomson in memory of her father, Frank Thomson, and her mother, Mary Elizabeth Clarke Thomson.

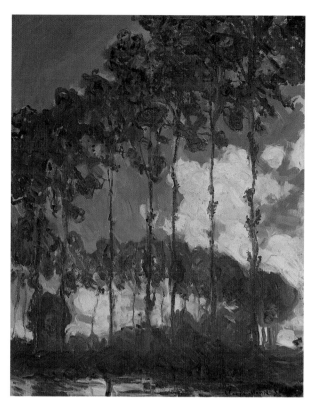

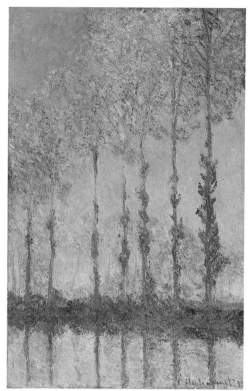

away from his home at Giverny, notably the series of London and Venice (see below, pp. 128–47 and 178–91). The numerous pentimenti in the series paintings further reveal the complex processes by which they were made. In many of the Grainstack canvases, the placing of the stacks themselves was altered during the execution of the canvas; in the first series of the Water Garden and the London paintings, the position of the bridges was often adjusted, as was the placement of the lily pads in many of the series exhibited in 1909.

The exhibition of the Grainstacks in 1891 would have further diverted attention from the subject matter of the pictures. Each new canvas added little information about the scene itself, apart from variations in the placing of the stacks. The principal focus would have been the constant variety of the weather effects and of the color harmonies that Monet used to transform these effects into paint. Monet himself insisted that the paintings in the exhibition "acquire their full value only by the comparison and the succession of the whole series."[15] But of course the individual pictures from the series were for sale, separately; their "full value" could be comprehended only during the short period that the exhibition was on view. Only with the *Grandes Décorations* did Monet find a way to transcend this central paradox in his notion of the series.

The subject matter of Monet's subsequent series was very varied, ranging from the zigzagging ranks of poplars on the banks of the River Epte (figs. 8 and 9) to the medieval façades of Rouen (fig. 10) and Venice and the fusion of the

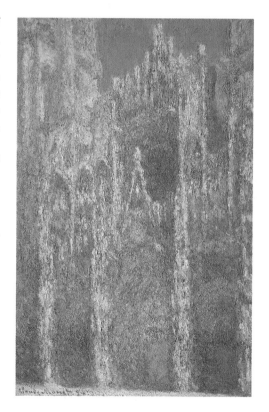

Fig. 10 *Rouen Cathedral, Sunlight Effect*, 1892–4 (W.1356), Museum of Fine Arts, Boston, Julia Cheney Edwards Collection.

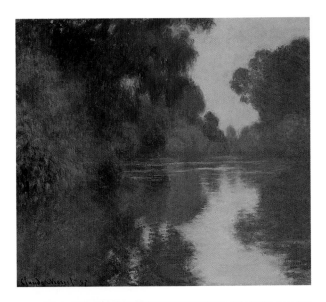

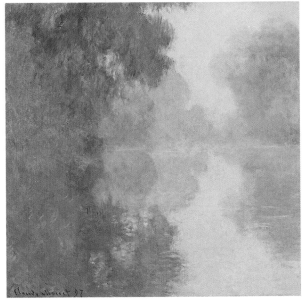

monumental and the industrial on the banks of the River Thames in London. Each subject, taken separately, was rich in associations, whether historical, political, nationalistic, or religious.[16] However, there is no sense that these successive series represent any sort of coherent thematic sequence; each differs from the last in both its forms and its connotations. Moreover, as with the Grainstacks, the subjects were presented in ways that downplayed their human significance, and the way in which they were exhibited would have augmented this effect. The central preoccupation in all of the series was the range of light effects that played across the varied surfaces of the forms in the scene, translated into colored touches on the canvas.

Monet himself insisted that the physical subjects of his paintings had little significance. He commented in 1891, at the Wheatstacks exhibition, "For me, a landscape does not exist in its own right, since its appearance changes at every moment; but the surrounding atmosphere brings it to life, the air and the light, which vary continually ... For me, it is only the surrounding atmosphere that gives subjects their true value."[17] Interviewed in Norway in 1895, he repeated this message: "To me the motif itself is an insignificant factor; what I want to reproduce is what lies between the motif and me." "I am pursuing the impossible. Other painters paint a bridge, a house, a boat ... I want to paint the air in which the bridge, the house, and the boat are to be found – the beauty of the air around them, and that is nothing less than the impossible."[18]

Yet Monet's choice of the subjects for his series was clearly not haphazard. He discussed this in rather different terms in 1892, in some of the most far-reaching comments on his own art that have survived, recorded by the American painter Theodore Robinson:

> He said that he regretted he could not work in the same spirit as once, speaking of the sea sketch Sargent liked so much. At that time anything that pleased him, no matter how transitory, he painted, regardless of the inability to go further than one painting. Now it is only a long continued effort that satisfies him, and it must be an important motif, that is sufficiently inspiring – "Obviously, one loses on one side if one gains on another, one can't have everything. If what I do no longer has the charm of youth, then I hope it has some more serious qualities, and that one might live for longer with one of these canvases."[19]

In common artistic parlance at the time, the motif was not simply a neutral term describing a landscape subject; rather, it was a subject that gained added value from its historical and poetic associations or its picturesque forms, or both. By this criterion the façade of Rouen Cathedral would clearly have qualified as a motif, but equally the banks of the River Seine at dawn, as shown in the series of

Mornings on the Seine (figs. 11 and 12), would not. What, then, made a motif "inspiring" for Monet?

The key factor was that it should offer the potential for protracted exploration, and, more specifically, that its forms, colors, and textures could act as the base, as the raw material, for a series of variations of light and color. The subject might be picturesque in conventional terms; but Monet made it clear, in discussing his responses to London, that atmospheric effects could transform a subject that offered little in its own right: "I adore London, it is a mass, an ensemble, and its so simple. What I like most about London is the fog. How could the English painters of the nineteenth century have painted its houses brick by brick? Those fellows painted bricks that they didn't see, that they couldn't see." "Without the fog, London would not be a beautiful city. It's the fog that gives it its marvellous

Fig. 14 *The Thames below Westminster*, 1871 (W. 166), National Gallery, London.

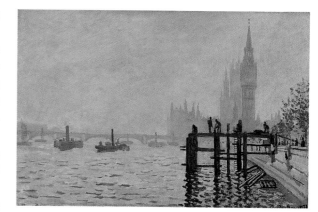

breadth. The regular, massive blocks become grandiose in this mysterious cloak."[20]

A further factor in Monet's choice of subjects was his recurrent wish to return to sites that he had painted many years before, as if to test out his art and his eye against his previous paintings and memories. His return visits to London in 1899–1901 were the fulfilment of a long-cherished plan to revisit the sites that he had painted in 1871 (fig. 14), and his contemporaneous series of Vétheuil was a renewed exploration of his motifs of 1879–81 (figs. 2 and 13).[21]

For Monet, the distinctive quality of a site lay in what he called the *enveloppe* – its distinctive light and atmosphere. Clearly in the first instance his notion of this distinctive light derived from his direct observation and the practical experience of painting directly in front of the scene. However, as he worked he developed a clearer idea of what he saw as the essential characteristics of a place, and might be forced to revise paintings that he had executed from nature in the light of this idea. In a revealing letter written in 1900 during his second spell in London, he described how he had realized that some of his paintings, that he thought almost finished, were "not London-like enough [*pas assez londoniennes*]"; he had been forced to add "some bold brushstrokes" in order to bring them into

Fig. 13 *Vétheuil*, 1901 (W. 1643), The Art Institute of Chicago, Mr. and Mrs. Lewis Larned Coburn Memorial Collection.

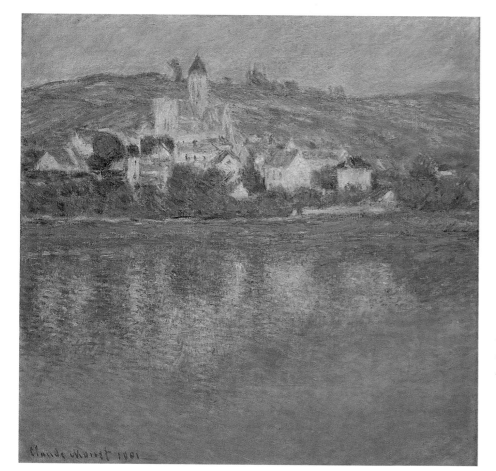

line with his idea of London.[22] On this occasion, the realization struck him while he was in London and able to refer back to the subject (albeit in changed lighting conditions). Often, though, this process of revision must have taken place in the studio; indeed, at the end of his final spell of work in London he concluded that "this is not a place where one can finish on the spot,"[23] and the London paintings were not exhibited until more than three years later.

This process of "realization," with all the revision and elaboration it involved, must have been central to Monet's pursuit of the "more serious qualities" in his paintings that he mentioned to Theodore Robinson in 1892: qualities that emerged only if he was able to go beyond the quick sketch, and qualities that allowed people to "live for longer" with his pictures. Conceptually, this aim made a clear distinction between different notions of time. The time embodied in the subject itself was the moment – the fleeting light effect – that was the starting point of the picture ("instantaneity," as he had described it to Geffroy). However, the picture was completed over an extended period, first of scrutiny of the external world, and then, crucially, of reworking, during which Monet's only points of reference were the colored marks that were already on the canvas, together with the other canvases of the same subject around him in the studio. Finally, he wanted the viewer to be able to live with the picture "for longer" – in a time that belonged within the viewer's subjective experience.

In these terms, there are fascinating parallels between Monet's program and the aesthetic ideas that the Symbolist poet Stéphane Mallarmé, by this date a close friend of Monet, was propagating at the time. In an interview in 1891 Mallarmé spoke of the role of the reader in the gradual decipherment of the work:

I think that there should only be allusion. The contemplation of objects, the image emanating from the dreams that the objects excite, this is poetry. The Parnassian poets take a thing whole and reveal it; through this they

lack mystery; they deny the human spirit the delicious joy of believing that it is creating. To name an object is to suppress three-quarters of the enjoyment of the poem, which is created by the pleasure of gradually apprehending it. To suggest it, that is the dream.[24]

Although we do not know how far Monet himself would have endorsed Mallarmé's program, he did insist at this date that the quality that he was seeking in his paintings was "mystery."[25] Moreover, similar language was used in these years by many critics, notably Gustave Geffroy, Georges Lecomte, and Octave Mirbeau, all three friends of Monet, to characterize his paintings and the effect they had on the viewer.[26]

In his surviving letters and recorded conversations Monet went no further in defining the experience that he sought to give the viewer; but the clearest evidence lies in the pictures themselves. From all of his series, a number of canvases survive that he did not regard as finished – or "realized" – at the time that he exhibited the series. Many of these he signed and sold late in his life (for example, cats. 15 and 17), and others remained in his studio at his death. Comparison of these with the paintings that he included in the series exhibitions (for example, cat. 14) shows what sort of effects he was seeking as he worked up a canvas to exhibition finish. In each case the unfinished works are broadly and rapidly sketched, in an informal technique reminiscent of many of Monet's canvases of the 1870s. By contrast, the finished paintings are more finely and elaborately worked, and their color schemes are carefully harmonized, with sequences of related hues recurring all across the canvas.[27] The result is complex but coherent, creating an immediate impact on the viewer, but offering a multitude of nuances and subtleties that can be explored at leisure. This was Monet's equivalent of the "unity" that Pissarro had "begun to see how to render" by 1890.[28] In 1892 Pissarro stated that he could achieve "the unity that the human spirit gives to vision" only by executing his finished paintings in the studio.[29] Monet never admitted this abandonment of his Impressionist principles, and, as far as we can tell, virtually always began his canvases on the site; however, as we have seen, their final effects, too, depended more on studio reworking than on the initial stimulus of the natural scene.

In some groups of finished paintings, for instance the Grainstacks and especially the Rouen Cathedral series, the resulting paint surfaces are densely impasted, bearing testimony to protracted reworking. In others, notably the Mornings on the Seine (figs. 11 and 12), the final effects of color and touch are just as complex, but are achieved without such extensive revisions. Presumably with this series, based on a scene with which he was very familiar, Monet was able to realize more rapidly the essential qualities that he wanted the series to convey, without the same

extended "laboratory" experiments in his studio. A similar contrast can be seen within a single series, in the Water Lily paintings exhibited in 1909 (see below, pp. 148–50). Those that bear the earliest dates – 1904, 1905, and 1906 – are for the most part much reworked, whereas those dated 1908, in particular, are extremely thinly painted and diaphanous, though without any loss of subtlety. The dates on these paintings were presumably added only in 1909, when they were ready for exhibition,[30] but we can assume that they reflect the date at which Monet began work on each canvas. His letters about his problems in finishing this series clearly reveal his difficulties in bringing them to the state he sought.[31] Only in 1908 did he see clearly what he wanted; consequently he was able very quickly to realize the final paintings to his complete satisfaction, whereas those begun earlier were repeatedly reworked in the studio and brought to realization only in 1908–9.

In his series paintings Monet was determined to remain true to his *sensations* of his chosen subject. Yet, in going beyond the quick sketch and the single canvas, he wanted "the comparison and succession of the whole series" to bring out what he saw as the essence of the subject; but this essence might elude him as he worked on each picture in turn, as in the London paintings that were "pas assez londoniennes." Initially his conception of a subject necessarily derived from his *sensations*; but at the same time it might need to be superimposed onto a group of paintings as he brought them to completion. In his early works his conception of a subject was inseparable from his perception; in the series, at some stage in the process, perception was subordinated to conception, and it was ultimately his ability to express his conception of a subject that allowed him to achieve the "more serious qualities" he sought.

Monet's late works embody a further paradox in the relationship between nature and art. For the water-lily pond at Giverny that was his favored subject was entirely of his own making. Although subject to the laws of natural growth, and at times to the destructive forces of the elements, this was "nature" wholly modeled to please the artistic eye and to offer subjects for his painting. Although Monet later said that originally he had planted his water lilies without thought of painting them, it is clear that from the inception of the water garden in 1893 he saw it as a source of potential motifs.[32] As the pond and garden appeared in their initial, small form in the series exhibited in 1900, and then, much enlarged, in the 1909 series and the *Décorations*, their forms were the product of Monet's visual imagination, combined with the skills of his gardeners and the fruits of the plant and seed catalogues that he so assiduously studied.

In thus forging "nature" to his own specifications, Monet had the precedent of the Japanese garden. Monet was an avid collector of Japanese prints, and, by the 1890s, could have had access to many sources of information about

Japanese gardens. Although in 1904 he said that he had not sought any resemblance to a Japanese garden, in 1909 he described the foot-bridge as "genre japonais,"[33] and the principles of design of the garden in many ways echo those of the Japanese garden, and particularly of the "tea gardens" or "strolling gardens" of the seventeenth and eighteenth centuries. Specifically, the garden was designed to be seen from many viewpoints, in such a way that it appeared larger than it was; the shapes are irregular, and contours of forms such as the pond are partly veiled; trees overhang the water and are reflected in it.[34]

The Water Lily series exhibited in 1909 marks another crucial stage in the development of Monet's picture-making. For it was only while working on the series that he began to focus exclusively on the water surface, unframed by reeds or the bank of the pond. In a late interview with Thiébault-Sisson, he described his concerns in the series:

> I have painted these water lilies a great deal, modifying my viewpoint each time . . . The effect varies constantly, not only from one season to the next, but from one minute to the next, since the water-flowers themselves are far from being the whole scene; really, they are just the accompaniment. The essence of the motif is the mirror of water, whose appearance alters at every moment, thanks to the patches of sky that are reflected in it, and give it its light and movement . . . So many factors, undetectable to the uninitiated eye, transform the coloring and distort the planes of the water . . .[35]

As we have seen, in Monet's paintings from the late 1870s onwards, and especially in the series, his central concern was to find ways of giving a sense of the unity of his whole field of vision. In the Water Lily paintings, this visual field becomes coextensive with the water surface; the ambient *enveloppe* is reflected on this surface. In Thiébault-Sisson's account, the lily pads were only an "accompaniment"; however, they serve a number of vital functions in the compositions, acting as a counterpoint to the forms of the reflected trees and clouds, and indicating, by their perspective, the receding plane of the water surface. Beyond this, the animated brushwork and color that Monet used in painting the pads and flowers create the pivotal points of reference around which the compositions revolve.

The paintings in the 1909 exhibition, like Monet's previous series, were for sale separately. However, in the late 1890s, even before he had begun his first series of the pond, he had conceived the idea of using the pond as the subject for a decorative scheme, to be installed around the dado of a circular room, below the molding, and had begun making studies for the project.[36] The idea was actively in his mind again at the time of the 1909 exhibition, when an interview recorded Monet's wish "to decorate a circular room of modest dimensions" with the painting all round the room, "up to half a man's height"; this room would be a dining room, with just a central table.[37] However, the project began to come to fruition only in 1914, when he started to work on a far more monumental scale than he had planned, on the canvases that were to lead to the *Grandes Décorations*.

Monet's plans up to 1909 were clearly for a private, domestic decoration; the spectator would have been placed above the scene, looking diagonally downwards towards the floor, as if on an islet surrounded by water. However, the final project was for something far larger and less intimate in scale. The plans for the installation of the *Décorations* went through changes, moving from the gardens of the Hôtel Biron (the Musée Rodin) to the converted spaces in the Orangerie in which it was finally installed. But from the outset Monet clearly envisaged this as a public work – public in scale, with its long sequences of canvases, each two meters high, and in the public setting of a museum.

Yet, paradoxically, the subject remains intensely private. As we look round the oval halls in the Orangerie, we are still invited to imagine ourselves on an island in the midst of a wide expanse of water – so wide that we never see its far banks. The enlarged scale means that we no longer look down into the paintings, but frontally at them; the invisible horizon, above the top edge of the canvases, is well above the eye-level of even the tallest visitor. Yet the experience remains intimate, as we scan these vast reflecting water-surfaces, punctuated in the inner room by willow-trunks.

Indeed, the viewpoints in the Orangerie are a reversal of the ways in which Monet himself would have viewed his pond. Installed as the *Décorations* are, we seem to look outward; but there is no central island viewpoint at Giverny. The imagined viewpoints that he recreated in his studio were from various points around the edges of the pond, looking inward and across its surfaces. This reversal of directions of vision is strangely (and coincidentally) like the current arrangement of the marble reliefs from the Parthenon (the Elgin Marbles) in the British Museum.[38]

In a sense, the all-round experience of the *Décorations* invites comparison with the painted panoramas that attracted such attention in the nineteenth century (for example, figs. 15 and 16). Viewed from a central look-out, these panoramas sought to give the viewer a startling illusion of reality by carefully manipulating the perspective of the scenes, so that they read correctly from any position on the viewing platform.[39] These panoramas were a genuinely popular art form; they focused on topical and quintessentially modern subjects such as cityscapes and recent battles, and attracted vast crowds when presented as part of big exhibitions such as the World's Fair of 1889.[40] Monet's *Décorations* are not installed like panoramas, because the visitor enters them through doors in the walls. However, the fundamental difference is that the panorama

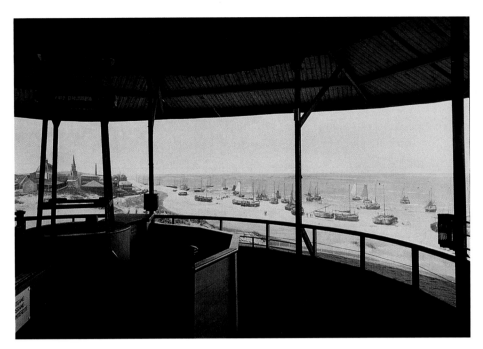

Fig. 15 Mesdag Panorama, The Hague. The viewing platform.

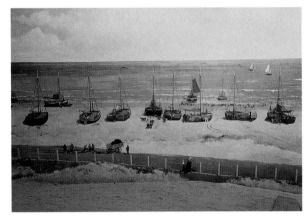

Fig. 16 H.W. Mesdag, *The Mesdag Panorama* (detail), 1880–81, Mesdag Panorama, The Hague.

placed the viewer in a position of power, on a commanding viewpoint that opened out a huge world to the eye, whereas, despite their size, the *Grandes Décorations* close down the scope of the viewer's gaze, by excluding the horizon and directing the eye downward onto the water surface. Only the reflections of clouds and sky hint at the huge spaces of a world above the water and beyond the enclosed garden. Moreover, unlike the illusionistic technique of the panoramas, the *Décorations* are treated in an emphatically painterly way. From wherever they are viewed, the complexity and animation of their paint surfaces are evident.

The viewer of the *Décorations* is free to look at them from near as well as far, which allows them to be seen in very different ways. Standing back in the center of the rooms in the Orangerie, the entire room is sensed as a whole although the eye explores it sequentially – like a panorama. Equally, one can immerse oneself in a single panel, stationary, and exclude any sense of its edge, of any

boundaries. Finally, moving in close to the painted surfaces, one finds that the image dissolves into paint, the lily pads and cloud reflections into calligraphic brush-marks. These are three quite different ways of viewing the whole project. Clearly the last, with its emphasis on the brush-mark, the gesture detached from its representational function, is what has particularly attracted the attention of artists and critics since 1945. But, as we have seen, even Monet's last pictures remain centrally concerned with his *sensations*, with his visual experiences of the external world, and with his explorations of the ways of "realizing" them in paint.

The very loose and improvisatory brushwork on parts of the *Décorations* raises questions about their degree of finish. The precarious health of Monet's final years, and notably the problems with his eyesight that led to operations for a cataract in 1923, meant that he worked only intermittently on the monumental paintings, and at times came to regret revisions that he had made to them. In addition, his changing plans for their installation meant that a number of canvases that were originally intended as part of the *Décorations* were omitted from the final scheme; some of these are included in the present exhibition (cats. 90–92).[41] Those that formed part of the original scheme are densely reworked, whereas Monet left off work on other canvases of the same format at a far earlier stage. Presumably, when he began them, Monet viewed all of the paintings of the same format as the *Décorations*, two meters high, as potentially a part of the *Décorations* themselves; however, we cannot be sure whether he regarded those that he discarded as complete works or as somehow unresolved. Indeed, in a sense, the final state of all the monumental paintings, including those in the Orangerie, should be regarded as provisional.

The assessment of Monet's late work is further complicated by the existence of many smaller unfinished works and preparatory studies, now viewed as works in their own right. In some of these, the paint-handling is very loose and at times seemingly incoherent; in addition, the strange coloring of some paintings, notably of the Japanese footbridge and the garden beside the house (cats. 79, 80, 86, and 87), is presumably the result of Monet's cataract, both before and after the operations.[42] Pictures such as these have aroused particular interest in the context of post-1945 abstraction, but it seems unlikely that Monet himself would have sanctioned their exhibition. Indeed, one suspects that a number of paintings survive that he would have wished to have been added to one of his legendary bonfires of paintings that did not satisfy him.[43]

In the broadest sense, in terms of his sustained commitment to realizing his personal sensations in paint, Monet was an Impressionist to the last. Yet, as we have seen, the view of the world that his paintings present changed in very many ways. The early works, from the late 1860s and early 1870s, look actively outward at the public spaces of the

modern world, fascinated by their variety; however, he explored his motifs only in single modestly scaled paintings, intended for sale to private collectors, rather than in the big public forum of the Salon or in a public art form such as the panorama. The *Grandes Décorations*, by contrast, adopt a form comparable to the panorama, and were designed for public spaces; but their vision is essentially inward-looking and private, despite their huge scale.

In his long career, three turning-points can be isolated that help to define what was new in his later work. The first of these was the gradual shift, from the mid-1870s onward, away from a focus on the objects seen to the act of seeing. The second was his pursuit of "more serious qualities" after 1890, as he came to paint and exhibit his pictures in series, and wanted the viewer to be able to "live for longer" with his pictures. The final change was the shift to mural-scale decorations; this transforms the work itself – no longer a portable commodity for private consumption, but part of a permanent public environment. This development marks a clear rejection of the ephemerality of the sketch, and, with this, of the aesthetic position for which the Impressionists had been notorious during the 1870s. Instead, the *sensation* now needed to be distilled and pondered into a pictorial unity before it could reach its artistic realization. The *Grandes Décorations* stand as the culmination of this process.

The notes for this essay begin on page 285.

THE REVOLUTION IN THE GARDEN: MONET IN THE TWENTIETH CENTURY

Paul Hayes Tucker

The Work: Painted and Horticultural

Between 1900 and his death in 1926, Monet produced some of the most novel paintings of his career – nearly four hundred and fifty views of London, Venice, and his gardens at Giverny that today are justifiably hailed as landmarks of late Impressionism. Filled with beauty, daring, and bravura, they stand as eloquent witness to an aging artist's irrepressible urge to express his feelings in front of nature. They also attest to his persistent desire to reinvent the look of landscape art and to leave a legacy of significance.

The number is impressive, especially when we realize that there were many years when Monet hardly touched a paintbrush and many others when he painted pictures that are far larger than standard size, especially the more than forty late Water Lilies, some of which are as long as six meters apiece. Equally daunting is the fact that Monet created these hundreds of paintings after turning sixty and that he worked on the last of them up until a month before his eighty-sixth birthday.

Approximately one hundred of the four hundred and fifty depict sites in London where he went between 1899 and 1901; another thirty-seven, areas in Venice where he and his second wife Alice Hoschedé vacationed in 1908. The remaining three hundred or so – nearly three-quarters of his entire output – represent aspects of his floral and water gardens: the rose-covered path leading up to his house, the artfully planted flowers on either side of that *allée*, the water-lily pond across the road and railroad tracks that divided his property, the Japanese bridge over the northern end of the pond, the irises along its sloping banks, and the weeping willow standing like a soulful orator shaking its tousled hair against the light on the pond's eastern edge.

That Monet concentrated so much of his artistic interest on his own acreage and handiwork and was able to extract so many paintings of [...] btle variety was unprecedented in his career, [...] among the other landscape painters [...] bably fair to say that no other site [...] ons inspired so many paintings b[...] the history of Western art. [...] tings are enormously d[...] ce, and technique. For[...] plex, even though they

rely on relatively simple means and depict easily recognizable subjects. Conceptually, they are not readily pinned down, despite what may appear to be fairly clear intentions. Visually, they can be shifting and unstable one moment, peaceful, calm, and reassuring another. While the product of some of the most severe restrictions Monet had ever placed upon himself, these three hundred canvases defiantly deny the notion that restrictions are a limitation, or that simple sites and subjects arise from simple ideas or yield easy results. As such, they define one of the fundamental norms of artistic practice in the twentieth century.

Elusive and mysterious, though fully measurable and humane, these paintings assert that Monet's physical remove to Giverny did not mean a relaxation of his intellectual and aesthetic powers. On the contrary, the time he spent observing his flowers, trees, and pond engendered a profound refocusing of those strengths as a personal imperative, largely in response to the pressures of the very contemporaneity he appeared to have abandoned. For while they may seem to be about nothing other than the beauty he found in his own backyard, these three hundred pictures were actually created in the midst of conflict and turmoil – the death of family members, his own threatened blindness, the perceived erosion of aesthetic principles in French art, the abandonment of nature, and worst of all perhaps, the horrors of the First World War. They encapsulate an entire era as seen and felt by an individual who by 1900 had become one of the world's most celebrated painters.

Monet's rise to international status at the dawn of the twentieth century is a complex tale essential to an understanding of his late work. Riddled with ironies, it takes Monet and his colleagues from their rebellious emergence in the 1860s to the heights of their profession. By the end of the 1890s, all of the once-reviled Impressionists were represented in the Musée du Luxembourg (the national museum for living artists); Renoir had been awarded both a government commission and the Légion d'Honneur, a decoration that was apparently offered to Monet as well although he is said to have refused it.[1] In 1900 Impressionism celebrated its fortieth birthday with its reigning members included in a room of their own in the Fine Arts section of the Paris World's Fair. Not surprisingly,

its privileged position as the only avant-garde movement in France had been compromised by the emergence of other modernist groups, such as the Neo-Impressionists, the Symbolists, and the Intimists, as well as by such younger practitioners as Toulouse-Lautrec and Van Gogh. All of these artists gave Impressionism a vintage look, making it appear less threatening. Furthermore, by the end of the century Monet and his colleagues were also widely imitated by mainstream painters.

The story ends for Monet in the late 1920s with the opening of his own museum, the Orangerie, housing nothing but his huge Water Lily decorative panels. Totally redesigned and renovated at state expense, the former greenhouse for Napoleon III stood on the southwestern corner of the Tuileries gardens, one of the most history-laden sites in Paris, with the Place de la Concorde and the Champs-Elysées at one end and the Musée du Louvre at the other. It was the perfect closing chapter.

The fact that Monet's story culminated so enviably provides one of the more revealing lessons in the history of art and taste. It owes its final lines to many authors and external forces, as Monet profited not only from the mainstreaming of Impressionism and the advantages of his advanced age but also from a host of political connections, unpredictable events, and converging interests. He managed many of these with exceptional skill; but they also often conspired against him with equal intensity, requiring further intervention as well as frequent doses of good fortune.

Before this story can be fully appreciated, however, a number of questions about the work Monet produced in the twentieth century must be addressed. Some are rather obvious – for example, why did Monet become so preoccupied with painting his gardens after having spent so many years rendering a broad range of sites and subjects? Others are less straightforward: How did the work evolve? What issues was Monet addressing? How did he conceive of his enterprise?

Unfortunately, simplistic answers to these questions, promulgated during Monet's lifetime, have persisted relatively intact to the present. Because of these, most people still believe that Monet built his gardens at Giverny to wall himself off from the world and to satisfy his craving for close contact with nature; that he attended to these gardens to bring them to perfection and spent his last twenty-six years painting them like a pantheistic poet who surrenders himself to the marvels of the earth; that he followed his instincts and sensations rather than a preconceived plan or rational method, which allowed his art to develop in a logical manner from relatively clear images of his flowers and water-lily pond to veritable abstractions of the same motifs.

His failing eyesight has generally dominated the popular discourse on Monet's art of the twentieth century, to such an extent that it has often come to explain it.[2] His eye problems were not minor; they stemmed from cataracts that developed in both eyes and caused Monet considerable trauma. They also affected a suite of pictures (see cats. 86 and 87) in which the color balance is noticeably askew. But the cataract in one eye at least was successfully removed in 1923 and did not cause the so-called "blurriness" of his late pictures, nor did this condition lead him to abstraction. Many of Monet's late paintings are as legible as his earlier work of the century. Those that are less distinct are not so because he was painting through some kind of ocular gauze. They are either unfinished or the natural progression of his continuing experimentation, done consciously for specific visual and aesthetic effects.

Another mistaken notion is that Monet built his gardens all at once. He moved to Giverny in 1883 and lived there for nearly seven years before he purchased the house and grounds, traveling extensively during that period without demonstrating the same attachment to his property that he developed in the twentieth century. He began to renovate the kitchen garden that lay at his doorstep before signing the ownership papers on November 19, 1890, but it was only after filing these documents that the most extensive changes occurred. The fruit trees, berry bushes, potato patches, and vegetable rows were replaced by tens of thousands of flowers, bulbs, and plants laid out in carefully arranged geometric beds, many of which were elevated slightly above ground level for easier tending.

Three years later, in February 1893, he acquired a parcel of land that would become the site of his water-lily pond. It was physically divided from the house and flower garden by a country road that ran along the eastern side of the Seine from Gasny to Vernon, and by railroad tracks for a line that serviced Pacy and Gisors. Four times a day (except Sunday), a train rumbled down the tracks right through Monet's estate, a poignant reminder of his ties to the contemporary world.

Despite these apparent intrusions on his country calm, Monet bought the parcel with the intention of digging a pond "for the purpose of growing aquatic plants" that would provide "something agreeable and for the pleasure of the eyes and also for the purpose of having subjects to paint," as he stated in his letters to the prefect of the Département in March and July 1893 when applying for construction permits.[3]

Approval was granted and work proceeded apace. By 1895 his Japanese bridge arched over the narrow northern neck of the newly dug oval pond just where the water flowed out to rejoin the Ru, a tributary of the Epte. In 1901 he purchased an adjacent parcel of land for a modest 1,200 francs, which allowed him to more than triple the size of the pond to approximately 1,000 square meters. In 1905, he increased the presence of the Japanese bridge by building a trellis over it, which soon became woven with wis-

taria.[4] And in 1910 he altered the contour of the pond once more, making it even more subtle.

Just as he tinkered with the water garden, so did Monet play with the plantings in the flower garden, adding and subtracting species so that it was never exactly the same from year to year. In fact, it changed in appearance almost every week from spring to fall; Monet orchestrated the blooming cycles so that one species began to flower when another was passing, using nature's magical ordering system to create an evolving array of color, light, and texture, much like his own paintings.

Despite his love of flowers, Monet did not use all of the acreage at his disposal to plant his natural palette. In the early part of the decade, he built a greenhouse at right angles to the main *allée* so that he could grow plants from seed and — most important perhaps — preserve his precious water lilies during the winter months. (The flowers were taken out of the pond in late fall and replanted in the early spring.)[5] In 1897 he usurped more space to build a sizable structure for the gardeners in the northwest corner of his garden, where he later garaged his automobiles. On the second floor of this building he made a studio, freeing up a large room in the main house that he had used for that purpose since he arrived. Finally, in 1915, he built a third, even bigger studio on the western side of the house.[6] Containing 276 square meters of floor space crowned by huge skylights, this airy, light-filled environment was where he painted his monumental Water Lily panels during the last decade of his life.

Of course, Monet neither built these structures himself nor dug his gardens. By 1892 he was employing a full-time head gardener and five assistants, an indication of how extensive his estate had become and how much attention it required. In effect, he was the lord of a miniature manor, with all of the headaches and attendant responsibilities.

Monet's income was commensurate with his new status. He earned substantial sums by the end of the 1890s, and even more in the years ahead. In 1900 he made 213,000 francs; in 1904, 271,000 francs; in 1909, 272,000 francs; and in 1912 369,000 francs. These were fabulous figures — a Parisian manual laborer's annual wage at the time was approximately 1,000 francs.[7] Monet's soaring wealth was the result not only of selling art but also of wise investments. He played the stock market and was as good at picking winners (or heeding his financial consultant's advice) as he was at painting pictures. Monet's earnings explain his ability to support a large family, maintain and expand his estate, buy his son Jean a house nearby, purchase not one but two new automobiles for himself in 1901 and 1904 as well as cars for his son Michel and stepson Jean-Pierre Hoschedé, take vacations when he felt the urge, and eat and drink what he pleased. In short, the last two and a half decades of his life were free of material want.

The large amount of money that Monet invested in the transformation of his property suggests the seriousness with which he approached his work both as an artist and as a horticulturist. When he decided to devote himself to painting his gardens, he was not following a whim or instinct. He never chose his subjects casually, as Gustave Geffroy pointed out in a review of Monet's exhibition at the Durand-Ruel gallery in 1898:

One of the numerous fantasies born of the accidental appellation "impressionism" is to believe that these thoughtful and willful artists did not actually choose their subjects. Choice, on the contrary, was always their lively and important concern. But it is thus that legends are made; these painters are customarily portrayed as instruments indifferently aimed at every site, and the mistake goes along, repeating itself.[8]

Having followed Monet's artistic development more carefully than almost any other critic, Geffroy was speaking with some authority when he made his pronouncement. And while he was thinking about Monet's career as a whole, he was reacting specifically to Monet's paintings of the 1890s, whose subjects (stacks of wheat, poplars, the façade of the Rouen Cathedral, the Seine, and the coast of Normandy) suggested multiple meanings — about nature, the seasons, agrarian traditions, and the beauties of rural France. All of these were also tinged with nationalistic sentiments, which greatly contributed to their popularity.[9] Reviewing a show of Monet's Mornings on the Seine and paintings of the Normandy coast in 1898, one critic, Georges Lecomte, went so far as to declare that the then fifty-eight-year-old artist could be compared only "to Claude Lorrain. Monet . . . is the epic poet of nature . . . full of enthusiasm, indulgence, and serenity, extracting from nature all of its joys. Such a painter," he concluded, "passionate in his solitude about all of the hopes and fears of his time . . . is one of the crowning jewels of our epoch."[10] A year later, another critic, Raymond Bouyer, who had previously been more reserved about Monet's achievements, expressed his unconditional praise for the artist in his last group show of the decade, held at Durand-Ruel's gallery in December 1899: "Monet's work," he wrote,

above all expresses France, at once subtle and ungainly, refined and rough, nuanced and flashy . . . Monet is one of our greatest national painters; he knows the beautiful elements of our countryside whether harmonious or contradictory . . . the contours of the cliffs effaced by fog, the water running under the fresh foliage, the stacks erected on the naked plains; he has expressed everything that forms the soul of our race . . . for me [Monet] is the most significant painter of the century; yes of the century.[11]

Given these reactions and the income that Monet realized from the sale of his various series paintings, the first question posed above, about his almost myopic concentration on his water and flower gardens, suddenly does not appear so simple. Abandoning the kinds of subjects he had selected for his series paintings to concentrate on his gardens was almost as radical a change in focus as his shift in the late 1870s from urban and suburban motifs to nonmodern ones.

It is made more complicated by his apparent lack of interest in painting his gardens until the late 1890s. Although, when applying for his permit, he had told the Département's prefect that he wanted to build the waterlily pond "for the pleasure of the eye and for motifs to paint," he completed only three pictures of the pond between 1893 and 1898 (fig. 17). He was evidently even less interested in painting his flower garden in the 1890s, as only one view of it from 1895 exists.[12]

What could explain this apparent disregard? And what finally led him to focus so intently on both gardens? He may have wanted to wait for the gardens to become as lush as possible, or perhaps he was considering less traditional ways of painting them. In neither case, however, did he need years to begin.[13]

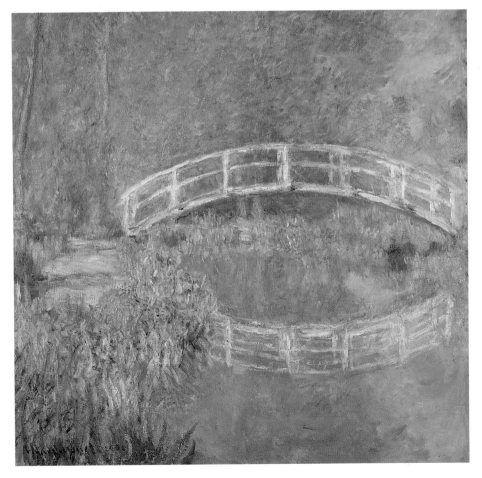

It is more likely that Monet was so immersed in his series paintings of the 1890s — often beginning one suite of pictures before exhibiting the previous one — that he was probably unwilling to drop a profitable way of working for a very different enterprise until the former had run its course. This occurred definitively in 1898, when he exhibited his last series paintings of the decade — his Cliffs and Mornings on the Seine — at the Galerie Georges Petit in Paris. They provoked considerable praise, so much in fact that *Le Gaulois* published a special Sunday supplement that reprinted major reviews of the artist's previous shows beginning with his huge joint retrospective with Rodin held in 1889 (fig. 18). Thus, just as the twentieth century was about to begin, the acclaimed master of Giverny appeared to have reached the top of his profession. But the best — and the worst — was yet to come.

Twists of Fate, 1897–1898

When Monet was completing his Mornings on the Seine and Cliff pictures in 1897, a Parisian journalist named Maurice Guillemot, on assignment for *Revue illustrée*, paid the artist a visit. This was no casual event — Monet never permitted such informality — but a carefully negotiated affair that Monet (and perhaps his dealer) hoped to use to promote himself and his work before his show in 1898.

There is ample proof that this was the strategy. Although Guillemot's visit occurred in August 1897, his article did not appear until the middle of March 1898, two months before the opening of Monet's exhibition at Petit's – perfectly timed to heighten the public's anticipation of the event. The piece was also unusual in that it documented Monet's working methods, including his departure from his house at 3.30 a.m. to paint on the River Seine. Not since the mid-1880s, when the artist was on Belle-Île off the coast of Brittany, did he grant a writer the privilege of watching him at work.[14]

Guillemot asserts that there, in "the real countryside" of Giverny, "Paris is forgotten, a dim memory." Monet's house was a "sanctuary," in Guillemot's eyes, "where every frame evoked the towering figure of an independent artist, freed from the atmosphere of the academy, carrying his work forward along new paths with the utmost conviction." He concluded the article with the statement "[Monet's] workshop – is nature itself." This was precisely the way Monet wanted to be perceived.

However, one of the most important sections of Guillemot's article is his commentary on Monet's water-lily pond and a decorative project based on that motif that Guillemot asserted he had begun. Guillemot wrote about walking around the pond, which he described as an "oasis," an "immobile mirror [on the surface of which] float water lilies, aquatic plants, unique species with broad spreading leaves and disquieting flowers of a strange exoticism." He continued: "These are the models for a decoration, for which [Monet] has already begun to paint studies, large panels, which," Guillemot claimed, "he showed me afterward in his studio." Then Guillemot laid out the most prescient part of the project:

> Imagine a circular room in which the dado beneath the molding is covered with [paintings of] water, dotted with these plants to the very horizon, walls of a transparency alternately green and mauve, the calm and silence of the still waters reflecting the opened blossoms. The tones are vague, deliciously nuanced, with a dreamlike delicacy.[15]

These lines are frequently cited as proof of Monet's initial engagement with what would become his great Water Lily decorations nearly two decades later. Having produced series paintings for more than seven years and exhibited them in spaces where he could recognize that the whole was often more than the sum of the parts, Monet could easily have come to imagine various forms of all-encompassing decorations that would fill an environment. It was a concept that had currency at the time. Many serious contemporary artists, from James Whistler and his Peacock Room of the 1870s to Puvis de Chavannes, Edouard Vuillard, and Odilon Redon, had created large-scale murals or decorative ensembles that would have

been known to Monet first- or secondhand. Such decorative projects were regarded by certain French critics in the 1890s as a reflection of a French tradition which encompassed the nation's great artists – Lebrun, Boucher, Fragonard, Delacroix, and Ingres. Oriental artists were also invoked, and may have been especially important to Monet, given his extensive collection of Japanese prints and his Eastern-influenced water-lily garden.

It is impossible to know how far Monet's thinking had progressed by the time of Guillemot's visit, or how much work he may have done to begin to test his pictorial ideas. Only a handful of paintings can be assigned to these years, and none of them can be securely dated. But judging from Guillemot's statements and the existence of these canvases Monet was beginning to stake out the territory as an alternative to his previous series paintings. It would have been yet one more instance of how he was able to continue to reinvent himself as a landscape painter and maintain a leadership role in contemporary art.

Other than Guillemot, no visitor or critic mentions the initiative; Monet never writes about it; and nothing seems to have come of it until much later.[16] In addition, the only canvases that might date to this moment are so surprisingly clumsy and airless (fig. 19) that they may have deterred Monet; a room lined with such pictures would have done nothing to enhance his reputation, which is probably why he never exhibited them and sold only one or two to close friends just months before he died in 1926.[17]

If these trial paintings do date from the 1890s, they at least suggest that Monet was not neglecting his pond as a motif. A group of four large paintings of chrysanthemums from 1897, also confirms that he was not completely disregarding his flower garden. Dense, colorful, and richly layered, they are far more vibrant than the concurrent Water Lilies, although they share the Lilies' strong surface orientation and sense of compositional novelty. Both groups were inherently decorative, but Monet decided to pursue

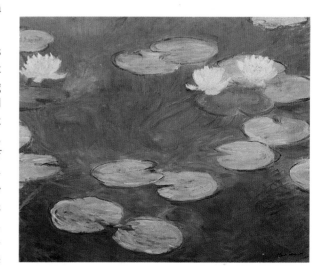

Fig. 19 *Pink Water Lilies*, 1897–9 (W.1507), Galleria d'Arte Moderna, Rome.

neither initiative. In fact, he stopped painting altogether for a year and a half, a period of inactivity that was longer than he had ever before experienced.[18]

There are a number of explanations for this extended lapse. He was gathering paintings for various exhibitions. He also experienced the loss of two people who had been quite close to him. The first was Alfred Sisley, who died in penury in January 1899, four months after his wife, thus leaving their two adult children orphaned. Moved by their plight, Monet organized a benefit auction for them, an undertaking that became extraordinarily time consuming because Monet wanted to include works from a wide range of people, which involved a lot of letter writing and detail work. The auction was held in May 1899 and proved to be relatively successful.[19] The second loss was his thirty-year-old stepdaughter Suzanne Hoschedé, who died on February 6, only five days after Sisley's funeral. Both Monet and his wife Alice (Suzanne's mother) were overwhelmed by grief. Although Suzanne had angered her step-father in 1892 when she had first announced that she wanted to marry the American painter Theodore Butler, she and her amicable husband had brought great joy to Monet and Alice, which made her passing all the more painful.

Ironically, during these difficult times, Monet's income rose dramatically. He earned 170,000 francs in 1898 and more than 224,000 francs in 1899. When combined with the loss of friend and kin, these huge sums perhaps took the edge off his otherwise formidable drive. The critical success of his exhibition in 1898 and the *Le Gaulois* coverage may also have caused Monet to consider his next step more carefully than usual. He did not want to rush his reentry into the Paris scene. His dominant position both behooved him to take his time and encouraged him to think more seriously about his legacy, which, according to the American critic William H. Fuller, led him to edit his oeuvre in the summer of 1898 by burning pictures that did not meet with his approval. Some of the preliminary Water Lilies may have fallen victim to this purge.[20]

But beyond these various preoccupations, it was surely no coincidence that Monet's unprecedented period of inactivity occurred shortly after his old friend Emile Zola began writing newspaper articles and widely distributed pamphlets about the plight of Captain Alfred Dreyfus. Dreyfus was a Jewish officer in the French army who had been accused of selling military secrets to the Germans in 1894. Court-martialed and found guilty, he was banished to Devil's Island in the Atlantic off the coast of French Guiana where the government had expected he would rot in ignominy. What began as a detested form of internal bleeding that the Army thought it had stanched suddenly erupted with Zola's intervention into almost uncontrollable hemorrhaging in December 1897.[21]

Although the full extent of the damage it caused is difficult to reconstruct today, it is fair to say that the Dreyfus Affair was one of the most searing episodes in French history. It divided the nation, scorched its soul, and imposed a kind of dystrophy on its psyche that left no one untouched, Monet included.

Monet, Zola, and the Dreyfus Affair

The Dreyfus Affair's destructive power was due to many factors, not the least of which was the impression that so much was at stake – the army, the nation, the traditions of "La France." From the point of view of those who believed that Dreyfus was guilty, the captain had not simply committed treason; he had placed the country in grave jeopardy by passing precious military documents to the enemy. They insisted that because of his betrayal of France, he deserved the punishment inflicted on him in 1894: the degradation of a sword-breaking ceremony in the courtyard of the Ecole Militaire, followed by deportation and solitary confinement nearly three thousand miles from his former offices in the Ministry of War on the rue Saint-Dominique in Paris.

Twenty-five years earlier, the same German war machine had humbled the French in 1870 by toppling Napoleon III's lavish Second Empire in a matter of weeks, laying siege to Paris for nearly ten months, and extracting painful settlement terms in the Versailles Treaty of 1871. That treaty had called for France to pay Germany a staggering indemnity of five billion francs and to give the victors Alsace and Lorraine, two of France's most treasured provinces. No French citizen would ever forget this.

In 1897, when Zola initiated his defense of Dreyfus, the nation could hardly allow itself the luxury of savoring thoughts of revenge. Government ministries had changed thirteen times in the previous ten years; there had been four different presidents since 1890 and more than twice as many new cabinets. Moreover, France's industrial production was lagging behind its European competitors; its social order had been rocked by anarchist bombs and socialist syndicates; and even its arts were under siege from the United States, England, and Germany.

Then Dreyfus had the audacity to undermine the country's faith in its rebuilt military, which had become the one source of strength the nation could count on. Paranoia quickly became the willing bride of prejudice – particularly anti-Semitism – making for a wedding of the worst of French traits. To the anti-Dreyfusards, who included Degas, Renoir, and Cézanne among Monet's contemporaries, such a marriage was justified because Dreyfus represented everything that was wrong with France. In their eyes, the country's political, social, and moral corruption was not due to any inherent French character flaw or systemic failure; "France was innocent," proclaimed the staunch nationalist Paul Déroulède in 1898.[22] The prob-

lem, they insisted, was non-French invaders, particularly Jews, who had penetrated the country under the guise of economic expansion and had contaminated it from within.[23] According to these anti-Dreyfusards, he and his kind had to be expunged – an imperative that many French had long been willing to endorse. "The Jew is the enemy of the human species," railed Paul Proudhon. "The race should be sent back to Asia or exterminated."[24]

As a counter to these expressions of hatred, Zola wrote his first article on the subject of France and the Jews in 1896, denouncing the anti-Semitism of people such as Edouard Drumont and his cronies, who had published scathing diatribes on what they perceived as an infestation of the country by Jews.[25] In September of that year, a Paris newspaper published information suggesting that there had been government misconduct during the course of Dreyfus's trial. That in turn led Dreyfus's wife to petition the Chamber of Deputies to reopen the case. The government refused, but in the summer of 1897 evidence began to mount against the real traitor, Ferdinand Walsin Esterhazy. A major in the French army, Esterhazy became the focus of a military investigation in November 1897, prompting Zola to write an article in defense of the vice-president of the Senate, Auguste Scheurer-Kestner, who had declared that Dreyfus had been wrongly accused. It was published in Le Figaro on November 25.

Zola wrote a second article, published in Le Figaro on December 1, in response to anti-Dreyfusards who claimed that Jewish bankers were behind the efforts to reopen the captain's case. Monet reacted immediately. "Bravo," he wrote Zola in a heartfelt letter of December 3, 1897, "and bravo again for the two beautiful articles . . . You alone have said what had to be said, and you have done it so well. I am happy to extend to you all of my compliments."[26] That Monet wrote Zola at all is remarkable because the two men had not been in contact for more than ten years. In fact, after writing favorably about Monet and his Impressionist colleagues in the 1860s, Zola grew cooler and then dismissed the group in the 1880s for having abandoned what he felt were avant-garde principles. From Zola's perspective, Monet's letter must have seemed like a missive from the blue.

What is even more surprising, however, is the fact that it was not an isolated occurrence. On January 13, 1898, Zola's now-famous "J'Accuse" appeared in the Parisian newspaper L'Aurore, filling all six columns of its front page. On January 14, Monet responded again. "My dear Zola, bravo again and with all my heart for your gallantry and your courage." Monet not only reiterated his admiration for Zola's daring defense of the Jewish captain but even offered to add his name to the list of the novelist's supporters that L'Aurore was to publish five days later.[27] Such a public declaration was extremely unusual for Monet. Although he was willing to lobby local authorities about

developments in Giverny or pressure the government to accept Manet's Olympia, he never participated in the activities of any national political groups, unless they were art-related, and even then he preferred to work individually, behind the scenes, as he did with his successful campaign for Manet's painting in 1890.[28]

The Dreyfus Affair ate away at him, though, as it did so many people, and in February 1898, when Zola was brought to trial on libel charges stemming from "J'Accuse," Monet reached out again to express his support for the author. He had wanted to attend the proceedings, he told Zola, but just before the lawyers presented their opening arguments, he came down with influenza, as did the rest of his family, which kept them all in bed for nearly three weeks. He expressed his disappointment to Geffroy several days into the trial. "It is not that I am indifferent to all that is happening," he asserted. "I have followed this disgraceful trial from afar, and with passion. How I would like to be there! You must be disheartened and saddened by the conduct of many people, and of the newspapers above all; they are so vile . . . If you should have a moment, however, I would like to know how people think this will all end." The following day, he wrote Zola directly to explain his absence from the courtroom:

> Sick and surrounded by others who are ill, I could not come to your proceedings and shake your hand, as had been my desire. That has not stopped me from following all of the reports with passion. I want to tell you how much I admire your courageous and heroic conduct. You are admirable. It is possible that when calm is restored, all sensible and honest people will pay you homage. Courage my dear Zola. With all my heart.[29]

Such candid expressions suggest how much Monet was moved by these circumstances. He therefore could not have helped but empathize with Zola over the price the novelist had to pay for his inflammatory defense of the innocent Dreyfus. Zola was found guilty of libel and sentenced to a year in prison and a 3,000 franc fine, the maximum penalty. He appealed the decision and received an annulment, but was convicted again in a second trial held in July 1898. Facing the same punishment, Zola fled the country, taking refuge in London. Monet tried to get his address in late August or early September only to be thwarted by the novelist's wife, who was following her husband's strict request not to reveal his whereabouts to anyone.[30]

The following summer, the Court of Appeals annulled the Dreyfus decision and ordered a new court martial for the captain. The day after this reversal, Zola abandoned his self-imposed exile and returned home on June 5, 1899. Although he continued to write books and articles, he never recovered his position among the nation's cultural élite; on the contrary, he became alienated from those

circles and grew increasingly depressed. On the morning of September 29, 1902, Zola died of asphyxiation caused by fumes from a fire in his bedroom fireplace. Some say it was an accident; others claim that it was the ultimate revenge of anti-Dreyfusards who had intentionally blocked the flue of his chimney.

Dreyfus lived longer but suffered continued humiliation. It took him twelve years to clear the trumped-up charges from his record. Even then, the army refused to apologize. In fact, an official admission of the army's wrongdoing was not issued until 1992, some fifty-seven years after Dreyfus's death. The Catholic Church, which during the Affair had waged an intense anti-Semitic campaign, was silent on the matter until it offered its apologies in 1997.

While reprehensible, the conduct of Church and State in this tragedy is only a small reminder of how ugly and protracted the whole Affair was, and how deeply it touched everyone in France. Although there were those who asserted that the Affair changed nothing – that the social system remained the same, businesses plodded onward, and people returned to their daily lives – it is also true that it posed "the question of conscience to every individual," as one later observer noted. "It constrained each one to react, to know, and to acknowledge himself."[31] Beliefs had been compromised by lies and innuendo, values eroded by treachery and evil. Léon Blum, an active Dreyfusard who became premier of France in the 1930s, declared "Something was shattered . . . [something was] over."[32]

The fact that Monet did not pick up a paintbrush for a year and a half after Zola's trial suggests a more indirect but no less profound response to the same depressing circumstances. Perhaps an even more revealing gauge of the depth of his feelings about the Affair is discerned in what

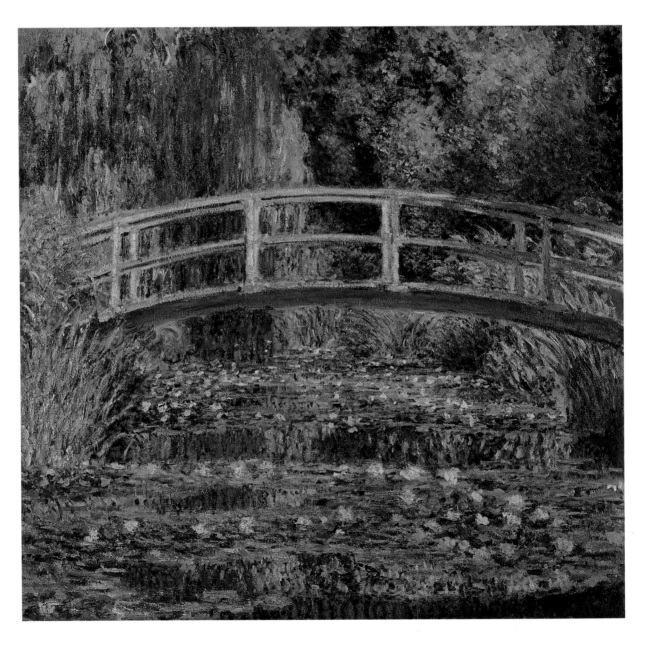

Fig. 20 *Water Lilies and Japanese Bridge*, 1899 (W.1509), The Art Museum, Princeton University. From the Collection of William Church Osborn, Class of 1883, Trustee of Princeton University (1914–1951), President of The Metropolitan Museum of Art (1941–1947); gift of his family.

22

he chose to paint from that moment on. Never again would he explicitly focus on French sites or subjects, with the sole exception of his fifteen nostalgic views of Vétheuil of 1901.

The shadow of disillusionment that the Affair cast across the nation had not excluded Giverny. Thus, Monet's belief in La France, which had sustained him from the beginning of his career in the late 1850s until these heinous events, was apparently no longer tenable. He had to find meaning somewhere else. His late work – which is surely his crowning achievement – is a moving record of that search.

Redefining Himself in 1899

When Monet finally took up his brushes and palette again in July 1899 he turned to his water-lily pond and began a series of views of the northern section of the garden crossed by the Japanese-style bridge that he had painted four years earlier (fig. 20). The dozen canvases that can be assigned to this new campaign have neither tonal nor technical affinities with those previous pictures although they depict essentially the same site. Monet was clearly rethinking these earlier essays and applying a new formula, as he was obviously also doing in relation to the so-called Water Lily studies that Guillemot supposedly saw in Monet's studio during his visit in 1897 (fig. 19). Where the latter are flat and surface-oriented, dull and listless, these new paintings are spacious, scintillating, colorful, and lively. They invite the viewer in with a generosity that even the 1895 pictures lacked, and they depict an environment that is extraordinarily lush. In comparison with the 1897 studies, it is as though Monet were painting a completely different pond.

In some ways, he was. The pond is now filled with lilies, so dense and rich they almost seem as if they would be strong enough to support us if we walked across them toward the bridge. The bridge appears larger and more substantial than in the earlier versions, just as the foliage, with its intricately woven but highly individualized patterns of thick brushwork and brilliant color, is now like a modern Savonnerie carpet. The sky rarely peeks through. Monet deftly closes off the background as well as all sides of the scene, containing our view so that we have no choice but to be seduced by the beauties of this almost exotic space.

How muffled and serene this spot appears, how restful and reassuring. Not only has Monet cordoned off the site so that nothing unwanted or disturbing intrudes upon it; he has also made everything within it so orderly and logical that the painting breathes an air of complete contentment despite the many complex parts that comprise the whole.

In fact, everything in these paintings seems more calculated and precise than anything Monet had done earlier in the decade, as if the order he envisions here could be

exacted by a painstaking but timely combination of pure discipline and desire. The forms are perhaps overly crisp; lights are constantly contrasted with darks of rigorously equal intensity. In figure 20 the bottom half of the painting is built up from a series of horizontal striations that in direction, color, and rigidity contrast with the curving forms of the lighter lily pads. The regimented rhythm of the water is broken by the bridge which arcs upward and seems almost suspended since Monet does not show where it begins or ends. He also counters the apparent symmetry of the setting with the off-center placement of the bridge while concealing or eliminating the bridge's reflection, unlike the 1895 versions, where he included many visual anchors to lock the structure more in place and make the scene more tectonic.

Ironically, these later views are an unabashed affirmation of Monet's Impressionist roots. They are filled with echoes of paintings of his garden at Argenteuil, such as figure 21, or of unpopulated forest paths and bodies of water also from the classic years of the 1870s.[33] To be sure, none of these pond paintings looks exactly like those earlier views, but almost everything about these watery, womblike images seems familiar: the dappled light, the quick, versatile handling, the simple composition, and the clear perspective system. It was as if Monet wanted not only to create a perfectly ordered world but also to reaffirm once again how flexible and radiant Impressionism could be as a style, how he as a painter could still render form, and how he could

Fig. 21 *Undergrowth in Argenteuil,* 1876 (W.409), courtesy of Christie's Images.

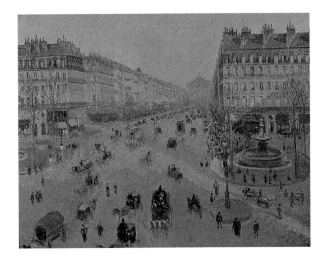

Fig. 22 Camille Pissarro, *L'Avenue de l'Opera, Sunshine, Winter Morning,* 1898, Musée des Beaux Arts, Reims.

paint with an attention to detail that many of his series pictures of the 1890s had suppressed in favor of nature's magical effects, particularly "instantaneity" and the "envelope of light" that he referred to on several occasions.[34] The former had become so much of a concern to him that he had made paintings that were increasingly interdependent, forcing them to rely more and more on each other for their full effect. This obsession culminated in the Mornings on the Seine, which were conceived and executed as a group with a precise order to create the impression of a carefully controlled temporal sequence. Similarly,

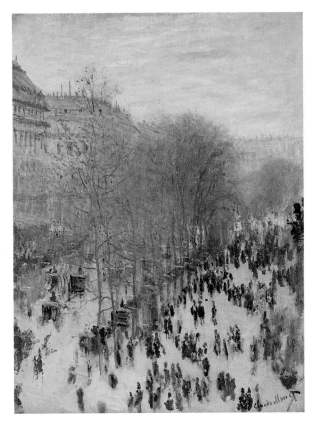

Fig. 23 *The Boulevard des Capucines,* 1873 (W.293), The Nelson-Atkins Museum of Art, Kansas City, Missouri, Purchase: the Kenneth A. and Helen F. Spencer Foundation Acquisition Fund.

Monet's interest in the envelope of light had so taken over his pictures that the envelope had not just wrapped his forms and blurred their edges; in the Mornings on the Seine and in several Cathedral paintings, it had almost completely dissolved the image. Where was one to go from there?

The Water Lily "studies" from 1897 had been one route out, but they were fundamentally unsatisfying, even as sketches, which is probably why Monet gave them up. He must also have realized that the images were practically unsalable and sorely disconnected from the tragedies of his times. If the country's cultural leaders were to provide some direction for the nation, with Monet prominently in that group, it would not be through such apparently aimless and unstructured images of blandly colored water lilies. The post-Dreyfus years called on artists of Monet's generation as cultural leaders to return to the tried and true, to familiar tactics and reassuring subjects.

Nowhere is this borne out more, surprisingly enough, than in the work of Camille Pissarro, who was a staunch Dreyfusard and who was himself Jewish. The self-declared anarchist-socialist had suffered the anti-Semitic disdain of his former friends and colleagues Degas and Renoir, who made cruel remarks about him as soon as the Affair broke. Nonetheless, in November 1898 the sixty-eight-year-old patriarch could tell his son Lucien that he was going to sit in front of his hotel window in Paris painting the same broad boulevards that he had been rendering for the past several years, "as if nothing has happened" (fig. 22).[35] Despite what he described as "the grave turn of events," he was not going to give up painting pictures that recall 1870s prototypes such as Monet's *Boulevard des Capucines* (fig. 23). He would soon up the ante and move to images of the Tuileries and the Louvre, the very same museum he had wanted to burn earlier in his life. It was a way of making peace with himself, earning a living, and, most important perhaps, providing his audience with paintings that would communicate the hope that he shared with his son that November day, ten months after Zola's "J'Accuse" appeared in print. "Despite all of these anxieties," Pissarro affirmed to Lucien, "let us hope it will end happily."[36]

Monet shared Pissarro's sentiments, although he was more specific in his feelings about the future. "I am certain," he confided to Geffroy, "that when heads cool, everyone who is sensitive will review the evidence and recognize that there is beauty in Zola's act."[37] He also believed that devoting himself to painting visually ravishing pictures that recalled 1870s precedents was not conservative escapism. Rather, it would provide the kind of leadership that the country desperately needed. So there is no fuzziness in these Kodalith-like views of his water-lily pond of 1899, no concessions to evocative mists, no blandness, inertia, or uncomposed forms. Everything is planned, secure, informed, and readable.

Monet even decided that these paintings should be more closely related than ever before, as if the changing times also called for a new definition of unity. Instead of the interdependence of his previous series paintings, in which the whole was always greater than the sum of its parts, he so narrowed the differences between each of these new Water Lilies that some appear almost to be duplicates. Although more subtle than Monet's temporary abrogation of his art, this change in thinking about how to make paintings and how they were supposed to look as an ensemble was another legacy of the Affair. The fundamental bonds common to those previous campaigns had been irreparably weakened, as had the widely shared, albeit romantic, notion of the nation's own integrity, which Monet's series paintings had tended to propagate. No wonder it took him so long to pick up his brushes and paints again. Having just been awarded some of the highest accolades of his profession for his exhibition in 1898 and labeled "the most significant painter of the century" carried with it enormous expectations.[38] It was not just his reputation that was at stake here; he had been given an even larger responsibility to uphold – like Zola, Clemenceau, and other Dreyfusards who rose to the occasion in the same difficult years to reclaim the ground that had been so trampled.

As Monet contemplated his next step in May and June of 1899, that obligation became weightier because Dreyfus returned to France to stand trial again. Anti-Dreyfusards in Paris protested his impending arrival and the court's decision to permit him another hearing; the President of the Republic was even attacked while attending the races at Auteuil.[39] The captain's second court-martial opened on August 7 and ended on September 9 with another guilty verdict. The decision prompted protests from around the world. There were even calls for boycotting the World's Fair scheduled to be held in Paris the following year. To ease the crisis, the government toyed with the notion of granting Dreyfus a pardon.[40] The Dreyfusards felt that this was utterly deceitful, since the guilty verdict would still stand. One of the most vociferous protesters was Clemenceau, who, as political editor of *L'Aurore*, the newspaper that had published "J'Accuse," had assumed a leading role in the controversy. The government "was humiliating the Republic before the saber," he raged.[41] But when even Clemenceau agreed that the pardon was Dreyfus's best option, the government's offer was accepted on September 12 and General Galliffet declared, "The incident is over."[42] However, there was another prolonged investigation after which the guilty verdict from Dreyfus's second court-martial was finally annulled on July 12, 1906.

During the acrimonious summer and fall of 1899, as pretrial deals were being brokered in Parisian back rooms and the trial began in Rennes, Monet immersed himself in his work, but not without following the proceedings, particu-

larly the seminal efforts of his friend Clemenceau. Monet admitted his engagement later in the year in a letter to Gustave Geffroy: "Could you tell me if Clemenceau received a letter from me?" he inquired of the critic in mid-December 1899. "I was surprised not to have received a response to it." His concern was based on the fact he had invested quite a bit in that piece of correspondence. "I had told him everything I thought of his beautiful campaign for justice and truth."[43] As a token of his esteem for Clemenceau and his vigorous defense of Dreyfus and Zola, Monet went so far as to give his friend one of his paintings – *Study of Rocks* (*Le Bloc*) (fig. 24).

When Clemenceau finally wrote to Monet, he expressed how thrilled he was.[44] They both understood that the massive, rugged rock surging upward toward the sky with forceful purpose and primitive nobility was analogous to Clemenceau's valiant stand against the forces of hate and evil that had so riddled their beloved France. Its simplicity and earthy palette were like planks in Clemenceau's platform, its unbounded energy and resolve a mirror of his own strength and determination.

The gift was not all one-sided, though; the metaphor worked both ways, for these characteristics of the painting and its strikingly contemporary content represented Monet as well. In a rare demonstration of hubris, Monet showed his hand and actually laid claim to these characteristics when he unabashedly told Geffroy he was sending Clemenceau the painting as a token of "reciprocal admiration." He wanted to make sure that the critic and the politician knew that he too had been fighting the good fight and that he was there in Giverny continuing to do his job for France as well.[45]

His 1899 Water Lily paintings obviously have none of the fiery bite of Clemenceau's famous rhetoric. Nor do they have the scarred and roughened surface or the monumentality of *Le Bloc*. In comparison to the numerous images by artists on both sides of the Affair, they also

Fig. 24 *Study of Rocks* (*Le Bloc*), 1889 (W.1228), courtesy of Her Majesty The Queen Mother.

appear slightly precious. How much further could one get from the scathing caricatures of such anti-Dreyfusards as Caran d'Ache, Forain and Lénepveu (fig. 25), for example, or from such Dreyfus supporters as Maximilian Luce, Félix Vallotton (fig. 26), and Henri Ibels. Even when Salon artists Jean Henner and Edouard Debat-Ponsan tried to elevate the discourse by making metaphors out of the affair, as in figure 27, they appear to make Monet's paintings seem removed and indifferent. Indeed, Debat-Ponsan's un-ambiguous figure of Truth attempting to escape the clutches of the military and the Church, was hung in the annual Salon and subsequently given by the artist to Zola as a token of his esteem. But none of these painfully pro-saic images was going to last or provide any leadership for French art.

By returning to the fundamentals of his craft in 1899 – to the purity of touch, the clarity of light, the distinctiveness of form, and the readability of space – Monet was not retreating; he was providing a clarion call for France to reexamine her building blocks, to encourage an honest accounting, and to start anew. It is appropriate, of course, that his vocabulary is an intensified form of Impressionism. By 1899 Impressionism was hailed as a national style, one that rightfully and properly represented the best charac-teristics of the nation, as Bouyer had asserted earlier that year.[46] That Monet now opted to speak in a higher-pitched voice also makes sense given the din of the moment. He wanted to be clear and he wanted to be heard.

He also wanted to make sure that his unmistakable French Impressionism was going to dominate the evident non-western aspects of his motif. France, of course, had to come first. The arching bridge can be – and was – easily associated with those in the prints of Hiroshige, while the garden with its exotic plants and its shifting, delicate order had distinctly Eastern echoes (fig. 28). But Monet's garden was also seen as a French space where the rationalism of the nation's eighteenth-century *philosophes* and the seduc-tiveness of rococo painters would be wedded to the pos-itivism of the nineteenth century and the advances of avant-garde artists such as the Impressionists. That was a better marriage than the recent one of paranoia and prej-udice, which critics were quick to confirm when they saw these pictures in 1900. "We will understand one day better than we do now," mused Jules Leclercq in *La Chronique des arts et de la curiosité* of December 1900, "what limpidity of the soul, what incantation of the beauti-ful things of nature [these paintings] represent, and how much the creator of these powerful and beautiful marvels belongs to the race of those lucid, welcoming, brilliant, sen-sible and penetrating men who were the ever gracious and intelligent painters of the eighteenth century." To him, the series embodied "the genius of an impassioned and measured people . . . To discredit it," he asserted, "is to dis-credit France."[47]

By tending to his own garden so meticulously and so dili-gently and by producing paintings of such startling beauty, Monet was finally affirming one of the most important principles of eighteenth-century thinkers, most specifically Voltaire – namely, that nature was the source of all good-ness and wisdom and that each person should cultivate his own garden. In so doing, everyone would recognize the values of being human and the ties that unite humans to each other. More pertinent lessons could not have been recovered for anyone who cared about post-Dreyfus France as she stumbled, shakily, into the twentieth century.

Monet's London Campaign, 1899–1904

Early in November 1898 Monet received word that his son Michel was gravely ill in London.[48] Michel, ten years younger than the artist's first-born son Jean, had gone to Britain to study English. Extremely upset, Monet immedi-ately left to join him. It turned out to be far less serious than he had been led to believe, allowing the relieved father to return to Giverny before a week had elapsed.

Although brief, Monet's trip was the first he had made to the English capital since a quick visit in late 1891 when he had been invited to participate in an exhibition at the New English Arts Club. After that, he always talked about going back again but had never acted on his wish. Ironically, Michel's medical emergency must have reminded him of London's relative proximity and the ease of the voyage; he could board a train at the Gare du Nord at 8.30 a.m. and be in Victoria Station by 5.00 p.m. It must also have rekin-dled his interest in the city's delights, because less than a year later he was back once more, ostensibly on holiday with his wife and his stepdaughter Germaine Hoschedé. It was a busman's holiday, though, as he had brought along his canvases and painting supplies.[49]

The family stayed at the Savoy, one of the city's leading hotels. They took a suite of river-view rooms on the sixth floor, and remained six weeks. Monet quickly converted one of the rooms into a studio, and while Alice and her daughter went sightseeing with Michel he set to work. He would return again for three months in 1900, taking rooms directly below the ones he had previously stayed in, as those were now occupied by victims of the Boer War. He went back a third time for another three-month period in 1901, all in the hopes of completing what had grown to be the largest group of paintings that he had ever started. By 1904, when he exhibited thirty-seven of them to rave reviews at Durand-Ruel's gallery in Paris, he could count almost one hundred "Londons," as he had come to call them, in various stages of completion. They were divided into three primary groups: forty-one views of Waterloo Bridge, thirty-four of Charing Cross Bridge, and nineteen of the Houses of Parliament. There was also a fourth, smaller

Fig. 28 Ando Hiroshige, *The Tenjin Shrine at Kameido*, woodblock print, Museum of Fine Arts, Boston, Gift of Dr. G.S.Amsden.

group consisting of three rough sketches of Leicester Square done at night from a balcony of a private club called the Green Room, and a suite of twenty-six pastels that he executed in 1901 while awaiting the delivery of his canvases, which had been detained in customs.

Suffering the administrative tangle of the English customs service was only one of the many ordeals that plagued this inordinately extended endeavor although not all aspects of the undertaking were unfavorable. In addition to being able to enjoy the amenities of the Savoy, which included a superb restaurant, Monet could see Charing Cross and Waterloo bridges from his room – which is why there are more canvases of these motifs than any other; he could work on them in the comfort of his hotel. For the Houses of Parliament, he had only to walk along the Victoria Embankment to St. Thomas's Hospital across Westminster Bridge, where he established a makeshift studio on a balcony affording a spectacular view of the neo-Gothic parliament buildings. Having friends in the capital was another advantage. The American painter John Singer Sargent, with whom Monet had become acquainted in the 1880s, had been living and working in London for many years and was extremely well connected. He provided Monet with an entrée into English society, including frequent dinners at the homes of some of Sargent's upper-class patrons. Although Monet could speak only a little English, he enjoyed these outings immensely, perhaps because he was often the guest of honor. He even went to see Queen Victoria's funeral procession in 1901 and declared that he wanted to paint it.[50]

The disadvantages of the campaign, however, were considerable, and sometimes seemed to outweigh its benefits. Having two studios, for example, became an annoyance. There were the problems of insufficient supplies, storage, and serenity, and he found himself torn between the two sites because of the schedule he had established. Mornings and early afternoons he painted his bridges, then devoted the mid- to late afternoons to his Parliaments. Many times when he was working at the hotel, he felt obliged "to put down a canvas that I could have finished within the hour because it is time to go to the hospital," as he told Alice during his third stay, in 1901. "It has to be said that working in two places is a bad idea."[51]

Working outside in winter at Monet's age was also not the wisest plan. He came down with pleurisy in March 1901, forcing him not only to abandon his views of Leicester Square but also to stop painting for the rest of the month. He left for Giverny in early April, not to return until December 1904, six months after the Paris exhibition of these London paintings had closed at Durand-Ruel's.

The most daunting practicality Monet faced was the weather. The light and atmosphere in the city changed with frustrating frequency, which helps explain the staggering number of canvases in the campaign, and Monet's

often-expressed agony over chasing a continually elusive goal. "This is not a country where you can finish a picture on the spot," he complained to Alice during the last visit. "The effects never reappear. I should have just made sketches, real impressions."[52] He compounded the problem, however, by starting picture after picture as conditions changed, uncharacteristically casting aside the patience and discipline that had served him so well. "I have worked and reworked some canvases as many as twenty times," he complained, "spoiling them as I went and ending up redoing them as a sketch anyway in double quick-time."[53]

Monet's litany of complaints, which he frequently repeated during the five years that he worked on these paintings, echoes those from nearly every painting trip he had undertaken since moving to Giverny in 1883. The weather was always unaccommodating, the conditions too fickle, his motif unrealizable, his abilities inadequate. But there is an edge to the anguish that he expressed about his Londons that is slightly different, a disparity that is mirrored in the enormous number of paintings he tried to paint. When Sargent came to see him at the Savoy in 1901, the American expatriate was more than a little amused to watch him desperately search through more than eighty canvases stacked up in his suite trying to find just the right one when the effect he was working on happened to change. Even Monet knew it was a little absurd.[54]

It is therefore understandable that he worked on many of these paintings as much in Giverny as he did in London; they had grown to an almost unmanageable number and were simply easier to keep in order in his more spacious studio at home. His decision to complete them in Giverny, however, cost him some public-relations points; a reporter found out and leaked that the great Impressionist was painting his Londons away from the sites and, worse yet, was relying on photographs. When Monet learned of the article, he erupted in a rare display of public anger.[55]

There is something curious about the urgency of Monet's complaints, the extension of the campaign, the number of pictures he started, the challenge of painting at night, the newspaper coverage, the angry defense – all of which suggest there was more at stake here than Monet's desire merely to set down those sulfurized effects of London's coal-dusted atmosphere in an accurate and compelling manner.[56] It certainly was not like his experience in summer 1899, when he had finally resumed painting. He had done the dozen views of his water-lily pond in record time. Durand-Ruel bought seven of them on November 5, just after Monet returned from London, although the artist continued to work on them over the next two months, finally delivering them to the dealer in the middle of January 1900.[57] Given the complexity of these pictures, Monet's speed was astonishing.

He was unable to muster the same facility with his

Londons. Although Durand-Ruel also reserved eleven of these canvases during that same November visit (which suggests that they were beginning to take shape), he did not actually have the opportunity to purchase any of them for two more years. Only in November 1901 did Monet finally let him have four, selling a fifth to a friend. Monet had sold just one other before then, a view of Charing Cross Bridge, which Durand-Ruel's rival Boussod, Valadon et Cie mysteriously managed to pry out of the artist sometime shortly after Durand-Ruel's visit in 1899.[58] Monet hung on to all of the others until his exhibition in 1904.

Monet was not pressed financially to sell any of them. He also could have more accurately dated the six he sold, all of which bear a date of 1899, even though only the one that Boussod, Valadon obtained left his hands before the beginning of 1900.

Why then did he seem to need to be surrounded by this large group of paintings? Why was he unable to complete them?

Surely the difficulty of the task that Monet had set for himself, together with his long hiatus, was the main reason for his uneasiness. Capturing the light and atmosphere of central London was a formidable challenge, even with Monet's considerable dexterity. The pictures bear this out. Most of the ones that were brought to a finished state have been heavily worked, just as Monet described in his letters to his wife. The surfaces are often multi-layered, with color and brushwork molded into one by the same force of will that had so separated them in the preceding Water Lily series. In fact, with their dense atmospheric effects, muffled or refracted light, and boldly contemporary subjects, these London pictures could not be further from the distilled views of his water garden that he had just completed with such "insolent perfection," as Daniel Wildenstein has so aptly described them.[59] Instead, he was reaching back beyond those pictures to his evanescent Mornings on the Seine and the envelope of light that had so dominated his earlier series paintings of the 1890s (fig.16).

Despite their evident differences, however, the 1899–1900 Water Lilies and the early Londons are united in two fundamental ways. First, the Water Lilies must have been a source of great encouragement to Monet. In addition to their exquisite beauty and their number, they were painted so quickly and so assuredly that Monet must have felt quite up to the task of tackling a new subject even if it was unwieldy – and foreign. Second, both look backwards as much as they do forward, specifically to the 1870s and to classic Impressionist images. The views of Charing Cross and Waterloo Bridges, for example – the first Londons that Monet began in 1899 – are inconceivable without his classic canvases of a quarter of a century earlier: *The Railway Bridge at Argenteuil* of 1873 (fig. 1), for example, *The Train* of 1872 (W.213, Private Collection, Japan) or,

even more important perhaps, the famous *Impression. Sunrise*, also of 1872 (fig. 29).

All three paintings were part of Monet's life in the late 1890s. The first two were owned by Durand-Ruel and Georges Petit, respectively, and were exhibited in Paris and St. Petersburg in 1899. The third, in the collection of the Duc de Monchy in Paris, was referred to in Monet's interview with Maurice Guillemot in 1897. Just as important were his views of the Thames from 1870-71, such as *The Thames below Westminster* (fig. 14), which was in Jean-Baptiste Faure's collection and had been included in Monet's huge retrospective with Rodin in 1889.

These 1870s precedents were double-edged touchstones for the fifty-nine-year-old artist. They were beautiful, iconic, and the product of a novel vision of what art could be; as such, however, they also posed a considerable challenge. He now had to find the resources and daring to equal or better them. As a result, the Londons became rather personal pictures, despite their focus on atmospheric effects distinct to the city. They really were about Monet, the aging artist reinventing himself in light of his past. (He would be over sixty-three when he finally exhibited the series.)

There are telling differences between the earlier and later work. The introspection, the depth of feeling, the sense of weight and gravity that the Londons possess are not to be found in the same measure in the earlier pictures. The surfaces of the paintings in the two groups tell the story. The earlier pictures are either more thinly rendered or more brazen, with less interwoven color and a less methodical touch. The Londons are denser and more labored, more careful and reflective.

However, Monet was not the prisoner of his previous accomplishments. By their number and diversity, his newest essays were designed to push those prescient but older pictures distinctly into the past. Thus, Monet seems to have tried to capture nearly every variety of light that the city offered, from dazzling brilliance (cat. 19), to dank and dreary haze (cat. 18) and misty gauze (cat. 12). The pictures span the color spectrum, from gray and green to pink and yellow, and they cover an entire day, beginning with views of dawn, moving through various moments of the morning and afternoon, and ending with scenes of early evening.

Despite all of their novelty, breadth, and ties to Monet's previous work, these paintings cannot be understood merely as the product of a private dialogue that Monet was conducting with himself or the inspired result of a long-held wish to work in London. He had never concentrated so much time, money, and effort on a painting campaign. Never had he attempted to span as great a range of effects, and at no point in the previous twenty years had he reverted to painting modern urban life.

So why did he turn to all of this now?

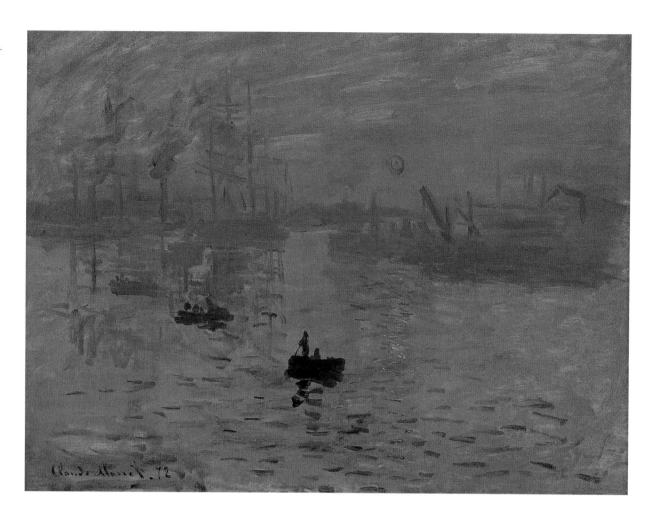

They were characteristic of the English capital, of course, but if he really had just wanted to paint the city, why had he not chosen more idyllic sites that would have been more in keeping with his supposed devotion to nature? The parks and gardens of the capital, for example, would have been perfectly suitable; he had painted them during his first stay in London.

Instead, he tackled something that seemed impossible and entirely different from everything he had been doing. No wonder every time he came back from London he was anxious to have a friend whose opinion he respected, such as Geffroy, see the paintings.[60] This was not just a private affair. Having been hailed as one of France's greatest artists after his exhibitions in 1898 and 1899, Monet felt the weight of his role in contemporary French art. His anointment had followed another event of considerable importance – the inauguration of an annex to the Musée du Luxembourg containing the Caillebotte bequest in 1897. The bequest had been artfully foisted upon the nation by Gustave Caillebotte, who had died in 1894, leaving his collection of sixty-seven Impressionist paintings to France with the stipulation that they remain in Paris and be hung together.[61] After considerable controversy about the terms of the bequest, a reduced version of the collection

was finally accepted in 1896. Even in its slimmer form, the gift was extraordinary. It contained two Manets, two Cézannes, six Renoirs, six Sisleys, seven Pissarros, seven Degas, and eight Monets. The once-reviled Impressionists had their first foothold on revered national ground.

Given this significant change in their standing, it is perhaps surprising that Monet initially fiercely resisted offers to participate in the State-sponsored exhibition of fine arts that was to be held as part of the 1900 World's Fair in Paris. When contacted in early January 1900 by Roger Marx, a journalist who had written glowingly about Monet and was now one of the curators of the show, Monet was exceptionally blunt: "Having no reason to participate in an official exhibition, I have absolutely decided to refuse to give my consent." His reasoning was equally forthright: "You know as well as I that we have operated outside of all official circles for too long for us to support such an affair. It isn't our place."[62] He had hoped that the other Impressionists who were still alive – Pissarro, Renoir, Cézanne, and Degas – would close ranks and resist Marx's offers as well. However, that would not be the case; Pissarro broke first, and then Renoir. After heated discussions, Monet finally relented, but only after he had extracted an essential concession from Marx: a separate

room to be devoted exclusively to the work of the core Impressionists. If they were going to be in the show, their space had to reflect the historical record.[63]

Monet then scurried to retrieve paintings from dealers and collectors, insisting on securing only those of "very high quality," especially examples from all of his series of the 1890s since they had solidified his standing at the forefront of modern French art.[64]

In the end, of all the Impressionists, Monet had the most paintings in the show – fourteen, twice as many as Marx had chosen to represent past French masters such as Jean-François Millet, Constantin Troyon, or Charles Jacques. In fact, as a group, the Impressionists outnumbered their Barbizon predecessors almost two to one, a mark of changing times. They were also recognized as having influenced other artists in the exhibition, from both France and abroad, prompting further calls for a separate Impressionist retrospective and praise for individual participants.[65] Monet himself received some of the highest accolades, particularly from Marx. "Never were pictorial faculties put to the service of such a refined and sensitive eye," the curator wrote. "Apart from Turner and Corot, modern landscape cannot count a master of more noble ability." Monet's participation perhaps had been worthwhile.[66]

If he was so keen on maintaining his reputation in France and on making sure the history of French art was accurately written, why then did he spend so much time and energy out of the country on his Londons? They seem even less related to his apparent objectives than his Water Lily pictures. At least with the latter, the site was created by a Frenchman in France, and they were painted in a distinctive, French style.

Monet had never limited his professional interests to France. In the later 1890s and early 1900s he participated in dozens of international exhibitions, from Missouri to Moscow, but he rarely left France to work. He also always wanted to show his pictures in Paris first, a preference that he communicated to Durand-Ruel in January 1900, just before leaving for his second trip to London.[67]

England had produced some of the greatest rivals to France's heralded landscape tradition. Monet had seen their accomplishments during his self-imposed exile in 1870–71 and on subsequent visits, and, like Pissarro and other artists of his generation, greatly admired their achievement. He also appreciated those modern artists who had taken up residence in London and had consistently engaged the English tradition as a personal agenda, such as James McNeill Whistler, whom he had come to know well in the 1880s. Monet surely had the American's Nocturnes and Thames views in mind when he set up his easels in the Savoy, as their poetic light, dematerialized forms, and unconventional compositions were a model of how modernism could revitalize past practices and provide aesthetic leadership.[68]

Monet was out to do the same. He had overcome his rivals at home; it was now time to take on those across the Channel, as he suggested to Alice after seeing a number of exhibitions in London in which he and his Impressionist friends Renoir, Sisley, and Pissarro were poorly represented.[69]

Of all the English painters who really mattered to Monet, the most important had been dead for almost fifty years, but during and after his lifetime, he had risen above the rest: Joseph Mallord William Turner, who had died in 1851. Ironically, but aptly, Roger Marx had singled Turner out in his praise for Monet at the World's Fair. It was not the first time the two artists had been compared. After the exhibition of Monet's Rouen Cathedrals in 1895, they were often linked because Turner had come to France in the 1830s and done numerous drawings and engravings of the same celebrated church while collecting material for one of the more popular books on French rivers, which first appeared in June 1833 and was frequently reprinted.[70] Turner's novel treatment of light and color, his expressive handling of paint, his sensitivity to nature's vagaries, and his defiance of his more traditional colleagues made the general comparisons appropriate. Turner also took on the great artists of the past with a combination of admiration and aggression. He trained his eye on the leading Dutch artists of the seventeenth century, for example Cuyp, Ruisdael, and Hobbema, and painted pictures based on theirs that would relegate them to the past. He did the same with French masters, most notably Claude Lorrain. Indeed, he produced his own versions of Claude's paintings and then insisted in his bequest to the nation that two of his challenges to Claude hang in perpetuity alongside the originals from which they took their cues, so that he would go down in history as having rivaled if not outdone one of the greatest landscape painters.

Monet appreciated that kind of aesthetic skirmishing and would have judged the results for himself in Trafalgar Square, as the Trustees of the National Gallery honored Turner's request and kept the four paintings together. Monet had some deprecating words about the English painter later on, declaring that he was an unsophisticated colorist, but in the 1890s he spoke highly of him, recalling in particular his *Rain, Steam and Speed* as well as Turner's watercolors done from nature.[71] Their shared interests and concerns extended beyond those of aesthetics, as both had a passion for the sea, wanted to control their own biographies, and desired to go down in history as the best of their kind.

It therefore stands to reason that Monet would have started one picture after another from his balcony above the Thames, worrying about the light, the brushwork, the color, the forms. He was doing battle not just with nature but also with one of the finest painters to have confronted that fickle subject and successfully wrestled it into paint.

facing page Detail of cat. 24.

After postponing his exhibition of these London pictures in May 1903 and contemplating a similar delay early the following year, he finally let them be seen in late spring of 1904. The show opened on May 9 and closed on June 7, having been extended three days so that Monet could see it one last time.[72] It contained eight views of Charing Cross Bridge, eighteen of Waterloo Bridge, and eleven of the Houses of Parliament. Durand-Ruel saw their potential and purchased eighteen of them before he opened the doors to his gallery. Two days later he bought two more and sold both the same day – one to the critic Raymond Koechlin, the other to Count Isaac de Camondo, who had one of the largest collections of Impressionist pictures in Paris. The exhibition was immensely popular, garnering more praise than any previous show Monet had mounted.[73]

Georges Lecomte felt that Monet had never "attained such a vaporous subtlety, such powers of abstraction and synthesis." The critic for the conservative newspaper *L'Action* agreed:

In his desire to paint the most complex effects of light, Monet seems to have attained the extreme limits of art. . . . He wanted to explore the unexplorable, to express the inexpressible, to build, as the popular expression has it, on the fogs of the Thames! And worse still, he succeeded.[74]

More than one critic noted the ties with Turner, but Gustave Kahn, the Symbolist poet and critic, made the essential point:

If it is true that Turner liked to compare certain of his works to certain of Claude Lorrain's, then one might place certain Monets beside certain Turners. One would thereby compare two branches . . . of Impressionism, or rather . . . it would integrate two moments in the history of visual sensitivity.[75]

Monet was delighted, so much so that he decided to stage a similar exhibition in London itself. Practicalities plagued this initiative, just as they had the whole campaign, largely because Monet wished to do the show on his own, "as an artist . . . for my personal satisfaction," as he baldly told Durand-Ruel.[76] He insisted that the dealer not include any of his Londons in a group show Durand-Ruel was talking about doing in the English capital. Monet wanted them exclusively for himself.

But in early 1905 he abandoned the project. It had proven to be too cumbersome. In addition, he was deep into his next suite of pictures and thus preoccupied. He harbored no regrets, however, particularly after Durand-Ruel went ahead with his London exhibition, in which Monet was handsomely represented. The show proved to be an unqualified success. "I am delighted with the success

[of your show]," he told the dealer in an uncustomary demonstration of generosity. The source of his pleasure was the satisfaction he derived from knowing that he and his colleagues had proven that their works were equal to if not better than anything England could produce, an aggressiveness that he had no qualms about expressing. "It is an excellent thing to have dealt London such a decisive blow," he gloated to the dealer.[77]

Reassured, he returned to his Giverny gardens and the project that would preoccupy him for the rest of his life.

Merging Art and Life in the Early Twentieth Century

Shortly before Monet left for London early in February 1900, he wrote his gardener a long letter giving him detailed instructions about what to do while he was away.[78] The precision of his requests attests to Monet's horticultural knowledge and to his concern for one of his most precious artistic creations. He cared almost as much about his plants and trees as he did about himself, declaring that flowers had inspired him to become a painter in the first place.[79] He spared no expense to satisfy his passion, reading more catalogues and horticultural price lists, as one critic reported, than articles by aesthetes.[80] Central to his life, his gardens at Giverny in the twentieth century became synonymous with his art and public persona.

The first paintings he finished after the new-year celebrations in 1900 were half-a-dozen canvases from the suite of twelve Water Lilies that he had begun in the summer of 1899. These paintings, plus five more that Monet completed between April and November, formed the core of his first show of the century, which opened at Durand-Ruel's on November 22, 1900 (see below, pp. 118–27). It was a landmark exhibition, as it was the first time that Monet put his Water Lily paintings before the public and the first time that he based a show so squarely on work that depicted his personal property. Both would have serious consequences for himself and his public and would help to shape the direction of his art over the course of the next twenty-six years.

In preparation for this show, Monet worked hard for ten months, returning to the banks of his pond almost immediately after unpacking from London. He took up where he had left off, beginning a new group of six more views of the same Japanese bridge, though now seen from three different vantage points (cats. 1–4). The first (cat. 1) is closest to the one he had assumed for the earlier 1899 group, although he has moved to the left, which pushes the bridge more off-center and causes it to rise more radically up the picture plane. In two other versions (cats. 2 and 3), Monet pulls even farther back, permitting the irises along the edge

of the water to become prominent elements in the lower-left corner of the scene. A sliver of sky now appears above them.

In three final views (see cat. 4) he takes several more steps back to reveal that he had been standing on the path that ran along the pond in order to paint the previous pictures. He now includes that path as a sweeping curve in the lower left, echoing the arc of the bridge and the bend of the shoreline. Having retreated so far from the water, the sliver of sky that had appeared in the other views here becomes a larger wedge with a long, wiggly extension that muscles its way through the thick foliage of the background as if struggling to reach down to touch the path or to sneak behind the resplendent bush on the left and encourage the bridge on its leap across to the opposite bank.

Everything in these scenes is more animated than in the first, distilled views. The plants along the banks quiver and shake as though activated by some internal force, while the light in the pictures darts in and out with greater drama, creating greater contrast and a heightened sense of presence. There is both a competitive and a complementary relationship among all the elements in the picture. For example, the larger waving leaves of the irises in the foreground are played off against the tighter, more manicured extensions of the bigger bush by the bridge. Both are set against the massive willow in the background, the thicker boughs of which drop more weightily behind the bridge, their strands looking like torrents of rain falling resolutely to the earth. Even the less distinct trees to the right punctuate that side of the pictures with stronger syncopations.

Most startling, however, is the color change. Instead of the cooler greens and blues of the first group, Monet employs a daring range of crimsons and violets which he boldly combines with olive-yellows and shimmering whites. The former tint the pond in certain canvases with a bloody richness that had not appeared before in Monet's work. The latter rise almost to a phosphorescent pitch in parts of the surrounding foliage, causing some of the pictures to become almost overheated, as if Monet were flirting with a new form of garishness. In views such as catalogue number 1, he even artfully uses an unpainted area of the primed canvas as the primary source of reflected light in the pond, creating a complexity of surface and depth, illusion and reality that is unmatched in any other picture in this series. Monet no longer felt the constraints of the previous summer, liberated perhaps not only by his return to painting but also by the challenges of the coal-charged skies of London that he had attempted to subdue.

Extracting these subtleties drove him crazy, as he confessed to his dealer in late June: "I have not stopped working since my return from London, but without getting to a point of being able to finish anything to my liking. I have nothing interesting to show and even less to sell." His ideas

about the latter had become quite firm. He told Durand-Ruel that he was "resolved never again to sell anything that I find just all right."[81] As with his selections for the World's Fair exhibition, anything he let out of his studio had to be of the best quality. His critical standards became more rigorous in direct relation to his increased status.

Monet foresaw the inevitable problem with this stance: he would never be satisfied and thus would never have anything to sell, a fact he freely admitted to the dealer. Two months later, things had not changed. "The summer has not been very good for me, despite the beautiful weather," he complained to Durand-Ruel. "However, I have worked a great deal, but because I have become slower and more demanding, I have not been able to do what I wanted." He also had been hit in the eye when playing with his children and had not been able to see out of it for almost a month. "You could well imagine that I was scared . . . for a moment, but it's over for now and I hope to be able to get back to work soon and make up for the lost time."[82]

It was a further two months before Monet appears to have considered the notion of exhibiting the pictures that had been preoccupying him, and it was not until early November 1900 that the show started to take shape.[83] He expected to include the Water Lily series plus a few other pictures, but Durand-Ruel wanted to make it "an important exhibition," as Monet characterized it in the middle of November.[84] The dealer intended to capitalize on the notices that Monet had received for his work in the exhibition at the World's Fair, which was scheduled to close on November 1. Monet's own solo show at Durand-Ruel's was to open three weeks later and run until December 15.

The Durand-Ruel show contained twenty-six works, evenly divided between paintings that Monet had done from 1889 to 1898 and those that he had completed in 1899 and 1900. It began with two canvases from the Creuse Valley campaign and moved on from there to five views of Norway, three Cliff pictures and three Mornings on the Seine. Monet's more recent work was represented exclusively by thirteen garden pictures (see cats. 5–8). The division of the show into what was in effect two shows in one – the first demonstrating great range, the other intense concentration – was apparently in response to the survey of French art from 1889 to 1900 that the state had mounted for the World's Fair. It had run simultaneously with the larger centennial exhibition of French art, which contained works made between 1789 and 1889. Monet had been included in the latter exhibition but not in the former. Durand-Ruel was making up the difference while imitating the breadth and focus of the official exhibitions. He was also establishing himself as Monet's primary representative, having purchased twenty-three of the twenty-six pictures in the show at various points before the opening. Although it may have been due to availability, all the

paintings from 1889–98 had already been shown in Paris. Most of them, perhaps as many as eleven, had been exhibited just two years earlier in Monet's acclaimed show at Georges Petit's. Now Durand-Ruel owned all thirteen of them.

Monet's earlier work provided an obvious foil for the sweep of his garden pictures, although the artist and the dealer may have been surprised by the mixed reactions of the critics. Most writers noted the similarities among all the 1899 canvases; some decried their lack of diversity. Arsène Alexandre, for example, who had written very favorably about Monet's 1898 exhibition, even cited the specific dimensions of the pictures to emphasize his point. He also suggested rather glumly that the Water Lilies made him question the validity of painting in series, especially with a motif like the lily pond, which he felt "is a bit simple and of a rather secondary interest."[85] Alexandre admitted that many of the pictures possessed "the splendor of [a] symphony," but he believed Japanese artists had been more adept at treating the same subject, varying their viewpoints and arranging forms more artfully, thus producing works of greater visual and aesthetic interest. He was to change his opinion after a visit made to Giverny the following year when he realized how spectacular and challenging Monet's motifs actually were.[86]

Other writers, such as A. E. Guyon-Vérax, took a far more sympathetic view, describing the site of the motif as "a delicious jumble . . . of dazzling greenery enclosing . . . an enchanting corner where everything is radiant."[87] Julien Leclerq, who had hailed an exhibition of Impressionist paintings at Georges Petit's the previous year as constituting "a glorious chapter to add to our history of French art," countered Alexandre directly with a pungent reading of Monet's aims and intentions: "In order to appear more discriminating than before, some hard-nosed individuals say to themselves it is time to criticize a bit [and] reproach Monet for not having taken a turn around the bridge, for not having varied . . . his vantage point."[88] Leclercq dismissed these criticisms, declaring that Monet's interest "is the light, always the light . . . and so that we may have no doubt about that, he does not want to distract us by varying his composition." Painting the bridge over and over, in Leclercq's opinion, allowed Monet "to make the shadows softer and more accentuated . . . the water lilies to sing ten different melodies . . . the greenery to accompany in ten different ways." Most importantly, perhaps, Leclercq saw Monet's initiative as expanding beyond the limits of his formal concerns and the specifics of his subject. His paintings represented the continuation of the enlightened thinking of eighteenth-century France, where painters and philosophers were united in their veneration of nature and were willing to bare their souls to reveal their sensibilities and values. To cast aspersions on the series was, therefore, in his opinion, to denigrate France.

Equating these Water Lily paintings with France and her history and challenging anyone who might criticize them by raising the specter of national pride might seem strange, or at least highly idiosyncratic, but even critics who were less enthusiastic about these new paintings saw Monet's efforts in chauvinistic terms. One of the most revealing was Charles Saunier, the recently appointed art critic for the liberal monthly La Revue blanche. Saunier regarded the Water Lilies as edenic and fairy-like: "The vapor distilled by the crushing heat permits strange irisations and makes this corner of nature pass from pink to mauve and from these hues to others." The problem for Saunier was the absence of any evidence of a human presence. He realized that this had also been the case with several of Monet's earlier series paintings, notably the Mornings on the Seine, although not the Stacks of Wheat and the Cathedrals because they "told us of the labor of man, his collaboration with nature."[89] Despite this reservation, Saunier hailed Monet's broader achievement, declaring that he had been able to express the essence of the nation in his art for nearly a decade. "Transport these Mornings on the Seine, Stacks of Wheat, and Cathedrals around the world," he urged, "and no matter where these paintings will be, the spectator, whoever he is, will admire and envy a country where the hand of man . . . built such beautiful monuments in the middle of such beautiful sites. Glory thus," he sang, "to the artist who with the aid of a few lines and some dashes of color can so grandly synthesize the land where he lives."[90]

The power of Monet's personality and the strength of his commitment to La France was given even greater specificity on the front page of Le Temps, the Parisian newspaper with one of the largest circulations in the country.[91] The article, one of the longest ever written on the artist, was perfectly timed with the exhibition. It also had a unique format; after several introductory paragraphs, it became essentially an interview with answers to questions run together into a narrative. Largely biographical, it offered Monet the ideal opportunity to tell his personal history as he wanted it recorded, and he took full advantage of the occasion, lacing his generally accurate account – of his birth in Paris, battles with the Salon jury, and commitment to his art – with a host of half-truths that made him appear more undisciplined and independent than he actually was. He also overstated certain key points – his military service, for example, which he claimed was an exhilarating seven years when it actually was only slightly more than one. He also rewrote the history of his relations with his dealer Durand-Ruel, describing him as "a savior" who for fifteen years was the sole outlet for Impressionism, when in fact the dealer stopped buying pictures from Monet in 1873 and did not begin again until the 1880s when Monet played him off against other dealers and marketed work himself. Given how sensitive the issue of the

military was after Dreyfus, however, and how important Durand-Ruel was to Monet and the sale of Impressionist pictures, these overstatements were clearly politic. So too was Monet's insistence on what he described as the "*raison d'être* of art . . . [namely] . . . truth, nature, and life." For that was what he was attempting to propagate in both this personal exposé and his newest work, even if the latter looked different from what he had produced previously.

Thiébault-Sisson seems to have had a similar objective in mind. In the first sentence of his opening paragraph, the critic emphatically declared that the paintings in Monet's show reveal "a decided change in the artist's manner," but he does not describe what had been altered. He simply praises Monet with a flood of superlatives, as if to counter any negative opinions about this new work and reassure his public that Monet was a man of strong convictions, based on reasonable, indeed laudable principles. Thiébault-Sisson emphasizes Monet's balance of arrogance and humility, single-mindedness and cooperation, drawing attention to his worldliness and entrepreneurial acuity When Durand-Ruel could no longer support him, for example, Monet did not hesitate to turn to other dealers, which stimulated more interest in his work and thus expanded his market. "Today," Monet concluded, "nearly everyone appreciates us to some degree." This was *laissez-faire* capitalism at its best with an end result that was good for everybody – dealers, collectors, the Impressionists, and, of course, Monet.

It was good for Thiébault-Sisson's public too, because Monet not only had a track record and the talent to merit his success, he had all the personal characteristics that allowed him to prosper, characteristics (it was implied) that should be models for others as well, because they were what had made France great. The bold, new direction of Monet's Water Lilies, whether his readers liked them or not, was only another indication of the artist's initiative and his ability to lead by independent example.

By grounding Monet's achievement in a self-constructed biography in addition to his work, Thiébault-Sisson was able to provide a remarkably resilient record of the man, which would become a frequently quoted source for decades to come largely because it appeared to come straight from Monet. It also provided a practical framework for understanding the more esoteric homage that Monet had begun to attract. As Jules Buisson noted in *La Chronique des arts* in 1899, Monet had long been called "a philosopher, a man of the spirit, a historian, a charming storyteller, [and] a gentleman."[92] Now, "circa 1900," as Steven Levine has rightly pointed out, he would be increasingly referred to as a great poet or "'a pure artist' in the order of the great artists of the past in Egypt, Greece, Italy, and Japan," detached from any worldly concerns, involved only in his garden and his art. Thiébault-Sisson's article was the perfect complement to that idea.[93]

Monet was more than happy to cultivate both sides of his emerging public persona – the poet, artist, and visionary, and the practical man, gardener, and businessman. From Thiébault-Sisson's article onward, he agreed to numerous interviews and visits from journalists who would make the trek from Paris to Giverny to report on the man and his surroundings. Their aims were generally the same as those of Arsène Alexandre, who initiated such articles following his visit in 1901: "A man is known by the company he keeps," Alexandre asserted, but, he added, "one may know a man better still if one knows his house . . . the material reflection of his tastes, his desires, his quirks, and his cultural level."[94]

However, Alexandre quickly realized that it was not so much the home as the garden that was most important to Monet. "Everywhere you turn, at your feet, over your head, at chest height, are pools, festoons, hedges of flowers, their harmonies at once spontaneous and designed and renewed at every season." And it was not just the flower garden, where "the effect . . . of the floral fireworks . . . is explosive and joyful, and every effect is planned," but also the water garden, which, according to Alexandre, "has inspired legends." He wanted to set the record straight and inform readers that the water garden had been part of Monet's life for a decade (an obvious exaggeration), just as Monet's series of Water Lilies "has been in progress for ten years, on and off" (another exaggeration). He even informs his readers that more often than painting *en plein air*, Monet worked in his studio, but he embellishes this admission by describing the building as "the large studio set amidst his flowering vegetable garden, like a combined market stall and observatory."

Everything about his description of Monet and his environment underscores the nearly complete integration Monet appears to have achieved between his art and his life, his painting and his garden. "The garden is the man," Alexandre affirms, even going so far as to assert that Monet's personality changes from the city to the country:

> The same man we find to be somewhat laconic and cold in Paris is completely different here, kindly, unperturbed, enthusiastic. When he has reason to come into the land of the boulevards, his smile is more than a little mocking and sarcastic; in his garden, among his flowers, he glows with benevolence. For months at a time, this artist forgets that Paris even exists; his gladioli and dahlias sustain him with their superb refinements – but cause him to forget civilization.

Such provocative statements border on hyperbole. Certainly, they contain kernels of truth, but they are richly embroidered, much like Monet's assertions in Thiébault-Sisson's article. Not surprisingly, like those autobiographical "facts," remarks of this kind were repeated by visitor after visitor to Monet's refuge. Why does all of this become so

significant to journalists? And why does it become so important to understanding Monet's art?

Alexandre suggests the answer and, not surprisingly again, it is not far from the rationale of Thiébault-Sisson's interview. According to Alexandre, Monet "is a painter who, in our own time, has multiplied the harmonies of color, has gone as far as one person can into the subtlety, opulence, and resonance of color" – a clear reference to the second group of Water Lilies of 1900 that Alexandre had just criticized. But now Alexandre understands those pictures differently, seeing them as embodying one of the three *raisons d'être* that Monet had tendered as the basis of his aesthetic – namely, the revelation of truth: "He has dared to create effects so true to life as to appear unreal, but which charm us irresistibly, as does all revealed truth."

Alexandre, of course, does not attempt to define what that "truth" is supposed to be, just as Thiébault-Sisson did not clarify the changes in Monet's art. Instead, like Thiébault-Sisson, he emphasizes the second of Monet's fundamental concerns: nature. "Who inspired all this?" Alexandre asks. "His flowers," he answers. "Who was his teacher?" he demands. "His garden," he responds. Alexandre does not advise everyone to pay the master of Giverny a visit: "For there is a gate . . . and it is not always open, even if one may always look through it." To rationalize this slight contradiction, he offers "not the least of the lessons learned on our excursion: great artists, superior men, can live in glass houses. One may see through glass – but not pass through it." In other words, observe what Monet has constructed – in his life, surroundings, and art – and follow his example. He does not have to invite you in and teach you personally. You can observe all the lessons he has to impart as freely and as often as you like in his art. And of course you can read about it in descriptions such as the one Alexandre offers. "Such is the lesson that a plot of earth, artfully sown, can teach," Alexandre concludes, echoing his eighteenth-century *philosophe* counterparts. "Such is the light that a mere hour's visit can shed on a man's character and career."

Monet's third *raison d'être* – life – lies at the heart of it all. Monet had fashioned a life close to nature that allowed him to understand and reveal truth through art. You did not have to be an artist to appreciate this agenda; that is why the art critic was not writing criticism in the art columns of the paper but instead sketching popular biography on the front page. Monet's life had a moral dimension to it that everyone should appreciate, if not perhaps imitate.

As with the association of his art with France, the suggestion that Monet's life was a model to be followed – because it was distinctive, honest, disciplined, poetic, and close to nature – was not Alexandre's invention. It had its origins in the late nineteenth century. It was expressed most directly and movingly in 1898 by Georges Lecomte, who knew Monet well. Writing about Monet's exhibition at Georges Petit's in June 1898, he observed:

> Attentive to all the flourishing of modern thought, to the so passionate efforts of our epoch for a better future, to the muffled travail of a society that wants to be more just and more free, does he not give us the reassuring example of his simple and straightforward life, all work and reflection, full of tender respect for the at once so noble and so precarious human plant?[95]

One senses Lecomte's strong republican bias in these words, but essentially he set the stage for the public's interest in this aspect of the artist.[96] Again, we should ask why. In part it has to do with the fact that Monet was becoming a celebrity. Once that began, Monet's private life became virtually equal to his art, or so intermingled that you could not isolate one from the other or the parts from the whole. It also had something to do with the fact that Monet's Water Lilies had the appearance of being more aloof than his earlier work; probing his personal life was a way of recovering some of the accessibility that those earlier pictures had offered. It was also a way of affirming Monet's Frenchness, even if he were going to be painting subjects that evoked aspects of the Far East. And it had something to do with the fact that he was one of the grand old men who was not going to abandon certain values or practices just because a new century was about to begin.

What better model for a country that was trying to find its way through the morass of political scandal and social excess! And what better art to hold up as an example of France's continuing achievement. Monet fully understood the role he was to play; he had partly helped to shape it. That was one of the reasons it took him so long to finish and exhibit his Londons. And it was one of the reasons it took him so long to go back in front of the public after showing those pictures, an event that was almost universally applauded. His next exhibition of new work was not until 1909, more than five years later. How could he uphold his reputation? How could he do better than what he had just done? How could he extract something new from the seemingly limited repertoire of his garden?

The Lilt of the Lilies and the Mandate of Nature

As Monet worked on his Londons and Water Lilies just after the turn of the century, he calculated his various escapes from his pond pictures of 1899. They came first in the form of his heated paintings of 1900 and then in an even more ambitious undertaking – the expansion of his water garden as a whole. In May 1901, barely a month after returning from the last of his painting campaigns in London, Monet purchased a plot of land that lay on the other side

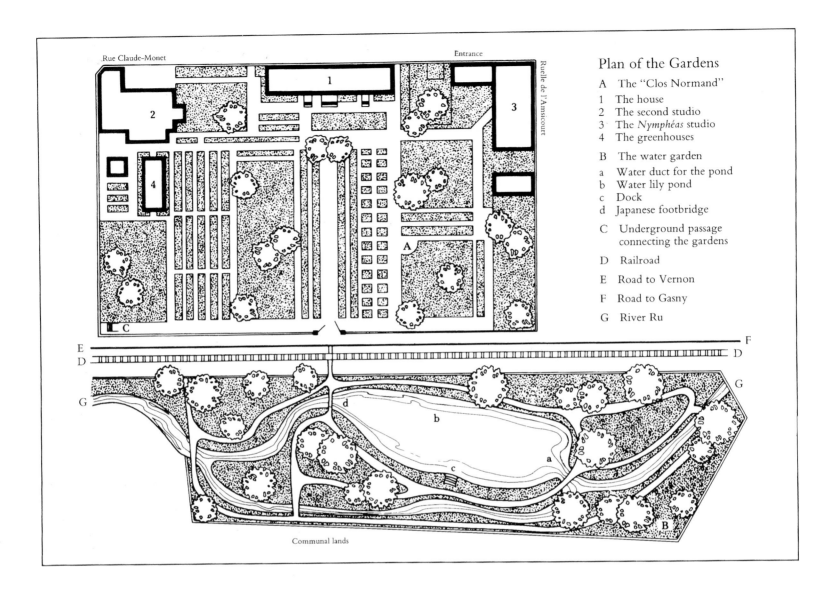

Ruelle de l'Amiscourt

Plan of the Gardens

A The "Clos Normand"
1 The house
2 The second studio
3 The *Nymphéas* studio
4 The greenhouses

B The water garden
a Water duct for the pond
b Water lily pond
c Dock
d Japanese footbridge

C Underground passage
 connecting the gardens

D Railroad

E Road to Vernon

F Road to Gasny

G River Ru

Communal lands

Fig. 30 Map of Monet's property at Giverny.

of the Ru, the tributary of the Epte that fed his pond. He intended to divert the stream by digging it a new bed and then using the reclaimed acreage for his aquatic wonderland. It took months to draw up the plans and obtain permissions from the Département prefect, the Giverny town council, and the Département des Ponts et Chaussées, but approval was eventually granted on December 11, and work began soon thereafter.[97]

It was a major project that required nearly three months to complete, but when the workmen finally left in late February or early March 1902, the place had been transformed. The Japanese bridge remained where it had been, but the surface area of the pond had more than tripled in size. The whole garden now spanned 65,000 square meters, or just over half a hectare (fig. 30). The largest expansion of the pond occurred on its eastern end, although the smaller section just beyond the Japanese bridge was also now significantly bigger. A miniature island was added on the southern side of the pond. In addition, four flat footbridges were laid across the rerouted Ru for

access to a second gravel path that meandered along the far side of the stream's new bed. Dozens of bushes, ferns, trees, and flowers were soon planted over the new acreage, with bamboo and ornamental cherry trees adorning the area that jutted out into the pond on the south side by the island. Most important perhaps, beginning on February 26 and 27, Monet began to sow his pond with an array of both tropical and hardy water lilies ranging in color from yellow and white to pink, red, and copper. As the project drew near its completion, Monet took the ultimate step and asked the Département prefect for permission to erect a trellis to close the garden off from the railroad that ran through his property. He wanted his newest creation to have at least the appearance of being separated from the realities beyond its iris- and willow-lined borders, even if the railroad "cuts his little world in twain . . . to his lasting sorrow," as one English visitor reported.[98]

Knowing it was going to be changed, Monet decided not to paint the water garden during the summer of 1901. Instead, nearly every day he climbed into the back seat of

the Panhard-Levassor automobile that he had purchased in December 1900 and rode up the Seine to Lavacourt across the river from Vétheuil, where he had lived and worked between 1878 and 1881. From the second-floor balcony of a modest house in the town, he began a series of fifteen views of the picturesque village, with its cluster of houses and crowning Romanesque church, under a variety of lighting and atmospheric conditions (fig. 13). These paintings were unabashed retreats to pictures he had done of the same site during his stay in Vétheuil more than two decades earlier (see fig. 2), and were suffused with sweet nostalgia for the time he had spent in that village some twenty years earlier. Their straightforward compositions and centrally aligned motif suggest a simplicity that even his garden views of 1899 lacked, just as their soft brushwork exudes a calm that his own backyard had not induced. They proved to be quite popular, though; Monet sold ten of them in the first three months of 1902 for 80,000 francs – enough to cover the cost of his garden renovations and to pay for his new car at least five times over.

He put aside the five views of Vétheuil he did not sell for the more pressing task of finishing his Londons and determining what he would make of his garden paradise. While he struggled with the former – they would take him another two years to complete – thoughts of Vétheuil appear to have lingered. When the weather became warmer and his flowers filled his garden with waves of striking color, he decided to paint a suite of four pictures of the main *allée* that led from his house to the water-lily pond (cats. 5 and 8). While these paintings recall earlier garden views that he had done in the classic years of the 1870s, they also contain strong echoes of paintings of his house and garden at Vétheuil from the early 1880s, such as figure 31, a picture that was still in Monet's hands.

He probably did not actually start this new group of pictures of his Giverny garden until late summer or early fall 1902, judging from the species of flowers that line the *allée* – a profusion of dahlias, orange nasturtiums, and violet asters, which bloom near the end of August. But when he did, he put those 1870 and 1880 precedents behind him; they literally and figuratively pale in comparison. One now senses the grandeur of Monet's estate, particularly in the view he painted while standing in the middle of the path, placing the house directly at the vanishing point of converging orthogonals of flower beds that conveniently begin in the immediate foreground (cat. 8). Thick foliage cushions the top half of each view, dipping and swaying under the enormous weight of greenery. Branches reach out to greet each other and brush the house in the background, much like Cézanne's pines in front of Mont Saint-Victoire. The light is so intense and so interlaced with the flowers and foliage that it has an almost tactile independence or the quality of a molten substance bonded to the forms it illuminates. Nothing could be more inviting, particularly the

views toward the house. The beige path is humanely measured by the appropriately spaced shadows; the front door and second-story window are wide open to greet us.

The path was almost 52 meters long. For all four of these pictures, Monet carefully positioned himself just about halfway down it in order to lend significance to the house at one end or, when he turned around, the pillars at the other (cat. 5). He gives no indication in the latter views that the water garden lay just beyond those stone sentinels; in fact, the path led directly from the front door of his house to the Japanese bridge, an alignment that neatly united the two gardens despite their different designs and effects. If he had moved further down the path toward the bridge, he would have had to deal with the road and the train tracks that bisected the property. Better to stand to one side and disguise their presence by the flood of light and the tangle of foliage, as he does so artfully in this mesmerizing picture.

Although the four paintings are among the lushest and most beautiful of his views of his house and garden, they were not the first that Monet had executed. He had done four others two years earlier in 1900 (including cats. 6 and 7), one of which (either cat. 7 or W.1624) he included in his exhibition at Durand-Ruel's in December of that year. It was the only painting of his Giverny flower garden completed in the twentieth century that he chose to exhibit during his lifetime.

Of these four views from 1900, only one depicts the central *allée* (cat. 6). It is a classic picture with the edges of

the perfectly clipped path leading with Renaissance precision to a vanishing point just above the door of the house, which is almost in the exact center of the nearly square canvas. If Piero della Francesca's anonymous followers who painted views of ideal Italian cities in the fifteenth century had lived into the twentieth and moved to the countryside, this is the image they would have envisioned. Beauty, order, and serenity are delivered to the doorstep without compromise or hesitation. Even Meindert Hobbema would have appreciated Monet's painting, because this is the modern version of his celebrated *Avenue at Middelharnis* (National Gallery, London).

That Monet did only one view of this site in 1900 is surprising, however, it is so perfect and seemingly immutable that it could hardly tolerate a duplicate or variant.

Two years later Monet cast off those restraints and returned to the same spot, perhaps because it was so beautiful and because the garden itself had become even more resplendent. This is immediately apparent when the first view, from 1900, is compared with the second, from 1902 (cats. 6 and 8). The later picture attests to the miracle growth: the flowers surge forward from their tiered beds in contrast to the earlier picture's more reserved species, which occupy flatter, more controlled spaces that are simply not as full. Even the boughs of the spruce trees are thinner and more individualized in the view from 1900, while the house itself is starker, causing it to be more conspicuous. In the later view, the house is more integrated into the whole by the more interwoven foliage and by the Virginia creeper which has climbed the rectangular trellis framing the wooden steps and front door.

Curiously, these eight paintings from 1900 and 1902 are the only ones that Monet painted of his flower garden during the first decade of the twentieth century. Over the next ten years he painted just two others, both in 1912. He would return to the garden during the final ten years of his life to produce some of the most strident and suggestive pictures of his late career (see below, pp. 232–51). But for almost twenty years what absorbed him more than any other subject during his long and fruitful life was the reflective expanse of his water-lily pond and its attendant plantings.

It is hard to know why he did not indulge himself more in his floral wonderland. Perhaps it was too hedonistic or, given how quickly the flowers came and went, too constraining as he could not put into practice the "slower and more demanding" methods that he had described to Durand-Ruel in 1900.[99] Nor could he vary his motifs as much as in the water garden. For despite the profusion of flowers, each species was carefully planted in separate although interrelated groups, according to their blooming cycles, which meant that the garden was itself a work of art, with its own palette, texture, composition, and drama. It forced itself on the viewer in a way that made it – not the painter or the viewer – the dominant element in the equation.

The water garden was less assertive. It was composed of less identifiable patterns of species and was based on a less decipherable overall design. Its paths curved and wandered unlike the straight and restrained ones in the flower garden. The trees were not spaced by strict geometry but by what appeared to be a more arbitrary or natural sequencing. The pond was completely irregular, with undulating edges and an unpredictable surface. The water lilies were the opposite of their counterparts on the other side of the railroad tracks. While nurtured and pruned into particular configurations, each group conformed to no precise, verifiable shape; and no one shape duplicated another. All of them together gave no hint of being part of a specific, preordained plan. The flowers themselves embodied the garden's innate sense of freedom as they opened and closed every morning and evening. Visitors who came late or lingered in the flower garden remember being vigorously ushered by Monet to the pond at the end of the day so that they could see it before the lilies bedded down for the night. The flowers were also hardy and long lasting; thus, Monet would not have been forced to work with or against their blooming habits.

The species offered less variety in terms of the flower's color, but in compensation it provided much greater complexity. For example, not every pad produced a flower. Consequently, there was no rational correspondence between the number of flowers and the number of pads. And exactly where the flower might rise in the cluster of pads was equally unpredictable. Neither of these indeterminate relationships seems to have anything to do with how close one pad was to another or how much water separated the clusters. The pads themselves were likewise highly individualistic, varying in shape, size, and hue. In the clusters, they acted like herded farm stock, bumping against each other and jostling for position in a quietly aggressive, slightly uneasy way. Occasionally, some escaped and floated off on their own or, conversely, appeared to be returning to the fold. Finally, the pads and the flowers suggested a unique dynamic. The petals ascend from their limpid, almost makeshift, clusters like precious stones hurriedly placed on display. Their rounded rise contrasts with the flat, horizontally spreading leaves, their zest and sparkle enhanced by their humble green supports. In no case is it possible to determine where the roots lie, for either the pads or the flowers. Both are suspended on the water like forms that have magically alighted or appeared. Defying gravity, they move not in a single direction like normal flowers which respond to air movements, but in many different and unanticipated ways.

And then there was the water. Monet had always been fascinated by water. It had nurtured him as he grew up in

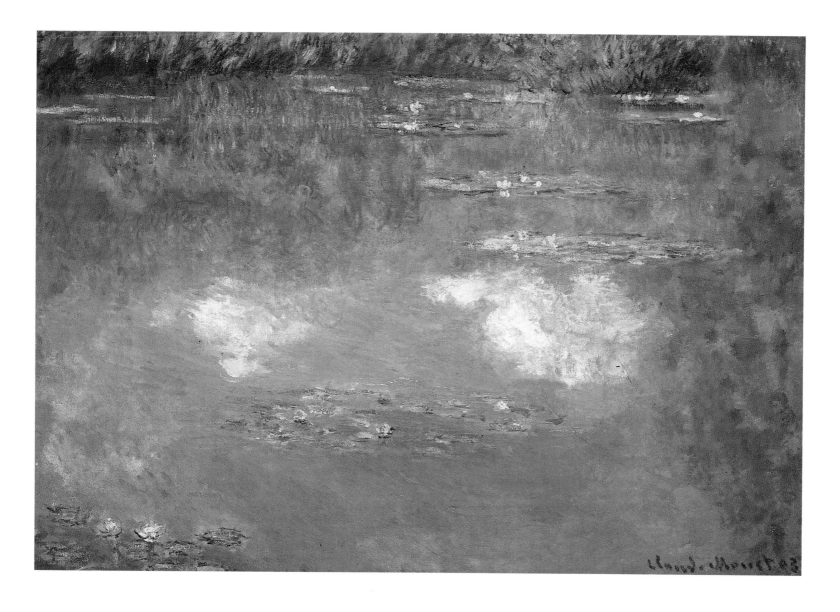

Sainte-Adresse on the Normandy coast, and it had sustained him as the years passed. Late in his life, he would arrange to have himself driven to the coast just to smell the sea air, a trip he would make even during the First World War. He once declared that he wanted to be buried in a buoy, presumably to be eternally one with the liquid substance and forever to experience the sea's swelling. In fits of anger, when he claimed he was going to kill himself, it was always going to be by drowning.[100]

He painted hundreds of pictures in which water, under all conditions and in all of its guises, played a role, beginning with his first signed and dated painting of 1858 whose immediate foreground is split by a quiet, country stream. Aside from light, it was his most consistent artistic companion and his most revered earthly element. Independent, elusive, and yet distinctly itself, it was not without faint echoes of Monet's own personality. Because it was also vital, life-giving, and able to assume an infinite number of shapes, it was also not so unlike an aesthetic ideal.

That Monet would have preferred the water garden

over the flower garden, therefore, is understandable. It offered him the ultimate in variety: an infinite array of color; constantly changing reflections; continual tensions between surface and depth, near and far, stability and the unknown, with everything bathed in an endlessly shifting but ever-present light. Filled with feeling yet distinctly physical, it remained mysterious and deeply contemplative, much like the cosmos as a whole.

It also must have contributed to the utterly unexpected group of Water Lilies that he completed in 1903 (fig. 32 and cat. 25). So startling are these pictures that they lead one to believe that they may have been preceded by canvases that did not survive his studio editing in 1907 and 1908; he reported shredding more than thirty canvases in 1907 alone.[101] This is apparent when any of them is compared either with the earliest Water Lilies from 1897 or with his views of the pond and Japanese bridge from 1899 and 1900. There is a lightness and airiness, a sense of expansiveness and daring in these new pictures that the former do not possess and which is radically

different from their treatment in the views of the Japanese bridge. This is particularly evident in the horizon that Monet raises so dramatically in some pictures, such as figure 32, and then completely abandons in catalogue number 25, enlarging the area occupied by the pond so that it takes up most or all of the canvas. Although Monet had eliminated the divisions between water, land, and sky in the earliest Water Lilies, pulling the pond boldly up to the top of the canvas to have it fill the entire picture plane, he had not evoked the depths of the water, the changing of the light, or the existence of other forms extending beyond the picture frame. In these new canvases he does so with great confidence.

Monet accomplishes these subtleties with an extremely refined palette and a more reserved touch, leaving behind the riotous colors, aggressive brushwork, and thick impasto of his Japanese Bridge pictures. He still varies his strokes throughout the scene to suggest a wide range of effects, but he does not rely on versatility or bravura to the same extent. He opts instead to sublimate his presence and to empty the scene of the visual incidents that so filled the previous pictures. In comparison to any of the earlier views of the Japanese bridge, figure 32 is almost vacant. The number of water lilies has been reduced to a bare minimum, and those he does include are spread so far apart that they become tertiary elements, far less important than the water and the reflections, topped off authoritatively by the bank in the background.

While the water lilies emerge in the immediate foreground of figure 32 and progress in a soothing curve toward the background foliage, they seem less conspicuous, not only because they are fewer and less dense but also because Monet has assumed a vantage point that warps the pond, causing the pads to appear progressively thinner the higher up on the canvas they rise. By the time they reach the bank's reflections in the background, they have become such slivers that in many cases they are rendered with a single stroke of the brush. Monet had had plenty of practice with perspectival effects of this sort, from

his Mornings on the Seine and Ice Floes of the 1890s to his views of the Seine breaking up in the winter of 1880 when he was in Vétheuil (fig. 33), but, for all of their sensitive handling, these precedents seem almost crude by comparison.

The novelty and the assurance with which Monet distributes the forms in Water Lilies (The Clouds) (fig. 32) contribute to the likelihood that others preceded it. But there is another, more compelling reason to believe this. Although hard to understand, given its seductive charms, Monet singled this painting out as one he wished he had destroyed, implying that he had edited others before it.[102] (Fortunately, this picture had been sold before he began his studio cleaning.) He told Durand-Ruel that he regretted letting it go and certainly did not want it in the projected Water Lilies exhibition that he and the dealer were contemplating in 1907. He did not offer any reasons for his opinion.

That its less fortunate mates did not survive adds to the difficulty of establishing a clear context for paintings such as the Dayton Water Lilies (cat. 25). Its edited horizon and the determined progression of the lilies up the picture plane suggest a logical extension of the stretched perspective of Water Lilies (The Clouds). It is as if Monet simply pulled everything closer to himself, adding the strands of foliage in the top left as a kind of visual anchor for the lilies and ourselves. They remind us of the pond's ties to some more defined reality than the shifting flowers and of the indefinite reflections on the even more ambiguous water.

As with much of Monet's work of the twentieth century, this painting might appear to be a logical next step from Water Lilies (The Clouds), but it did not then spawn a natural successor. The next suite of pictures that Monet executed (see cats. 26 and 27), revert to Water Lilies (The Clouds) as much as they rely on the initiatives of the Dayton painting. There are definite differences, to be sure. The newer canvases are nearly square, unlike any of the preceding ones. In addition, Monet has shifted his viewpoint so that the small island that projected out from the bank on the top right in Water Lilies (The Clouds) now pokes into the scene on the far left, just where the bank appears to begin. Monet has thus moved toward the eastern half of the pond and turned to look almost due west; the Japanese bridge is outside of the picture to the right.

These differences aside, however, the pictures do not aggressively pursue the Dayton version's flattened space. They maintain the latter's focus on the larger clusters of lilies. There are more of those clusters here and they appear closer and thus bigger, but the pictures retain the background bank of Water Lilies (The Clouds). In fact, Monet provides even more foliage here than he had in the earlier view, giving the pond a clear boundary, which the Dayton picture had daringly sacrificed.

Fig. 33 *Floating Ice*, 1880 (W.568), Shelburne Museum, Vermont.

As amalgams of the two prototypes, these newer pictures are a good reminder that Monet's work of the twentieth century did not progress along a clear, unbroken line. He experienced fits and starts, he glanced sideways and backwards, he traced and retraced his steps and then he traced them again. In part, this was the result of working under such strict, self-imposed limitations; in some ways he was always painting the same picture. In part, it derived from the more methodical working practices he had adopted. It also had something to do with his age and the doubts that plagued him, as well as his keen awareness of his place in the history of art.

This does not mean that it was not a continuous learning process or that he was unwilling to take risks. In fact, if one compares these 1904 Water Lilies to their predecessors, it is quickly apparent that Monet has added considerable complexity. He has made the water an entirely different entity, for example. In some areas, there are many more color changes than in the earlier pictures; there is also more activity on the surface, reminiscent of the 1899 and 1900 views of the Japanese bridge. In other areas, the color is more monochromatic, but it is more challenging because it is less light-filled than in the earlier pictures, where the blues almost appear scintillating by comparison. These deeper tonalities are particularly striking. When Monet allows the darker greens to take over, as in the version in Le Havre (W.1664), the painting becomes surprisingly mysterious, almost brooding, with the water-lily pads seemingly illuminated by a phosphorescent glow that culminates in the firefly-like flickering of the multi-colored flowers.

Even the different treatment of the background bank in the newer pictures creates complications that he did not have to confront in their precedents. Although the bank defines the edge of the space, it curves up and out of the scene, unlike its strictly horizontal counterpart in *Water Lilies* (*The Clouds*). Its arc warps the water and the picture as a whole in a more oblong, almost awkward, manner. In all the earlier pictures the water bends, but much more consistently from foreground to background, imitating the horizontal distribution of the elements. The water lilies in the newer pictures move more resolutely into the background as if reacting to this movement. In fact, they tend to float more independently and to hug the bank, mirroring its curve. Occasionally, as in the Le Havre canvas, this causes some congestion; the clusters are forced by the pressure of the pond's orientation to merge into a single lane, like travelers on a crowded highway.

One would have thought that having devised these greater complications Monet would have pursued them further. But once more that was not the case. In 1905 he painted three pictures that have almost nothing to do with any of these Water Lilies, the most striking of which is figure 34.

The expansiveness of these paintings, particularly the openness of the pond, reflects the changes of the garden as much as it indicates Monet's willingness to depart from a fixed line of aesthetic inquiry. The general enlargement of the garden must have encouraged Monet to broaden his touch and pushed him to charge his view with a *frisson* that animates every element in figure 34. The foliage of the trees shivers, the lilies seem to leap and dance off their pads; the pads themselves are in flux. Even the sky is swathed with huge blue and white strokes as if strong winds are causing the clouds to scud more rapidly across the expanse. If there is life in nature, it is made visible here.

But as soon as Monet starts down this path, he pulls back. He paints no other pictures like these – ever. In fact, he does only three other views of his pond that approximate the breadth of these three 1905 canvases; figure 42 is one. All of them depict a much calmer moment and an emptier section of the pond, looking toward the western bank and the pergolas that supported climbing roses. All of them were done in the summer of 1913, two years after his wife Alice had died, just as Monet slowly cast off his mourning cloak and tried to return to his art.

What then caused him to retreat from this initiative? Why did he not celebrate the sublime new scale of his marvelous creation with more pictures like figure 34. The answer seems to lie in the paintings themselves, as they tend to raise some of the same questions as the views down the flower-garden *allée*. They contain many spectacular moments but perhaps they do not pose enough problems or cause enough difficulty, which is maybe why Monet decided to raise the horizon in figure 34. It was a modest way to complicate the space and add another band of molten color.

It also may help to explain why during the summer of 1905 Monet began and finished a suite of twelve other pictures that are radically different from these swoon-inducing scenes and his Londons, which he continued to labor on at the same time. They fall into two distinct groups. In one, (cats. 28 and 29), Monet returned to the compressed space of catalogue number 25 without the overhanging branches, but he increased the presence of the reflections, which flatten the scene even further and make the water appear less penetrable. He has used the reflections of the surrounding trees to unite the top and bottom of the picture, as he had in the Dayton canvas, but he has also pulled the lilies closer to the surface of the canvas, making the image both more contained and more dynamic. He was extremely faithful to the configurations of the plants, although the precise location of the flowers varies from image to image. The paint is more layered, its surface more matte, all of which combines to muffle or absorb the light rather than reflect it. In many passages, Monet narrowed the value differences between the pads and the reflections to increase the muted qualities of the

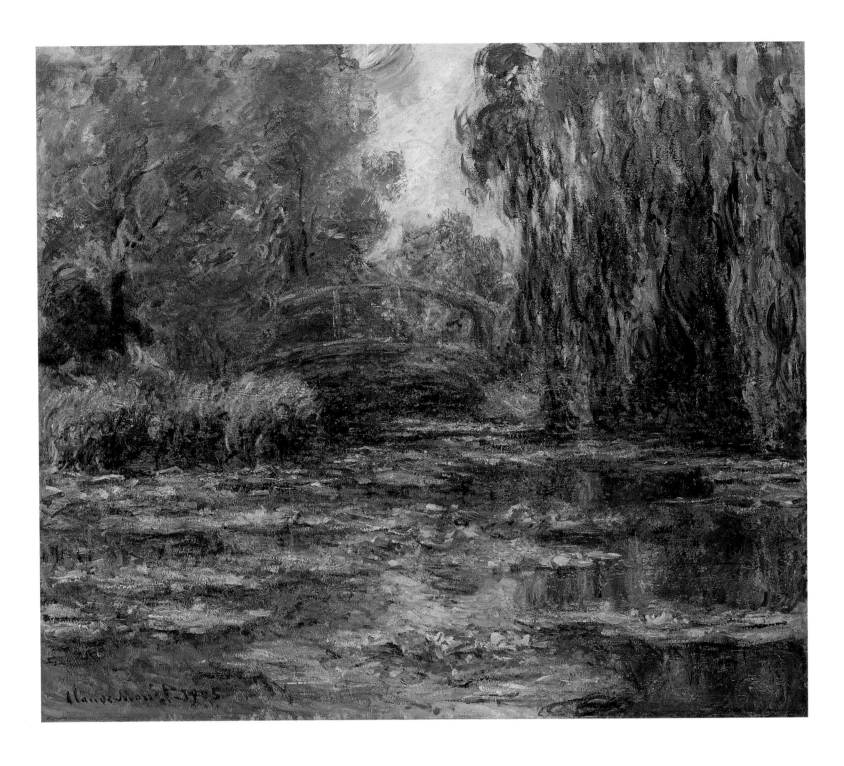

Fig. 34 *The Water Lily Pond with Bridge*, 1905 (W.1670), The Bellagio Gallery of Fine Art, Las Vegas.

scene and to enhance the pressure of the whole image on the nearly square format of the canvas. Each picture possesses a tightly controlled range of color, from rich greens and pale violets to deep blues and chalky whites, but they are different one from the other, which makes each view unique despite the nearly uniform composition of the group.

The second group is not as diverse in color, but it too follows a relatively strict compositional format, with single, roaming pads in almost exactly the same location in each. The reflections are much more varied, though. They have a striated quality, as opposed to the more consistent mass-

ings in the companion group. They are also made up of different kinds of brushstrokes and more individualized touches of color. The foliage in particular is so entangled that it is impossible to identify specific shapes or any kind of horizon.

Having staked out these opposing terrains, Monet heads off in a different direction over the course of the next two years. Some pictures are startlingly bright, such as Chicago's *Water Lilies* of 1906 (cat. 32), with chalky sky-blues laid on top of bold white priming that reflects more light than Dayton's of three years earlier. Others are more muted but actually more scintillating. What is clear about

all of these paintings is Monet's utter resistance to duplication or to predictable results. It is also apparent that within the limitations he has set for himself, he has been able to uncover not only a broad range of effects but also a host of underlying rhythms and relationships that suggest an equally large number of potent ideas, not all of which are merely pictorial.

As a cosmos that both reflects a reality and contains many others, the pond suggests a series of complications and disjunctures that are resolved or held together by artful means. In the Chicago picture the nearly square canvas (90 × 93 cm) is divided into very irregular sections. One is the area containing the reflected foliage, which pushes down from the background with no apparent logic. The foliage even angles off to the far right where it mysteriously reaches back to connect with what appears to be reflected foliage from trees above and behind Monet's vantage point, although there is nothing to confirm this. These two darker sections at the top and bottom are divided by an equally irregular band of lighter blue that also cuts through the scene on an obtuse angle. In addition to breaking the picture into two unequal parts, this band of light helps to clarify some of the essential inversions that Monet holds up in this picture as worthy of our contemplation.

The sky, for example, is now in the lower half of the picture, not where it traditionally belongs. Conversely, the largest area of earth or ground is at the top. The light appears more solid or tangible than the ground, even though it should be more ephemeral. The largest forms in the picture are at the top – the reflected foliage and the large clusters of water lilies – while the smallest are at the bottom. Perspective systems generally demand the reverse. The odd configuration of water lilies creates a triangle that struggles to escape the confines of the square, while the flowers in the lowest quadrant float alone, detached from each other and any pods.

Nevertheless, the picture maintains its integrity. The triangle remains tentatively poised before it breaks up; the longest bough of reflected foliage generously curves as it approaches the center, as if caught up in the excitement of its encounter with the shimmering flow of water; the solitary lily pads and sentinel-like flowers at the bottom are ushered out on to the watery stage by their clustered companions on the left and gamely perform their part by keeping the whole picture buoyant.

Such detailed analysis of these remarkable Water Lily paintings underscores their subtleties and Monet's inventiveness and obsessiveness. But what was Monet really doing pushing and pulling, adjusting, and refocusing the same basic elements over and over again?[103] He no longer had to sell any of these paintings to make a living. In fact, other than figure 32, which he sold in 1904, he refused to part with any of his Water Lilies until he finally showed them in 1909, keeping them at his side as referents for each successive group, a practice he continued with his *Grandes Décorations*.[104] Divorced from commercial concerns and rigorously limited in subject matter, they can be considered, on one level at least, to be largely concerned with picture making, with how an artist constructs pictorial problems and goes about solving them.

Because Monet was looking at his own creations when making these paintings – three times over in the form of the pond, the pictures, and then the pictures as a group – the creative process involved was fundamentally self-reflective. That the paintings multiplied like poetic permutations, therefore, has as much to do with his own deep-seated concerns about his creative activity as it does with mere picture making. That is one reason why these paintings produced such doubt and uneasiness and why they led to more work; Monet could barely bring himself to admire what he was in the process of creating.

One hardly needs Monet's letters to confirm this. The paintings themselves are explorations of shifting relationships and priorities, chance and uncertainty, things that are difficult or impossible to pin down, elisions and absences, and presences that are not tangible, moments that cannot be securely verified.

Monet felt sapped at various points when producing these pictures, but he happily avoided the perils of what some contemporary writers saw as a modern form of narcissism.[105] Unlike that tragic classical figure who expired because of his frustration with his reflected image, Monet always proffered and believed in the possibilities of transformation. Again, the pictures bear this out. Awareness, though incomplete, is lent a profundity in these paintings that Monet had not previously suggested. Knowledge, while fickle, is affirmed as a viable entity that can be acquired. Feeling, while amorphous, is trumpeted continuously. And vision – that most treasured of faculties – is held in special awe.

Surely this is one of the primary reasons why Monet scrupulously tried to avoid duplication and granted himself so few opportunities to make easy, seductive pictures. He simply refused to allow painting – to him, the most precious of human activities – to descend to a form of mannerism or to become a cliché. It also helps to explain his rare criticism of younger artists, specifically Albert Besnard and Gustave Loisseau, whom he accused in an interview with Louis Vauxcelles in 1905 of plagiarizing Impressionism rather than expressing their own personality, a criticism he extended to Maurice Denis and to Gauguin, dismissing the latter as an aesthetic sponge.[106] By contrast, he had nothing but praise for his contemporary Paul Cézanne precisely because of his individuality and independence, as well as his unflinching devotion to nature.

In October 1906, as Monet worked away on his Water Lilies, Cézanne died – just four months after Monet had bought another of his paintings.[107] Of the original

Impressionists, only Renoir and Degas were left. Pissarro had died in 1903, Sisley in 1899, and Morisot in 1895, which placed an even greater weight on Monet's shoulders. Little wonder that he was so concerned with originality. In December 1906, barely two months after Cézanne's death, he decided that he was ready to put his own work on the line and arranged with Durand-Ruel to mount a show of his Water Lilies in the spring of 1907.[108] He would take up the cudgels and lead the way. As he prepared for the show, he even decided to paint two still lifes as nostalgic homage to his departed colleague from the south.

His decision to press ahead with his exhibition sprang from pressure exerted by the living as well as by the dead. There were still plenty of painters and critics in Paris, for example, who did not hesitate to declare that Impressionism was not only outmoded but also antithetical to the new century's need for an art that would uphold the nation's grand traditions. In their eyes, Impressionism gave too much rein to the individual, it ignored basic tenets of picture making, and it substituted prosaic subject matter for evocations of the ideal.[109]

Hostility to Impressionism was part of a larger struggle that was taking place in Paris over the ways in which France's traditions could and should be defined. The outcome would determine who had the strongest claims to those traditions, and thus who deserved the greatest prominence on the nation's artistic stage. This struggle created curious alliances, most particularly in the Salon d'Automne. Founded in 1903 as an alternative to the annual state-sponsored exhibition, the Salon d'Automne tried to distinguish itself from competing shows by staging retrospectives of major deceased artists each year in conjunction with its contemporary offerings. In the first three years, the Salon honored Gauguin (who died in the spring of 1903 just before its inauguration), Puvis de Chavannes in 1904, and in 1905 Ingres and Manet. As James Herbert has observed, "a generation or even half a generation earlier, pairing Manet and Ingres would have been the stuff of polemics."[110] But as one of the founders of the Salon wrote in the catalogue to the 1905 show, "The Salon d'Automne has attempted to demonstrate, through these retrospective exhibitions, the constant legitimacy of the revolutionary effort to rejoin tradition . . . Like Puvis last year, Ingres and Manet are going to affirm for us that the revolutionary of today is the classic of tomorrow."[111]

Monet understood what that metamorphosis meant but he was less compromising. His decision in 1906 to exhibit his Water Lilies the following year was a manifestation of his longstanding determination both to make better paintings than anyone else and to put those products in front of the public. In this instance, it was not only spurred on by Cézanne's passing and the aesthetic skirmishes with his survivors, but also galvanized by the Fauve artists who had captured center stage after their appearance in the Salon d'Automne of 1905. Vauxcelles had singled them out for particular praise in his review of the show just after he had interviewed Monet in Giverny.[112] As he and everyone else immediately recognized, these younger Fauve artists had learned their lessons from the Impressionist handbook. Matisse had begun that schooling in the 1890s, retracing the Impressionists' footsteps in Paris and its suburbs, even going to such distant sites as Belle-Ile off the coast of Brittany in 1897 to paint the same ocean-battered côte sauvage that Monet had rendered in the 1880s. One of Matisse's friends was accurate in describing the emerging artist in 1897 as "doing Impressionism and think[ing] only of Claude Monet."[113] Matisse, like André Derain, Maurice Vlaminck, and Albert Marquet, was trying to put his forefather behind him and to devise a style of his own that would speak about the challenges of making art in the new century.

The Fauves were not alone in this, of course. The young Pablo Picasso had demonstrated his keen interest in the same agenda between 1900 and 1905. He had headed straight for the Moulin de la Galette when he first arrived in Paris in the fall of 1900 determined to redo Renoir's classic image of that famous outdoor dance hall. He also haunted the cafés, restaurants, and theaters of the capital à la Manet, Degas, and their protégé Toulouse-Lautrec, and produced picture after picture that took their cues from his nineteenth-century predecessors while waging a frontal assault on their ensconced position at the forefront of French painting.[114]

Picasso had begun to make a name for himself in Parisian art circles, but he was more idiosyncratic than the older Matisse and the Fauves, whose united presence at the Salon d'Automne of 1905 and again at the same Salon the following year was proof of the group's staying power. So too was the evidence of their influence. Georges Braque, Raul Dufy, and Louis Valtat, all produced work in 1906 that bore witness to how quickly the Fauve's strike on traditional criteria had been taken up by talented contemporaries.

One of the most telling paintings in that 1906 Salon d'Automne was an entry by Derain, a view of the same Waterloo Bridge that Monet had painted only two years earlier, perhaps figure 35.[115] Part of a suite of nearly thirty views of London commissioned by Vollard that Derain had done during two campaigns in the English capital in 1904 and 1905, this picture was both an homage to the elder Impressionist and an unabashed warning. For while Derain was paying Monet the ultimate compliment of painting the same locale as Monet had rendered a few years before, the twenty-six-year old was also out to put the senior citizen in his place, offering up a stark but strikingly vibrant scene painted with workmanlike slabs of crude color laid on with brushes that were probably larger than any that Monet

owned.[116] Monet went to the Salon d'Automne in 1906[117] – Blanche Hoschedé and Theodore Butler both had paintings in the show – but he preferred no verbal opinion either about Derain and his fellow Fauves or about Picasso (considering how raw their art probably appeared, it is unlikely that he would have held it in high regard). Monet responded instead with work, using the Water Lily exhibition that he proposed to mount in 1907 to affirm his standing vis-à-vis his aesthetic offspring.

But the exhibition never took place. Early in April 1907, only two weeks after confirming arrangements for the event, including keeping the gallery as one continuous open space, Monet told Durand-Ruel that he could not proceed with the plans. He was contrite, but direct; he simply felt that he had not finished enough pictures to his satisfaction and that the rest would have to be completed "in front of nature."[118] As Monet expected, the dealer was not pleased. He told Monet that the show did not have to be very big, and that if he was going to pull out he should let the dealer have two or three pictures in compensation.[119] Monet responded immediately: "Like you, I am very sorry about not being able to exhibit the series of Water Lilies this year . . . It may be true that I am very hard on myself," he admitted, "but," he added in his own defense, "that is better than showing things that are mediocre."[120] He had said this before when postponing the exhibition of his Londons, but now, three years later, his self-censorship was even more severe. He quickly countered Durand-Ruel's suggestion about the size of the show, telling him it had nothing to do with the number of pictures he wanted to include. Instead, the postponement was the result of his aesthetic criteria: "I really do not have enough satisfactory ones to put the public to the inconvenience of coming." He expressed none of his typical frustration; in fact, he claimed he was "full of fire and confidence" about being able to make better pictures, but he did not want to let any out yet, even for a reduced exhi-

bition. "I need to have the finished ones before my eyes," he told the dealer, "in order to compare [them] to the ones I am going to make . . . as the whole effect can only be produced by . . . the ensemble."[121]

Not having exhibited new work since his Londons three years earlier, Monet was proceeding with extreme caution, wanting to make sure that when he reappeared on the national stage it was with unmistakable poise.

It is difficult to know exactly where his series stood that spring – whether pictures really were in need of a lot of attention, as he claimed, or whether his fervent denial about enlarging the show was in fact a backhanded admission of his intent. He had exhibited thirty-seven Londons. Perhaps he felt he needed to top that. What is more certain, however, is that he had become increasingly concerned about the project, even taking the drastic step of destroying works that he felt were unsalvageable or unacceptable.[122] This action, which lowered the number of paintings available for the show, indicates that the ensemble was not right, and in the summer of 1907 he set out to rectify that.

Between late April and late September he wrote only six letters.[123] This uncharacteristic silence was because he was completely absorbed in his work, which was proceeding so well that he invited his dealer to come and see the results for himself.[124] When Durand-Ruel finally visited, most likely in March 1908, he did not like what he saw.[125] It was strikingly different from what he probably expected. Canvases in a vertical format had replaced the squares and horizontals of the previous pond views; intense color had returned, as had vigorous brushwork and rich impasto. And Monet had devised more dramatic compositions. Although the motif of a narrow band of light twisting through turning foliage and spilling out to create a large pool at the bottom of the scene had appeared in many previous Water Lilies – such as catalogue number 00, from 1905 – it had always been just one of many elements submerged in the feast of visual incidents that Monet had packed into his pictures. Here, he isolated it and enlarged it so that it dominates the scene.

These are without doubt some of the most compelling paintings Monet had yet produced, which he appears to have sensed when he wrote to Durand-Ruel with atypical enthusiasm in September 1907. The dark reflections of the foliage are surprisingly active in their gestures and depths. They also occupy most of the canvas, as if the unseen world and its unchartable rhythms have become more important than what is tangible and confirmable. The water lilies are again divided between the multiple clusters at the top of the picture and the two groups at the bottom, the latter often appearing less united and uniform and thus more tentative and transitory than their more regulated counterparts above. The light of the reflected sky ripples through the foliage at the top of the scene as it

descends down the canvas, passing under the pads that push out from the darker reflections on either side. The light then spills out into a twisted bell-like pool in the middle of the picture, creating eddies and surface patterns across the lower half of the image that contrast with the direction, shape, and orientation of the surrounding lily pads and foliage. Monet's touch in this area is startlingly free, his paint strikingly porous, allowing the white priming of the canvas to flicker throughout the area. By employing this strategy, Monet is perhaps suggesting the ultimate integration of his most trusted of aesthetic companions – light and water – and has embedded them here in the literal foundation of his image – his primed canvas – with unprecedented subtlety and zeal. These are painters' pictures, in which everything is contested – lights and darks, shapes and forms, surface and sky.

Durand-Ruel did not think he could sell them. His worries were well founded to the extent that Monet did not conceive of the paintings to be hung politely over the mantelpieces in people's living rooms. Their formats alone suggest as much, while their contrasts confirm it. These pictures would certainly energize his ensemble of Water Lilies and reestablish Monet's boldness as an artist. It is hardly a coincidence that they would have appeared in the wake of the Fauve's arrival. Monet still had a few more lessons to impart to them.

Ironically, the first that they received publicly came from one of his earlier works – specifically one of his Cathedral paintings of the 1890s. When twenty of them had been exhibited in 1895, they had elicited powerful responses, although none more positive perhaps than that penned by Monet's friend Clemenceau.[126] On the front page of his newspaper La Justice, Clemenceau had called upon the President of France to purchase all twenty to give to the nation, a plea that had gone unheeded. Twelve years later, in October 1907, Clemenceau was France's prime minister and thus able to realize at least part of his wish. At his urging, the French National Museums decided to buy its first painting by Monet. Not surprisingly, it was one of his Cathedrals (W.1319, Musée d'Orsay, Paris).[127] It was without doubt the toughest of the series. The façade stretches emphatically across the scene, causing it to be absolutely parallel to the picture plane. It employs a quite dingy palette; its browns, grays, and purples are in striking contrast to the seductive range of color that Monet used in the others. He even drained the light and atmosphere in this image, leaving the monumental façade to stand solemnly alone, unadorned and immutable.[128] In 1907, in addition to the old tenets of life, nature, and truth – currently under attack by contemporary artists – what really counted in Monet's book was seriousness, determination, and work based on visual sensation. It also helped, of course, to have friends like Clemenceau in high places.

Monet must have relished the notion of the State com-

ing to him to buy a picture. Just two years earlier, he had refused a request from the Musée du Petit Palais to donate works to its collection.[129] Now the tables were turned. Monet also must have loved the idea of selling the government such a challenging painting that, on many traditional counts, could be considered unattractive. It was another way for him to savor the sweetness of revenge, something he implied in the "slight smile" that he allowed himself when he told Walter Pach, the American painter and critic who visited him in December 1907, that the picture constituted "my first order from the government."[130]

In 1908, with Durand-Ruel's negative reactions to his new Water Lilies in mind, Monet decided to rethink his show, the importance of which had been increased by the government's purchase. In typical fashion, after attempting to coerce his dealer to buy the 1907 paintings jointly with the rival dealer Bernheim-Jeune, Monet canceled the exhibition. Initially, he blamed Durand-Ruel. "From the moment that my new paintings did not meet with your complete approval, it appeared to me that it was going to be difficult for you to mount the exhibition."[131] A month later, he was in a more contrite mood and finally assumed the responsibility: "I am at the end of my tether and would end up being ill if I were going to continue with [this] impossible undertaking."[132] It seems that the pressure of not having shown new work in four years was taking its toll. And if both dealers were worried about his most recent Water Lilies, he had better devise a new strategy.

Durand-Ruel had suggested that he rest and take his mind off the show. Monet agreed. But in late June, after almost two months off, he was back at work, so intensely that he could admit to Gustave Geffroy in the middle of August, after six weeks of unbroken work, that his "landscapes of water and reflections have become an obsession." When Lucien Pissarro asked to visit, Monet refused; he was so engrossed in his work that he saw no one except between 3 and 5 p.m., which was the only time he took a break.[133] However, by the end of September, as the weather began to change, he was pulled away by an invitation to visit Venice, which Alice seemed to have insisted was too tempting to pass up (see below, pp. 178–91).

Barely two weeks after he had returned to Giverny, in December, he was back in the fray. He negotiated an exclusive deal with the Bernheim-Jeune brothers for all the paintings that would result from the Venetian campaign, making Durand-Ruel furious. Monet was, on some level at least, getting back at the dealer for his perceived role in the canceled Water Lily show earlier that spring. He tried to gloss over his reprisal, telling Durand-Ruel that it was better for both of them if his gallery was not the artist's sole representative.[134] He was effectively playing one dealer off against the other, in a way reminiscent of his tactics of the 1880s.[135] A month later, however, in compensation, he informed Durand-Ruel that he could announce

"without fear" the long-postponed show of his Water Lilies which Monet felt should open on May 5, 1909. Stating that the trip to Venice had allowed him to see his pictures with a better eye, he declared with absolute confidence, "I will be ready."[136]

As might be expected, Durand-Ruel was pleased, although it is unclear whether he had actually seen the pictures Monet had produced before his Italian trip. However, as the dealer was soon to discover, Monet had heeded his advice. Monet had maintained his focus, more or less, on the same basic motif of his 1907 pictures – the stream of light weaving through the tangle of foliage on its way to a broader space in the lower section of the canvas. He still used the water lilies to unite the reflections of the foliage and tie the top of the painting to the bottom, but beyond that, these new pictures could not be more different. Gone is the strident color, the aggressive brushwork, the curious vertical shapes, the tensions between reflections and surface forms, the strong contrasts of light and dark, and the sense of surprise and unease.

Much of this change is due to the way that Monet manipulated the shapes in the scenes. The reflected foliage, for example, has been rounded out significantly, its errant boughs brought into the fold, its internal rhythms calmed. The foliage also has fewer openings on the interior, and appears more consistent. The larger reflections at the top are spread further apart, allowing the stream of light to pass more gracefully through the middle of the scene. The lilies at the bottom tend to be higher on the canvas, making them appear less cropped and thus more permanent. Monet has reduced their number just as he did those at the top of the picture, occasionally to as few as two or three clusters, as in catalogue number 47. With fewer visual incidents overall, the surfaces of the pictures assert their primacy with remarkable authority.

This result is greatly enhanced by the muted palette Monet employs. In many of the paintings the colors are so close in value that they create an emphatic, flattening effect, pulling the image over the canvas so tightly, as in catalogue number [same], that it is almost a struggle to read the space. When he uses colors of higher value, as in catalogue number 44, he so measures their intensity that he achieves the same results.

In the end, these pictures attest to the pressure that Monet has applied to the elements at his disposal. Space and form have been so compromised that they play only a minor role in the scenes. Light is so continuous that it loses its hold on forms and ceases to be physical. Local color has all but been eliminated. Most important perhaps, bravura has been capped. What is left is the residue of all of these matters. They coalesce on the surfaces of the pictures to suggest a kind of essential presence, like some enchanting fragrance or the sensed rhythms of silence. Thus the paintings are not only the opposites of their predecessors; they

border on becoming non-pictures, on being mere remnants of the pictorial, collections of poetically arranged shapes and colors that have their own internal logic, separate and distinct from everything else, including vision.

This is especially true when these paintings are compared with pictures done at exactly the same time by Matisse, Picasso, or Derain. The latter appear much more physical and sculptural, more concrete and structural, conscious, and intellectual.

It was with the novelty of his canvases and Monet's extended absence from the contemporary scene in mind that a carefully planned article on the exhibition appeared as advanced publicity in *Le Gaulois* the day before the May 5 opening. It tempted potential visitors by declaring that Monet "is going to deliver to the public, after a long hesitation, anxiety, and modesty that true artists will understand, if not a new manner of his generous talent, at least an unforeseen application of his qualities, something that is the result of a slow gestation, a strict control of his impressions."[137] The author, a young reporter named Jean Morgan, had never written on Monet before, but for this assignment he had been granted special access to the master, an arrangement made by Durand-Ruel and grudgingly accepted by Monet. Morgan had gone to Giverny and had looked carefully at the pictures. He had taken detailed notes not only on what he saw but also on what he heard; there are distinct echoes of the master's voice in his words: "His vision increasingly is simplifying itself, limiting itself to the minimum of tangible realities in order to amplify, to magnify . . . the impression of the imponderable."[138]

Affirming the near-abstract qualities of Monet's recent work, the writer suggested the effects of the new pictures:

> Soon this vivid belt [of light] diminishes in importance, the water invades the entire canvas, becoming the fluid field upon which the mysterious blossoms of the water lilies open out . . . translated by spots of yellow, green, blue . . . the air and the water intermingle in a single light mist that absorbs each element . . . [including] the impalpable golden dust of the invisible sun.[139]

Morgan's article was the perfect trailer for the exhibition, although the Parisian art world had been anticipating the show for months. It opened as scheduled with forty-eight paintings, more than any of his previous twentieth-century exhibitions. Monet had insisted upon calling it *Les Nymphéas: Séries de paysages d'eau* (not *Réflexions* as Durand-Ruel had suggested), most likely as an homage to Gustave Courbet, who had titled a seascape exhibition in 1867 *Paysages de mer*.[140] It was a subtle way to remind his viewers of his roots in French realism. Few who saw the show were disappointed. Indeed, the response was overwhelmingly enthusiastic, even surpassing the outpouring of accolades that the Londons had earned. From Monet's point of view, it had been worth the wait.[141]

One of the most important points made by the critics concerned how far Monet had pushed himself beyond his previous work and thus how novel his new pictures appeared. It must have warmed Monet's heart. Even at sixty-eight he could still run at the head of the pack and have plenty of kick. This was particularly true when critics tried to deal with the issue that Morgan had raised in his article – namely, how nearly abstract the paintings seemed. Henry Eon put it most succinctly in his review in Le Siècle: "Monet has reached the final degree of abstraction and imagination allied to the real that his art of the landscapist allows."[142]

Ironically, though appropriately, Monet was given the last word on these pictures. It appeared in the august Gazette des beaux-arts in a sensitive review by Roger Marx, the same critic who had helped to organize the centennial exhibition at the World's Fair in 1900.[143] Because the magazine was monthly, the review did not appear until the last days of the exhibition; Marx had learned a lot in the interim. He notes that Monet's "system is familiar" but that he "has not heretofore undertaken to push its consequences quite so far." According to Marx, Monet "is pursuing the renewal of his art according to his own vision and his own means." Marx moves quickly to specifics to underscore his points.

> No more earth, no more sky, no limits now; the dormant and fertile waters completely cover the field of the canvas; light overflows . . . Here the painter deliberately broke away from the teachings of Western tradition by not seeking pyramidal lines or a single point of focus. The nature of what is fixed, immutable, appears to him to contradict the very essence of fluidity . . . Through the incense of soft vapors, under a light veil of silvery mist, 'the indecisive meets the precise.' Certainty becomes conjecture and the enigma of the mystery opens the mind to the world of illusion and the infinity of dreams.[144]

Marx then stops his poetic monologue to allow the artist himself to speak. While admitting that "the indeterminate and the vague are modes of expression that have a reason for existing and have their own characteristics," Monet undercut Marx by declaring that he was not embracing abstraction but rather celebrating the visual world and the power of art to suggest the grandeur and beauty of nature. "The richness I achieve comes from nature, the source of my inspiration . . . I have no other wish than to mingle more closely with nature and I aspire to no other destiny than to work and live in harmony with her laws."[145] Although Marx quibbled with the subjective and objective implications of Monet's observations, he had no doubts about his achievement. "Never in all the years since mankind has existed and men have painted," he proclaimed, "has anyone painted better or quite like this."

How could Monet ever do better? Unlike his younger contemporaries, he had an incomparable guide. All of the critics recognized this, but it was Georges Meusnier, the editor of the Journal des arts, who stated it most poetically: "Nature, at the call of the painter, has come in person to place herself on the canvas."[146] She would do so again in the years ahead in ways that would affirm not only Monet's stature in contemporary French art but also his mandate to be the "harbinger of nature," as Roger Marx asserted. "The more one thinks about it," Marx concluded, "the more he seems to merit it."[147]

Monet and Venice

Although Monet's trip to Venice was supposed to be a holiday, an opportunity for him to take some well-deserved time away from his pond and paintings, the sexagenarian could not go to one of the most famous cities in the history of art without bringing the implements of his craft. The splendor of the place and its aesthetic legacy demanded no less. He may also have been afraid that if he did not take advantage of this opportunity to record his impressions of La Serenissima, he might not get another. After all, it had taken him sixty-eight years to get there. Upon arriving in Venice, on October 1, he countered that suspicion with heartfelt assertions that he would be back the following year for another engagement with its beauty. "One cannot come to Venice without wanting to return," he told the Florentine writer Carlo Placci in mid-October, three weeks into his stay.[148]

Time and history would conspire against that wish, but those same two forces would also become his steadfast allies and inform his work from this unique campaign in ways that even he could not have anticipated – at least not entirely, because no artist could go to Venice without entering into an explicit, though perhaps unstated, pact with the past. In addition to the titans of Western art that the city had produced – Bellini, Giorgione, Titian, Tintoretto, Veronese, Tiepolo, Guardi, and Canaletto – Venice had also attracted major artists from every country in Europe in a nearly unbroken line that extended back across several centuries. Those artists had made the pilgrimage to this aesthetic mecca to discover for themselves the spirit of their venerated Venetian predecessors, to see firsthand the celebrated products of their labors, to experience the environment that had so nurtured their achievements, and – if history would look kindly upon newcomers – to assume their own position in that heralded group of foreigners who had made personal contributions to the history of art using Venice as one of their ports of entry.

Given the sublimity of its setting, the city had held particular sway over landscape painters, such as Bonington

Fig. 36 Monet and Alice in the
Piazza San Marco, Venice, 1908.

like of distant and extended travel and, most importantly, by his desire to continue to work on his new Water Lily paintings despite the turn of the season and the consequent change in light. In addition, at sixty-eight, he may have believed that Venice's art-historical legacies were essentially irrelevant to his education or career.

However, when he told his friend Octave Mirbeau, "No . . . I will not go to Venice," he was surely expressing his anxiety about having to deal with a city that had featured in so many chapters in the history of Western art.[150] It would be one more challenge to contest, one more piece of the past to pull into the present. Lurking behind that concern was the deeper uneasiness that as enchanting a place as Venice might seduce him – as it had almost everyone else who had gone there – and then lead him to make the kind of art that he had been desperately trying to avoid: those broad, beautiful vistas of pure charm and intoxication. In the seemingly more controlled world of his garden, he could contain these urges better; in the clutches of Venice – well, that was another matter.

But Alice seems to have insisted on the trip, and his Water Lilies must have been sufficiently advanced to allow him the luxury of considering a break. On the positive side, there are several other factors that may have prodded him to go. He had been represented in the city's Biennale three times since 1895, and may have been intrigued by the possibility of seeing where his paintings had hung.[151] Furthermore, contemporary artists had suddenly taken an interest in the city, with Sargent visiting it almost every year between 1902 and 1913, Matisse in 1907, and Signac in 1903, 1904, and 1908.[152] Monet himself was seduced by a watercolor that Signac had made of the Grand Canal in 1908, adding it to his collection shortly after it was completed.

This increased interest in Venice not surprisingly occurred at the very same time as the reprinting of John Ruskin's *The Stones of Venice*. Laurens published the first French translation in 1906; Hachette brought out a rival translation two years later, when Monet purchased a copy, probably in preparation for his visit. The temptation to follow in Ruskin's footsteps may have been enhanced by the luxurious accommodation Monet was offered: the Palazzo Barbaro, a large fifteenth-century Gothic palace on the Grand Canal, owned by Mrs. Daniel Sargent Curtis, an American heiress, a distant relative of Sargent, and a friend of another wealthy woman, Mary Young Hunter, whom Monet and Alice had met in London some years earlier. When Mrs. Curtis lent Mrs. Hunter her palazzo in 1908, Mrs. Hunter invited the Monets to join her. The palazzo afforded Monet both supreme comfort and superb views of the Grand Canal, the main artery of the city, which in early October would have lost much of its tourist traffic, to Monet's great delight. Not that he was anti-tourism. He was there on his own tourist junket and he did what was

and Turner in the first half of the nineteenth century, and Manet, Boudin, Renoir, Whistler, Sargent, Signac, and Ziem in the second half, the last three spilling over into the twentieth century. The city was accustomed to the influx, giving it further encouragement with the establishment of the international Venice Biennale in 1895 which the city still hosts today.

Although Monet finally succumbed to the call of Venice, perhaps because it was the only other foreign art capital apart from London and Madrid that held real meaning for him, he resisted going right up to the day of departure.[149] This reluctance may have been fueled by his growing dis-

expected: he went sightseeing, took gondola rides, even had his photograph taken with Alice and the pigeons in the Piazza San Marco (fig. 36). He liked being in popular places during the off-season, and Venice in early autumn would have fitted that bill perfectly. The weather cooperated as well, at least most of the time. The occasional rain and cold caused him to complain and despair, but they eventually passed, providing him with "quite wonderful [conditions], just a little cold in the morning, but so beautiful that there's no time to worry about it."[153]

When he wrote this letter to the Bernheim-Jeune brothers at the end of November 1908, he was feeling pressed because he had already stayed much longer than he had anticipated – two months by then. He was also thoroughly engrossed in his work – so much so that Alice had taken over as the primary correspondent, even writing to Geffroy and reporting that Monet was unable to "tear himself away from his beloved motifs."[154] Her account was accurate, for Monet had previously always made an effort to write to his old friend. However, he was working on so many paintings in Venice that every hour was precious to him, and he was careful about spending it on anything else. As hard on himself as he was on his friends, he maintained a strict painting schedule: he was at work between 7.45 and 8.00 in the morning, not quitting until mid-afternoon during the first month, and late afternoon during the second and third. Alice worried that he was pushing himself too hard. "At his age," she confided to her daughter, "he ought to take greater care of himself," although she amusingly admitted she was happy he was painting something "other than the eternal water lilies."[155]

At least he did not have to exert himself to get to the sites he decided to paint. Some of them were literally at the doorstep of either the Palazzo Barbaro or the Grand Hôtel Britannia, to which he and Alice moved around October 19. After being houseguests for almost three weeks, they had probably decided it was time to move on. Mrs. Hunter had delayed her departure for a spa in Aix-en-Provence on their account, and Monet "was starting a new painting every day," according to Alice, which meant a longer stay than either Mrs. Hunter or the Monets had initially planned.[156]

Of the sites that Monet selected, he had easiest access to three: the Grand Canal seen from the steps of the Palazzo Barbaro, the subject of his largest and most compelling suite of Venice pictures (cats. 49–51); the Palazzo Contarini-Polignac, the sumptuous Renaissance palace directly across from the Curtis's, which he rendered in two hauntingly beautiful canvases (cats. 56 and 58); and the island and church of San Giorgio Maggiore looking down the Grand Canal from the Britannia, a view he painted six times under quite different light conditions (fig. 31). Monet could have done these last six paintings without leaving the hotel, just as he could have completed the other two groups without moving from the Palazzo Barbaro.

Most of the other sites were not much farther away. He did six views of the Palazzo Dario and the Palazzo Da Mula, both on the Grand Canal across from the Curtis's house (cat. 57 and fig. 37). The Palazzo Dario, featured in four of the six canvases, is the first tall sunlit structure on the right in his views looking down and across the canal from the steps of the Palazzo Barbaro. The Palazzo Da Mula was even closer to Mrs. Curtis's. It is just out of view on the right in those same four pictures. For two other groups of paintings, Monet had to hire a gondola, but he did not have to go very far. He either went down the Grand Canal to the island of San Giorgio (which had been the focus of his views from the Grand Hôtel Britannia) and looked back across the water at the Doges' Palace (cats. 54 and 55), or he sat in the boat in the middle of the lagoon (the Canale di San Marco) with the island directly behind him and painted several close-up views of the same celebrated building (cats. 52 and 53). The latter are fewer than the more distant views of the palace – three versus five – most likely because it was difficult to stay in the gondola in the middle of the busiest artery in the city for an extended period of time. It was also more expensive to rent the boat for several hours than it was to hire a water taxi to take him to San Giorgio.

Just before he left Venice on December 7, Monet began seven more paintings: three of a smaller canal (the Rio della Salute, next to the great church), two of sunsets over San Giorgio Maggiore, and two sketches of boats along the water's edge in nondescript locations. Thus, the Venice campaign, which lasted ten weeks, resulted in a total of thirty-seven paintings.

However, few if any of these were finished during Monet's stay in Italy. He may not have even begun all thirty-seven during his time in Venice. As with his Londons, which these paintings tend to recall, he most likely worked others up from those he brought home in order to test certain pictorial ideas and to expand the group sufficiently in order to exhibit them, all of which caused him trouble.

He had set himself up for this sort of difficulty before he had even left Giverny; the month he anticipated spending in Venice, for example, was not nearly enough time to do serious work. He knew he was in trouble soon after he arrived. In fact, he was almost ready to pack up and leave during his first week, because he was certain he would never be able to do anything worthwhile. The city was "too beautiful to be painted," he told Alice, going so far as to declare that no one had been able to render it properly.[157]

Monet was fretting well before he had to perform; none of his crates of canvases had even arrived in Venice when he was creating this drama for himself. When he finally set to work he felt better, but he tried to lower expectations,

Fig. 37 *Palazzo Da Mula*, Venice, 1908 (W.1764), National Gallery of Art, Washington, Chester Dale Collection.

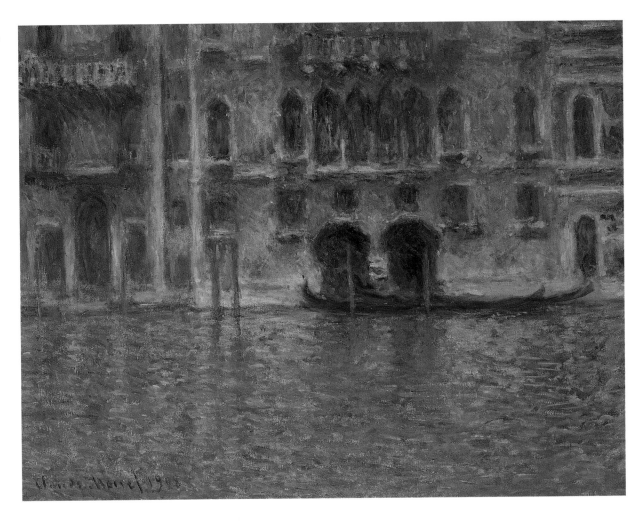

telling Durand-Ruel in the middle of October, "I am full of admiration for Venice, but unfortunately I won't be able to make this a very long stay; by consequence, I won't be able to work seriously. I am doing several canvases a little haphazardly just to have some record. But I am counting on having a good go at it next year. I am not sure when we will be returning. It will depend on the weather."[158]

Happily, the weather served him well; otherwise he would not have stayed as long. So too did the city. As Alice told Geffroy, "Venice has got hold of him and won't let him go!" Monet echoed these remarks the day of his departure: "Well, [my enthusiasm for Venice] has done nothing but grow, and the moment has now come to leave this unique light. I grow very sad. It is so beautiful . . . what a dreadful shame that I did not come here when I was young and would dare anything! . . . The only consolation," he pined, "is the thought of coming back here next year . . ."[159]

His experiences over the ten weeks before he stole some time to write this letter had actually not been so different from those of most of his previous painting campaigns. There was at least one important distinction in this case, however. All of his efforts culminated — at least during his time in Venice — in an atypical sense of gratitude, which he expressed in a warm thank-you note to Mrs. Curtis:

"This was a real pleasure, a true joy for me and I very much wanted to let you know that." Monet was not just being polite, as he repeated his enthusiasm to Geffroy: "I have spent some delightful moments here and nearly forgot that I am the old man that I am."[160]

Monet was lucky that his stay had been so memorable, as he would have to draw upon the richness of his recollections to be able to complete these pictures, much as he had with his Londons. For, like those problematic paintings, these Venetian views would take him several years to finish; the first group would not go out of his studio until March 1912, when they went straight to Bernheim-Jeune's for an exhibition that opened in May.

What was the problem? Upon his return to France in December, he had to contend with completing the Water Lilies that he had begun six months earlier, in the summer of 1908, and reviewing all of his other pond paintings since the Japanese Bridge pictures of 1900 to select those he wanted for his Water Lilies exhibition. Considering that there were many more than the eighty examples that exist today, this was a daunting job. That he started to edit them makes sense; it made life easier.[161] After the May 1909 exhibition of his *Paysages d'eau*, he talked about working, but never in reference to the Venice pictures; he also

never put his words into practice. He savored the praise his Water Lilies had garnered, entertained numerous guests, took a trip to Cherbourg and Landemer in Basse-Normandy, suffered the pain of constant headaches, and essentially avoided work.

The year 1910 brought no apparent interest in returning to the Venice pictures – indeed, no interest in painting at all. He had two good excuses for his conduct that year, however. First, the Seine overflowed its banks so severely in January that water came halfway to the house, wreaking havoc on both his gardens. Monet feared the complete loss of his creations, although he was sanguine enough to hope that he was merely overreacting. It turned out that the damage was not as bad as he thought, although the restoration of the flower garden did require enormous manpower and significant funds. He decided to take the opportunity (perhaps as a way of overcoming his heartache about the losses) to redesign the banks of the water-lily pond, and to repair the cement bottom. In the midst of his expenditures and personal concerns, he generously responded to two solicitations to aid flood victims, sending money to one and a painting to another.[162]

Work on his gardens was finished by spring, but from February onward, he had to contend with the fact that his beloved Alice had become seriously ill with a rare and fatal form of chronic myelogenous (spinal) leukemia. Despite radiation therapy and a remission from the end of May through the summer, her condition deteriorated during the winter of 1910, and by the middle of May 1911 she was dead.

Monet was at her side when she expired at four in the morning on May 19. Her death was without doubt the most crushing event he had ever experienced. She had been a lifeline for him, a source of solace and strength, a model mother to her own children and an exemplary stepmother to Monet's. She had run the household with efficiency and care, made certain that her husband's needs and demands were always met and that his personal life was as orderly and consistent as possible so that he could concentrate on his work. No one admired him more as a person; no one could have done better for him.

The pain that Monet felt was searing and long-lasting. His friends rallied around him and offered him comfort, as did his family, but he could barely function. Clemenceau, writing to Monet almost a month after the tragedy, tried to coax him back from the depths by urging him to "remember the old Rembrandt in the Louvre . . . he clutches his palette, determined to stand fast to the end through terrible trials. That is the model."[163] The Tiger of France was tougher than the painter; Monet put up a good front, but he was heartbroken and incapacitated.

It took him months to find "the force and the courage . . . to deal with this cruel separation." In July 1911 he confessed to Geffroy, "No one could know how much I am suffering. I am a lost man, finished, alas!"[164] This was not hyperbole; he was truly devastated. In August he admitted to the Bernheim-Jeune brothers, "I don't have a taste for anything and don't even have the courage to write."[165] It was not until early October that he began to recover some of his spirit, which allowed him to start thinking about returning to work. When he raised the possibility of painting again, the first pictures he mentioned were his Venice views, even though they were three years old by then. By October 23 he proudly announced that he had taken them up again and that everything was going well. He had even retouched other paintings that Durand-Ruel wanted to buy.[166]

However, it would be another five months, almost to the day, before he let any of the Venice pictures go, turning over fifteen to one of Bernheim-Jeune's gallery assistants on March 29, 1912. Within a week he was terrified that they were really not good enough and that they did not merit "all the fuss" that they apparently had caused at the dealers when the crates had been opened. He wanted the brothers to be clear on one point at least – "there was not a series among the views, just different motifs repeated one, two, or three times."[167] This was at least one reason why he was so concerned about the group. They might easily be considered a kind of hodgepodge or – worse yet – a highly commercial venture that would tarnish his reputation.

To allay his worries, Monet invited Geffroy to Giverny to see the remaining canvases several weeks before the opening. If he had been hoping for constructive criticism, he must have been disappointed, for all he received was praise. In fact, Geffroy was so enthusiastic about the pictures, Monet had to offer him strong disclaimers: "I would like to be as satisfied with them as you appear to be. There are some that are not bad, but . . . I fear that your friendship blinds you."[168] He went even further when twenty-nine of them went on view at the end of May and the critics sang their almost predictable odes to the master yet again. When Signac wrote to congratulate him Monet responded with unusual cynicism. "Even though the insidious critics of the first hour [of my career] have left me alone," the older artist barked, "I remain equally indifferent to the praises of imbeciles, snobs, and traffickers."[169]

What lay behind the denials, the panic, the protracted neglect of these paintings until after Alice's death? Definite answers are difficult to come by. Most important perhaps, Monet was dealing with a loaded commodity, a fact that cannot be overemphasized. Physically, Venice was an Impressionist's paradise, a phantasmagoria of light, air, and color so tangible that it seemed to have been painted every day by a master artist just for the delight of visitors. In addition, its museums and public buildings contained works of art that had provided inspiration for generations of artists. Monet marveled at the Tintorettos during his first

week there and gawked at the buildings bathed in late afternoon light during his obligatory gondola rides with Alice at the end of the day.[170] The Venetians had been central to his efforts from the beginning; Monet's *Déjeuner sur l'herbe* of 1865 (the largest and most ambitious painting of his early career), while based on Manet's infamous image, was inconceivable without Titian's sublime *Pastoral Concert*. Although he soon became too busy to visit all of the city's art collections, he was still walking and working in the places where other great artists before him had walked and worked, and he clearly felt their presence.

However, there was another dimension to this heralded city and its noble past that Monet also had to face, namely that it had long been taken over by tourism. From a cynical point of view, such as the one Octave Mirbeau expressed, there was nothing substantive about the place; it was all mists and mirages, wedding-cake architecture bobbing on watery highways that were plowed by impossible-looking boats manned by operatic aspirants.[171] As such it had been exploited, most importantly by artists, beginning with Guardi and Canaletto who had devoted their lives to producing paradigmatic postcards for wealthy Europeans on the Grand Tour. Alice counted no less than six Canaletto clones, including a woman, painting on the Campo San Giorgio at the same time that Monet was just paces away working on his views of the Doges' Palace.[172]

How was Monet going to reconcile the opposing sides of this Janus-like city? How could he pay homage to its celebrated history, perhaps even contribute to its artistic legacy, when he was painting the very kinds of subjects that had been rendered so often that they had become almost meaningless? Would he not be perceived as pandering to public taste instead of trying to elevate it, which was his responsibility as one of France's leading painters?

Monet devised several solutions. Most important, he emphasized the city's miragelike quality. Either he filled his scenes with such moist light that the buildings lose detail – which is just the opposite of what most view-painters wanted to achieve – or he heightened the contrast between lights and darks, thereby suppressing specifics in favor of a play of brilliant moments against multicolored shadows. In both instances he achieved similar effects; the buildings appear to emerge mysteriously from the enveloping atmosphere or to float magically on the surface of the constantly moving water.

If he assumes a position relatively close to a building, he either arranges the structures so they are absolutely parallel to the picture plane, as in the case of the palazzi, or he pulls them so tightly across the surface, as in the paintings of the Doges' Palace, that the abstract geometry of the composition is given as much emphasis as the view itself. He increases the stress on the picture plane in all of these scenes by reserving large sections of the lower half of the painting – sometimes the whole lower half and more – for

nothing but water and, in the case of the palazzi, by cropping their upper stories. The latter tactic forces us to look down as much as up, while it also flattens the buildings, making them as decorative and abstract as the geometric shapes of their ornate façades. In his views of the palazzi, the reflections are also minimized, largely because the light is somber and the color scheme consistent. In his paintings of the Doges' Palace, the opposite occurs: he stretches the reflections of the building's brilliantly lit façade straight down the canvas, uniting the top and bottom of the picture while differentiating the building from the darker water on either side with the precision of an architectural draftsman.

Monet deploys one other sly strategy. In three of the six views of the Grand Canal (W.1737, W.1740, and W.1741), he includes the steps of the Palazzo Barbaro on the left. They jut into the scene with unnerving immediacy, like the lurching prow of an invading boat. More radical is the triangular wedge of the Campo San Giorgio which protrudes into the lower part of all of the views of the Doges' Palace seen from San Giorgio Maggiore (cats. 54 and 55). Darker than everything else in the scene yet much purer, more defined, and more abstract, the Campo San Giorgio is like a silent but insistent counter to the dappled waters and sun-bathed buildings on the other side of the lagoon. There are strong echoes here of Georges Seurat's artful use of similar geometric forms in the foregrounds of his views of Port-en-Bassin of 1888 and Gravelines of 1890 (fig. 38), just as there are hints of similar tactics in Fauve paintings by Matisse and Derain of 1905. However, unlike these general precedents, Monet seems to be trying to oppose two different worlds: the tactile, physical solidity of his vantage point and the ethereal, evanescent qualities of the view. By conjoining them so bluntly, particularly in the paintings of the Doges' Palace, where he demarcates the differences between the two by the cool, clear edge of the campo, he is both locking his activity into a verifiable reality

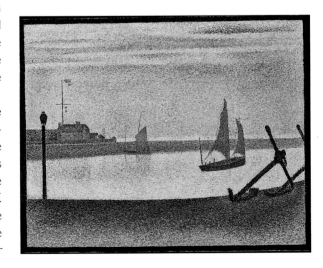

Fig. 38 Georges Seurat, *The Channel of Gravelines, Evening* 1890, The Museum of Modern Art, New York. Gift of Mr. and Mrs. William A.M. Burden.

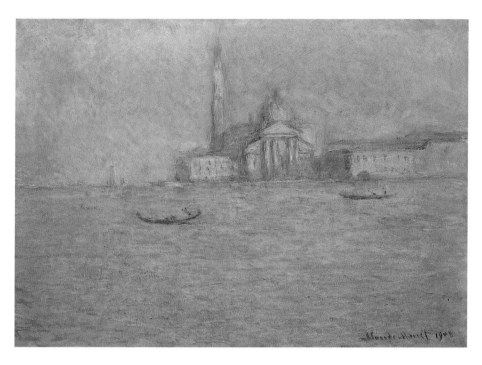

Fig. 39 *The Church of San Giorgio Maggiori*, 1908 (W.1749), Indianapolis Museum of Art, The Lockton Collection.

and drawing attention to the abstract constructs of his practice. In the process, he makes Venice appear at once magical and mundane, which is how most visitors experienced this world of popular enchantment. It is for that reason as well that, in many of these Venetian pictures, time appears to have been reconsidered or decreed irrelevant. At one moment it could be abandoned or falsified, at another, recovered or affirmed.

With Monet's temporary abandonment of these paintings and then Alice's tragic death, these notions grew deeper and more profound for the aging Impressionist, as did his ideas about time and history. Finishing the pictures far from the sites they represented, in his studio rather than *en plein air*, and years after the initial encounter, the paintings became meditations on the nature of experience, the practice of art, and the multiple levels of human understanding as much as they are about Venice and its particulars.

Monet suggested this himself when he told the Bernheim-Jeune brothers that the pictures were "souvenir[s] of such happy days passed with my dear Alice."[173] He also implies this in simple ways – how the light and atmosphere, for example, soften forms, but not so completely as to disguise their identity. It is also apparent in more complicated juxtapositions of individual elements. In the views down the Grand Canal, for example, catalogue numbers 49–51, the buildings march anonymously into the distance like the progress of time itself. They are eventually crowned by the domes of Santa Maria della Salute as if the buildings are a merging of moments that culminate in something larger and grander than the sum of their parts. This progression is both complemented and caricatured by

the poles that recede in no logical order into the distance, leaning left and right as if idiosyncratically altered by time and change. In addition, they seem to grow smaller as they move down the canal, which is the opposite of the buildings, a contrast that Monet emphasizes by having the largest pole in the immediate foreground overlap the base of Santa Maria della Salute in the background. He even highlights the crowns on the poles which mimic the chimneys and the church's domes.

The contrasts and tensions that Monet devised for these views raise these pictures above the overtly picturesque and differentiate them from other, less demanding canvases in the group, such as his views of San Giorgio Maggiore (fig. 39). However, he was still rightfully concerned that people might not recognize how much he had tried to define different territory for view painting, how much emphasis he had placed on the artifice of the enterprise, and how large a role he had granted to ambiguity, recollection, and introspection. He therefore asked Octave Mirbeau to write the essay for his catalogue. As one of the most outspoken social critics of his day, Mirbeau was the perfect choice to counter any claims that Monet was merely pandering to a public.

Mirbeau did not disappoint his friend. With a cynicism that was as biting as Monet's pictures were beautiful, he condemned Venice as a city that was "nothing more than a color postcard . . . a town that is no longer a town but a mere decoration, a motif."[174] He had few compliments for past artists or writers who had attempted to represent it but who instead "had extracted it from nature." Monet, he claimed, had done the opposite; he "restored it to nature . . . by translating [the light of the city] as the most intelligent dancer translates a feeling. Movements . . . are so well interwoven one with the other that they seem to be a single movement and that the dance is perfect and complete like a circle."[175] For Mirbeau, Monet was "the master of the unseizable light" to whom everyone was indebted. "All painters today," he asserted, "owe their palette to Claude Monet." However, his impact was not limited to the present, since, in Mirbeau's mind, Monet had already become a historic figure whose accomplishments were part of an incomparable art-historical legacy. "No future painter will be able to be free of the problems that Claude Monet has solved or posed," he declared, "The work of Claude Monet has already passed into the language of painting, as the work of a writer of genius passes into the language of writing and enriches it forever."[176]

Ironically, nowhere in his ten pages of text did Mirbeau ever refer to a specific painting in the show, despite the fact the handsome catalogue that the Galerie Bernheim-Jeune produced included nine full-page photographs of individual works (eight black-and-white and one in color). Perhaps Mirbeau knew that his role as catalogue essayist was to clear the stage and allow his hero-painter to stand

upon it alone and triumphant. He performed that function with fierce precision. Those who came to see Monet's show responded with almost unreserved enthusiasm. Even Guillaume Apollinaire, who had only recently trumpeted the advent of Picasso and Braque's Cubism, had nothing but praise for Monet's accomplishment.[177]

But when the exhibition came down on June 8, 1912, and the paintings and the rave reviews were relegated to history, Monet was again faced with the inevitable problem of what to do next. At the age of seventy-one, without his beloved Alice, the prospects were never more daunting.

The March to Immortality

Between the end of his exhibition of Venetian views in early June 1912 and the outbreak of the First World War in August 1914, Monet painted less than half a dozen pictures – two views of his house from the northwestern corner of his flower garden, which he completed in 1912 (fig. 41), and three views of the rose-covered pergolas across the tracks in the water garden as seen from the eastern banks of his water-lily pond (fig. 42). The former contain faint echoes of his garden views from 1900 (cat. 7); the latter vaguely recall the suite of Japanese Bridge pictures that he had executed in 1905 (fig. 34).

Despite certain resemblances to those earlier works, each of these new groups is quite distinctive. The various

Fig. 40 Monet retouching *The Rose-covered Pergola, Giverny*, 1913, published in *Je sais tout*, January 15, 1914.

forms of foliage in the views of the house, for example, surge and swirl as if competing for prominence in the scene while the house peers into the fray from behind the tangled brushwork like an inquisitive though somewhat fearful spectator. The vitality of the bushes and trees in these two pictures is repeated in the flower-wrapped pergolas and the far bank in the water-garden paintings, although the intensity of the views of the house is slightly reduced here because of the smaller size and the distance of the fauna. As was true with Monet's first pairs of water- and flower-garden pictures at the turn of the century, these three new pond paintings are meditative, mysterious, and expansive, commensurate with their Eastern inflection. In contrast, the two views of the house are restless and competitive, typical of their more Western ties.

The most striking fact about these two groups of pictures is their extremely modest number. Never had Monet produced so little over such an extended period of time. As word circulated about his inactivity, people began to think that he was perhaps giving up his craft. If he had wanted to, he certainly was wealthy enough to do so. Having sold all of the Venetian paintings from the 1912 show and most of the Water Lilies from his exhibition three years earlier, Monet had added hundreds of thousands of francs to his already substantial coffers, allowing him the freedom to do whatever he pleased.[178] He also had a personal inventory of paintings that he could tap if he needed extra cash. Although the cost of running his estate and supporting his extended family was considerable, he could afford these expenses even if he did not paint another picture for the rest of his life.

The idea that Monet was contemplating retirement was based not only on his minimal output and intermittent presence in Paris but also on the unavoidable fact that he was getting older. When he put his final touches on figure 42 in late November 1913, providing a much heralded photo opportunity for a reporter for the Parisian weekly *Je sais tout* (fig. 40), he had just turned seventy-three. Along with Degas and Renoir (who would die in 1917 and 1919, respectively), he was the last of the venerable intransigents who had initiated the revolution in French art in the 1860s and 1870s and had helped to drag a conservative culture into the modern age. Even Seurat and Gauguin, the leaders of the subsequent generation of avant-garde artists, had long since died (the former in 1891, the latter in 1903), leaving the field open to a new crop of painters who had left their mark on the nation's art and taste well before Monet posed for the *Je sais tout* photographer.

Fauvism had run its course by then too, leaving Matisse, Derain, Vlaminck, and their followers to pursue the implications of their once tightly shared aesthetic in highly idiosyncratic ways. Picasso's *Demoiselles d'Avignon* had been hanging in that artist's studio since 1907, provoking astonishment and anxiety among those who saw it while

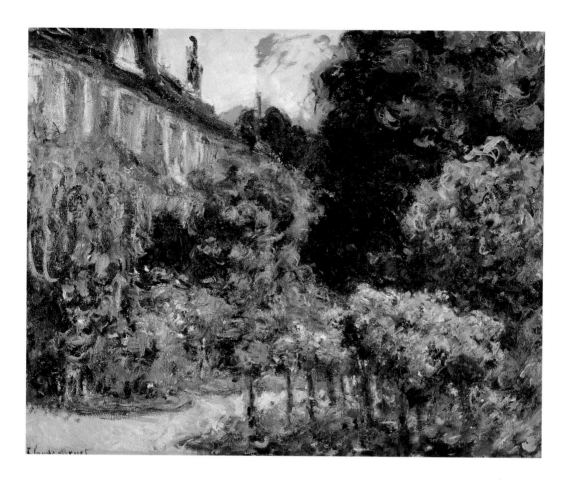

Fig. 41 *The Artist's House at Giverny*, 1912 (W.1778), Private Collection.

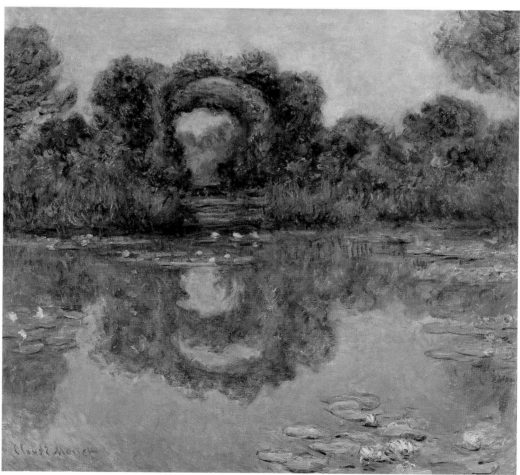

Fig. 42 *The Rose-covered Pergola, Giverny*, 1913 (W.1779), Phoenix Art Museum, Gift of Mr. and Mrs. Donald Harrington.

spawning some of the most radical alterations to painting's traditions since the invention of Renaissance perspective. By 1912–13 Picasso and Braque had begun to rethink those alterations and were entering the Synthetic phase of Cubism. Several years earlier, in February 1909, the incendiary Italian poet F. T. Marinetti had published "The Foundation and Manifesto of Futurism" on the front page of *Le Figaro*, less than a month before the opening of Monet's exhibition of *Paysages d'eau* at Durand-Ruel's. The following year saw the first abstract paintings by Kandinsky and Delaunay, and the year after that the storming of Paris again by the Futurists who, in February 1912, opened their first exhibition in France in the very same rooms of the Bernheim-Jeune Gallery in which Monet showed his Venetian pictures two months later.

If that were not enough to make Monet seem fundamentally grounded in the nineteenth century, 1912 was also the year that Marcel Duchamp created his first "ready-made" – a bicycle wheel turned upside down and mounted on a common kitchen stool – and painted *Nude descending a Staircase*, which caused a fury when it was included in the Armory show of modern art held in New York in February and March 1913.

Monet also had work in that groundbreaking exhibition, but as part of the older, more expensive guard. His paintings commanded between $7,700 and $11,000, whereas Duchamp's now-famous cubo-futurist nude could have been had for a mere $324, a clear signal that the elderly Impressionist and his equally aged or deceased colleagues were of another era.[179]

People were therefore not completely wide of the mark when they presumed Monet might be putting down his brushes soon after the Armory show closed. Monet himself reinforced the speculation on several occasions, most specifically in a letter of July 18, 1913, to Geffroy: "I am becoming lazier and lazier, to the point where I put off everything to the next day. Without pluck and having no taste for anything, I end my days very sadly."[180]

However, this was not really his intent. The depression that he expressed in this letter, and in others, and his unusually low productivity between the end of his Venice show and the summer of 1914 can be traced to recent events – Alice's death, his mixed feelings about the Venetian pictures, and then the death of his older son, Jean. His malaise was exacerbated by yet another disturbing development. In late July 1912 he discovered that he could not see out of his right eye. A specialist in Vernon diagnosed early cataracts in both eyes. Monet was terrified. The doctor reassured him that he would be able to see perfectly if he had the cataracts surgically removed. This did not ease Monet's mind.[181] A second physician in Paris confirmed the existence of the cataracts but prescribed a treatment that would either postpone the operation or circumvent it entirely.

Monet opted for the treatment, unable to bear the thought of anyone operating on his eyes not because of the surgery itself but because he believed that his vision "afterwards would be completely changed, which for me is central."[182] The treatment seemed to work; at least his sight did not deteriorate. When the weather cooperated he was able to paint, although he did not push himself very hard. By January of the following year, his condition had not worsened; but his morale had dropped even further, prompting a flurry of gloomy letters and a quick two-week trip to Saint Moritz, which turned out to be the perfect antidote to his decline.

In April 1913 he reported that his sight was clearer but that he could not tolerate bright outdoor light.[183] Through Geffroy he arranged to see another doctor, and was resigned to the possibility that he would now have to undergo the dreaded operation, a fear that persisted through early June.[184] By mid-July, that threat had faded; his eyes seemed to have improved, permitting him to begin his paintings of the rose-covered pergolas.

These paintings, like the views of his house from the previous year, contain no hint of the difficulties he was experiencing. His palette is appropriately balanced, his forms are clearly described, his sense of light and atmosphere completely assured. The cataracts, apparently, had not affected his art. Equally surprising, perhaps, given his penchant for venting his anxieties, is that Monet did not mention the problem again until the end of the decade, nor did his friends or colleagues. One may assume that the medicine had sufficiently arrested whatever deterioration had taken place, for by late May and early June 1914 Monet had thrown himself into his work with renewed energy and conviction.[185]

The threat of having his sight compromised by an operation probably contributed to his new, feverish pitch: "I am in the thick of work," he informed Félix Fénéon in the middle of June.[186] So absorbed was he that he decided to skip one of the biggest events of the summer – the opening of the Camondo bequest of modern paintings at the Louvre, of which fourteen were by him.[187] His intensity was also heightened by the extended period away from his easel and by the ideas for new projects that had germinated during those two years. As they began to take shape in late 1913 or early 1914, it became evident that the two views of his house and the three of the pond and pergola done in 1912 and 1913 were only warm-up pictures, typical of the kind he had done after similar periods of relative inactivity earlier in his life. As Monet told a visitor in 1912 with typical understatement, he felt like "a beginner with everything to relearn" – an assertion that is contradicted by these pictures, and by those that follow.[188] In fact, the pictures that Monet began to produce in June and July of 1914 – all close-up views of his water-lily pond (cats. 59 and 60). – are so brazen and ambitious and such an advance over

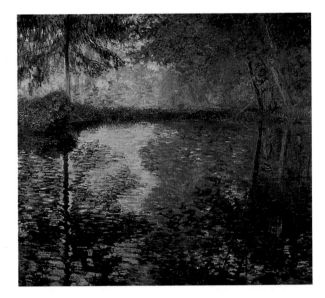

the house and pergola pictures of the previous two years that one suspects that Monet painted other works in between and then later edited or destroyed them.

What is immediately striking is the size of these new pictures; they are extremely large, generally one and a half to two meters square. Monet had not attempted such large canvases since the four decorative pictures that he had done for the Hoschedé country house in Montgeron some thirty years before (fig. 44). These pictures were relatively fresh in his mind when he began thinking about his new project, as they all had been on the market or in recent exhibitions.[189] The project that Monet embarked upon in 1914 demanded a seriousness of purpose and an ambitiousness of scale that must have made these seminal, though quite different, panels important touchstones.

The other remarkable feature of these new pictures is how little they actually resemble anything he had done up until then, including the Montgeron panels despite the almost uncannily similar subject of figure 44. Part of their novelty lies in the fact that they are not finished and were not intended to be exhibited or sold. Their rough workmanship and apparent lack of planning are largely the result of their experimental nature. Monet was essentially using them to test out pictorial ideas on a new, rather formidable scale. Given that he neither signed nor dated them, it is impossible to order them with any precision. The smaller canvases (which measure 1.30 × 1.50 m, and 1.50 × 2.00 m) were probably the first, as it is unlikely that Monet would have begun this new project of the *Grandes Décorations* with the larger, more challenging formats. In addition, one or two of these smaller canvases, such as

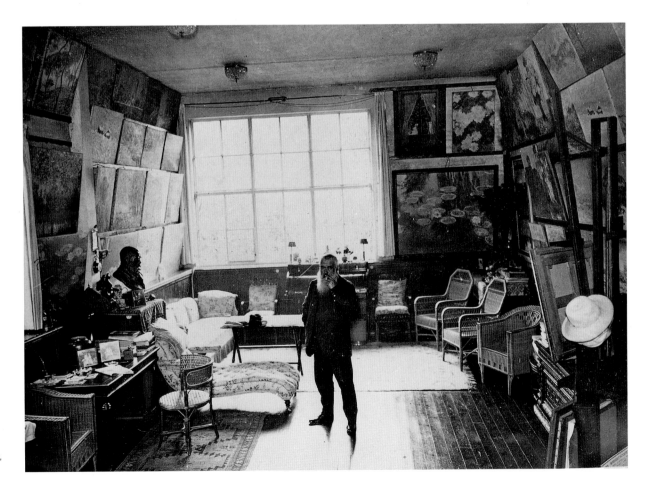

Fig. 43 Monet in his first Giverny
studio, mid-November 1913,
published in *Je sais tout*, January 14,
1914.

62

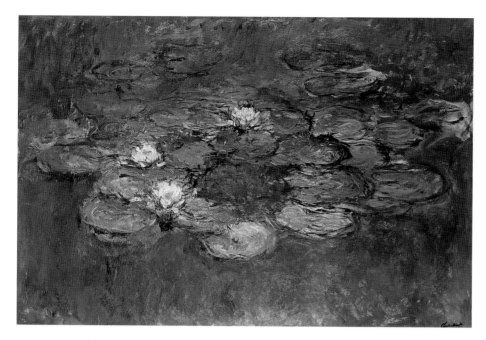

Fig. 45 *Water Lilies*, 1914–15 (W.1784), Private Collection, courtesy of Knoedler.

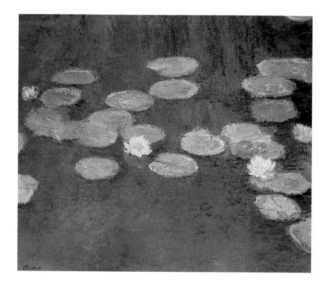

Fig. 46 *Water Lilies*, 1897–99 (W.1508), Private Collection.

figure 45, are evidently outgrowths of Monet's earliest essays in this genre, such as figure 46. Monet had kept this picture and at least one other close at hand, contrary to his claims to Geffroy that he had stumbled upon them in his basement in April 1914.[190] They appear in a photograph that was taken around November 20, 1915, when André Arnyvelde came to interview Monet for *Je sais tout* (fig. 43). Figure 46 hangs prominently over Monet's left shoulder on the wall in the background; another, figure 19, is the first in the lowest row of pictures just behind Monet's desk to his right. Their presence in this very personal space, together with the fact that the largest canvas is one of the few framed paintings in the room, strongly suggests their importance to his thinking well before he embarked on his project.

More important perhaps, they underscore the longevity of that scheme. It had been more than sixteen years since

Monet had told Guillemot about his vision of a circular room decorated with water-lily paintings.[191] The notion of a totally enclosed space lined with paintings that would carry the viewer into realms of aesthetic reverie would have been reinforced each time Monet expanded his water-lily pond or hung an exhibition of closely related canvases.

Why did Monet wait so long to act on this idea of painting "in the round"? And what may have finally motivated him to move from concept to canvas? These are questions about which Monet is typically silent. Nevertheless, a few points can be made. Obviously, Monet was not getting any younger, a fact that was sharpened by Alice's death and the consequent disruption of his otherwise calm and comfortable life.[192] He was also deeply affected by the poor health of his son Jean, who suffered a stroke a month after the Venice show closed in the summer of 1912 and whose health continued to fail until his death in January 1914 at the age of forty-seven. Coming so soon after losing Alice, Jean's stroke totally unnerved Monet. The grieving widower became the tortured father as he watched his son's health decline over the next year and a half. Unable to do anything to reverse his son's fate, Monet, understandably, could not muster the interest or the will to attempt a project as large as he had envisioned. But after Jean's death, Monet discovered a new strength and resolve, the product perhaps of his profound sense of loss and an evident need to find deeper meaning in his life.

Monet was also motivated to begin his project by another negative in his life: his Venetian pictures. Although they had provoked enthusiastic responses among critics and collectors and held important personal memories for him, they ran counter to his preferred way of making art. He considered them too nostalgic in feeling and too uneven in quality, and thus not his best works. He would not let them be the final canvases of his career; his last chapter had to be a superior effort.

When contemplating what he was going to do after the Venice show, he must have spent a lot of time thinking about what point he had reached before that trip. What did the last Water Lily pictures of 1908 have to offer him? What could he take from them that he could apply to a new set of canvases? They must have appeared to have exhausted most of his options, at least if he were going to retain some kind of recognizable subject matter: there was virtually nothing left in them – no sky, very few water lilies, no clear distinction between up and down or left and right, minimal drawing, and greatly reduced chiaroscuro. Even the paint was generally applied in a matte, dry manner that made for a relatively opaque, unmodulated surface. Critics therefore had not been misguided when they had spoken about these paintings as veritable abstractions, claims they could not have made about contemporary work by other artists, such as Kandinsky and Delaunay, who would even-

tually produce the first non-objective images. Even Picasso in 1908 was producing works of almost chiseled plasticity.

However, these 1908 pictures presented Monet with a provocative opportunity. Inherent in their radically reduced pictorialism was the invitation to make pictures that would emphasize the planar, decorative nature of painting – its essential flatness, its non-linear, non-tactile, mural character, its reliance on color, and its ability to seduce viewers through a form of symbiosis. Paying scant regard to specific times of day, weather conditions, or the seasons, these pictures were unlike most of Monet's earlier work. At least, they did not rely on the familiar tropes of the romantic and uneven Venice pictures. Thus, what he appears to have set out to do was to take the lessons that he had learned from his sizable body of Water Lilies and apply them to the decorative pictures that he had begun in 1897.

This forced marriage might appear to be a surprising reversal or a curiously non-linear tactic, but he had done this many times before. His Venetian pictures were a return to the pictorialism of his Londons and a retreat from the Water Lilies that had preceded them. The Water Lilies themselves, for all of their internal logic as a group, do not individually march forward in lockstep. There are many pictures in this suite that lead Monet into digressions or into dead ends – for example, the circular paintings of 1907, which he did not pursue (cats. 35–8), or the Dayton painting of 1903 (cat. 25), with the overhanging foliage that does not reappear until late in the development of the decorative scheme for the Orangerie, such as in catalogue number 62.

It is important to underscore these twists and turns in Monet's career in the twentieth century, as they correct the widespread perception that his work followed an almost preconceived path to some predetermined goal. Given the number of new artists, styles, and ideas about art that circulated in France in the first decade of the century, such a zig-zag path was more than understandable; the competition provided ample opportunity for Monet to take stock of himself, which occurred more frequently than he could have anticipated or cared to admit. He had been absolutely consistent in his response to the challenge, however, always asserting Impressionism's continuing validity. His success during these years, like that enjoyed by Renoir and Degas, confirmed his conviction. So too did the impact of Impressionism on the artists and movements of the century. Not only had Boccioni and the Futurists begun as Impressionists, so too had such diverse figures as Duchamp, Delaunay, and Kandinsky. Even Picasso continued to deal with its legacies long after the invention of Cubism. Indeed, for all of its novelty, a picture such as his portrait of Kahnweiler (fig. 47) is inconceivable without the Impressionists' broken brushwork, scintilating light, and dissolution of form in enveloping atmosphere.[193]

Despite its seminal role, however, Impressionism had been usurped by other, more radical developments long before Monet contemplated his next move in 1913 and 1914. Thus, his decision to begin his monumental Water Lily project may well have been a way to correct that situation. It offered him a number of opportunities: to prove, once again, the continuing vitality of the movement to which he was so closely associated; to recover the leadership role that Impressionism had once enjoyed; to provide an even more bountiful legacy to future generations; and to institutionalize Impressionism even further.

The latter is particularly important, as Monet began the project knowing that it was the most ambitious task he had ever undertaken – and the largest, which meant that he conceived of it as destined for a substantial space. He could not have known whether that space would be public or private, but the number of times from the mid-1890s onward that art critics and supporters had called for the government or a millionaire to commission him to decorate a room or a "vast hall" would have instilled in him the hope of his dream becoming a public reality.[194]

By early 1914 Monet had reason to be encouraged. Many of his paintings were already hanging in the nation's top museums – eight in the Musée du Luxembourg (via the Caillebotte bequest of 1897), seven in the Musée des Arts Décoratifs (via the Moreau-Nélaton bequest of 1907), and fifteen in the Louvre (via the government's purchase of his Rouen Cathedral in 1907 and the Camondo bequest of 1911).[195] He had gained other institutional footholds at home and abroad. He was represented in the Liège and Lyons museums, the Petit Palais in Paris, the Kunsthalle in Bremen, the National Gallery of Ireland, the Art Institute of Chicago, the Worcester Art Museum, and the Museum of Fine Arts in Boston. The Savonnerie factory had even woven tapestries for the Manufacture Nationale des Gobelins based on his Water Lily paintings of 1904, allowing him to join a distinguished group of predecessors-Boucher, Fragonard, Vernet, Oudry, Coypel, de Troy, and Jouvenet, among others – who had either designed tapestries or had tapestries woven after their work.[196] Thus, when Monet began his Grandes Décorations, his record of national patronage would have led him to be optimistic about his prospects for institutional support.

It is hard to know exactly when Monet started his canvases, but mid- to late May 1914 seems most likely. He was ill in January; Jean died at the beginning of February; and his other son, Michel, underwent an operation in March. At the end of April he emerged from this debilitating mixture of malady and mourning, telling Geffroy that he was "obsessed with the desire to paint," and that he was going to "return to big things" based on "the tentative pictures of long ago," an apparent reference to the Water Lily paintings of the 1890s.[197] By June 1, 1914 Monet was completely engrossed in his work. His enthusiasm continued at

Fig. 47 Pablo Picasso, *Daniel-Henri Kahnweiler*, 1910, The Art Institute of Chicago, Gift of Mrs. Gilbert W. Chapman in memory of Charles B. Goodspeed.

this feverish pitch all month; according to a letter that he wrote to Durand-Ruel at the end of June, he was up at 4 a.m. every day and painting until the sun went down. By early July he was so pleased with his progress that he strongly encouraged Geffroy to come to Giverny to see the results. It was a propitious start.[198]

It is difficult to know what Geffroy saw when he visited Monet for lunch during the second week of the month, but as July gave way to August Monet's promising beginning was abruptly halted as Germany invaded Luxembourg, causing France to declare war on its belligerent neighbor. On September 1 the beleaguered painter wrote Geffroy a poignant letter making his concerns apparent: "I should have written you a long time ago, but alas! I have been depressed for a month and I don't know what I have been doing. What I know well is that in the present state of things and in my isolation, a letter from a good friend like you is a comfort which helps to endure these agonies."[199] Monet was particularly nervous about his loved ones: "A lot of my family have left, without our knowing where they are; only my Michel . . . is still with me, together with Blanche. Germaine Salerou, who was here with her children, left yesterday; a mad panic has possessed this whole area." With typical fortitude, he insisted that he was all right, despite the fact that he was almost alone in his once crowded and boisterous house. He was determined to withstand anything that fate might bring, telling Geffroy in crushingly blunt terms that he was keenly aware of the worst that might befall him: "As for me, I will stay here all the same, and if these savages must kill me, it will be in the midst of my canvases, in front of all of my life's work."[200]

It is difficult to determine the precise mixture of stoicism and anxiety that Monet felt as French troops marched off to the Front to counter the German invasion. As the nation braced itself once more for the horrors of human combat there was a pervasive confidence that the army would extract its revenge on France's hated enemy across the Rhine. But, of course, nothing was assured. Indeed, as Monet pointed out, panic lay just beneath the surface of the country's consciousness, ready to erupt at a moment's notice. That was largely because the memory of 1870 was so fresh in people's minds; such a swift and painful defeat was not easy to forget, especially when the Germans appeared to be reenacting the speed of that earlier assault. On August 2 and 3 seventy-eight German divisions had marched across the border into Luxembourg and Belgium. By August 20 Brussels had fallen and by September 1, when Monet wrote the letter to Geffroy, those same troops were threatening Paris. This *blitzkrieg* had led residents of Giverny to believe that they could be overrun; Germaine Hoschedé sought safety in the Loire, a Département that had remained secure even during the Prussian occupation more than forty years before.

Although he knew the comfort of being far from the fray, having fled during the Franco-Prussian War, Monet did not accompany Germaine. This time he was not going anywhere, even if it meant dying in his studio – a decision made as much out of pride and resignation as from his characteristic determination and his rage at the Germans. It underscores how deeply Monet believed in his enterprise, how much he invested in it, and how ultimately it represented his life and values. The September 1 letter also attests that Monet would not be swayed by fear or pessimism; in a postscript he even criticized his friend Mirbeau for being too negative.[201]

Despite his determination, Monet was living a divided emotional life. He was buoyed up by the promising reports from the front, but he was also riddled with worries.[202] This condition, so typical of the moment, would become a considerable burden for Monet during the months and years ahead, not only because of his personal commitment to his country but also because members of his own family became involved in the war effort. His son Michel was excused from active duty because of his operation, but he volunteered anyway and in April 1915 was deployed to Orbel. Monet's stepson Jean-Pierre Hoschedé was conscripted in the first mobilization of troops in August 1914, assigned to the transport corps of the army, and sent off to the front on August 10. He left with his stepfather's blessings and encouragement: "Don't forget to send us news; above all, be courageous and prudent and rest assured that our hearts are with you." The patriarch also added a touching reminder: "Think of us. Those who remain are also to be pitied."[203]

Thus, Monet's empathy for the soldiers in the trenches, which he expressed consistently throughout the war, had distinctly personal dimensions. Having just lost two family members, the prospect of seeing others die was difficult to bear, and it was all around him. "One sees wounded soldiers in every village," he declared in that same letter to his dealer. To his dismay, he also learned that Clemenceau's son had been hit. A month later both of Renoir's sons were wounded. Everything that Monet had worked for seemed to be hanging in the balance. There was nothing he could do to help, although he tried to allay his anxieties by supplying "all the vegetables necessary" for the makeshift hospital that had been set up in Giverny for early casualties of the conflict.[204]

There were many artists who marched off to the front – Braque, Derain, Léger, La Fresnaye, Segonzac. Those who stayed at home, such as Monet and Matisse (who had volunteered for the army but had been turned down because of his age), found their primary refuge in work. "It is the best way not to think too much about the sadness of the present," Monet confessed to Geffroy at the end of 1914, even though merely painting pictures made him feel guilty: "I should be a bit ashamed to think about little investigations into forms and colors while so many people

suffer and die for us.''[205] He repeated this sentiment often over the ensuing years, emphasizing the evident disparity of making art while people were leaving their family and friends to defend the nation. But he recognized that succumbing to melancholy was not going to change things, that his obligation was to do what he did best, namely to paint. Work became not just an escape but an environment like any other in which action could be taken and serious statements could be made. As Matisse put it to his friend Charles Camoin, ''I work all day and with ardor. I know there is only that, good and sure. I can't engage in politics as, alas, almost everyone does, so to compensate I have to make strong and sensitive paintings.''[206]

Other artists made the claims for art's validity during the war with greater verve, though none perhaps more forcefully than the editors of the magazine *L'Elan*, which was launched in April 1915:

> Our only goal is to propagandize on behalf of French art . . . [and] the true French spirit . . . Foreigners may think that art in France belongs only to peace. Those who are fighting, our friends, write to us how much more strongly the war has attached them to their art; they would like some pages in which to show it. This journal will be those pages. This journal . . . will fight against the Enemy, wherever he is, even in France.[207]

Monet had never been politically aggressive. Thus, it is not surprising that his work did not appear in magazines like *L'Elan*, but that does not mean that he was unpatriotic or any less committed to nationalistic causes. On the contrary, the war brought out deep-seated feelings that he had harbored for his country and that he had manifested previously under more metaphorical or aesthetic guises. In early 1915, for example, just three months before the appearance of *L'Elan's* inaugural issue, he was approached by a member of a committee intent on gathering names of distinguished individuals to support the publication of a book entitled *Les Allemands déstructeurs des cathédrales et des trésors du passé*. Monet responded with uncharacteristic enthusiasm: ''Under normal circumstances, I do not like to put my name forward and am hardly in favor of committees. Things are not the same today, and if you believe that my name can be of some use to the work that you have begun, it is with my full blessing that I put it at your disposal.''[208]

During the course of the war Monet received innumerable requests for money or works of art to be auctioned off for patriotic efforts. Again, these were things that he usually would have avoided but which he agreed to support time and again throughout the conflict. He even consented to be filmed while painting by his water-lily pond for a film that Sasha Guitry made in 1915, featuring France's leading cultural figures. He never would have allowed such an intrusion had it not been for the war. That he was shown in the act of painting in Guitry's film emphasizes the way in which the war affected the conjuncture of his public and private selves. Above all else, it was his art that preoccupied him most during these tragic years; and it was through the act of painting that he wanted to be seen as performing his public service.

By early January 1915, he was feeling confident enough about his project to invite Raymond Koechlin, the former head of the Société des Amis du Louvre and a formidable figure in Parisian art circles, to visit Giverny to see what he described for the first time as his ''Grandes décorations.'' ''It is a very large thing that I have undertaken, certainly at my age,'' he told Koechlin, ''but I am not despairing about finishing it, so long as my health holds out.'' Monet seemed somewhat amused to learn that Koechlin had suspected what the initiative entailed. ''As you have guessed, it is a project that I have been involved with for some time already; water, water lilies, plants, but on a very large scale.'' He told Koechlin that he was welcome to come and see ''the beginnings of this work,'' which suggests both how far the pictures had progressed and how much Monet wanted to assure his visitor that they were still a long way from being finished.[209]

That they had been sufficiently developed to show to someone like Koechlin, however, is significant, as it indicates that Monet must have been confidant about what he had accomplished thus far and proud of having worked during the cold winter months, despite (if not because of) the horrors around him. Much of what he had been able to achieve had been in the confines of his studio, away from his motif – a poignant reminder that these pictures are much more than views of his water-lily pond or poetic evocations of nature's eternal magic, although both of these readings are central to their meaning.

So engrossed was he in his work from January to September 1915 that he appears to have written very few letters. He also turned down a tempting invitation from the Bernheim-Jeune brothers to stay with them for a week in August at their country house in Bois-Lurette.[210] After fourteen months, the project was consuming him. It was also growing in ways that perhaps even he had not envisioned, especially in terms of the number of paintings he had begun. His second studio by the greenhouse was no longer large enough to accommodate his production, so sometime that spring or early summer he decided that he had to build a bigger facility. The Départemente *sous-prefet* issued a permit for the work on July 5; presumably construction began immediately after that.[211]

The building proved to be frightfully expensive. Even Monet was embarrassed, telling Jean-Pierre Hoschedé in August 1915 that it cost nearly twice as much as what he had paid for his entire Giverny estate in 1890 – 35,677 francs versus 20,000.[212] He was also taken aback at how ugly the structure was: ''I am ashamed to have made this

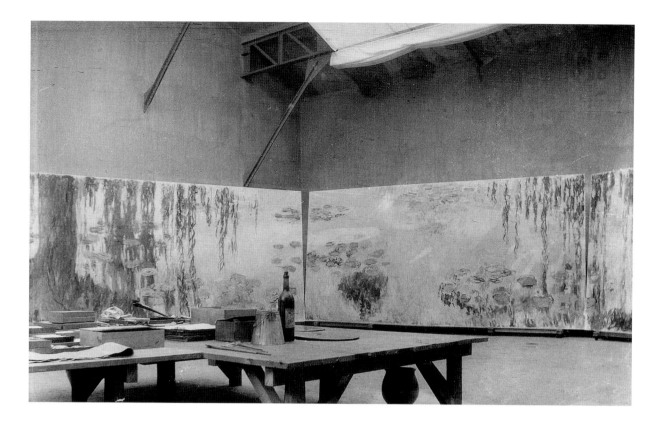

myself," he admitted to his stepson, "I who always cried out against those people who compromise Giverny's beauty."[213] Practicality took precedence over aesthetics, an indication again of how the war altered his thinking. Monet may have winced at the building's exterior, but he never expressed another word of regret. Nor did he blink when the bills came in; he simply paid them and moved in as soon as he could, which was toward the end of October.[214]

His single-minded, unemotional focus on getting this job done was symptomatic of Monet's overriding determination to achieve his goal of completing his *Grandes Décorations* regardless of the circumstances. The resulting building, though unattractive, was astonishing: 276 square meters of raw space in which to paint, contemplate, and arrange his canvases. The new studio must have been exhilarating, for in addition to its cavernous size, it was filled with northern light that flooded the interior from the structure's glass ceiling some fifteen meters above the tile floor. It was in many ways a modern space more typical of a late-twentieth-century studio for a successful Abstract Expressionist or Color Field artist than for a nineteenth-century landscape painter.

It certainly contributed to Monet's surge of activity during the course of the following year, as he stuck relentlessly to what he described as his "satanic travail."[215] He rarely left Giverny in 1916, saw few visitors, and worked on nothing else but his panels. He fretted about the folly of it all but continued to find the results deeply satisfying, par-

ticularly because of the way that the paintings "occupy my spirit", as he so often put it.[216] Having such a fulfilling distraction was to be envied, especially considering that his son Michel "spent three terrible weeks at Verdun," caught in one of the fiercest battles of the war, while the war itself dragged on, relentlessly inflicting trauma and shocking everyone with the evident meaninglessness of the carnage and destruction.[217] Near the end of November 1916 he thought that he was close to finishing some of his big panels, an optimism that he communicated to the Bernheim-Jeune brothers. He even went so far as to agree to a visit by Matisse, who wanted to see what Monet had been working on for two and a half years.[218]

Monet's confidence was solidly based: photographs taken in late 1915 or early 1916 (fig. 48), reveal how far he had advanced on at least four of the large panels, but in less than two weeks after his letter to the Bernheim-Jeune brothers, Monet's spirits suddenly fell. On December 14, 1916, he explained to Sasha Guitry that he had "lost" the pictures in the process of "improving" them, which threw him into a terrible state.[219] "I no longer have the courage to do anything," he lamented to Geffroy more than a month later in January 1917, "[I am] saddened by this horrible war first of all, worried about my poor Michel, who is risking his life at every moment, and finally, disgusted with what I have done."[220]

It is hard to know whether he really did lose his pictures in the process of reworking them or whether he was struck by a bolt of fear and depression that frayed his

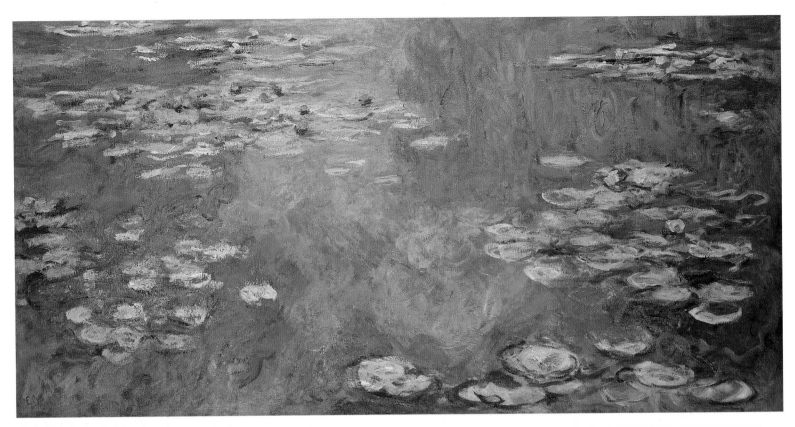

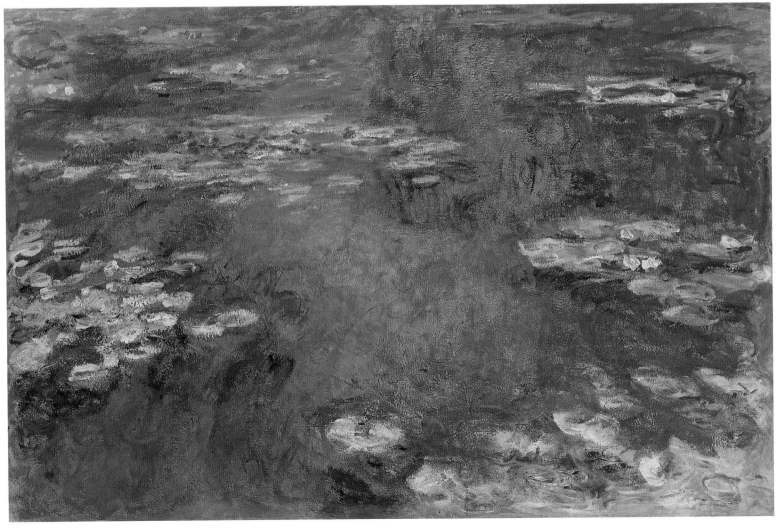

nerves and caused him to back out of his appointment with Matisse. Whatever the reason, this was the first real impasse he had faced in more than thirty months of working on the project, and it took its toll. He refused to allow the Durand-Ruels to come to Giverny to photograph the pictures. (They had wanted to present the paintings to potential clients.) "I have no photographs of the *décorations* [*sic*] and will make none until the work – which by the way does not always proceed as I would wish – is a little closer to being finished, at least in part," Monet curtly informed the dealers, "so for now, it is useless to talk of sales and prices."[221] It would take the Durand-Ruels another eleven months to gain access to these pictures. When they finally came on November 11, 1917, Monet allowed them to photograph the now-temporarily framed canvases, but he would not let the paintings out of his studio, despite the dealer's urgent pleas. So stubborn was Monet about the whole project that he refused to relinquish any of these pictures, or any of the more than one hundred studies and related works, until after the end of the war, and then only hesitantly and sparingly. Except for approximately a dozen pictures which he sold or gave away between 1918 and 1923, and the twenty-two panels that eventually went to the Orangerie in 1927, the trove of pond paintings that had preoccupied him since 1914 remained in his studio, unknown to the public until the early 1950s.

Monet's possessiveness emphasizes how seriously he took his task, as the vast majority of these one hundred-plus paintings were in fact studies or unfinished works. They provided Monet with reference points or guidance as he proceeded with the *Grandes Décorations*, and he did not want to be without them if they could help him complete his project in any way. He also did not want the project to be misrepresented. Being unfinished, these dozens of paintings would not have provided the public with an accurate sense of his aims and intentions.

It is also reasonable to assume that for the increasingly solitary Monet, who was locked in a long-running battle

with himself, the past, and the pressures of the present, these paintings must have served as sources of solace – a kind of self-created family that reaffirmed his vitality and his purpose. At a time when the world seemed to have lost its direction and much of its joy and beauty, such reassurances were to be welcomed.

Monet's concern about letting any of the sketches escape suggests his nineteenth-century roots. As is evident from a comparison of one of the Water Lilies that Monet sold in 1919 and one of the closely related but unfinished canvases from the studio (figs. 49 and 50), there is no mistaking what he wanted to protect. The finished painting is broadly brushed with rich surfaces and relatively loose drawing; note how casually the water-lily pads seem to be encircled at the lower right. The palette is strong, the composition is open on the edges and split down the middle; but the brushwork in the sketch is much more aggressive, and its color contrasts are considerably more strident. These factors combine to make the various parts of the sketch compete more forcefully against each other. In fact, everything in this canvas is more agitated and uncertain. Even the water-lily pads appear both less defined and more independent, although they occupy essentially the same locations as in the finished picture. Moreover, the balance between the foliage and the reflections of sky in the water is more precarious. The foliage pushes across the surface of the canvas more energetically in the sketch, reducing the amount of the canvas devoted to the curving section of blue sky which, in addition to being cramped, is crowded with other incidents – isolated strands of foliage and bolder pink clouds, for example.

The greater gentility of what Monet considered to be a finished picture is made even more explicit with catalogue number 71. Here, the painted surface is almost evanescent, the light nearly ethereal. Paint is applied more like a wash than a palpable substance capable of coagulating and being given different textures. Chiaroscuro is minimized, reminiscent of the last Water Lilies from 1908; the pads and the reflections are also quite harmoniously disposed, even more so than those in the same earlier pictures. It is perhaps not surprising that Monet donated this picture to the Société d'Initiative et de Documentation Artistique in Nantes, which had approached him in 1922 for a painting that they could use to encourage the advancement of modern art in the city.

To a late twentieth-century viewer accustomed to abstract painting and the advances of Abstract Expressionism or its offshoots, many of the rougher, less tame pictures might seem perfectly acceptable, but to Monet they were not. In fact, after having sold a truly remarkable painting (fig. 51, unfortunately now lost) to Japanese collector Prince Kojiro Matsukata, Monet was horrified to discover in 1924, two years after the sale, that the painting was included in an exhibition at Georges

Petit's. He immediately contacted the gallery and, with Clemenceau's help, had it removed. He did not wish his public persona to be compromised, nor his decorative project preempted, by such a painting.[222]

Matsukata's picture, like the many others in Monet's studio, was directly related to that all-consuming project, which only added to Monet's alarm. In fact, Matsukata's picture is the largest of seven studies, including catalogue numbers 64–8 for the diptych that would eventually cover the west wall in the second room of the Orangerie. All of these paintings are extraordinarily aggressive, a quality particularly evident in Monet's brushwork. So thick, large, and unmodulated are his strokes in this suite that they make Van Gogh's appear staid and controlled and Fauve paintings overly calculated. In addition, the murkiness of the water in these scenes, like the unmixed bursts of color that sit so independently on the surfaces of the canvases, are more than just startling. They have no parallels in Monet's past and few points of reference in the work of his contemporaries.

This quickly becomes apparent when these studies are compared to some of the iconic paintings of the period, or to any of Picasso's Cubist pictures from the same moment, such as *Still Life with Cards, Glasses, and Bottle of Rum* ("*Vive la France*") (1914–15; fig. 52). Monet's canvases appear out of synch, bizarre, and defiantly individualistic. Matisse would have been surprised if he had set eyes upon these during his planned visit to Giverny in December 1916. (The Matsukata picture was dated to that year in the Petit exhibition, which suggests that it might have been available to the younger Matisse.) How distant they would have seemed from Matisse's most recent work, such as *The Piano Lesson*, 1916 (fig. 53), with its restrained handling of paint, rigid divisions between forms, and rigorously ordered composition. Unlike Monet, Matisse left nothing to chance in *The Piano Lesson*, despite its many pentimenti. For this painting is about discipline and duty, appropriate for a wartime effort by an artist who had wanted to fight. And yet, like Monet's views of his pond, there is also a yearning for beauty and a desire for abandon. They are expressed in the swath of green outside the open French doors and in the bronze lap of the luxuriating female nude below, whose relaxed demeanor and sensual curves are a striking contrast to the rectilinear authority of the seated figure in the upper right. Although ruled by this anonymous matron, erect on her stool, and by the rhythm of the metronome in front of him, the young boy at the piano – like the artist at his easel – practices his craft to hone his skills, all in an effort to make an art that is as clear and lyrical as the arabesque on the music rack or the balcony to the left. Linked by the black edge of the piano and its stand, these flowing forms allow us, at least momentarily, to escape the divided world of the present and to imagine the freedom that art – and nature – can provide, a freedom that Monet's paintings express unabashedly.

It is unclear whether Matisse ever made the trip to Giverny during that winter of 1916–17, but he did come in the spring.[223] In either case, he might have been thinking of the elder Impressionist when he decided to create a companion piece to *The Music Lesson* in 1917 (fig. 54). Everything about this pendant is relaxed and fulfilling; cooperation and pleasure reign. Even the seated woman at the upper right is more at ease, but most important, beyond the wide-open doors of this more richly painted space is bountiful nature, more inviting than the rigidly bifurcated green and gray wedges of the earlier picture. What occupies pride of place in this verdant garden is an oval pond reminiscent of Monet's. But, just as Monet did not want his almost hedonistic sketches to be seen by the public, so Matisse had to inject some measure of sobriety into his modern rococo scene. Thus, everyone in this picture is doing something – practicing, reading, knitting, thinking. Even the nude by the side of the pool raises her arm and lowers her head as if contemplating something important, thereby moderating the eroticism she exudes while drawing attention to the surging foliage above her, a riot of green that calls to mind the multiple growths along the edge of Monet's pond that capped his Water Lily pictures of 1904 (cats. 26 and 27).

The irony is that whereas Matisse's pendant is fuller and more legible in contrast to his spare and abstract first version, Monet's pictures move in a radically different direction – to something cryptic, almost incomprehensible, multilayered and immense. There is nothing spelled out in his scene, no names like Pleyel or Haydn, no clear indication of spatial relationships, no discipline imposed on his brush or hand. They simply did not have enough restraint or pictorial integrity for them to be accepted as fully realized works of art. Monet was convinced that if he had let them out of his studio, they would have seriously diminished his standing as one of France's most serious artists.

Fig. 52 Pablo Picasso, *Still Life with Cards, Glasses, and Bottle of Rum* ("*Vive la France*"), 1914–15, Private Collection, Chicago.

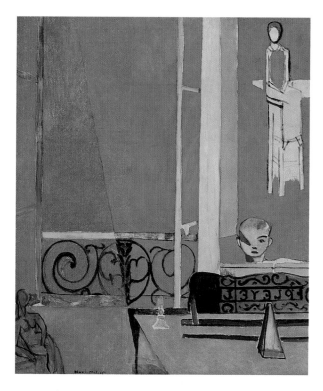

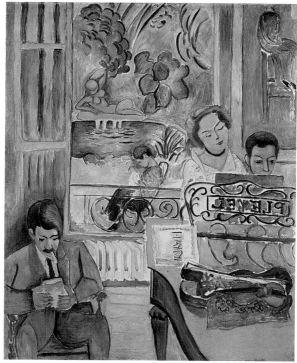

Of course, they were only studies or works in progress, never intended for public view. Thus, the comparison with Matisse – or any other contemporary artist during the war – is somewhat unfair. None of them would have put pictures like Monet's in front of the public, although Matisse and Picasso did agree to mount a joint exhibition in early 1918 as an unprecedented – and unrepeated – demonstration of solidarity, another indication of what the war could wreak.[224] However, nothing in that show approached the brazenness and intrepidity of the work Monet was producing; neither artist could have risked such daring. In fact, neither Matisse nor Picasso was even painting pictures as bold as Monet's in war-torn France, nor were their avant-garde contemporaries. When the war broke out artists quickly realized that the shattered forms of Analytical Cubism, the nihilism of Futurism, and the insularity of abstract art were not going to find the same critical or financial support as they had before the conflict began. As one writer succinctly put it in December 1917, "Do you remember – before the war – the diversity of views, opinions, tendencies, directions, theories in French pictorial art? The grossest extravagances became a daily spectacle . . . and that experiment for experiment's sake was an idle preoccupation."[225]

Although this proclamation was made by a conservative observer of the cultural scene, artists of all stripes had to rethink their allegiances and redefine their practices. The times demanded no less. Thus, principles that once may have been novel and productive were soon determined to be elitist and disconnected. What had formerly been inspiring and expansive was suddenly just the opposite. If France was sacrificing her young to safeguard a tyranny-free future, then artists could be expected to make their appropriate contributions. That meant shedding their individualism and self-indulgent experimentation and creating works of art that could stand as testimonials to the country's "moral force," as the critic Francis Carco declared in December 1915.[226] "Almost every Parisian artist was no longer painting only for himself or his colleagues," Kenneth Silver has eloquently observed, "now all were making art with at least an eye out for such abstract glories as France, civilization, and eternity. The burden of such a new set of ambitions must have been enormous."[227]

This did not mean that Cubism disappeared or that abstract art was banned. However, as Silver has established, it did mean that abstraction in France was so disparaged that artists virtually abandoned it as an option for picture-making. Cubism survived, but only in an altered form, as evident from Picasso's *Still Life with Cards* (fig. 52). The fragmented motifs, monochromatic palette, and indecipherable spaces that had been the hallmarks of Braque and Picasso's Analytical Cubist paintings of 1909–12 had begun to be supplanted by the brighter colors and ornamental patterns of Synthetic Cubism after the invention of collage and *papier collé* just before the war. But when it broke out, that shift was significantly hastened, particularly by Picasso. With his soulmate Braque at the front, the Spaniard had to negotiate Cubism's transformation on his own, which he did in surprising ways: deploying Seurat's pointillist dots in his *Still Life with Cards* (and again in his remake of Le Nain's *Peasants' Meal* in 1917), sharpening his drawing so that elements are given clear and precise

outlines, and arranging his forms more logically in relatively readable environments, many of which have distinct echoes of tradition – for example, in *Still Life with Cards*, the drapery on the left, the wainscoting on the right, and the flowered wallpaper in the background. Artists who, before the war, had been applying paint with a liberal, Impressionist flourish were now laying it down with a discipline and control that reflected the need for solidity in an uncertain time. Picasso blatantly included the French tricolor in *Still Life with Cards* together with the words "Vive la" above the flag to announce the patriotic cry so dear to his adopted countrymen and women; it was the only time he was so forthright in a work that he put before the public. Even if it were tinged with irony – which it may have been – the fact that Picasso incorporated a wartime slogan into a picture is evidence of the war's invasiveness and how it could alter the look and meaning of avant-garde art.

Others were more adamant about the inappropriateness of pre-war avant-garde activities and the need for greater stringency. One of the most vocal was Robert Delaunay, who had been nurtured on Cubism and Futurism and who, in 1910, had painted one of the first abstract pictures in France. As soon as the war broke out, and on many subsequent occasions, he renounced the entire modernist initiative of the pre-war years without a hint of regret or responsibility. "I am delighted with what you say," he told a friend in December 1916. "The newest art [is] in reaction or rather in opposition to all the painting or artistic tendencies called Cubist-Futurist . . . Among the young there is a great reaction against this amorphous art, and these profiteers are no longer à la mode – it's finished."[228]

Delaunay had returned to figuration and thus had separated himself from those he was condemning, although he did not mention his own involvement with these developments. In many respects, he was voicing what had become a widely shared opinion. With the country at risk, art had to stand strong. It could not propagate open-endedness, uncertainty, or lack of clarity, qualities that suddenly were associated with the fractured images of the pre-war avant-garde. Such traits were regarded as being "not French," and to cultivate them would hinder the nation's war effort.

Of course, Picasso himself was not French, nor were his friend and fellow Cubist Juan Gris and Cubism's primary proselytizer Daniel-Henry Kahnweiler. In fact, the movement as a whole, though supported and practiced before 1914 by dozens of French artists and critics, quickly became labeled "foreign" after August of that year, which made it even more suspect and undesirable. In December 1916 an unrepentant and increasingly jingoistic Delaunay again repeated this consensus with chilling conviction: "This stupid painting . . . was made by certain mystifiers who, for the most part, were foreigners to France, but who fooled the world by saying 'made in Paris' . . . I am happy to see that there are men who have not allowed themselves to be invaded by this rot: as I said, which is not French but of which we are now obliged to cleanse Paris – great Paris, which forever renews itself."[229]

While startling, Delaunay's condemnation of pre-war practices was only one of many about-faces that the conflict produced. Picasso's transformation from Cubist and outsider to more restrained Cubist and Frenchman was another, although this initial makeover was also only the first step in an even more striking metamorphosis that the cagey noncombatant performed beginning in 1915. Responding to the calls for a return to fundamentals and French traditions, he started making precisely drawn pencil portraits that were unabashedly based on Jean-Dominique Ingres's famous nineteenth-century prototypes (fig. 55). He also began to produce pictures of classical figures rendered in vaguely academic guises that recalled the heroics of France's Mediterranean heritage and her deep roots in the cultures of Greece and Rome. How far these images are from those that he and Braque had been trumpeting only a few years earlier!

Monet read the same newspapers as his fellow painters. He listened to the same reports, heard the same gossip, felt the same uneasiness, and thus understood the situation as well as anyone else, which is at least one reason why he

felt the all-consuming need to press on with his project. Although his expansive panels filled with diaphanous light and veils of color may originally have been conceived as a decorative scheme for a millionaire collector and although they did not conform to the *retour à l'ordre*, they could not remain so innocent and detached when Europe was being torn apart, especially if artists were expected to make art for the nation and provide symbolic support for their soldiers at the time of the country's greatest need. He admitted as much when he told a friend that he too had thought about the possibility of an armed conflict "for a long time" before it erupted.[230] Thus, when the Germans began to mobilize in late spring 1914, exactly when Monet decided to stretch his canvases for his long-delayed project, he could not have failed to comprehend the magnitude of his undertaking. And when the guns of August sent tremors of terror across France, Monet's project – by the sheer force of history – became something else entirely, altered in scale and meaning in ways that he could not have foreseen in the 1890s but which were now powerfully apparent.

He was therefore understandably energized when he applied paints to his palette in late May 1914 and stepped up to his easel. These canvases would be his ultimate legacy to his nation and to history. This energy sustained him for more than two years, allowing him to press ahead on his pictures as the war raged around him, until he began to panic in late 1916, when Matisse was supposed to visit. Although such anxiety attacks had descended on him throughout his career, this one seems to have been more acute than any before, a natural product of the circumstances.

As the years went by and the war and his project dragged on, he often complained – about the lack of progress he was making, about not being able to finish his work, about his advancing age and fatigue, and about the foolishness of having undertaken such a daunting enterprise in the first place. "Disgusted with what I am doing," he confided to Geffroy in January 1917, "and seeing that I will not achieve my goal, I feel I am at the end of my tether and am no longer good for anything."[231] These laments were intermingled with occasional expressions of optimism about his work and of pleasure about a visitor's positive reactions (such as those of journalist Thiébault-Sisson upon seeing the pictures in early February 1918). But these lighter moments were always overshadowed by his apprehension about the seemingly endless conflict and by his anxiety about its terrible effects on his country, friends, and family.

So, when the government approached him in April 1917 to do a painting of Reims Cathedral, which the Germans had bombed at the beginning of the war, he leaped at the opportunity.[232] Although it meant putting his *Grandes Décorations* aside for a while (which may have

been something of a relief at that point), the offer provided an outlet for the rage and frustration that had been building up in him during these years. Reims's decimated but still-standing cathedral was a proud symbol of France's history and resilience. As such, it was both a more specific and a more poignant wartime motif than his seemingly serene water-lily pond. For some unknown reason, though, the commission was never carried out. After Monet enthusiastically accepted the government's official offer on November 1, 1917, and told Durand-Ruel that he was going to Reims to see the building, he did not mention it again, and no documents have appeared to shed light on the matter.

Nevertheless, the fact that Monet was "flattered and honored" by this commission (as he stated in his acceptance letter) suggests that it would have been a welcome way for him to demonstrate his support for the war effort and his willingness to stand in a leadership position. It may even have boosted his confidence in his *Grandes Décorations*; ten days after Monet mailed his acceptance letter Durand-Ruel came to Giverny with his sons to see the pictures. The visit proved to be important as the dealers took several photographs of the panels in Monet's new studio (figs. 56 and 57). They are the only record of the ensemble at this stage of its evolution. And what they show is an impressive array of approximately twelve carefully arranged panels, most of which measure 2 meters high by 4.25 meters long. They have been set on easels with casters raised a few inches above the floor and temporarily framed, at least at the top, with a modest wood molding. One suite of four panels depicts the pond with two cropped willow trees (fig. 56); a diptych to the right of these canvases concentrates on agapanthus flowers along the edge of the pond (fig. 57); a single panel, tucked behind the suite of willows in figure 57, appears to be another pond picture, perhaps a preliminary iris panel that was eventually dropped from the final scheme.

Some of these paintings appear more finished than others – for example, the willow panels in figure 56, as compared to the agapanthus diptych. The willows also seem more closely related to extant studies, such as catalogue numbers 67 and 68. However, it is equally evident from the many differences between these studies and the larger panels that the former did not serve as cartoons for the latter. It is also apparent that the willow panels were changed considerably before they left the studio for the Orangerie in 1927. The shapes of the trees were altered, as were the number of flowers, the amount of foliage, and the precise location of these elements. The agapanthus diptych experienced even more radical transformations, as is evident when the two panels that appear in figure 57 are compared with their final incarnations (W.1975 and cat. 90). Water lilies were added, shifted, and painted out, agapanthus altered, moved, and then reduced. Many of these

Fig. 56 and 57 Monet's *Grandes Décorations* in the artist's third Giverny studio, photographed by Joseph Durand-Ruel, November 11, 1917, Archives Durand-Ruel.

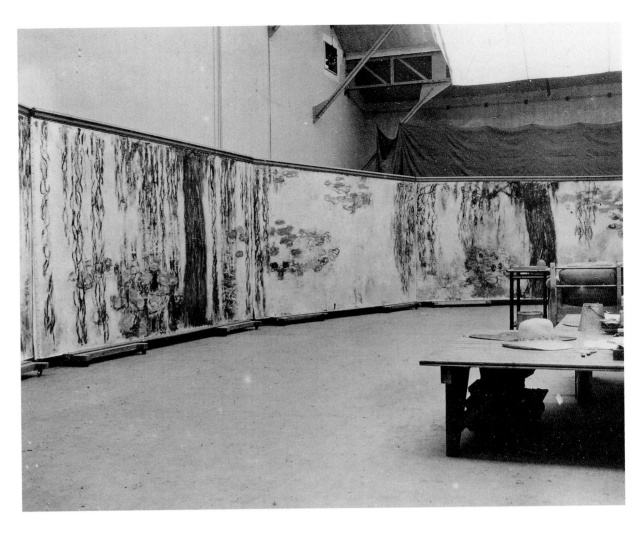

changes may have been precipitated when Monet decided to expand the ensemble by adding another panel, thus turning the diptych into a triptych. Although extensively developed like the Weeping Willow panels, these canvases were not used when the Orangerie was selected.[233]

Despite all of these permutations, the photographs reveal Monet's control of the project. Although one of the *Weeping Willow* panels is in a different location in two of the images, indicating it had been moved around during the Durand-Ruels' visit, Monet knew where he was going with the pictures and how they were to be arranged. And despite their enormous scale, he had made considerable progress. Thiébault-Sisson was justifiably impressed when he came to Giverny in early February 1918 and saw the paintings at an even more advanced stage. So too were the Bernheim-Jeune brothers, who visited in the middle of March.[234]

Whether prompted by conversations with his visitors, by the result of the strides he had made on his project or by his desire to do something in a smaller, more marketable format, Monet suddenly ordered twenty 1 x 2 meter pre-stretched canvases on April 30, 1918.[235] As soon as they were delivered, he began a new group of paintings of his water garden, perhaps *en plein air* at the pond's edge.

Although the long, horizontal format of this new suite owes a debt to his *Grandes Décorations*, the compositions also recall strategies that he had employed in his 1907 paintings. Like those daring earlier pictures, the dozen or more of these newer canvases that he completed over the course of the next sixteen months are dominated by three irregularly shaped areas of light and shadow. These are created by a single vertical band of reflected sky that pushes through the darker sections of mirrored foliage spreading out horizontally on either side. In contrast to the earlier 1907 pictures, the newer canvases have a physical and emotional expansiveness that allow them to breathe in a bolder, fuller fashion, even though each of them depicts a greater number of plants and has a more heavily worked surface.

While very beautiful, these paintings raise some difficult questions: Why were they made? Did they have a specific function, or were they merely a distraction from Monet's primary task at hand? What is particularly curious is the fact that they were not conceived or executed as an ensemble, unlike catalogue number 90, which is compositionally related to *Green Reflections* in the Orangerie (fig. 58), but which is the central panel of the triptych that Monet most likely considered as part of his initial scheme for his *Grandes*

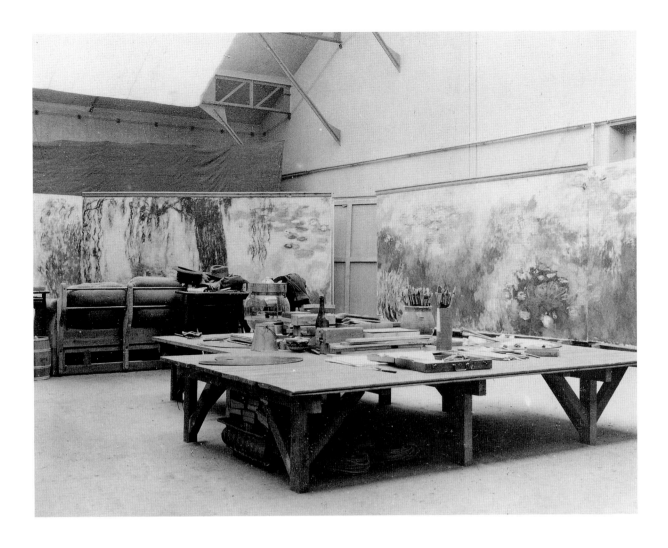

Décorations. One could say that these two-meter canvases served as preparatory studies for larger pictures (for example, W.1983). But it is odd that Monet made so many of them, especially because they are less varied than earlier sketches and because so few of them left Monet's studio until the 1950s.

The problem becomes stranger when we realize that three of the 1 × 2 meter canvases that he ordered in April 1918 were used for equally independent views of his Japanese bridge, a motif that he had not painted in more than ten years. All the elements in these pictures are rendered with keen attention to their physical characteristics, and they occupy a space that is relatively readable. But the paintings are so teeming with life that Monet's brush appears to have been transformed from an instrument to set paint on to the canvas into an ancient divining rod that has led us to a site of some secret pagan ritual. Everything in each picture is moving, rising, falling, stretching, twisting, turning. No section yields to another, no stroke seems subordinate to its mate.

In addition to their unusual density, bravura, and scale, these three two-meter Japanese Bridge paintings are surprising because, unlike all of the Water Lily sketches

he had done, they are independent canvases, not preparatory works or an interrelated group. No one in the late teens in France was making paintings like these. The scenario becomes even more complicated because Monet did not stop with these three panels. Over the course of the next few years, he painted twenty more views of the same Japanese bridge, such as catalogue numbers 77–80. Although reduced to more traditional, easel-size canvases, these paintings may have gained something in the translation, as the paint practically seethes on the smaller surface, with a tumultuousness that often overwhelms the image. To be sure, some of these paintings are unfinished, and all of them, like their larger mates, appear to be independent works. Nineteen of the twenty did not see the light of day until long after Monet's death. But one went to the Bernheim-Jeune brothers (cat. 77), who bought it in November 1919 at the same time as they acquired four finished *Water Lilies*, including figure 49.

This was the first time that Monet had parted with a sizable number of recent works since selling his exhibited Venetian paintings to Bernheim-Jeune *en bloc* in 1912. He had sold only four other late pictures during this seven year

stretch – letting two go in December 1918, and two more in January 1919 (cats. 75 and 82). In format, site, and style, the four represented a marked departure from Monet's activities during the war years, making their sale particularly significant. Instead of a broad expanse of water and reflections, catalogue number 75 presents only a rounded corner of the pool rendered vertically, not horizontally. Instead of a blend of earth and sky with no divide between them, the painting provides a clearly defined terrestrial area that leads logically and gradually on a comforting curve into the background, where the scene is closed off with a screen of densely foliated trees penetrated by streams of warm yellow light. Within this more traditional arena, Monet flexes his painterly muscle, applying his medium in as many ways as there are elements in the view – blotching it, swirling it, layering it, dragging dry brushes across wet pigment, entangling wet strokes in wet strokes, pulling pigment up from the surface in some areas and mushing it down in others. It is as if he were trying out all of the discoveries he had made while working on the *Grandes Décorations* but had not permitted himself the pleasure of including in one particular picture, especially one of such salable size.

In the Weeping Willow paintings, such as catalogue numbers 81–4, he goes even further. There is a recognizable foreground, a curving path into the background, and a wealth of foliage charged by flickering light. But everything here is much more intense than in its companion garden paintings – the contrast of darks and lights, the handling of the paint, the pressure of the image against the surface of the canvas, and the difficulties of reading the forms in the scene.

Most of these challenges derive from the way that Monet has rendered the tree. Twisting and arching like a strained but seasoned performer, the gnarled trunk rises with elegant effort from the bottom of the canvas to the top, changing color continuously as it climbs up through the tightly enclosed space. When it pushes beyond the midway mark, it tilts backward and raises its armlike branches to paw the air to the right. It seems to emit a cry (impossible to tell whether one of horror or of delight) while it shakes its faceless head at the foliage and the light. Its taut and twisting torso, like its thin but assured extensions, seems to be in perfect harmony with the quivering leaves around it. Like an aging parental guardian, or a weathered landscape painter, the tree appears to be both the cause of this confusion and the engaged witness to its effects. Poised between the water and the land, the inside and the outside, it celebrates the energy that enlivens its environment while it frets about the disorder that disrupts it. Like the tree's combination of grandeur and simplicity, the picture thus vacillates between staunchness and alarm, sweetness and sorrow, offering its viewers a quintessentially modern mixture of contradictory sensations.

Fig. 58 *Green Reflections*, 1916–26, Musée de l'Orangerie des Tuileries, Paris.

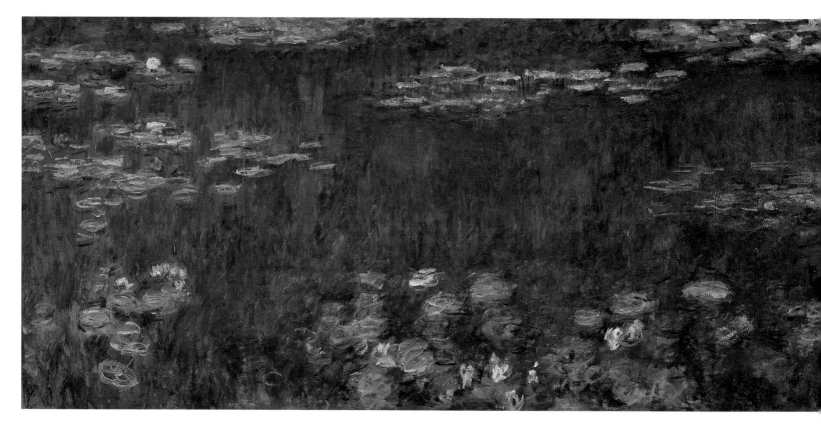

Trees had long been the bearers of deep meaning for Monet, from the Bodmer oak in the Forest of Fontainebleau that he had painted in the 1860s to the poplars of his series paintings in the 1890s.[236] What could be more appropriate than for him to choose the weeping willow. At once noble and mundane, vulnerable and inspiring, it was the ideal metaphor both for the concerned artist during wartime and for France as a whole, particularly in 1918. For when Monet began painting these pictures in late spring/early summer of that year, the war appeared to be tilting in Germany's favor. Fear became the inevitable handmaiden of hope among French citizens, causing most people to believe that the nation would soon fall and that the Germans would march into Paris.[237] "What an unnerving life we are all living," he told Durand-Ruel in mid-June 1918. "I sometimes wonder what I would do if the enemy suddenly attacked. I think that it would be necessary to leave everything like everyone else . . . [but] it would be really difficult."[238] A week later, he had reversed himself. He would stay in Giverny even if it were overrun and declared once again that he would rather die among his pictures than abandon them to the enemy. He even refused to ship his studio contents to the Rouen museum for safekeeping or to Bernheim-Jeune's vault, options that he had recently been offered.[239]

That Monet chose to paint the willow with such searing conviction underlines his belief that he had no alternative but to be completely honest with himself. "I don't have much longer to live," Monet confided to Bernheim-Jeune in early August. And I must dedicate all of my time to painting, with the hope of arriving at something that is good, or that satisfies me, if that is possible."[240] These paintings achieved that level of gratification, thanks as much to historical developments as to Monet's hand and brush. As the heated leaves of summer turned their autumnal colors in the fall of 1918, the tide of the war began to change. The Allies mounted a counteroffensive in September and by early November the Germans had been pushed out of France and Belgium and forced to the peace table. The nation breathed a collective sigh of relief and waited with anxious excitement for the enemy's formal surrender.

So pleased was Monet about this reversal of fortune that he wrote to his old friend Clemenceau on November 12 to express his elation and to offer the nation a token of his esteem. "I am on the verge of finishing two decorative panels that I want to sign on the day of the Victory," he told the recently appointed prime minister (previously the minister of war), "and I am going to ask you to offer them to the State. . . . It's not much, but it is the only way I have of taking part in the victory. I would like these two panels to be placed in the Musée des Arts Décoratifs and would be happy that they were chosen by you."[241]

This patriotic gesture demonstrates how deeply Monet felt about his country and alerts us to how easily those

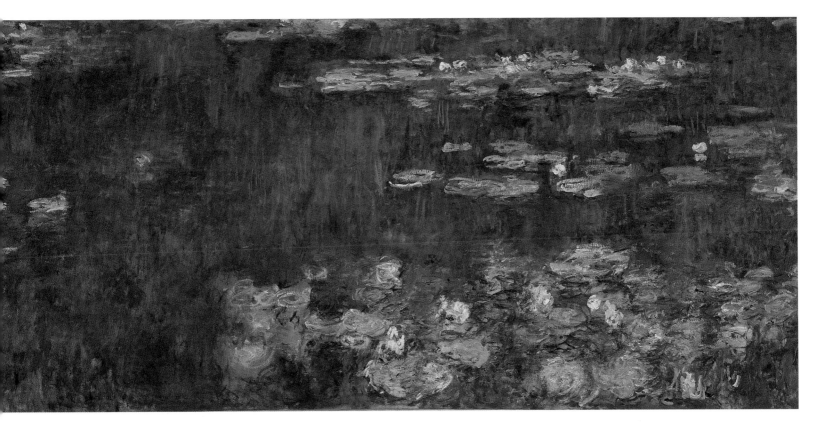

emotions could become embedded in his work. Even two seemingly innocent decorative panels could possess multiple layers of meaning that reached beyond his Giverny studio to embrace the nation and its history. Although these two panels have never been specifically identified, they most likely would have been two of his recent Water Lilies, as he referred to them as "panneaux décoratifs."[242] In addition, they had been the primary focus of his attention, and two of them would have made an appropriate pair. He also had plenty of them to spare. But the final selection was made when Clemenceau, accompanied by Geffroy, came on November 18, just four days after Monet's seventy-ninth birthday. It was Clemenceau's first day off from work in years. Monet could hardly contain his pride when he told the Bernheim-Jeune brothers that he had had the pleasure of hosting the man who had led France to victory and who had deigned to share his first hours of post-war freedom with him at Giverny.[243]

The visit proved to be historic. Monet's initial idea of giving two decorative panels changed when Clemenceau saw the Weeping Willow paintings. The prime minister must have been moved by the latters' power and their compelling combination of torment and triumph, just as he had been swept away by the drama of Le Bloc (fig. 24). So now he chose one Water Lily panel and one Weeping Willow. Monet did not resist the notion. On the contrary, he was happy to inform one of the Bernheim-Jeune brothers a week after the meeting that an agreement had been reached about the gift, although he asked them to keep it under wraps until it became official.[244]

While mutually agreeable, the change in the donation was particularly important to Monet. It not only diversified his gift, but also legitimized his Weeping Willows. Those pictures may well have had a life of their own; the Bernheim-Jeune brothers had made at least tentative inquiries to Monet about them.[245] However, Clemenceau was in a position to raise them to the highest level of critical acclaim and, even more significantly, to make them immediately part of the nation's patrimony. Given their radical facture, compressed space, and jarring juxtapositions, they were not canvases that government officials or museum curators would have rushed to acquire.

Encouraged by Clemenceau's endorsement, Monet decided to sell two other Weeping Willows to the Bernheim-Jeune brothers in December, including catalogue number 82. The dealers quickly made arrangements with Durand-Ruel to take half shares in the pictures. While this may have been a good-faith gesture between them, it was more likely a hedge against the novelty of the canvases and the dealers' difficulty in placing them. It proved to be an astute business decision, as one picture did not sell for seven years, and the other for more than thirty.

The Bernheim-Jeune brothers and Durand-Ruel also jointly purchased the two recent garden pictures that

Monet parted with in January 1919 (W.1879, Musée d'Art, Geneva, and cat. 75). Again, neither firm appears to have been willing or able to have invested in these paintings on their own. Reinforcing their conservative purchasing habits, which they had developed in response to the near-collapse of the art market during the war, was the fact that Monet had not had a solo show since his Venice exhibition of 1912. Indeed, with the exception of just one work – (W.1780), which Monet had offered to Georges Petit for an exhibition to benefit the Fraternity of Artists in 1917 – the Parisian public had not seen any new paintings by the Impressionist patriarch since that Venice show. The dealers were therefore taking a risk. So too was Monet, which is why he had protected his interests and let so few of his recent pictures out. He did not want to compromise his reputation after the critical triumph of his Venetian views, even if he did not hold those pictures in very high esteem. The radical change in his work since then only increased his level of concern.

Monet confirmed this when he wrote the Bernheim-Jeune brothers to find out the opening date for the January 1919 exhibition that the dealers had planned, in which these four recent paintings were scheduled to appear together with several others and a group of sculptures by Rodin. He told them he was not interested in attending the vernissage; he just wanted to know when it was.[246] This was completely out of character for Monet, but so too was the work. However, there is a simple explanation for his inquiry: he wanted to keep his eye out for reviews in the papers.

Oddly enough, the exhibition appears to have attracted no attention, except for a short review of it in La Chronique des arts.[247] This is perplexing, as the Bernheim-Jeune brothers had apparently announced the show for nearly two months and thus must have intended it to be a post-armistice homage to two of the most important figures in French art, one of whom had died two years earlier but who had willed his collection to the nation. Compared to Monet's earlier achievements or to the work of his contemporaries who had embraced a rigorous form of classicism, his new pictures probably seemed abhorrent or bizarre. Moreover, everything about them – their individualism, heightened color, unrestrained brushwork, and emphasis on nature – had been disparaged during the war as anti-modern, anti-productive, and even anarchical.[248] Artists and critics alike asserted that art was supposed to be based on notions of the collective and that the maker's hand had to be suppressed in favor of smoother, more disciplined, and more anonymous surfaces. Drawing was to be imposed on forms, color held in abeyance, compositions ordered by logic. And nature, if adopted as a subject, had to be harnessed to more mechanical ends, not presented in its uncontrollable, "natural" state. Even in 1920, the Cubist André Lhote could condemn Impressionism as

the "religion of instinct . . . [and] the negation of all principles."[249]

Monet could not have overlooked the paradoxes of his predicament. By devising a highly personalized way of expressing a nineteenth-century sensibility with radical twentieth-century means, he was reinventing himself and French painting once again. Under normal circumstances, such ingenuity would have placed him at the forefront of his profession, but these were far from ordinary times. The fickleness of history now caused these novel forms to work against him. Suddenly he was on the periphery if not actually standing alone, left behind by a culture that now mistrusted the ideas on which his art rested while shunning the language in which it spoke.

Monet's solution was simply to do what he always did: stick to his principles and continue to work. At seventy-eight, he felt no need to compromise. Although he was not about to change course, that does not mean that he was unconcerned. In November 1919, when Parisian dealer Maurice Joyant invited him to exhibit his *Grandes Décorations* in Joyant's spacious new gallery, Monet graciously declined: "There is hardly anything more serious than an exhibition at my age, and although friends push me to do it, I am very hesitant."[250] The last surviving Impressionist was not being facetious. Almost a year earlier, when the Bernheim-Jeune brothers wanted to send Félix Fénéon to Giverny to interview Monet for the gallery's publication, he had also turned them down: "without false modesty . . . I have done as a painter what I could and that seems enough to me. I do not want to be compared to the great masters of the past, and, besides, [Fénéon] owns my work; that seems sufficient."[251]

It was surely with this paradox in mind, however, that he decided to finish four of the two-meter Water Lilies and then sold them to the Bernheim-Jeune brothers in November 1919. They were a way to begin to regain some lost ground. Unfortunately, the strategy did not work. The dealers could not place them, and finally cut their losses by selling Durand-Ruel a half interest in all four in January 1921. As a further indication of the problems posed by these works, the Bernheim-Jeune brothers sold their half shares in two of them to Durand-Ruel in 1922. Still, neither dealer was able to place any of the four until 1928, when Bernheim-Jeune sold two of them to the same Swiss collector who had purchased a Weeping Willow and a Corner of the Garden. This failure was a clear indication of how far contemporary taste had changed and thus how difficult it was going to be to develop a following for his late work.

Monet tried two other tactics. First, he gave pictures away – a two-meter Water Lily to Nantes in 1922, and a Corner of the Garden to Grenoble in 1923 (cats. 71 and 74). In the first instance, he had been solicited by a group interested in promoting contemporary art in Nantes, the second by the curator of the Musée des Beaux-Arts in Grenoble, who wanted to have Monet represented in the museum's collection. These were the largest and most serious donations he had ever made, more so than those he had given to patriotic causes during the war, and they left his studio without any preconditions or financial compensation. Monet must have been touched by the requests; he would not have responded so generously otherwise. On a practical level, the timing could not have been better. With dozens of pictures in his studio and plenty of money in the bank, he was in a position to extend himself. In addition, he knew that the two pictures would be seen by a wider audience than he could attract to Giverny. They were thus an ideal way for him to affirm his personal vision for contemporary art. What better way to accomplish that goal than to be invited to do so and to be held up as a model.[252]

His second tactic was closely related to the first. He became determined to find a permanent, public home for his Water Lily project. At the urging of both Clemenceau and Geffroy, he eventually expanded his offer to the State; instead of two paintings, he would donate the dozen decorative panels that he had been working on since 1914. It took nearly a year for details to be reviewed, but on September 27, 1920, in the quiet of his Giverny gardens, Monet came to an unofficial agreement about the gift with Paul Léon, the minister of fine arts, and Raymond Koechlin, the Parisian power-broker/collector, both of whom had come to Giverny to shape the deal at the artist's request.[253]

Monet's gift came with strings attached. In return for the dozen Water Lilies, the State would be obliged to purchase Monet's *Women in the Garden* (Musée d'Orsay, Paris; W. 67), the huge painting of 1866–7 that had been rejected at the Salon of 1867 and had remained in Monet's possession ever since. The price: a staggering 200,000 francs. Monet was extracting his revenge even during a moment of his greatest generosity. The State would also design and build a museum that would conform to Monet's wishes. All parties seemed satisfied.

The following day, September 28, 1920, Léon began the process of building Monet's monument by contacting Louis Bonnier, one of France's leading architects, and offering him the commission. Bonnier readily accepted. However, like any grass-roots initiative that might rise to the highest levels of the country's bureaucracy, this bequest and new museum would go through many metamorphoses and take six and a half years to complete. On the surface, everything initially seemed fine. Approximately two weeks after their informal agreement at Giverny, word of the deal was leaked to the press by Thiébault-Sisson and Arsène Alexandre.[254] Everything depended on parliamentary approval, they cautioned, but this was an exceptional opportunity. One article even claimed that Monet was

donating his house and gardens. While politicians argued about the merits of the donation, the public-relations machine was being appropriately oiled. In the middle of November 1920, two days after Monet's eightieth birthday, a newspaper reported that the painter might be offered the seat on the Académie des Beaux-Arts vacated by the recently deceased Luc-Olivier Merson. The report was true, but Monet turned the offer down, much to the regret of those who were backing his arrangements with the State.[255]

Behind the scenes, things were not so smooth. Problems with the building's design arose almost immediately. Monet envisioned a structure with a single elliptical interior that would be built in the garden of the Hôtel Biron, the grand seventh-arrondissement residence that his compatriot Rodin had donated to the State to house his collection. Aligning two of the greatest artists of the late nineteenth century made eminent sense. However, the elliptical interior did not; it proved to be too costly. A circular design was offered as an alternative. Monet was not pleased, and countered by reducing the number of pictures he would give from twelve to eight. This prompted the Ministry of Fine Arts to back down and offer to renovate an existing building. They suggested the Jeu de Paume and the Orangerie. After visiting both sites in early April 1921, Monet agreed to accept the Orangerie, only to renege on his commitment three weeks later, having decided that the space would be too narrow. Two months after that, in June 1921, he said he would reconsider his position if the building's interior could be converted into two contiguous rooms, which would provide more space and allow for more paintings — eighteen instead of twelve. After further discussions, which lasted until early November, Léon finally accepted the proposal, which had been amended once again to include twenty panels instead of eighteen.[256]

It was decided that the new proposal required a new architect. Bonnier was replaced by the architect for the Louvre, Camille Lefèvre. When Lefèvre's plans were completed on January 20, 1922, the donation had expanded once more — from twenty panels to twenty-two. Less than three months later Monet changed his mind again, dropping the *Agapanthus* diptych for a single panel representing *Sunset* which lowered the total number of paintings to nineteen. On April 12, 1922, Monet and Léon notarized the contract based on this new configuration. It called for Monet to deliver the nineteen panels by April 1924 and the State to invest 600,000 francs in the renovation of the Orangerie. Legislative approval followed on December 4, 1922.

Then the problems really began. Secretly, Monet was not certain he could hold up his end of the bargain, a suspicion he had harbored for some time. In addition to the amount of canvas he was supposed to cover, he was

having difficulty seeing. In 1919 his cataracts had started to bother him again. Clemenceau urged him to consider surgery, a notion Monet fiercely resisted, fearing as before that an operation might permanently impair his vision. Over the next year his condition deteriorated further, and he admitted to Geffroy in the summer of 1920 that he could no longer work outside because of the intensity of the light.[257] In January 1921 a journalist quoted him as saying he saw "less and less . . . I need to avoid lateral light, which darkens my colors. Nevertheless, I always paint at the times of day most propitious for me, as long as my paint tubes and brushes are not mixed up. . . . I will paint almost blind, as Beethoven composed completely deaf."[258] He immediately regretted having granted this interview, and declaring that journalists "have a way of making me talk which is hardly to my taste, and moreover they are inclined to change totally what I tell them."[259] By May 1922 he told Clemenceau that his eyesight was gone, and repeated the same fact soon afterward to a critic, Marc Elder. Clemenceau had little sympathy for his countryman. "The clock will not stop for you," he warned the stubborn painter.[260]

In September Monet finally agreed to consult with a noted Parisian ophthalmologist, Dr. Charles Coutela, who promptly told him what he already knew; he was legally blind in his right eye and had only ten percent vision in his left.[261] Against his better judgment but with very little choice, Monet scheduled surgery for November 18, 1922. Nine days before he was supposed to enter Coutela's Neuilly clinic, he panicked and postponed the operation until January, claiming he had influenza. He was going to try to avoid the problem at all costs.

The new year increased Monet's resolve, and in the second week of January 1923 he underwent the first of what would be a three-step process to remove the cataract in his right eye. The second step occurred at the end of the month, the third in mid-July. Each operation required considerable recuperation time, generally a week or two under professional surveillance. Monet was hardly an ideal patient, and these recovery periods severely tested his tolerance. When he was allowed to return home after the second procedure, he became extremely upset because his sense of color balance was impaired.[262] This was a normal side effect of the operation, which Dr. Coutela tried to correct with special glasses and tinted lenses, but the glasses did not calm the terrified painter, because they did not work immediately. Even as his eyes healed, his color perception changed, which annoyed him further and caused him to try several other sets of glasses. At the end of 1924 he finally settled on a pair made by the Meyrowitz company that seemed to make a difference.

There is little doubt that Monet's eye problems affected the look of his pictures, but not in the ways that are generally believed. His paintings had become progressively

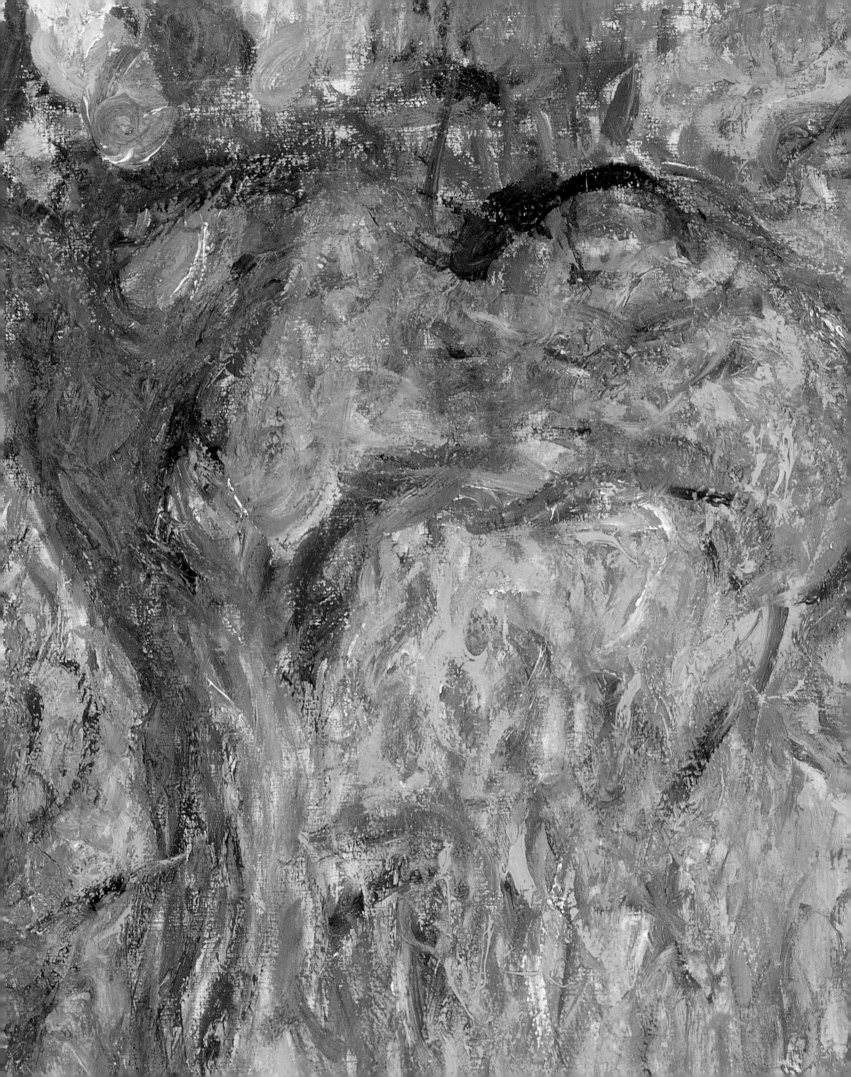

blurry but not because he could not see. If that were the case, he would not have been able to write the more than two hundred and fifty letters that he penned in his distinctive script between January 1919 and the eve of his first cataract operation four years later. More important, he would not have been able to continue to work successfully. In fact, he felt perfectly confidant about touching up older paintings, even ones from the 1880s that were rendered with considerable specificity, and his dealers were happy to purchase these retouched pictures, offering no complaints about their appearance.[263] During these same four years, Monet plugged away on his *Grandes Décorations* and produced many new canvases – the signed and dated two-meter Water Lilies, for example, which are much more finished than the many sketches that he executed at the same time. In fact, the touch in these more finished pictures is not so different from that in several vertical Water Lilies of 1907. If Monet was unable to see clearly enough and was not completely satisfied with the way these new paintings looked, he would never have let them go in front of the public.

The Bernheim-Jeune brothers also purchased one of Monet's Japanese Bridge pictures (cat. 77), the only signed and dated canvas from the twenty-four views of the bridge that he completed between 1919 and 1923.[264] If Monet's eyesight declined during these years, the effects are not apparent in this suite of pictures. Although they show some differences in his handling of paint and considerable change in his palette, the canvases are not less readable. Monet was fully aware of the shifts in color, pointing them out to an occulist, Dr. Jacques Mawas, and a painter-friend, André Barbier, when they came to visit him in Giverny in November 1924. He showed them two pictures, telling them that he painted one before his operation and the another after. According to Barbier, the former had "a curious, rich, sumptuous harmony, but the colors [were] transposed. The second depict[ed] the bridge on a fine summer's day . . . [and] possess[ed] such unity, such freshness, despite nature's constant changes."[265] It is impossible to know which paintings Monet used for this demonstration, and in some ways, it does not make much difference, as the group is divided into two separate subgroups – pictures dominated by strong reds and yellows and those that have a cooler green-and-blue cast. This difference is directly related to the color imbalance that Monet experienced after the cataract operation and is evident in other pictures from these same years – his views of his house from the garden, for example, such as catalogue numbers 86 and 87 where there is a similar disparity between red/orange canvases and green/blue ones.

This was a common side effect of the operation (known as xanthopsia and cyanopsia) that the prescription glasses and tinted lenses eventually corrected. What does not appear to be a problem is Monet's ability to render form.

There are no significant differences between the orange/red or the green/blue subgroups in the way the scenes are described. Nor do the pictures reveal inconsistencies in color. On the contrary, they all maintain unified tonal harmonies, testifying to Monet's careful choice of pigments and his rigorous control over their application. His colors may have been intense, but their value and saturation levels have been held to a uniform pitch.

The same is true of some of the most haunting pictures that Monet produced in these last years of his life, the suite of seven views down his rose-covered path, such as catalogue number 85 . As with the Japanese Bridge paintings and the views of the house from the garden, Monet returned in these pictures to a site of earlier inspiration (cats. 5, 6, and 8), and once again, he rendered the motif with such vivid color and aggressive brushwork that it barely resembles its counterpart in the earlier works. The pathway vacillates between an *allée* and a vortex, at once alluring and dangerous, elegiac and energized. Its converging orthogonals, so reminiscent of Renaissance perspective systems, contrast with the fiery skeins of paint above them, as though the order of the past were juxtaposed with the uncertainty of the present, the urge to conform with the will to change. Standing with his back to his house, Monet allows himself to be consumed by the arching trellises with their tangled foliage rising to the top of the canvas, by the charged groundcover on either side of the path, and by the unexpected flashes of light that pierce the scene, creating dozens of dazzling moments. As with his other late garden views, the level of discourse in these pictures has been raised substantially, but the integrity of the image and the emotional clout of the color have been fiercely maintained as a calculated, calibrated whole.

Thus, what is striking about all of these late garden pictures is not just their obvious distance from earlier work or their evident departure from conventional description. Even more to be admired is the sure touch and consistency that Monet demonstrated in painting them. There are no jarring contrasts that disrupt the scenes, no glaring lapses to make them falter or seem inept. Their radical appearance is deliberate, not accidental. That Durand-Ruel considered all of them "atrocious and violent" is only natural.[266] They were assaults on tradition and defiant counters to contemporary taste, but they were what Monet wanted to paint, whether his dealers wanted to buy them or not.

As poignant reminders of Monet's inventiveness and moving records of his ability to practice his craft in spite of his physical deficiencies, these garden pictures operate on many levels. By their numbers alone – nearly sixty-five – they suggest their centrality to Monet's thinking. Not all of them are carried to the same level of finish, but as a group they required a considerable amount of time to paint, time that Monet perhaps should have devoted to his *Grandes Décorations*.

Monet's procrastination on that project grew, especially after the contract with the State was signed and he was faced with the daunting task of painting almost twice as many pictures as he had initially projected at a time when his eyesight was unreliable. At the outset he was quick to assure friends and officials that he would be able to meet the agreed-upon deadline, even writing to Léon immediately after his first cataract operation in January 1923 to affirm his commitment.[267] Clemenceau and other members of Monet's inner circle soon found that the octogenarian dispensed those assurances too freely, and that as the months elapsed they became harder to fulfill. Not that Monet avoided work. He lost much of 1923 because of his eye problems, but by October of that year his ability to discern color appeared to be restored; and by early November he was back in his studio determined as he told Clemenceau to "finish by the date fixed."[268] He worked feverishly over the next six months to make the April deadline, but it came and went and Monet was not done. Clemenceau negotiated an extension.

Part of the problem was the enormous scale of the project, which tended to overwhelm Monet. He also had to rethink his original program from the twelve panels for the one room of the Hôtel Biron to the twenty-two for the two rooms of the redesigned Orangerie. In addition, his eyes remained fickle. By the summer of 1924, he confessed to Dr. Mawas that he could not see certain colors: "I know these colors exist because I know that on my palette there is red, yellow, a special green, a certain violet; I no longer see them as I once did, and yet I remember exactly what colors they used to make."[269] A new series of glasses only partially solved the problem. In October he told Clemenceau that he was giving up. Clemenceau would have none of it, informing his friend in no uncertain terms that he had better get back to the task: "At your request, a contract was passed between you and France, in which the State has met all of its obligations . . . On your account, the State is obliged to go to great expense, because of what you requested and even approved in person. You must therefore make an end of it, artistically and honorably, for there are no ifs in the commitment that you made."[270]

Despite the ferocity of this rebuke, Monet wrote Léon in late December or early January 1925 to say that the deal was off; he would not be delivering the panels. When Clemenceau learned of this, he exploded: "I don't care how old, how exhausted you are and whether you are an artist or not," he raged to Monet in a letter of January 7, 1925, "you have no right to break your word of honor, especially when it was given to France."[271] Clemenceau threatened to end their friendship if Monet did not reverse his decision, a tactic of intimidation that seemed only to make Monet more depressed. After months of inactivity and hand-wringing, during which time Monet told Barbier,

"It's the end for me in terms of painting," he suddenly experienced a complete turnabout.[272] With the aid of yet another set of glasses, his eyesight, inexplicably, was "totally restored," as he ecstatically told Barbier. "I am working as never before, am satisfied with what I do, and if the new glasses are even better, my only request would be to live to be one hundred."[273]

This veritable "resurrection," as he described his new condition to the Bernheim-Jeune brothers, was almost nothing short of miraculous, especially given the discouragement that he had experienced with his project. He even had to suffer the loss of yet another family member, Marthe Hoschedé Butler, who died in Giverny on May 7, 1925. But with the stamina of someone half his age, he returned to work, confident that he would be able finally to hold up his end of the long-unfulfilled contract. He estimated delivery in the spring of 1926; by February he proudly told Clemenceau the panels would be ready to leave his studio as soon as the paint had dried.[274]

As history would have it, the paintings would not be taken off their easels for another eleven months. According to Clemenceau, Monet could not bring himself to part with them. And neither Clemenceau nor Léon had the heart to enforce what by then was hardly a binding agreement. The panels had become an extension of Monet, inextricably linked to his identity and spirit. He did not prize other works from his hand as highly. During the course of the summer, perhaps knowing his end was near, Monet edited his stock, destroying dozens of works that did not come up to his standards. Monet claimed to have shredded sixty; Blanche Hoschedé thought that number was high. In any case, he was shaping his legacy as he saw fit.[275]

Because the *Grandes Décorations* were going to be his primary contribution to that endowment, he could not let the panels go right away. He could not even permit them to stay in his studio without adjusting them further, this despite having been diagnosed in August of 1926 with an incurable tumor on his lung and an advanced case of pulmonary sclerosis. In September he told Clemenceau that if he did not recover, he "had decided to give them as they are," although he could not help adding the caveat, "at least part of them."[276] Full satisfaction always seemed to escape him. Monet was completely in character, therefore, when he took up his pen on October 4 and wrote the ever-patient Léon what would be the last letter of his life, telling his friend that "I have regained my courage and despite my weakness am back at work," albeit, he admitted, "in very small doses."[277]

Two months later, on December 5, with his beloved gardens bedded down for winter, his son Michel, and his faithful companions Clemenceau and Blanche Hoschedé at his side, the last of the nineteenth-century masters died. His funeral, which was held three days later, was a simple

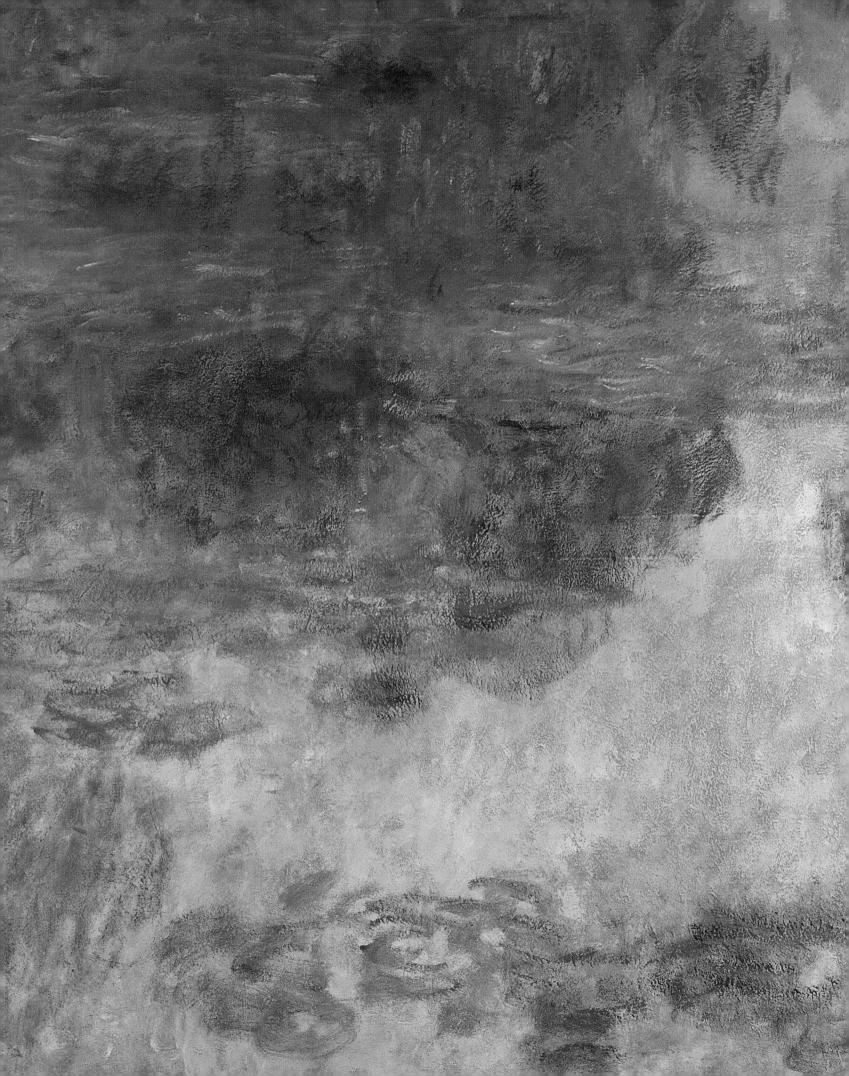

affair, as had been his wish. He was buried in Giverny next to Alice and Ernest Hoschedé, the Hoschedé daughters, Suzanne and Marthe, and Monet's cherished Jean. There were no fanfares or speeches. Attendance had been restricted to some fifty people.

In late December fine-art handlers from Paris came for the great panels. Over the course of the next five months, they took the paintings off their stretchers and adhered them to the walls of the Orangerie, according to Monet's instructions. This was to be a truly permanent installation. The museum was officially opened on May 17, 1927, by Edouard Herriot, minister of public instruction and fine arts with members of the Académie des Beaux-Arts and other dignitaries and politicians in attendance. The event received considerable coverage in the Parisian press. Many of his old supporters – François Thiébault-Sisson, Gustave Kahn, Arsène Alexandre, and Georges Rivière, among others – wrote glowing articles about Monet's dazzling powers and his extraordinary gift to the nation. Clemenceau followed with a book on the Water Lilies that was published in 1928.[278]

But these were mostly older critics who had been raised in the nineteenth century and nurtured on the same ideals as their departed friend, and thus stood some distance from the cutting edge of contemporary art. Those closer to that mark had quite a different opinion of Monet's achievement. As the painter Jacques-Emile Blanche snidely observed, the walls in the museum were too white, the light too harsh, and there were no chairs for visitors. More important, the paintings were "too pretty [and] too genteel." In his opinion, "they could pass for a theater set" or, worse, for "wallpaper."[279] The noted cultural observer Eugenio d'Ors was even more dismissive, declaring that the Water Lilies were "an ephemeral divertissement . . . which one sees without looking, apprehends without thinking, and forgets without regret."[280] The harshest criticism of all came a few years later, when the distinguished art historian of Impressionism Lionello Venturi delivered his verdict that the Orangerie was "Monet's most serious artistic mistake."[281]

To these artists and critics, jaded by the war and searching for security, Monet's paintings were all wrong. They relied on color harmonies and expressive brushwork, rather than rigorously defined compositional structures and carefully controlled decorative patterns. They propagated freedom and experimentation, not focus and restraint. They celebrated the shifting, incalculable world of nature, instead of the disciplined one of rational, rebuilt France. Therefore they could not possibly satisfy the country's deep yearnings for an art that embodied postwar

values. Maurice Denis had confidently articulated those values in 1915 in a book on what the nation should expect in the years after the war: "What are we waiting for, in order that a great epoch may be possible in France?" he asked, "Above all, victory! And then a return to good sense. Revolutionary prejudices, the excesses of individualism, the love of paradox, the fetishism of the unexpected and the original – all the blemishes on our art are also the blemishes on French society."[282]

With their ill-defined forms and independent touches of paint, their unpredictable light and limitless space, Monet's *Grandes Décorations* embraced these paradoxes and uncertainties. In the novel language of the twentieth century, they expressed his quintessentially nineteenth-century sensibility – one that was grounded in the primacy of vision and experience and that reveled in the tentative, the ambiguous, the personal, and the sublime. None of this matched the moment. It would take another quarter century, and the art-world realignments that occurred after the next world war, for the wonder of these paintings to be rediscovered. Appropriately, that occurred through two nearly simultaneous, though unrelated developments: French Surrealist painter André Masson's reappraisal of the Water Lilies in a seminal article on the Orangerie murals in 1952, and the rising demand for Monet's late work by an American public eager to acquire paintings that had remained in his studio until the 1950s.[283] The pairing could not have been more unlikely – one more contradiction to add to Monet's paradoxical legacy. Masson was a highly cultivated, aging painter who had spent his life pursuing the intangible and the esoteric; the Americans were a swaggering group of collectors, institutions, artists, and critics, flush from the victories of the Second World War and their country's triumph on the international art scene with Abstract Expressionism. But Masson knew something about the transmutative powers of painting even if his art was a long way from Monet's Impressionism; similarly, the Americans had a deep appreciation for the value of individualism and a long-standing affection for the beauties of nature.

Suddenly, as if posthumously stage-managed by the patriarch-magician that the artist had become in the twentieth century, Monet's late work emerged in the 1950s as authoritative and visionary. Although it would experience the vicissitudes of the marketplace over the ensuing decades, it would only increase its hold on the collective imagination of an ever-expanding public, a tribute to Monet's deeply human roots and the power of his art to affirm the vitality of the spirit.

facing page Detail of cat. 88.

The notes for this essay begin on page 285

OCEANIC SENSATIONS:
MONET'S *GRANDES DECORATIONS*
AND MURAL PAINTING IN FRANCE FROM 1927 TO 1952

Romy Golan

facing page Detail of cat. 92.

Museum/Mausoleum

Most of us have come to think of the installation of the *Grandes Décorations*, given by Monet to the French State and unveiled to the public in two specially designed rooms at the Musée de l'Orangerie on May 17, 1927 (fig. 59), as the official crowning of Monet's career. This was not exactly the case. Monet's late decorative panels languished half-forgotten from the day of their installation through the 1930s, damaged by water leaking through the vellum skylight and the Allied bombing of the summer of 1944. Not until 1952, a quarter of a century after their installation, did the French State finally begin to restore the Orangerie. Twenty years later, bits of shrapnel were still embedded in the paint on two of the panels, and it was not until July 1978 that the *Grandes Décorations* were shown to the public completely cleaned and restored.[1]

Indeed, one could say that it was the mausoleum side of the phonetic association between "museum" and "mausoleum" noted by Theodor Adorno in his essay "Valéry's Proust Museum" that characterized the initial reception of Monet's last work.[2] The *Décorations* seem to have constituted a kind of "blind spot" in what ought to have been — especially in light of the revival of interest in mural painting in France (and elsewhere) during the 1930s — a congenial context for Monet's mural-size works.

Fig. 59 The *Grandes Décorations* installation at the Musée de l'Orangerie: room 1.

Spectacular as it looks today, the Orangerie installation of twenty-two canvases of what was, in fact, a even larger series of Water Lilies was the result of a compromise between Monet and the State that had a direct impact on the reception of these works. Ground plans reproduced in the literature focus on the two oval rooms and their small oval antechamber.[3] Although these plans show that there was, in fact, direct access to the paintings from the sides at the back (fig. 61) they do not sufficently stress the fact that these rooms — designed by Camille Lefèvre and aligned in an elegant enfilade along the Seine, in a flow that echoes Monet's water reverie — were the back rooms of a building that had a front room of equal length. Extending to the west, this room, the Annexe du Luxembourg, was devoted to temporary exhibitions. Although promised a separate Monet museum in the Hôtel Biron in the early 1920s, Monet was eventually driven into a splendid cul-de-sac. The unpublished correspondence between the artist's increasingly disgruntled family and an unnerving succession of directors, ministers, deputy directors, and deputy ministers in the meanders of French bureaucracy reveals the extent of the neglect of the *Décorations*.[4] While the public streamed to the exhibitions of Old Master works in the front room, only a few curious or melancholy souls ventured to see the decorative panels. As Georges Clemenceau first lamented in 1928, and the Monet family repeatedly complained, there was no indication in the front room that the *Décorations* were exhibited beyond.[5] In 1935 Flemish tapestries were exhibited on moveable partitions placed in front of Monet's paintings, and in a letter sent to the Direction des Beaux-Arts in September 1936, Monet's son feared that this would happen a second time during a Rubens exhibition that was scheduled for later that year.[6]

The Water Lily decorative ponds (fig. 60) have been celebrated since the 1950s as one of the high points in the history of modernism. In 1982, in an article that hinged on two very different readings of "an art of exhibitionality," art historian Rosalind Krauss singled them out as the culmination in the transformation of landscape painting into a compressed, horizonless space, expanded to correspond to the absolute size of the wall:

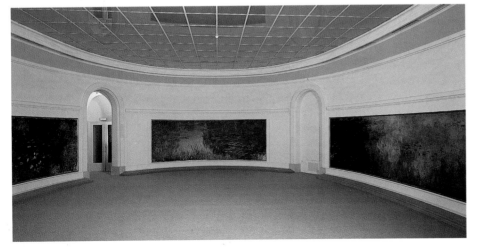

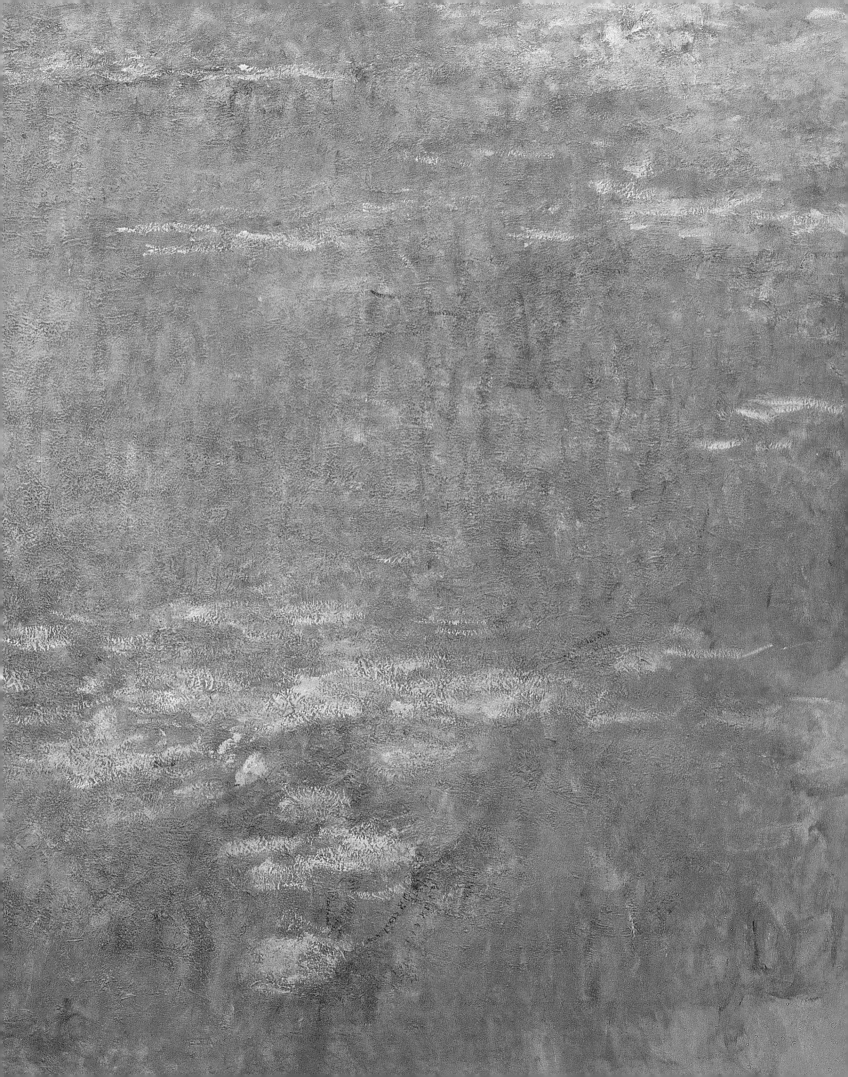

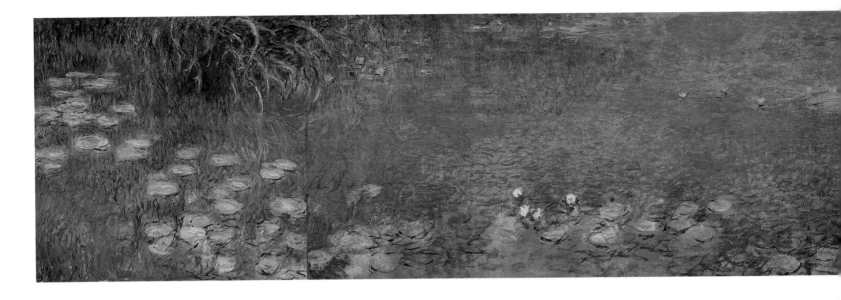

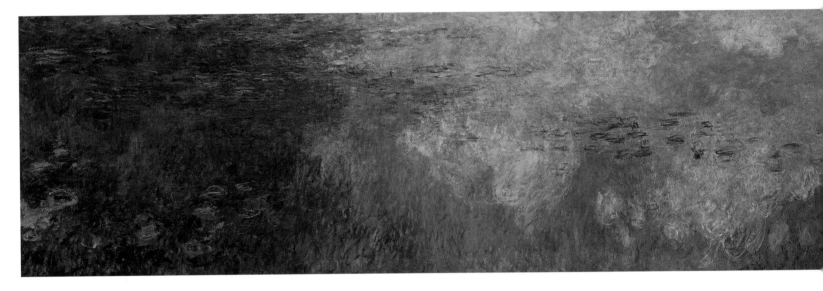

Fig. 60 *Water Lilies: Morning* (top); *Clouds* (above), c.1925, Musée de l'Orangerie des Tuileries, Paris.

The synonymy of landscape and wall (the one as the representation of the other) of Monet's *Water Lilies* is thus an advanced moment in a series of operations in which aesthetic discourse resolves itself around a representation of the very space that grounds it institutionally. This constitution of the work of art as a representation of its own space of exhibition, is in fact what we know as the history of modernism.[7]

This isomorphism between the work of art and its exhibition space fits in a compelling fashion the teleology of modernism according to Clement Greenberg's famous dictate that painting should increasingly express its two-dimensionality – a dictate he had specifically applied to the *Grandes Décorations* in his important essay of 1957, "The Later Monet."[8] It sits much less comfortably, however, with what Walter Benjamin – in one of the most important essays of the interwar years, "The Work of Art in the Age of Mechanical Reproduction" (the second point of reference of Krauss's article) – called "an art of exhibitionality." Writing from Paris in 1936 in great spirits, heartened by the recent victory of Léon Blum's Front Populaire, Benjamin

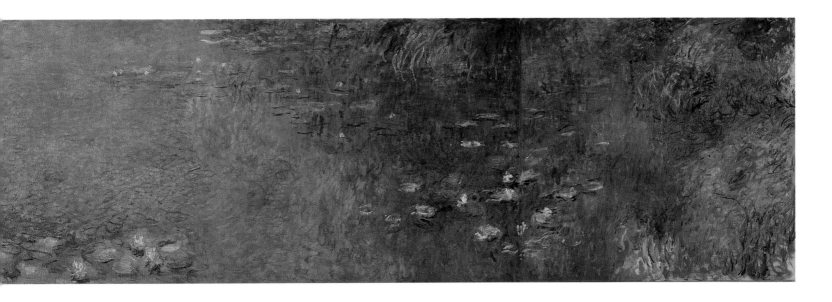

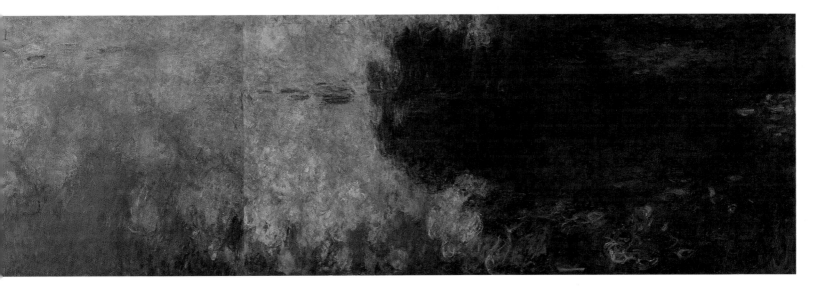

celebrated what he saw as the final erosion of the aura and ritual surrounding the unique, handmade, elitist work of art. He attributed this erosion to the advent of Socialism and the dissemination of photography and film. Far from belonging to what Benjamin defined as "an art of exhibitionality," which he associated with the condition of works designed for mechanical reproduction, the *Décorations*-as-mural resides wholly in the realm of aura. Benjamin described the polarity thus:

> Works of art are received and valued on different planes. Two polar opposites stand out: with one, the accent is on the cult value; with the other, on the exhibition value of the work. Artistic production begins with ceremonial objects destined to serve in a cult. One may assume that what mattered was their existence, not their being on view. The elk potrayed by the man of the Stone Age on the walls of his cave was an instrument of magic. He did expose it to his fellow men, but in the main in was meant for the spirits. Today the cult value would seem to demand that the work of art remain hidden. Certain statues of gods are accessible only to the priest in the cella . . . It is easier to exhibit a portrait bust that can be sent here and there than to exhibit the statue of a divinity that has been fixed in place in the interior of a temple. The same holds for the painting as against the mosaic or fresco that preceded it.[9]

As critics like Pierre Olmer and Alexandre Benoît, among others, did not fail to notice, few spaces in Paris felt more like a temple and, indeed, closer to a cella, than the two back rooms of the Orangerie.[10]

Oceanic Sensations

The question of whether the paintings belonged to the realm of aura or to the rationalism inherited from nine-

teenth-century positivism constituted the major point of dissension between the authors of the two most important books written on the *Grandes Décorations* at the time of their unveiling: Louis Gillet's *Trois variations sur Claude Monet* of 1927 and Georges Clemenceau's *Claude Monet: Les Nymphéas* of 1928.[11] Gillet, the art critic, wanted to push the late decorative panels to the brink of the inchoate and away from Western logocentrism towards Eastern mysticism:

> How shall I attempt to describe the indescribable? Nothing but curves, nothing but ellipses quietly echoed by the pattern of the pavement; naked surfaces without moldings meant solely to support this watery decor. . . Here is perhaps the only great work in Europe whose affinity lies with Chinese thought, with the prayers of the Far East about water, mist, the flow of things, detachment, *Nirvana*, the religion of the Lotus. Let us not complain if one of us, in a drop of water under the sky of the region of the Vexin, swept by the winds and clouds of the Ocean, has rediscovered the great ecstasy of the other side of the world, this secret of forgetfulness and self-effacement of the individual, which is still one of the forms of adoration.[12]

Clemenceau, the statesman, wrote his book out of friendship but also out of civic and didactic duty. Disappointed that no catalogue had been prepared to accompany the installation of the *Décorations* and painfully aware of its desertion by the public, Clemenceau wanted to secure the legacy of works for whose donation he had been largely responsible.[13] Thus, after going through the motions of describing Monet's poetic aspiration to the infinite, Clemenceau shifted gears. He launched into an attempt to reconstruct the rationale of sequential order of the installation of the twenty-two panels supposedly intended – yet never released – by Monet before his death: a thankless task, needless to say. Keeping at bay the loss of visual coordinates produced by the formlessness of the series, Clemenceau desperately looked for a firm grounding, a safe place to stand on, a "repoussoir effect" that he claimed to have found in one of the late decorative panels, which functioned, in his words, as the "witness picture" for the viewer to begin his journey. In a chapter entitled "The Critic Criticized" he then singled out the writings of one critic; Louis Gillet: "A great admirer of Monet" – he acknowledged – "a great prose stylist, but a pitiless metaphysician, who insists that the painter of the *Water Lilies* leads us through flowery roads down to the bottomless depths of non-being."[14] Clemenceau's answer to Gillet's Nirvana was science: the breakdown of atoms and the presence of vibratory waves. To Gillet's words "imaginary," "subjectivity," and "mirage," he counterposed "reality," "objectivity," and "a fully evolved retina." Yet he ended by admitting that "my disagreement with Monsieur Gillet concerns philosophy, not art."

This disagreement about "philosophy, not art" elicited by the *Décorations* can be mapped onto a very similar disagreement between the French writer Romain Rolland and Sigmund Freud in an epistolary exchange that took place at exactly the same time. Its subject was the notion of "oceanic sensation." As Freud relates in the first chapter of *Civilization and its Discontents* (1930),

> I had sent him [Rolland] my small book that treats religion as an illusion [*The Future of an Illusion*, 1927] and he answered that he entirely agreed with my judgement upon religion, but that he was sorry I had not properly appreciated the true source of religious sentiments. This, he says, consists in a particular feeling, which he himself is never without, which he finds confirmed by many others, and which he may suppose is present in millions of people. It is a feeling which he would like to call a sensation of "eternity," a feeling as of something limitless, unbounded – as it were, "oceanic" . . . One may, he thinks, rightly call oneself religious on the ground of this oceanic feeling alone, even if one rejects every belief and every illusion. The views expressed by my friend caused me no small difficulty. I cannot discover this "oceanic" feeling in myself. It is not easy to deal scientifically with feelings.[15]

Rolland, immersed in Hindu philosophy in the late 1920s, embraced this oceanic sensation, as had Gillet in front of the Water Lily decorative panels, and compared it, again like Gillet, to Nirvana, a pantheistic and mystical sensation of self-abnegation and oneness with the universe.[16] This sensation was dismissed by Freud the neurologist/psychoanalyst – as it had been, although mostly implicitly and in less sinister and extreme terms by Clemenceau, the secular and Republican statesman – as an irrational, regressive, crypto-religious manifestation.[17]

In *Trois variations sur Claude Monet* Gillet had described the late decorative panels as blind painting ("une peinture aveugle"), with a palette run amok ("une palette égarée"), as a work painted in agony, groping along in great fear and doubt, by faint eyes filled with darkness and a visual organ in ruins ("l'organe n'était qu'une ruine"). Comparing them to Beethoven's final quartets, composed in total deafness, Gillet used what may well have been a pun on the word mural: "les oreilles murées," walled-in ears.[18] Poetic as these phrases sounded, they proved the most undesirable set of metaphors for a French reader in the 1920s, for reasons of memory, trauma, and history.

Upon entering the *Décorations* rooms at the Orangerie, today's visitor finds a text panel with a statement extracted from a letter written by Monet to Clemenceau on November 12, 1918:

The Water Lilies of Claude Monet constitute the artistic and spiritual testament of the painter. It was on the day of the Armistice, November 11, 1918, that Monet decided to offer France, like a bouquet of flowers he said, the canvases inspired by the garden he had devised at his house in Giverny. According to his will, these rooms were open to the public only in 1927, upon his death.

A generous but untimely gift. In the wake of France's postwar *rappel à l'ordre* (call to order) – a mindset and a whole culture that yearned for the reassuring formal stability and solidity of Neo-classicism[19] – Monet, as the quintessential Impressionist painter, was subject to vitriolic attacks reviving some of the allegations that had first been hurled at him in the 1860s and 1870s. The painter André Lhote began a virtual crusade against the artist. Reviewing a Monet show in 1921 at the Galerie Bernheim-Jeune in the prestigious literary journal *La Nouvelle Revue française*, Lhote, choosing the impeccably composed classical landscapes of Nicolas Poussin as Monet's nemesis, summoned a typical postwar metaphor of bodily mutilation:

> Indifferent to all these landscapes that only begged to be copied to enter the museums for posterity . . . the century's greatest eye and hand, preferring the pond of Giverny, has committed one of the most frightful artistic suicides. Can our times produce nothing else but mutilated geniuses?[20]

Such criticism of the direction in which Monet's late work evolved was compounded by the fact that the unveiling of the *Grandes Décorations* unfortunately coincided with the official celebration of the end of postwar reconstruction in 1927.[21] Doubly dedicated to French victory by Monet, the *Décorations* in fact continued to be inseparably yoked not so much to victory as to the trauma of war. As defined by Freud in the aftermath of the First World War, trauma was characterized by a suspension of narrative, a sense of the

uncanny, temporal delay (a return of the repressed), and unwitting repetition (the double wound) – symptoms that the late decorative panels seemed to enact on all counts.[22]

The year 1927 marked a further loosening of the grip of the *rappel à l'ordre* on French consciousness. The wound of the trenches dramatically resurfaced, ten years after the fact, with the Surrealists' involvement with automatism. Most significant in this respect are André Masson's "sand paintings" of 1926–7, described as "champs de carnage" (fields of carnage) by the poet Georges Limbourg at the time of their first public viewing in 1929 (fig. 62).[23] Masson's entangled and carnivorous configurations of underwater plants and animals made of sand violently spattered with paint were about eternal primordial struggle. By being made out of actual sand, these paintings also stood as the most powerful example of the indexical imprint of the physical trace of the soil of the trench onto the surface of the canvas. In contrast, Monet's Water Lily decorative panels, diaphanous in their pastel colors and smudging of pigment, were about eternal repose, and thus were aligned with Romain Rolland's concept of "oceanic sensation" which was intimately related to the writer's lifelong dedication to pacifism. But Nirvana, when revisited through Freud, also meant death, and so too was death a lingering obsession for Monet while he worked on his Water Lilies.[24] One may thus argue that the mural-size formlessness of the *Grandes Décorations*, the quasi-automatic gestural application of the paint, and the sense of claustrophobia produced by the Orangerie installation, functioned as a particularly uncanny reminder of the extreme *dépaysement* (a poetic term for historical and geographical deterritorialization) of the unprecedented experience of fighting for months on end half-buried in the trenches. The canvases' elongated shape and even their horizontal measurements seemed to echo the actual size of the trench itself (fig. 63).

What we have here is an immense field of color, the most dematerialized image ever painted, turned into a *lieu de mémoire*, a visionary *sight* transformed by history and trauma into a commemorative *site*.[25] What the Viennese art historian Aloïs Riegl would have called an "involuntary

Fig. 62 André Masson, *Battle of Fishes*, 1926–7, The Museum of Modern Art, New York, Purchase.

Fig. 63 Postcard of a trench on the Marne, 1914–15.

monument" in his essay "The Modern Cult of Monuments: Its Character and Origin" (published posthumously at the very time of the unveiling of the Water Lily panels), has been transformed into its opposite: an "intentional commemorative monument."[26]

Monet was right then to be apprehensive, in his long negotiations with the State, about the fate of the Water Lily decorative panels after his death. His stipulation of *marouflage* (a gluing technique used since the nineteenth century to transfer paintings on canvas onto walls) in the contract he signed in April 1922 was partly meant to protect the canvases from moisture damage, and ensure their evenly flat surface. More importantly, however, it functioned as a tacit guarantee that the paintings could not be removed to storage in some museum basement.[27] In fact it ended up ensuring that the paintings would never be moved.

In 1931, four years after Monet's death and the unveiling of the *Grandes Décorations*, a large restrospective of 128 works was held in the Orangerie. It was the only exhibition of his work at a French museum between the two world wars, and as the catalogue introduction by Paul Jamot, senior curator at the Louvre, indicated, Monet's standing had hardly improved. Jamot chose to address the Impressionist "problem" head-on. He granted that young artists could be forgiven their indifference to and even scornful condemnation of Impressionism, since they had to be allowed to look at the past in search of whatever stimulated their imagination, but he held that the duty of the critic was to understand the succession of antagonistic artistic doctrines as a generational phenomenon. The excesses produced by Impressionism, its dissolving subtleties, the exaggerated predominance of the sensory over the intelligible, had sooner or later to provoke a reaction in favor of principles of solidity, order, and composition.[28]

In this context, the matter-of-fact, even indifferent tone of Jamot's telegraphic account of Monet's last years acted almost as a confirmation of the inevitability of Monet's lingering irrelevance: "He was a leader in his youth. To be able to lead others means to have in oneself the principle of solitude. He ended his life as an artist, as a loner, mute patriarch of painting in the immense universe of his garden of Giverny."

The exhibition drew remarkably few reviews, and their authors were even fiercer than Lhote had been in 1921. While nothing in the catalogue indicated that the *Décorations* were given pride of place in the exhibition, in spite of the fact that it was held at the Orangerie, it was these works that provoked the most disparaging comments. Calling the *Décorations* a true catastrophy, a huge mistake at the end of Monet's oeuvre, the critic Alexandre Benoît wrote:

How empty this work is, what a misunderstanding this strange and truly pitiful crowning of Monet's career. What kind of vanity seduced him into this sort of monumental decoration when the man had no talent for this kind of work? What an irony that France, which has at times lightheartedly allowed the greatest masterpieces of this illustrious son to be plundered, should have erected for his weakest works, and the vastest, an entire temple that more than anything resembles the first-class cabin of an ocean-liner.[29]

What felt – in deflationary order – like an oceanic sensation to Gillet and the cabin of an ocean-liner to Benoît, became likened to plain nausea (or seasickness) by the critic Albert Flament. Commenting most memorably on the "affect" of the Orangerie as a space rather than on the "effect" of the Water Lily decorative panels as paintings, he ended with a metaphor that returned to the First World War:

Claude Monet is at home in the old Orangerie where two rooms, which look more like crypts, are occupied by the decorations he worked on during the last years of his life. These two rooms, probably conceived by Monet himself, are as featureless as possible, their ceilings way too low, the lighting too diffuse. I tried a number of times to linger to hear the harmonies intended by the old master of Giverny. A migraine hit me almost instantaneously, my sight became blurred. My only desire was to escape. One needs architectural features for a room one intends to decorate. By architecture I mean solids and voids, doors, windows . . . The canvases do not reach high enough. One feels as if a tray were sitting on one's head. It is quite amazing how they have managed to transform a ground floor into what feels like a basement, a cave, a war bunker. The real Monet is not to be found here, in this, alas, permanent space at the Orangerie![30]

Mural Effects in 1937

For all France's discomfort with this unwanted gift, the late decorative panels were not exactly forgotten in the later 1930s. A long letter dated May 10, 1937, and addressed to Blanche Monet-Hoschedé (the artist's step-daughter) from Henri Verne, the Directeur des Musées Nationaux, indicates that the State made a major attempt to pull these works out of what Verne called "their splendid isolation."[31] Arguing that neither Monet nor Clemenceau would have refused to consider his proposition if they had been alive, Verne urged the Monet family to allow the *Grandes Décorations* to be removed and placed in the pristine, light-filled rooms of the new Musée d'Art Moderne,

Fig. 64 Exterior of the Musée d'Art Moderne (now the Musée d'Art Moderne de la Ville de Paris), Avenue du Président Wilson, Paris.

part of the large Trocadéro complex being inaugurated at the 1937 Paris World's Fair (fig. 64).[32] Given three rooms where the panels would be installed almost exactly as in the Orangerie, Verne wrote, this masterpiece by the great artist would be placed in the midst of all the art movements that either derived from it or reacted against it. Alternatively, Verne proposed, one could wait for the paintings' entry into the Louvre, where a new arrangement of the French Schools was planned for the wing then occupied by the Ministry of Finance.[33] Verne pleaded for the first solution, part of a seven-museum project on the Trocadéro hill. There the public would stream to see the *Décorations* without having to pay an extra admission fee, and visitors would draw a lesson about modernity that would be the ideal homage to Monet. Both museums would be open in the evenings for all to see, Verne added, noting one of the great populist policies of the Popular Front.

The response of the Monet family, sent three days later on May 13, 1937, was highly defensive, and negative. They saw this proposal as yet another affront to the master, a betrayal of his wish in the contractual stipulation with the State, and yet another excuse on the part of government officials to do nothing to improve the condition of the *Grandes Décorations* where they were. In short, they wrote, "the Water Lilies should not leave the rooms of the Orangerie, where they should remain *forever*." It was thus the obstinacy of Monet's family that appears to have prevented the late decorative panels from being secured as a fountainhead in the master narrative of modernism, thereby averting the fate of similar canvases acquired in 1955 by the Museum of Modern Art in New York.

More interesting perhaps, is the fact that this proposed relocation might have placed the late decorative panels at the crux of one of the main debates of the 1930s, and one of the major concerns of the organizers of the 1937 World's Fair: the revival of mural painting.[34] In response to

the misgivings about modernity kindled by the Great Depression, the 1930s were marked by a sharp critique of the fragmentation, nomadism, and commodification of easel painting. This condition came to be perceived by both the political Left and Right as a symptom of the alienation and anomie of modernity under capitalism. Concomitant with this critique was the constant call, after 1930, for the need to "re-humanize" the nakedness of modern architecture, and revise Adolf Loos's famous ban on decoration in "Ornament and Crime" of 1908. Painting should be given "a home", it should retrieve the social function murals were believed to have had in Antiquity and the Middle Ages, and – in rhetoric echoing that of the New Deal and the Works Programme Administration in the United States – it should provide work for the scores of unemployed artists who were victims of the economic crisis. The need to reintegrate painting, sculpture, and architecture was debated at the International Congress of Modern Architecture (C.I.A.M.) of 1933, and it became the dominant theme of the Convegno Volta held in Rome in 1936 – the two most important international meetings of architects during the 1930s.

In France this debate involved both nostalgics, such as Gustave-Louis Jaumes, and modernists such as Fernand Léger, Amédée Ozenfant, the Delaunays, and Félix Aublet (fig. 65). Oddly enough, yet typical of the ideological confusion of the 1930s, the rhetoric of the two camps at times sounded almost the same. While Ozenfant kept an even-handed tone in his entry, "La Peinture murale: divorce de l'architecture et de la peinture," for the new *Encyclopédie française* of 1935,[35] the critic Louis Chéronnet launched into an amazingly angry and inflamed plea in his article "Au pied du mur," published in the review *Europe* in 1936. A champion of Léger and an enthusiast of advertising and large street billboards, Chéronnet used the pathological language of cultural degeneration that tends to be associated with the rantings of the Right in the 1930s. He hailed

Fig. 65 Félix Aublet and Robert Delaunay, mural for the façade of the Railway Pavilion, Paris World's Fair, 1937, Musée National d'Art Moderne, Paris.

the mural as "the only cure for the sickness of contemporary art . . . [an art that] has become a monstrous tumor, an accident detached from all obligation, from all spiritual or social contingency, a gratuitous creation, a commodity made to satisfy individual needs."[36]

Similarly, in his "Discours aux architectes" at C.I.A.M in 1933 and in a lecture entitled "Le Mur, l'architecte, le peintre," delivered in Zurich later that year, Léger launched into a surprisingly bitter attack – considering his reputation as an arch-modernist – against recent architecture: "The modern architect has gone too far in his magnificent attempt to cleanse through emptiness. [Modern architecture has become] a modern Minotaur, drunk with light and clarity . . . The average man is lost in front of large dead surfaces."[37] For Léger this critique went hand-in-hand with a repeated attack against the triumph of the individualism of easel painting in the Italian Renaissance. Assuming a nationalistic stance Léger claimed – along with the medieval historian Henri Focillon in books such as Peinture romane des églises de France of 1938 – that it was the French Romanesque that had been home to the best mural art, and it was the collective experience of the great cathedrals that he wanted to retrieve. So fully was Léger identified with this cause that one contemporary review compared mural-size works similar to his Le Transport des Forces (fig. 66) – executed for the main staircase of the Palais de la Découverte at the 1937 – both in terms of their ocher grounds, dark reds, and ultramarine blues, and their busy story-telling – albeit in abstract form – to twelfh-century murals.[38] Even Le Corbusier, whose identity was intrinsically tied to the whitewashed aesthetic of high modernist architecture, was repeatedly attracted in the 1930s to the possibility of a painted architecture (fig. 67). Invited to speak at the Volta Congress in 1936 he knew who his interlocutors might be in Fascist Rome.[39] He thus chose to adopt a much more Loosian tone than he otherwise might have:

> The smell that emanates from the writings, speeches, and endless discussions over here is one of incense burned in certain chapels, a smell of resurrection of sacred art, of plagiarism of dead art, like the inevitable fresco . . . What we need are painters retooled for modern architecture. Polychrome murals that will dynamite the wall.[40]

The months leading up to the 1937 Fair saw a veritable flurry of editorials and articles in the art columns of such daily and weekly papers as Beaux-arts, Comoedia, Marianne, and L'Intransigeant demanding mural commissions from artists.[41] In his review of the fair, "La Renaissance de la fresque et du décor," published in the most popular French illustrated weekly L'Illustration, the critic Jean Gallotti declared himself satisfied.[42] Rightfully so, as 345 works had been commissioned from 464 artists for the exhibition.[43] It is quite ironic in this respect, unless we are to understand it as an apotropaic gesture, that Walter Benjamin chose to announce the final erosion of the aura of the work of art in 1936, precisely at the moment when aura was making a major comeback in the form of the mural.[44]

Yet, in all of this commotion about murals, not a single word was uttered about the Water Lily decorative panels in the years 1936–7. This silence is somewhat baffling, for even though they remained in situ at the Orangerie, the Monet rooms stood as a prime example of a modern mural installation. Moreover, as their medium (oil) had seeped deep into the wall itself since their marouflage (which would have made their relocation a most delicate undertaking), the panels were as close to the real thing – fresco – as anything produced in France during the 1930s. For despite all the rhetoric about muralism, virtually none of the works being discussed at the time was a true mural; most were large easel paintings painted in a studio, taken off their frames, and subsequently affixed rather than glued to the wall. Raoul Dufy's 600-square-meter La Fée Electricité (fig. 68), an immense curved painting meant to revive the visual wonder and didactic purpose of the nineteenth-century panorama,[45] and one of the great hits of the 1937 fair, had been painted in a hangar outside Paris. Its 250 panels of canvas on plywood were painted with a

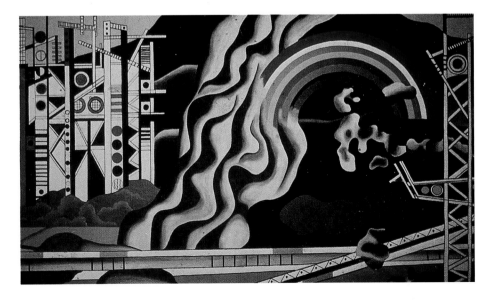

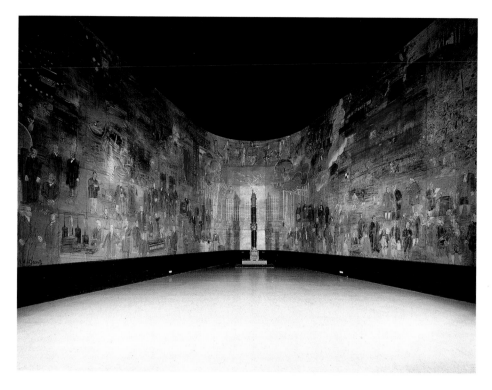

della Triennale in Milan, then almost immediately packed off to the Italian pavilion at the 1937 Paris fair (fig. 70). It survives today in the Palazzo delle Comunicazioni in Milan.[48] To all intents and purposes therefore, these murals were, like easel paintings, contingent, nomadic (a concept that would become crucial in the late 1940s and 1950s.) Nevertheless, whether figurative or abstract in style these works managed to convey a "mural effect" that evoked the monumentality and stability of architecture, an effect that was precisely what the evanescent late decorative panels so utterly "failed" to deliver.

An Inversion of Signs

These very "shortcomings" of the Water Lily decorative panels – their ethereal quality, their transient effects, the fact that they were painted by a staggering giant struggling alone against blindness and death in his studio at Giverny in the midst of the First World War (fig. 72) – all of which had made the *Grandes Décorations* so unpalatable to the French throughout the interwar years – was what made them so attuned to the new pathos of the aftermath of the Second World War. An inversion of signs took place in 1945. After the war a concerted attempt was made in both Europe and the United States to rid murals of some of the ideological overtones they had acquired in the 1930s. It was essential that painting be epic and remain mural size, but it was also crucial that it should convey a sense of lonely, existential struggle. It was, moreover, imperative to convey a feeling of impermanence in order to dispel any distasteful association with an art that had been so often – most memorably in Italy – produced in the service of political regimes that aspired to last into the next millennium.

Abstract Expressionist painting of the New York School did just that. Jackson Pollock's great walls of painterly accident were created in the most spectacular fashion on everything the wall was not – in other words the floor – in

Fig. 69 Copy of a French medieval fresco, c.1936. Musée des Arts et Monuments Français, Paris.

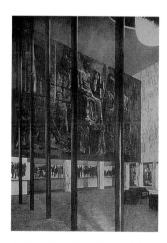

Fig. 70 Mario Sironi, *Fascist Labor* installed in the Italian Pavilion at the Paris World's Fair, 1937.

varnish-gum lacquer and mounted side by side in the Electricity Pavilion as a background to four huge generators. After the fair closed, the painting was dismantled and went into storage until it was reinstalled in 1964 in the Musée de la Ville de Paris.[46] Even the murals executed for the permanent buildings at the time of the exhibition – works such as Gustave-Louis Jaulmes's forty-meter-long neo-Pompeian painting of mythological scenes for the Grand Foyer of the new Théatre du Trocadéro, were painted on a series of canvases affixed to the wall. Those murals, intended to simulate the wear and tear of time, were made in pieces: the reproductions of French medieval frescoes that filled a new second floor of the Musée des Arts et Monuments Français – refurbished for the Fair in 1937 – were executed in a chemical (washable) paint called Stick B, devised to simulate centuries-old patina on thin slices of fibro-cement and subsequently affixed to the museum wall (fig. 69).[47] Mario Sironi's huge mosaic of 1936–7 entitled *Fascist Labor* seemed the most obdurate mural of all (fig. 71). It was intended to celebrate the grandeur of Rome in the the year that Italy declared itself an empire. The work of a truly melancholy modernist, its state of pseudo-ruination with gold tesserae mixed with browns and ochers and an irregular, bashed surface, was also a reminder of the historical wisdom to be drawn from the rise and fall of empires. Yet it too was made of separate panels of a cement base, ninety-six of them, each one square meter in size, set with hundreds of stones, glass, and enamel pieces, ready to be installed, transported, and relocated at will. Upon completion it was shown in the Palazzo

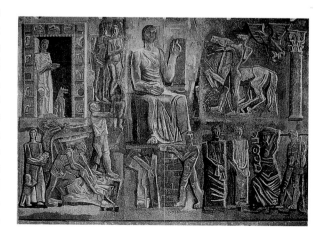

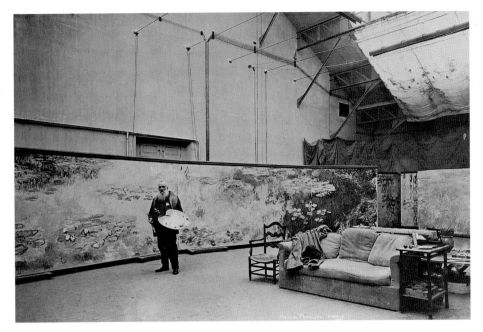

much photographed isolation in the studio (fig. 73). Tellingly enough, after completing his first truly large canvas, entitled *Mural*, for Peggy Guggenheim's New York apartment in 1943, Pollock, or whoever gave titles to his paintings, switched to more poetic titles, such as *Sea Change, Out of the Web, Lavender Mist*, and *Autumn Rhythm* (fig. 80).[49]

It is through the lens of Abstract Expressionism that the Water Lily panels resurfaced as a "revelation." It took the Americans, however, rather than the French, to experience it. In France, files in the Archives du Louvre reveal yet another period of intense correspondence from the summer of 1949 to the fall of 1952 between the Monet-Hoschedés and an ever-more bureaucratized Fourth Republic.[50] Flexing their muscle, Monet's heirs appealed once again to the government to bring an end to the "lamentable" state of the Water Lily decorative panels' disrepair, the "disgusting" condition of the vellum over the glass ceiling that blocked natural light, and to the continuing lack of explanatory wall texts in the front room of the Orangerie. Indeed, one of the two rooms was being used on a regular basis as a storage area for other works of art, a state of affairs the Monet-Hoschedés deemed "all the more inadmissible" in view of the fact that special funds had recently been allocated for the maintenance of national museums. Such appeals were seconded by Paul Schommer and Georges Salles, both Directeurs des Musées de France, in letters to two different architects – M. Haffner, Architecte en Chef of the Louvre and Tuileries, and M. Bocage, Architecte Chef d'Agence – urging the immediate accomplishment of what had been promised for years. Meanwhile, as Paul Facchetti, who gave Jackson

Pollock his first solo show in Paris in 1952 recalled in an interview years later:

> For us [the French] it [the discovery of Abstract Expressionism] was an extraordinary adventure: we discovered a painting triumphant with the freedom of color and rhythm. There was a great impulse given by Pollock. The American painters, on the other hand, those who came to Paris after the war with their famous G.I. Bills, they were impressed by European culture, and they all rushed like flies to one place: the Orangerie, to look at the *Nymphéas* by Monet, those colored rhythms with no beginning or end.[51]

And so it was in 1952, in what was to become a customary scene of delayed reaction *vis-à-vis* Americans, that the ex-Surrealist André Masson – the man who had already unwittingly crossed paths with Monet with his "sand paintings" in 1927 (fig. 62), but who had also, significantly enough, spent the war years in exile in New York meeting some of the future Abstract Expressionists – wrote "Monet le fondateur," an essay as elated as it was belated:

> One could dream of a Monet turning towards the use of large canvases, clear and iridescent, the preserve of Veronese, of Tiepolo. Do not dream any more; consider his supreme work, the *Nymphéas*. Despite their monumental dimensions, they do not have the characteristics of grand Venetian or Flemish decoration. His disposition of spirit appears to me to be that of a great easel painter who decides to yield to his vision a field vast enough – imposing enough – so that it embraces the world. A cosmic vision, shall I say, if this word had not been diverted

Fig. 74 Georges Mathieu, *Les Capétiens partout*, 1954, Musée National d'Art Moderne, Paris.

Fig. 76 (*below right*) Le Corbusier, *Unesco* tapestry, 1956 (designed in 1952). Winterthur Insurances, Swizerland.

Fig. 75 Jean Lurçat, *Apocalypse: The Lady and the Dragon*, Notre-Dame de Toute Grace, Assy. 1950.

in these last years and uttered in relation to everything and everyone . . . A deserted site in the heart of Paris, a consecration of the inaccessible. One of the peaks of French genius.[52]

It was also in 1952 that Le Corbusier, still in search of "mural effects," began to promote what he called the *Muralnomad* (fig. 76):

Modern tapestry is no longer out of fashion. It is and will be the mural of the *nomad*. The painted mural one rolls under one's arm. We are all nomads, living in rented apartments and in future *Unités d'Habitation*.[53]

In fact, the most interesting response to the mural question in postwar France was perhaps not *peinture informelle* and the enormous canvases of Georges Mathieu – which despite looking like an homage to Monet were largely intended to upstage Pollock (fig. 74) – but modern tapestry. As was well understood by its two main champions, the painter and tapestry maker Jean Lurçat, and Jean Cassou, the new and influential director of the Musée National d'Art Moderne in Paris, tapestry could best resolve the ideological double-bind of the "mural effect" after the Second World War. It was crucial to its revival that tapestry retrieve the mural function it had had in the Middle Ages and not continue to try to imitate painting as it had done since the triumph of easel painting in the Italian Renaissance (fig. 75).[54] Yet it was also crucial that it spell out its contingency. In a rhetoric typical of the postwar years – that of the "Family of Man" – feudal lords were likened to desert tribesmen, in their peripatetic existence

and their use of tapestries as portable decoration. Thus the critic Germain Bazin stated in *La Tapisserie française: muraille de laine* in 1946:

Originating in the Orient, imported to the West by Byzantium and then by the Crusades, favored by nomads in the Middle East, tapestries were used as wall hangings by the medieval lords who moved them around like a tent from castle to castle . . . The few mural paintings that have come down to us [in France] from distant times were nothing but *ersatz* versions of tapestries.[55]

Not only were tapestries no longer described as simulacra of easel painting, but it was medieval wall painting that now came to be seen as an imitation of mural tapestry.

One is reminded of the review written by Albert Flament, the critic who had spoken of seasickness as he lingered in the Water Lily rooms at the time of the Monet retrospective at the Orangerie in 1931:

What we have here is a series of enlarged easel paintings lined up side by side rather than a real decoration. Monet's decoration seems to have been commissioned by a nomad to be unfolded at night on the movable partition of the tent where he would sleep. This is a "batik" by a painter of immense talent.[56]

Nomadism, which in the 1930s stood for the debased, exilic, and diasporic condition of modern man and of easel painting, had now, in the critical discourse of the 1950s, become a synonym for human survival. Thus, through a transvaluation of signs over the course of a quarter century the *Grandes Décorations* emerged almost intact, as fresh as they were at the time of Monet's death.

The notes for this essay begin on page 290.

THE MONET REVIVAL
AND NEW YORK SCHOOL ABSTRACTION

Michael Leja

In the late 1950s a wave of interest in Monet's paintings surged in New York and swelled east across the Atlantic and west to Los Angeles. As museum exhibitions of his work appeared throughout the United States – the first in thirty years[1] – and as the art press, newspapers, and mass-circulation magazines substantially increased their attention to his work, commentators routinely marveled at the speed and size of the surge they found themselves sustaining. With surprising unanimity they traced its origins to 1955 or so and understood it as a brilliant rediscovery in which artists, critics, collectors, and curators collaborated. Yet this commentary was permeated by the anxiety that artworld opinion was becoming faddish and that a cadre of influential individuals – "the taste bureaucracy" – might be shaping dominant trends.

The Monet revival of the late 1950s is significant for three reasons. First, it engineered a reinterpretation of Monet's art, giving it new historical importance and contemporary relevance, thereby motivating further exhibition and critical attention. The Monet phenomenon of today, with museums and art publishers dependent upon the seemingly inexhaustible ability of his work (and Impressionism at large) to generate large audiences and revenues, springs from this moment. Second, it illuminates some of the mechanisms by which artistic reputations are shaped and reshaped. The Monet revival was so precipitous and so distinct, and provoked so much contemporary analysis, that it stands as an especially clear illustration of the dynamic interrelations of agents and institutions in a rapidly expanding and increasingly powerful artworld centered in New York. Third, the Monet revival was enmeshed in both the making and the critical assessment of contemporary American paintings. It participated both in the devising of formal analyses and modernist genealogies for Abstract Expressionism and in the development of new departures from this increasingly academic mode.

How was it, first of all, that Monet needed to be rediscovered? His art had long held a strong market and audience in the United States, and although he may not have commanded frequent solo exhibitions at major museums, he was regularly included in shows of Impressionism and French modern art. The slump in his reputation was primarily an effect of the lack of interest within the small but influential contingent of avant-garde artists and their supporters. Between the world wars American modernists generally followed their European counterparts in seeing Monet as "a dead issue," as one painter put it.[2] His reputation suffered from the challenges to his work posed by more radical figures, such as Paul Cézanne, Henri Matisse, and Marcel Duchamp. For these artists and their promoters, formlessness and naturalism defined Monet's art and stood as the antitheses of their own commitments to structure, pure form, or the critique of art. Likewise, the consensus among American modernists was that Monet's place in the history of avant-garde art was that of "a vaporizer of form, a doctrinaire whose contribution Cézanne had to make 'solid' and Van Gogh, passionate."[3] Such assessments became codified into clichés that survived well into the 1950s despite sporadic efforts to dismantle them.[4] But in the mid-1950s the partisans of avant-gardism changed their minds about Monet, and authorities who had formerly been dismissive became enthusiastic admirers.

This collective change of mind entailed a revaluation of Monet's early and late styles, which helped to keep the reversal from seeming frivolous or from resembling middlebrow taste (which in general had remained more sympathetic to Monet's art).[5] In the older view, the paintings considered most significant were his earlier ones, in which illusionism and pictorial structure were loosened but not jeopardized. His late work, by contrast, was disdained as wildly excessive in its amorphousness. In 1953 *Time* magazine admired the "Flemish reticence" of Monet's early paintings and lamented the changes that made his later work "fanatical" and "dated."[6] All but a few of Monet's paintings acquired by American museums in the decade following the Second World War were done before 1882.[7] The new view of Monet inverted this hierarchy; not only did the late work come to seem Monet's most significant, but the very latest and most difficult of the late work became the most prized. The paintings of Monet's last years, from 1914 to 1926, particularly the most abstract of the Water Lilies, were now seen as the culmination of his career.

Before the 1950s most of these paintings were considered little more than leftovers from the Orangerie mural project: sketches, unfinished or inferior efforts, or outright

Fig. 77 Claude Monet, *Water Lilies* (W.1982), destroyed: formerly collection of the Museum of Modern Art, New York.

failures. Most remained in Monet's studio at his death, unsigned and undated.[8] Monet himself had not wanted to exhibit or sell them, and the artist's heir, his son Michel, allowed them to sit in the Giverny studio for nearly thirty years until interest among collectors and dealers indicated that they might have some value. In 1949 some were included in an Impressionist exhibition at the Basel Kunsthalle. Walter Chrysler, Jr., one of the preeminent collectors of modern French art in the United States, may have been the first to purchase one of the mural-size works.[9] Taken to the Giverny studio in 1950 by Parisian art dealer Katia Granoff, Chrysler bought from Michel Monet one of the most beautiful of the large, late Water Lily paintings (W.1983, now in the Carnegie Institute, Pittsburgh). In 1952–3, museums in Zurich, Paris, and The Hague collaborated on a large Monet exhibition which included some of the murals. The Zurich version of the exhibition contained a large number of Water Lilies, four of which were purchased by collector Emil Bührle, including a large diptych (cat. 88) and a single panel which he donated to the Zurich Kunsthaus.[10] By far the most influential and highly publicized early purchase came in the spring of 1955, when the Museum of Modern Art in New York bought a mural-sized work directly from Michel Monet (fig. 77). The acquisition was initiated by Alfred Barr, MoMA's director of Museum Collections and founding director, who had learned from Chrysler and John Rewald, author of a history of Impressionism published in 1946, that many late paintings were available at the studio.[11] MoMA's purchase was seen at the time as "bold and canny," and it was to be critically important to the Monet revival.[12]

Sometime following the MoMA purchase, Granoff acquired a cache of the late works from the Giverny studio, some of which she exhibited at her Paris gallery in the summer of 1956. *Time* magazine announced that the show set off "a regular goldrush" – it quoted one American buyer as saying "the prices seemed to go up 1,000,000 francs a week" – yet many works remained unsold. Fourteen were sent to the Knoedler Gallery in New York and were exhibited the following October with other late Monets. The American market was eager. By the end of 1956 all but one were sold to prominent collectors and museums, with the largest commanding prices around

$55,000, more than four times what Chrysler had paid in 1950.[13] Only a year and a half earlier Knoedler had dismissed as "insufficiently interesting" a suggestion that it organize a Monet exhibition.[14] By 1957 *Arts* magazine's report on national trends in museum acquisitions highlighted the large number of Monet's works, especially later ones, and a month later MoMA boasted that it had recently acquired three more important paintings from "Monet's wonderful last decade."[15] A nascent market for late works led to the release of a new supply of extreme and questionable paintings, which fanned the flames of the revival, making Monet seem all the more radical and modern to his new admirers.

These discerning and adventurous buyers were not generally credited with *initiating* the Monet revival, however. That role went to artists. *Time* magazine named French surrealist André Masson as the one responsible for "starting the bandwagon" rolling by writing in the French journal *Verve* in 1952 that the Orangerie was the "Sistine Chapel of Impressionism."[16] Masson's short essay "Monet le fondateur" asserted that Monet's *Grandes Décorations* were his supreme works, and it expressed the hope that young French artists would discover Monet and the new beginnings his work offered. American critics and journalists generally agreed that Masson's essay was influential, and they cited his aphorism about the Orangerie repeatedly, but they believed American painters were already well ahead of their French counterparts in building upon Monet's late work. What had really provoked the Monet revival was not Masson's words but the paintings of the Abstract Expressionists – Jackson Pollock, Clyfford Still, Willem de Kooning, Barnett Newman, Mark Rothko, and some of their associates – who had educated the vision of contemporary viewers to recognize the achievement of Monet's late work. Similarities between the late Water Lilies and recent New York School paintings were widely acknowledged as the stimulus for the reinterpretation and new appreciation of Monet's work. No matter that Monet himself may have failed to understand some of his late paintings and may have thought them unfinished works, studies, or failures. As critic Clement Greenberg put it in 1956, "even Monet's own taste had not caught up with his art . . . That he himself could not consciously recognize or accept 'abstractness' – the qualities of the medium alone – as a principle of consistency makes no difference: it is there, plain to see in the paintings of his old age." When Greenberg noted that "recently, some of the late Monets began to assume a unity and power they had never had before," he explained this as an effect of the lessons recently learned from the paintings of the Abstract Expressionists.[17] Critic Thomas Hess concurred:

In the past decade paintings by such artists as Pollock, Rothko, Still, Reinhardt, Tobey, and writings by such

artists as André Masson and Barnett Newman have made us see in Monet's huge late pictures and in the smaller, wilder sketches he made for them a purity of image and concept of pictorial space that we now can recognize as greatly daring poetry.[18]

Barr and his MoMA colleagues certainly had Abstract Expressionism in mind when they purchased the *Water Lilies* panel in 1955. Barr did not go to Giverny to choose the painting himself but left the task to Dorothy Miller, curator of collections at MoMA, and James Thrall Soby, chairman of the Museum Collections Committee. Miller wrote to Barr from Paris describing the painting they had selected: "I think it is simply beautiful and wonderfully suited to our purpose. It is more freely and spontaneously brushed than several of the others which have an embossed leathery surface from being worked over and loaded with paint, and are peeling off in parts."[19] That MoMA was especially interested in a broadly brushed example is one indication of where the museum planned to situate late Monet in its history of modern art. Barr affirmed the link to Abstract Expressionism at every stage of the acquisition process: in his initial proposal to the committee overseeing MoMA's acquisitions, in the press release announcing the first exhibition of the painting, and in the wall label accompanying the painting in the gallery. In all of these documents Barr cited the work's relevance to subsequent expressionist abstraction, particularly to the work of Kandinsky (who "founded the tradition which flourishes today under the name of abstract expressionism") and to "the young abstract painters of our mid-century." Both the press release and the wall label named Monet's late style "abstract impressionism," appropriating a term recently coined in the reviews of new paintings by some younger New York School artists.[20]

MoMA's new painting was widely celebrated in the national media during the next few years. It was reproduced in color in *Life*, *Time*, and *Art News*, and in black and white in numerous other magazines and newspapers.[21] Barr wrote to Mrs. Simon Guggenheim, who had provided the funds for the purchase, that he was "a little surprised but very pleased to know that the Monet has been one of the most generally and enthusiastically admired paintings we have acquired in many years."[22] The painting helped to stimulate magazine and newspaper articles which told and retold the story of Monet's once-scorned late work, done in near blindness and declining strength, finally rediscovered thanks to recent paintings by his young modernist descendants. This engaging narrative – the latest variation on a theme familiar in the history of art – together with the sensuous beauty of the paintings helped to build a considerable American audience for Monet's work. When MoMA's new *Water Lilies* was destroyed in a fire at the museum in 1958, less than three years after its arrival,

another round of reproductions of the painting appeared in the *New York Times*, *Newsweek*, *Life* (which published "before" and "after" photographs of the canvas), and in news publications across the country.[23] By this time the painting had achieved extraordinary celebrity, and the museum received many sympathetic letters from individuals nationwide who were grieved by its destruction.[24] The museum acted quickly to replace it and did so several times over; in 1959 it purchased two large Water Lilies, a triptych (W.1972–4) and a large single panel (cat. 92). By then, these panels were in short supply, since numerous American museums and collectors had followed MoMA's lead. Having lost its prized early selection, MoMA acquired panels less ideally suited to its purposes – less gestural paintings with "leathery" surfaces that, moreover, required extensive restoration work.[25]

Ironically, the leading figures among the Abstract Expressionists had never associated themselves with Monet or consciously looked to him for pictorial ideas. His work went virtually unmentioned in the statements through which the New York painters claimed descent from various Cubists, abstractionists, and Surrealists. The only one of them to write about Monet was Newman, and his discussions were unpublished and equivocal at best. When Hess linked Newman's writings with Masson's in the passage quoted above, he must have had in mind letters the artist wrote in 1953 and 1957 to William A. M. Burden, president of the Museum of Modern Art. In these letters, which Newman may well have distributed to Hess and other editors of leading art magazines and newspapers in hopes they would be published or quoted, he used the museum's recent Monet acquisitions to needle MoMA and call attention to omissions and partiality in its account of the history of modern art. He wondered whether the museum's belated recognition of Impressionism represented "an attempt to avoid the charge of faulty scholarship or whether it marks a true change in the policy that has denied to the American people the experience of art as an act of the spirit." The later letter explained that Newman had no special investment in Monet: "I did not then nor do I now wish to supplant Cézanne with Monet or with anyone else in the promulgation of any theory of art or in a struggle over art influences. I have been concerned only that a healthier, fuller picture should emerge concerning French nineteenth-century painting." Newman's earlier letter understandably had been interpreted by Barr as a statement of admiration for Monet's paintings; Barr wrote in the reply to Newman he drafted for Burden, "We are glad to know that you admire Monet's art." Whatever his intentions, then, Newman's letter may have contributed to the Monet revival, if he was among the artists Barr had in mind when he justified MoMA's 1955 mural purchase as a response to the new interest among younger painters in Monet's late work.[26]

As other writings by Newman make clear, Monet and Impressionism represented much that the New York School artists opposed. In an earlier unpublished essay entitled "The Problem of Subject Matter," Newman criticized the Impressionists for their "monist aesthetic" and for their inability to see that drawing and subject matter, not just color, were also problems facing modern painting.[27] Despite such substantial conflicts, the received wisdom by the late 1960s was that Newman's writings had helped to generate the Monet revival.[28]

The case for the relevance of late Monet to Abstract Expressionism rested primarily upon similarities of form, scale, and style, and here critics, art historians, and curators had a crucial part to play. The verdict was not unanimous – some critics objected that the much remarked resemblances between late Monet and Abstract Expressionism were superficial.[29] Two individuals were influential in articulating powerful arguments for the connection, remaking Monet into a precursor of abstract art: Clement Greenberg, arguably the most influential critic in the United States at the time, and William Seitz, a young art historian, curator, and painter then teaching at Princeton.

In the summer of 1954 Greenberg made his first trip to

Fig. 78 Barnett Newman, *Concord*, 1949, The Metropolitan Museum of Art, New York, George A. Hearn Fund, 1968.

Europe in fifteen years. During his time in Paris he must have visited the Orangerie and studied Monet's *Grandes Décorations* because shortly after his return to New York his analysis of Abstract Expressionism took a decisive turn. In two important essays – "'American-Type' Painting," published in the spring of 1955 and addressing the art of the leading figures in the New York avant-garde, and "The Later Monet," published in December 1956 and presented by *Art News* as "the first extensive American study" of Monet's art – Greenberg adjusted his influential analysis of Abstract Expressionism in light of what he saw as the distinctive and relevant features of Monet's late work. In his view, Monet's late paintings were the most radical and consistent realization of Impressionism's most revolutionary insight: "that values – the contrasts and gradations of dark and light – were indispensible neither to the representation of Nature nor to the integrity of pictorial art."[30] Monet's art suppressed values and in doing so broke with European traditions of using contrasts of dark and light to create the illusion of three-dimensionality and to structure a composition. According to Greenberg, Monet's "close-valued" Water Lilies flattened the image and limited its illusionism in order to enhance the appreciation of formal qualities and to purify the means of painting. When Monet introduced flowers and lily pads as strong accents of hue to vitalize and focus the laterally expanded pictorial field, he sacrificed his commitment to the careful balance of painted surface and illusionistic depth in favor of the surface as the site of unity and concentration in the work. In other words, considerations of form replaced nature as the source of pictorial values in painting.

Greenberg's Monet was a solver of pictorial problems. His late work offered modern painting another path to flatness and purity; it presented a kind of pictorial structure, which he termed "chromatic and symphonic," an alternative to the "architectonic" variety developed in Cubism and early abstraction. Monet's late work was a rich resource in modern art history mined only recently in the art of Still and Newman (fig. 78), who pursued chromatic pictorial structures. Greenberg's new appreciation of this achievement led him to elevate these artists to the top of his hierarchy, replacing Pollock at the pinnacle. Formerly, Greenberg had valued most highly those artists he saw advancing Cubist strategies for organizing a picture.

Greenberg's analysis was disputable both as an account of modern art history and as a description of the paintings in question, but its authority in the late 1950s and early 1960s was unmatched. Part of his project was to establish a rich and complex paternity for the New York School artists within the heroic, European avant-garde. Monet's late work became further evidence (along with the art of Picasso, Miró, and others) that the New York artists were the legitimate descendants and worthy successors of the great French modernists.

William Seitz's account of Monet's significance differed substantially from Greenberg's. For one thing, he gave more emphasis to Symbolist elements in the late work – to their "mysterious and enveloping" qualities, and to "their darkening quietness and extension, which is both tranquil and ominous."[31] Seitz too believed Monet's achievement was fully appreciated only in light of recent New York School painting, but he wished to bring Monet into the history of abstraction much earlier, as an important but unacknowledged influence on Kandinsky and Mondrian. In 1956 he argued that Kandinsky's encounter with Monet's *Grainstacks* (in Moscow in 1896; see fig. 6) "was the pivotal event which impelled him toward a purely abstract, musical art."[32] Moreover, the "fluctuating planar structure" of Monet's paintings of poplars, his façades of Rouen Cathedral, and his views of Venice were crucial sources for Mondrian as he developed his own pulsating grids departing from grainstacks, façades, and trees in the second decade of the century.[33]

Seitz was not as explicit as Greenberg in drawing significant parallels between Monet and the Abstract Expressionists, although his art-historical work in the mid-1950s concentrated on these two subjects. In his dissertation on Abstract Expressionism, completed in 1955 for Princeton with Barr serving as his adviser, he invoked Monet numerous times but to minor effect.[34] (As Seitz was also a painter, he may have been one of the younger artists interested in Monet to whom Barr referred, if his passion for Monet was communicated to Barr early enough in their conversations, which began in 1950.) Upon completing his work on the Abstract Expressionists, Seitz turned his attention immediately to Monet; by the fall of 1955 he was preparing a presentation on "Monet and Abstract Painting" for the annual meeting of the College Art Association. The paper was subsequently published, but not before the *New York Times* outlined Seitz's argument for its readers, noting the wide interest his paper had attracted.[35] Seitz went on to compose an essay for the catalogue of the 1957 Monet exhibition in Saint Louis and Minneapolis, and MoMA commissioned him to curate its grand Monet exhibition – the culminating event of the Monet revival – which opened in 1960 and traveled to the Los Angeles County Museum of Art. In addition to the catalogue for this exhibition, Seitz wrote a book on Monet, also published in 1960.

Seitz may have made his strongest statements about the relation between Monet and New York School painting through the Monet exhibition he curated. His judgments of individual works and of significant tendencies in Monet's oeuvre were colored by his interest in Abstract Expressionism. Like Barr and Miller, Seitz held strong beliefs about Monet's significance for art history, beliefs that affected his assessments of individual paintings and of styles and tendencies in Monet's oeuvre. In his catalogue essay he warned viewers that his selection of works for the

MoMA exhibition *Claude Monet: Seasons and Moments* might appear "bizarre" to some of them, but in his defense he noted "that each generation discovers its own values, and that standards of artistic worth have never remained static."[36]

In the historical position attributed to Monet's art by Seitz on behalf of MoMA, spirituality played a crucial and multifaceted role. Monet was a naturalist, but one for whom "nature had always appeared mysterious, infinite, and unpredictable as well as visible and lawful. He was concerned with 'unknown' as well as apparent realities."[37] An "instinctive pantheist," Monet's "belief in a nonmaterial reality constituted an essential stage in a development from the physicalist theory of Courbet toward the metaphysical naturalism which motivated the early paintings of Mondrian and Kandinsky, and which is so much alive at the present moment." Seitz presented Monet as an artist who was "pushing naturalism to its bursting point," which came in his late work, when he "re-formed nature according to inner anguish and the distorted vision that he resented, to produce his only truly expressionistic works."[38] In this view, Monet was a crucial bridge in the history of modern art, connecting Courbet and Kandinsky, materialism and spiritualism, naturalism and abstraction. Moreover, the spirituality of Monet's communion with nature pointed back to the writings of Ralph Waldo Emerson and Henry David Thoreau as surely as the artist's nearly abstract paintings pointed ahead to Pollock and Newman. Consequently, Monet assumed a form familiar to American audiences. Furthermore, Seitz's Monet resonated better with the spiritual and psychological interests of the Abstract Expressionists – better than did Greenberg's – and answered Newman's critique of Impressionism's "monism."[39]

If Abstract Expressionism facilitated certain interpretations of Monet's late work, the Water Lilies also affected attitudes toward New York abstraction. Before the later 1950s MoMA's support of the Abstract Expressionists was less than enthusiastic; the museum's interest seems to have grown during the Monet revival, and this timing may be more than coincidence. The different but powerful explanations articulated by Seitz and Greenberg concerning Monet's place in the history of modernist abstraction may have facilitated an understanding of the Abstract Expressionist artists among MoMA's curators.[40]

At least one reviewer felt that Seitz's interpretation of Monet's significance motivated a selection of works that distorted the artist's career, making it essentially a progression toward Abstract Expressionism. Artist Larry Rivers criticized the MoMA exhibition for

[reducing] Monet by its emphasis and its ideology . . . [Seitz] makes of Monet a weather bureau . . . [there are] no major figure paintings or still-lifes. What we are given

the razor edge where vision mediates between the world out there and the inner experience of the mind, sensibilities and emotions. As a nature poet, Monet's psychic state was more determined by the weather than by any other influence."[43] The dynamic relation between nature and psyche perceived in Monet's painting marks another important link to Abstract Expressionism.

Critics too were representing Monet in ways that magnified his relation to Abstract Expressionism. Some described his forms using language permeated by the critical vocabulary developing in relation to New York School painters. For example, Thomas Hess wrote of Monet's late paintings as "a web of hues . . . the handwriting loops and swirls, pushes down aggressive oblique hatchings."[44] An inattentive reader might take the subject of such writing to be Pollock. By 1959 a popular new book on modern painting, *Mainstreams of Modern Art* by *New York Times* art critic John Canaday, codified the new view of Monet – "Monet's landscapes and the late semi-abstract paintings into which they merged are his historically important work" – and presented Monet as "a bridge between the naturalism of early impressionist painting and a contemporary school of extreme abstraction."[45] The book juxtaposed a reproduction of MoMA's recently destroyed *Water Lilies* with Pollock's *Autumn Rhythm* (fig. 80) and proposed "Abstract Impressionism" as "an appropriate term to describe Pollock's sparkling interweaving of dots, splashes, and ropelike lines of color." The book became a popular textbook for college courses on modern art in the 1960s and 1970s and introduced more than one generation of students to the work of Monet and Pollock.

is a controlled and severe arrangement by subject and place that makes Monet very modern and very weather-bent. A painter with no prior idea of the outcome, only sure he wants to paint something – all very "New York School."[41]

Seitz's exhibition (fig. 79) included photographs he had taken of the locations where Monet had painted.[42] These inclusions heightened the exhibition's emphasis on nature as Monet's subject, not to portray him as weather-obsessed, but rather to highlight the processes by which nature was transformed into transcendental abstraction. Rivers's point about the exhibition being very New York School rings truer if we connect it with one of Seitz's arguments about Monet: "[some of his paintings] tremble on

That Monet's late paintings suddenly seemed to bear an obvious resemblance to works by the premier Abstract

Fig. 80 Jackson Pollock, *Autumn Rhythm (Number 30)*, 1950, The Metropolitan Museum of Art, New York, George A. Hearn Fund, 1957.

Fig. 81 Philip Guston, *Painting*, 1954, The Museum of Modern Art, New York, Philip Johnson Fund.

Fig. 82 Joan Mitchell, *Painting*, 1953, Collection Walker Art Center, Minneapolis, Gift of the T.B. Walker Foundation, 1956.

Expressionists in the mid-1950s may have been due in part to the mediation of several younger, lesser known New York School artists. Between 1952 and 1955, before Greenberg, Seitz, and others began to articulate connections between Monet and Abstract Expressionism, reference to Impressionism was becoming a distinctive feature of the paintings of some emerging New York artists devising new variations on Abstract Expressionist forms. Philip Guston (fig. 81), Joan Mitchell (fig. 82), Sam Francis (fig. 83), Nell Blaine (fig. 84), Miriam Schapiro, Wolf Kahn, Hyde Solomon, and others were taking gesture painting in directions marked by evocation of natural forms, flickering color, patterned brushwork, and/or a calmer, meditative mood. The work of these artists varied significantly, but it generally distinguished itself from first-generation Abstract Expressionism through fragmented pictorial fields with smaller, more discrete and often more regularized brushstrokes, and suggestions of representational elements, especially landscape forms. Reviews of their work frequently noted that in their paintings lessons drawn from Monet, Renoir, Sisley, and Pissarro were being assimilated to abstraction and Expressionism. Impressionism in the broader sense was the point of reference in this art and in the criticism it elicited, not Monet's late paintings *per se*, which drew no special attention. Introducing Impressionism into Abstract Expressionist modes helped to generate and focus debates about purity or allusion in abstraction, inner- or outer-directed art, public or private reference, and originality or "confiscation" of past styles. Impressionism offered these artists a way to revitalize Abstract Expressionist painting and to distinguish themselves within that movement's growing ranks. By spring 1955, when MoMA was selecting its first Water Lilies panel and Greenberg's "'American-Type' Painting" was just appearing, painter and critic Elaine de Kooning was noting that these "Abstract-Impressionists . . . outnumber Abstract-Expressionists two to one, but, curiously, are seldom mentioned."[46]

Soon there would be no lack of attention to these artists, as the tendency they represented joined forces with the late-Monet revival.[47] In 1956 painter Louis Finkelstein published an article titled "New Look: Abstract-Impressionism," which defined this movement and related it to a "kind of vision" he associated with Impressionism: a vision "concerned with the qualities of perception of light, space, and air."[48] Abstract Impressionism marked a significant shift in direction in New York School painting, according to Finkelstein. Whereas first-generation Abstract Expressionism was concerned primarily with concepts and feelings — with psychology, the technical resources of art making, science, inner experience, vehement emotion, formal invention, and so on — Abstract Impressionism aimed to reemphasize the visual experience of the world as a subject for painting. It also insisted upon the compatibility of abstract and representational modes. Finkelstein asserted, *contra* Greenberg, that evoking natural forms and exploiting illusions of depth did not compromise a painting's significance. Abstract Impressionism was clearly antagonistic toward the prevailing Abstract Expressionist "academy" and toward Greenberg's assessment of the challenges facing modern painting, as well as toward the stark polarization of abstraction and representation basic to his argument. Greenberg by then was recognized as the leading spokesman for the first-generation artists, so his theories were an obvious target for emerging avant-gardists, but some of the arguments identified with him were accepted as premises by the younger artists. As represented by Finkelstein, the Abstract Impressionists shared with Greenberg and his followers the belief that

advanced painting was essentially optical, that is, that it resisted suggestions of tactility or any other kind of non-visual perception in its evocation of form and space. Their disagreement centered on what true opticality was.

Moreover, Abstract Impressionism presented itself not as refusing established polarities but as embracing currently disfavored sides of some familiar conflicts in Western art history: it preferred color over line, percept over concept, optical art over haptic, contemplative over athletic process, space over surface, reality over unreality, nature over culture. Finkelstein concluded by wondering whether "our general visual sensibilities [have] become so flabby through looking at television and living in ugly apartments" that any appeal to visual sensation seemed incomprehensible?[49]

Finkelstein's closing remark aligned Abstract Impressionism with traditionalism and high culture, and to some observers such conservatism was the movement's shortcoming from the beginning. For these commentators, it not only marked a retreat to less radical artistic terrain – a *juste milieu* modernism – but it even came to seem analogous to Eisenhower Republicanism. As Abstract Expressionism entered a period of malaise and academicism in the later 1950s, William Rubin noted that

> we are now *en passage*, as it were, regrouping and waiting for the maturation of the second generation ... Since 1950 there has been a détente, a relaxation, which has an analogue in the spirit of conservatism that has pervaded American political and economic thought and that is symbolized by the Eisenhower administration ... I have sensed in the last few years a trend away from the dynamic Abstract-Expressionism of painters like Pollock and de Kooning towards a more passive, detached, and meditative art of sensations, such as that of Rothko and Guston.[50]

Rubin's opposition of a passive art of sensation to active gestural painting invokes clichés of gender identity, which aligns his essay with contemporary calls for a recovery of masculinity as a remedy for the malaise of American culture.[51]

The front ranks of the Abstract Impressionists contained many more women than did Abstract Expressionism, and reasons why the former offered women easier entrance into the avant-garde are not hard to imagine. When juxtaposed to Cubist discipline and structure, Impressionism acquired a feminine valence, even when it was associated with the work of Pollock and de Kooning. Patrick Heron, the English artist and critic reviewing MoMA's exhibition *Modern Art in the United States*, then at the Tate Gallery, London, wrote that de Kooning's color was "all ladylike, gossamer, pastel tints! Very beautiful, very delicate, very rich in a muted way. But surprisingly feminine and impressionist, with white in all his charming pinky-green mixtures ... Similarly, Pollock's Number 1, 1948 is as silvery-white-gray as a Monet of snow."[52]

The question of Abstract Impressionism's politics is complex, as Rubin's judgment begins to suggest. The aesthetic conservatism of this art seems to have helped it

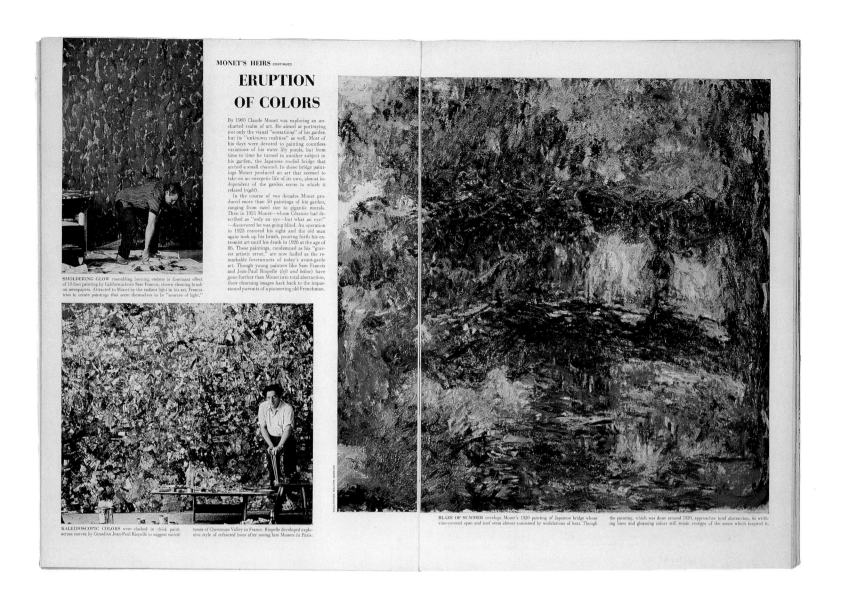

Fig. 85 *Life*, "Old Master's Modern Heirs," December 2, 1957, pp. 98 and 99.

Within the image:

MONET'S HEIRS CONTINUED

ERUPTION OF COLORS

By 1900 Claude Monet was exploring an uncharted realm of art. He aimed at portraying not only the visual "sensations" of his garden but its "unknown realities" as well. Most of his days were devoted to painting countless variations of his water lily ponds, but from time to time he turned to another subject in his garden, the Japanese roofed bridge that arched a small channel. In these bridge paintings Monet produced an art that seemed to take on an energetic life of its own, almost independent of the garden scene to which it related (*right*).

In the course of two decades Monet produced more than 50 paintings of his garden, ranging from easel size to gigantic murals. Then in 1921 Monet—whom Cézanne had described as "only an eye—but what an eye!"—discovered he was going blind. An operation in 1923 restored his sight and the old man again took up his brush, pouring forth his extremist art until his death in 1926 at the age of 86. These paintings, condemned as his "gravest artistic error," are now hailed as the remarkable forerunners of today's avant-garde art. Though young painters like Sam Francis and Jean-Paul Riopelle (*left and below*) have gone further than Monet into total abstraction, their churning images hark back to the impassioned pursuits of a pioneering old Frenchman.

SMOLDERING GLOW resembling burning embers is dominant effect of 10-foot painting by Canadian-born Sam Francis, shown cleaning brush on newspapers. Attracted to Monet by the radiant light in his art, Francis tries to create paintings that seem themselves to be "sources of light."

KALEIDOSCOPIC COLORS were slashed in thick paint across canvas by Canadian Jean-Paul Riopelle to suggest varied tones of Chevreuse Valley in France. Riopelle developed explosive style of refracted hues after seeing late Monets in Paris.

BLAZE OF SUMMER envelops Monet's 1920 painting of Japanese bridge whose vine-covered span and roof seem almost consumed by undulations of heat. Though the painting, which was done around 1920, approaches total abstraction, its writhing lines and gleaming colors still retain vestiges of the scene which inspired it.

become a populist form of modernism.[53] When *Life* magazine reported on Monet's "Modern Heirs" in *late 1957*, describing for its readers how "the scorned work of Monet's later years inspires a present generation of painters . . . producing their own variety of explosively stroked, vibrantly colored paintings," it did so without the superciliousness and ridicule that had become characteristic of its coverage of avant-garde art (fig. 85).[54] This article was *Life*'s second that year to celebrate Abstract Impressionist artists: an earlier one on the new prominence of women among avant-garde painters had featured Joan Mitchell and Nell Blaine.[55] And when *Life* went on to explain first-generation Abstract Expressionism to its readers two years later, it treated this more insistently abstract art as if it warranted the same sorts of viewing practices as Abstract Impressionism – specifically, the discovery of vague references to the visual world.[56]

If Abstract Impressionism managed somehow to reconcile highbrow traditionalism with mass-market populism, this was only one of its political complexities. Another concerned the character of its turn toward nature.[57] Insofar as its appeal to nature was shallow, nostalgic, or cosmetic, Abstract Impressionism was a "suburbanization" of Abstract Expressionism, accompanying the most striking demographic development of the 1950s. Alienation, hyperstimulation, and other effects of urban existence, often discovered by critics in Abstract Expressionist paintings, were calmed through exposure to suburban spaciousness, lawns, and shrubbery. On the other hand, to the extent that Abstract Impressionism went against the grain of the culture's firm commitment to the pursuit of better living through science, it was an artistic harbinger of ecological consciousness. Late in the decade, the specter of nature's obsolescence along with startling publicity about the effects of exposure to radiation and about the reckless dumping of radioactive waste roused opposition to the agenda of the military-industrial complex.[58] Paradoxically, Abstract Impressionism's "passivity" and aesthetic conservatism may have helped prepare the cultural ground for politically progressive environmental activism.

At least one contemporary critic's reaction to Monet's Water Lilies suggests that these paintings evoked vivid fantasies of optical immersion in atmospheric nature, which may have provided relief from feelings of entrapment in a denaturalized world. Critic and art historian Leo Steinberg found in Monet's paintings a pure fantasy of being in nature without physical constraints:

> you can invert the picture or yourself at will, climb upwards with slow, sinking clouds or drift with lily leaves across a nether sky; lie cheek to cheek with the horizon, search among opaque waters for diaphanous shrubs, and find the source of light at its last destination . . . in the *Water Lilies*, the law of gravity – that splendid projection of the human mind too firmly lodged in its body – is abrogated, as in the underwater movies of Cousteau . . . The whole world is cut loose from anthropomorphic or conceptual points of reference.[59]

Steinberg's point of departure was the absence of a horizon line in Monet's murals and the disorienting positioning of the spectator that resulted. His response was extreme in imagining release from gravity, the body, and all mental moorings, but some nature fantasy was implicit in much of the critical writing on Monet and his newfound heirs. When Steinberg imagined that Monet's painting allowed a viewer to "tip portions of it into horizontal planes, then let them snap back to an upright sheet . . . you can invert the picture or yourself at will," he engaged in a viewing practice that would be fully developed in his subsequent concept of the "flatbed picture plane," in which the surface and space of the canvas are perceived as oriented not traditionally as a window, on a vertical axis, but as a horizontal plane that has been swung up into a vertical position. The 1950s combines of Robert Rauschenberg epitomized this approach, and Steinberg invoked Monet's Water Lilies as "portent and antecedent" of works such as *Bed* (1955; Museum of Modern Art, New York).[60]

The politics of the Monet revival and Abstract Impressionism hinged on other issues besides the return to nature. The outer-directed focus of this art – its inclination to seek content not within the self but in the natural world – was also politically charged. As Finkelstein's essay made clear, Monet's art gave focus, legitimacy, and direction to painters seeking to effect just such a reorientation of New York School painting, while simultaneously enabling them to continue to work within a now familiar and nationalist pictorial language. This change of focus, however, seems to have been somewhat less thoroughgoing than it appeared. Seitz ended both his 1960 exhibition catalogue and the introduction to his book on Monet with the same quotation – a remark Monet made to his friend Georges Clemenceau: "Your error is to wish to reduce the world to your measure, whereas, by enlarging your knowledge of things, you will find your knowledge of self enlarged." This quotation carried such weight in Seitz's essays because it encapsulated so neatly one more conservative value of Monet's late work for American viewers in the late 1950s. That self and spirit could be found in nature was a welcome lesson, alleviating the solipsism and self-involvement of academic Abstract Expressionism without radically reorienting its project.[61]

It seems safe to say, in conclusion, that circumstances in the United States in the 1950s were such that a Monet revival was overdetermined. This is what gave it the unusual speed and magnitude that made it so striking to the New York artworld, and prompted some commmentators to worry about a "taste bureaucracy" or to distance themselves with disclaimers: "the first impulse is to back away from a vogue – even when one's own words may have contributed to it."[62] The Monet revival was no frivolous or conspiratorial creation of the leading arbiters of culture, but it was a vogue, fueled by the capacity of Monet's work to service various cultural interests.

Despite its intensity, the Monet revival was not long-lived. With the rise of Happenings, Neodada, Pop, and Minimalism in the later 1950s and the 1960s, Abstract Impressionism came to seem little more than a last gasp of Abstract Expressionism, and Monet soon sank again into general irrelevance for contemporary avant-garde artists. But the new and crucial historical position Monet acquired during this episode, and the strong institutional presence he secured in museums across the United States, gave his work a charge that enabled curatorial and critical enthusiasm to merge with popular interest. The blockbuster Monet exhibitions of the 1990s are fruits of this convergence.

The notes for this essay begin on page 291

Chronology

A full and exemplary chronology by Charles F. Stuckey has been published in Charles F. Stuckey, *Claude Monet 1940–1926*, exhibition catalogue, Art Institute of Chicago, July 22–November 26, 1995

1840
November 14
Birth of Oscar Claude Monet at 45, rue Laffitte, Paris

c.1845
Monet family moves to Ingouville, outside Le Havre, Normandy

1856–7
Meets Eugène Boudin

1858
August–September
Exhibits a landscape painting at a Le Havre contemporary art exhibition organized by the Société des amis des arts du Havre

1859
Exhibits caricatures of actors and musicians in the window of an art and photography shop in Le Havre

1860
Enrolls at the Académie Suisse in Paris; meets Camille Pissarro

1861
Drafted into military service; serves only one and a half years of the normal seven-year term

1862
Summer
While working on the Channel Coast, meets Jongkind

Late
Enters Charles Gleyre's atelier; meets Auguste Renoir and Frédéric Bazille

1863
May
Salon des Refusés; included works by Cézanne, Fantin-Latour, Jongkind, Manet, Pissarro and Whistler

1864
March
Meets the young medical student Georges Clemenceau, later editor, politican, and Prime Minister of France; become lifelong friends

Late
Gleyre's atelier closes: Monet ceases formal art training

1865
May
Exhibits for the first time at the Paris Salon: 2 large marine paintings

October
Commences work on *Déjeuner sur l'herbe*; Camille Doncieux poses, as well as Bazille and Courbet

1866
January
Camille Doncieux poses for *Woman in a Green Dress*; she becomes Monet's companion (they marry in 1870)

May
Has 2 paintings accepted at the Paris Salon

1867
April
Opening of the Exposition Universelle, Paris

May
Rejected by the Salon jury, together with Bazille, Pissarro, Renoir, and Sisley

August 8
Birth of his son Jean

1868
May
One painting accepted by the Salon jury; favourably reviewed by Emile Zola

1869
Late summer
Working with Renoir at La Grenouillère, Bougival

Winter 1869–70
Poses for two group portraits of artists assembled in a studio: Bazille's *Rue de la Condamine Studio* and Fantin-Latour's *A Studio in the Batignolles Quarter* (a homage to Edouard Manet)

1870
May
Monet and Boudin rejected by the Salon jury; Daubigny and Corot resign in protest

June 28
Marries Camille Doncieux

May
Durand-Ruel makes his first recorded purchase of a work by Monet

July 19
Official declaration of the Franco–Prussian War

October
Monets flee from the war to London

1871
In London, meets up with Camille Pissarro through Durand-Ruel, enters 2 paintings into the Royal Academy Summer Exhibition (rejected) and has 2 paintings included in the International Exhibition, South Kensington

June–November
Monets travel to The Netherlands (Zaandam and Amsterdam) before returning to France

December
Rents a house at Argenteuil, on the River Seine to the west of Paris (resident in the town until 1878)

1872
During this year Durand-Ruel purchases 29 works by Monet; the dealer includes paintings by Monet in the 4th and 5th Society of French Artists exhibitions at the German Gallery, London

1873
Monet sells 24,800 francs worth of paintings
Durand-Ruel suspends direct financial support of the Impressionists (reestablished in 1881)

1874
April 15–May 15
1st Impresionist Exhibition held at the photographer Nadar's former studio, 35, boulevard des Capucines, Paris

1875
March 23–24
Impressionists auction own work at the Hôtel Drouot, Paris

1876

March 30–end April
2nd Impressionist Exhibition held at Galerie Durand-Ruel, 11, rue Le Pelletier, Paris
Publication of Edmond Duranty's *La Nouvelle Peinture*, the first publication to place Impressionism within the context of Constable, Corot, Courbet, Boudin, and Jongkind

September
Invited to Rottembourg, the country home of the collectors Ernest and Alice Hoschedé at Montgeron, close to Yerres, to paint four decorative panels; possible beginning of the liaison between Monet and Alice Hoschedé

1877

April 4
The 3rd Impressionist Exhibition opens at 6, rue Le Pelletier, Paris

1878

Plans for the 4th Impressionist Exhibition abandoned for this year. Exceptionally, Renoir returns to the Salon and has one work accepted

June 5–6
Bankruptcy of Ernest Hoschedé: auction of his art collection, including 16 works by Monet, at the Hôtel Drouot, Paris; the depressed market produces very low prices

August–September
Monet family moves to Vétheuil, and shares a house with Ernest and Alice Hoschedé and their six children

1879

April 10–May 11
4th Impressionist Exhibition held at 28, avenue de l'Opéra, Paris

July
Exhibition at the offices of the newspaper, *L'Evénement*, together with Sisley and Pissarro

September 5
Death of Camille Monet at the age of 32 years

1880

Choses not to exhibit at the 5th Impressionist Exhibition (April 1–30), but has one painting accepted at the Salon which opens on April 30

June 6
First one-man exhibition of 18 works at the gallery of *La Vie moderne*

June
Publication by Emile Zola of three articles critical of the achievements of Impressionism in *Le Voltaire*

c.September 10
Monet stays with his brother on the Normandy coast; start of 6 years' renewed involvement with this coastline.

1881

February
Durand-Ruel reetablishes direct financial relationship with the Impressionists.
Together with Caillebotte, Cezanne, Renoir, and Sisley, Monet does not exhibit at the 6th Impressionist Exhibition held April 2–May 1

October 31
Durand-Ruel buys two 'decorative' paintings of gladioli; in 1882 he will commission similar still lifes for the doors of his salon

Mid-December
Alice Hoschedé and her children move to Poissy, together with Monet and his two children

1882

March 1–April 2
7th Impressionist Exhibition held at 251, rue Saint-Honoré, Paris; dominated by landscapes by Monet and Sisley

Autumn
Three works included in an exhibition at the Gurlitt Gallery, Berlin

1883

February 28–March 27
One-man exhibition at Galerie Durand-Ruel, Paris
Gustave Geffroy writes his first article on Monet in *La Justice*, edited by Clemenceau

April 29
Moves to Giverny, where rents a house

September–December
Durand-Ruel exhibits 3 paintings by Monet in Boston ("American Exhibition of Foreign Products, Arts and Manufactures")

Second half of December
Brief visit to the Mediterranean with Renoir; visits Cézanne at l'Estaque

1884

January–April
Stays at Bordighera, on the Italian Riviera; also paints on the French Riviera at Menton

1885

May 15
10 works included in 4th International Exhibition at Galerie Georges Petit, Paris

Summer
Working at Etretat

1886

February 6
Opening of 3rd Les XX Exhibition, Brussels, including 10 works by Monet

April 10
Opening of *Works in Oil and Pastel by the Impressionists of Paris*, at the American Art Gallery, Madison Square, New York; organized by Durand-Ruel and including around 40 works by Monet

April 26–May 6
Visits The Netherlands

May–June
8th and final Impressionist Exhibition; Monet does not exhibit

June 15
Opening of 5th International Exhibition at Galerie Georges Petit, Paris; includes 12 recent paintings by Monet

September–November
Visits Belle-Ile, off the Brittany coast

December–January 1887
Modern paintings exhibition, New York, includes 9 works by Monet

1887

April 7–8
Makes his first sale to the Galerie Goupil-Boussod, Valadon &Cie

May 8
6th Annual International Exhibition opens at Galerie Georges Petit, Paris; includes about 17 paintings by Monet

Late
Goes to London; visits Whistler

1888

January–May
Stays at Antibes, on the Mediterranean

Mid-July
Visits London for three days, staying with John Singer Sargent

1889

February–March
Exhibits with Degas at the Montmartre branch of Boussod & Valadon, run by Theo van Gogh

February
Exhibits 4 works at Les XX, Brussels

February–May
Visits the Creuse Valley; makes 24 paintings

June 21–September 21
Monet–Rodin retrospective exhibition at Galerie Georges Petit, Paris

1890

July–February
Organizes subscription to buy Manet's *Olympia* for the State

November 17
Purchases house and garden at Giverny

October (– January 1891)
Working on the Wheatstack series

December 3
First purchase by a museum: National Gallery of Norway, Oslo, buys *Rain at Etretat* (W.1044)

1891

Extensive work on the garden at Giverny

March 19
Death of Ernest Hoschedé

Spring
Starts work on his Poplars series

May
One-man exhibition at Galerie Durand-Ruel, Paris, including 15 Wheatstack paintings

December 8–22
Visits London; sees Whistler

1892

February
Visits Rouen to start work on the Rouen Cathedral series; returns early March

February 29–March 10
Exhibition, *Monet, Series of Poplars on the Banks of the Epte*, at Galerie Durand-Ruel, Paris (15 paintings)

March 28–April 9
23 works by Monet shown at St. Botolph Club, Boston

July 16
Civil marriage of Monet and Alice Hoschedé at Giverny

1893

February 5
Purchases land on the other side of the railway tracks, on the south side of his garden; immediately starts planning his water garden

February–April
Returns to Rouen to work on the Cathedral series

1894

January
Plans to extend the house at Giverny and to construct a new studio

1895

January
Exhibiton of 40 works by Monet at Durand-Ruel Gallery, New York

February 4–16
Exhibition of 27 works by Monet at St. Botolph Club, Boston

February–April
Visits Norway

May 10–31
Exhibition at Galerie Durand-Ruel, Paris, including 20 Rouen Cathedral paintings

1896

February
Official acceptance by the state of 40 works from the Caillebotte bequest to enter the Musée du Luxembourg, Paris; includes 8 works by Monet

Works at Pourville

Summer
Begins Morning on the Seine series

November–January 1897
3 works included in the 1st Carnegie International, Pittsburgh

December
The National Gallery, Berlin, buys a Vétheuil painting

1897

Builds gardener's house with large studio above in the northwest corner of the garden at Giverny

Mid-January
Returns to Pourville to continue working

April–October
Two works included in the 2nd Venice International Exhibition

May–September
3 works in the Dresden International Exhibition

Summer
Continues work on Morning on the Seine series

August
Mention made to the journalist Guillemot that Monet is making studies of water lilies in his garden for a decorative scheme for a dining room

1898

Publication of Emile Zola's "J'Accuse" in Clemenceau's *L'Aurore*; Monet applauds Zola's defense of Capt. Alfred Dreyfus, the Jewish army officer wrongly convicted of treason

June 2–July
One-man exhibition at Galerie Georges Petit, Paris, including Norway, Pourville, and Morning on the Seine Series

November 10–15
Brief visit to London to see Michel Monet who is ill

1899

January–February
12 works included in an exhibition in St. Petersburg

January 29
Death of Alfred Sisley. Monet arranges memorial exhibition and benefit auction (May 1)

July–early September
Paints series of some 12 views of the Japanese Bridge

Mid September–mid October
In London with Alice and Germaine Hoschedé; starts work on the London series (Charing Cross Bridge and possibly Waterloo Bridge)

1900

February–April
Second visit to London; continues work on Charing Cross and Waterloo Bridges series and starts the Houses of Parliament series

May 1
Opening of the Exposition Universelle, Paris; Monet included in the Exposition Centenale

November 22–December 22
Exhibition of 26 recent works at Galerie Durand-Ruel, Paris, including 12 of the Japanese Bridge and 1 of the flower garden

1901

January 23–April
Third visit to London; completes initial creation of 97 paintings and 26 pastels

May 10
Buys land on the south side of the River Ru (tributary of the River Epte, which drains his pond); plans to extend the pond

July–Autumn
Works on the Vétheuil series from a house across the River Seine at Lavacourt

1902

The Musée des Beaux-Arts, Lyon, and the Musée du Petit Palais, Paris, acquire works by Monet

February 11–25
38 works exhibited at Durand-Ruel Gallery, New York, including the first London painting to be shown in public

February 15–28
Véthueil series included in an exhibition at Galerie Bernheim-Jeune, Paris

1902–3

Winter
Works on many London paintings in preparation for an exhibition to be held in 1903 (postponed to 1904)

1903

Summer
Begins first paintings that will eventually constitute the Water Lily series ("Les Nymphéas")

November 13
Death of Camille Pissarro

1904

March
Publication in London of Wynford Dewhurst, *Impressionist Painting*, dedicated to Monet

May 8–June 4 (extended to June 7 at Monet's request)
Exhibition of *Series of Views of the River Thames at London* at Galerie Durand-Ruel, Paris: 37 paintings shown

July–August
Works on his Water Lily series

September(?)
Exhibition of 13 London paintings at Cassirer Gallery, Berlin

October 8–28
Visits Madrid and Toledo with Alice and Michel

1905

Constructs trellis above the Japanese Bridge

January–February
Large Impressionist exhibition organized at Grafton Galleries, London, by Durand-Ruel: includes 55 works by Monet

March
Loan exhibition of 95 paintings by Monet (including 7 London subjects) (with sculpture by Rodin) at Copley Hall, Boston

Summer
Continues work on the Water Lily series

October–November
Salon d'Automne, Paris: includes "les Fauves," Derain, Matisse, etc.

December
13 works included in *Opening Season 1905–1906* exhibition, Toledo Museum of Art (Ohio)

1905–6

Continuing acclaim for his preeminent position from contemporary writers such as Rémy de Gourmont, Gustave Geffroy, Théodore Duret, and André Fontainas

1906

March 8
2 works of the 1880s acquired by Museum of Fine Arts, Boston; first of 39 works eventually to enter the museum's collection

Summer
Continues work on the Water Lily series

22 October
Death of Paul Cézanne

Late December
Agrees with Durand-Ruel to a May 1907 exhibition of his Water Lily series

1907

January 28–February 14
Exhibition of 27 works at Durand-Ruel Gallery, New York

February
Attends inaugurated exhibition of Moreau-Nélaton Bequest (including his *Déjeuner sur l'herbe*); instrumental in the transfer of Manet's *Olympia* from the Musée du Luxembourg to the Louvre, Paris

Spring
Works in his studio on the Water Lily series; abandons plan to exhibit in May

Late May through summer
Returns to the water-lily pond to start on his vertical Water Lily compositions

Late October
State purchase first painting from Monet: of a Rouen Cathedral

1908

April
Decides once again to cancel his Water Lily series exhibition

June
Returns to work on the final group of the Water Lily series paintings

September 30–December 7
Visits Venice with Alice; initially stay at the Palazzo Barbaro-Curtis and then at the Grand Hôtel Britannia: starts 37 paintings

1909

May 6–June 5
Exhibition of *Les Nymphéas: Séries de paysages d'eau* at Galerie Durand-Ruel, Paris: 48 paintings shown to great critical and popular acclaim

1910

January
Severe floods submerge the water-lily pond: Monet undertakes important changes to the shape of the pond

Late February
Alice ill with myelogenous leukemia

July
Worcester Art Museum (Mass.) acquires 2 works, including a Water Lily painting; first such subject to enter an American public collection

Autumn
9 works included in a loan exhibition of the collection of Mrs. Potter Palmer at the Art Institute of Chicago

December
Sells 3 paintings, including a Water Lily painting, to Musée des Beaux-Arts, Le Havre, for a nominal price

1911

February 8–25
17 works exhibited at Durand-Ruel Gallery, New York

May 19
Death of Alice Monet

facing page: Detail of cat. 69

August
45 works exhitibed at the Museum of Fine Arts, Boston (first American museum exhibition devoted to the artist)

October–December
Finishes some Venice paintings

1912
May 28–June 8
Exhibition of 29 Venice paintings at Galerie Bernheim-Jeune, Paris under the title "Monet Venise"

July
Learns that he has a cataract problem, and son Jean has a stroke; virtually stops painting until 1914

Late October
7 Venice paintings exhibited at the Brooks Reed Gallery, Boston (will mount exhibitions including Monet annually until 1923)

1913
January
Group of Venice paintings shown at Durand-Ruel Gallery, New York

February 15–March 15
5 paintings included in the International Exhibition of Modern Art (the so-called "Armory Show"), at the 69th Armory, New York; exhibition transfers in the summer to the Art Institute of Chicago and to Copley Hall, Boston

Summer
Paints the group of 3 Flowering Arches works

1914
9 February
Death of Jean Monet

February 1–16
20 works exhibited at Durand-Ruel Gallery, New York

March 2–21
50 paintings form a retrospective exhibition at Galerie Durand-Ruel, Paris

April
Announces intention to undertake a new departure in his painting: to create decorative panels on a large scale.

Summer
Works on this larger scale (2m and more)

August 1
Outbreak of First World War; Jean-Pierre Hoschedé leaves for the Front (August 11)

1915
At work on his large-scale paintings, including possibly some destined for possible inclusion in his *Grandes Décorations*

March
Saint Louis Art Museum purchases a Charing Cross Bridge painting

Summer
Constructs a third, large studio on the northeast corner of his property: 15m high and an area of 23 × 12 m (276 square metres), to accommodate his large panels

1916
January–February
Sends works to a benefit exhibition at Galerie Bernheim-Jeune, Paris

May 22
Orders delivery of 6 stretched canvases 1.5 × 2m and 6 of 1.3 × 2m

1917
April 30
Agrees to paint Reims Cathedral, badly damaged during enemy action; the work never materializes

Summer
Working outside in the water garden

November 17
Death of Auguste Rodin

1918
Early February
Has 8 out of 12 projected 2 × 4.5m panels already under way, as well as some 6m and 8m panels

March–July
Germans bombard Paris; Monet resolves to stay at Giverny

April 30
Orders 20 stretched canvases 1 × 2m from Paris

Summer
Constant work on Garden and Water Lily panels

November 11
Armistice

November 12
Offers Weeping Willow painting and Water Lily decorative panel to the State to celebrate the Allied victory

1919
January 18–end
Monet–Rodin exhibition at Galerie Bernheim-Jeune, Paris, includes 4 paintings of 1918

May
16 recent paintings exhibited at Durand-Ruel Gallery, New York

August
Setting aside the Water Lily panels, works on smaller-scale paintings, including a Japanese Bridge painting dated to this year

November
Eyesight appears to be deteriorating; prevented from finishing Water Lily panels

3 December
Death of Auguste Renoir

1920
Spring
Continued concern over his eyesight

June 4
Visit from Mrs. Charles Hutchinson (wife of the president of the Board) and Mr. and Mrs. Martin Ryerson (collectors) on behalf of the Art Institute of Chicago with a view to purchasing ?30 Water Lily panels as a decorative scheme for the museum

September
Plans for the construction of a pavilion in the garden of the Hôtel Brion, the Musée Rodin, Paris, to house the Water Lily decorative panels (offered by Monet in 1918); the architect is Bonnier who works closely with Monet through to the end of the year

November 14
Monet's eightieth birthday

1921
Janaury 21–February 2
45 paintings exhibited in a retrospective exhibition at Galerie Bernheim-Jeune, Paris

January – March
Works with Bonnier to review both eliptical and circular space for the *Grandes Décorations*; the former even harder to resolve, so decision taken to house the 12 panels offered by Monet in a converted building

February 2
State agrees to purchase *Women in the Garden* for 200,000 francs as a condition of *Grandes Décorations* donation

April
Agrees to proposal to renovate the Orangerie to accommodate the *Grandes Décorations*

October
Resolution of proposal that *Grandes Décorations* now take up two rooms in the Orangerie; necessitates an increase the number of panels from 12 to 18

November
Revision of decorative scheme proposed; now includes 20 panels

December
Bonnier replaced by Camille Lefèvre, architect of the Louvre

1922

January
The total number of panels to be accommodated in the Orangerie has risen to 22

January 4–21
19 paintings exhibited at Durand-Ruel Gallery, New York

February 5
Death of Paul Durand-Ruel

May
Increasingly acute eye problems prevent Monet from working; admits that he has ruined several large panels over the winter and has also destroyed some

July
Donates *Water Lily Pond* (dated 1917 but probably made 1918–22; 1 × 2m) to the Société d'Initiative et de Documentation artistique, Nantes (enters the Musée des Beaux-Arts de Nantes in 1938)

Late October
References to slashed canvases and canvases piled up for burning

1923

January
Operation at the Neuilly clinic of Dr. Coutela for the cataract on his right eye; further operation on the right eye at end January; using corrective dark glasses

March
Exhibition of 18 works at Durand-Ruel Gallery, New York

May 18
Donates *Water Lily Pond at Giverny* to the Grenoble Museum

July 18
Third operation on his right eye undertaken at Giverny

August–November
Seeing predominantly in yellow, Monet tries out several corrective glasses which counteract the problem; suggestion that he should undergo an operation on the left eye

1924

January 4–18
More than 60 paintings exhibited at Galerie Georges Petit, Paris, to benefit the victims of the September 1 earthquake in Tokyo

February
10 Water Lily paintings exhibited at Durand-Ruel Gallery, New York

March–June
Clemenceau goads Monet to finish the *Grandes Décorations*

Summer
Acquires new corrective Zeiss glasses

November 28
Musée municipale d'Art et d'Industrie, Saint-Etienne, acquires a 1907 Water Lily tondo

1925

Eye sight improving with the use of Zeiss glasses

August
Works on a group of easel paintings of his house and rose garden (cats. 74–87)

By November
Anticipates completing the *Grandes Décorations* by the following spring

1926

June
Report that Monet is using absorbant paper since he finds that tube paints have too much oil in them; he wishes to achieve dry-paint effects

July
Evidence of destruction of around a further 60 canvases at Giverny

Late August
Diagnozed as having an incurable tumor on his left lung

December 5
Death of Monet at 1pm at Giverny

December 8
Burial of Monet at the cemetery at Giverny

1927

May 17
Official inauguration of the *Grandes Décorations* in the Orangerie; open to the public on May 20

Monet's group of eighteen Japanese Bridges, started in 1899 and revisited in 1900, reflects a moment of critical change in the artist's development. The series echoes his painting strategy of the previous decade and anticipates new concerns, both in technique and in subject matter, which were to dominate his output over the next twenty years. The first twelve canvases, begun in summer 1899, depict the Japanese-style footbridge that Monet had constructed in 1893 over the narrowest part of the pond in his water garden. The majority of the canvases are roughly square in format, bisected laterally by the gentle arc of the bridge that spans the surface of the water. On this surface float pads of water lilies, receding into the distance: the flowers and their leaves interrupt the reflection of the tall trees in the distant background, including the vertical branches and leaves of a weeping willow at left. In the summer of 1900 Monet returned to the motif, producing another six paintings (including cats. 1–4), altogether bolder and more vividly colored than the 1899 canvases. Both the 1899 and the 1900 canvases were much admired: Durand-Ruel exhibited nine of the earlier group and three of the later in Monet's first exhibition of the twentieth century (November 22–December 15, 1900), which included also a further thirteen works from the 1890s. By 1901 eight of the bridge paintings had been sold to such private collectors as Sergei Shchukin of Moscow, the American collectors H. O. Havemeyer and Harris K. Whittemore, and Count Isaac de Camondo, who purchased two paintings, including the only 1900 canvas to find an immediate buyer (cat. 2).

The paintings in this series herald the appearance of the dominant theme of Monet's twentieth-century production — the study of the complex relationships between earth, water, atmosphere, and light through the depiction of the surface of the pond — but they follow upon the paintings of the nineties. The forceful geometry of the bridge recalls the natural architecture of the Poplars series of 1891, while the essentially unchanging point of view invites comparison with the Morning on the Seine compositions of 1897. Nonetheless, Monet permitted himself a certain amount of movement within the relatively static format, and in the group of canvases from 1900 he shifts his perspective from side to side, so that the intense symmetry of the 1899 group is abandoned for a more panoramic effect — in the case of catalogue number 4 including a large section of the bank on which he stood and an area of sky at upper left. The 1900 paintings show an increased vivacity of texture, a greater reliance on long, curling brush-strokes rather than the mosaic textures of 1899, and above all a greater intensity of color, marked by the presence of ruby and amethyst hues among the turquoise and emerald tints that had held sway in the previous year.

It had been Monet's habit, in the 1870s and 1880s, to paint the gardens of the houses in which he lived, at Argenteuil or Vétheuil for example. Remarkably, despite the care that he had lavished on his garden in the 1890s, the bridge paintings of 1899 mark Monet's first concerted effort at documenting any part of the garden of the house in which he had lived at Giverny since 1883. He had attempted to paint the bridge somewhat earlier, in the winter and summer of 1895 (W.1392, W.1419, W.1419a), and in that year he painted also a view of the garden path with its flowering borders (W.1420). He was to move once more from the water garden to the flower garden in 1900, initiating a series of views of the bordered pathways that led, in strictly geometrical formations, south from the façade of his house towards the road, the railroad, and the water garden beyond. Between 1900 and 1902 he produced some eight such paintings. (A further group of four or five canvases, showing the curving trunks of fruit trees rising above curving paths, was painted in the orchard that lay to the west.) The flower garden views are often marked, as in The Garden (cat. 7), by the vivid juxtaposition of red and green hues that dominated the 1900 bridge series; they share with that series a preoccupation with showing passages of bright light and deep shadow side by side, as in The Main Path through the Garden at Giverny (cat. 8). While in the majority of the views of this part of the garden Monet looked north along the pathways towards the pink stucco façade of his house (see cats. 6–8), another group explored the view to the south. In The Path at Giverny (cat. 5) the artist looked away from the house toward the end of the flower garden, the so-called clos normand, including at right the posts that supported the iron garden gate at the pathway's end.

The flower-garden views were never exhibited as a series, although one of the first of them — either catalogue number 7 or a close variant (W.1624) — was exhibited at Durand-Ruel together with the paintings of the Japanese bridge. It is probable that the London theme of Monet's 1904 exhibition preempted the presentation of the group in any organized fashion before that time, and it is certain that after 1904 the painter's imagination was fixed on the motifs that could be found in the water-lily garden. The paintings gradually left Monet's studio over the next twenty years.

previous pages Detail of cat. 91.

facing page Detail of cat. 3.

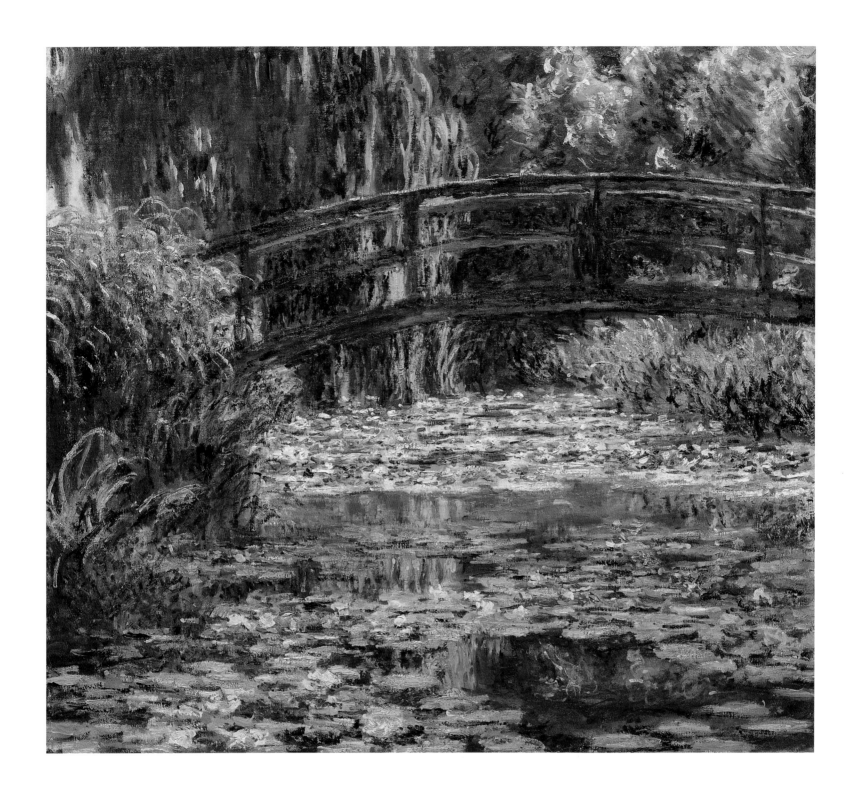

1 *The Bridge over the Water Lily Pond*, 1900, oil on canvas, 89 × 100 cm (W.1628). The Art Institute of Chicago,
Mr. and Mrs. Lewis Larned Coburn Memorial Collection

Not exhibited at Galerie Durand-Ruel, Paris, November – December 1900; bought from Monet in December 1900 by Léonce Rosenberg

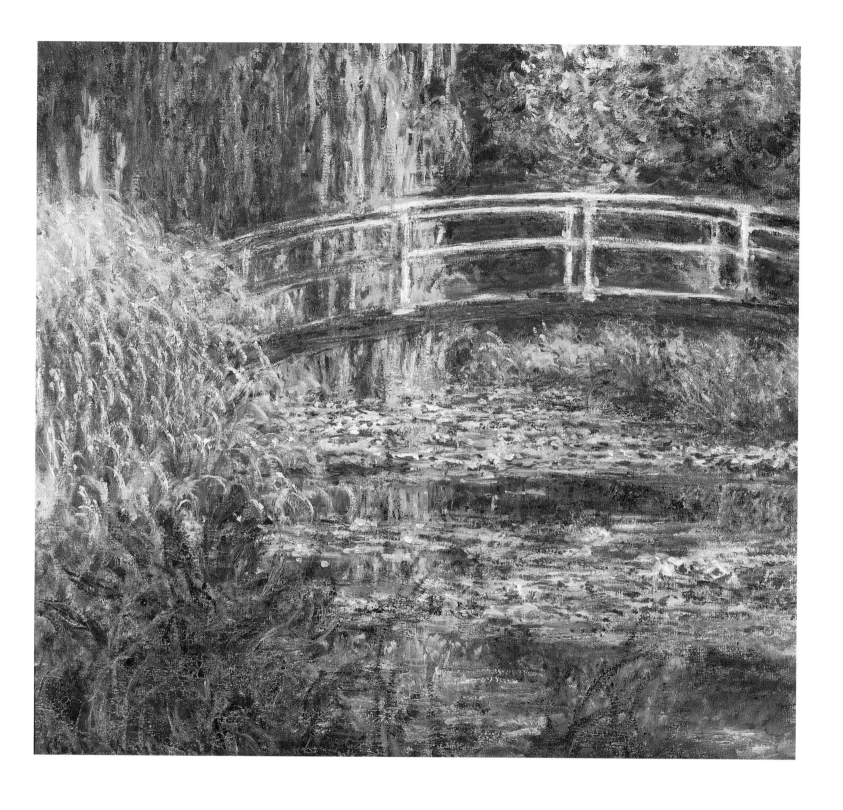

2　*The Water Lily Pond (Symphony in Rose)*, 1900, oil on canvas, 90 × 100 cm (W.1629).
Musée d'Orsay, Paris; legacy of Comte Isaac de Camondo, 1911

Exhibited at Galerie Durand-Ruel, Paris, November – December 1900; bought from Monet on November 21, 1900 by Durand-Ruel
and sold the same day to Comte Isaac de Camondo, Paris

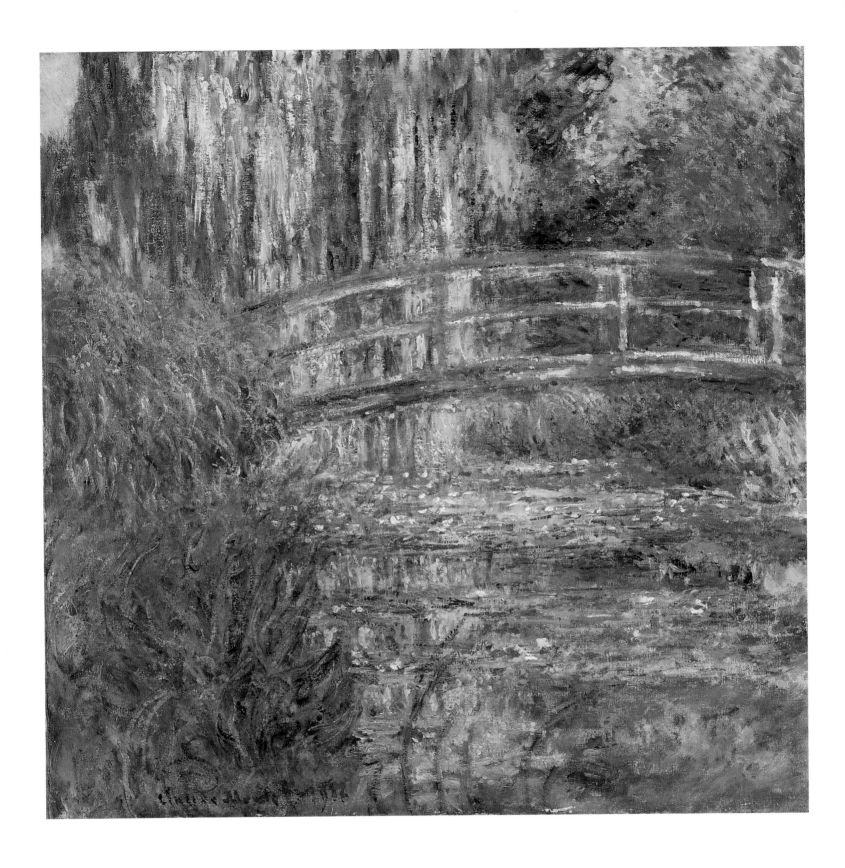

3 *The Water Lily Pond*, 1900, oil on canvas, 90 × 92 cm (W.1630). Museum of Fine Arts, Boston.
Given in Memory of Governor Alvan T. Fuller by the Fuller Foundation

Not exhibited at Galerie Durand-Ruel, Paris, November – December 1900; bought from Monet in December 1900 by Léonce Rosenberg

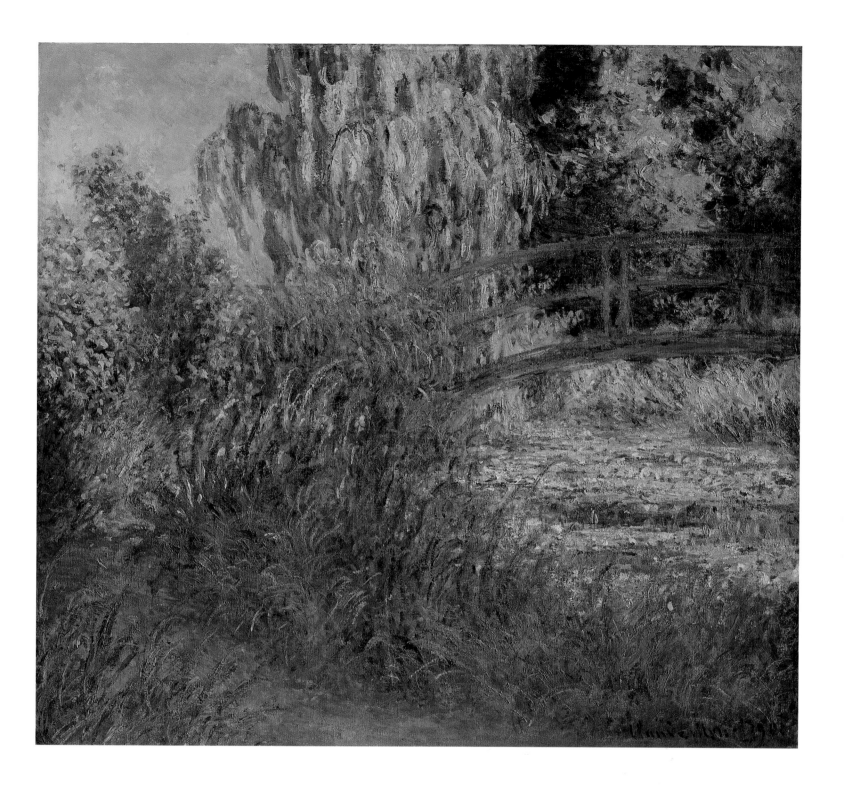

4　*Path along the Water Lily Pond*, 1900, oil on canvas, 89 × 100 cm (W.1633). Private Collection

Not exhibited at Galerie Durand-Ruel, Paris, November – December 1900; bought from Monet in December 1900 by Léonce Rosenberg
and first exhibited at Durand-Ruel Gallery, New York, in 1924

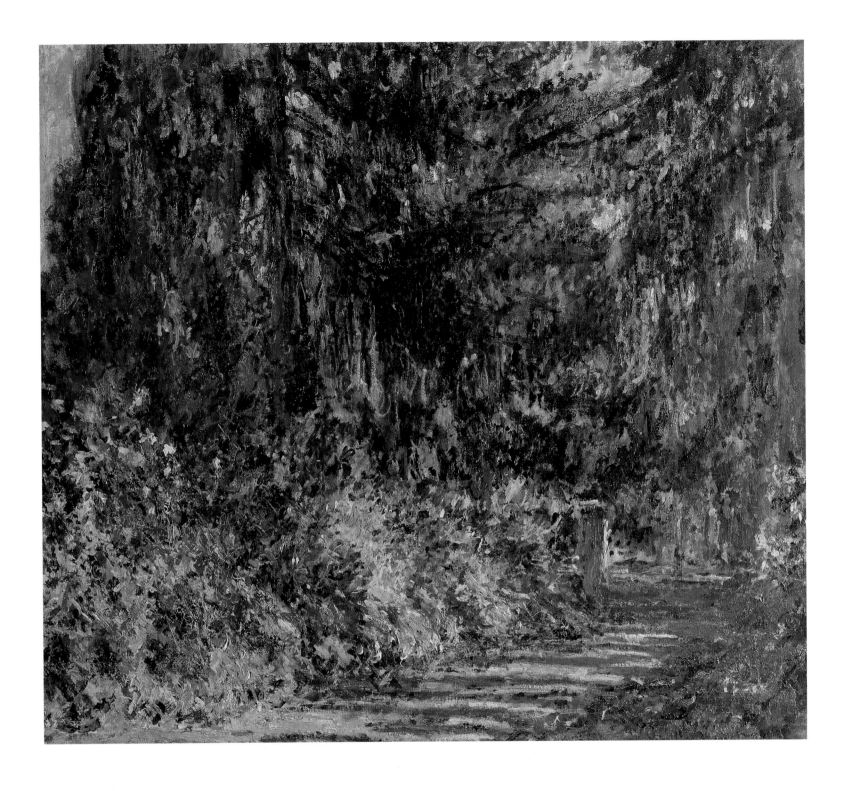

5 *The Path at Giverny*, 1902, oil on canvas, 81 × 92 cm (W.1652). Private Collection

Remained in Monet's studio until bought from Monet in May 1912 by Bernheim-Jeune

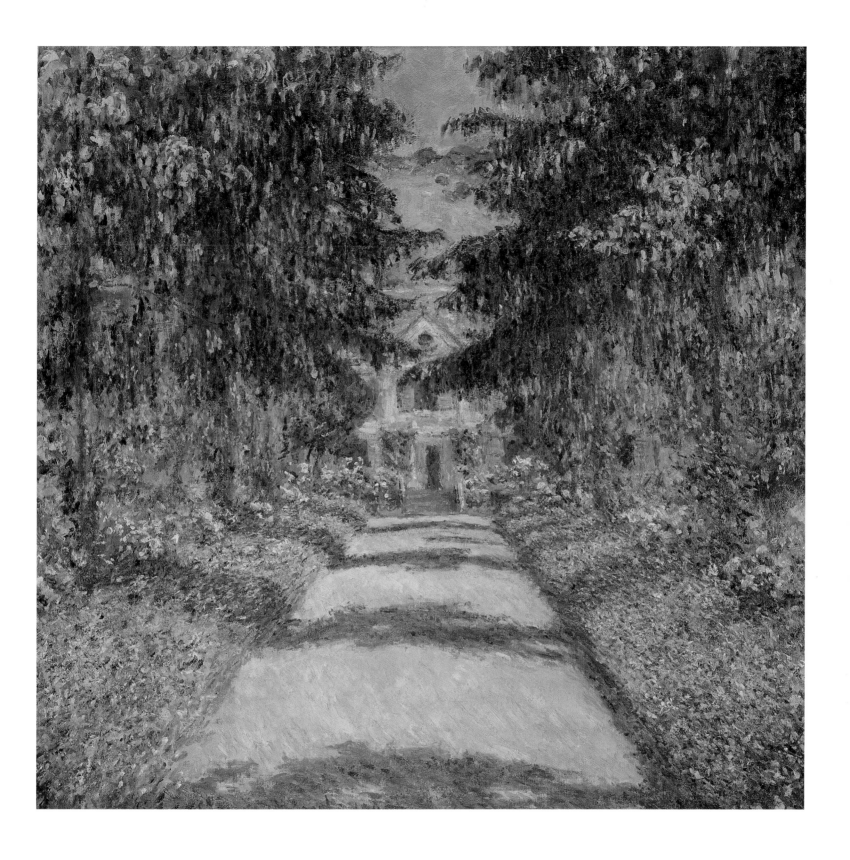

6 *The Main Path at Giverny*, 1900, oil on canvas, 88 × 92 cm (W.1627). Private Collection

Not exhibited at Galerie Durand-Ruel, Paris, November – December 1900; possibly bought from Monet in September 1905 by Bernheim-Jeune

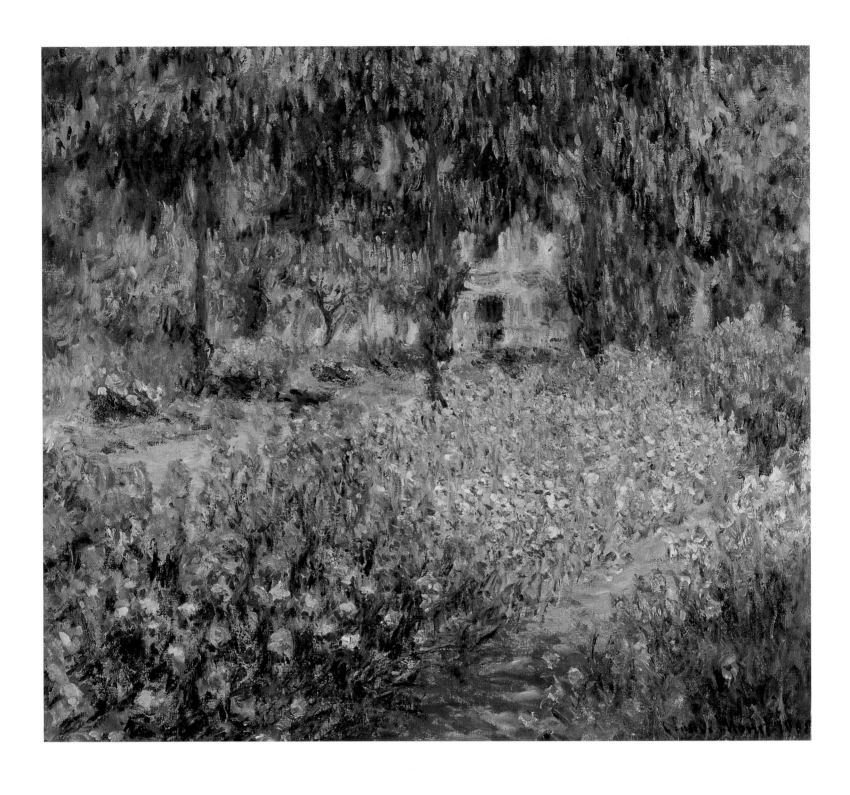

7 *The Garden*, 1900, oil on canvas, 81 × 92 cm (W.1625). Ralph T. Coe

(?)Exhibited at Galerie Durand-Ruel, Paris, November – December 1900; bought from Monet in November 1900 by I. Montaignac

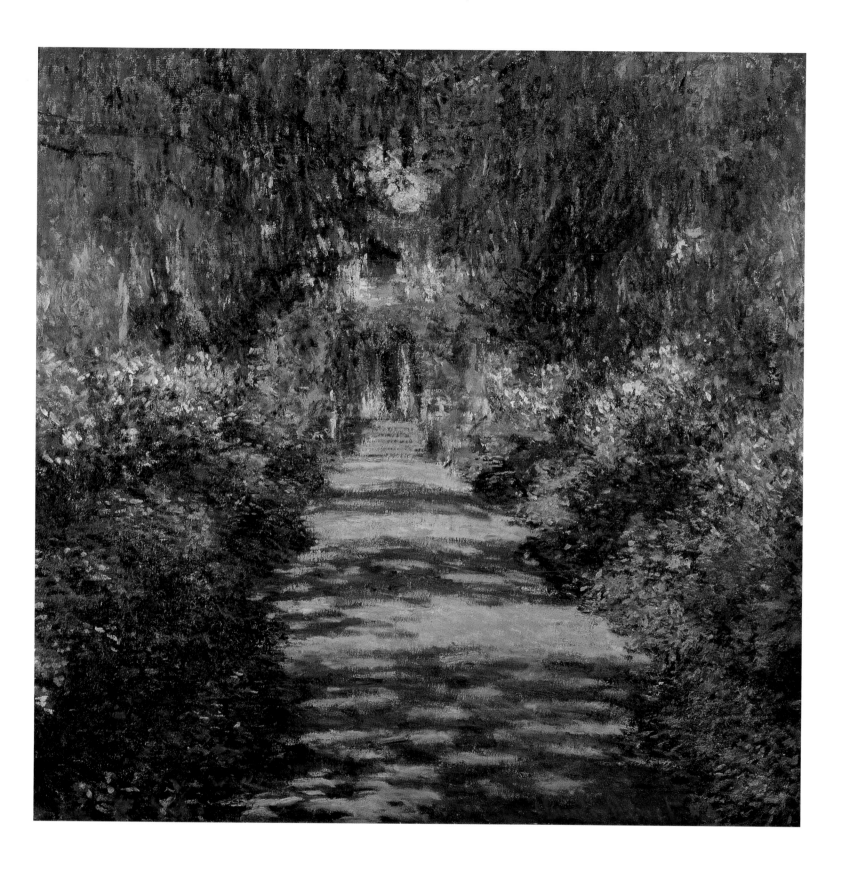

8 *The Main Path through the Garden at Giverny*, 1901–2, oil on canvas, 89 × 92 cm (W.1650). Österreichesche Galerie Belvedere, Vienna

Bought from Monet in April 1904 by Durand-Ruel and sold the same year to Robert von Mendelssohn, Berlin

Monet spent three periods in London during the initial preparation of his London series: from about September to the end of October 1899; February 9 to April 5, 1900, and January 25 to about March 30, 1901. He had already visited the city in 1870–71, in the summers of 1887 and 1888, in December 1891 and in November 1898 – and as early as December 1880 he had considered creating a group of paintings of the River Thames. Finally, in 1899 he embarked upon the series which, over the next five years, was to produce ninety-five views of the Thames in three major subject groups and three sketched records of Leicester Square by night.

The choice of London was certainly in part inspired by the extraordinary light effects that the city offered during the winter months, when sunshine was diffused through a dense atmosphere of mist mingled with coal smoke from domestic fires and industrial furnaces. These had informed the later work of J. M. W. Turner, and James McNeill Whistler's views of Battersea and Chelsea made in the 1860s and 1870s. Turner's compositional solutions were also echoed by Monet in the strong vertical counterbalance of the sun and its reflection in such stridently horizontal subjects as *Houses of Parliament* (cat. 24), in the Charing Cross Bridge paintings and the Waterloo Bridge group (cats. 10 and 12, and 16 and 20). Whistler's insistence upon a dominant tonality permeates many of the series, even to the extent of Monet's possibly adopting, as in the case of the *Houses of Parliament* (cat. 23) a subtitle for the painting resonant of those adopted by the American artist: "Symphonie en rose." Whistler's Thames views, together with the example of Camille Pissarro's contemporaneous serial paintings of the Seine at Rouen and Paris may have encouraged Monet's choice of the Thames views, although their expanse of sky and water also allowed Monet to investigate the inversion of compositional components – bridge, chimney stack, smoke, sun – already explored in his 1890s series, the Poplars on the Epte (exhibited 1892) and Mornings on the Seine (exhibited 1898).

On all three visits to London Monet stayed at the Savoy Hotel, on the north bank of the Thames. From his windows he could see Waterloo Bridge to his left and Charing Cross Bridge to his right. A few hundred meters upstream, on the south bank of the river lay St. Thomas's Hospital, where a balcony on one of the pavilions presented a view directly across the water to the Houses of Parliament. It was from these two vantage points that, by March 1901, Monet had started at least thirty-five views of Charing Cross Bridge, forty-one of Waterloo Bridge and nineteen of the Houses of Parliament.

Charing Cross appears to have been the first motif upon which Monet worked in fall 1899; four paintings were dated 1899, of which one was sold in November to the dealer Boussod et Valadon immediately after the artist's return to Giverny and the other three to Durand-Ruel in November 1901. The first campaign may also have included a start on the Waterloo Bridge motif, although the Houses of Parliament were only embarked upon during his second London visit. Once all three motifs had been started Monet stuck to a strict daily timetable: he would work on Waterloo Bridge and Charing Cross Bridge in the morning, and transfer his "studio" to the St. Thomas's Hospital balcony in the afternoon to capture the effects of the setting sun behind the Houses of Parliament. The resultant paintings confirm this daily routine, as the vast majority of the Waterloo and Charing Cross Bridge paintings show the bridges themselves silhouetted against a light source coming from behind, while the Houses of Parliament paintings were predominantly made at or near sunset. A few exceptions do exist; one view of Parliament was made after sunset, while at least three Waterloo Bridge paintings (including cat. 19) were made later in the day when the sun, having broken through the fog, falls upon the bridge from an angle that endows it with an architectonic quality and highlights its classical architectural details.

The viewpoints for the London series paintings were confined to a small geographic area, which nonetheless permitted shifts in Monet's angle of vision. These were put to compositional advantage by the artist to create sub-series within each group. Thus, ten of the Charing Cross Bridge views (including cat. 9) retain a reference to the Victoria Embankment along the Thames on the lower right-hand side, with the Houses of Parliament in the background. Catalogue numbers 10, 11, and 13 form part of a large group in which Monet has shifted his angle of vision to the left, eliminating the Victoria Embankment but retaining the Houses of Parliament; this building is excluded altogether through a further shift to the left, as in catalogue number 12, one of a sub-series of nine canvases. In the case of the Waterloo Bridge paintings, the angle of vision remains more consistently focused, although a pair of paintings pulls the angle of vision down into the water such that the bridge rises to the top of the canvas, thus eliminating the industrial backdrop. No Houses of Parliament painting represents the full river façade of Barry and Pugin's neo-Gothic building, from the Victoria Tower in the west to Big Ben in the east. Catalogue numbers 21 and 23 nonetheless show a considerable extent of the building from Victoria

facing page Detail of cat. 17.

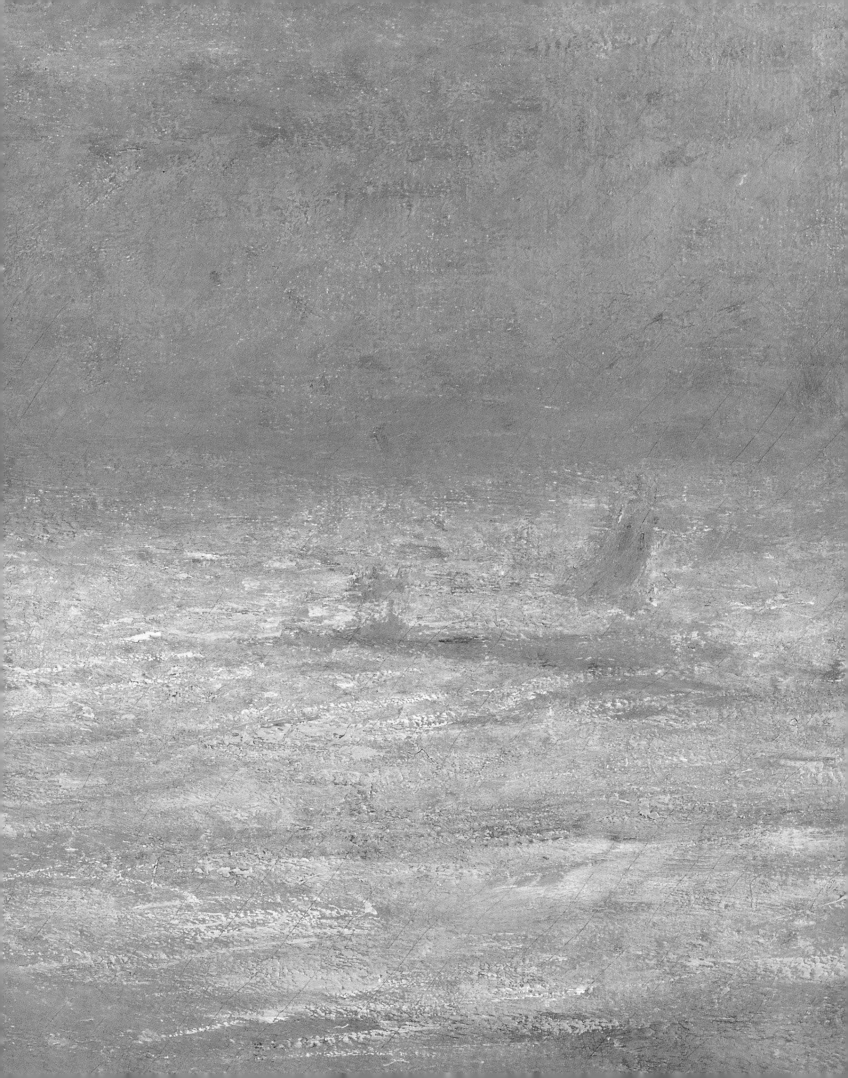

Tower, whereas two other paintings (cats. 22 and 24) focus more specifically on the Victoria Tower and the western end of the building.

Waterloo Bridge, built 1811–17, was a vehicular and pedestrian bridge linking the western end of the City of London to the industrialized south bank. Monet's views of this bridge not only capitalize upon the verticality of the smoking chimney stacks on the further bank to counterbalance the horizontality of the classically detailed bridge (see cats. 14 and 18), but also use the intense traffic activity on the bridge itself to orchestrate the bridge's upper silhouette and to enliven its overall tonality through touches of complementary colors (see cat. 18). Charing Cross Bridge, on the other hand, was built to bring trains from south London across the Thames into Charing Cross Station (1863). A functional pier and beam bridge, it drives boldly through the middle of each of Monet's compositions, the steam from the engines creating additional layered patches of scintillating light (see cats. 9, 10, and 11). In contrast to the two bridge groups, the Houses of Parliament compositions are generally devoid of human activity, apart from an occasional boat (as in cat. 23), with the articulation of space and light expressed solely through the placing of the setting sun in relation to the silhouette of the building and its reflection in the water below.

Monet wanted to capture in the London series that distinctly "London-like" characteristic given by its fog. He apparently worked at great speed, selecting, according to the specific weather conditions, either a canvas already embarked upon or starting afresh. This method had major implications as it meant that he had a vast number of canvases on the go at any one time, most of which remained in "sketch" form in order to capture his motifs "in all times of the day, in all the harmonies." Back in his studio in Giverny Monet found it difficult to bring these unfinished canvases to completion from memory. He not only fought to keep the maximum number together so that he could work concurrently on a group, but also apparently destroyed some or was in danger of ruining others through retouching and reworking.

Exhibition plans for the London series were laid in 1903 and *Séries de vues de la Tamise à Londres (1900–1904)* eventually opened on May 9, 1904, at Durand-Ruel's Paris gallery; it was billed to close on June 4 but remained open a further three days. The exhibition consisted of thirty-seven paintings, of which eight (including cats. 10, 11, and 12) were of Charing Cross Bridge, eighteen of Waterloo Bridge (including cats. 14, 16, 18, and 20), and eleven of the Houses of Parliament (including cats. 22 and 23). While the exhibited paintings of Charing Cross and the Houses of Parliament were dated between 1902 and 1904, two of Waterloo Bridge were dated 1900 (including cat. 14), one was dated 1901 and the remaining fifteen either bore dates between 1902 and 1904 or were not dated at all. The exhibition was a critical and commercial success; reviewers stressed Monet's achievement in capturing atmospheric effects and the affinity between his treatment of London and the paintings of Turner. Durand-Ruel, anticipating the demand for the series, bought eight Waterloo Bridges and nine Houses of Parliament in May 1904 before the exhibition opened, followed by six further Waterloo Bridges in June (including cat. 14, exhibited 1904). In May 1905 Durand-Ruel purchased two Charing Cross Bridges (including cat. 10, exhibited 1904) and in October 1905 he bought a further four Charing Cross Bridges (including cat. 11, exhibited 1904, and cat. 9, not exhibited 1904), and three Houses of Parliament (including cat. 24, not exhibited 1904). By 1914 at least six Houses of Parliament, nine Charing Cross Bridges and ten Waterloo Bridges had found their way into American collections.

Paintings from the London series that were not included in the 1904 exhibition but subsequently sold fall into three general categories. Those, such as the Charing Cross Bridge (cat. 9) and the Houses of Parliament (cat. 24), which left Monet's studio in October 1905, probably experienced very little additional finishing, the Zurich *Houses of Parliament* in particular remaining relatively thinly and broadly painted. Those that left the studio at a considerably later date, such as the Charing Cross Bridge that was sold to Durand-Ruel and Bernheim-Jeune in March 1917 (cat. 13), and the two Waterloo Bridges (cats. 17 and 15) that left the studio in October 1911 and December 1920 respectively, are more problematic. Neither catalogue number 13 nor catalogue number 15 is dated. The bolder, richer, and more dabbled paintwork in catalogue number 13 seems more akin to the breadth of handling that Monet was exploring contemporaneously in such two-meter panels as catalogue numbers 72 and 73, while the dominance of a single tonality in the Washington *Waterloo Bridge* (cat. 15) sets it apart from the more nuanced tonalities and relatively more detailed compositions of those paintings in the group that either were exhibited in 1904 or left the studio shortly thereafter. When placed beside the Fogg *Charing Cross Bridge* (cat. 12), a painting dated 1903 and definitely included in the 1904 exhibition but sold by Monet to Durand-Ruel only in December 1920, the similarities in tonality and general absence of descriptive detail in both works suggest that they may have been worked up – or over – side by side before leaving the studio some twenty years after their initial inception. The third category of London series paintings covers those works that remained unsold on Monet's death in 1926, of which there were ten Charing Cross Bridges, four Waterloo Bridges and one Houses of Parliament – no examples of which are included in the present exhibition.

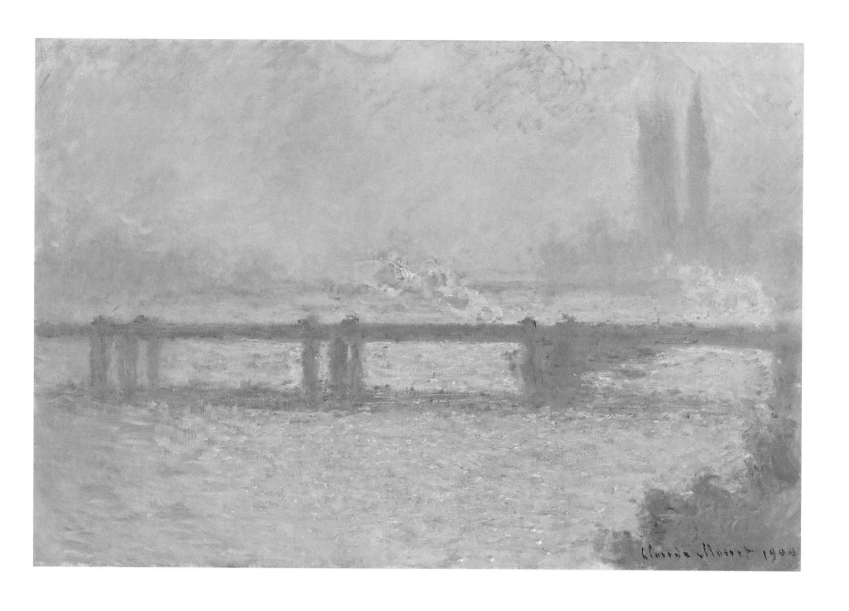

9 *Charing Cross Bridge, Overcast Weather,* 1900, oil on canvas, 60 × 92 cm (W.1526). Museum of Fine Arts, Boston.
Given by Janet Hubbard Stevens in Memory of her mother, Janet Watson Hubbard.

Not exhibited at Galerie Durand-Ruel, Paris, May – June 1904; bought from Monet in October 1905 by Durand-Ruel
and sold in 1907 to Mr. and Mrs. Joseph Derwin Hubbard, Chicago

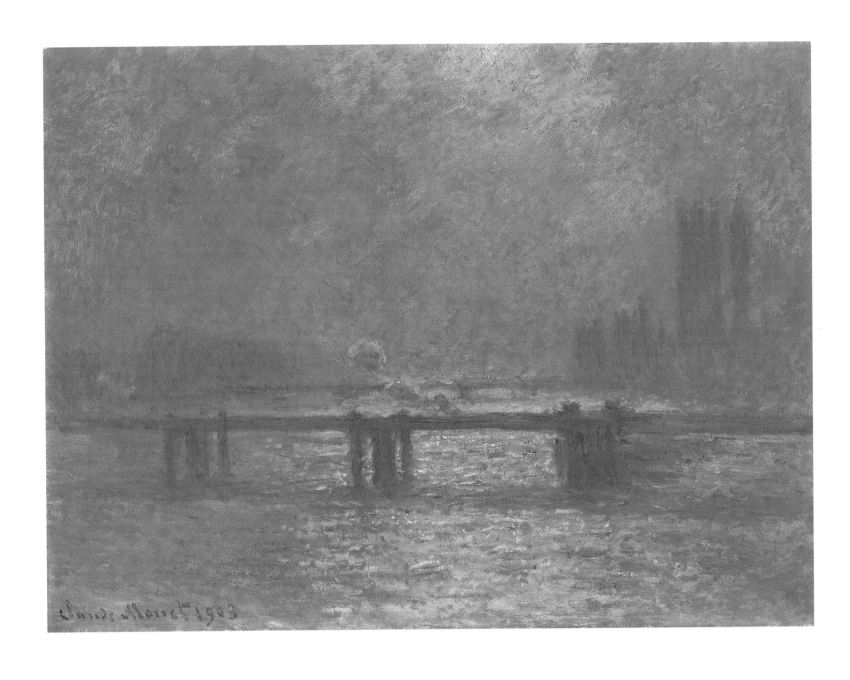

10 *Charing Cross Bridge, The Thames*, 1903, oil on canvas, 73 × 100 cm (W.1537). Musée des Beaux-Arts, Lyon

Exhibited at Galerie Durand-Ruel, Paris, May – June 1904; bought from Monet on May 11, 1904 by Durand-Ruel
and sold the same day to Raymond Koechlin, Paris

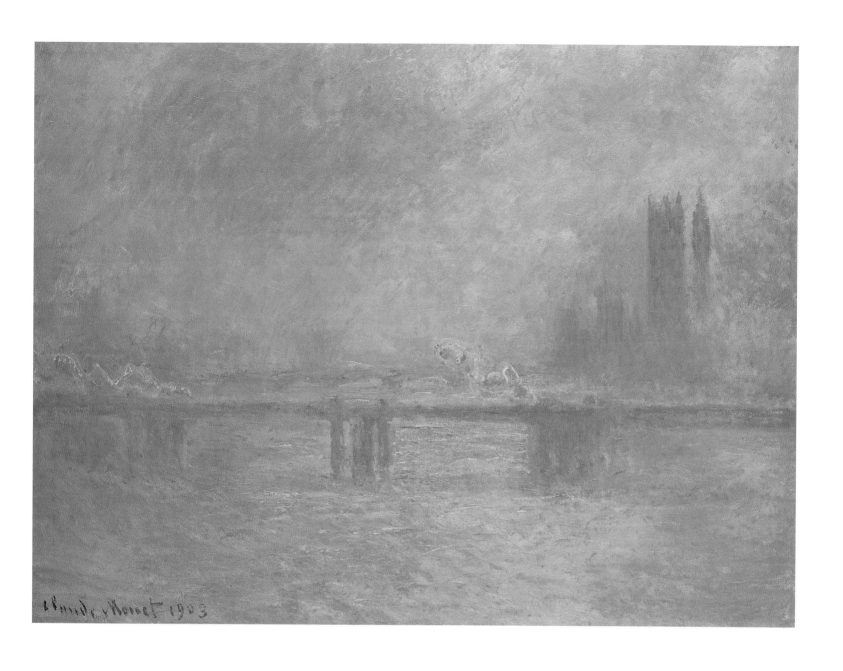

11 *Charing Cross Bridge, The Thames*, 1903, oil on canvas, 73 × 100 cm (W.1536). Yoshino Gypsum Co., Ltd. (deposited at Yamagata Museum of Art)

Exhibited Galerie Durand-Ruel, Paris, May – June 1904; bought from Monet in October 1905 by Durand-Ruel
and sold in December 1911 to Arthur B. Emmons, Newport, R.I.

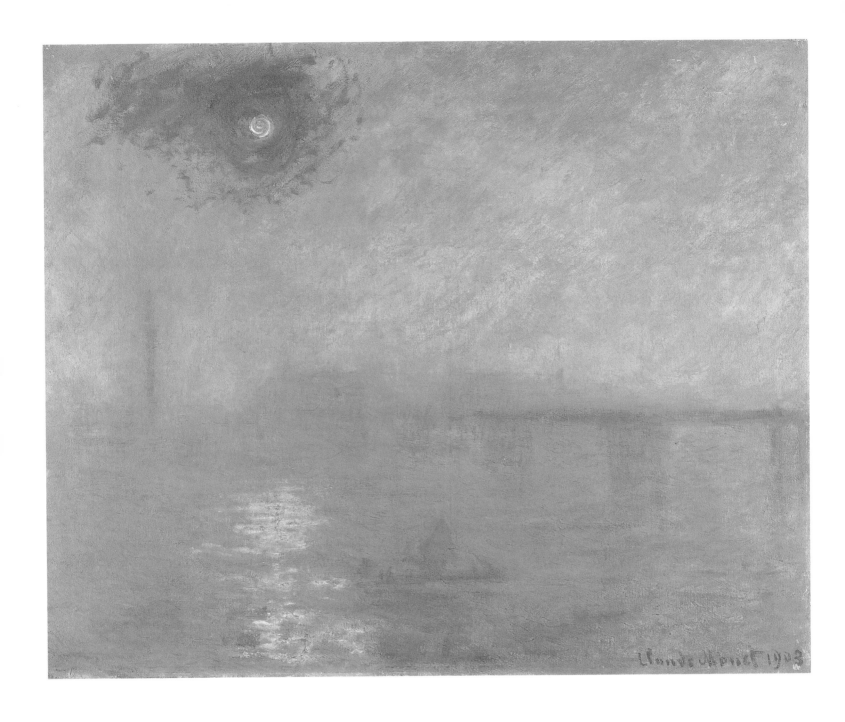

12 *Charing Cross Bridge, Fog on the Thames*, 1903, oil on canvas, 73 × 92 cm (W.1554). Fogg Art Museum,
Harvard University Art Museums, Gift of Mrs. Henry Lyman.

Exhibited at Galerie Durand-Ruel, Paris, May – June 1904; bought from Monet in December 1920 by Durand-Ruel and Bernheim-Jeune

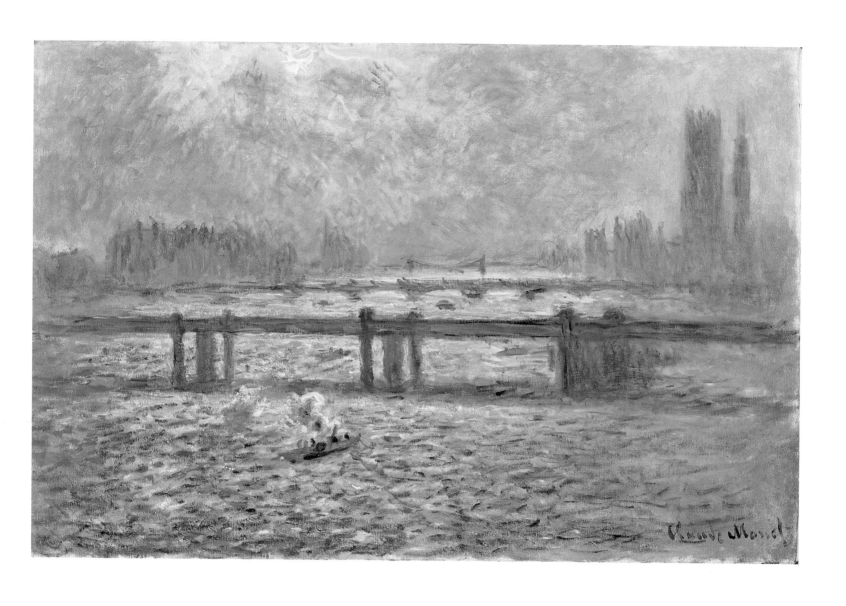

13 *Charing Cross Bridge, Reflections on the Thames*, 1899–1904, oil on canvas, 65 × 100 cm (W.1532). The Baltimore Museum of Art:
The Helen and Abram Eisenberg Collection

Not exhibited at Galerie Durand-Ruel, Paris, May – June 1904; bought from Monet in March 1917 by Durand-Ruel and Bernheim-Jeune

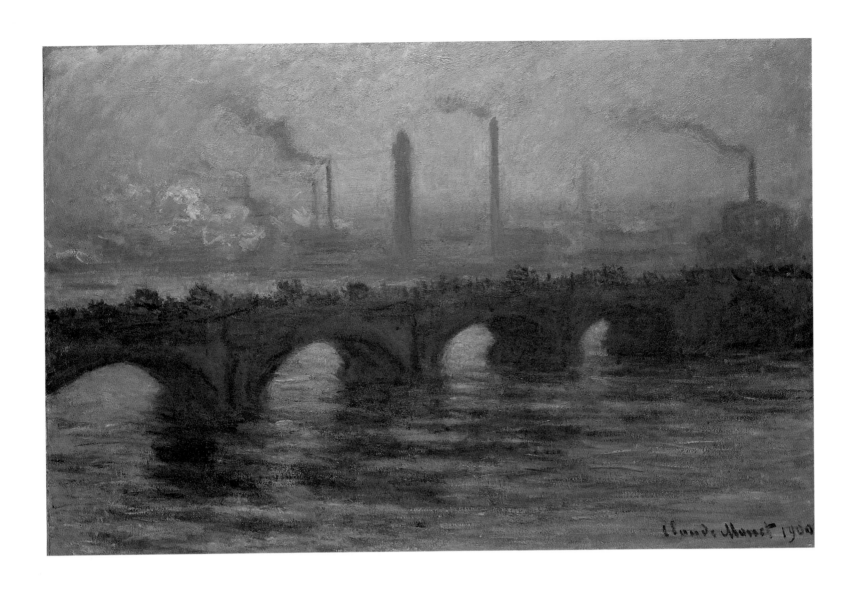

14 *Waterloo Bridge, Overcast Weather*, 1900, oil on canvas, 65 × 100 cm (W.1556). Hugh Lane Municipal Gallery of Modern Art, Dublin

Exhibited at Galerie Durand-Ruel, May – June 1904; bought from Monet in June 1904 and sold in April 1905 to Hugh Lane, London and Dublin

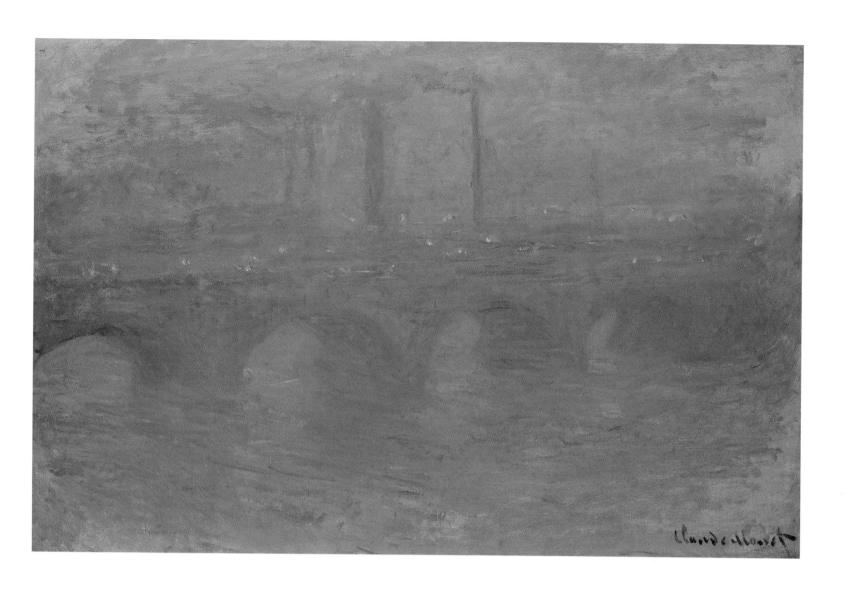

15 *Waterloo Bridge, Dusk*, 1904, oil on canvas, 65 × 100 cm (W.1564). National Gallery of Art, Washington,
Collection of Mr. and Mrs. Paul Mellon

Not exhibited at Galerie Durand-Ruel, May – June 1904; bought from Monet in December 1920 by Durand-Ruel and Bernheim-Jeune

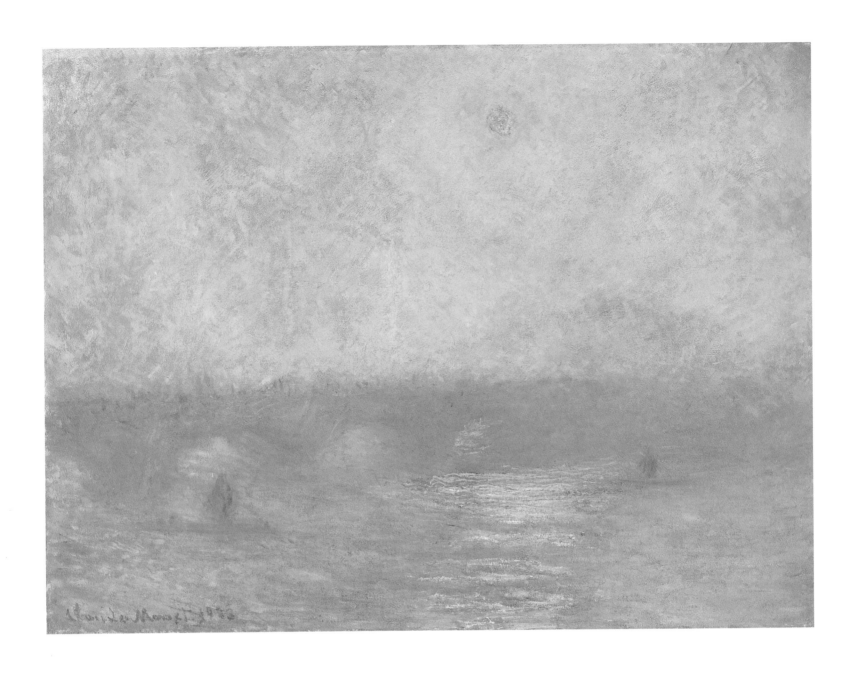

16 *Waterloo Bridge, Effect of Sunlight in the Fog*, 1903, oil on canvas, 73 × 100 cm (W.1573). National Gallery of Canada, Ottawa

Exhibited at Galerie Durand-Ruel, May – June 1904; bought from Monet in October 1905 by Durand-Ruel
and sold in February 1907 to William Lowell Putnam, Boston

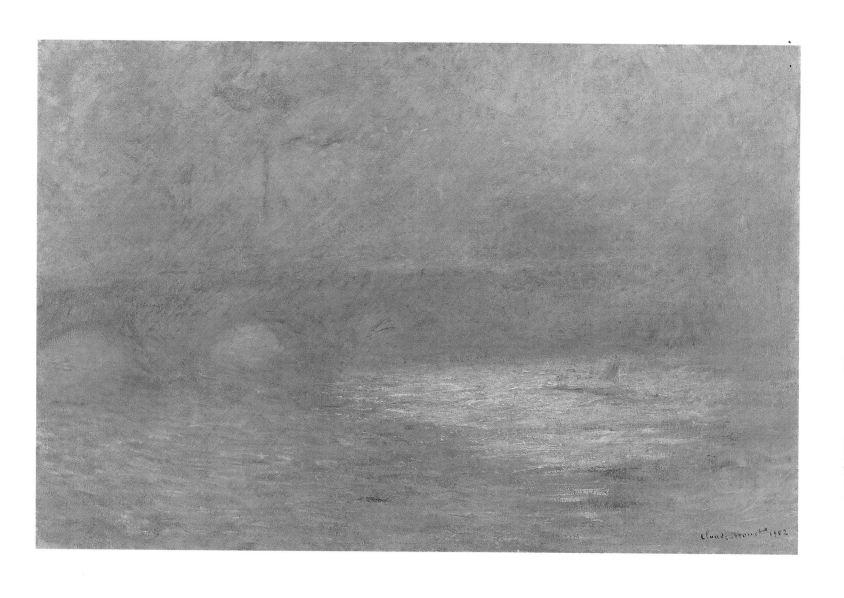

17 *Waterloo Bridge*, 1902, oil on canvas, 65 × 100 cm (W.1581). Kunsthaus Zürich, Donation Walter Haefner

Not exhibited at Galerie Durand-Ruel, Paris, May – June 1904; bought from Monet in October 1911 by Durand-Ruel

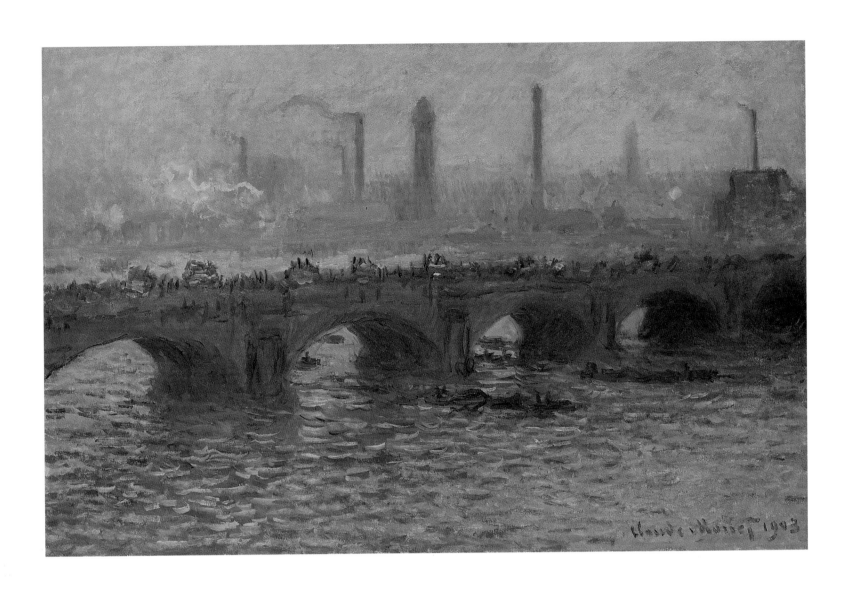

18 *Waterloo Bridge, Grey Weather*, 1903, oil on canvas, 65 × 100 cm (W.1561). Copenhagen, Ordrupgaardsamlingen

Exhibited at Galerie Durand-Ruel, Paris, May – June 1904; bought from Monet in December 1905 by Durand-Ruel

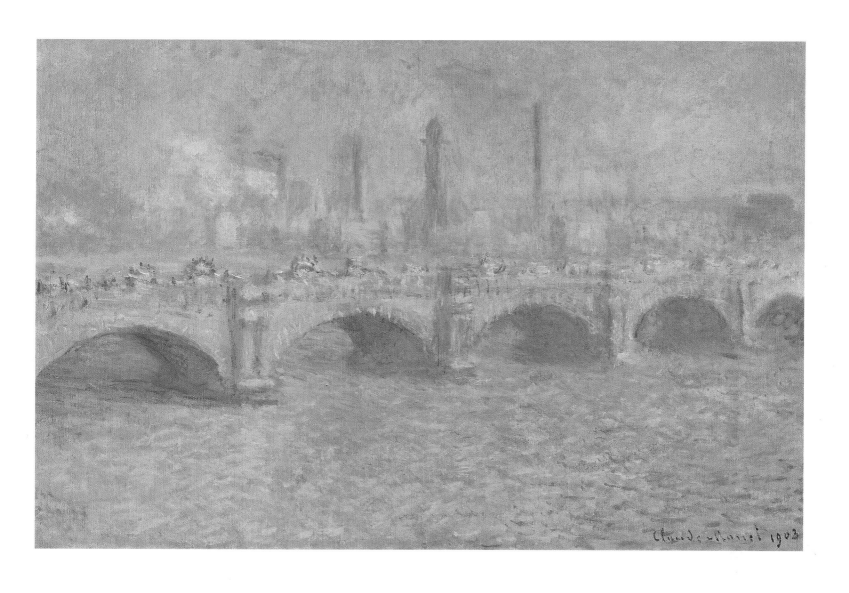

19 *Waterloo Bridge, Sunlight Effect*, 1903, oil on canvas, 65 × 100 cm (W.1587). Collection of McMaster University, Hamilton, Canada;
Gift of Dr. Herman Herzog Levy, OBE

Exhibited at Galerie Durand-Ruel, Paris, May – June 1904; bought from Monet in May 1904 by Durand-Ruel
and sold in November 1905 to Baron de Meyer, Datchet, Bucks., U.K.

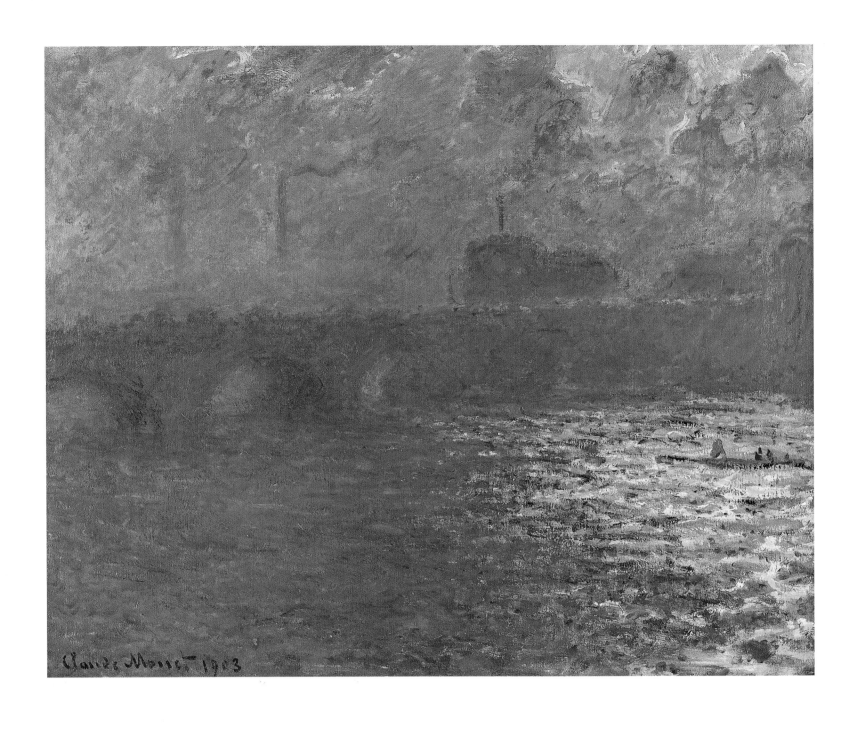

20 *Waterloo Bridge, Sunlight Effect*, 1903, oil on canvas, 73 × 92 cm (W.1567). Milwaukee Art Museum, Gift of Mrs. Albert T. Friedmann

Exhibited at Galerie Durand-Ruel, Paris, May – June 1904; bought from Monet in May 1904 by Durand-Ruel
and sold in October 1904 to Paul Cassirer, Berlin

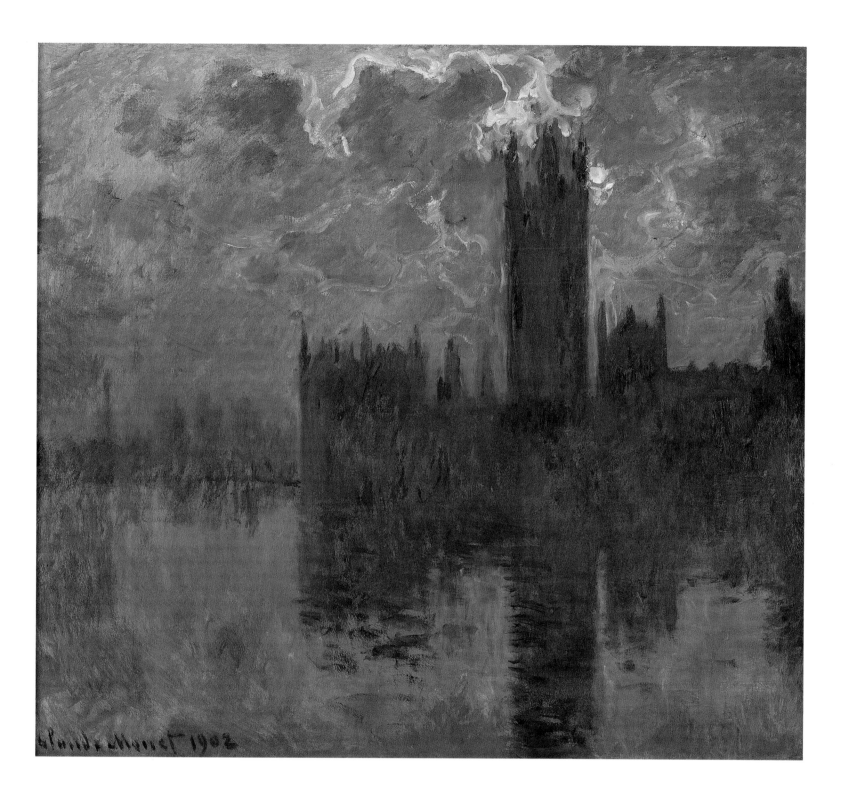

20a *Houses of Parliament, Sunset*, 1902, oil on canvas, 81 × 92 cm (W.1603). Private Collection

Exhibited at Galerie Durand-Ruel, Paris, 1904; bought from Monet in May 1904 by Durand-Ruel
and sold within the year to P. van de Velde, Le Havre

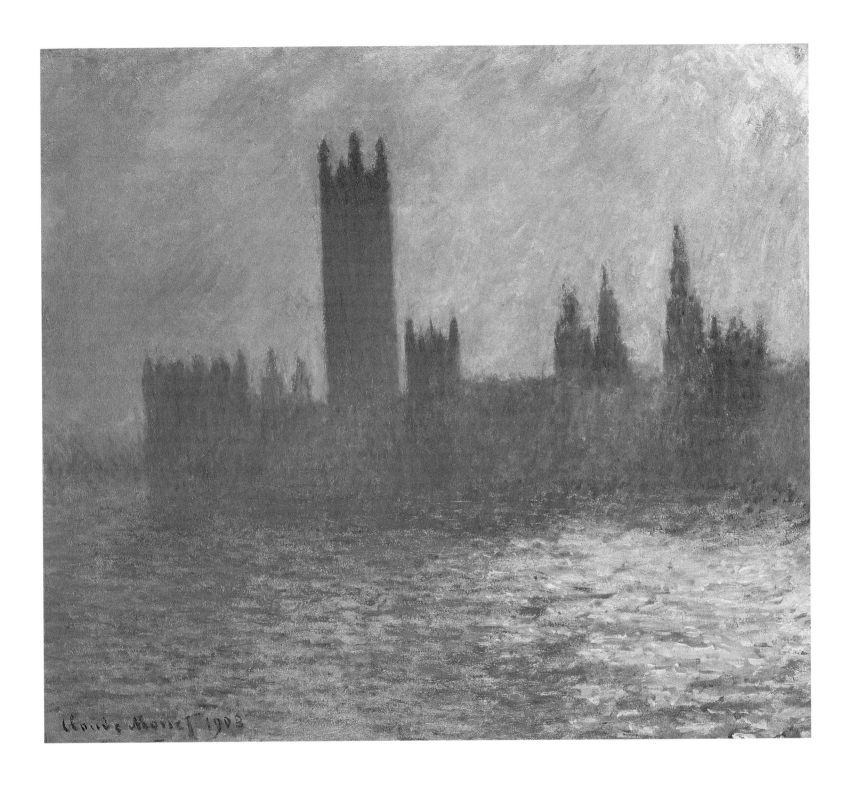

21 *Houses of Parliament, Sunlight Effect,* 1903, oil on canvas, 81 × 92 cm (W.1597). Brooklyn Museum of Art,
Bequest of Grace Underwood Barton

Exhibited at Galerie Durand-Ruel, Paris, May – June 1904; bought from Monet in May 1904 by Durand-Ruel

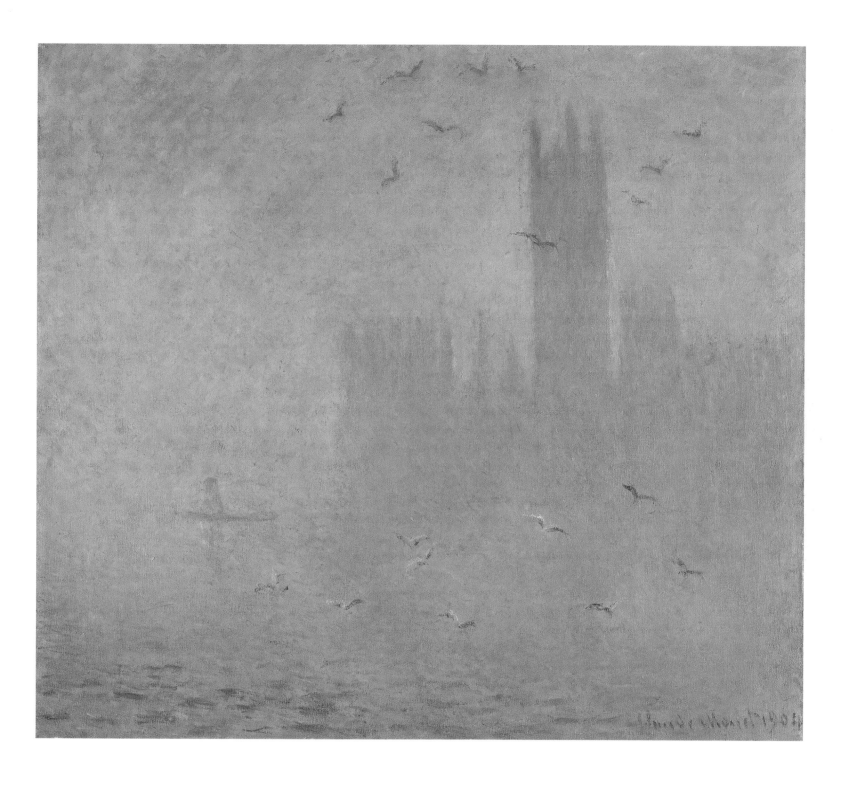

22 *Houses of Parliament, Seagulls*, 1904, oil on canvas, 81 × 92 cm (W.1613). Pushkin State Museum of Fine Arts, Moscow

Exhibited at Galerie Durand-Ruel, Paris, May – June 1904; bought from Monet in May 1904 by Durand-Ruel
and sold in November 1904 to S. I. Shchoukine, Moscow

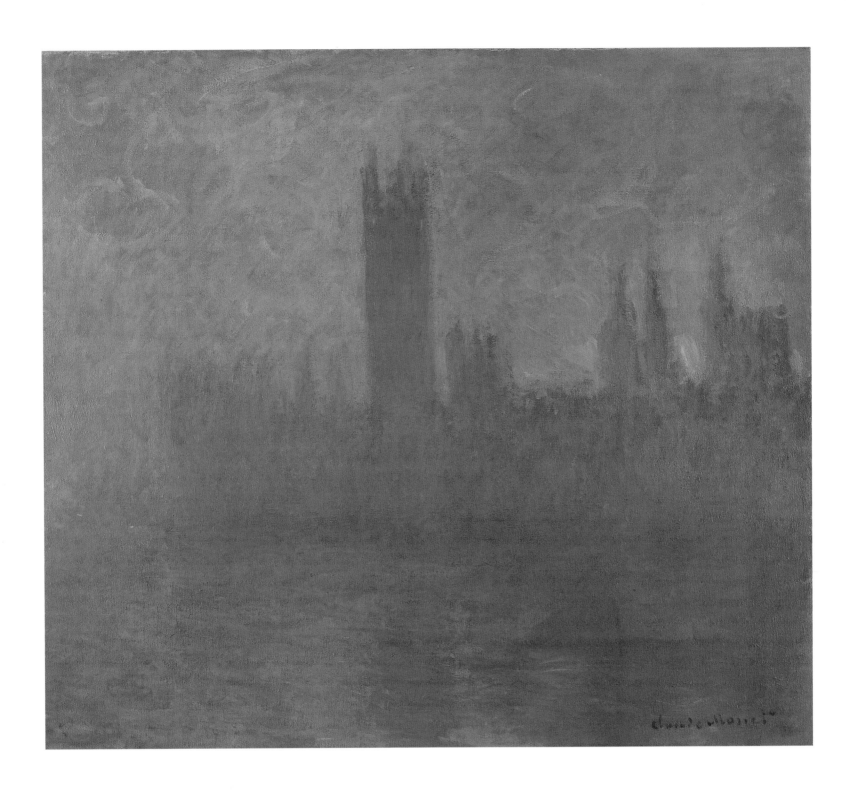

23 *Houses of Parliamen, Symphony in Rose*, 1900–01, oil on canvas, 81 × 92 cm (W.1599). Private Collection, Japan

Not exhibited at Galerie Durand-Ruel, Paris, May – June 1904; possibly given by Monet before 1916 to Lamberjack in exchange for a car

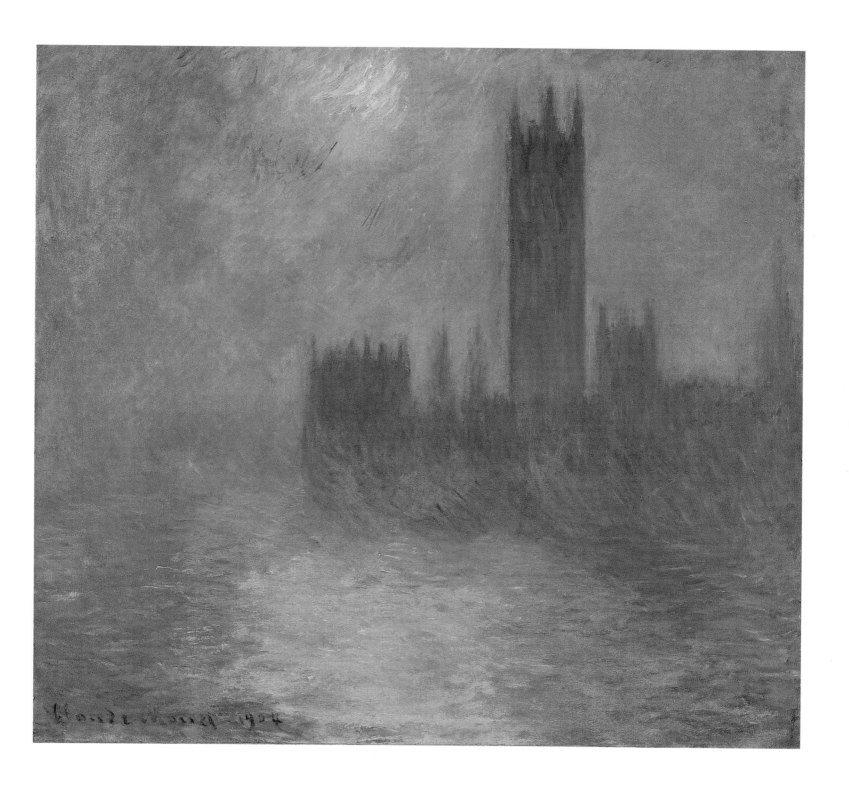

24 *Houses of Parliament, Sunset*, 1904, oil on canvas, 81 × 92 cm (W.1607). Kunsthaus Zürich, Donation Walter Haefner

Not exhibited at Galerie Durand-Ruel, Paris, May – June 1904; bought from Monet in October 1905
and sold in December 1905 to Charles Harrison Tweed, New York

The most extensive and most significant of Monet's series exhibitions in the twentieth century took place at Durand-Ruel between May 6 and June 5, 1909. The exhibition was entitled *Les Nymphéas: Séries de paysages d'eau* and featured a group of radically innovative "water landscapes" depicting the water lilies (*nymphéas*) that grew in the pond in Monet's Giverny garden. The exhibition was a profound success for Monet: his dealers purchased a large number of the paintings before the exhibition opened; the critical reception of the Water Lilies was uniformly enthusiastic; and the public was thus made aware that once again Monet had challenged the canon of landscape painting, this time through dream-like evocations of the natural world inverted and reflected in the spangled surface of the water.

The forty-eight paintings on view were the fruit of five years of labor, beginning in the summer of 1903 – before the London paintings exhibition – and culminating in the summer and autumn of 1908. In 1901–2 Monet had enlarged the pond in the water garden, greatly increasing its surface area and providing more room for the cultivation of water lilies. Although it is recorded that he had treated isolated clumps of flowers and foliage as early as 1897, and had shown the flower-dappled surface of the pond beneath the bridges of 1899 and 1900, it was only after the enlargement of the pond that Monet began to treat its surface as a motif in itself. The first such canvases, from 1903, demonstrate the painter's tentative exploration of the subject, his will to anchor the viewer in space by the inclusion of the distant bank or a lanky shock of willow boughs falling into the composition at upper left (see cat. 25). Five canvases dated 1904 – another is lost – likewise depict a distant bank fringing the upper margin of the compositions (see cats. 26 and 27); since the trees reflected in the water are captured in such great detail, as is the case in catalogue number 26, this barely perceptible "horizon" is crucial to the grounding of the image in the viewer's space. Three other canvases from 1904 show the Japanese bridge from the eastern bank of the pond, in a conventionally picturesque conception of the landscape (see W.1668, W.1669, and W.1670).

Not until 1905, it seems, did Monet completely eliminate any directly depicted image of the world above the horizon, turning his vision downward on to the surface of the pond and seeing trees and sky only as reflections. Between 1905 and 1907 the painter completed some two dozen canvases employing this consistent formula, in which horizontally striated islands of flowers and leaves are juxtaposed with the undulating reflections of the world above the water, forms that are perceived by the viewer as the vertical axis of the composition (see cats. 28–34). This perceptual play of horizontal flowers (seen directly) and vertical trees and sky (seen as if in a mirror) is then further complicated: conventional spatial recession, indicated by the diminishing scale of the flowers and leaves, is played against the flat surface of the canvas, made apparent by the vigorous, textural brushwork with which most of the paintings are elaborated. The square format of many of these compositions served to balance the play of horizontal and vertical elements, but in 1907 Monet introduced two further options. In a group of circular canvases, he strove to balance vertical and horizontal through the elimination of any axial bias (see cats. 35 and 36); two more were completed in 1908 (cats. 37 and 38). In a group of some fifteen emphatic verticals, he gave strong preference to the reflected image of trees and, above all, sky (see cats. 39–43). In the summer of 1908 a last group of thirteen canvases was made, in which the question of axial orientation was largely put aside in favor of a growing interest in painterly and coloristic effects, pulling both the directly observed lilies and the trees and sky seen in reflection forward towards the surface of the canvas itself (see cats. 44–8).

Monet and Durand-Ruel balanced these groups carefully in selecting the paintings for exhibition in 1909. Generally, they eliminated the most conservative paintings: only one of the 1903 pictures (cat. 25), and only one of the views of the bridge from 1904 were chosen. Five of the 1904 square-format views were shown, including catalogue numbers 26 and 27. The canvases of 1905–7 – the most "classic" of all the views – were represented by some seventeen compositions, including catalogue numbers 28–30 and 32–4. (Catalogue number 31, which is part of this group, was not exhibited in 1909.) All four of the circular canvases were included (cats. 35–8). In spite of Durand-Ruel's initial distaste for the 1907 vertical compositions, thirteen of the fourteen finished paintings of this type were selected for inclusion in the catalogue (one was eliminated in the hanging of the exhibition), including catalogue numbers 39–43. Finally, a group of seven 1908 *Water Lilies* was assembled for display (see cats. 44–8).

Both before and during the exhibition Durand-Ruel found clients for the paintings. The earliest buyers, from the summer of 1909, included the Parisians Henry Bernstein (cat. 32) and Eugène Hirsch (cat. 30), as well as Sarah Choate Sears of Boston (W.1674). The following months saw the Water Lilies make their way across the Atlantic in great profusion: In

December 1909 Alexander Cochrane of Boston purchased two Water Lily compositions (cats. 28 and 33); other collectors in New York, Boston, and Denver bought canvases throughout 1910 and 1911 (see cats. 26, 29, 34, 42); and in July 1910, the Worcester Art Museum became the first American institution to acquire a painting by Monet by purchase (cat. 45). Thus, in spite of the suggestion in the press that the Water Lilies should be kept together as a group, in recognition of their success as a decorative ensemble, the paintings were dispersed to a wide variety of owners. It is noteworthy that one Parisian collector, Henri Canonne, who owned in the course of his career some forty paintings by Monet, purchased his first Water Lily around 1920 (cat. 39) and went on, by 1924, to purchase ten others (none of which is exhibited here). Thus at the time that Monet was known to be feverishly at work on his *Grandes Décorations* a collector was assembling for himself an unparalleled ensemble of easel pictures on the same theme: these paintings were dispersed once more in 1939 and 1942.

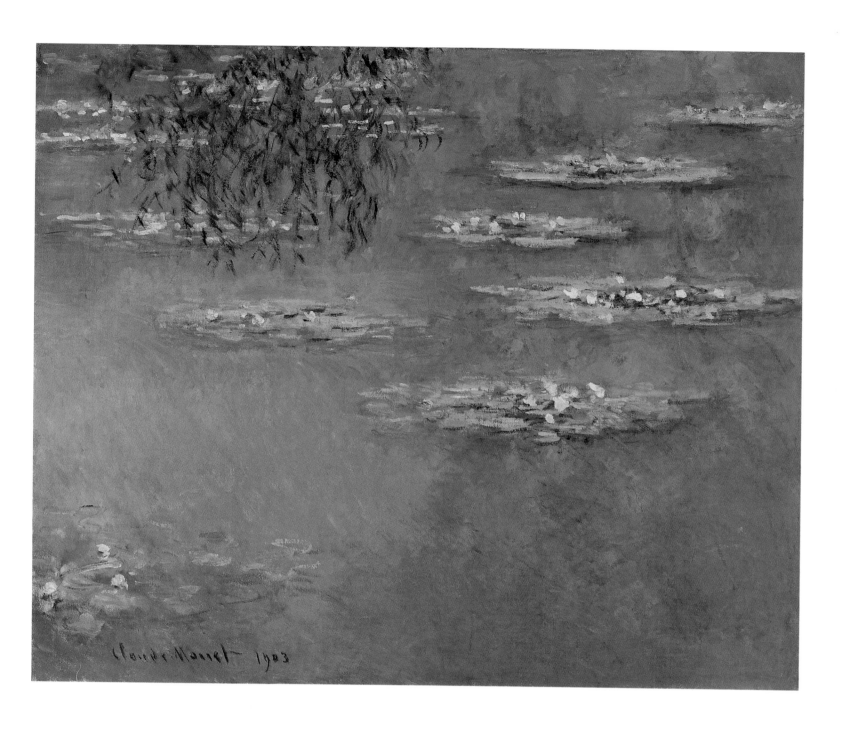

25 *Water Lilies*, 1903, oil on canvas, 81 × 100 cm (W.1657). The Dayton Art Institute, Gift of Mr. Joseph Rubin

Exhibited at Galerie Durand-Ruel, Paris, May – June 1909; bought from Monet in April 1911 by Durand-Ruel and Bernheim-Jeune

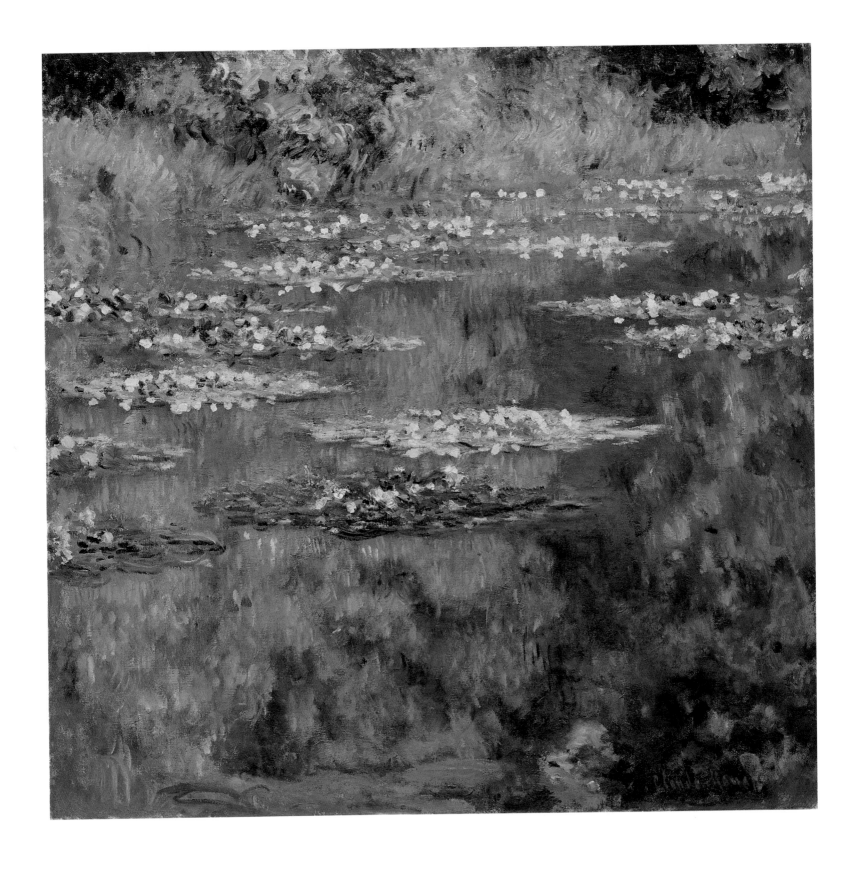

26 *Water Lilies*, 1904, oil on canvas, 89 × 92 cm (W.1666). Denver Art Museum, Funds from the Helen Dill bequest

Exhibited at Galerie Durand-Ruel, Paris, May – June 1909; bought from Monet in June 1909 by Durand-Ruel and Bernheim-Jeune
and sold in 1911 to Katherine A. Toll, Denver

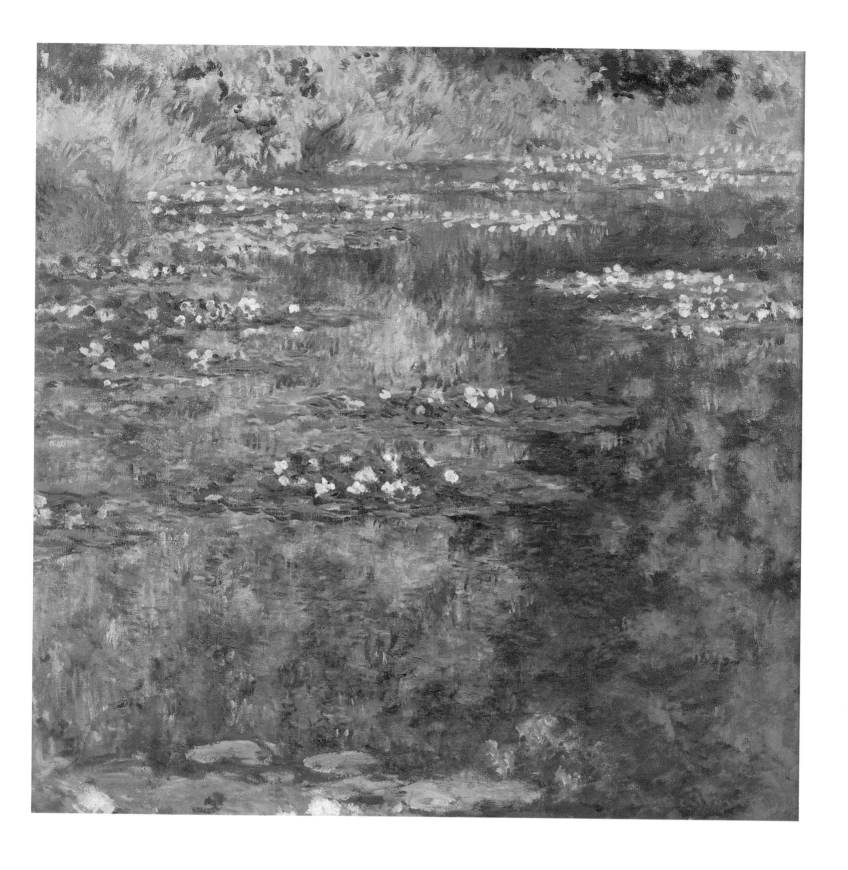

27 *Water Lilies*, 1904, oil on canvas, 90 × 92 cm (W.1667). Recovered after World War II and placed in trust with
the Musées Nationaux de France; Caen, Musée des Beaux-Arts (dépôt du Musée d'Orsay)

Exhibited at Galerie Durand-Ruel, Paris, May – June 1909; returned to Monet after the exhibition
and lent 1910–13 to the Gobelins Tapestry Studio, Paris

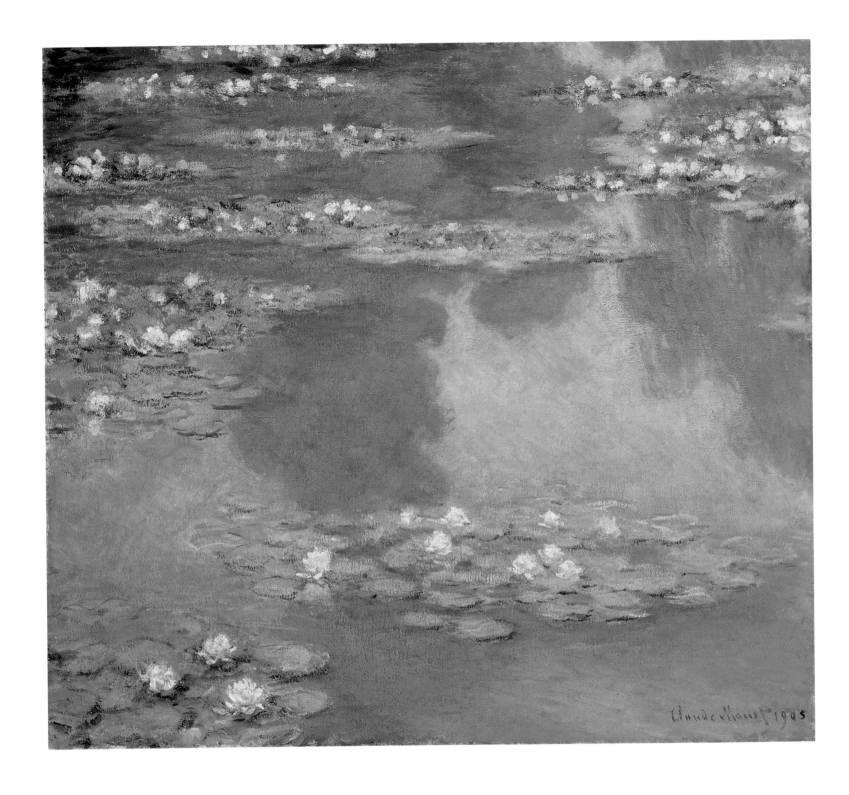

28 *Water Lilies*, 1905, oil on canvas, 90 × 100 cm (W.1671). Museum of Fine Arts, Boston. Gift of Edward Jackson Holmes

Exhibited at Galerie Durand-Ruel, Paris, May – June 1909; bought from Monet in June 1909 by Durand-Ruel and Bernheim-Jeune
and sold on December 10, 1909 to Alexander Cochrane, Boston

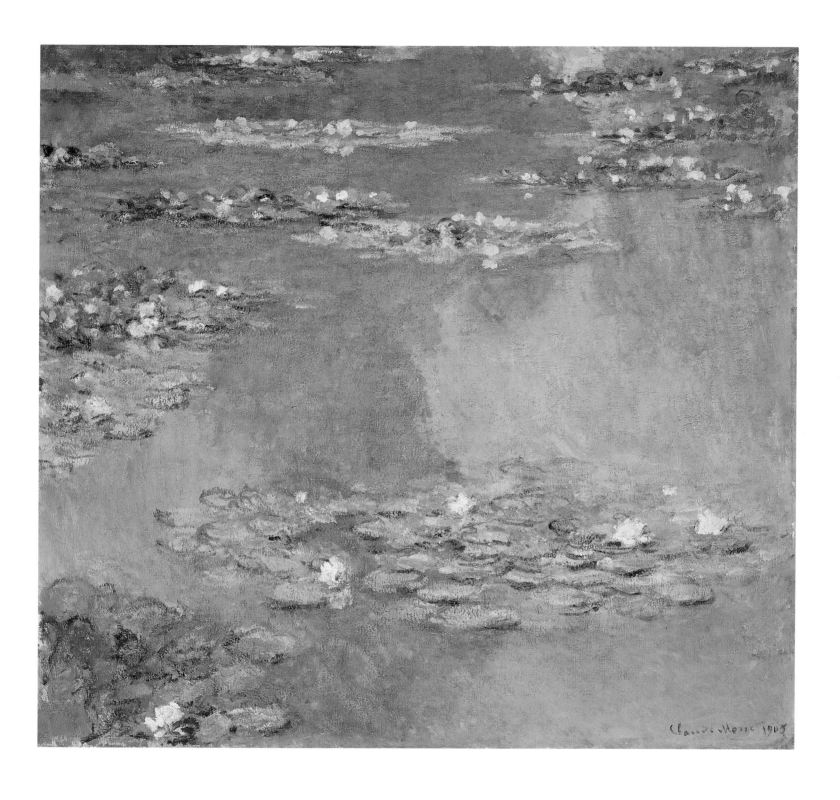

29 *Water Lilies*, 1905, oil on canvas, 90 × 100 cm (W.1672). Private Collection (courtesy of Hirschl & Adler Galleries, New York)

Exhibited at Galerie Durand-Ruel, Paris, May – June 1909; bought from Monet in June 1909 by Durand-Ruel and Bernheim-Jeune

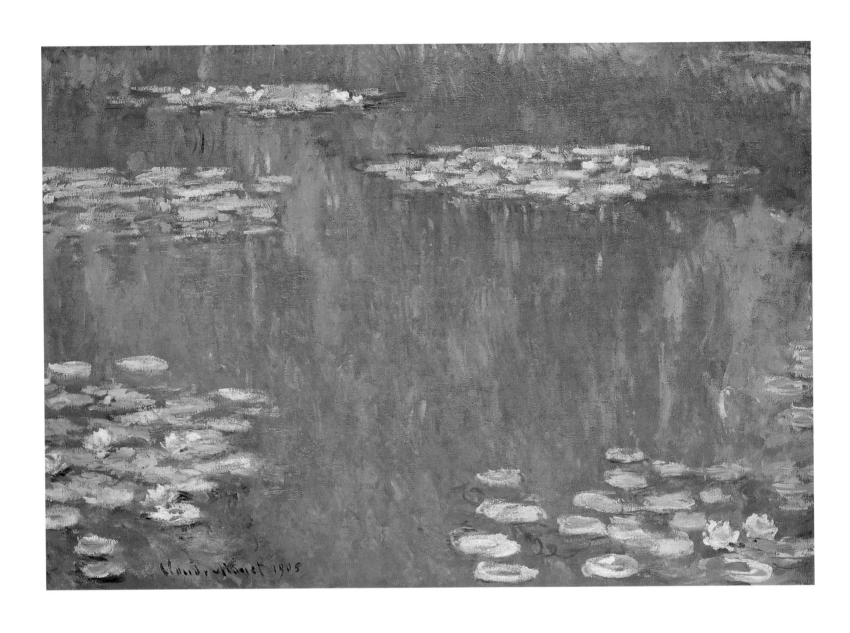

30 *Water Lilies*, 1905, oil on canvas, 73 × 105 cm (W.1678). Private Collection

Exhibited at Galerie Durand-Ruel, Paris, May – June 1909; bought from Monet in June 1909 by Durand-Ruel and Bernheim-Jeune
and sold during the exhibition to Eugene Hirsch, Paris

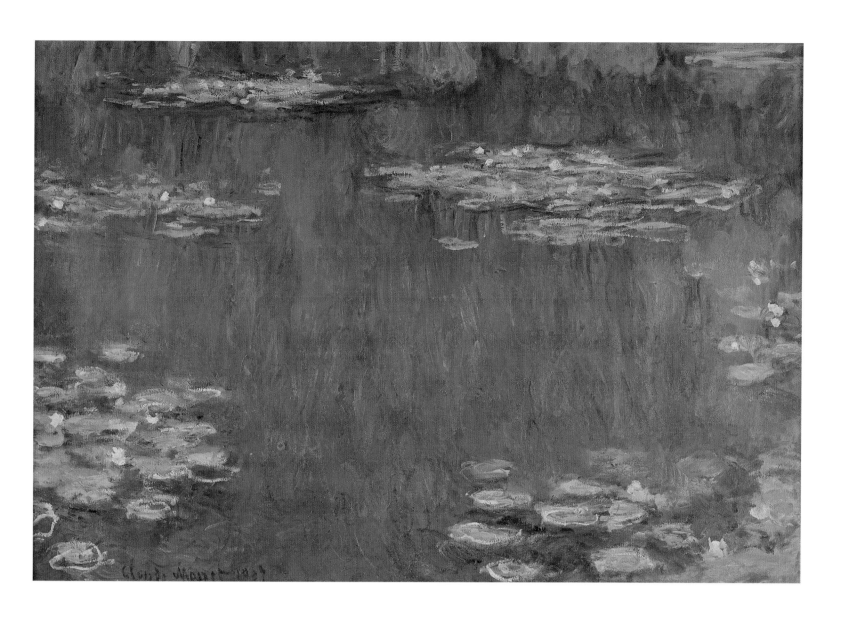

31 *Water Lilies*, 1905–7, oil on canvas, 73 × 100 cm (W.1682). Private Collection

Not exhibited at Galerie Durand-Ruel, Paris, May – June 1909; bought from Monet in August 1923 by Bernheim-Jeune

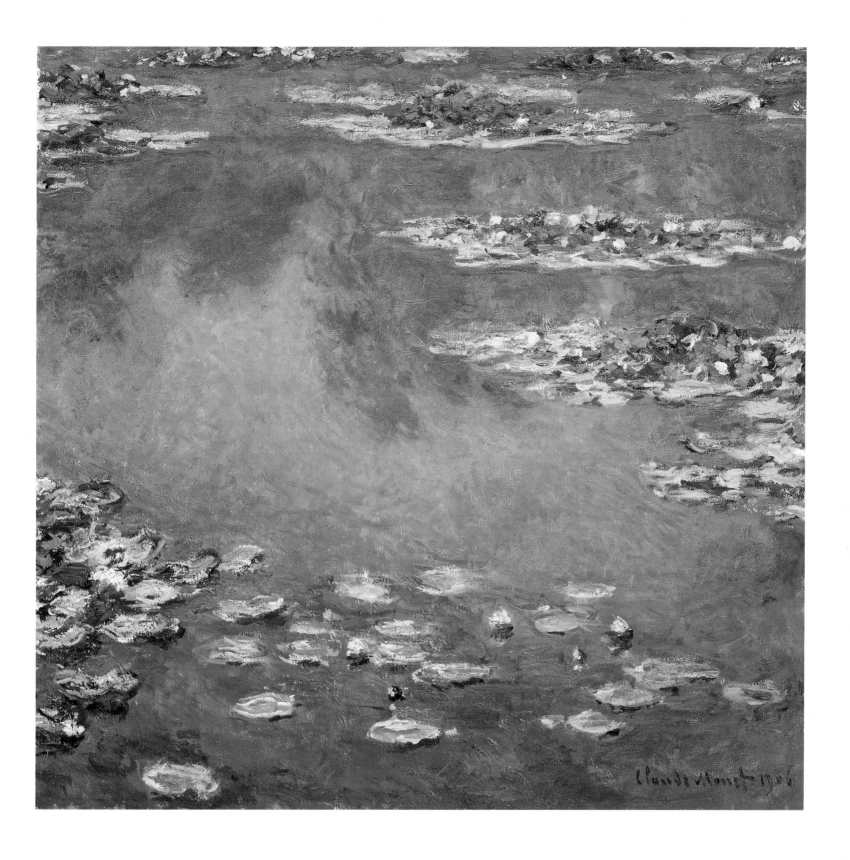

32 *Water Lilies*, 1906, oil on canvas, 90 × 93 cm (W.1683). The Art Institute of Chicago, Mr. and Mrs. Martin A. Ryerson Collection

Exhibited at Galerie Durand-Ruel, Paris, May – June 1909; bought from Monet in June 1909 by Durand-Ruel and Bernheim-Jeune
and eventually sold in 1914 to Martin A. Ryerson, Chicago

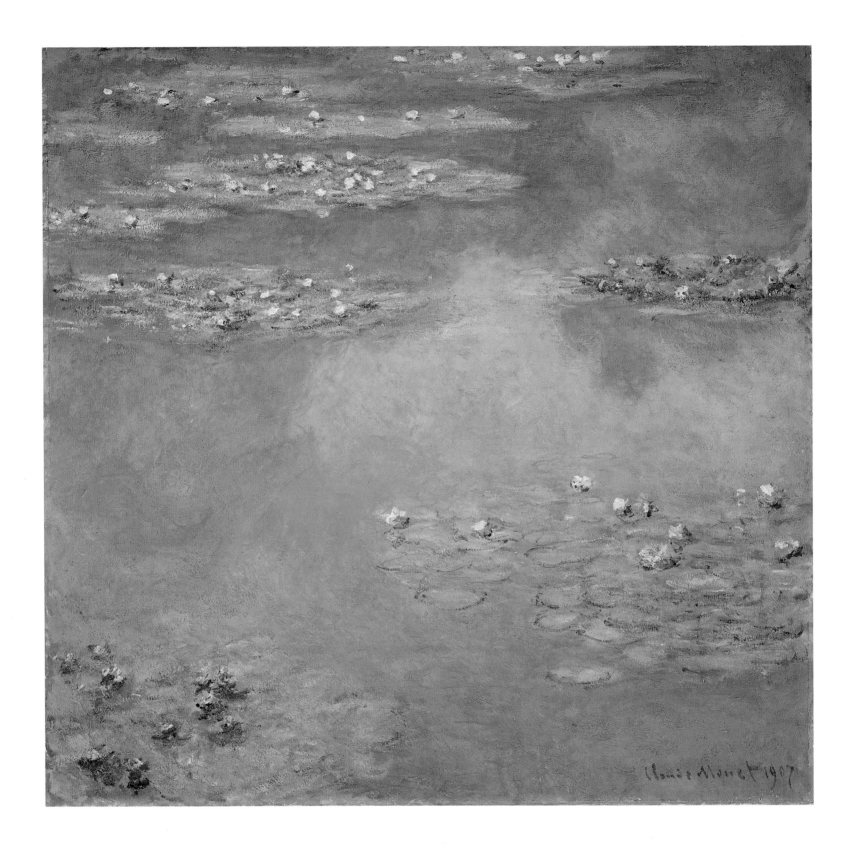

33 *Water Lilies*, 1907, oil on canvas, 90 × 93 cm (W.1697). Museum of Fine Arts, Boston. Bequest of Alexander Cochrane

Exhibited at Galerie Durand-Ruel, Paris, May – June 1909; bought from Monet in June 1909 by Durand-Ruel and Bernheim-Jeune
and sold in December 1909 to Alexander Cochrane, Boston

34 *Water Lilies*, 1907, oil on canvas, 93 × 89 cm (W.1699). Private Collection, Japan

Exhibited at Galerie Durand-Ruel, Paris, May – June 1909; bought from Monet in June 1909 by Durand-Ruel and Bernheim-Jeune
and sold the same year to Cornelius Bliss, New York

35 *Water Lilies*, 1907, oil on canvas, diameter 81 cm (W.1702). Private Collection

Exhibited at Galerie Durand-Ruel, Paris, May – June 1909; given by Monet in 1914 to Sasha Guitry, Paris

36 *Water Lilies*, 1907, oil on canvas, diameter 81 cm (W.1701). Musée d'Art Moderne de Saint-Etienne

Exhibited at Galerie Durand-Ruel, Paris, May – June 1909; sold by Monet in 1924 to the City of Saint-Etienne

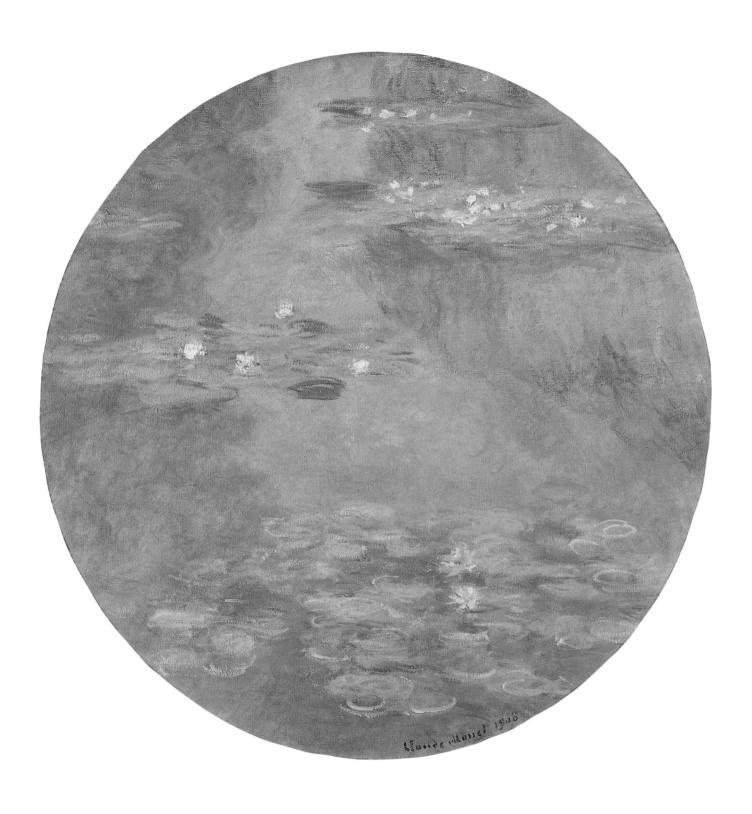

37　*Water Lilies*, 1908, oil on canvas, diameter 90 cm (W.1724). Musée municipal A.G. Poulain, Vernon

Exhibited at Galerie Durand-Ruel, Paris, May – June 1909; returned to Monet after the exhibition
and lent 1910–13 to the Gobelins Tapestry Studio, Paris

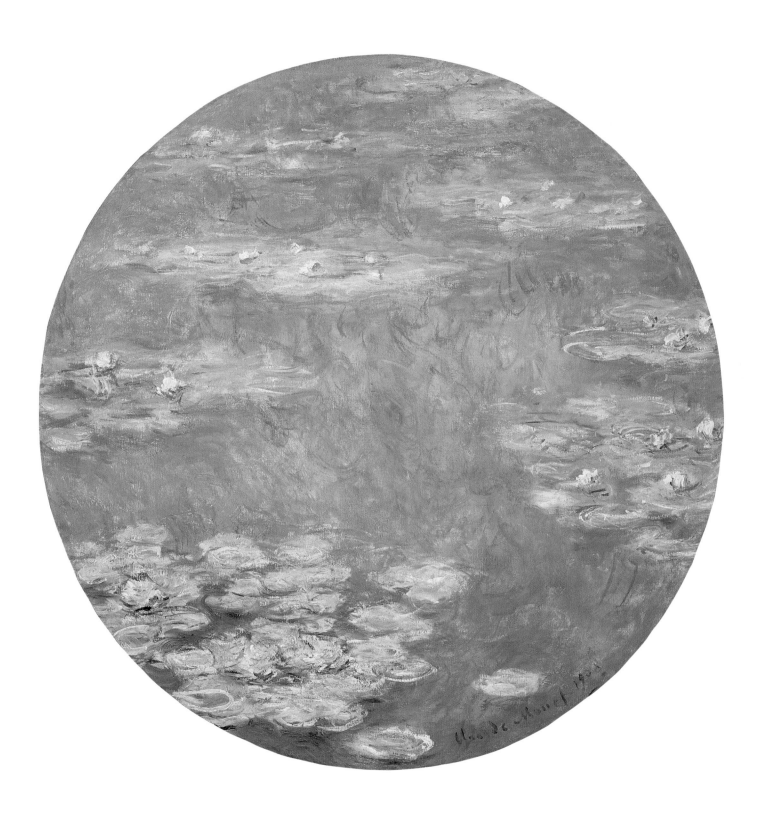

38 *Water Lilies*, 1908, oil on canvas, diameter 81 cm (W.1729). Dallas Museum of Art, Gift of the Meadows Foundation, Incorporated

Exhibited at Galerie Durand-Ruel, Paris, May – June 1909; offered by Monet in 1918 to a charity sale at Galerie Georges Petit, Paris

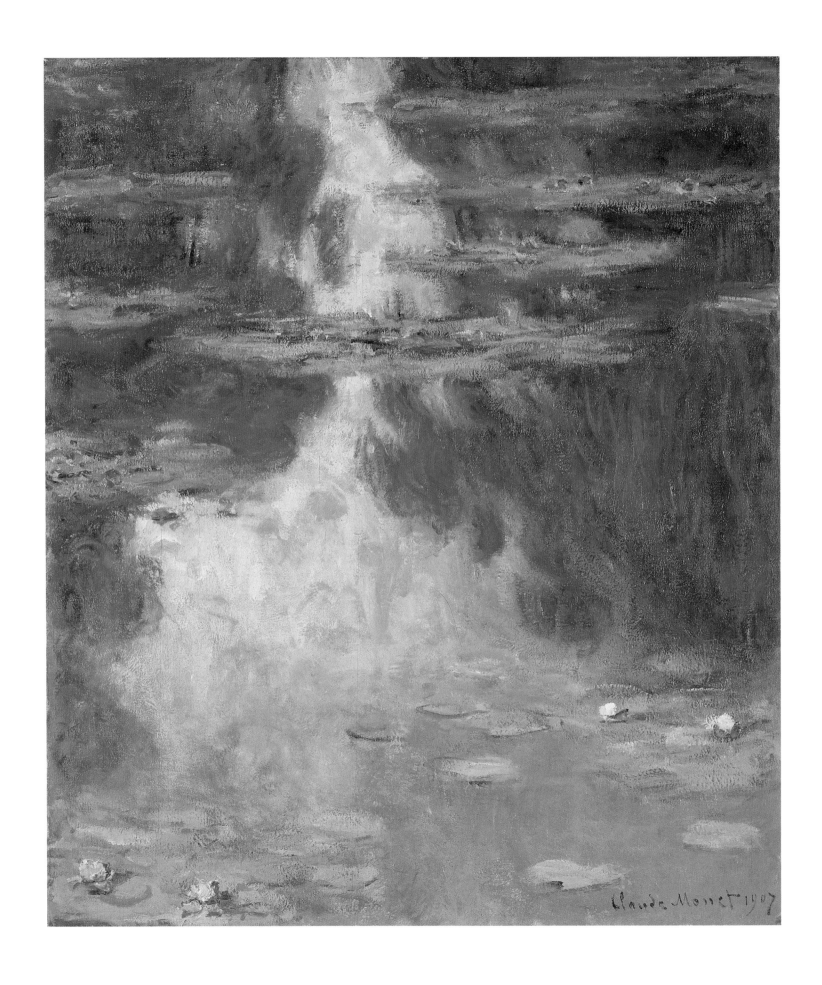

39 *Water Lilies*, 1907, oil on canvas, 92 × 81 cm (W.1703). The Museum of Fine Arts, Houston; Gift of Mrs. Harry C. Hanszen

Exhibited at Galerie Durand-Ruel, Paris, May – June 1909; bought from Monet in May 1920 by Durand-Ruel and Bernheim-Jeune

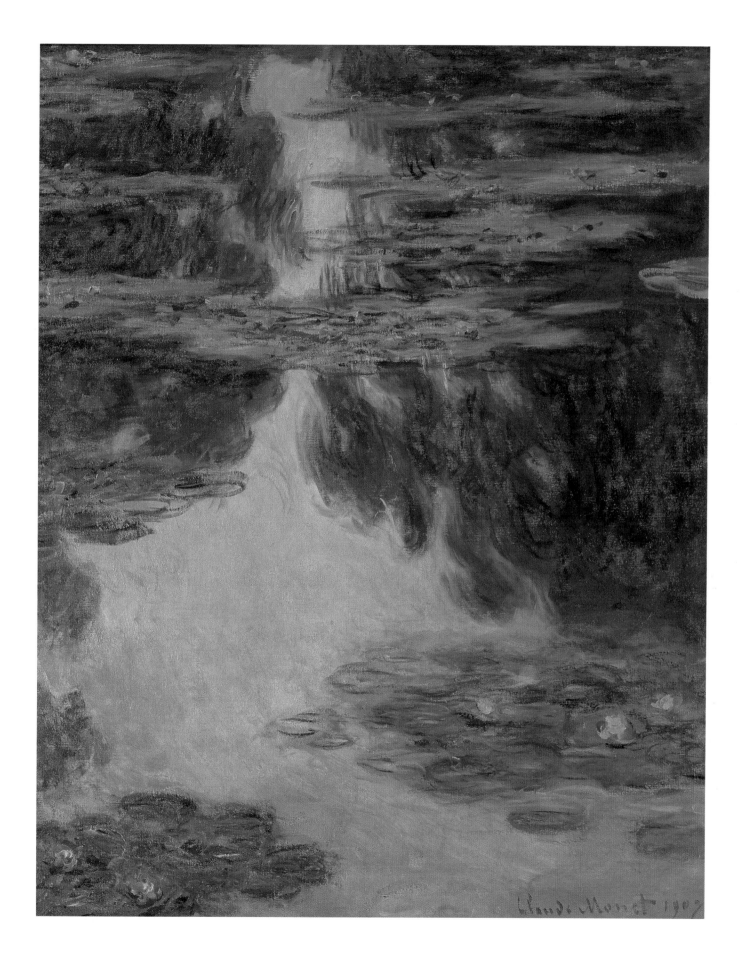

40 *Water Lilies*, 1907, oil on canvas, 92 × 73 cm (W.1705). Private Collection

Exhibited at Galerie Durand-Ruel, Paris, May – June 1909; offered by Monet in February 1918 for a charity sale at the Janson-de-Sailly Hospital,
Paris, in aid of the First World War wounded

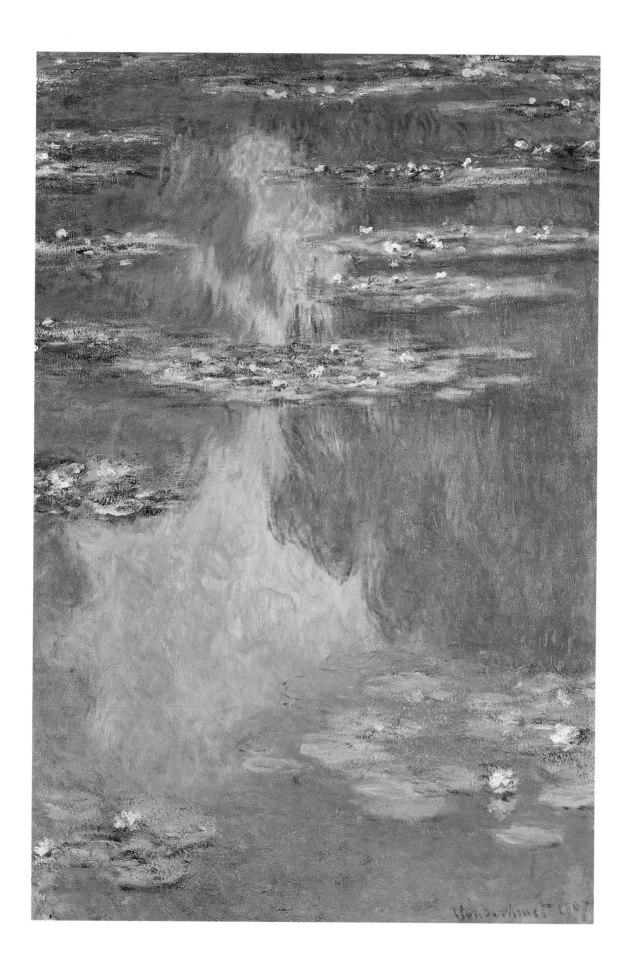

41 *Water Lilies*, 1907, oil on canvas, 106 × 73 cm (W.1709). Private Collection

Exhibited at Galerie Durand-Ruel, Paris, May – June 1909; bought from Monet in August 1910 by Durand-Ruel and Bernheim-Jeune
and sold in October 1911 to Hunt Henderson, New Orleans

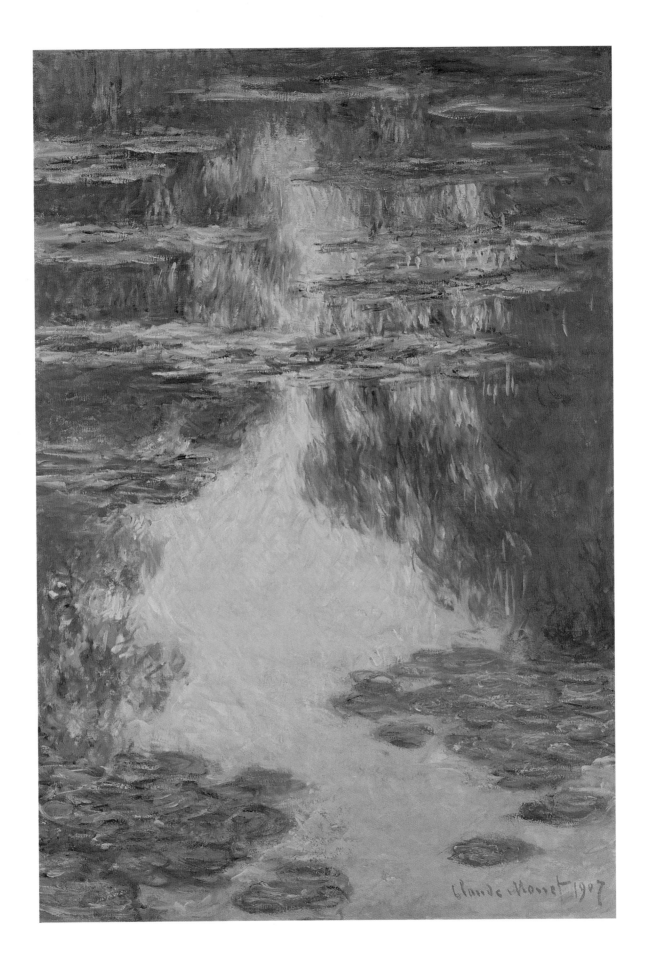

42 *Water Lilies*, 1907, oil on canvas, 105 × 73 cm (W.1716). Göteborg Museum of Art, Göteborg, Sweden

Exhibited at Galerie Durand-Ruel, Paris, May – June 1909; bought from Monet in June 1909 by Durand-Ruel and Bernheim-Jeune
and sold by the former in 1911 to Harris Wittemore, Naugatuck, R.I.

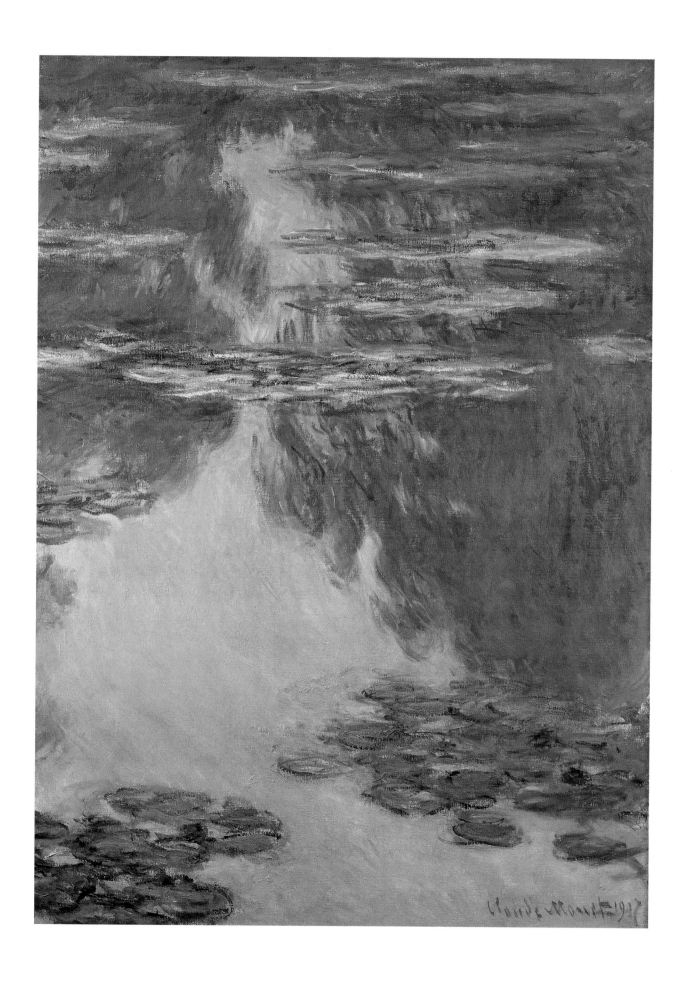

43 *Water Lilies*, 1907, oil on canvas, 100 × 73 cm (W.1715). Bridgestone Museum of Art, Ishibashi Foundation, Tokyo

Exhibited at Galerie Durand-Ruel, Paris, May – June 1909; bought from Monet between 1919 and 1922 by Sanji Kuroki, Tokyo

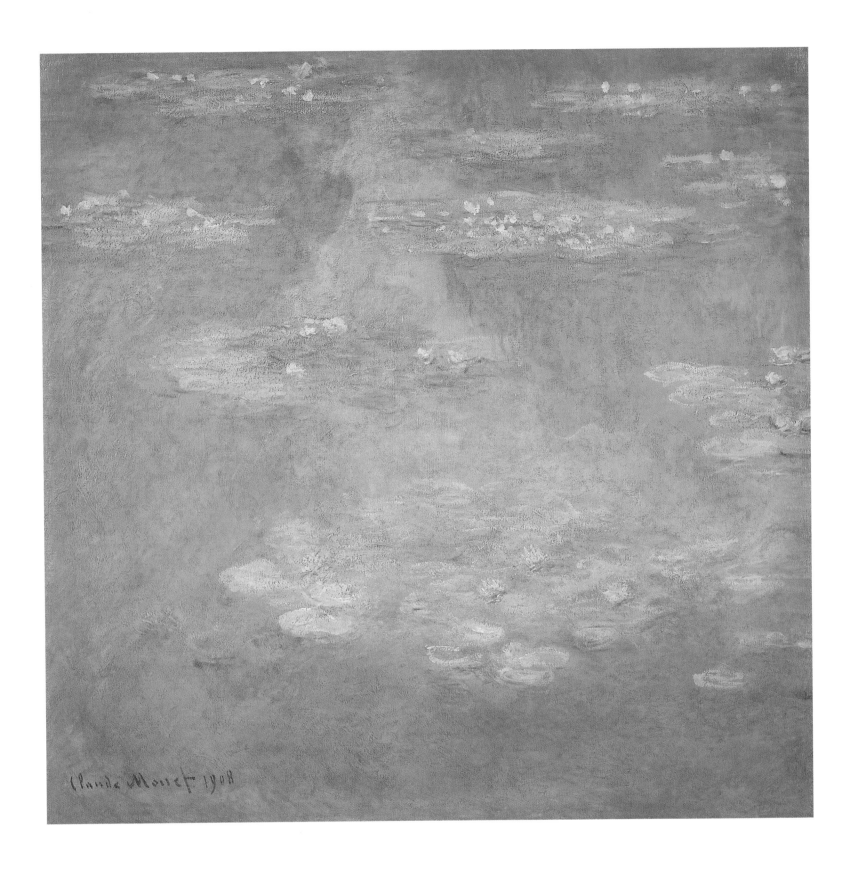

44 *Water Lilies*, 1908, oil on canvas, 90 × 92 cm (W.1721). Private Collection, Japan

Exhibited at Galerie Durand-Ruel, Paris, May – June 1909; bought from Monet in March 1913 by Durand-Ruel and Bernheim-Jeune

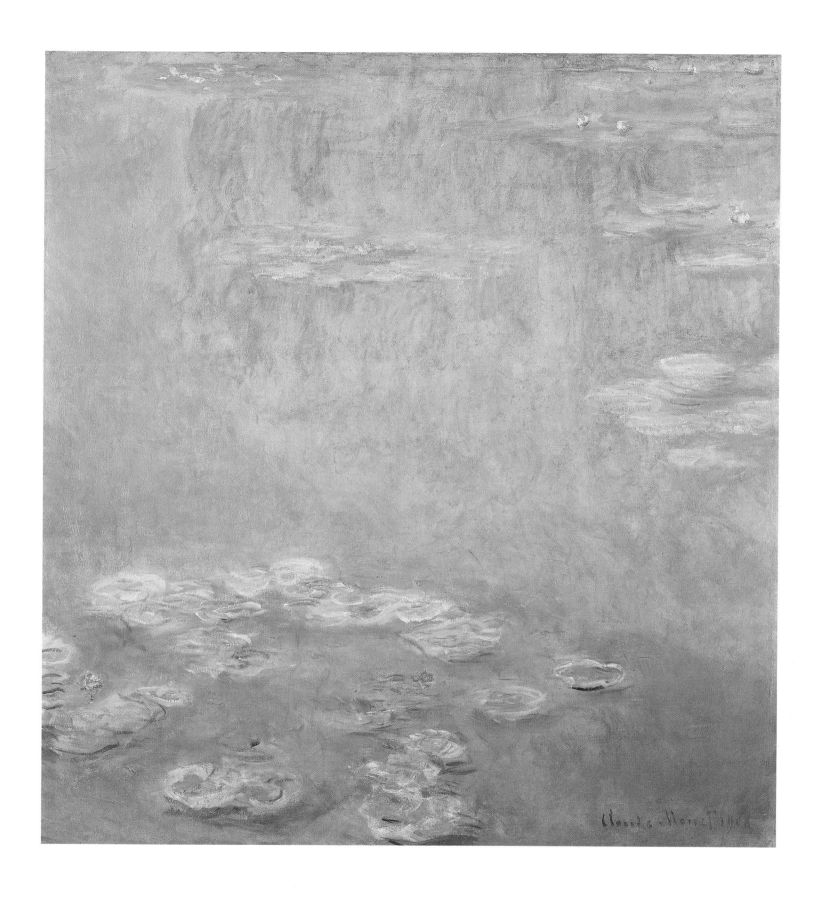

45 *Water Lilies*, 1908, oil on canvas, 92 × 90 cm (W.1733). Worcester Art Museum, Worcester, Massachusetts, Museum purchase

Exhibited at Galerie Durand-Ruel, Paris, May – June 1909; bought from Monet in May 1910 by Durand-Ruel and Bernheim-Jeune
and sold by the former in July 1910 to the Worcester Art Museum

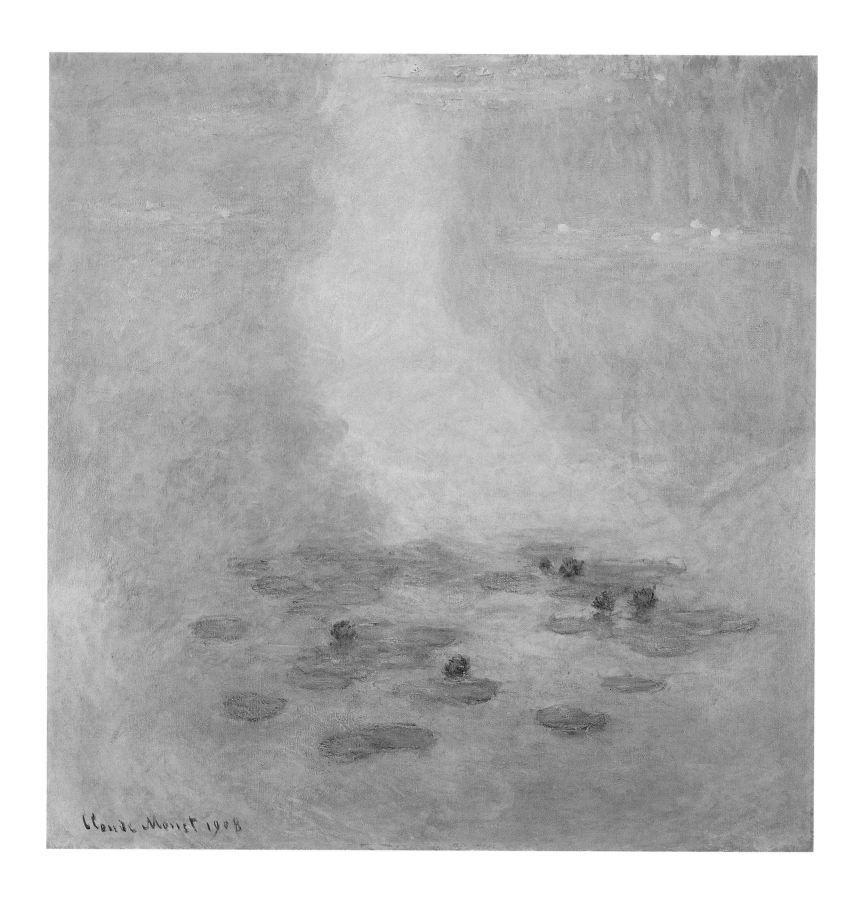

46 *Water Lilies*, 1908, oil on canvas, 100 × 100 cm (W.1730). Maspro Denkoh Art Museum

Exhibited at Galerie Durand-Ruel, Paris, May – June 1909; bought from Monet in March 1911 by Durand-Ruel and Bernheim-Jeune

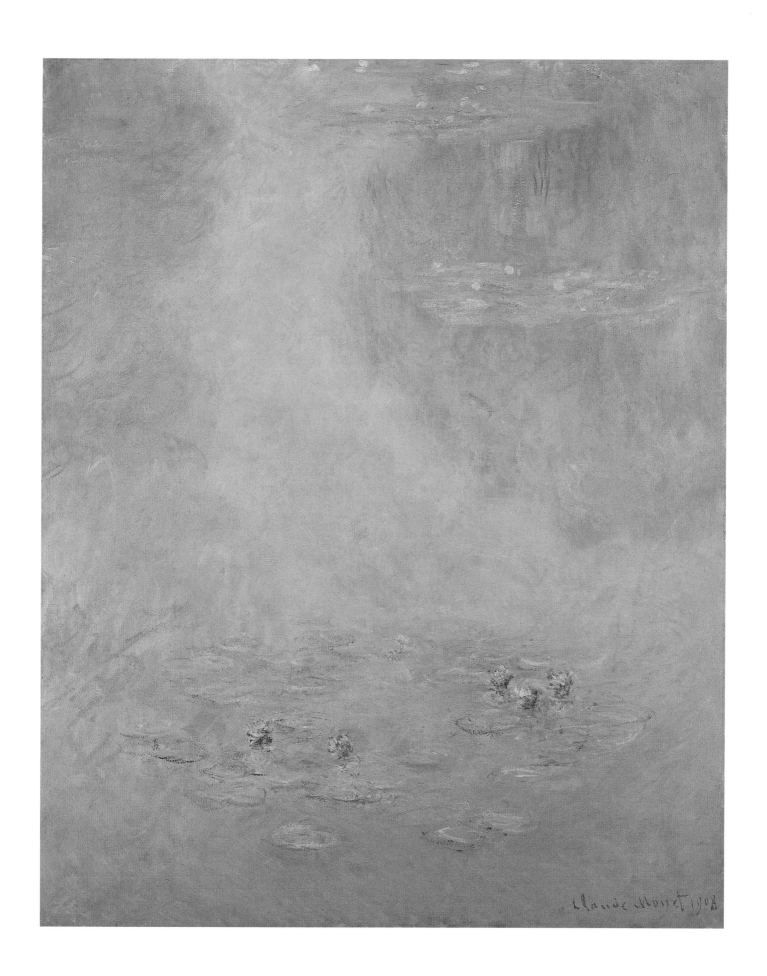

47 *Water Lilies*, 1908, oil on canvas, 100 × 81 cm (W.1732). National Museum and Gallery, Cardiff

Exhibited at Galerie Durand-Ruel, Paris, May – June 1909; bought from Monet in March 1913 by Durand-Ruel and Bernheim-Jeune
and sold by the former in July 1913 to Miss Gwendoline Davies, Newton, Wales

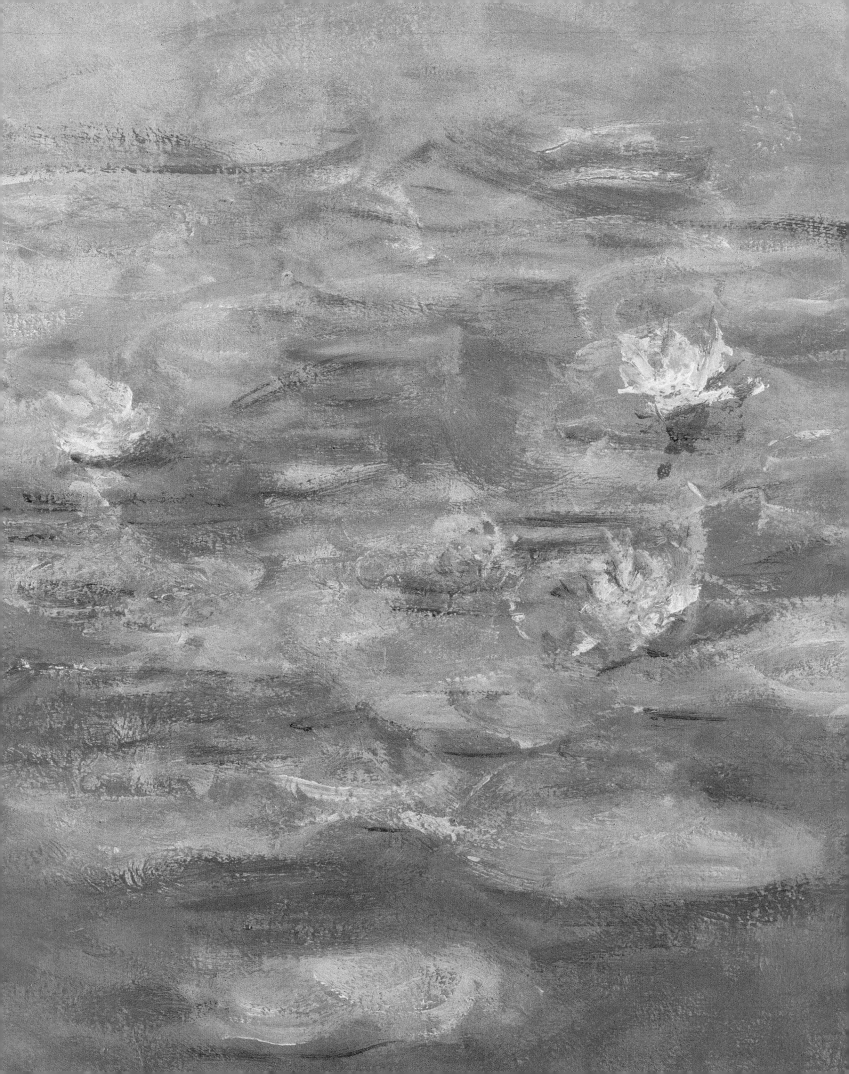

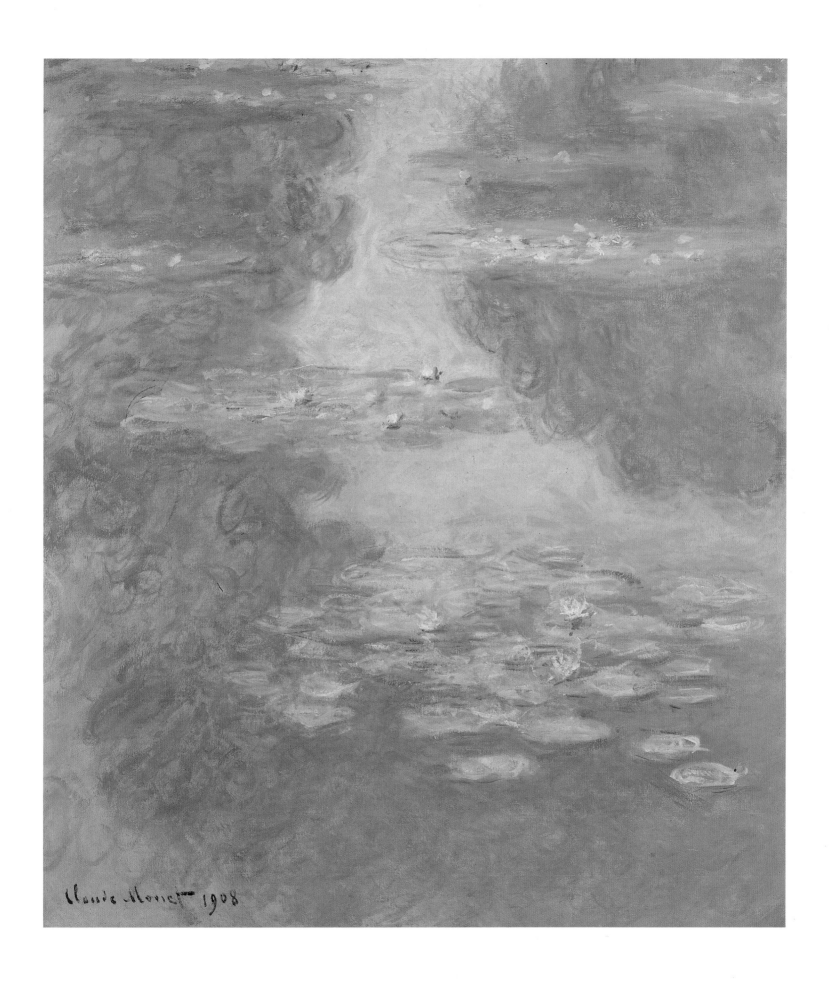

48 *Water Lilies*, 1908, oil on canvas, 92 × 81 cm (W.1725). Mr. G. Callimanopulos

Exhibited at Galerie Durand-Ruel, Paris, May – June 1909; bought from Monet in December 1920 by Durand-Ruel and Bernheim-Jeune

Monet visited Venice with his wife from October 1 to December 7, 1908. The couple first stayed with Mrs. Mary Hunter at the Palazzo Barbaro-Curtis, before moving into the Grand Hôtel Britannia on October 19. Intended as a holiday after the creation of some hundred Water Lily paintings (*Paysages d'eau*) over the preceding five years, the visit was quickly transformed into a period of intensive creativity which produced thirty-seven compositions, of which thirty-five were brought to completion after the artist's return to Giverny. Twenty-nine were purchased jointly by Bernheim-Jeune and Durand-Ruel, twelve in March 1912 and the remainder in May 1912. These were all exhibited at Galerie Bernheim-Jeune in Paris from May 28 to June 8, 1912, including nine shown in the present exhibition (cats. 49–56 and 58).

Like the London series, Monet's Venice series consisted of sub-groups of paintings, identified by motif. The ten sub-groups were made up of six views of the Grand Canal (including cats. 49–51), three of the Doge's Palace (including cats. 52 and 53), six looking across the Lagoon toward San Giorgio Maggiore, six from San Giorgio Maggiore toward the Doge's Palace (including cats. 54 and 55), four of the Rio de la Salute, two of San Giorgio Maggiore at dusk, one up the Grand Canal, and eight frontal views of palaces on the Grand Canal – four of the Palazzo Dario (including cat. 57), two of the Palazzo da Mula and two of the Palazzo Contarini (cats. 56 and 58).

Venice offered Monet contact with a specifically resonant artistic tradition and with aesthetic options that invited him to extend the artistic concerns with which he had been engaged since the early 1890s. He encountered works by the great masters of the painterly tradition – Giorgione, Titian, Veronese – who had informed Delacroix's colorism, in turn so central to the evolution of Impressionism. As a painter of the architecture of the floating city, Monet allied himself with the *vedute* tradition of Canaletto and Guardi, with the picturesque representations of Corot and Bonington, and with the historical vision of Ruskin. Engaged since the 1890s with series paintings concerned to depict the dominant tonality of the air that lies between the subject and the artist/viewer (the *enveloppe*) and, in the Poplars (1892) and Mornings on the Seine (1898) series, the reflection of subject and light on water, Monet drew upon such predecessors in Venice as Turner and Whistler, and the achievements of his London series.

A striking characteristic of Monet's Venice series is a relative disregard for recording the effects of changing light and weather conditions across the motifs of each of his sub-groups. Rather, in addition to mapping the city visually, in a

manner somewhat similar to Alfred Sisley's approach to serial painting after 1880, Monet focused upon the play of light upon façade and water, the fractured reflection of architecture within the water and the oscillation of that reflection returned from the water to the façade. Such concerns are pursued most potently in the sub-group of palazzi (see cats. 56–8), which are viewed frontally from across the canal, establishing façade and reflection as a complementary sequence of horizontal compositional bands. The dominant blue tonality of such paintings, despite the extensive introduction of touches of intense red, purple, and green, establishes a monochromatic effect that echoes a similar compositional treatment and tonal effect caught in pastel, oil, and the etcher's ink in Whistler's views of Venice (1879–80).

Although most of the Venice paintings fail to break free from a picturesque approach, two sub-groups involve a more radical treatment of light or composition that hints at the innovative approach to subject and technique that was to mark Monet's paintings after 1914. The views of San Giorgio Maggiore at dusk employ an exaggerated palette which ignites the sky and water in a riot of pinks, yellows, greens, and blues, leaving the subject of the composition itself, the church, suspended as an accentless, hovering silhouette. The traditional *vedute* composition of the six paintings of the Doge's Palace seen from San Giorgio Maggiore (see cats. 54 and 55) is undermined by the insertion of the strident diagonal of the terrace cast in shadow at the bottom of the composition.

Of the five views of the Doge's Palace seen from San Giorgio Maggiore that were exhibited at Bernheim-Jeune in 1912, only two were sold by the end of 1913, and only one of the two views of San Giorgio Maggiore at dusk was included in the exhibition; it was sold the following October. The remaining twenty-three more approachable, exhibited subjects quickly found purchasers: all six of the views of the Grand Canal (including cats. 49–51) and five out of seven of the palazzi sub-group (including cat. 58) had been sold by the end of 1913. Of the two views of the Doge's Palace, one was sold in 1913 (cat. 52), the other in 1917 (cat. 53). By the end of 1913 four Venice subjects had been purchased by the indefatigable Misses Davies of Newton, Wales (including cat. 50), and twelve had entered American collections, of which four went into the collection of Arthur B. Eammons of Newport, Rhode Island (including cat. 52), two went to Alexander Cochrane of Boston (including cat. 51), two to separate New York collections (Joseph F. Flanagan and Grace M. Edwards, see cat. 54), one to Arthur Meeker of Chicago, one to Edward A. Faust of Saint Louis, and one to Hunt Henderson of New Orleans (cat. 49).

facing page Detail of cat. 50.

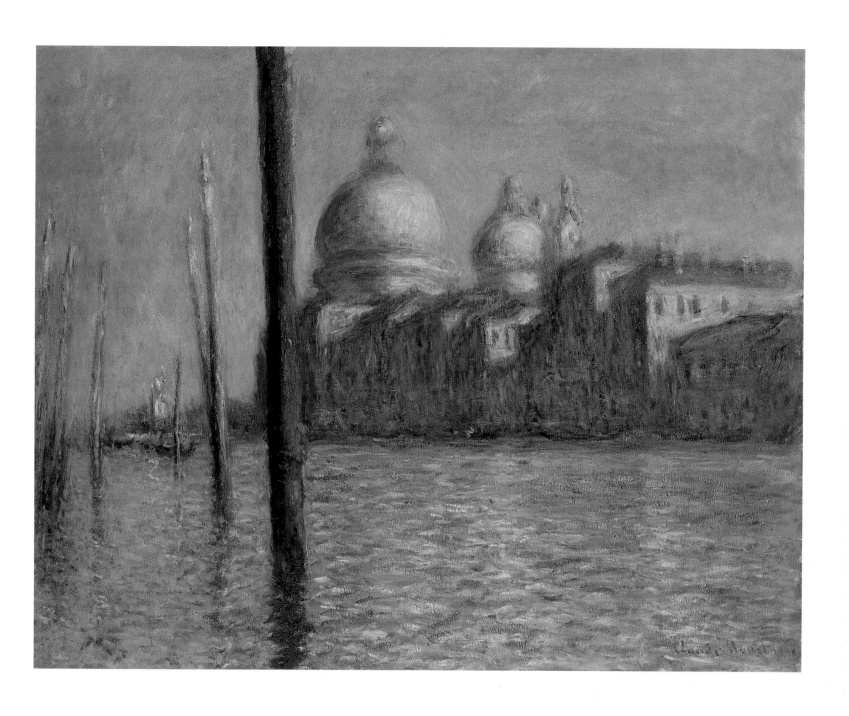

49 *The Grand Canal*, 1908, oil on canvas, 73 × 92 cm (W.1739). Private Collection

Exhibited at Galerie Bernheim-Jeune, Paris, May – June 1912; bought from Monet in May 1912 by Durand-Ruel and Bernheim-Jeune
and sold by the former in October 1913 to Hunt Henderson, New Orleans

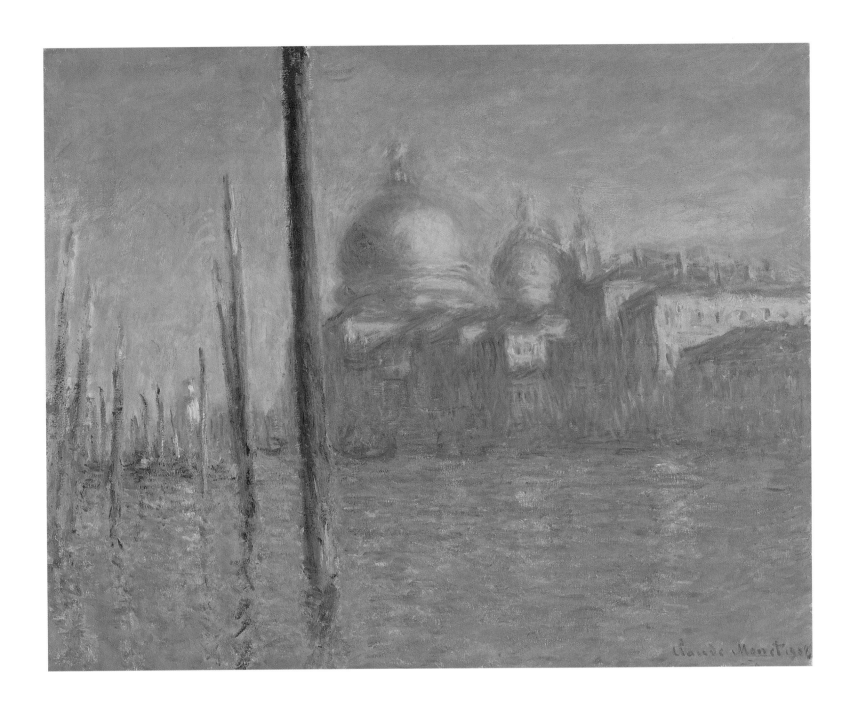

50　*The Grand Canal, Venice,* 1908, oil on canvas, 73 × 92 cm (W.1736). The Fine Arts Museums of San Francisco, Gift of Osgood Hooker

Exhibited at Galerie Bernheim-Jeune, Paris, May – June 1912; bought from Monet in March 1912 by Durand-Ruel and Bernheim-Jeune
and sold by the latter in October 1912 to Miss Gwendoline Davies, Newton, Wales

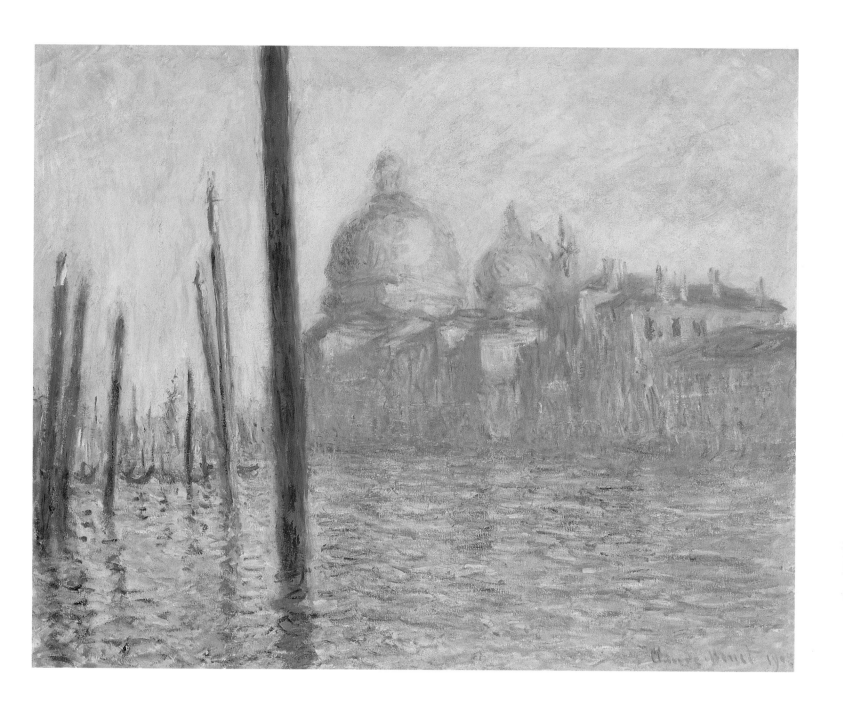

51 *The Grand Canal*, 1908, oil on canvas, 73 × 92 cm (W.1738). Museum of Fine Arts, Boston. Bequest of Alexander Cochrane

Exhibited at Galerie Bernheim-Jeune, Paris, May – June 1912; bought from Monet in March 1912 by Durand-Ruel and Bernheim-Jeune
and sold by the former in November 1912 to Alexander Cochrane, Boston

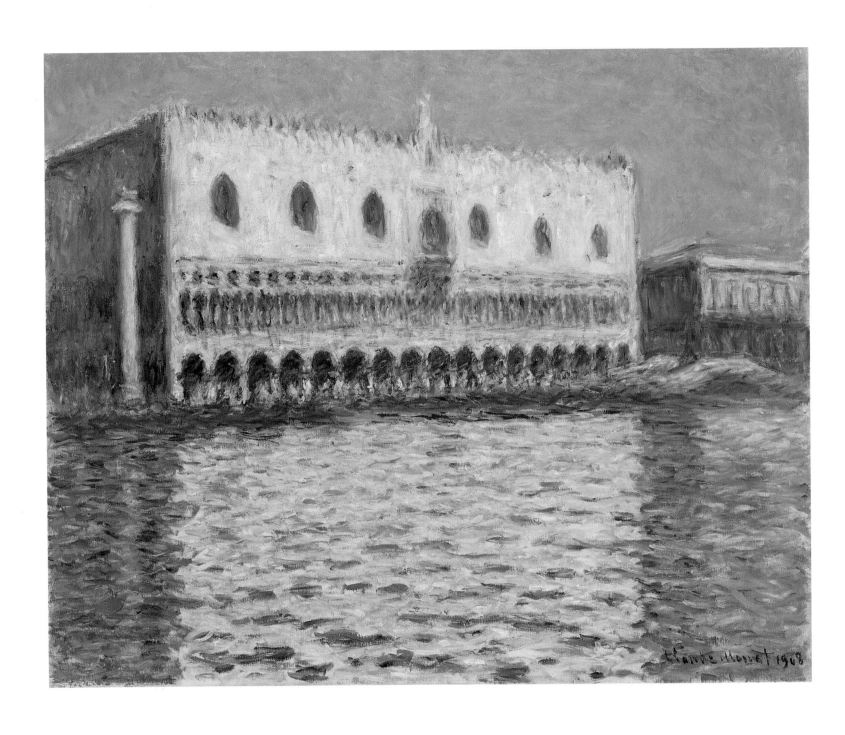

52 *The Palazzo Ducale*, 1908, oil on canvas, 81 × 100 cm (W.1743). Brooklyn Museum of Art, Gift of A. Augustus Healy

Exhibited at Galerie Bernheim-Jeune, Paris, May – June 1912; bought from Monet in May 1912 by Durand-Ruel and Bernheim-Jeune
and sold by the former in December 1913 to Arthur B. Eammons, Newport, R.I.

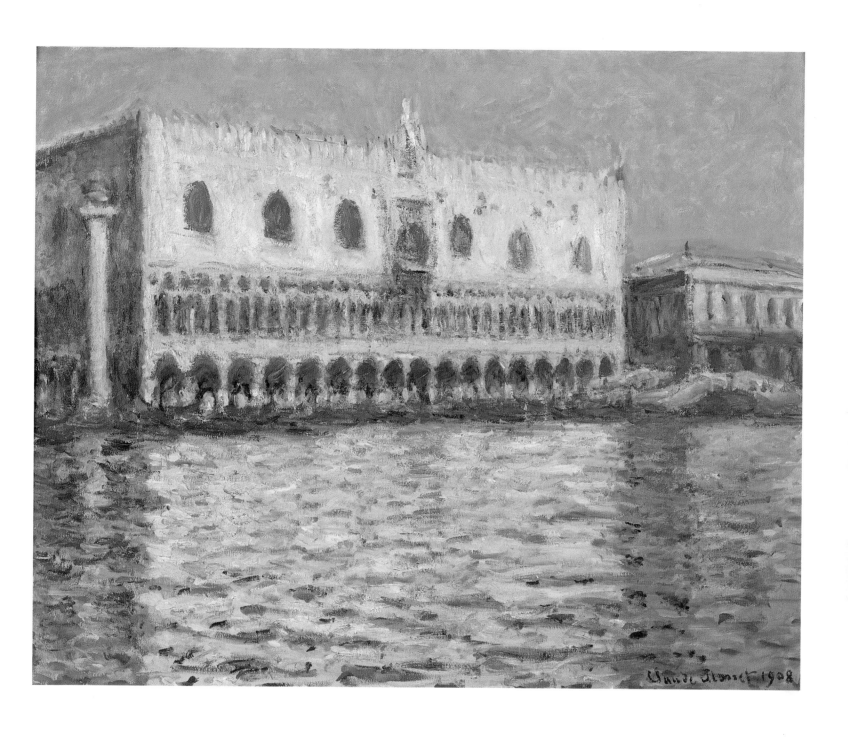

53 *The Palazzo Ducale*, 1908, oil on canvas, 73 × 92 cm (W.1742). Mr. and Mrs. Herbert Klapper

Exhibited at Galerie Bernheim-Jeune, Paris, May – June 1912; bought from Monet in May 1912 by Durand-Ruel and Bernheim-Jeune
and sold by the former in 1917 to Dubied, Neuchâtel, Switzerland

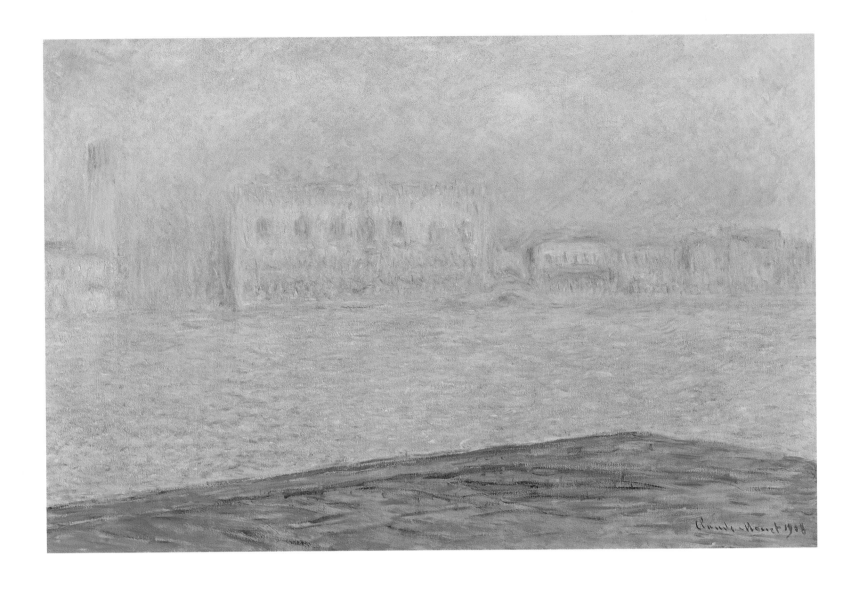

54 *The Palazzo, Ducale seen from San Giorgio Maggiore*, 1908, oil on canvas, 65 × 100 cm (W.1751).
Kunsthaus Zürich, Donation Walter Haefner

Exhibited at Galerie Bernheim-Jeune, Paris, May – June 1912; bought from Monet in May 1912 by Durand-Ruel and Bernheim-Jeune
and sold by the former in December 1912 to Miss Grace M. Edwards, New York

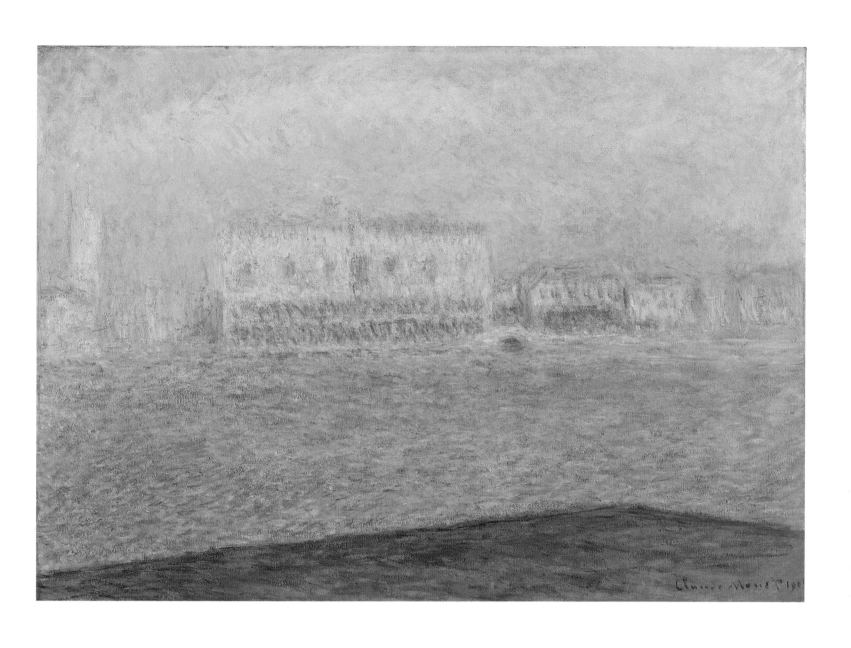

55 *The Palazzo Ducale seen from San Giorgio Maggiore*, 1908, oil on canvas, 65 × 92 cm (W.1755). The Metropolitan Museum of Art; Gift of Mr. and Mrs. Charles S. McVeigh, 1959

Exhibited at Galerie Bernheim-Jeune, Paris, May – June 1912; bought from Monet in May 1912 by Durand-Ruel and Bernheim-Jeune

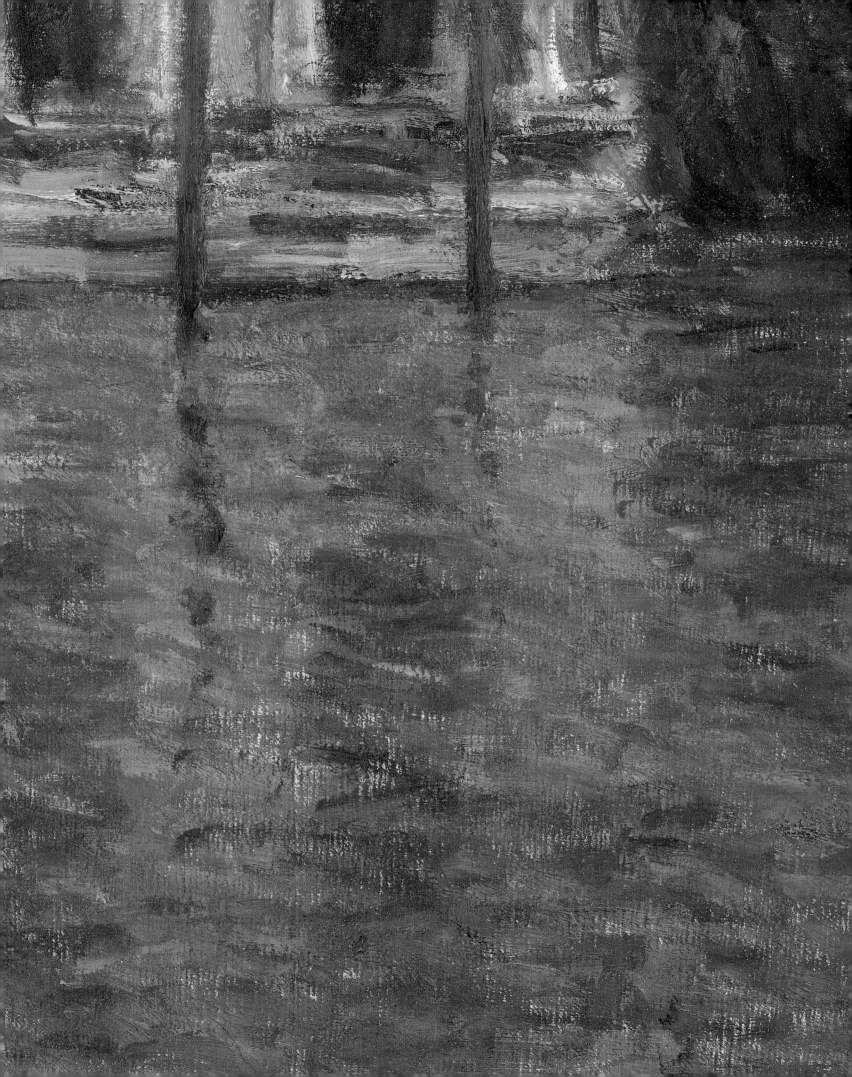

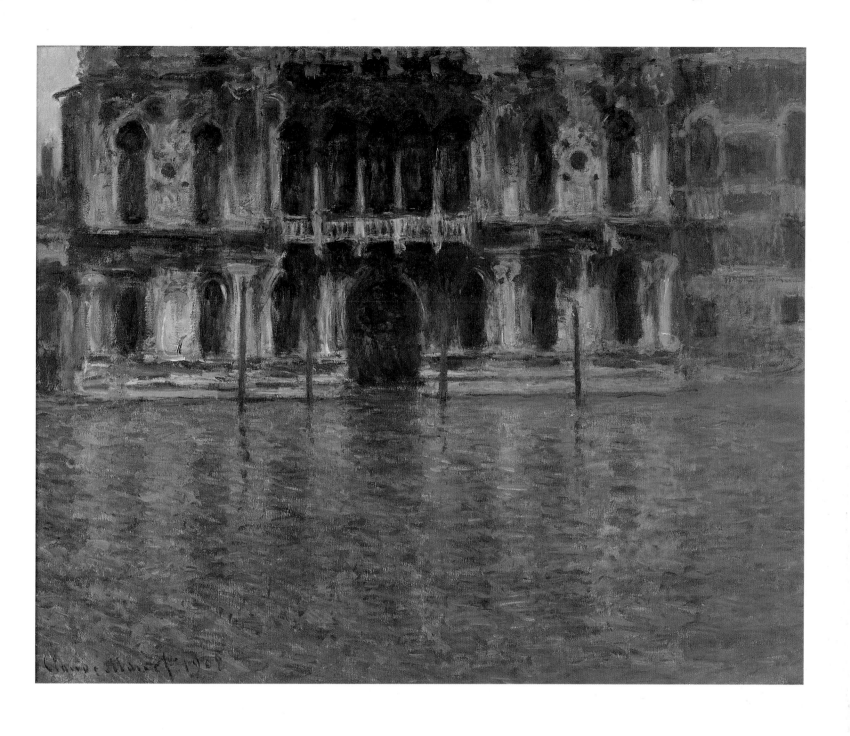

56 *The Palazzo Contarini*, 1908, oil on canvas, 73 × 92 cm (W.1766). Courtesy of Helly Nahmad Gallery, London

Exhibited at Galerie Bernheim-Jeune, Paris, May – June 1912; bought from Monet in May 1912 by Durand-Ruel and Bernheim-Jeune
and sold in June 1917 to Adolph Lewisohn, New York

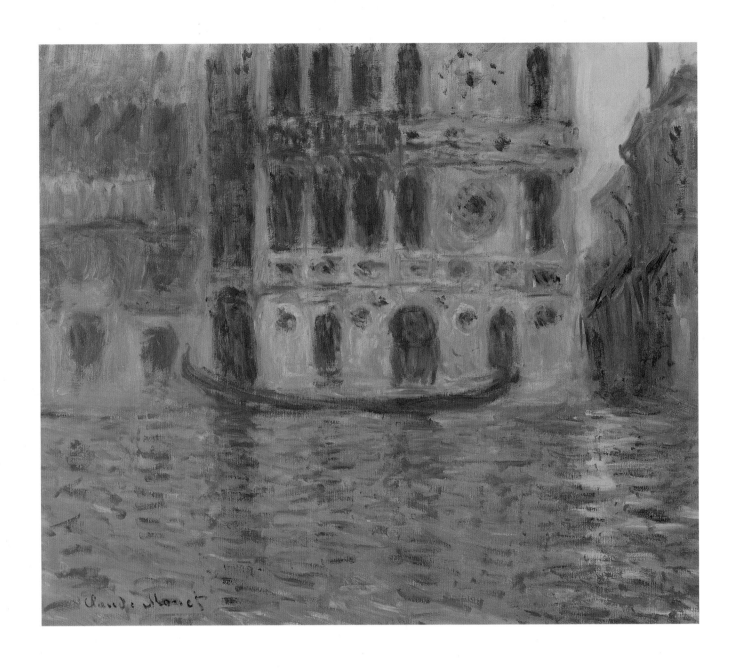

57 *The Palazzo Dario*, 1908, oil on canvas, 56 × 65 cm (W.1760). Private Collection

Not exhibited at Galerie Bernheim-Jeune, Paris, May – June 1912; first exhibited Galerie Bernheim-Jeune, Paris 1921

58 *The Palazzo Contarini*, 1908, oil on canvas, 92 × 81 cm (W.1767). Kunstmuseum, St Gallen, Switzerland

Exhibited at Galerie Bernheim-Jeune, Paris, May – June 1912; bought from Monet in May 1912 by Durand-Ruel and Bernheim-Jeune
and sold by the former in December 1912 to Arthur Meeker, Chicago

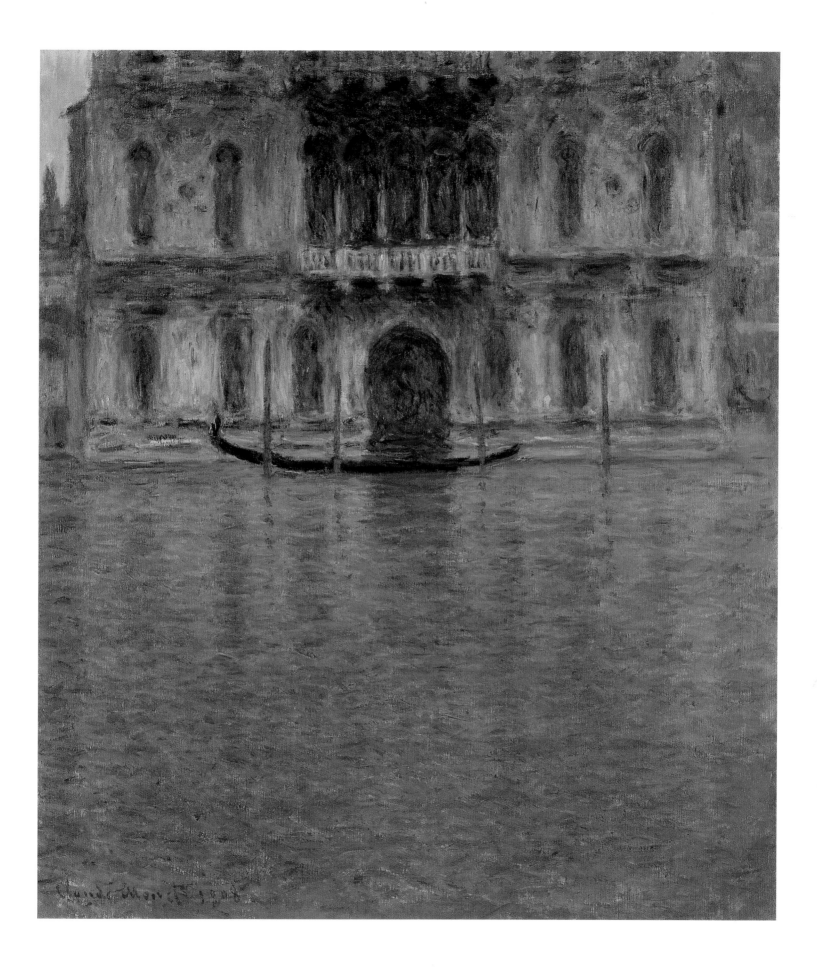

In the spring of 1914, after an extended period of relative inactivity, Monet found himself, as he said, "obsessed by the desire to paint." By the early summer he was back at work, refusing to leave Giverny, impatient to move forward with the work at hand. Unfortunately, we have very little record of what paintings Monet made in this first real resurgence of creativity following the death of his wife in 1911, but photographs of the period (see fig. 43) show the painter at work on a wholly new type of picture, unlike virtually anything that had appeared in his work up to this date.

The most novel feature of this new work was its radical shift in scale. In a group of canvases begun around 1914, the artist began to paint water-lily compositions measuring some two meters square – big canvases, that is, taller than a man, and each roughly four times the size of the water-lily compositions of 1905–8. This shift in size was accompanied by a shift in facture. Monet used large splotches of brilliant color to define the water lilies' flowers and leaves, and summarily indicated forms by bold, broad strokes of paint dragged across the surface of his overscale compositions. The huge canvases were carried to the side of the pond, where Monet would paint upon them in the shade of his white garden umbrella.

The purpose of these canvases must have been unclear at first to Monet's family and friends. On occasion in the past the painter had attempted large-scale paintings of this kind. But previously he had been motivated either by the desire to have his paintings noticed by virtue of their scale at the Salon or among the Impressionists – as in the *Women in the Garden* (W.67), refused by the Salon jury of 1867, or *La Japonaise* (W.387), a set-piece of the Impressionist exhibition of 1876 – or by his plans to paint decorative compositions speculatively for a client – as in the case of the four paintings, each nearly two meters square, worked up for Ernest Hoschedé in 1876 (W.416, W.418, W.420 and W.433) or the view of Bordighera painted for Berthe Morisot in 1884 (W.857). The two-meter square paintings of 1914 and the following years had no such obvious end in view. First of all, in a reversal of his common practice, Monet kept these paintings from the public eye. Only one of them was sold, in 1922, to Monet's friend and collector Prince Matsukata. Signed and dated 1916, the canvas is now in the National Museum of Western Art, Tokyo (W.1800), and is typical of a group of canvases (see cats. 59, 60, and 63) that repeat, on an enlarged scale, the essential formats of the pre-1905–8 Water Lilies. When, in 1924, the Tokyo panel was exhibited to the public, Monet was displeased. It seems, however, that his opposition to its exhibition (along with another, even larger view of water lilies, W.1971) was motivated by his desire to keep these "decora-

tive panels" – as he then called them – secret until after the inauguration of the *Grandes Décorations*, which he was hoping to complete and install shortly thereafter.

The two-meter square panels were not, themselves, conceived as decorations. They were, on the other hand, the principal explorations of the pattern and color of water, flowers, leaves, trees, foliage, and reflections that served Monet in the elaboration of the three- four- and six-meter wide panels that he prepared for his donation to the state (see below, pp. 218 and 252). Once again, he used them to explore on a new scale effects that he had treated in the first years of the century. The striated vertical patterning seen in catalogue number 60, for example, is reminiscent of similar patterns that had first been noted in the Water Lilies of 1905 or 1907 – for instance in catalogue numbers 30 and 31. In a series of studies of the reflections of willows (cats. 64–8) these effects are given further definition, the lighter skeins of paint outlining, in the negative, the shadowy reflection of the trunk of a willow tree. Turning his attention to the bank of the pond, Monet completed a series of pictures of the flowering plants – agapanthus, daylilies, and irises – that grew in huge tufts at the water's edge. Paintings of this type (for example, cats. 69 and 70), remind us of Monet's fascination with bankside plants in the bridge paintings of 1900 (see cats. 3 and 4).

Carted from the bank of the pond to the large studio, the panels could be placed side-by-side to build up the panoramic views Monet desired for the decorations. Thus, the study of water lilies seen through leaves (cat. 62) might have been placed in the studio to the right of one of the portrayals of the massive trunk of a willow (cat. 61) so that Monet could transcribe the continuous view that they created on to a lengthy stretch of canvas, which would, in time, be installed as one of the Orangerie decorations. These beautiful paintings were thus, for Monet, not pictures for sale or exhibition, but a series of working studies, brilliantly and boldly executed, that served his needs at a critical period of transition in his working methods. As such, they remained in his possession (with the exception of the painting sold to Matsukata) until his death, and remained unsold and essentially unknown until nearly twenty-five years later. As Michael Leja demonstrates (see above, pp. 98–108), in the decades after the Second World War – in an artistic climate ready to receive such novel masterpieces of "Impressionism" – these paintings were gradually dispersed from the artist's estate. Of the works exhibited here, catalogue number 60 first found a buyer in 1949; catalogue number 62 entered the collection of the Musée d'Orsay only in 1981.

facing page Detail of cat. 65.

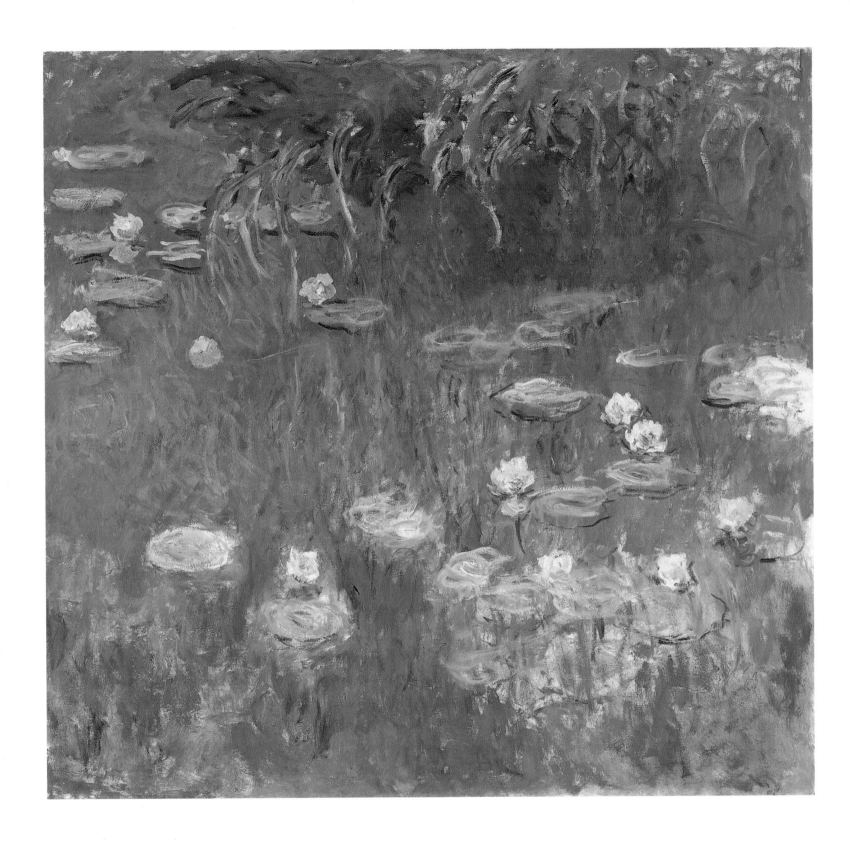

59 *Yellow and Lilac Water Lilies*, 1914–17, oil on canvas, 200 × 215 cm, (W.1804). The Toledo Museum of Art;
Purchased with funds from the Libbey Endowment, Gift of Edward Drummond Libbey

Remained in Monet's studio; first exhibited Zurich, Paris, and The Hague 1952 and bought that year by Emil Bührle, Zürich

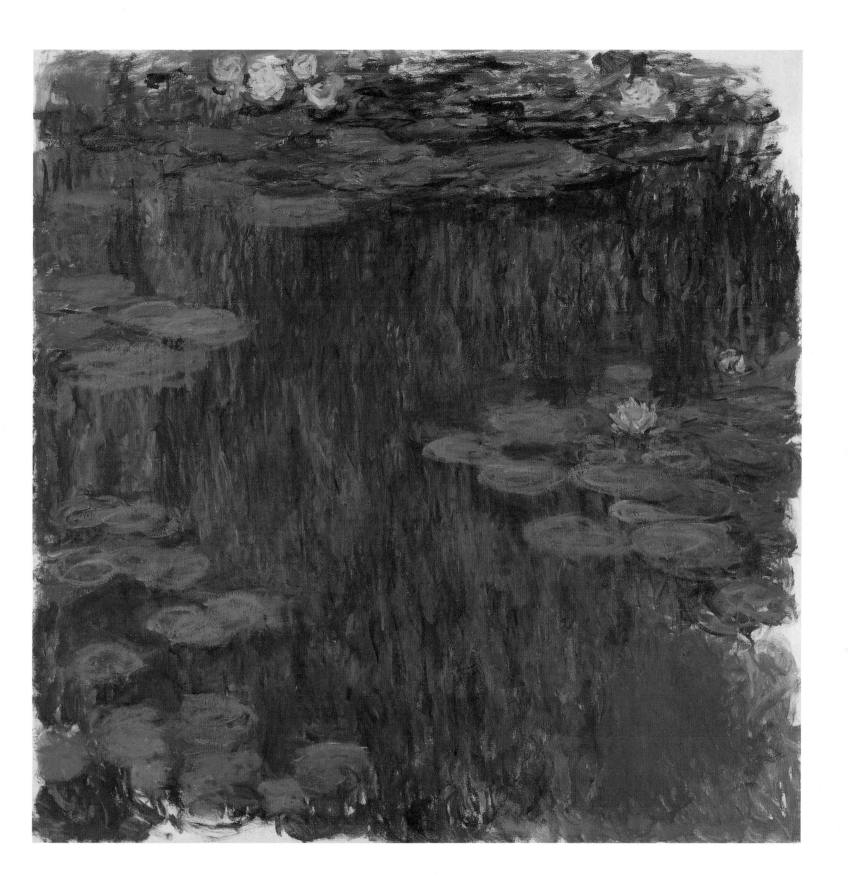

60　*Water Lilies*, 1914–17, oil on canvas, 200 × 200 cm (W.1803). Private Collection

Remained in Monet's studio and never exhibited during his life; bought out of the exhibition *Impressionisten*, Kunsthalle Basel, 1949

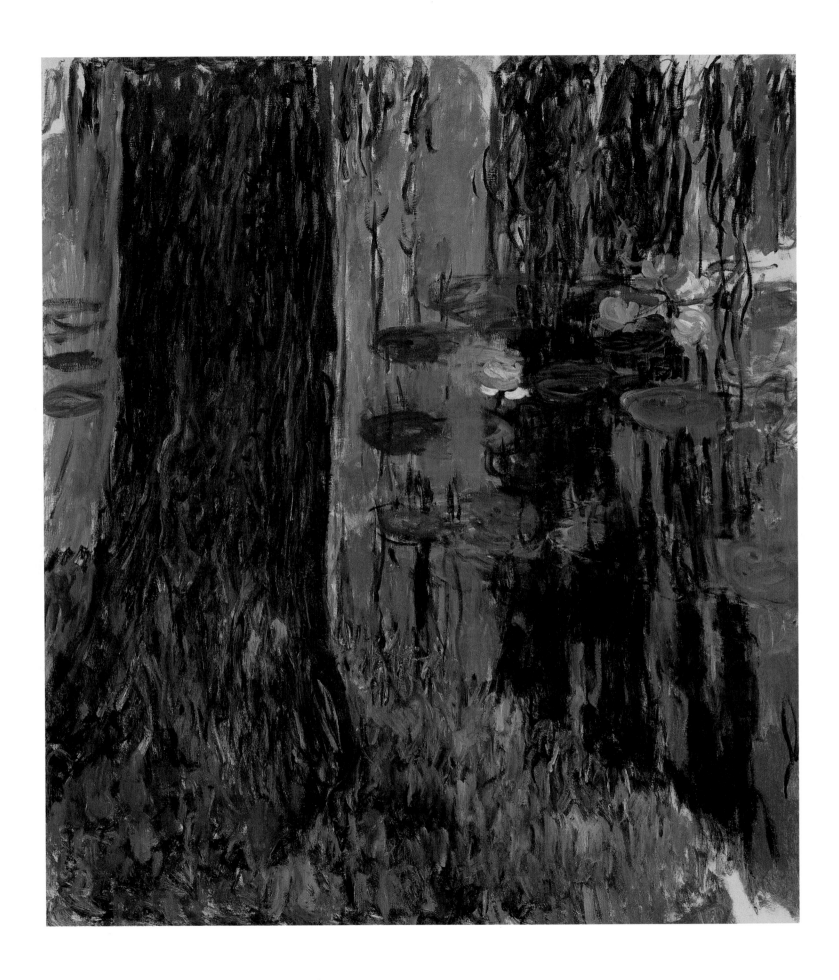

61 *Weeping Willow and Water Lily Pond*, 1914–19, oil on canvas, 200 × 180 cm (W.1849). Private Collection

Remained in Monet's studio and never exhibited during his life

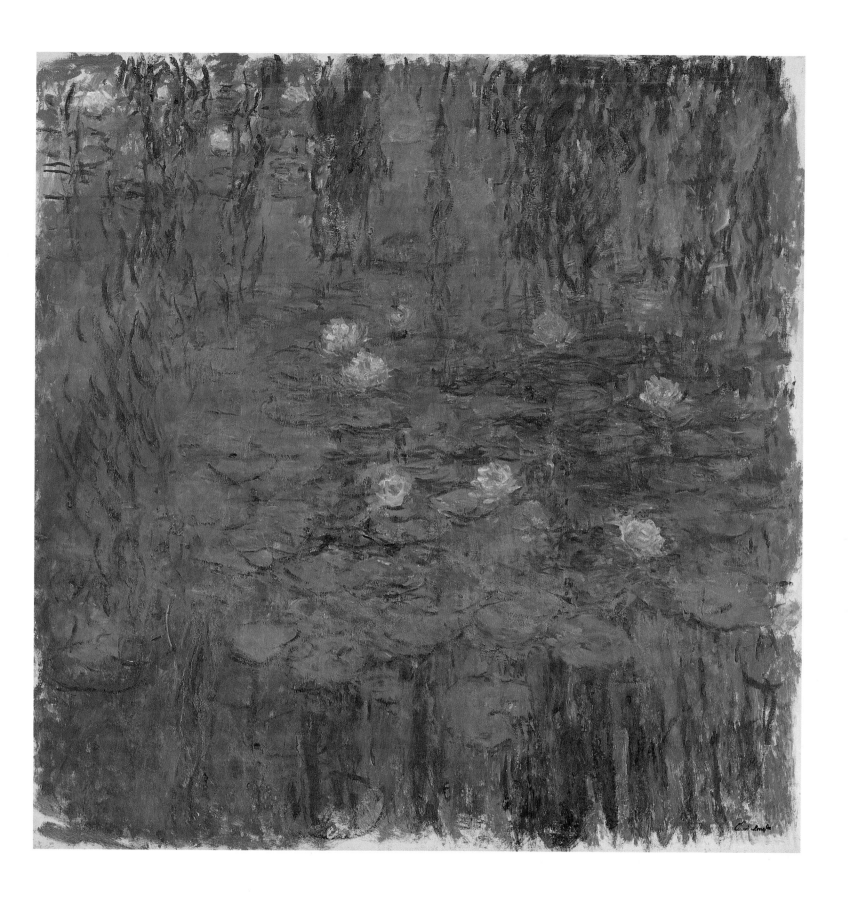

62　*Water Lilies*, 1914–19, oil on canvas, 200 × 200 cm (W.1853). Musée d'Orsay, Paris

Remained in Monet's studio; first exhibited Basel 1949

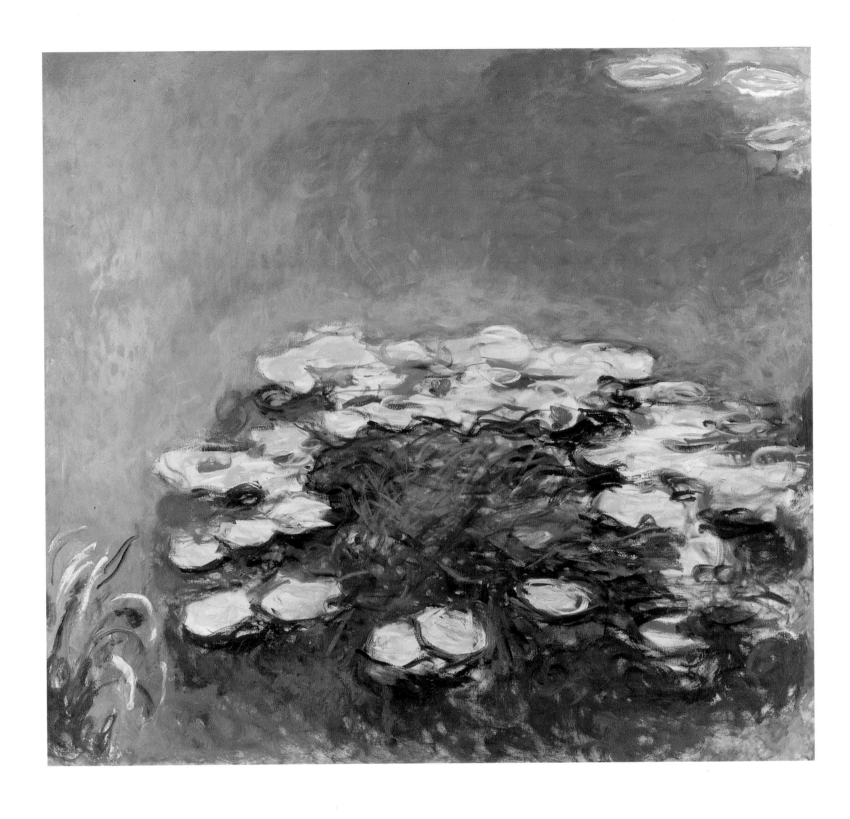

63 *Water Lilies*, 1914–17, oil on canvas, 180 × 200 cm (W.1810). Asahi Breweries, Ltd.

Remained in Monet's studio and never exhibited during his life; in a New York collection by around 1958

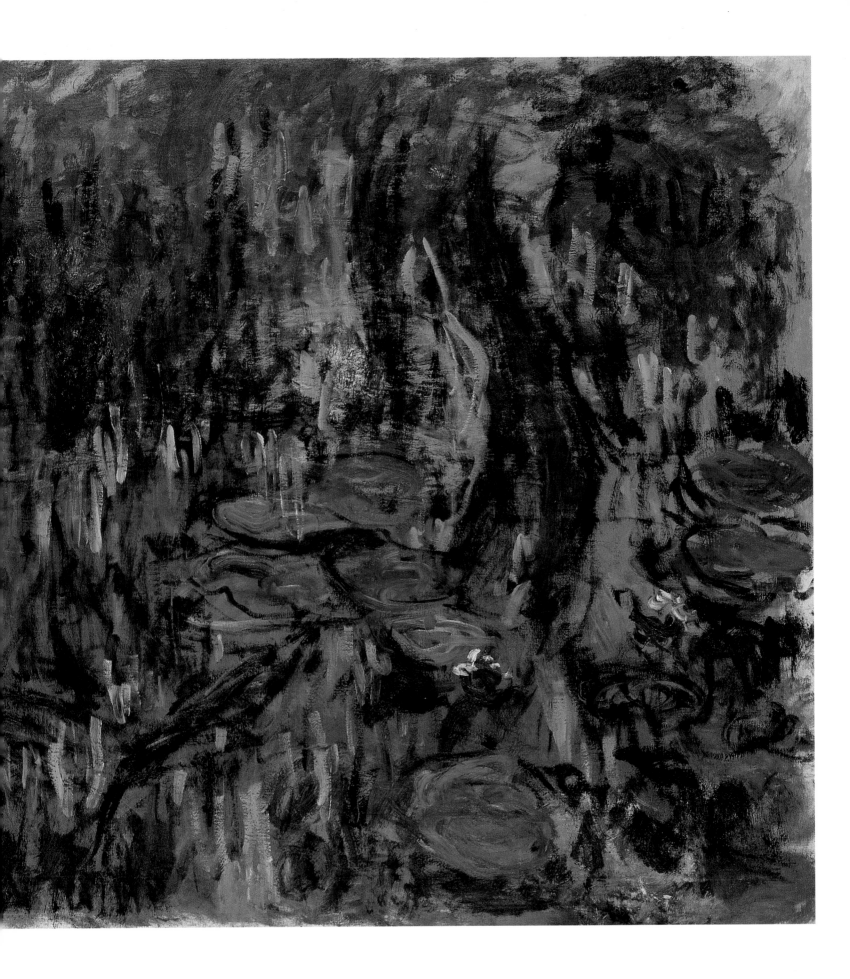

64 *Water Lilies, Reflections of Weeping Willows*, 1916–19, oil on canvas, 130 × 200 cm (W.1861). Kitakyushu Municipal Museum of Art

Remained in Monet's studio and never exhibited during his life; given in 1960 by Katia Granoff to the Museum of Modern Art, New York

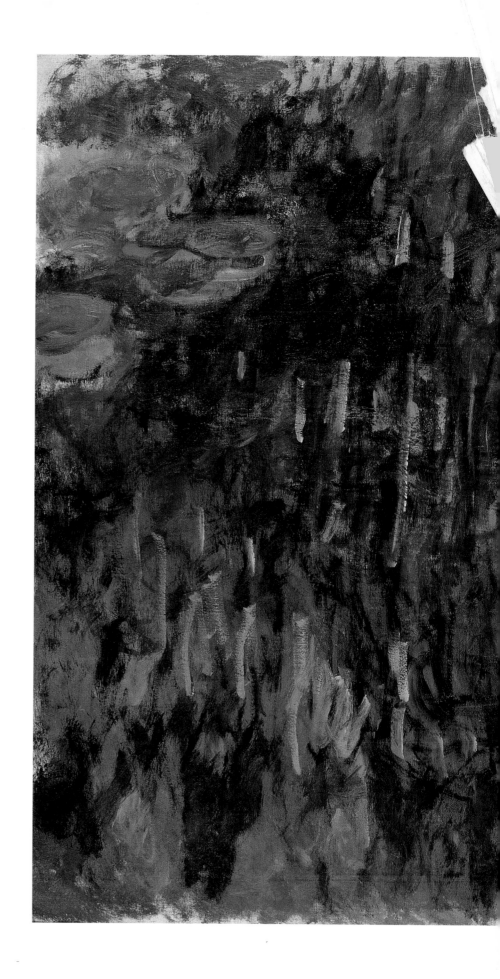

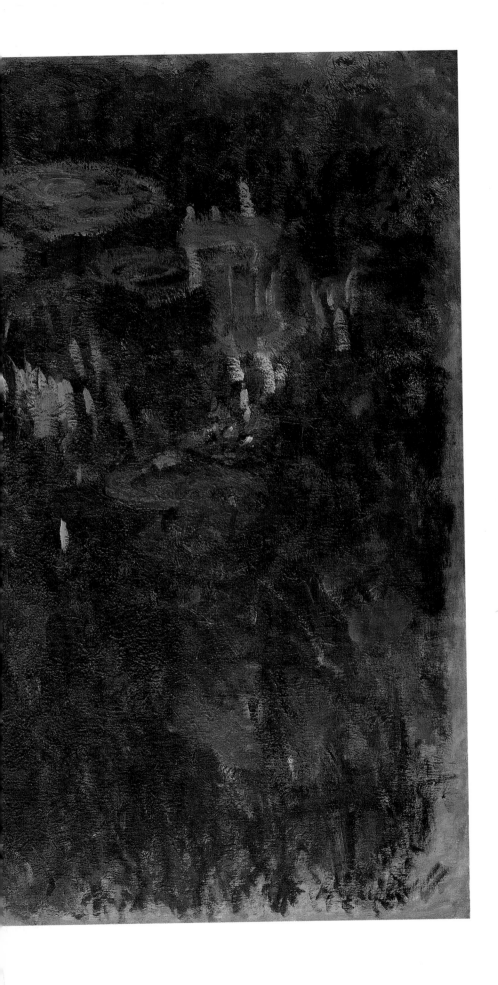

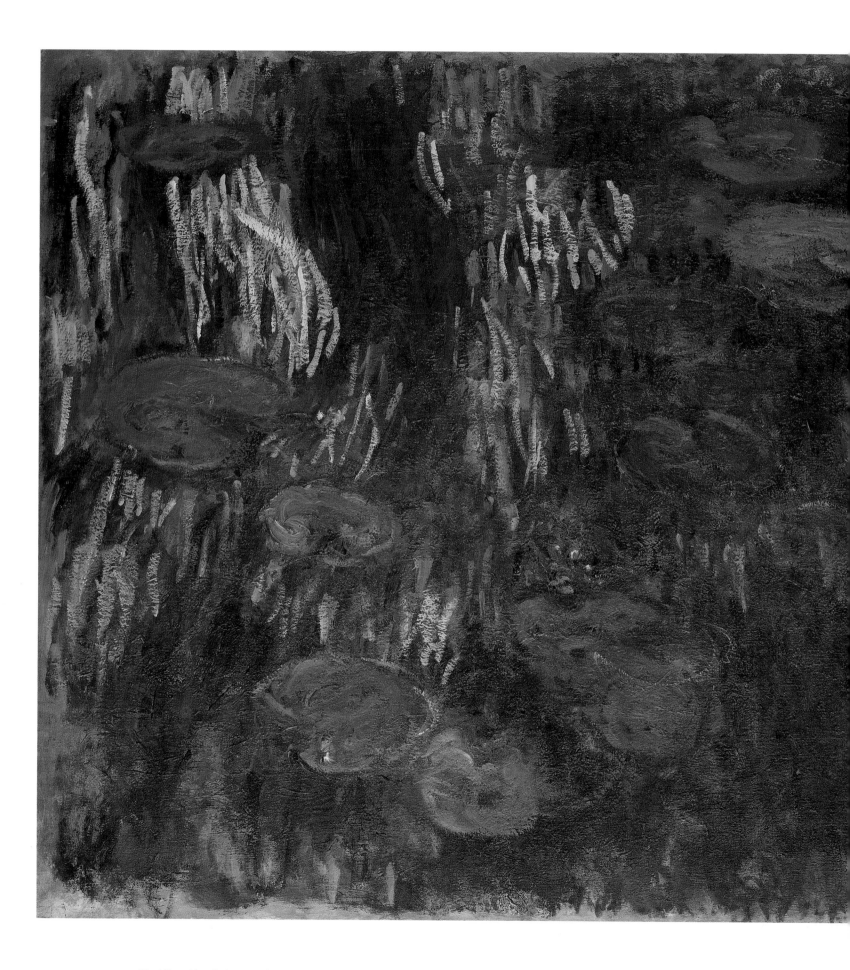

65 *Water Lilies, Reflections of Weeping Willows*, 1916–19, oil on canvas, 130 × 200 cm (W.1858). The Metropolitan Museum of Art; Gift of Louise Reinhardt Smith, 1983

Remained in Monet's studio and never exhibited during his life; entered the Metropolitan Museum of Art, New York, in 1983

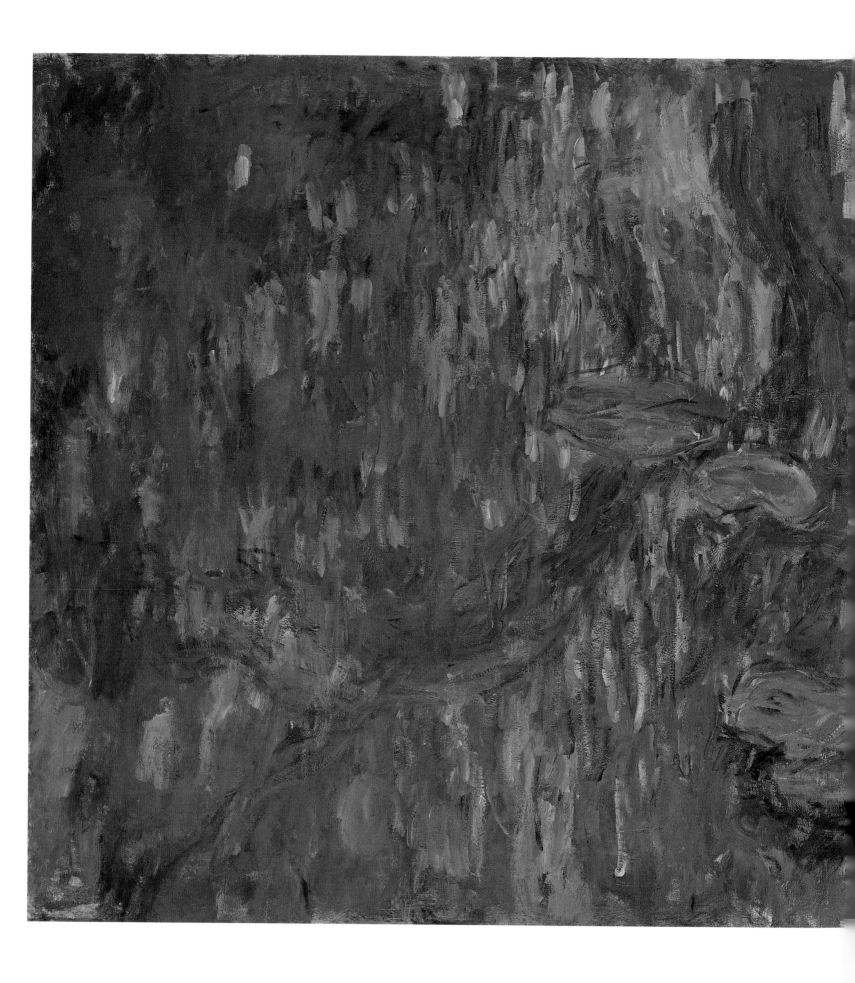

67 *Water Lilies, Reflections of Weeping Willows,* 1916–19, oil on canvas, 130 × 200 cm (W.1860). Private Collection

Remained in Monet's studio and never exhibited during his life; in a Chicago collection after 1961

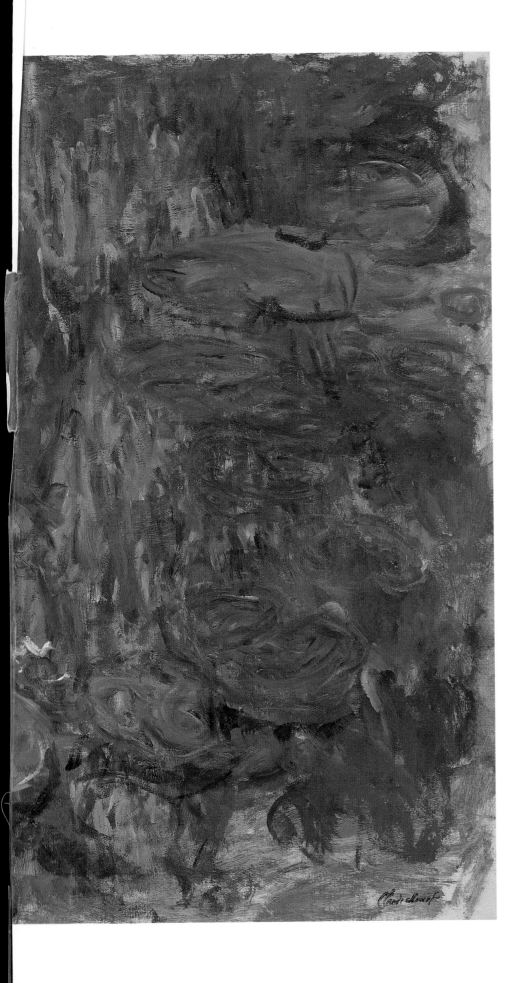

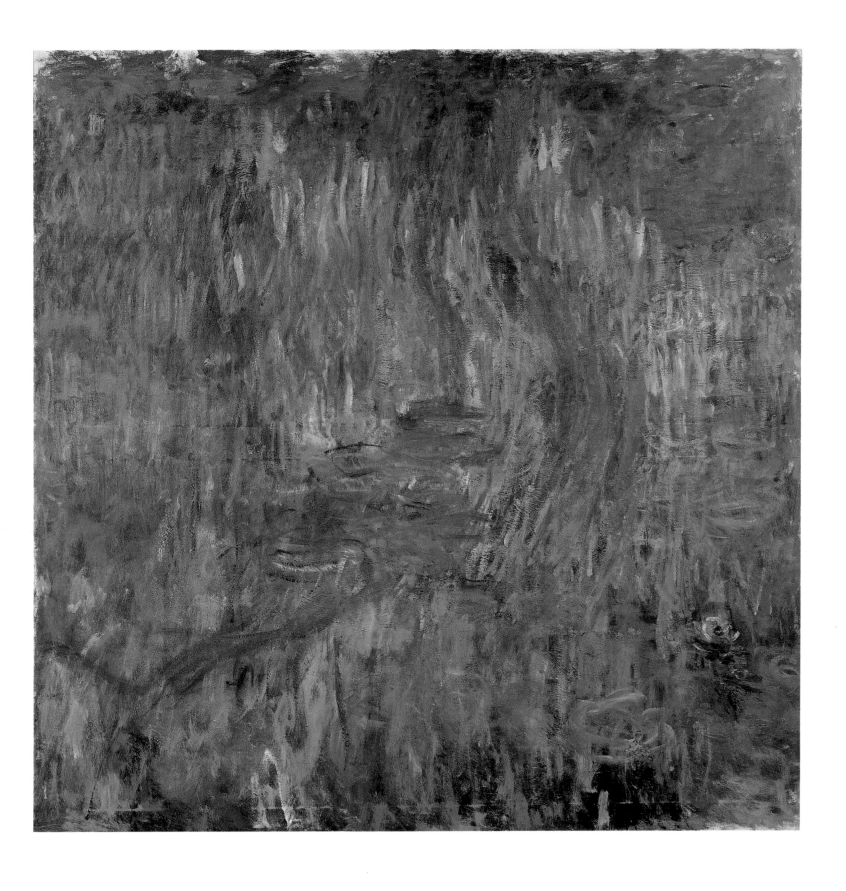

68 *Water Lilies, Reflections of Weeping Willows*, 1916–19, oil on canvas, 200 × 200 cm (W.1862). Musée Marmottan-Claude Monet, Paris

Remained in Monet's studio and never exhibited during his life

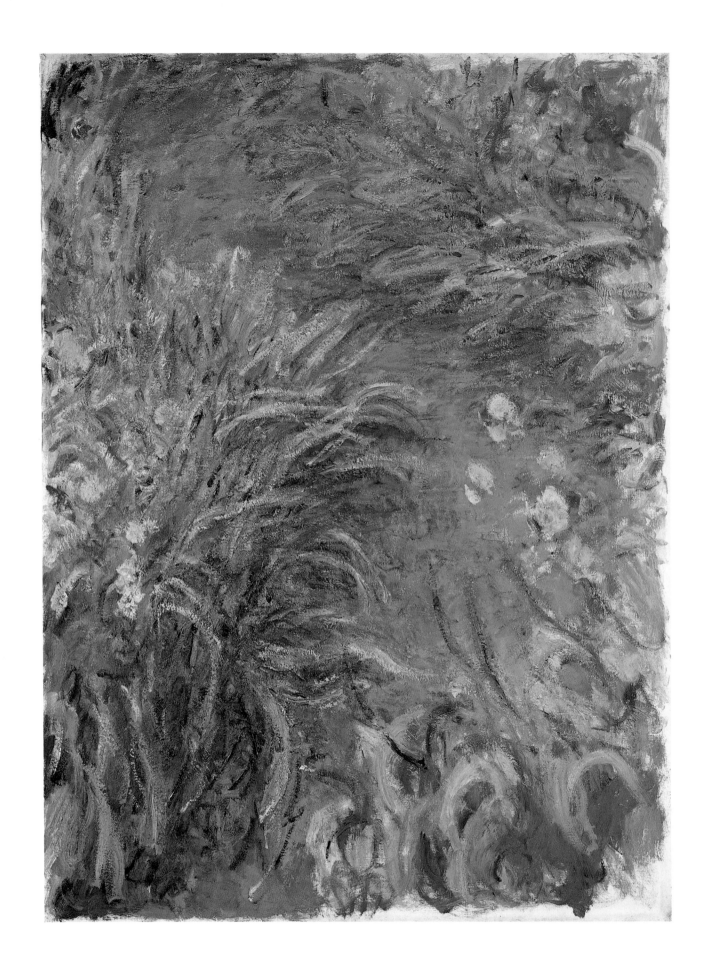

69 *The Path in the Iris Garden*, 1914–17, oil on canvas, 200 × 150 cm (W.1829). The National Gallery, London

Remained in Monet's studio and never exhibited during his life; possibly exhibited Basel 1962 and bought by the National Gallery in 1967

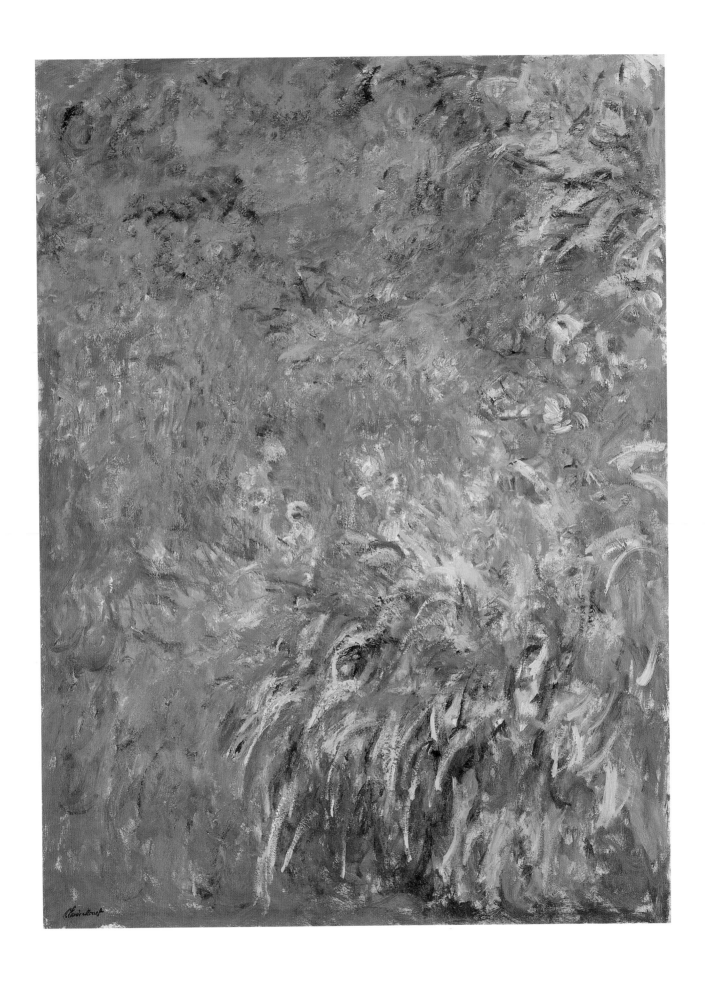

70　*Irises*, 1914–17, oil on canvas, 200 × 150 cm (W.1832). Virginia Museum of Fine Arts. The Adolph D. and Wilkins C. Williams Fund

Remained in Monet's studio and never exhibited during his life; first exhibited Basel 1962

Taking its subject once again from the pond itself, this group of overtly horizontal paintings was probably made from 1917 to around 1922. Devoid of any aggressive striated reference to willow fronds, either in reality or in reflection (see cats. 62 and 60), the nineteen paintings (with two "outriders") focus quite specifically on the water, the clumps of water lilies and the inverted reflection of the sky. They have two distinct formats: five measure 1.3 × 2 m. (W.1883–5, W.1888, and W.1889) and fourteen measure 1 × 2 m. (including cats. 71–3). Only one work was dated 1917 (cat. 71), and a further four, purchased by Bernheim-Jeune in November 1919, were dated to that year. Three were exhibited during Monet's lifetime, two in 1921 at the Galerie Bernheim-Jeune, Paris (W.1890 and W.1891), and one in Durand-Ruel's New York gallery the following year (W.1894). The painting dated 1917 (cat. 71) was presented by the artist to the Société d'Initiative et de Documentation Artistique (subsequently the Société des Amis du Musée des Beaux-Arts de Nantes) in July 1922.

It has been suggested that the larger canvases (1.3 × 2 m) may have been made in 1917, whereas those of 1 × 2 m must have been started after April 1918, when Monet received a major shipment of such canvases at Giverny. It is uncertain whether he continued to work on the paintings that remained in his studio after 1919. That 1917 was almost certainly the year in which the campaign was begun is suggested by the fact that Monet ascribed the Nantes panel (cat. 71) to that year. It is, however, a canvas of 1 × 2 m, and hence must have been started in 1918. Given that it left his studio only in 1922, Monet may have appended the earlier date in order to signal the initiation date of the group as a whole.

These paintings occupy a pivotal position between two groups of Water Lily pictures. They adopt the horizontal formats and extend the experimentation with composition and technique initiated in the group of larger-scale representations of the pond upon which Monet had embarked after 1913 (see cats. 59–68). However, in contrast to the 1914–19

groups (for example, cats. 59 and 60, and 64–6), where color was applied far more densely and, in the case of all but catalogue number 63, with dominant vertical striations down the surface of the canvas, the paint of the later group is handled much more loosely and transparently. Furthermore, the water-lily clumps sit towards the lateral edges of the canvases framing the central sections with their ribbon-like cascades of reflected sunlight and cloud forms, a compositional procedure that had characterized the vertical Water Lilies paintings of 1907 (see cats. 39–43). Now treated on an extended horizontal format, the framed cascades of reflected light presage the large *Grandes Décorations* canvases (including cats. 88 and 92 and W.1983).

Comparison between the undated and the dated paintings in the c.1917–c.1922 group also provides important insight into Monet's working procedures in bringing a composition to completion. Catalogue number 71 is painted across the full extent of the canvas, with the constituent parts of the composition unified through diaphanous veils of blue and yellow. In other works (including cats. 72 and 73) Monet has progressively staked out the constituent parts of the composition, both in the use of more strongly contrasted hues to describe fronds, flowers, and reflected sky and in the application of sweeping, graphic brushwork that maps out the edges of lily pads, describes the cascades of light, and establishes references to a reflected residual presence of grasses or reeds on the banks of the pond. Catalogue number 73 even reveals areas of white, untouched canvas.

The fact that Monet could conceive of at least six of these paintings as independent, finished works sets the c.1917–c.1922 group apart from the earlier larger-scale paintings of 1914–19. Apart from financial considerations, it is possible that Monet saw the finished canvases as forerunners in the public domain of the late Water Lily *Grandes Décorations*. Thirteen paintings (and the two "outriders") remained in his studio in 1926.

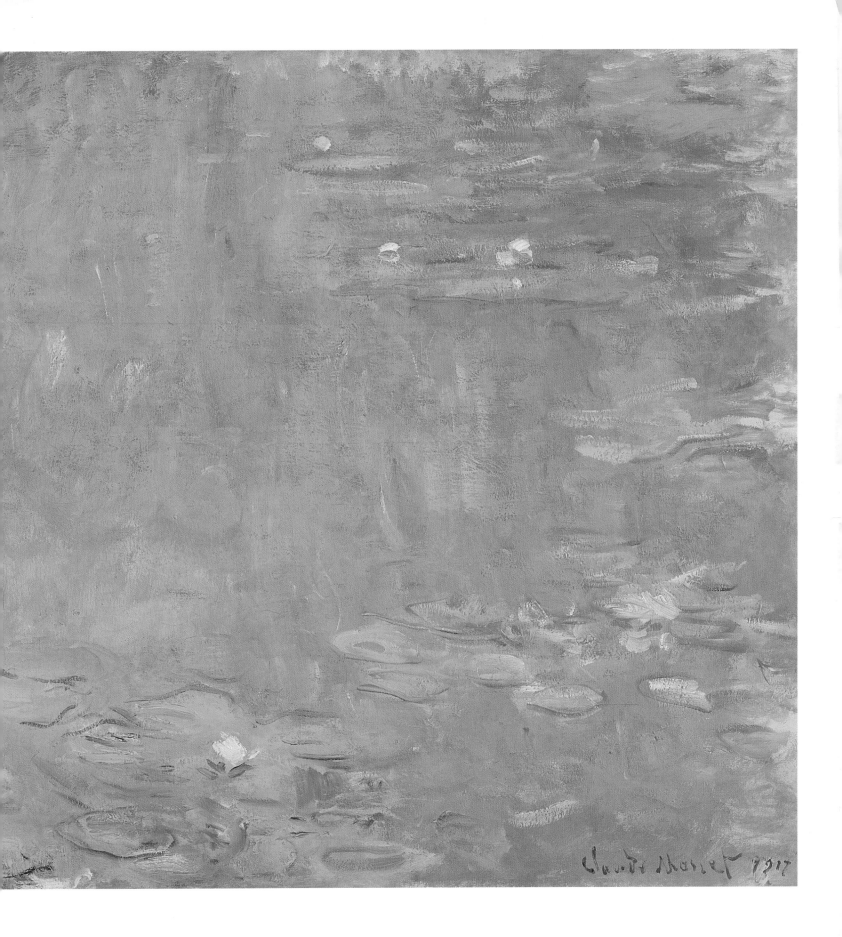

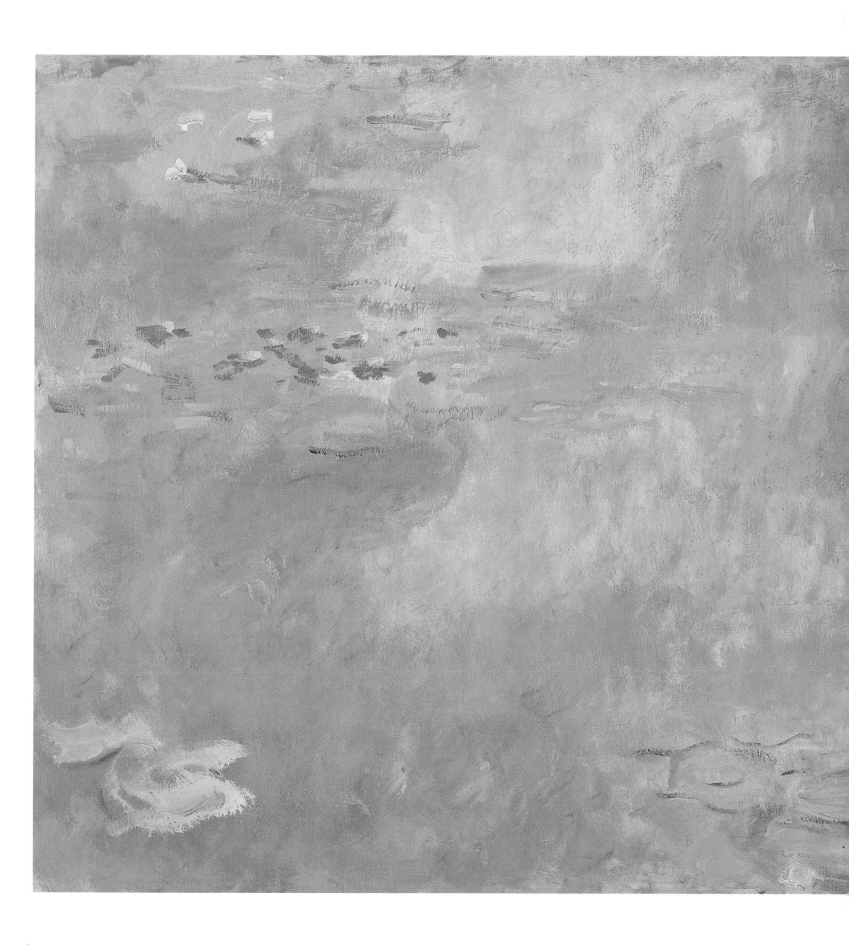

71　*The Water Lily Pond*, 1918–22, oil on canvas, 100 × 200 cm (W.1886). Musée des Beaux-Arts de Nantes, Nantes, France

Given by Monet in July 1922 to the Société d'Initiative et de Documentation artistique (subsequently the Société des amis du Musée des Beaux-Arts de Nantes)
and transferred to the museum in 1938; exhibited New York and Los Angeles 1960

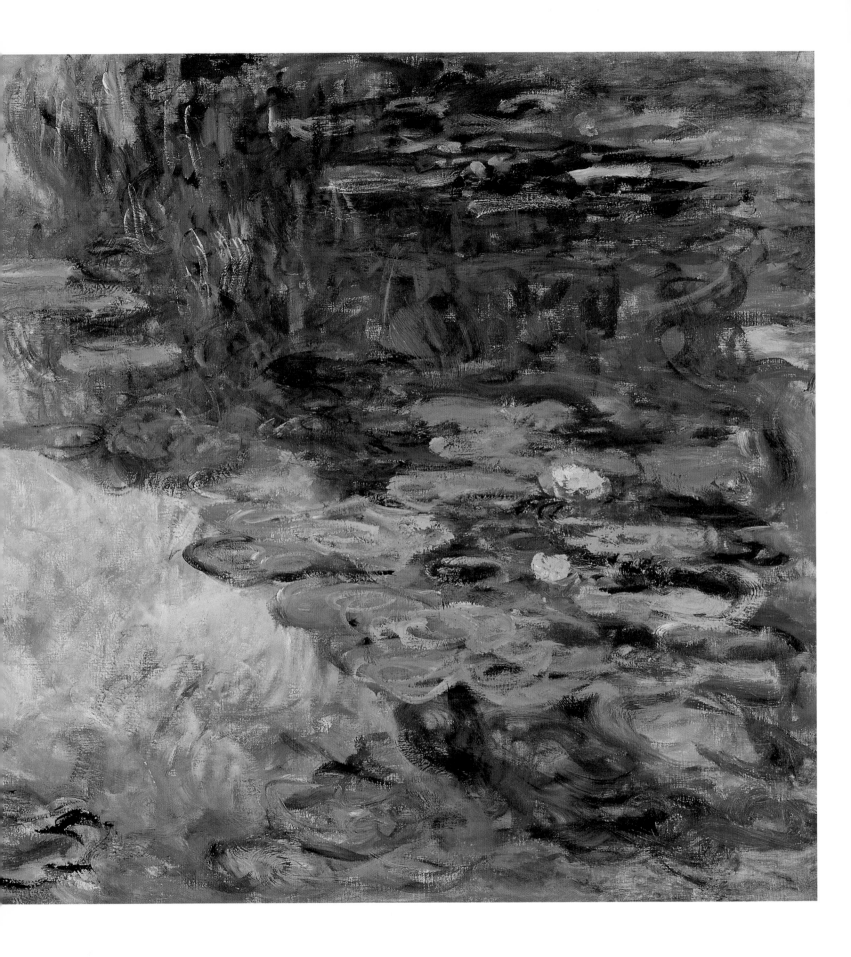

72 *The Water Lily Pond*, begun 1918, oil on canvas, 100 × 200 cm (W.1895). Honolulu Academy of Arts.
Purchased in memory of Robert Allerton, 1966

Remained in Monet's studio and never exhibited during his life

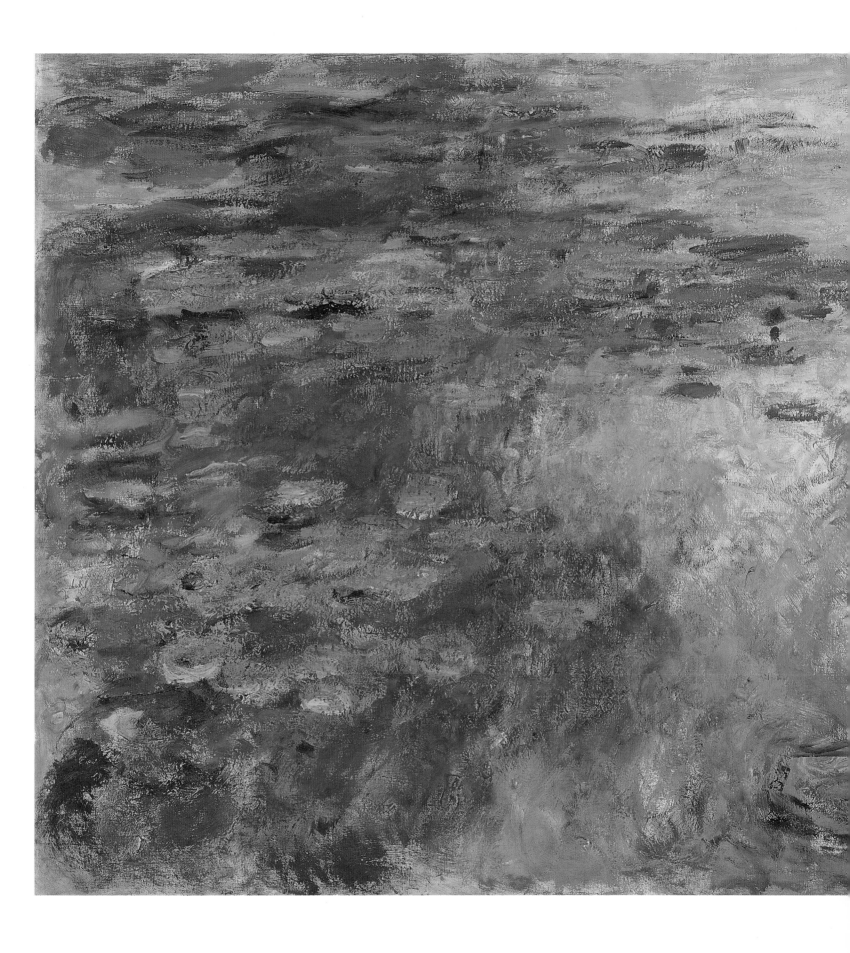

73 *The Water Lily Pond*, begun 1918, oil on canvas, 100 × 200 cm (W.1896). Benesse Corporation, Okayama, Japan

Remained in Monet's studio and never exhibited during his life

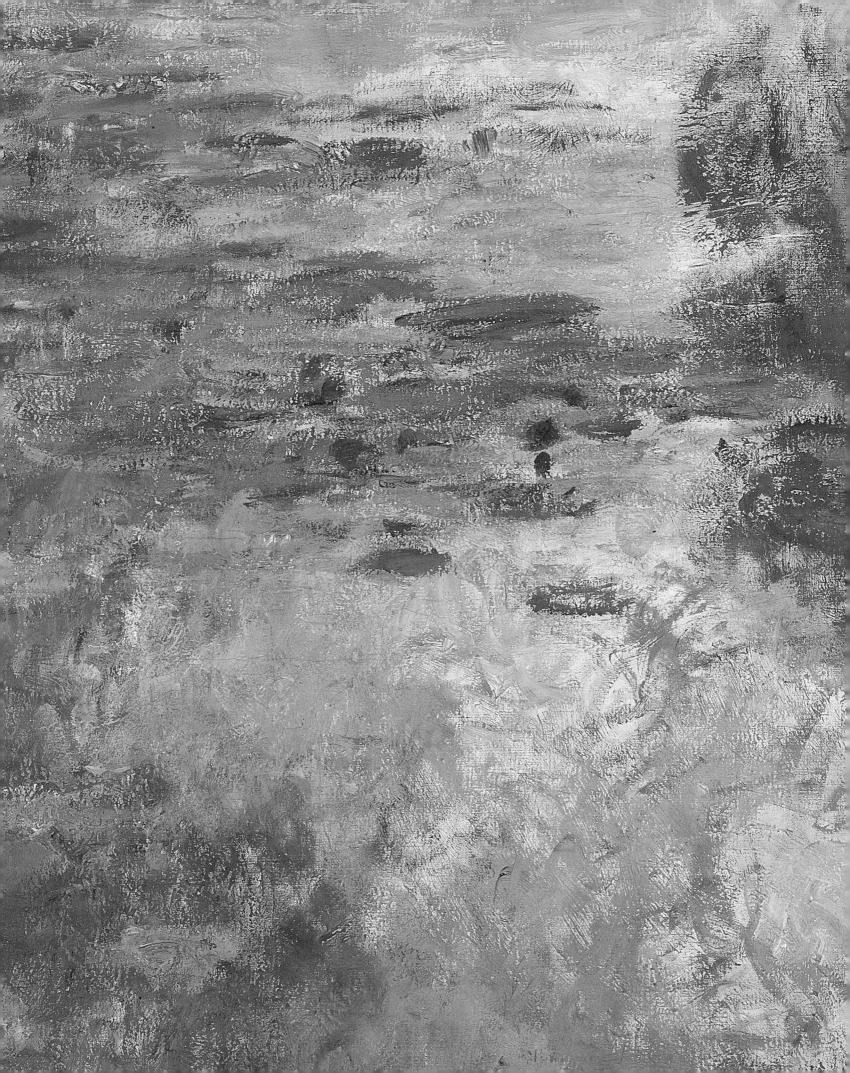

The paintings included in this group represent Monet's return to the solid terrain of his garden, which was initiated towards the close of his extensive engagement with the water-lily pond after 1913. In some instances, as in the Weeping Willow and the Water Lily Pond at Giverny groups (see cats. 81–4; 74 and 75), he retained vestiges of reference to the pond itself, while in others he revisited subjects such as the views of the garden path (see cat. 84), the house (see cats. 86 and 87) and the Japanese Bridge (see cats. 77–80), which he had initially confronted around 1900 (see above, pp. 118–27). Some of the paintings, for example catalogue numbers 86 and 87, were undertaken immediately before and after his cataract operation in January 1923, and adopt exaggerated tonalities of strident reds or blues.

These sixty-nine later views of the garden at Giverny fall into six sub-groups: the Water Lily Pond at Giverny (six paintings and one related canvas); the Weeping Willow (ten paintings with a further three subsidiary views); the Japanese Bridge (twenty-four paintings); the Path under the Rose Arches (seven paintings); the Artist's House seen from the Rose Garden (eight paintings), and the House among Roses (ten paintings). These can all be brought together within three general areas. The Water Lily Pond at Giverny sub-group (see cats. 74 and 75) appears to be the most conventional in the treatment of weeping willow, pond, and path that recedes legibly into the depth of the composition. Even the sharply articulated range of colors seems committed to an objective description of this corner of the garden. It is all the more puzzling that Monet chose to donate one of this sub-group (cat. 74) to the Musée des Beaux-Arts, Grenoble, on May 18, 1923, in order "to encourage modern tendencies" in that collection. The Artist's House seen from the Rose Garden (see cats. 86 and 87), the House among Roses and the Path under the Rose Arches (see cat. 85) are more adventurous in both palette and technique. While the Path under the Rose Arches adopts a consistently red, yellow, and brown tonality, the other two sub-groups fall into two types dominated by red and by blue palettes, probably consistent with Monet's vision before and after his cataract operation. Technically these sub-groups also present a contrast between those paintings in which the paint is laid on in broad, calligraphic brush strokes and others where it is stabbed into the canvas in short, square brush-stroke jabs (see cat. 87), which create a mosaic-like effect. The third group is yet more radical; it covers the Weeping Willow and the Japanese Bridge paintings. In the Weeping Willow (see cats. 81–4), the tree, whose reflection had been the subject of such persistent study within the various Water Lily compositions over the preceding fifteen years, now becomes the focus of attention, its trunk and drooping boughs being pulled up to the front plane of the canvas and treated with a rhythmic pattern of descending, heavily loaded brush strokes that sear the surface of the painting itself. The Japanese Bridge sub-group presents the bridge crowned by its wisteria-festooned pergola (see cat. 77). These two elements are knitted together with bank, reeds, water lilies, and reflections through a complex web of expressive gestural brushwork and cast in specific tonalities of predominantly green–yellow (see cat. 77), blue–green (see cat. 78) or red–green (see cats. 79 and 80) effects. Seen as portents and legitimizers of the New York School of Abstract Expressionism (see above, pp. 98–108), it is significant that two of the Japanese Bridge sub-group paintings (cats. 79 and 80) were exhibited for the first time at the Knoedler Gallery, New York, in 1956, and entered American collections the following year, two years after the Museum of Modern Art had acquired its first great Water Lily decorative panel (fig. 77).

Only seven of the sixty-nine paintings were dated, including two Weeping Willows (cats. 82 and 83), three Water Lily Pond at Giverny (including cats. 74 and 75), one Japanese Bridge (cat. 77) and one Artist's House seen from the Rose Garden (cat. 86). Several points can be extrapolated from these few dated works. First, given that at least one Water Lily Pond at Giverny (cat. 74) was dated 1917, it is possible to suggest that Monet had returned to "terra firma" by that year, working concurrently with the two-meter-long canvases also started in that year. Second, the one dated Japanese Bridge (see cat. 77) indicates that by 1919 Monet had returned to a subject initially explored some twenty years earlier. Third, although one of the eight views of the Artist's House seen from the Rose Garden was dated 1922, their strikingly dominant palettes of red and blue are evidence of Monet's changing eyesight and thus indicate that both this sub-group and the House among Roses were probably made in the closing four years of the artist's life. Finally, the extensive absence of dated works emphasizes the fact that some sixty-two paintings from this group remained in Monet's studio on his death and must therefore probably be considered "unfinished." Apart from the painting given to Grenoble in 1923 (cat. 74), of the remaining six, five were sold jointly to Bernheim-Jeune and Durand-Ruel, two in 1918 (including cat. 82) and three in the 1920s (see cats. 75 and 77); one was sold probably in the following year to the Japanese collector Matsukata (cat. 83). These six works were also the only ones exhibited during Monet's lifetime, five being included in a 1919 Bernheim-Jeune exhibition in Paris, and one in an exhibition at Galerie Georges Petit five years later.

facing page Detail of cat. 75.

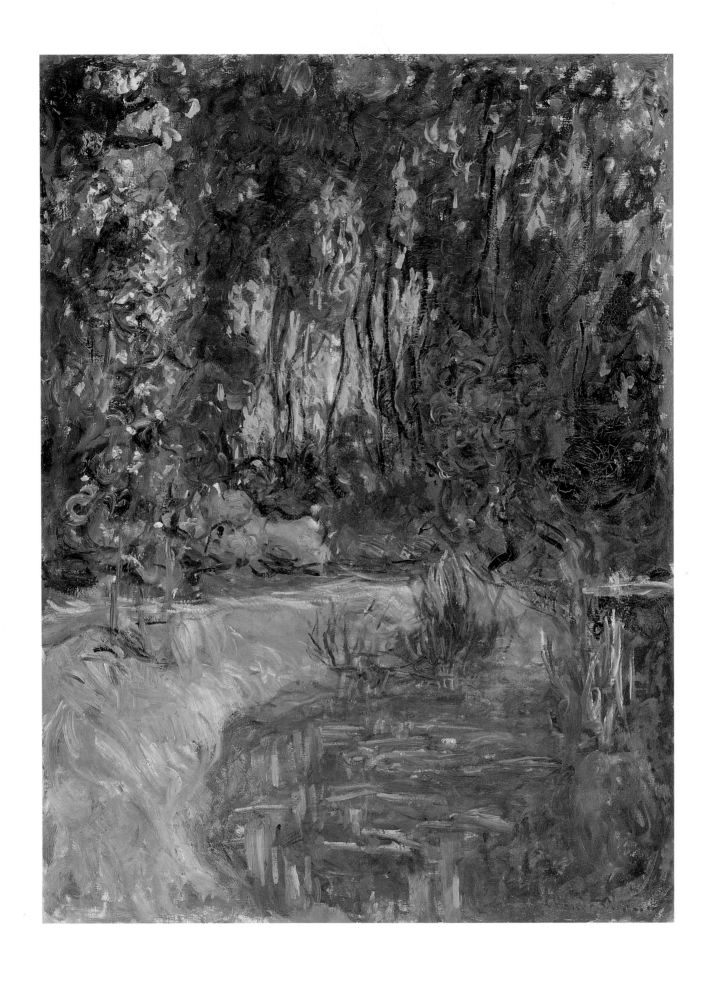

74 *The Water Lily Pond at Giverny*, 1917, oil on canvas, 117 × 83 cm (W.1878). Musée de Grenoble

Given by Monet in May 1923 to the Musée de Grenoble to encourage modern art

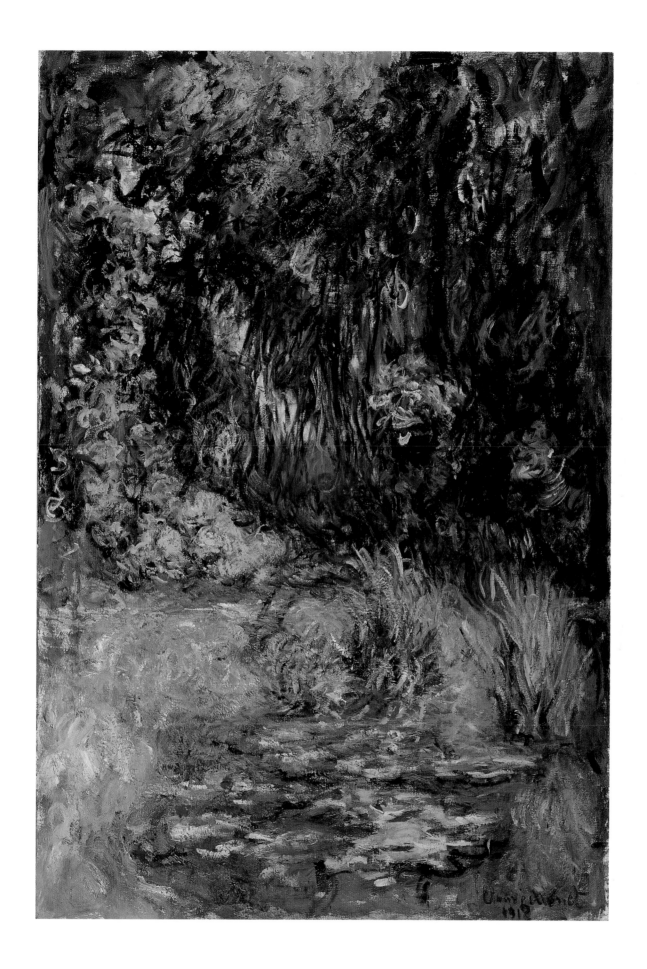

75　*The Water Lily Pond*, 1918, oil on canvas, 130 × 88 cm (W.1880). Private Collection

Bought from Monet in January 1919 by Bernheim-Jeune and Durand-Ruel; exhibited Galerie Bernheim-Jeune, Paris, 1919,
at Durand-Ruel Gallery, New York, 1919, and possibly at Galerie Bernheim-Jeune, Paris, 1923

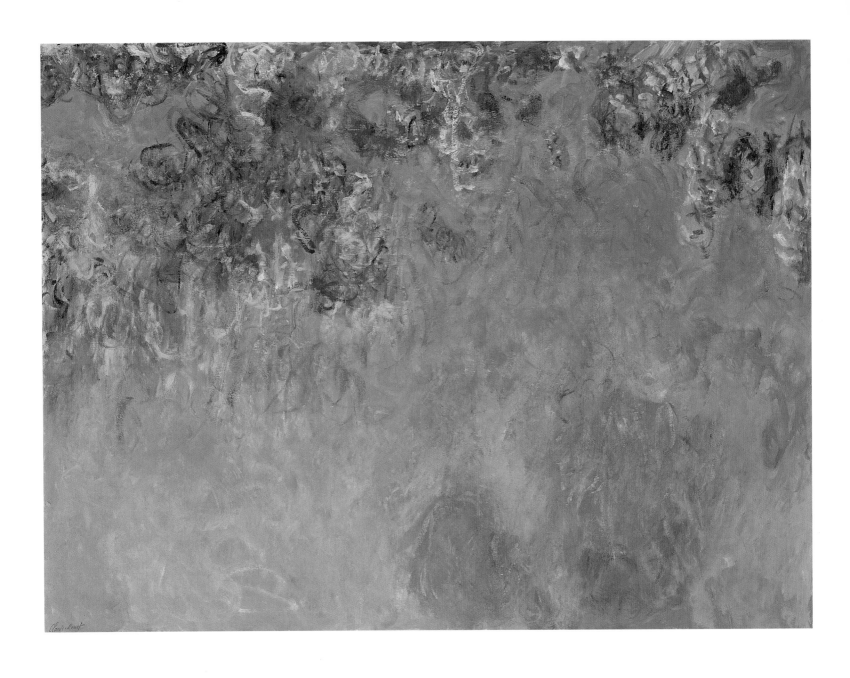

76 *Wisteria*, 1917–20, oil on canvas, 150 × 200 cm (W.1908). Haags Gemeentemuseum

Remained in Monet's studio and never exhibited during his life; around 1960 with G. David Thompson, Pittsburgh

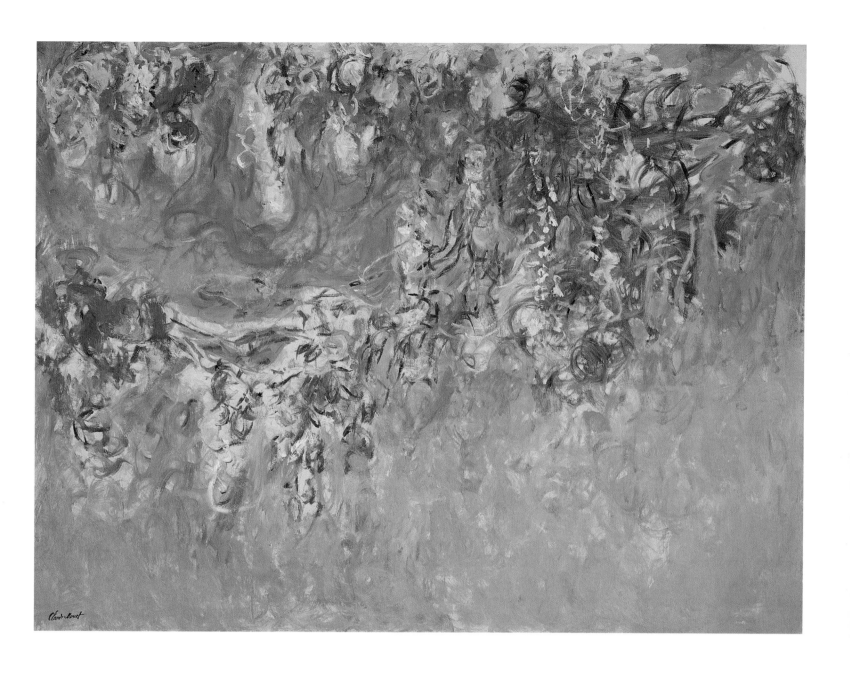

76a *Wisteria*, 1917–20, oil on canvas, 150 × 200 cm (W.1909). Allen Memorial Art Museum, Oberlin College, Oberlin, Ohio.
R.T. Miller, Jr. Fund, 1960

Remained in Monet's studio and never exhibited during his life; first exhibited Saint Louis and Minneapolis 1957 and bought by the museum in 1960

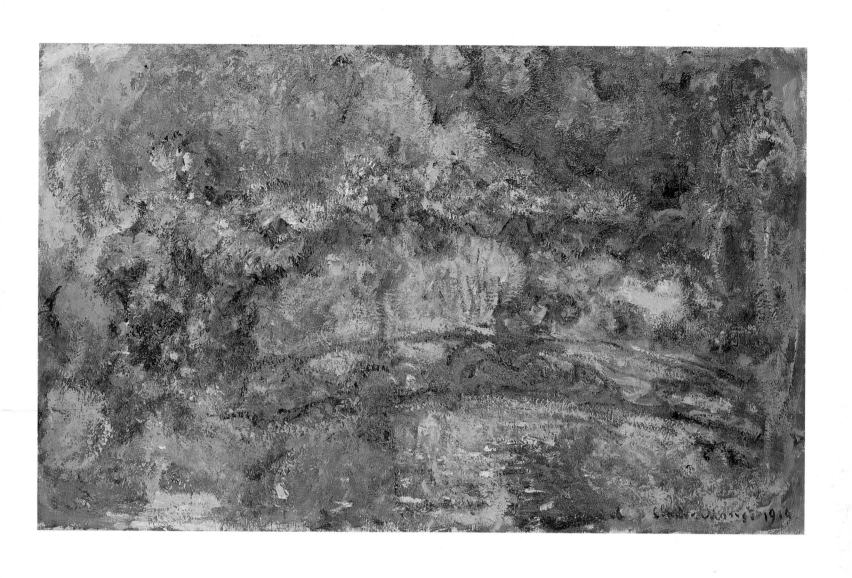

77 *The Footbridge over the Water Lily Pond*, 1919, oil on canvas, 65 × 107 cm (W.1916). Öffentliche Kunstsammlung Basel, Kunstmuseum

Bought from Monet in November 1919 by Bernheim-Jeune; exhibited Galerie Bernheim-Jeune, Paris 1921 and Durand-Ruel Gallery, New York 1922;
exhibited New York and Los Angeles 1960

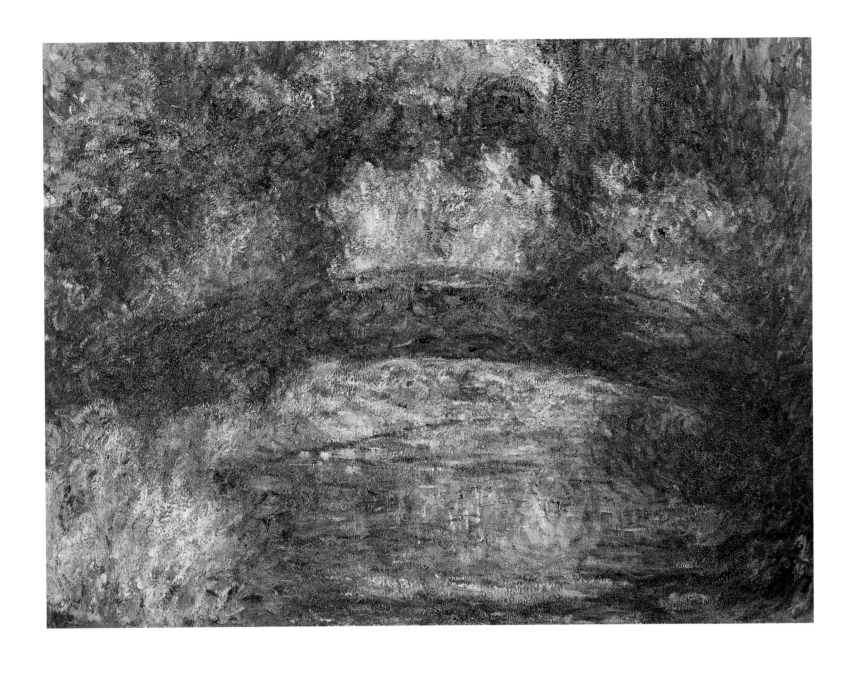

78 *The Japanese Bridge*, 1919–24, oil on canvas, 89 × 116 cm (W.1921a). European Private Collection

Remained in Monet's studio and never exhibited during his life; in a Paris collection by about 1940

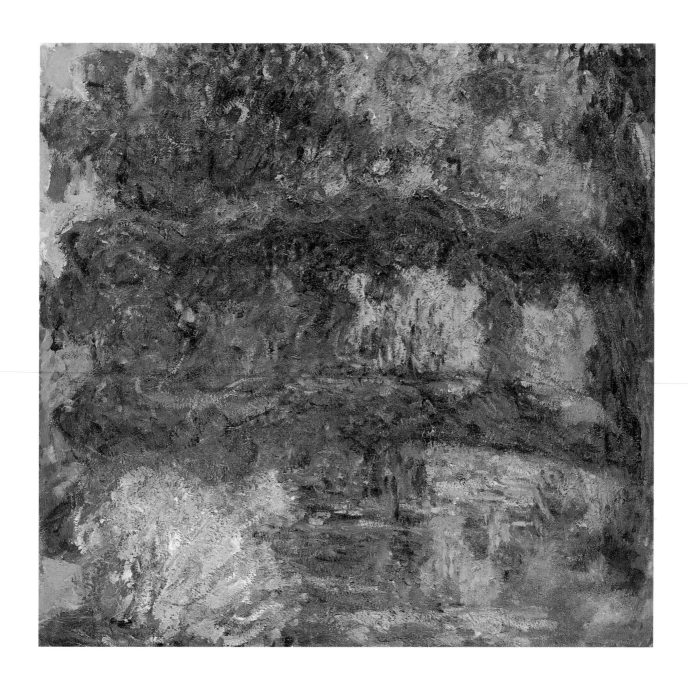

79 *The Japanese Bridge*, 1919–24, oil on canvas, 89 × 91 cm (W.1930). Philadelphia Museum of Art:
The Albert M. Greenfield and Elizabeth M. Greenfield Collection

Remained in Monet's studio and never exhibited during his life; with Knoedler Gallery, New York, 1956
and in the collection of Mr. and Mrs. Albert M. Greenfield 1957

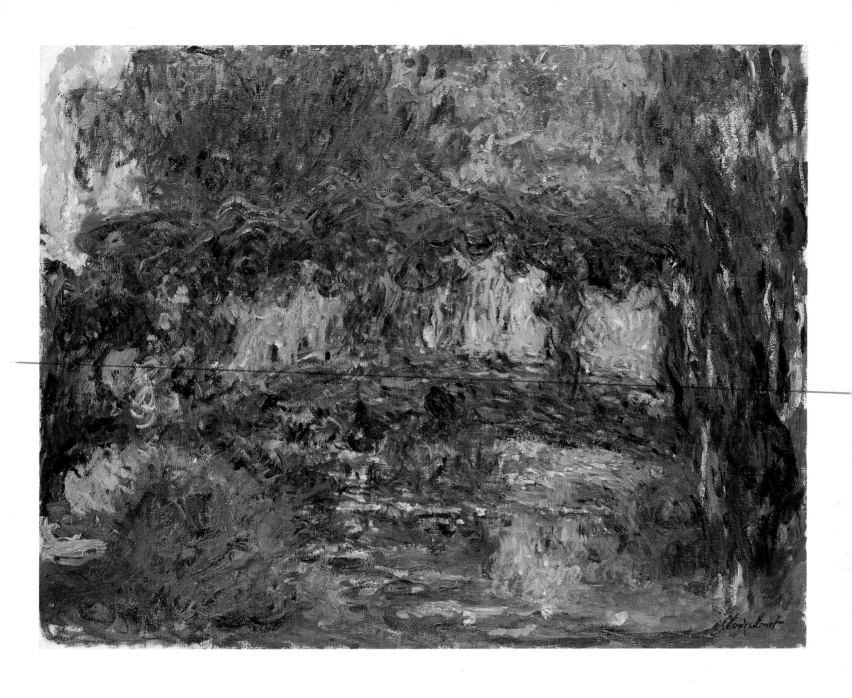

80　*The Japanese Bridge*, c.1919–24, oil on canvas, 89 × 116 cm (W.1931). The Minneapolis Institute of Arts,
Bequest of Putnam Dana McMillan

Remained in Monet's studio and never exhibited during his life; with Knoedler Gallery, New York, exhibited Saint Louis and Minneapolis 1957
and bought the same year by Putnam Dana McMillan

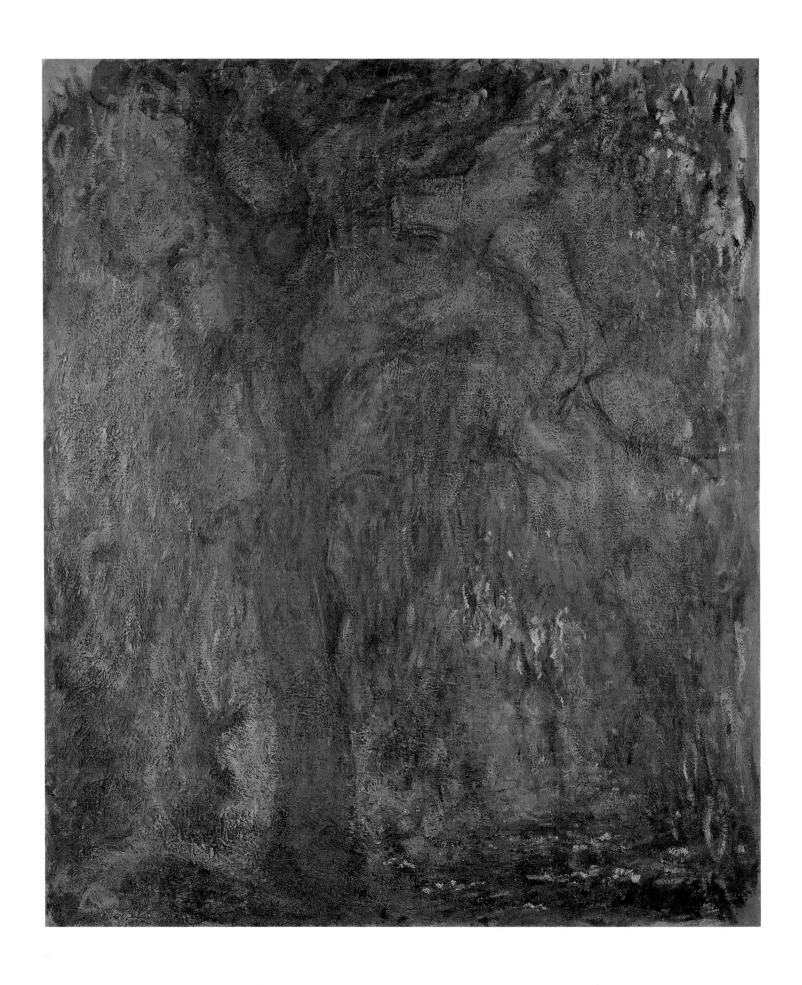

81 *Weeping Willow*, 1918–19, oil on canvas, 130 × 100 cm (W.1871). Private Collection

Remained in Monet's studio and never exhibited during his life

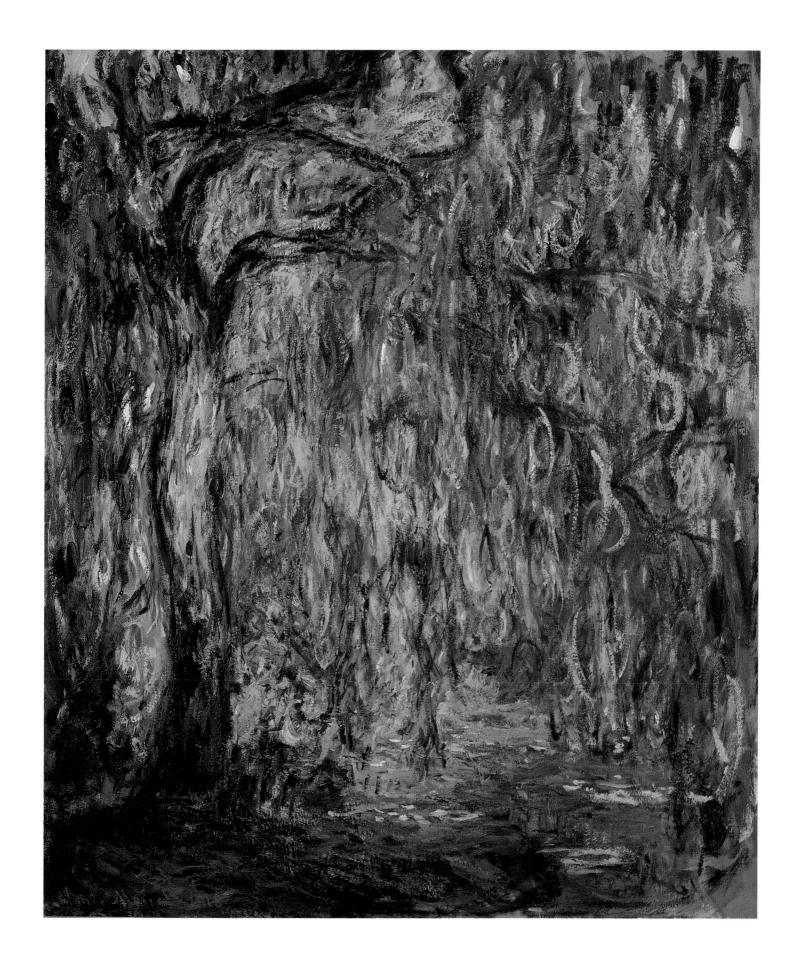

82 *Weeping Willow*, 1918, oil on canvas, 130 × 110 cm (W.1869). Columbus Museum of Art, Ohio;
Gift of Howard D. and Babette L. Sirak, the Donors to the Campaign for Enduring Excellence, and the Derby Fund

Bought from Monet in December 1918 by Bernheim-Jeune; exhibited Galerie Bernheim-Jeune, Paris, 1919 and 1923

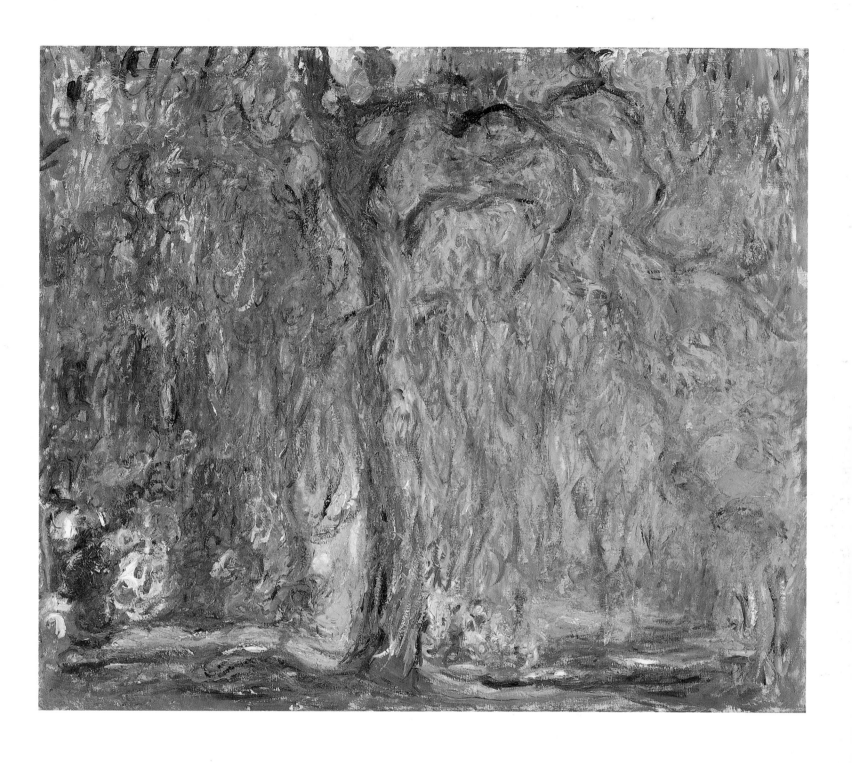

83 *Weeping Willow*, 1918–19, oil on canvas, 100 × 120 cm (W.1876). Kimbell Art Museum, Fort Worth, Texas

Bought from Monet in around 1922 by Kojiro Matzukata; exhibited Galerie Georges Petit, Paris 1924

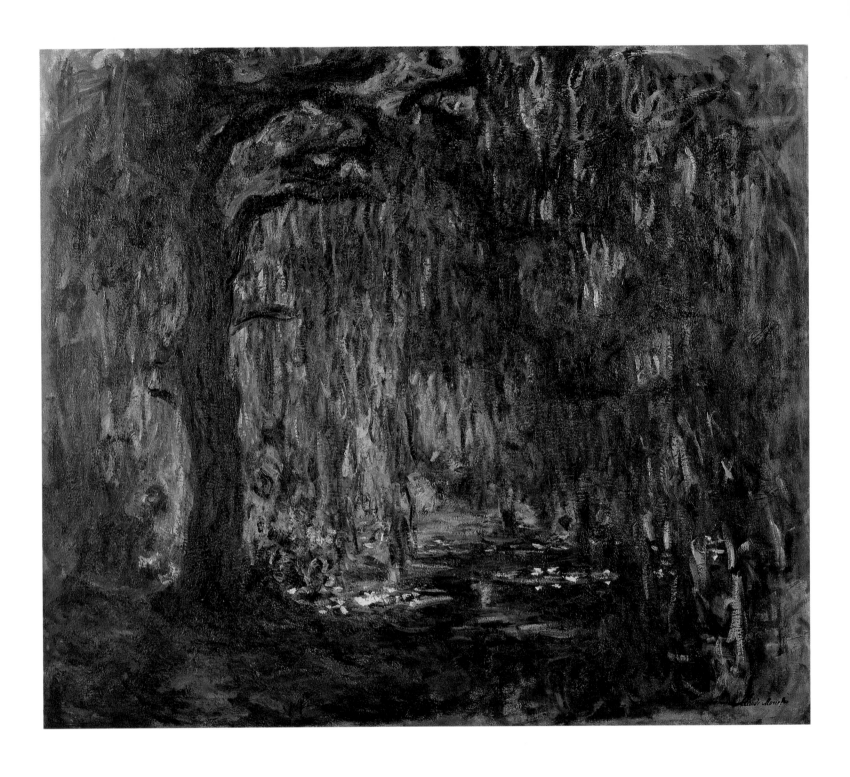

84 *Weeping Willow*, 1918–19, oil on canvas, 130 × 152 cm (W.1870). Private Collection

Remained in Monet's studio and never exhibited during his life

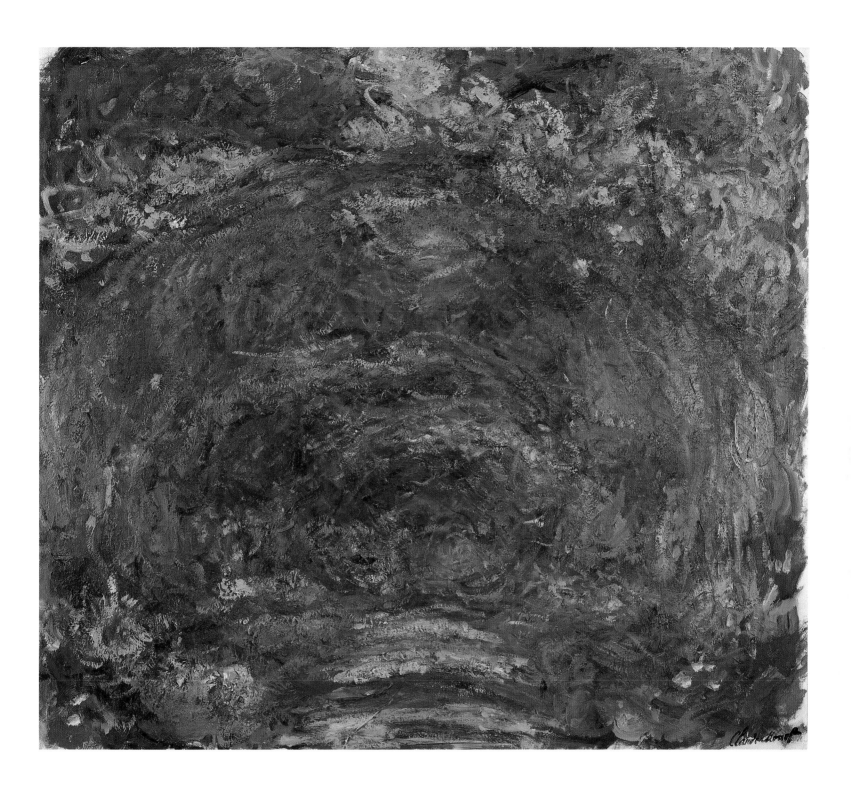

85 *The Path under the Rose Arches*, 1918–24, oil on canvas, 89 × 100 cm (W.1936). Private Collection, Switzerland

Remained in Monet's studio and never exhibited during his life

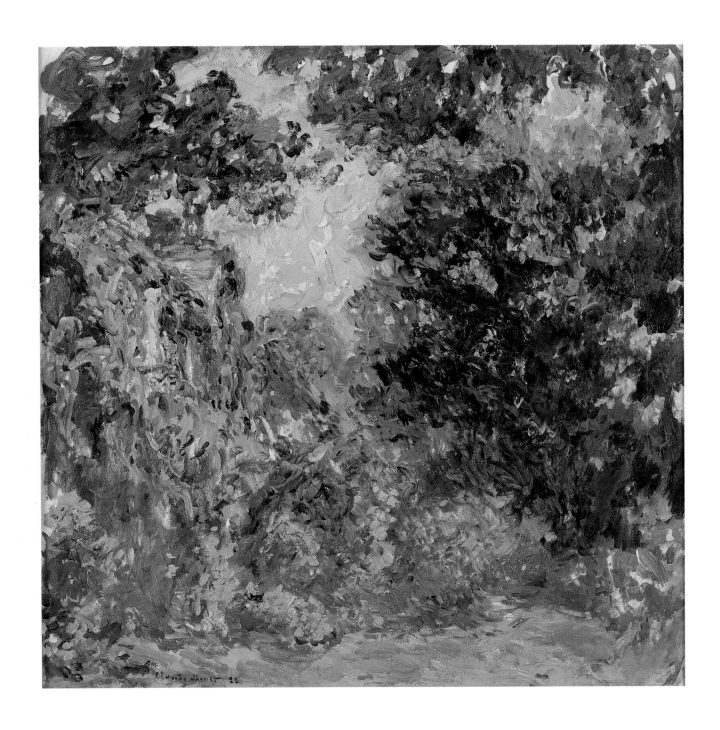

86 *The Artist's House seen from the Rose Garden*, 1922–4, oil on canvas, 81 × 93 cm (W.1944).
Musée Marmottan-Claude Monet, Paris

Remained in Monet's studio and never exhibited during his life

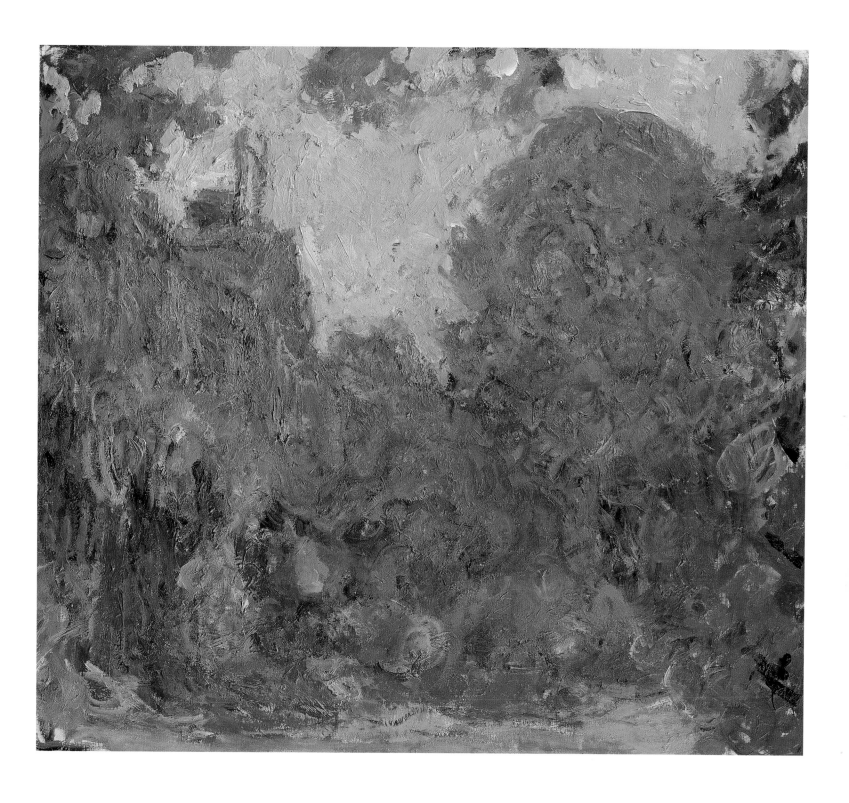

87 *The House seen from the Rose Garden*, 1922–4, oil on canvas, 89 × 100 cm (W.1946).
Musée Marmottan-Claude Monet, Paris

Remained in Monet's studio and never exhibited during his life

The mural decorations that Monet had first envisioned in 1897, and had begun in the spring of 1914, were well under way by the summer of the next year, when the artist began work on a new studio to the east of his house. The new studio was specially built to house the large-scale panels that he was painting at the time – each measuring two meters in height by three or more than four meters in width, but increasing in size to six meters after the completion of the construction. Although the momentous project was begun, it seems, without a clear idea of the ultimate destination of the murals, the painter's desire to offer one of the panels to the State at the close of the First World War led to the lengthy negotiations with Clemenceau that resulted in the donation of a much greater number of panels (see above, pp. 73–85). It was eventually decided that they should be housed in Paris, in a building constructed to display them; in the end, the Orangerie in the Tuileries Gardens was adapted to house the ensemble. From 1919 onwards, the project took on a new fervor, and while Monet continued to create easel paintings unrelated to the decorations – the Weeping Willow canvases, views of his house, or of the Japanese bridge, for example (cats. 81–4, 86–7, 77–80) – almost all his efforts were directed at the completion of the decorative cycle.

With the aid of the 2 × 2 meter studies (cats. 59–63) as well as the more panoramic Water Lilies measuring 1 × 2 meters (cats. 71–3), and even referring to the Water Lilies that he retained from 1907–8, Monet worked and reworked the gigantic canvases, moving from one to another, shifting their relationships as the plan unfolded. In all, more than 170 meters of canvas were placed on stretchers measuring 2 × 3, 2 × 4.25, or 2 × 6 meters. One such panel was sold in 1922 to Prince Matsukata (W.1971), but this was only one of more than forty begun between 1914 and 1919 and brought to completion by 1926. The decorations chosen to be mounted at the Musée de l'Orangerie consisted of twenty-two panels of either 4.25 or 6 meters in length, altogether measuring more than 90 meters. At the Orangerie architectural spaces were created to receive these panels in groups of two, three, or four. Many possible combinations were proposed; but there remained, in Monet's estate, after the installation of the Paris decorations, nineteen more panels, totaling more than almost 80 meters. Beginning in 1952, these paintings were sold to private collectors and museums in Europe and the United States: seven such panels are included in this exhibition.

One of them, catalogue number 92, was by virtue of its continuous six-meter expanse almost certainly originally a candidate for inclusion in the Orangerie cycle. It might have been installed by itself at the western end of the first room or, possibly, in altered form, as the right half of a twelve-meter panorama originally projected for the second room. Catalogue numbers 90 or 91, each of which measures 4.25 meters, might also have been chosen for the Orangerie: indeed the Saint Louis panel (cat. 90) is the centerpiece of a three-panel continuous composition (the other panels, W.1977 and W.1979, are at the Nelson-Atkins Museum of Art, Kansas City, and the Cleveland Museum of Art) which seems to figure in preliminary plans for the donation. In both of these works, the organization of the composition, with scattered islands of flowers and foliage drifting on a luminously colored surface, relates closely to such panels in the Orangerie as the *Green Reflections* installed on the eastern wall of the first room.

The remaining decorations in the exhibition, four three-meter panels making up two compositions (cats. 88 and 89), are more difficult to classify. In the final scheme, none of the nine surviving three-meter panels (the two diptychs here, and the triptych in the Beyeler Collection, Basel, W.1968–70) was chosen to be mounted at the Orangerie. Does this signify that they had a different role in the elaboration of the project? In their format (each diptych measures six meters) and in their composition, with its mass of reflected foliage at the right and left, both paintings relate closely to such works as catalogue number 92 and the six-meter *Sunset* in the first room of the Orangerie: the Zurich diptych, in fact, is so closely related to the latter that it might almost be considered a study for that work. They are certainly less densely painted than either the Orangerie decorations or most of the four-and-a-quarter- or six-meter panels: this gives them a sense of atmosphere and luminosity that is sometimes curiously absent from the more intricately worked surfaces of the Paris paintings. It is possible that the three-meter panels – more easily manipulated than the larger canvases – are among the earliest that Monet attempted before the construction of the vast studio he needed to accommodate the six-meter panels. Their atmospheric effects invite comparison with the water lilies he had exhibited in 1909 (for example, cats. 42 and 47). Their fresh and vibrant surfaces may present to us the painter's first engagement with the process of broadening his vision towards the triumphant panoramas of his last years.

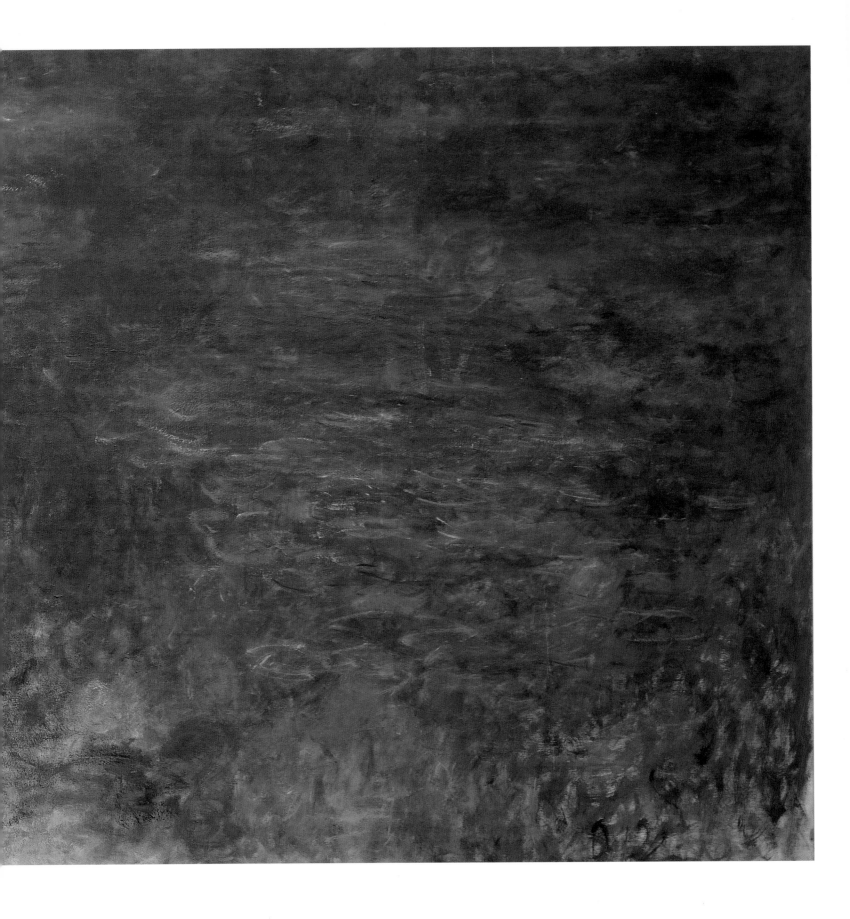

88 *The Water Lily Pond*, c.1915–26, oil on canvas, 200 × 300 cm (each) (W.1964–5). Kunsthaus Zürich (1952/64)

Remained in Monet's studio; first exhibited Zürich, Paris, and The Hague 1952; bought in 1952 by Emile Bührle, Zürich,
and given that year to the Kunsthaus Zürich

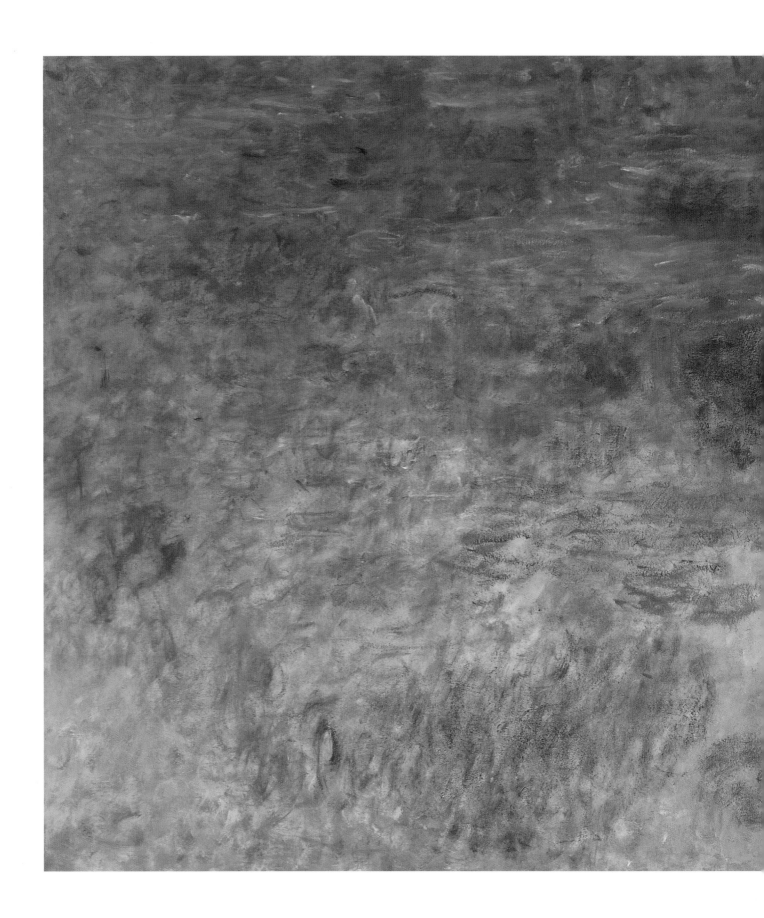

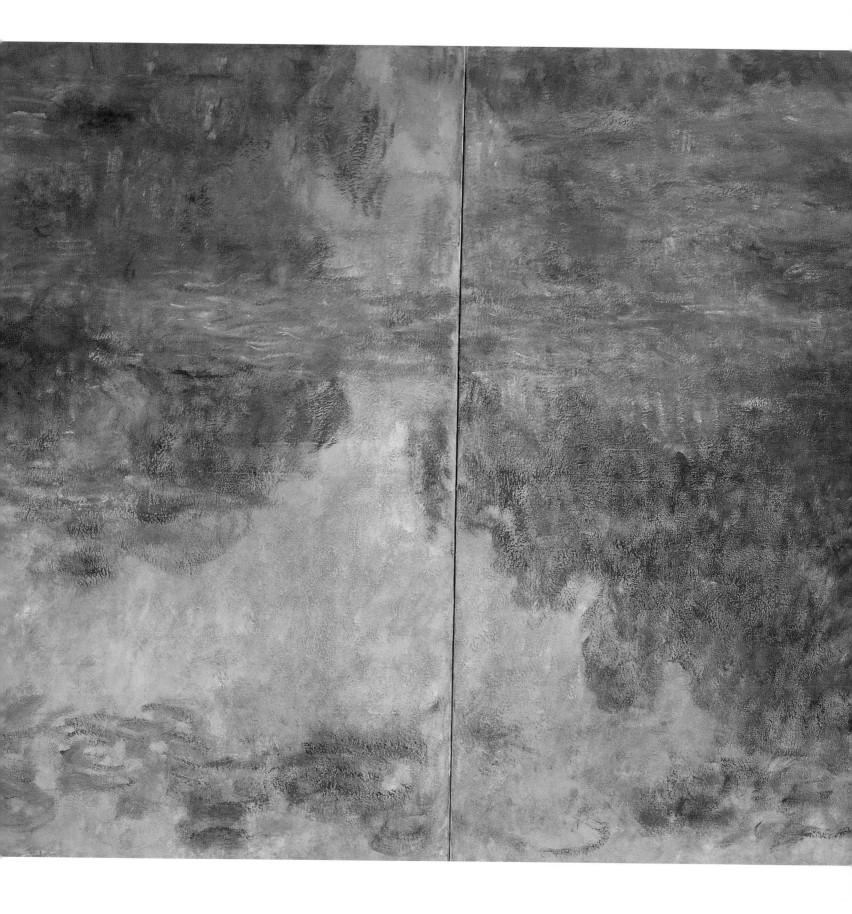

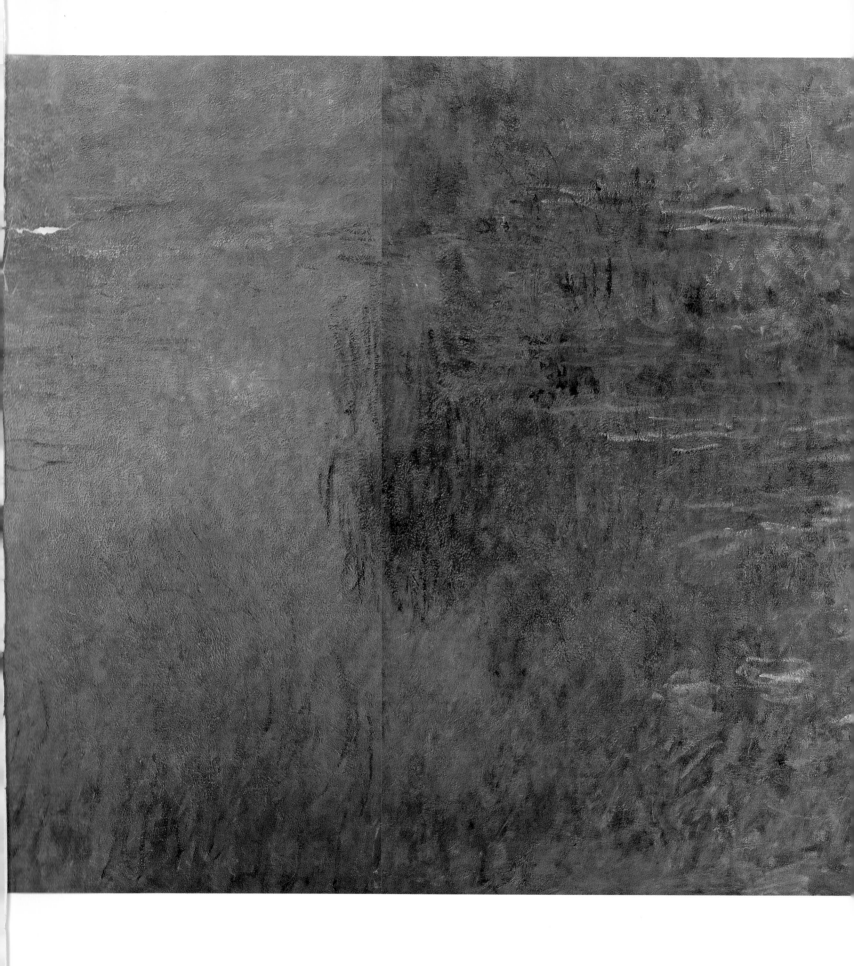

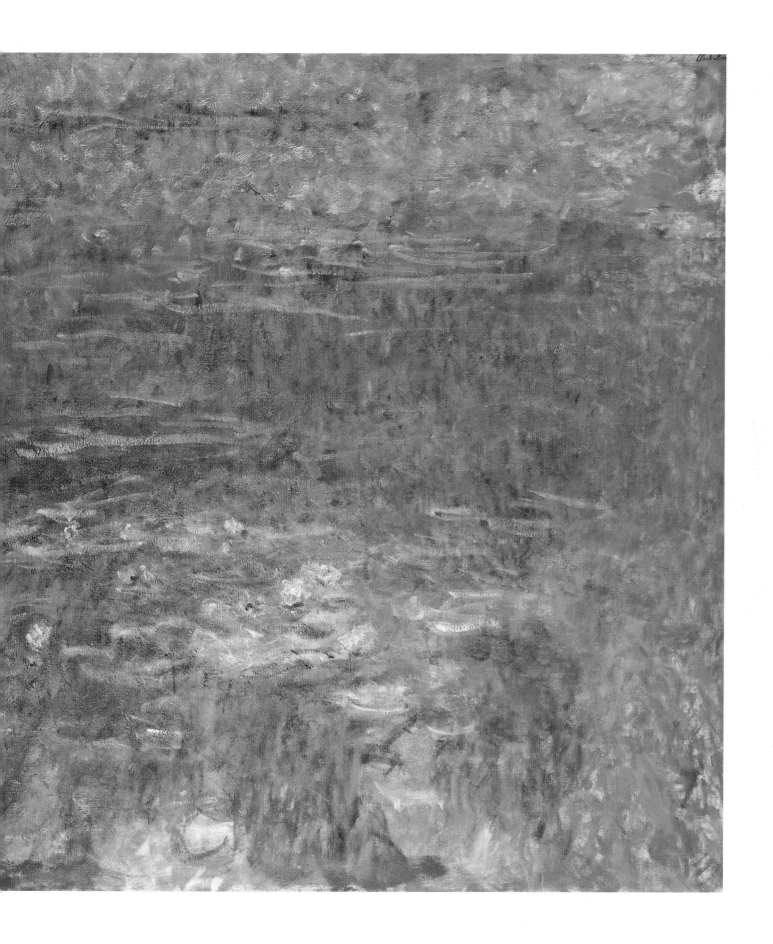

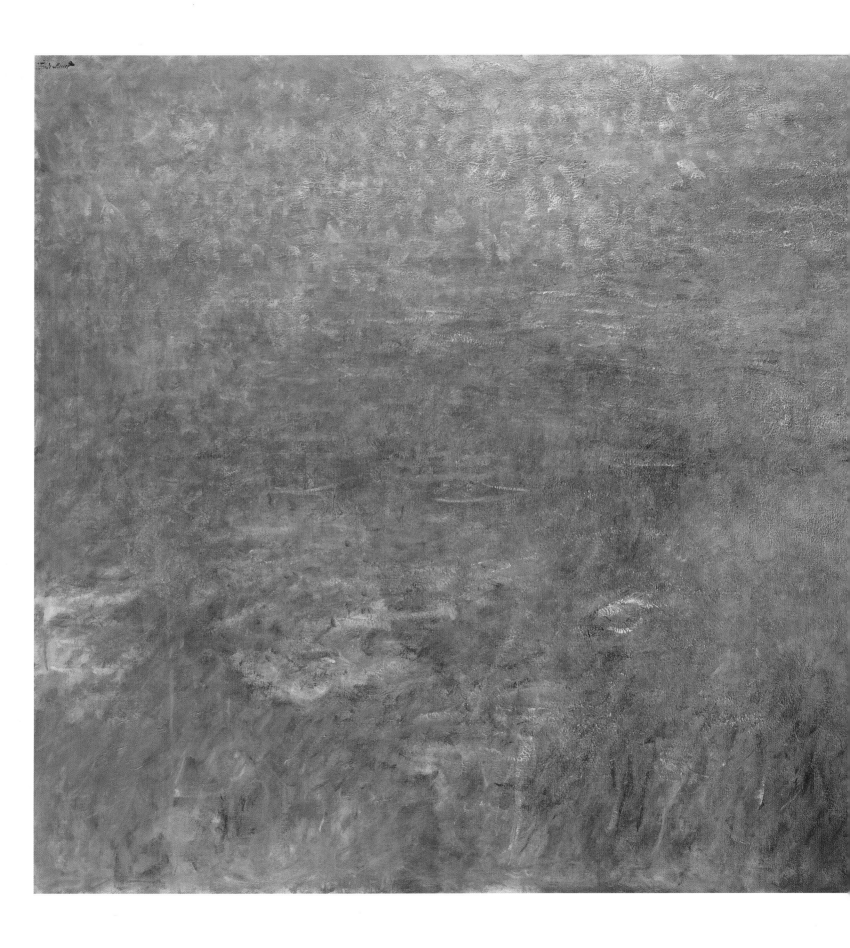

89 *Water Lily Pond*, c.1915–26, oil on canvas, 200 × 300 cm (each) (W.1966–7). Courtesy of Galerie Larock-Granoff, Paris

Remained in Monet's studio; exhibited for the first time in *Monet in the 20th Century*

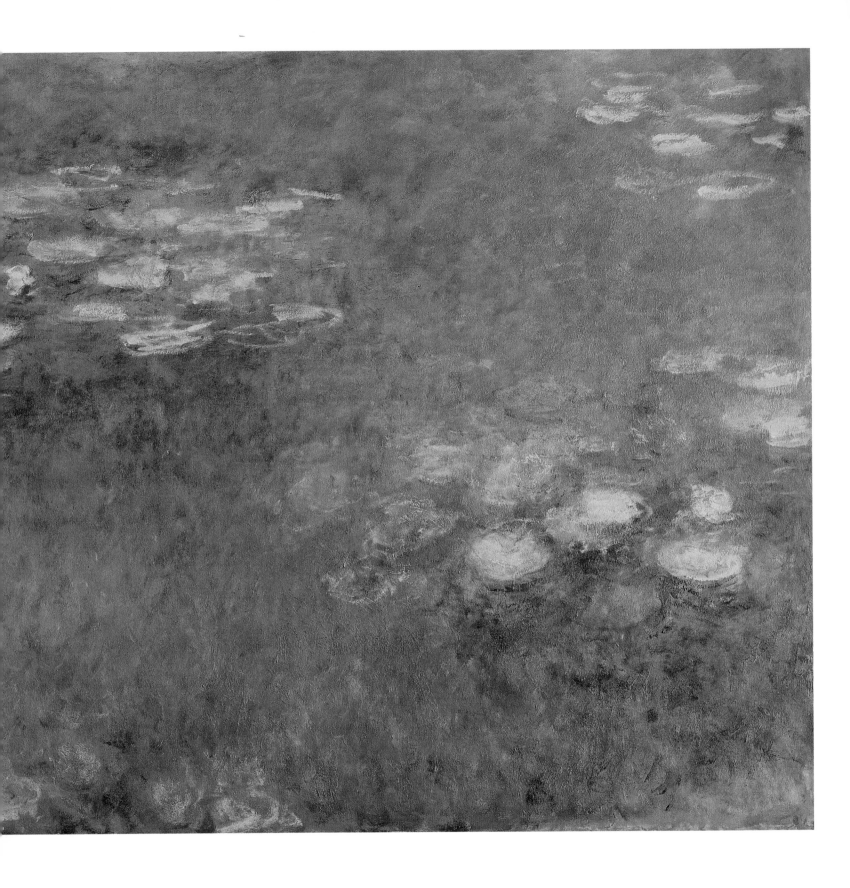

90 *Agapanthus*, c.1916–26, oil on canvas, 200 × 425 cm (W.1976). The Saint Louis Art Museum, The Steinberg Charitable Fund

Central part of a triptych (W.1975, Cleveland Museum of Art; W.1977, Nelson-Atkins Museum of Arts, Kansas City).
Remained in Monet's studio; with Knoedler Gallery, New York, 1956 and given the same year to the museum;
exhibited Saint Louis and Minneapolis 1957

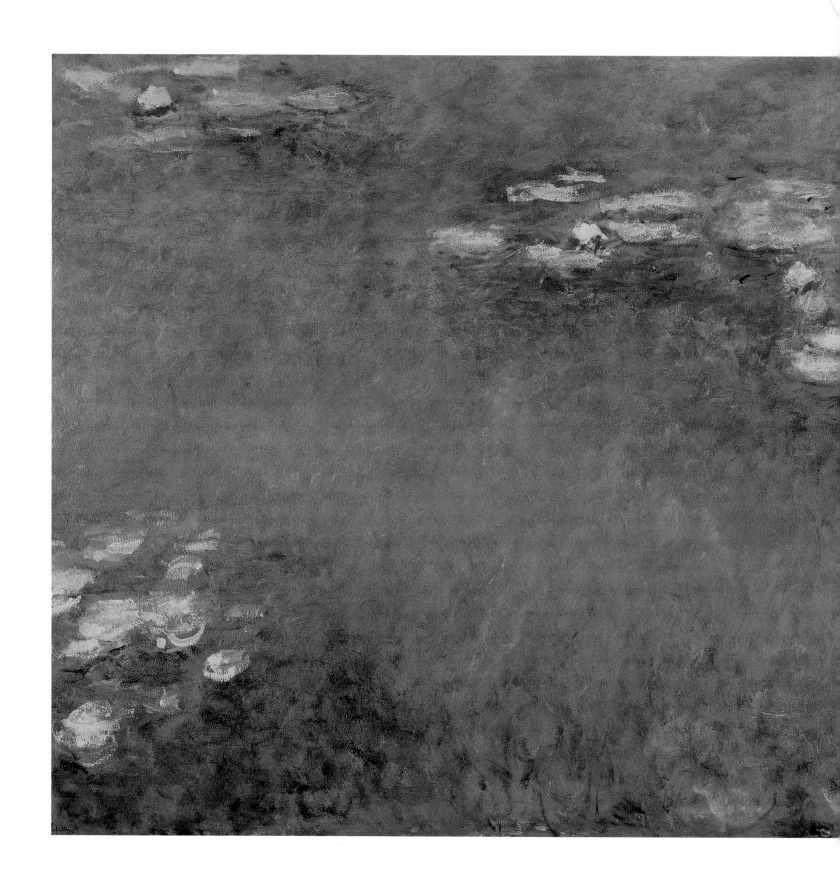

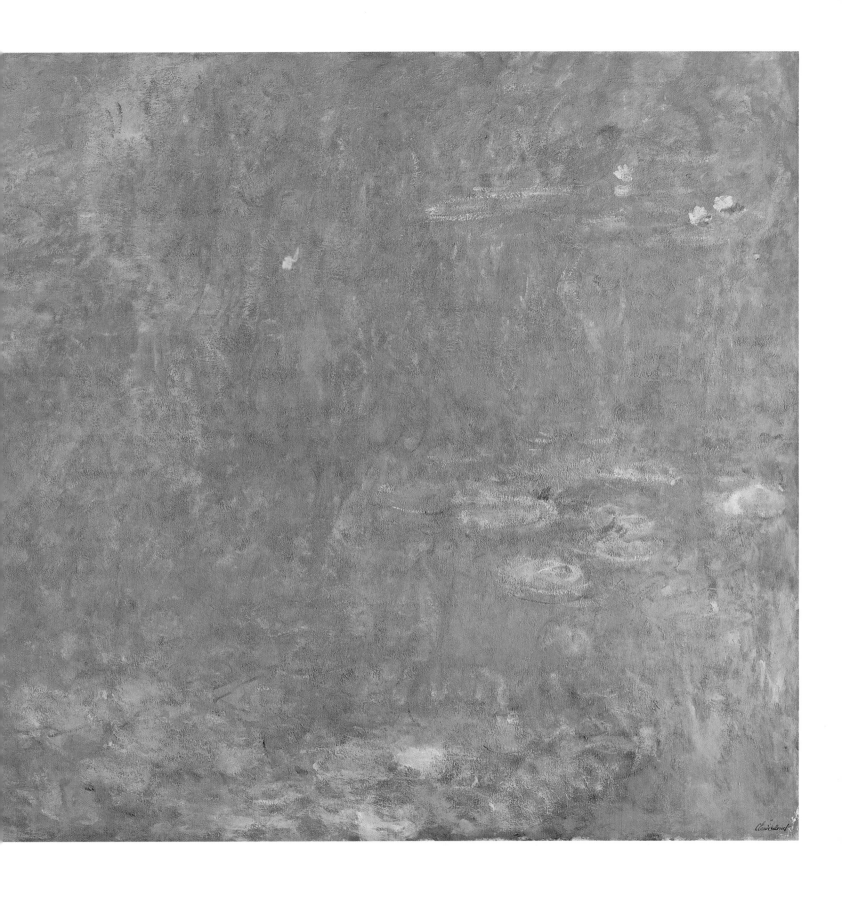

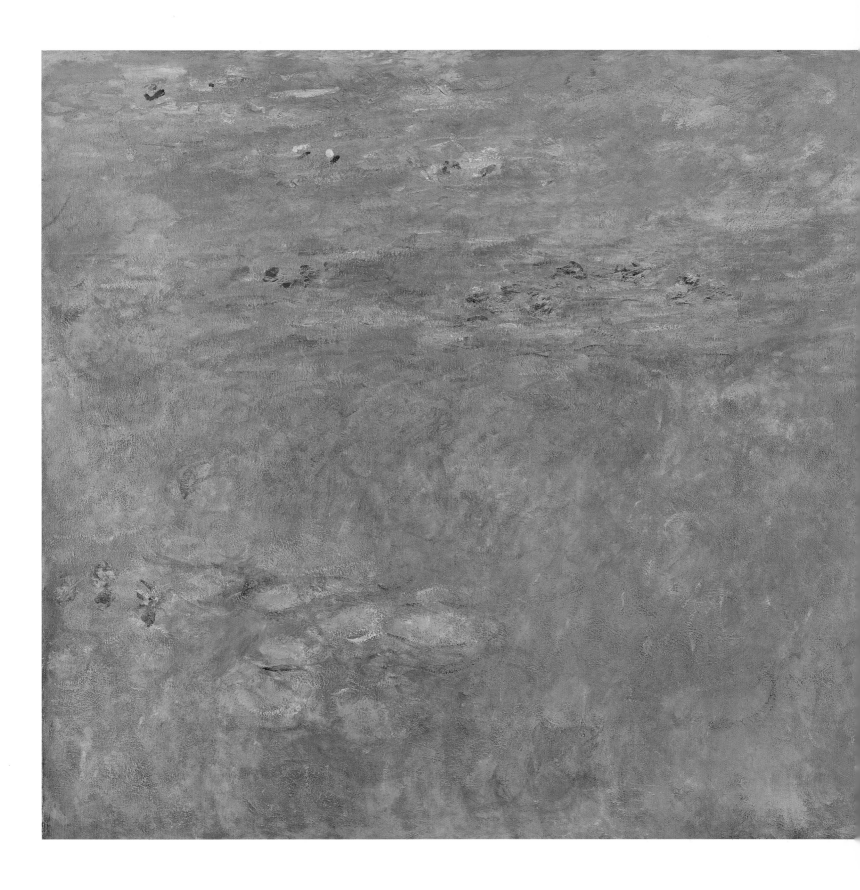

91 *Water Lily Pond, c.*1916–26, oil on canvas, 200 × 425 cm (W.1978). The National Gallery, London

Remained in Monet's studio; exhibited New York and Los Angeles 1960 and bought in 1963 by the National Gallery

92 *Water Lily Pond*, c.1916–26, oil on canvas, 200 × 600 cm (W.1981). The Museum of Modern Art, New York. Mrs. Simon Guggenheim Fund

Remained in Monet's studio; bought by the Museum of Modern Art in 1959 together with a triptych (W.1972–4),
to replace another six-meter panel (W.1982) acquired in 1955 and destroyed by fire in 1958

Catalogue Apparatus

Exhibition Checklist

The Garden at Giverny 1900–1902

1 The Bridge over the Water Lily Pond, 1900
Le Pont sur le bassin aux nymphéas, Giverny
Oil on canvas: 89 × 100 cm
Signed and dated u.l., 1900
W.1628
The Art Institute of Chicago, Mr. and Mrs. Lewis
Larned Coburn Memorial Collection (1933.441)

2 The Water Lily Pond (Symphony in Rose), 1900
Le Bassin aux nymphéas (harmonie rose)
Oil on canvas: 90 × 100 cm
Signed and dated l.l., 1900
W.1629
Musée d'Orsay, Paris; bequest of Comte Isaac de
Camondo, 1911– (RF 2005)

3 The Water Lily Pond, 1900
Le Bassin aux nymphéas
Oil on canvas: 90 × 92 cm
Signed and dated l.l., 1900
W.1630
Museum of Fine Arts, Boston. Given in Memory of
Governor Alvan T. Fuller by the Fuller Foundation
(61.959)

4 Path along the Water Lily Pond, 1900
Bassin aux nymphéas et sentier au bord de l'eau
Oil on canvas: 89 × 100 cm
Signed and dated l.r., 1900
W.1633
Private Collection

5 The Path at Giverny, 1902
L'Allée à Giverny
Oil on canvas: 81 × 92 cm
Signed and dated l.r., 1902
W.1652
Private Collection
Boston only

6 The Main Path at Giverny, 1900
La Grande Allée, Giverny
Oil on canvas: 88 × 92 cm
Signed and dated l.c.l., 1900
W.1627
Private Collection
London only

7 The Garden, 1900
Le Jardin
Oil on canvas: 81 × 92 cm
Signed and dated l.r., 1900
W.1625
Ralph T. Coe

8 The Main Path through the Garden at Giverny, 1901–2
Une Allée du jardin de Monet, Giverny
Oil on canvas: 89 × 92 cm
Signed and dated l.r., 02
W.1650
Österreichesche Galerie Belvedere, Vienna (MG 207)

Series of Views of the Thames in London 1899–1904

9 Charing Cross Bridge, Overcast Weather, 1900
Charing Cross Bridge, temps couvert
Oil on canvas: 60 × 92 cm
Signed and dated l.r., 1900
W.1526
Museum of Fine Arts, Boston. Given by Janet Hubbard
Stevens in Memory of her mother, Janet Watson
Hubbard (1978.465)

10 Charing Cross Bridge, The Thames, 1903
Charing Cross Bridge, la Tamise
Oil on canvas: 73 × 100 cm
Signed and dated l.l., 1903
W.1537
Musée des Beaux-Arts, Lyon (B.1725)
London only

11 Charing Cross Bridge, The Thames, 1903
Charing Cross Bridge, la Tamise
Oil on canvas: 73 × 100 cm
Signed and dated l.l., 1903
W.1536
Yoshino Gypsum Co., Ltd. (deposited at Yamagata
Museum of Art)

12 Charing Cross Bridge, Fog on the Thames, 1903
Charing Cross Bridge, brouillard sur la Tamise
Oil on canvas: 73 × 92 cm
Signed and dated l.r., 1903
W.1554
Fogg Art Museum, Harvard University Art Museums,
Gift of Mrs. Henry Lyman (1979.329)
Boston only

13 Charing Cross Bridge, Reflections on the Thames,
1899–1904
Charing Cross Bridge, reflets sur la Tamise
Oil on canvas: 65 × 100 cm
Signed l.r.
W.1532
The Baltimore Museum of Art: The Helen and Abram
Eisenberg Collection (BMA 1945.94)

14 Waterloo Bridge, Overcast Weather, 1900
Waterloo Bridge, temps couvert
Oil on canvas: 65 × 100 cm
Signed and dated l.r., 1900
W.1556
Hugh Lane Municipal Gallery of Modern Art, Dublin
(115)

15 Waterloo Bridge, Dusk, 1904
Waterloo Bridge, nuit tombante
Oil on canvas: 65 × 100 cm
Signed l.r
W.1564
National Gallery of Art, Washington, Collection of
Mr. and Mrs. Paul Mellon (1983.1.27)

16 Waterloo Bridge, Effect of Sunlight in the Fog, 1903
Waterloo Bridge, le soleil dans le brouillard
Oil on canvas: 73 × 100 cm
Signed and dated l.l., 1903
W.1573
National Gallery of Canada, Ottawa (NGC 817)
Boston only

17 Waterloo Bridge, 1902
Waterloo Bridge
Oil on canvas: 65 × 100 cm
Signed and dated l.r., 1902
W.1581
Kunsthaus Zürich, Donation Walter Haefner (1995/2)

18 Waterloo Bridge, Grey Weather, 1903
Waterloo Bridge, temps gris
Oil on canvas: 65 × 100 cm
Signed and dated l.r., 1903
W.1561
Copenhagen, Ordrupgaardsamlingen
London only

19 Waterloo Bridge, Sunlight Effect, 1903
Waterloo Bridge, effet de soleil
Oil on canvas: 65 × 100 cm
Signed and dated l.r., 1903
W.1587
Collection of McMaster University, Hamilton, Canada;
Gift of Dr. Herman Herzog Levy, OBE (1984.007.0043)

20 Waterloo Bridge, Sunlight Effect, 1903
Waterloo Bridge, effet de soleil
Oil on canvas: 73 × 92 cm
Signed and dated l.l.,1903
W.1567
Milwaukee Art Museum, Gift of Mrs. Albert T.
Friedmann (M.1950.3)

21 Houses of Parliament, Sunlight Effect, 1903
Le Parlement, effet de soleil
Oil on canvas: 81 × 92 cm
Signed and dated l.l., 1903
W.1597
Brooklyn Museum of Art, Bequest of Grace
Underwood Barton (68.48.1)

22 Houses of Parliament, Seagulls, 1904
Le Parlement, les mouettes
Oil on canvas: 81 × 92 cm
Signed and dated l.r., 1904
W.1613
Pushkin State Museum of Fine Arts, Moscow (3306)

23 Houses of Parliament, Symphony in Rose, 1900-01
Le Parlement, symphonie en rose
Oil on canvas: 81 × 92 cm
Signed l.r.
W.1599
Private Collection, Japan

facing page Detail of cat. 4

24 *Houses of Parliament, Sunset*, 1904
Le Parlement, coucher de soleil
Oil on canvas: 81 × 92 cm
Signed and dated l.l., 1904
W.1607
Kunsthaus Zürich, Donation Walter Haefner (1995/3)

Water Lilies (Series of Water Landscapes) 1903–1909

25 *Water Lilies*, 1903
Nymphéas
Oil on canvas: 81 × 100 cm
Signed and dated l.l., 1903
W.1657
The Dayton Art Institute, Gift of Mr. Joseph Rubin (1953.11)

26 *Water Lilies*, 1904
Nymphéas
Oil on canvas: 89 × 92 cm
Signed and dated l.r., 1904
W.1666
Denver Art Museum, Funds from the Helen Dill Bequest (1935.14)

27 *Water Lilies*, 1904
Nymphéas
Oil on canvas: 90 × 92 cm
Signed and dated l.r., 1904
W.1667
Recovered after World War II and placed in trust with the Musées Nationaux de France; Caen, Musée des Beaux-Arts (dépôt du Musée d'Orsay) (75-1-23; MNR 214)

28 *Water Lilies*, 1905
Nymphéas
Oil on canvas: 90 × 100 cm
Signed and dated l.r., 1905
W.1671
Museum of Fine Arts, Boston. Gift of Edward Jackson Holmes (39.804)

29 *Water Lilies*, 1905
Nymphéas
Oil on canvas: 90 × 100 cm
Signed and dated l.r., 1905
W.1672
Private Collection (courtesy of Hirschl & Adler Galleries, New York)

30 *Water Lilies*, 1905
Nymphéas
Oil on canvas: 73 × 105 cm
Signed and dated l.l., 1905
W.1678
Private Collection

31 *Water Lilies*, 1905–7
Nymphéas
Oil on canvas: 73 × 100 cm
Signed and dated l.l., 1907
W.1682
Private Collection

32 *Water Lilies*, 1906
Nymphéas
Oil on canvas: 90 × 93 cm
Signed and dated l.r., 1906
W.1683
The Art Institute of Chicago, Mr. and Mrs. Martin A. Ryerson Collection (1933.1157)

33 *Water Lilies*, 1907
Nymphéas
Oil on canvas: 90 × 93 cm
Signed and dated l.r., 1907
W.1697
Museum of Fine Arts, Boston. Bequest of Alexander Cochrane (19.170)

34 *Water Lilies*, 1907
Nymphéas
Oil on canvas: 93 × 89 cm
Signed and dated l.r., 1907
W.1699
Private Collection, Japan

35 *Water Lilies*, 1907
Nymphéas
Oil on canvas: diameter 81 cm
Signed and dated l.c. r., 1907
W.1702
Private Collection

36 *Water Lilies*, 1907
Nymphéas
Oil on canvas: diameter 81 cm
Signed and dated l.r., 1907
W.1701
Musée d'Art Moderne de Saint-Etienne (924)

37 *Water Lilies*, 1908
Nymphéas
Oil on canvas: diameter 90 cm
Signed and dated l.r., 1908
W.1724
Musée municipal Alphonse-Georges Poulain, Vernon (25.4.1)

38 *Water Lilies*, 1908
Nymphéas
Oil on canvas: diameter 81 cm
Signed and dated l.r., 1908
W.1729
Dallas Museum of Art, Gift of the Meadows Foundation, Incorporated (1981.128)

39 *Water Lilies*, 1907
Nymphéas
Oil on canvas: 92 × 81 cm
Signed and dated l.r., 1907
W.1703
The Museum of Fine Arts, Houston; Gift of Mrs. Harry C. Hanszen (68.31)

40 *Water Lilies*, 1907
Nymphéas
Oil on canvas: 92 × 73 cm
Signed and dated l.r., 1907
W.1705
Private Collection

41 *Water Lilies*, 1907
Nymphéas
Oil on canvas: 106 × 73 cm
Signed and dated l.r., 1907
W.1709
Private Collection

42 *Water Lilies*, 1907
Nymphéas
Oil on canvas: 105 × 73 cm
Signed and dated l.r., 1907
W.1716
Göteborg Museum of Art, Göteborg, Sweden (GKM 2232)

43 *Water Lilies*, 1907
Nymphéas
Oil on canvas: 100 × 73 cm
Signed and dated l.r., 1907
W.1715
Bridgestone Museum of Art, Ishibashi Foundation, Tokyo (F.P.23)

44 *Water Lilies*, 1908
Nymphéas
Oil on canvas: 90 × 92 cm
Signed and dated l.l., 1908
W.1721
Private Collection, Japan

45 *Water Lilies*, 1908
Nymphéas
Oil on canvas: 92 × 90 cm
Signed and dated l.r., 1908
W.1733
Worcester Art Museum, Worcester, Massachusetts, Museum purchase (1910.26)

46 *Water Lilies*, 1908
Nymphéas
Oil on canvas: 100 × 100 cm
Signed and dated l.l., 1908
W.1730
Maspro Denkoh Art Museum

47 *Water Lilies*, 1908
Nymphéas
Oil on canvas: 100 × 81 cm
Signed and dated l.r., 1908
W.1732
National Museum and Gallery, Cardiff (NMW A 2480)

48 *Water Lilies*, 1908
Nymphéas
Oil on canvas: 92 × 81 cm
Signed and dated l.l., 1908
W.1725
Mr. G. Callimanopulos

Venice 1908–1912

49 *The Grand Canal*, 1908
Le Grand Canal
Oil on canvas: 73 × 92 cm
Signed and dated l.r., 1908
W.1739
Private Collection
London only

50 *The Grand Canal, Venice*, 1908
 Venise, le Grand Canal
 Oil on canvas: 73 × 92 cm
 Signed and dated l.r., 1908
 W.1736
 The Fine Arts Museums of San Francisco, Gift of
 Osgood Hooker (1960.29)
 Boston only

51 *The Grand Canal*, 1908
 Le Grand Canal
 Oil on canvas: 73 × 92 cm
 Signed and dated l.r., 1908
 W.1738
 Museum of Fine Arts, Boston. Bequest of Alexander
 Cochrane (19.171)

52 *The Palazzo Ducale*, 1908
 Le Palais ducal
 Oil on canvas: 81 × 100 cm
 Signed and dated l.r., 1908
 W.1743
 Brooklyn Museum of Art, Gift of A. Augustus Healy
 (20.634)

53 *The Palazzo Ducale*, 1908
 Le Palais ducal
 Oil on canvas: 73 × 92 cm
 Signed and dated l.r., 1908
 W.1742
 Mr. and Mrs. Herbert Klapper
 Boston only

54 *The Palazzo Ducale seen from San Giorgio Maggiore*,
 1908
 Le Palais ducal vu de Saint-Georges Majeur
 Oil on canvas: 65 × 100 cm
 Signed and dated l.r., 1908
 W.1751
 Kunsthaus Zürich, Donation Walter Haefner (1995/4)

55 *The Palazzo Ducale seen from San Giorgio Maggiore*,
 1908
 Le Palais ducal vu de Saint-Georges Majeur
 Oil on canvas: 65 × 92 cm
 Signed and dated l.r., 1908
 W.1755
 The Metropolitan Museum of Art; Gift of Mr. and Mrs.
 Charles S McVeigh, 1959 (59.118.1)

56 *The Palazzo Contarini*, 1908
 Le Palais Contarini
 Oil on canvas: 73 × 92 cm
 Signed and dated l.l., 1908
 W.1766
 Courtesy of Helly Nahmad Gallery, London

57 *The Palazzo Dario*, 1908
 Le Palais Dario
 Oil on canvas: 56 × 65 cm
 Signed l.l.
 W.1760
 Private Collection

58 *The Palazzo Contarini*, 1908
 Le Palais Contarini
 Oil on canvas: 92 × 81 cm
 Signed and dated l.l., 1908
 W.1767
 Kunstmuseum, Sankt Gallen, Switzerland

Studies: Water Lilies, Weeping Willows, and Irises 1914–1919

59 *Yellow and Lilac Water Lilies*, 1914–17
 Nymphéas jaunes et lilas
 Oil on canvas: 200 × 215 cm
 W.1804
 The Toledo Museum of Art; Purchased with funds
 from the Libbey Endowment, Gift of Edward
 Drummond Libbey (81-54)

60 *Water Lilies*, 1914–17
 Nymphéas
 Oil on canvas: 200 × 200 cm
 W.1803
 Private Collection

61 *Weeping Willow and Water Lily Pond*, 1914–19
 Saule pleureur et bassin aux nymphéas
 Oil on canvas: 200 × 180 cm
 W.1849
 Private Collection
 Boston only

62 *Water Lilies*, 1914–19
 Nymphéas
 Oil on canvas: 200 × 200 cm
 W.1853
 Musée d'Orsay, Paris (RF 1981–40)
 Boston only

63 *Water Lilies*, 1914–17
 Nymphéas
 Oil on canvas: 180 × 200 cm
 W.1810
 Asahi Breweries, Ltd.

64 *Water Lilies, Reflections of Weeping Willows*, 1916–19
 Nymphéas, reflets de saule
 Oil on canvas: 130 × 200 cm
 W.1861
 Kitakyushu Municipal Museum of Art
 London only

65 *Water Lilies, Reflections of Weeping Willows*, 1916–19
 Nymphéas, reflets de saule
 Oil on canvas: 130 × 200 cm
 W.1858
 The Metropolitan Museum of Art; Gift of Louise
 Reinhardt Smith, 1983 (1983.532)
 Boston only

66 *Water Lilies, Reflections of Weeping Willows*, 1916–19
 Nymphéas, reflets de saule
 Oil on canvas: 100 × 200 cm
 W.1857
 Benesse Corporation, Okayama, Japan

67 *Water Lilies, Reflections of Weeping Willows*, 1916–19
 Nymphéas, reflets de saule
 Oil on canvas: 130 × 200 cm
 W.1860
 Private Collection
 Boston only

68 *Water Lilies, Reflections of Weeping Willows*, 1916–19
 Nymphéas, reflets de saule
 Oil on canvas: 200 × 200 cm
 W.1862
 Musée Marmottan-Claude Monet, Paris (5122)

69 *The Path in the Iris Garden*, 1914–17
 Le Chemin dans les iris
 Oil on canvas: 200 × 150 cm
 W.1829
 The National Gallery, London (NG 6383)
 London only

70 *Irises*, 1914–17
 Iris
 Oil on canvas: 200 × 150 cm
 W.1832
 Virginia Museum of Fine Arts. The Adolph D. and
 Wilkins C. Williams Fund (71.8)

Work in Progress *versus* Finished Work c.1917–c.1922

71 *The Water Lily Pond*, 1918–22
 Le Bassin aux nymphéas
 Oil on canvas: 100 × 200 cm
 Signed and dated l.r., 1917
 W.1886
 Musée des Beaux-Arts de Nantes, Nantes, France
 (938.6.1.P)

72 *The Water Lily Pond*, begun 1918
 Le Bassin aux nymphéas
 Oil on canvas: 100 × 200 cm
 W.1895
 Honolulu Academy of Arts. Purchased in memory of
 Robert Allerton, 1966 (HAA 3385.1)

73 *The Water Lily Pond*, begun 1918
 Le Bassin aux nymphéas
 Oil on canvas: 100 × 200 cm
 W.1896
 Benesse Corporation, Okayama, Japan

The Garden at Giverny: A Return to Firm Ground c.1916–c.1926

74 *The Water Lily Pond at Giverny*, 1917
 Coin de l'étang à Giverny
 Oil on canvas: 117 × 83 cm
 Signed and dated l.r., 17
 W.1878
 Musée de Grenoble (MG 2168)

75 *The Water Lily Pond*, 1918
 Coin du bassin aux nymphéas
 Oil on canvas: 130 × 88 cm
 Signed and dated l.r., 1918
 W.1880
 Private Collection

76 *Wisteria*, 1917–20
 Glycines
 Oil on canvas: 150 × 200 cm
 W.1908
 Haags Gemeentemuseum (27.161)
 Not exhibited

76a *Wisteria*, 1917–20
 Glycines
 Oil on canvas: 150 × 200 cm
 W.1909
 Allen Memorial Art Museum, Oberlin College, Oberlin,
 Ohio. R.T. Miller, Jr. Fund, 1960 (60.5)

77 *The Footbridge over the Water Lily Pond*, 1919
 La Passerelle sur le bassin aux nymphéas
 Oil on canvas: 65 × 107 cm
 Signed and dated l.r., 1919
 W.1916
 Öffentliche Kunstsammlung Basel, Kunstmuseum
 (G.1986.15)
 Boston only

78 *The Japanese Bridge*, 1919–24
 Le Pont japonais
 Oil on canvas: 89 × 116 cm
 W.1921a
 European Private Collection

79 *The Japanese Bridge*, 1919–24
 Le Pont japonais
 Oil on canvas: 89 × 91 cm
 W.1930
 Philadelphia Museum of Art: The Albert M. Greenfield
 and Elizabeth M. Greenfield Collection (74-178-038)

80 *The Japanese Bridge*, c.1919–24
 Le Pont japonais
 Oil on canvas: 89 × 116 cm
 W.1931
 The Minneapolis Institute of Arts, Bequest of Putnam
 Dana McMillan (61.36.15)

81 *Weeping Willow*, 1918–19
 Saule pleureur
 Oil on canvas: 130 × 100 cm
 W.1871
 Private Collection

82 *Weeping Willow*, 1918
 Saule pleurer
 Oil on canvas: 130 × 110 cm
 Signed and dated l.l., 1918
 W.1869
 Columbus Museum of Art, Ohio; Gift of Howard D.
 and Babette L. Sirak, the Donors to the Campaign for
 Enduring Excelence, and the Derby Fund. (91.001.041)

83 *Weeping Willow*, 1918–19
 Saule pleureur
 Oil on canvas: 100 × 120 cm
 Signed and dated l.l., 1919
 W.1876
 Kimbell Art Museum, Fort Worth, Texas (AP 1996.02)

84 *Weeping Willow*, 1918–19
 Saule pleurer
 Oil on canvas: 130 × 152 cm
 W.1870
 Private Collection

85 *The Path under the Rose Arches*, 1918–24
 L'Allée de rosiers
 Oil on canvas: 89 × 100 cm
 W.1936
 Private Collection, Switzerland

86 *The Artist's House seen from the Rose Garden*, 1922–?4
 La Maison de l'artiste vue du jardin aux roses
 Oil on canvas: 81 × 93 cm
 Signed and dated l.l., '22
 W.1944
 Musée Marmottan-Claude Monet, Paris (5108)

87 *The House seen from the Rose Garden*, 1922–?4
 La Maison vue du jardin aux roses
 Oil on canvas: 89 × 100 cm
 W.1946
 Musée Marmottan-Claude Monet, Paris (5086)

Water Lilies: The *Grandes Décorations* c.1915–c.1926

88 *The Water Lily Pond*, c.1915–26
 Le Bassin aux nymphéas, le soir
 Oil on canvas, diptych: 200 × 300 cm (each)
 W.1964–5
 Kunsthaus Zürich (1952/64)

89 *Water Lily Pond*, c.1915–26
 Le Bassin aux nymphéas
 Oil on canvas, diptych: 200 × 300 cm (each)
 W.1966–7
 Courtesy of Galerie Larock-Granoff, Paris

90 *Agapanthus*, c.1916–26
 L'Agapanthe
 Oil on canvas: 200 × 425 cm
 W.1976
 The Saint Louis Art Museum, The Steinberg Charitable
 Fund (134.56)
 Boston only

91 *Water Lily Pond*, c.1916–26
 Le Bassin aux nymphéas
 Oil on canvas: 200 × 425 cm
 W.1978
 The National Gallery, London (NG 6343)

92 *Water Lily Pond*, c.1916–26
 Le Bassin aux nymphéas
 Oil on canvas: 200 × 600 cm
 W.1981
 The Museum of Modern Art, New York. Mrs. Simon
 Guggenheim Fund (712.59)

Addendum

20a *Houses of Parliament, Sunset*, 1902
 Le Parlement, soleil couchant
 Oil on canvas: 81 × 92 cm
 Signed and dated l.l., 1902
 W.1603
 Private Collection

Notes to the Essays

Abbreviations

AH Alice Hoschedé

GBJ Georges Bernheim-Jeune

GG Gustave Geffroy

GP Georges Petit

JBJ Joseph Bernheim-Jeune

JPH Jean-Pierre Hoschedé

PDR Paul Durand-Ruel

W.I, II, III, IV Daniel Wildenstein, *Biographie et catalogue raisonné*, Vol. I: 1840–1881; Vol. II: 1882–6; Vol. III: 1887–98; Vol. IV: 1899–1926; Vol. V: Supplément aux peintures, dessins, pastels, index (Lausanne: La Bibliothèque des Arts, 1974–91)

W.XXX Monet's paintings as numbered by Wildenstein

w.xxx Monet's letters as numbered by Wildenstein, and found at the end of each volume of his catalogue raisonné. A date enclosed in square brackets indicates the possible date of an undated letter

Stuckey 1995 Charles S. Stuckey, *Claude Monet*, exh. cat. (Chicago: Art Institute of Chicago, 1995)

MONET: THE LAST IMPRESSIONIST?

1 Letter from Monet to Bazille, Dec. 1868, w.44.

2 Letter from Monet to GG, June 7, 1912, w.2015.

3 Letter from Monet to Charteris, June 21, 1926, w.2626.

4 See especially Richard Shiff, "The End of Impressionism," in *The New Painting: Impressionism, 1874–1886*, exh. cat. (Fine Arts Museums of San Francisco, 1986), 61–89.

5 See John House, "Curiosité," in *Impressions of French Modernity*, ed. Richard Hobbs (Manchester: Manchester University Press, 1998), 33–57

6 Letter from Pissarro to Esther Isaacson, May 5, 1890, in *Correspondance de Camille Pissarro*, ed. Janine Bailly-Herzberg, vol. 2 (Paris: Editions du Valhermeil), 1986, letter 587, p. 349.

7 See John House et al., *Landscapes of France: Impressionism and its Rivals*, exh. cat. (London: South Bank (Hayward Gallery), 1995); presented as *Impressions of France: Monet, Renoir, Pissarro, and their Rivals* (Boston: Museum of Fine Arts), esp. 122–3, 128–9, 136–7.

8 For a searching and thoughtful analysis of Impressionist vision (although without positing a significant shift in the later 1870s) see Joel Isaacson, "Constable, Duranty, Mallarmé, Impressionism, Plein Air, and Forgetting," *Art Bulletin* Sept. 1994: 426–50.

9 *See Landscapes of France/Impressions of France*, esp. 126–7, 154–5, 162–5.

10 Letter from Monet to Théodore Duret, March 10, 1888, w.855.

11 On Monet's work during the 1880s, see John House, *Monet: Nature into Art* (New Haven and London: Yale University Press, 1986); on these exhibitions, see esp. 211–13.

12 On the series, see House, *Monet: Nature into Art*, 193–204; for an alternative view of the genesis of Monet's series, which places more emphasis on continuity between the 1880s and the 1890s, see Grace Seiberling, *Monet's Series* (New York and London: Garland Publishing, 1981).

13 See John House, "Time's Cycles: Monet and the Solo Show," *Art in America* Oct. 1992: 128–35; for a different view, which emphasizes the associational values of Monet's subjects during the 1890s, see Paul Hayes Tucker, *Monet in the '90s: The Series Paintings*, exh. cat. (Boston: Museum of Fine Arts; London: Royal Academy of Arts, 1989–90).

14 Letter from Monet to GG, Oct. 7, 1890, w.1076.

15 W. G. C. Bijvanck, "Une Impression (Claude Monet)," in *Un Hollandais à Paris en 1891* (Paris: Perrin, 1892), 177.

16 For discussion of the associations of the subjects that Monet chose for his series of the 1890s, see Tucker, *Monet in the '90s*.

17 Bijvanck, "Une Impression," 177.

18 Interviews recorded by H. Johsen and H. Bang, quoted in Jean-Pierre Hoschedé, *Claude Monet, ce mal connu*, 2 vols. (Geneva: Pierre Cailler, 1960), vol. 2, 110–12.

19 Theodore Robinson, MS Diary, June 3, 1892 (New York, Frick Art Reference Library).

20 René Gimpel, *Journal d'un collectionneur, marchand de tableaux*, (Paris: Calmann-Levy, 1963), 88, 156.

21 He had written of his wish to paint London's fog effects again in 1887 (letter to Théodore Duret, Oct. 25, 1887, w.797). His final decision to start work there in 1899 was precipitated by the presence of his son Michel in London; this, togther with the 1901 series of the quintessentially French site of Vétheuil, raises questions about Paul Tucker's suggestion that Monet's decision to paint in London was in some sense the result of a disillusionment with France precipitated by the Dreyfus Affair (Tucker, *Monet in the '90s*, 248–9).

22 Letter from Monet to AH, March 25, 1900, w.1539.

23 Letter from Monet to AH, March 10, 1901, w.1616.

24 Mallarmé, quoted in Jules Huret, *Enquête sur l'évolution littéraire* (Paris: Charpentier, 1891), 60.

25 Robinson, Diary, June 19 and July 29, 1892.

26 See Steven Z. Levine, *Monet and his Critics* (New York and London: Garland Publishing, 1976).

27 See House, Monet: *Nature into Art*, 167–70.

28 See n. 6 above.

29 Paul Gsell, "La Tradition artistique française, I: L'Impressionnisme," *Revue bleue* March 26, 1892: 404.

30 On Monet's practices in signing his paintings, see House, *Monet: Nature into Art*, 177–9.

31 See especially letter from Monet to Paul Durand-Ruel, April 27, 1907, w.1832.

32 Marc Elder, *Chez Claude Monet à Giverny* (Paris: Bernheim-Jeune, 1924), 12; letter from Monet to the Préfet de l'Eure, July 17, 1893, w.1219, asking for permission to create the garden "for the pleasure of the eyes and also as a source of motifs to paint."

33 Maurice Kahn, "Le Jardin de Claude Monet," *Le Temps* June 7, 1904; letter from Monet to Roger Marx, June 1, 1909, w.1993.

34 For further discussion, see John House, "Le Jardin d'eau et la 2e séries des nymphéas (1903–1909)," in *Claude Monet au temps de Giverny*, exh. cat. (Paris: Centre Culturel du Marais, 1983), 150–52.

35 François Thiébault-Sisson, "Les Nymphéas de Claude Monet," *Revue de l'art* July 1927: 44.

36 Maurice Guillemot, "Claude Monet," *Revue illustrée* March 15, 1898: 3. It is uncertain whether any of these studies survive; Daniel Wildenstein has identified a group of canvases (W.1501–8; see W.IV, 150–52) that may belong to this initial project.

37 Arsène Alexandre, "Un Paysagiste d'aujourd'hui," *Comoedia* May 8, 1909; Monet also mentioned the plan in a letter to Rober Marx, June 1, 1909, w.1993; Marx elaborated on the project in an imaginative re-creation of Monet's conversation in "Les 'Nymphéas' de M. Claude Monet," *Gazette des beaux-arts* June 1909: 529. See W.IV, 67–8.

38 I owe this comparison to Eric Fernie.

39 The finest surviving landscape panorama is the Mesdag Panorama, painted by Hendrik Willem Mesdag and his assistants in The Hague in 1880–81, and showing the view from the dunes of Scheveningen along the beaches, back towards The Hague, and out across the North Sea.

40 For a recent discussion of panoramas in the context of Parisian popular culture, see Vanessa R. Schwartz, *Spectacular Realities: Early Mass Culture in Fin-de-Siècle Paris* (Berkeley and Los Angeles, 1998), 149–76.

41 For the project as it stood in 1920, with photographs of the paintings in their state at that date, see W.IV, 318–19.

42 For a contemporary response to the odd coloring of some pictures, see W.IV, 125.

43 On these bonfires, see e.g. W.IV, 56, 136.

THE REVOLUTION IN THE GARDEN

I would like to express my unbounded gratitude to Maggie, Jonathan, and Jennie for all of their support during the realization of this essay, to Suzanne Delay for her invaluable research assistance, to William D. and Mary Elizabeth Tucker for their editorial advice, to Kate Diamond for her wisdom and guidance, and to Steven Frankel, my inestimable ally, for all of his persistence and perspicuity.

1 There is no record that Monet was offered the Cross of the Légion d'Honneur, and no direct evidence of his refusal. However, Octave Mirbeau's correspondence strongly suggests that Monet was in line for the award and that he turned it down. See Octave Mirbeau, "Lettres à Claude Monet," *Cahiers d'aujourd'hui*, 5 (Nov. 29, 1922): 165, and W.III, 11, n. 724. Monet raised the issue in a letter to GG when he claimed that he did not need government officials or their crosses; see w.1023 to GG Jan. 21, 1890. On his reaction to Renoir's award, see w.1565 to GG Aug. 23, 1900 and w.1566 to Renoir [end of Aug. 1900]. On the Musée du Luxembourg and the Impressionists, see Geneviéve Lacambre, "Introduction," *Le Musée du Luxembourg en 1874*, exh. cat. (Paris: Musée du Luxembourg, 1974); Marie Berhaut, "Le Legs Caillebotte, Verités et contre-verités," *Bulletin de la Société de l'histoire de l'art français* 1983: 209–23; Marie Berhaut and Pierre Vaisse, "Le Legs Caillebotte; Annexe: documents," *Bulletin de la Société de l'histoire de l'art français* 1983: 223–39; Pierre Vaisse, "Le Legs Caillebotte d'après les documents," *Bulletin de la Société de l'histoire de l'art français* 1983: 201–8; Kirk Varnedoe, *Gustave Caillebotte* (New Haven and London: Yale University Press, 1987), 197–204; and Paul Hayes Tucker, *Claude Monet: Life and Art* (London and New Haven: Yale University Press, 1995), 165–6.

2 On Monet's eye problems, see W.IV, 77, n. 711; James G. Ravin, "Monet's Cataracts," *Journal of the American Medical Association* July 19, 1985, 394–9; J. Haut Roger and Amalric, "L'Operation de la cataracte de Claude Monet, correspondance du peintre et G. Clemenceau au Docteur Coutela," *Histoire de la science medicale* 18, no. 2 (1984): 19–27; P. G. Moreau, "La cataracte de Claude Monet," *L'Ophtalmologie des origines à nos jours* 13 (1981): 141; Monique Dittière, "Comment Monet retrouvera la vue après l'operation de la cataracte," *Sandorama* 32 (Jan.–Feb. 1973): 26–32.

3 w.1191 and w.2885 to Préfet de Eure March 17 and 23, 1893, and w.1219 and w.1220 to Préfet de Eure July 17 and 28, 1893. Monet's property was 9,600 square meters; see, W.IV, 191. On its renovation, see the seminal article by Robert Gordon, "The lily pond at Giverny: The changing inspiration of Monet," *The Connoisseur* 184, no. 741 (Nov. 1973): 154–65. Monet's efforts provoked local opposition and counter-action on his part. See w.2889 and 2890 to A. Lauvray April 20 and 28, 1893, and w.1195 to AH [21 March 1893]. Monet's inspiration for the pond may have come from Japanese sources, as has often been suggested. See for example, John House, "Monet: le jardin d'eau et la 2e séries des Nymphéas (1903–9)," in Centre Culterel du Marais, *Claude Monet au temps de Giverny*, exh. cat. (Paris, 1983), 150–65. It may also have derived from the water lily pond that the Etablissement Latour-Marliac installed as part of its display at the Universal Exposition of 1889. Headed by Joseph Bory Latour-Marliac, the company was the first to hybridize water lilies, prized specimens of which were unveiled at the same world's fair. Company archives contain responses to orders that Monet placed in the early 1890s. My thanks to Barbara and Sarah Davies of Stapeley Water Gardens, Ltd., the present owner of Ets. Latour-Marliac, for their help with information relating to this early interest in water lily cultivation.

4 On the trellis see W.IV, 47–8, and w.2634a and b to Préfet de Eure, Jan. 21, 1902. On the purchase of the land in 1901, see w.1641 to Préfet de Eure Aug. 13, 1901, and W.IV, 26–9. Permission to construct the Japanese bridge was granted by the préfet on July 24, 1893; see W.III, 577.

5 This greenhouse was noted by Julie Manet in *Julie Manet: Journal, 1893–1899* (Paris: Librarie C. Klincksieck, 1979), 23; see Stuckey 1995, 225, and Bernard Denvir, *The Chronical of Impressionism* (Boston: Little Brown, 1993), 193.

6 Michel Hoog, *Les "Nymphéas" de Claude Monet au Musée de l'Orangerie* (Paris: Réunion des Musées Nationaux, 1984), 13, and Claire Joyes et al., *Monet at Giverny* (London: Mathews, Miller & Dunbar, 1975), 32, state that the new studio was constructed in 1897. Stuckey 1995, 232, implies August 1899.

7 Monet's finances have been conveniently tallied by Wildenstein. See W.IV, 23 (for 1900), 25 (for 1901), 33–4 (for 1902), 41 (for 1904), 69 n. 627 (for 1909), and 77 (for 1912). On comparative wages, see Louis Chevalier, *La Formation de la population parisienne au XIXe siècle* (Paris: Presses Universitaires de France, 1949); Olivier Marchand, *Le Travail en France, 1800–2000* (Paris: Nathan, 1997); David H. Pinckey, *Napoleon III and the Rebuilding of Paris* (Princeton: Princeton University Press, 1972); E. H. Phelps Brown, *A Century of Pay* (London: MacMillan, 1968). In Emile Zola's *La Bête humaine* of 1890, a working-class family of four lived on six thousand francs a year; see trans. Leonard Tancock (London: Penguin Books, 1977), 20.

8 Gustave Geffroy, "Claude Monet," *Le Journal* June 7, 1898, repr. in *Le Gaulois* (supplément), June 16, 1898; see also the review by Georges Lecomte, "La Vie artistique: Claude Monet," *Droits de l'homme* June 10, 1898, as quoted in Steven Z. Levine, *Monet, Narcissus, and Self-Reflection* (Chicago: University of Chicago Press, 1994), 188: "Once again the great painter demonstrates, to those who accuse him of painting at random, with what taste he chooses his motifs, with what concern for the décor he interprets them." Similar assertions are made by André Fontainas, "Claude Monet . . .," *Mercure de France* n.s. 27 (July 1898): 278–82.

9 The stacks and poplars were distinct features of the French countryside: the Gothic one of the nation's greatest artistic innovations; the Seine one of her most important rivers; the Norman coast one of her most dramatic sites which was also rich in history. On these and other meanings of the series paintings see Robert L. Herbert, "Method and Meaning in Monet," *Art in America* 67, no. 5 (Sept. 1979): 90–108, and Paul Hayes Tucker, *Monet in the '90s: The*

10 Series Paintings (New Haven and London: Yale University Press, 1990).

10 Lecomte, "La Vie artistique."

11 L'Angèle, [Raymond Bouyer], "Lettre d'Angèle, Chronique du mois: L'impressionnisme: Corot–Monet, etc.," *L'Ermitage* 10 (May 1899): 390–400.

12 W.140, presently in the E. G. Bührle Collection, Zurich.

13 On not working, see w.1468 to GG July 5, 1899. Photographs of the gardens taken before 1898 reveal considerable growth, suggesting Monet did not have to wait as long as he did for either to become lush. See Gordon, "The lily pond at Giverny," for these photographs.

14 The privilege was granted to Gustave Geffroy, who subsequently became one of Monet's staunchest friends and supporters. Guillemot's article, "Claude Monet," *Revue illustrée* 13 (March 15, 1898), was also unusual because he appears to have written only one other art-related article, which was on the Caillebotte bequest. See "La Question Caillebotte," *Le Figaro* March 13, 1897. Monet also does not seem to have known him before his visit.

15 Guillemot, "Claude Monet."

16 Monet refers to a large study for a decorative project in a letter w.2973 (1394bis c) to GG of Aug. 3, 1897, but this is before Guillemot's visit.

17 W.1502 was sold to Gimpel in July 1926; W.1503 passed to Kurashi Kitada in 1926, although this picture may well date to the teens.

18 On this unprecedented period of inactivity see w.1468 to GG July 5, 1899.

19 For the Sisley auction Monet obtained works from Renoir, Pissarro, Lebourg, Cazin, Besnard, Thaulow, Fantin-Latour, Roll, Helleu, Degas, Lerolle, Guillaumin, Zandomeneghi, Aman-Jean, Raffaelli, Vuillard, Carrière, Menard, Cassatt, Morisot, Caillebotte, Rodin, Bartholomé, and even Cézanne. While attesting to the effort Monet expended for his deceased colleague, the roster also underscores how broadly Monet conceived of the undertaking and the range of artists he convinced to contribute. See w.1445–62 to various people March 17–April 27, 1899.

20 William H. Fuller, *Claude Monet and His Paintings* (New York: J.-J. Littler, 1899), 15.

21 On the Dreyfus Affair, see Jean-Denis Bredin, *The Affair: The Case of Alfred Dreyfus*, trans. Jeffrey Mehlman (New York: George Braziller, 1986); Norman L. Kleeblatt, ed., *The Dreyfus Affair: Art, Truth, and Justice* (Berkeley: University of California Press, 1988); Patrice Bousell, *L'Affair Dreyfus et la presse* (Paris: A. Colin, 1960); and John Grand-Carteret, *L'Affair Dreyfus et l'image* (Paris: E. Flammarion, [1897]).

22 Bredin, *The Affair*, 296, n. 51.

23 Anti-Dreyfusards felt that he was "the representative of a different species," as Maurice Barrès, the fiery right-wing novelist, journalist, and former legislator from Nancy asserted in 1898. See Bredin, *The Affair*, 296.

24 Ibid., 293.

25 Emile Zola, "Pour les Juifs," *Le Figaro*, May 16, 1896, as cited in Bredin, *The Affair*, 137.

26 w.1397 to Zola Dec. 3, 1897.

27 See Georges Clemenceau, "Le 'Syndicat' grandit," *L'Aurore* Jan. 18, 1898, which includes the names of those who had signed the "manifeste des intellectuels." On Monet's second letter to Zola, see w.1399 to Zola Jan. 14, 1898. Monet had expressed his disdain for the government during the Franco-Prussian war when he learned, mistakenly, that government troops had killed Courbet; see w.55 to Camille Pissarro May 27, 1871.

28 Thus, when approached to sit on a pro-Dreyfus committee in March 1898, Monet told the solicitor, "I have written my friend Zola directly about what I think of his courageous and beautiful conduct. But being part of some committee is not my business." See w.1404 to A [?] March 3, 1898.

29 w.1402 to Zola Feb. 24, 1898; w.1401 to GG Feb. 15, 1898.

30 See letter from Alexandrine Zola to Emile Zola of Sept. 5, 1898, as quoted in Owen Morgan and Alain Pages, eds.,

October 1897–September 1899, vol. IX, *Correspondance de Zola*, ed. E. H. Bakker (Montreal: Les Presses de l'Université de Montreal, 1978), 303, n. 5. My sincere thanks to Professor Morgan for having brought this letter to my attention and for having been such an invaluable resource for all questions related to Zola and Dreyfus. Monet expressed his concern to Geffroy as well. See w.1403 to GG Feb. 25, 1898, and w.1401 to GG Feb. 14, 1898, presently in the collection of the Stanford University Art Museum.

31 Bredin, *The Affair*, 531–2.

32 Léon Blum, *Souvenirs sur l'Affaire* (Paris: Fasquelle, 1929; Gallimard, 1981), 81, as quoted in Bredin, *The Affair*, 197.

33 See W.396 or W.431.

34 On "instantaneity" see w.1076 to GG Oct. 7, 1890.

35 Letter from Pissarro to his son Lucien, Nov. 19, 1898, in John Rewald, ed., *Camille Pissarro: Letters to his son Lucien*, 4th ed. (London: Routledge & Kegan Paul, 1980), 332.

36 Ibid.

37 w.1403 to GG Feb. 25, 1898.

38 [Bouyer], "Lettre d'Angèle," 390–400; and Lecomte, "La Vie artistique."

39 Bredin, *The Affair*, 385.

40 Ibid., 430.

41 Ibid., 432.

42 Ibid., 433–4.

43 w.1482 GG Dec. 15, 1899.

44 Clemenceau letter to Monet Dec. 23, 1899. Clemenceau's phrasing is wonderfully idiosyncratic: "Vous taillez des morceaux de l'azur pour les jeter à la tête des gens. Il n'y aurait rien de si bête que de vous dire merci. On ne remercie pas le rayon de soleil." See *Georges Clemenceau à son ami Claude Monet: Correspondance* (Paris: Editions de la Réunion des Musées Nationaux, 1993), 72.

45 w.1482 to GG Dec. 15, 1900.

46 [Bouyer], "Lettre d'Angèle."

47 Julien Leclercq, "Le Bassin aux Nymphéas de Claude Monet," *La Chronique des arts et de la curiosité* Dec. 1, 1900: 363–4.

48 w.1416 and w.1417 to PDR Nov. 10 and 14, 1898.

49 On Monet's campaign in London see Grace Seiberling, *Monet in London*, exh. cat. (Atlanta: High Museum, 1989); John House, "The Impressionist Vision of London," in Ira Bruce Nadel and F.S. Schwarzbach, eds., *Victorian Artists and the City* (New York: Pergamon Press, 1980); and Alan Bowness, ed., *The Impressionists in London*, exh. cat. (London: Arts Council of Great Britain, 1973).

50 w.1592 to AH Feb. 2, 1901.

51 w.1611 to AH March 2, 1901.

52 w.1616 to AH March 10, 1901.

53 Ibid.

54 Duc de Trévise, "Le Pèlerinage de Giverny," *Revue de l'art ancien et moderne* Feb. 1927: 126. On Sargent's amusement, see Evan Charteris, *John Sargent* (New York: Charles Scribner, 1927), 126, as cited in W.IV, 16, n. 133.

55 w.1764 to PDR Feb. 12, 1905, in response to *pièce justificative* 180 letter PDR to Monet, Feb. 11, 1905; on the leaked story, see AA in "News from our Parisian correspondents," *Courrier de l'Aisne* June 9, 1904, as cited in Stuckey 1995, 225.

56 The 16 million tons of bituminous coal that Londoners burned during the winter while Monet was working in the capital mixed with the damp conditions of the northern climate to create the dense, colorful air that he was attempting to render; on the amount of coal consumed, see Raymond Smith, *Sea-coal for London: A History of the Coal Factors in the London Market* (London: Longman, 1961), 235. On Monet's hesitation about selling "Londons" before the show and the importance that he attached to the series as a totality, see w.1712 to PDR March 2, 1904.

57 w.1474 to PDR Nov. 6, 1899, for purchase; w.1492 and w.1493 to PDR Jan. 15 and 16, 1900, for delivery.

58 Boussod, Valadon et Cie. purchased W.1521. The five others that Monet sold were W.1522–4, W.1531 and W.1555.

59 W.iv, 9.

60 w.1482 to GG Dec. 15, 1899; w.1632 to GG April 15, 1901.

61 This stipulation derived from Monet's subscription for Manet's *Olympia*. On that subscription, see Tucker, *Monet in the '90s*, 55–61. On the Caillebotte bequest see above, n. 48.

62 w.1491 to RM Jan. 9, 1900; w.2633 to PDR Jan. 4, 1900.

63 For a taste of these discussions, see W.iv, 19–20. For Pissarro and Renoir breaking ranks, see w.1552 to Roger Marx April 21, 1900. On Pissarro's opinion of the show, see his letter to his son Lucien of April 21, 1900, in Rewald, *Camille Pissarro*, 340.

64 w.1552 to Roger Marx April 21, 1900. On obtaining works of high quality, see w.1553 to PDR April 22, 1900. On his series paintings and contemporaneity see, for example, Léon Bazalgette, "Les deux cathédrales de Claude Monet et J.-K. Huysmans," in *L'Esprit nouveau dans la vie artistique, sociale et religieuse* (Paris: Société d'éditions littéraires, 1898), 376, 389, where the astute critic asserted "If there really is a modern art, an art linked to today's thought, the painter of the Cathedrals, from every point of view, is one of its representatives."

65 Robert de La Sizeranne, "L'Art à l'Exposition de 1900, II: Le Bilan de l'Impressionnisme," *Revue des deux mondes* 70 (June 1, 1900): 628–51.

66 Roger Marx, "Un Siècle d'art," in *Maîtres de hier et d'aujourd'hui* (Paris: Calmann-Levy, 1914), 100.

67 w.1492 to PDR Jan. 15, 1900, about works staying in France. Monet had long held this opinion. See, for example, w.578 to PDR July 28, 1885; w.651 to PDR Jan. 23, 1886; and w.868 to PDR April 11, 1888.

68 Whistler had completed a suite of lithographs of Charing Cross Bridge in 1896 also while staying in the Savoy. Cross-sections of his work were often exhibited in Paris during the decade, including his marines, which were shown at the Champs de Mars in 1894; see Pissarro to his son Lucien April 28, 1894, in Rewald, *Camille Pissarro*, 238. For Monet's admiration of Whistler see Walter Pach, "At the Studio of Claude Monet," *Scribner's Magazine* June 1908, as cited in Stuckey 1995, 254.

69 w.1588 to AH Jan. 26, 1901.

70 See Leitch Ritchie, *Wanderings by the Seine* (London: Longman 1834). On Turner and Monet, see Tucker, *Claude Monet: Life and Art*, 170–73.

71 On Monet's reference to Turner's *Rain, Steam and Speed*, see Theodore Butler, MS Diary, Frick Art Reference Library, Sept. 1, 1892.

72 On the extension of the show see *pièce justificative* 168 PDR to Pieter van der Velde and E. Decap March 30, 1904; on Monet contemplating a second delay see w.1723 to PDR April 28, 1904; on canceling the show see w.1693 to PDR May 10, 1903.

73 On the critical reaction to the show see Seiberling, *Monet in London*, 92–8; W.iv, 38–40 and n. 368; and Steven Z. Levine, *Monet and his Critics* (New York: Garland Publishing, 1976), 336–73. The two paintings Durand-Ruel bought and sold were W.1610 and W.1537.

74 La Masque Rouge, "Notes d'Art: L'Exposition Claude Monet," *L'Action* May 12, 1904; Georges Lecomte, "Un Homme," *Petit république socialiste*, May 11, 1904.

75 Gustave Kahn, "L'Exposition Claude Monet," *Gazette des beaux-arts* July 1, 1904, as quoted in Stuckey 1995, 227. Kahn also affirmed the importance of Turner to Monet's first visit to London at the beginning of his article, claiming that Monet and Pissarro were "captivated by Turner's precise yet fairy-tale magic." For other references to Turner, see Louis Vauxcelles, "Notes d'art: une exposition de Claude Monet," *Gil Blas* May 11, 1904; "Claude Monet Exhibition," *Daily Telegraph* May 24, 1904; and Wynford Dewhurst, *Impressionist Painting: Its Genesis and Development* (London: George Newnes, 1904).

76 w.1751 to PDR Dec. 8, 1904.

77 w.1768 to PDR March 8, 1905. His interest in the Impressionists' success in England dated from at least the early 1880s. See, for example, w.354 to Duret May 20, 1883. See also Kate Flint, ed., *The Impressionists in England: The Critical Reception* (London: Routledge & Kegan Paul, 1984).

78 w.1501a to his gardener [Feb. 1900].

79 Joyes, *Monet at Giverny*, 37.

80 Guillemot, "Claude Monet."

81 w.1562 to PDR June 1900.

82 w.1564 to PDR Aug. 21, 1900.

83 On the show taking shape, see w.1575 to PDR Nov. 9, 1900.

84 w.1576 to PDR Nov. 17, 1900.

85 Arsène Alexandre, "La Vie artistique, 'Les Nymphéas' de Claude Monet," *Le Figaro* May 7, 1900: 5.

86 Alexandre described the gardens with enraptured prose: "Damascened with large round leaves of water lilies, encrusted with the precious stones that are their flowers, this water seems, when the sun plays upon its surface, the masterpiece of a goldsmith who has combined the alloys of the most magical metals." Arsène Alexandre, "Le Jardin de Monet," *Le Figaro* Aug. 9, 1901, as quoted and translated in Levine, *Monet, Narcissus and Self-Reflection*, 200.

87 A. E. Guyon-Vérax, "Exposition Claude Monet, Galeries Durand-Ruel," *Journal des Artistes* Dec. 9, 1900: 3314. For other critical reactions, see in particular Gustave Geffroy, "Claude Monet," *Le Journal* Nov. 26, 1900. Also see Tucker, *Monet in the '90s*, 310, and Levine, *Monet and his Critics*, 244–51, and W.iv, 21–3.

88 Julien Leclercq, "Petites expositions: 'Le Bassin aux Nymphéas' de Claude Monet," *La Chronique des arts et de la curiosité* Dec. 1, 1900: 130–31.

89 Charles Saunier, "Petit Gazette d'art: Claude Monet," *La Revue blanche* 25, no. 181 (Dec. 15 1900): 624.

90 Ibid.

91 François Thiébault-Sisson, "Claude Monet, les années d'épreuve," *Le Temps* Nov. 26, 1900.

92 Jules Buisson, "Un Claude Monet de l'exposition Petit," *La Chronique des arts et de la curiosité* Feb. 25, 1899: 70–71.

93 Levine, *Monet and his Critics*, 245.

94 Arsène Alexandre, "Le Jardin de Monet."

95 Georges Lecomte, "L'Exposition Claude Monet," *Revue populaire des beaux-arts* 2 (25 June 1898): 58–9, quoted and translated in Levine, *Monet, Narcissus, and Self-Reflection*, 188–9.

96 Mirbeau contributed to this as well. See "Claude Monet," *L'Art dans les deux mondes* March 7, 1891: 183–5.

97 On the building of Monet's water garden, see Gordon, "The lily pond at Giverny." For precise measurements of the garden see Elizabeth Murray, *Monet's Passion* (San Francisco: Pomegranate Artbooks, 1989), 63.

98 Dewhurst, *Impressionist Painting*, 46. On the petition to the préfet for the trellis, see w.2885 (1197a) to Préfet de l'Eure March 23, 1893.

99 w.1564 to PDR Aug. 21, 1900.

100 On this trip to the Normandy coast during the First World War, see w.2242 to G/JBJ Oct. 10, 1917. On drowning, see w.40 to Bazille 29 June [1868]; on being buried in a buoy, see Jacques-Emile Blanche, *Propos de peinture, III: De Gauguin à la Revue nègre* (Paris: 1928), 34–5, as quoted in House, *Nature into Art*, 26; on his love for the sea, see for example, w.730 to AH Oct. 30, 1886.

101 w.1832 to PDR April 27, 1907. This was not a new practice. In the 1880s he talked about destroying canvases that did not please him. See w.377 to PDR Oct. 18, 1883.

102 On wanting to destroy W.1656, see W.iv, 53, and w.1832 to PDR April 27, 1907.

103 By the middle of 1907 Monet had made more than fifty paintings of his pond. He was also still working on his "Londons" in December; see, w.1789 to PDR Dec. 17, 1905; for evidence of work though October see w.1784 and 1787 to PDR Oct. 20/26, 1905.

104 For Monet's refusal to sell pictures see w.1832 to PDR April 27, 1907.

105 Levine explores this issue of narcissism extensively in Levine, *Monet, Narcissus and Self-Reflection*.

106 Louis Vauxcelles, "Un après-midi chez Claude Monet," *L'Art et les artistes* Dec. 7, 1905: 85–90.

107 On this purchase see w.1805 to PDR June 13 1906. Monet owned a dozen paintings by Cézanne, making his collection one of the largest outside of the artist's own. In addition to being of the same generation and fighting the same political battles with the Salon and the commercial system, Cézanne had also been dismissed by critics (including his boyhood friend Zola). Moreover, Cézanne was a man of nature who maintained an unbending belief in the centrality of sensations. His works also bore all of the evidence of its gestation and of the artist's struggles to make his craft conform to what he felt and saw. So deeply did Monet respect Cézanne that a rumor developed in Paris that Alice had to put her husband's Cézannes in a closet when the master of Giverny was feeling discouraged about his own work. See Maurice Denis, *Journal*, ii, (1905–20) (Paris: 1957), 46, cited in Stuckey 1995, 238. In 1908 he also apparently expressed grave concern about being compared to Cézanne when an exhibition of Impressionist still-life painting in which there were eleven Monets and five Cézannes opened at Durand-Ruel's in late April 1908; see letter from PDR to Monet 21 April 1908, partially cited in W.iv, 55 and n.509.

108 w.1818 to PDR Dec. 28, 1906.

109 See, for example, Emile Bernard, "Du culte de la personalité," *La Rénovation esthetique* 3 (Sept. 1906): 260–61, as quoted and translated in James Herbert, *Fauve Painting: The Making of Cultural Politics* (New Haven and London, Yale University Press, 1992), 134.

110 Herbert, *Fauve Painting*, 9.

111 Ibid.

112 Louis Vauxcelles, "Le Salon d'Automne, salle VI, H. Matisse, Marquet . . .," in *Supplément à Gil Blas* Oct. 17, 1905; in the same article, Vauxcelles pointed to the number of pseudo-Impressionists in the Salon and the evidence of what he described as "Givernisms." Also see W.iv, 47, n. 432.

113 Jack Flam, *Henri Matisse, 1861–1919* (Ithaca: Cornell University Press, 1986), 51. Marquet surely had Monet in mind when he painted his suite of views of Notre-Dame in Paris in 1904 and 1905, titling them according to their time of day or weather conditions, much like Monet's Rouen Cathedral series.

114 This dialogue was made amply apparent by *Picasso: The Early Years, 1892–1906*, exh. cat. (Washington, D.C., National Gallery of Art, 1997), and by John Richardson's masterful biography, *A Life of Picasso, 1881–1906*, i (New York: Random House, 1991).

115 Because of poor record keeping, this entry has not been able to be specifically identified. According to Judi Freeman the Thyssen-Bornemisza painting is a very likely candidate. My thanks for her critical guidance on this point.

116 Monet could have encountered the remaining two dozen or more canvases from this campaign at Ambroise Vollard's gallery, which he haunted for his Cézannes. In an unvarnished attempt to capitalize on the Impressionist's hugely successful London show of 1904, Vollard had not only backed Derain's trips to England but also purchased all of the pictures the artist had produced during his stays. This was a shrewd business venture not a personal attack on Monet as Vollard counted himself among Monet's admirers, admonishing Paul Signac in the late 1890s to heed the patriarch's example when the younger Neo-Impressionism was sanctimoniously declaring that Impressionism had seen its day. The dealer also commissioned Renoir to do a portrait of Monet in 1906. But he clearly was investing more heavily in the younger Fauve painter. On the portrait, see, Centre Culturel du Marais, *Claude Monet au temps du Giverny*, 281, cited in Stuckey 1995, 238; on admonishing Signac see w.2014 to Signac June 5, 1912; on Vollard's support of Derain's London trip see Derain's letter to the President of the Royal Academy

London, May 15, 1953, quoted in John Elderfield, *The "Wild Beasts": Fauvism and its Affinities*, exh. cat. (New York: Museum of Modern Art, 1976), 152, n. 82.

117 See letter from Alice Hoschedé to Germaine Salerou of Oct. 24, 1906, in Centre Culturel du Marais, *Claude Monet au temps du Giverny*, 281, and in Hoog, *Les "Nymphéas" de Claude Monet*, 17.

118 W.1831 to PDR April 8, 1907; on confirming plans earlier see W.1830 March 25, 1907.

119 W.IV, *pièce justificative* 198 PDR to CM April 25, 1907.

120 W.1832 to DR April 27, 1907.

121 Ibid.

122 On destroying canvases see W.V, *pièce justificative* 345 JDR to Mrs. W.L. Putnam Feb. 9, 1907. Monet had often expressed his concern about the number of works in his shows in relation to the size of his previous exhibitions; see, for example, W.1690 to PDR March 23, 1903.

123 W.1833–6, W.3016–17. Although others may come to light, it is unlikely that they will be numerous as Monet was too absorbed in his work even to talk to the mayor of Giverny about the dust on the road on front of his house. See W.3017 to A. Collignon July 20, 1907. He did take time out for art, however, as two of the letters concerned another Cézanne that he wanted to purchase. See W.1835 and W.1836 to PDR and GDR June 13 and 19, 1907.

124 W.1837 to PDR Sept. 20, 1907.

125 On PDR's negative reactions to Monet's new work, see W.1844 to PDR March 20, 1908.

126 Georges Clemenceau, "La révolution de cathédrales," *La Justice* May 20, 1895: 1. On other reactions to these paintings see Levine, *Monet and his Critics*, 177–222; W.III, 66–8; and Tucker, *Monet in the '90s*, 187–99 and 307–8.

127 Monet had personally repurchased this Cathedral painting when it had come up at auction in 1901, an indication of how much he literally and figuratively invested in the group. See Archives nationales F21 4248 and W.IV, 54 and n. 493. Also see W.1823 to Clemenceau Feb. 8, 1907.

128 Monet owned at least six finished Cathedrals, plus two sketches. Among the former were W.1318 (sold 1920), W.1322 (sold 1902); W.1328 (sold 1918); W.1329 (sold 1920); W.1349 (sold 1907), W.1359 (sold 1906); the sketches were W.1320 and W.1327. He therefore could have offered the State a range from which to choose.

129 Letter from PDR to Henry Lapauze Nov. 22, 1905, Archives DR, quoted in W.IV, 47, n. 421.

130 Stuckey, *Monet: A Retrospective*, 253. Monet seems to have had second thoughts about the State purchase. In a letter that no longer exists, he apparently asked for the picture back, claiming it "prendra date, un jour, dans l'histoire de l'art." Cited in Michel Hoog, "La Cathédrale de Reims de Claude Monet, ou le tableau impossible," *La Revue du Louvre* 1 (1981): 22–4, and in W.IV, 54 n. 493. Obviously, he changed his mind.

131 W.1844 to PDR March 20, 1908.

132 W.1850 to PDR April 29, 1908.

133 W.1855 to L. Pissarro Aug. 24, 1908, and W.1854 to GG Aug. 11, 1908.

134 W.1872 to PDR Dec. 29, 1908.

135 Squabbling over the Venice pictures began as soon as Monet arrived in Italy. Durand-Ruel asked to have all of Monet pictures from the campaign, but Monet told him Bernheim-Jeune had already posed the same request; see W.1864 to DR Nov. 4, 1908.

136 W.1875 to DR Jan. 28, 1909.

137 Jean Morgan, "Causeries chez quelques maîtres: Claude Monet," *Le Gaulois* May 5, 1909: 1–2.

138 Ibid.

139 Ibid.

140 On Monet's insistence regarding the title of his show and DR's alternative see W.1875 to PDR Jan. 28, 1909; and Stuckey 1995, 241. Perhaps not by coincidence, Bernheim-Jeune staged a Courbet show in March 1909 which Monet visited; see W.1882 to GG March 29, 1909.

141 On the critical reaction to this hugely successful show, see

142 Levine, *Monet and his Critics*, 297–334, and W.IV, 66–8.

142 Levine, *Monet, Narcissus and Self-Reflection*, 216.

143 Roger Marx, "Les 'Nymphéas' de M. Claude Monet," *Gazette des beaux-arts* ser. 4, 1 (1909): 523–31.

144 Ibid.

145 Stuckey, *Monet: A Retrospective*, 255–67.

146 Levine, *Monet, Narcissus and Self-Reflection*, 223.

147 Marx, "Les 'Nymphéas' de M. Claude Monet."

148 W.1862 to Carlo Placci Oct. 20, 1908; for Monet's departure date see W.1860 to GG Sept. 28, 1908; for his arrival see Philippe Piguet, *Monet et Venise* (Paris: Editions Herscher, 1986), 25.

149 On Monet's resistance to going to Venice, see letters from Alice Hoschedé to Germaine Salerou Sept. 24, 27, and 28, 1908, as quoted in Piguet, *Monet et Venise*, 25.

150 This denial is quoted by Mirbeau in his essay for the catalogue to the Venice exhibition. See *Claude Monet: "Venise"* (Paris: Bernheim-Jeune, 1912), n.p.

151 On Monet's participation in international exhibitions, see the extremely useful compilation in W.V, 295–304.

152 The popularity of contemporary Venitian views is supported by the success of a show of eighty-six watercolors, many of them depicting aspects of the city, that Sargent staged at Knoedler's in New York in 1909. The Brooklyn Museum purchased eighty-three of the works and would have bought the whole lot if the other three had not already been claimed. My thanks to Barbara Dayer Gallati for this information. See her "Controlling the Medium: The Marketing of John Singer Sargent's Watercolors," in *Masters of Color and Light: Homer, Sargent, and the American Watercolor Movement*, eds. Linda S. Ferber and Barbara Dayer Gallati (Brooklyn Museum of Art in association with the Smithsonian Institution Press, 1998), 117–41.

153 W.1867a to G/JBJ Nov. 30, 1908. On Monet's tourist activities see letters from AH to Germaine Salerou Oct. 5 and 6, 1908, as quoted in Piguet, *Monet et Venise*, 28. From one letter, AH to Germaine Salerou Oct. 21, 1908, we know that Monet also visited museums in Venice; see Piguet, *Monet et Venise*, 33.

154 W.IV, 287.

155 AH to Germaine Salerou Nov. 23, 1908, as quoted in Piguet, *Monet et Venise*, 47. On taking care of himself, see AH to Germaine Salerou Nov. 30, 1908, as quoted in Piguet, *Monet et Venise*, 50.

156 See W.IV, 61, on moving so as not to strain relations with their hostess. On new paintings daily, see AH to Germaine Salerou Oct. 16 and 17, 1908, as quoted in Piguet, *Monet et Venise*, 30–31. On Mrs. Hunter's delayed departure see AH to Germaine Salerou Oct. 13 and 14, 1908, as quoted in Piguet, *Monet et Venise*, 30.

157 Piguet, *Monet et Venise*, 27.

158 W.1861 to DR Oct. 19, 1908.

159 W.1869 to GG Dec. 7, 1908; on Alice's comments to Geffroy, see W.IV, 387.

160 W.1869 to GG Dec. 7, 1908. For Monet's note to Mrs. Curtis, see W.1870 Dec. 7, 1908.

161 W.1884a April 20, 1909; for editing, see Centre Culturel du Marais, *Claude Monet au temps du Giverny*, 273.

162 For Monet's response to flood victims, see W.IV, 72, and W.1915, W.1917, and W.1918 to PDR March 4, and April 15 and 18, 1910. The painting he donated for a benefit auction was a Charing Cross Bridge picture (W.1529), today in the National Museum of Wales, Cardiff.

163 Clemenceau to Monet July 12, 1911, quoted in *Georges Clemenceau à son ami Claude Monet: Correspondance*.

164 W.1971 to GG July 11, 1911.

165 W.1976a to G/JBJ Aug. 28, 1911.

166 W.1984 to DR Oct. 23, 1911.

167 W.2001d to G/JBJ April 8, 1912; on turning the paintings over see W.2001a to G/JBJ March 29, 1912.

168 W.2009 to GG May 6, 1912; W.2019 to GG July 6, 1912.

169 W.2014 to Paul Signac June 5, 1912.

170 On his admiration for the Tintorettos, see letter from AH to Germaine Salerou Oct. 6, 1908, as quoted in Piguet,

Monet et Venise, 28.

171 For Mirbeau's negative reaction to Venice, see Mirbeau, *Claude Monet: "Venise."*

172 Piguet, *Monet et Venise*, 41.

173 W.2001b to BJ April 1912.

174 Mirbeau, *Claude Monet: "Venise."*

175 Ibid.

176 Ibid.

177 Guillaume Apollinaire, "Claude Monet," *L'Intransigeant* 31 (May 1912).

178 Monet made 339,000 francs just from the sale of his Venetian pictures to Bernheim-Jeune. See *pièce justificative* 240, JBJ to Monet May 17, 1912.

179 On the Armory show and these prices, see Milton Brown, *The Story of the Armory Show* (Washington, D.C.: The Joseph H. Hirshhorn Foundation, 1963). Monet was represented by five works: W.157, W.508, W.911, W.1019, W.1514.

180 W.2074 to GG July 18, 1913.

181 W.2024 to DR Aug. 1, 1912; W.2023 to GG July 26, 1913. On Monet's cataracts, see Ravin, "Monet's Cataracts": 394–9, and Dittiere, "Comment Monet recouvre la vue": 26–32.

182 W.2024a to G/JBJ Aug. 5, 1912.

183 W.2065 to GG April 27, 1913.

184 W.2069 to Raymond Koechlin June 1, 1913.

185 In 1916 Monet reassured Koechlin that his sight was fine. See W.2180 May 1, 1916.

186 W.2121 to Félix Fénéon June 17, 1914.

187 On the complications of this donation and its installation at the Louvre see Germain Bazin, *French Impressionists in the Louvre* (New York: Abrams, 1958), 54–7.

188 W.I, 837. His remark may also have been prompted by the fact he had not painted his water-lily pond in five years or his house in ten.

189 Monet had tried to purchase *The Turkeys* (W.416) in 1903 and 1909, and had been interested in its whereabouts since the 1880s. See W.535 to Duret [end of Nov. 1884]; W.1687 and 1689 to DR Feb. 28 and March 11, 1903; and W.1902a to G/JBJ July 2, 1909. Durand-Ruel purchased *The Garden at Montgeron* (W418) from Faure in 1907, the same year Vollard sold *The Pond at Montgeron* (W.420) to the Russian collector Ivan Morosov. The fourth in the group, *The Hunt* (W.433), remained in Durand-Ruel's personal collection.

190 W.2116 to GG April 30, 1914.

191 Stuckey 1995, 230.

192 Monet even had to suffer the ignominy of the forced sale of Alice's possessions slyly engineered by her estranged son Jacques, who had been cut off from the family and had used the legal system to take revenge on his stepfather and siblings. Monet bought back most of the items to distribute to the other children but it was a painful affair that compounded his grief about Alice's passing. On this sale see, W.IV, 77 and n. 703.

193 There is no way of knowing whether Monet saw any of Picasso's Cubist pictures in the aggregate; the only reference to the Spanish master he made came in 1925 when he admitted seeing Picasso's work "in reproduction in the reviews," and declared "it doesn't do anything for me . . . I don't want to see it, it would make me angry." See W.IV, 446.

194 After his Water Lily show of 1909, there was talk of a millionaire commissioning Monet to decorate "a circular room . . . [with] a painting of water and flowers passing through every possible modulation," as one critic after the World's Fair in 1900 wrote in the *Gazette des beaux-arts*, "If I were a millionaire – or Fine Arts minister – I would ask M. Claude Monet to decorate a vast festival hall in a public place for me." Clemenceau had even urged the President of France in 1895 to buy all of the Cathedral paintings for the nation. On Clemenceau's plea, see *La Justice* May 20, 1895: 1; on the visions for a public space see, André Michel, "Les Arts à l'Exposition Universelle de 1900: L'Exposition Centennale: La Peinture française," *Gazette des beaux-arts*

Nov. 1900: 477–8; Arséne Alexandre, "La Semaine artistique: un paysagiste d'aujourd'hui et un portraitiste de jadis," *Comoedia illustré* 8 (May 1909): 3.

195 The Camondo gift was particularly important as it was the first time that works by living artists (Monet, Degas, and Renoir) were made a legal part of the Louvre's permanent collection and physically displayed on its walls. Before this bequest, all contemporary art acquired by the State that was to remain in Paris went to the Musée du Luxembourg. Only after the artist was dead for ten years could it be transfered to the Louvre. On the Camondo bequest and the deliberations of the museum's acquisition's committee, see Bazin, *French Impressionists in the Louvre*, 40, 54–5.

196 On this commission which was initiated in 1908 but not officially awarded until 1910, see W.v, 178–9, and the following letters all to GG: w.1944 Nov. 11, 1910; w.1947 and w.1949 Dec. 3 and 27, 1910; w.1950 Jan. 12, 1911; w.1959 April 11, 1911; and w.1987 Nov. 25, 1911. By this time, Monet's paintings had been acquired by bequest or direct purchase by a variety of museums in Europe and the United States. In 1900, for example, the Liège Museum was given an 1874 view of Le Havre (W.294) for its permanent collection. In 1902 the Lyons Museum purchased views of Etretat (W.821) and Vétheuil (W.586) and the Petit Palais in Paris was bequeathed an ice-floe picture (W.576) of 1880. In 1903 the Art Institute of Chicago bought a view of Pourville (W.1423) of 1896, the first work by Monet to enter an American museum. In 1906 the Kunsthalle in Bremen purchased his *Woman in a Green Dress* (W.65). That same year the Museum of Fine Arts, Boston bought three paintings, an early marine of 1873 (W.259), a view of the Petit Dalles (W.621) of 1880 (W.621), and a Creuse Valley picture (W.1221) of 1889; they were the first of what would become thirty-nine works by Monet in its permanent collection. Two years later the National Gallery of Ireland accepted the donation of one of his Waterloo Bridge pictures (W.1556), and in July 1910 the Worcester Art Museum became the first American museum to purchase a Water Lilies (W.1731). In 1911, Boston's Museum of Fine Arts acquired a Morning on the Seine (W.1481); and in 1912 the Kunstverein in Frankfurt bought an early seascape (W.86) and a view of Etretat (W.1029) from a show of Monet's work that they had organized.

197 w.2116 to GG April 30, 1914; in another letter to Geffroy w.2124 of July 6, 1914, he tells his friend that he has been working diligently for two months, which suggests that it was some time in May when he began his project.

198 w. 2124 to GG July 6, 1914, and w.2123 to PDR June 29, 1914.

199 w.2128 to GG Sept. 1, 1914.

200 Ibid.

201 Ibid.

202 w.2129 to JDR Oct. 9, 1914.

203 w.2126 to JPH Aug. 10, 1914.

204 W.new vol. i, 404; on Renoir's son, see w.2129 to JDR Oct. 9, 1914; on Clemenceau's son, see w.2128 to GG Sept. 1, 1914.

205 w.2135 to GG Dec. 1, 1914.

206 See Matisse's letter to Charles Camoin, April 10, 1918, in Danièl Giraudy, "Correspondance Henri Matisse–Charles Camoin," *Revue de l'art* no. 12 (1971): 21, quoted and translated in Kenneth E. Silver, *Esprit de Corps: The Art of the Parisian Avant-Garde and the First World War* (Princeton: Princeton University Press, 1989), 34. For Monet's reactions, see, for example, w.2141 to PDR Jan. 15, 1915, w.2142 to Raymond Koechlin Jan. 15, 1915, and w.2173 to Thérèse Janin March 2, 1916.

207 Untitled article, *L'Elan* no. 1. (April 15, 1915): 2, as quoted and translated in Silver, *Esprit de Corps*, 55 and n. 52.

208 w.2143 to a committee member Jan. 16, 1915.

209 w.2142 to Raymond Koechlin Jan. 15, 1915.

210 w.2154 to G/JBJ Aug. 18, 1915.

211 On the third studio, see W.iv, 84 and w.2158 to GG Sept. 29, 1915.

212 w.2155 to JPH Aug. 19, 1915; on specifics of the cost see W.i, 84, n. 775.

213 w.2155 to JPH Aug. 19, 1915.

214 w.2160 to GG Oct. 24, 1915.

215 w.2170 to JPH Feb. 8, 1916.

216 w.2173 to Mme. Janin March 2, 1916; on the folly see w.2200 to GG Nov. 13, 1916.

217 On Monet's comments about Michel in Verdun, see w.2193 to GG Sept. 11, 1916.

218 w.2205 to G/JBJ Nov. 28, 1916.

219 w.2208 to Sacha Guitry Dec. 14, 1916; on believing he was almost finished with certain panels, see w.2205 to G/JBJ Nov. 28, 1916.

220 w.2210 to GG Jan. 25, 1917.

221 w.2216 to GDR Feb. 9, 1917, quoted and translated in Stuckey 1995, 248.

222 w.2545 to Léonce Bénédite Jan. 9, 1924; also W.iv, 430.

223 w.2229 to G/JBJ May 1, 1917, and w.3040 to Albert Marquet May 7, 1917.

224 On this unprecedented two-man show, see Silver, *Esprit de Corps*, 200.

225 Ibid., 146.

226 Ibid., 147.

227 Ibid., 165.

228 Ibid., 147.

229 Letter from Robert Delaunay to Weichsel Dec. 12 1916, Delaunay papers, Bibliothèque Nationale, Paris, as quoted in Silver, *Esprit de Corps*, 147.

230 On Monet's admission about the war, see w.2148 to Joyant Feb. 25, 1915. On his guilt about the war see w.3041 (2262a) to Clemenceau Feb. 3, 1918.

231 w.2210 to GG Jan. 25, 1917.

232 On the commission, see Hoog, "La Cathédrale de Reims de Claude Monet," 22–4; W.iv, 54, and w.2249 to Albert Dalimier Nov. 1, 1917.

233 There are several other points made by these photographs. It is evident from them that Monet had many pictures in progess at once. Canvases are on both sides of the movable easels, while others are leaning up against the walls. Moreover, the walls and the pictures are awash with sunlight pouring in from the generous skylights that span the space. But one section of wall is covered with a large piece of dark fabric, as if Monet wanted to have a more traditional background reference than the modern, monochromatic walls, either for color balance or for thinking about the type of space in which the pictures might ultimately appear. The photographs also attest to Monet's fastidiousness; his preparation tables are impeccably neat, his floor immaculate.

234 On the sale of these paintings see w.2266 to G/JBJ March 21, 1918. Monet had sold eight paintings to the Durand-Ruels in March 1917 (w.2220 to GDR March 26, 1917). Before that sale he had not parted with any recent work since 1913. On Thiébault-Sisson's visit see "Autour de Claude Monet, anecdotes et souveniers: I," *Le Temps* Dec. 19, 1926; II, Jan. 8, 1927. Thiébault-Sisson would later assert that Monet had completed eight of the twelve panels he had been working on and had begun the remaining four, together with a group of six- and eight-meter-wide canvases. Given Monet's penchant for working on many canvases at once, this report is probably not entirely accurate. Thiébault Sisson did not file the report until well after the fact in 1926 and 1927.

235 On the order see, w.2271 to Mme. Barillon April 30, 1918.

236 Monet even admitted to Alice during a trip to the Massif Centrale in 1889 that an old tree along the banks of the Creuse River was essentially a stand-in for himself; see w.974 to AH May 6, 1889; on associations of the poplars, see Tucker, *Monet in the '90s*, 115–51.

237 w.2276 to JDR June 18, 1918.

238 w.2275 to JDR June 15, 1918.

239 w.2277 to GBJ June 21, 1918.

240 w.2278 to GBJ Aug. 3, 1918.

241 w.2287 to Clemenceau Nov. 12, 1918. Monet expressed

his relief when the Peace Treaty was finally signed in 1919. See w.2316 to JBJ June 24, 1919.

242 See w.2290 to G/JBJ Nov. 24, 1918; w.2233 to Jacques Zoubaloff Feb. 2, 1920; and w.2545 to Bénédite Jan. 9, 1924. Following Alexandre's claims, Wildenstein suggests, with qualifications, that Monet intended to offer The Clouds, the diptych that eventually became part of the Orangerie program. See, W.iv, 414. Spate suggests it was Green Reflections, although she does not provide any supporting evidence. See Virginia Spate, *Claude Monet: Life and Work* (New York: Rizzoli, 1992), 303.

243 w.2299 to G/JBJ Nov. 24, 1918.

244 Ibid.

245 Ibid.

246 w.2302 to G/JBJ Jan. 24, 1919. There is considerable confusion as to how many paintings were in the show and which ones they were. The invitation that the gallery mailed claimed there were twenty-eight. Wildenstein identifies eleven of them: W.1017, W.1377, W.1392, W.1534, W.1658, W.1722, W.1868, W.1869, W.1879, W.1880.

247 *La Chronique des arts et de la curiosité* Jan.–Feb. 1919: 169.

248 On anti-individualism during the war see Silver, *Esprit de Corps*, 197–8.

249 André Lhote, "Tradition et triosième dimension," *Nouvelle Revue française* no. 85 (Oct. 1920), quoted in Silver, *Esprit de Corps*, 210. For further proof of impressionism's alienation, see Ibid., 210–16.

250 w.2327 to Joyant Nov. 20, 1919. This invitation may well have been prompted by Monet's earlier inquiry about Joyant's space. See w.2148 to Joyant Feb. 25, 1915.

251 w.2290 to G/JBJ Nov. 24, 1918.

252 That Monet donated a major, though relatively restrained, Water Lilies first and then a more challenging Corner of the Garden is telling. It appears that he wanted to establish his Water Lilies initially, as no works from that series had been seen in Paris except for the four signed and dated pictures that Bernheim-Jeune purchased in November 1919. That he would have upped the ante with a more daring painting for Grenoble also makes sense as it immediately entered the collection of a major museum.

253 W.iv, 94 and w.2367–70 and W.3053.

254 On leaks to the press about Monet's donation, see Thiébault-Sissons "Art et curiosité: un don de Claude Monet à l'Etat," *Le Temps* Oct. 14, 1920, and Arsène Alexandre, "L'Epopée des Nymphéas," *Le Figaro* Oct. 21, 1920: 1.

255 On the seat on the Académie des Beaux-Arts, see Stuckey 1995, 251, and W.iv, 97. On rumors that Monet was donating his house and garden, see ibid., 251.

256 The eighteen-panel offer of late October 1921 included Green Reflections (2 panels), Agapanthus (2 panels), The Clouds (3 panels), Morning (3 panels), Three Willows (4 panels) and Reflections of Trees (2 panels) facing each other with two six-meter panels on either side. In early November Monet's letter to Léon refers to these eighteen, but he included two more in a list that accompanied his note. See W.iv, 421.

257 w.2355 to GG June 11, 1920. On Clemenceau's urgings, see W.iv, 90, and w.2324 to Clemenceau Nov. 10, 1919.

258 Marcel Pays, "Une visite à Claude Monet dans son ermitage de Giverny," *Excelsior* 26 Jan. 1921.

259 w.2399 to GBJ Jan. 26, 1921.

260 On Clemenceau's comments, see Stuckey 1995, 253; on Monet's admissions to Elder, see w.2494 May 8, 1922. On his admission to Clemenceau, see w.2493 May 4, 1922.

261 On Coutela's diagnoses, see W.iv, 106–8.

262 "I only see blue. I no longer see red . . . [or] yellow," he informed a new specialist, Dr. Mawas, Maurice Denis's oculist, who had come to Giverny, probably in June 1924, through the intercession of Monet's artist friend André Barbier. "I know that on my palette there is red, yellow, a special green, a certain violet. I no longer see them as I once did, and yet I remember very well the colors which they gave me." Tucker, *Claude Monet: Life and Art*, 222, n. 101.

Recollections of Dr. Jacques Mawas June [7], 1924, quoted in W.IV, 120.

263　See w.2387 to DR Dec. 1, 1920 where Monet speaks about retouching an Etretat painting of the 1880s.

264　See letter from André Barbier to Monet, Dec. 13, 1924, as quoted in W.IV, 125.

265　Ibid.

266　See letter from JDR to PDR Oct. 20, 1923, as quoted in W.IV, 116.

267　w.2521 to Léon Jan. 18, 1923.

268　w.2541 to E. Clémentel Nov. 7, 1923.

269　*Recollections of Dr. Jacques Mawas*, [7] June 1924, quoted in W.IV, 120.

270　Clemenceau letter to Monet, Oct. 8, 1924, quoted in Hoog, *Les Nymphéas de Claude Monet*, 110.

271　Clemenceau letter to Monet Jan. 7, 1925, quoted and translated in Stuckey 1995, 129, and in Hoog, *Les Nymphéas de Claude Monet*, 110–11.

272　w.2600 to André Barbier May 22, 1925.

273　w.2609 to André Barbier July 17, 1925.

274　*Georges Clemenceau: Correspondance*, 178; for Monet's use of the term "resurrection" see w.2612 to GBJ Oct. 6, 1925.

275　On Monet's editing, see René Gimpel, *Diary of an Art Dealer*, trans. Joseph Rosenberg (New York: Farrar, Strauss & Giroux, 1963), 318–19.

276　w.*2683 to Clemenceau Sept. 18, 1926.

277　w.2630 to Léon Oct. 4, 1926.

278　Georges Clemenceau, *Les Nymphéas* (Paris: Librarie Plon, 1928), repr. as *Claude Monet: Cinquante ans d'amitié* (Paris: Palatine, 1965). For reviews of the Orangerie at the time of its opening see, for example, Marcel Sauvage, "Les Nymphéas de Claude Monet au Musée de l'Orangerie," *Comoedia* May 17, 1927; François Thiébault-Sisson, "Art et curiosité. A l'Orangerie des Tuileries: Les 'Nymphéas' de Claude Monet," *Le Temps* May 18, 1927; Pierre Guillais, "A Orangerie: M. Herriot dans les salles des 'Nymphéas' de Claude Monet," *Le Soir* May 18, 1927; Louis Paillard, "Un musée de Claude Monet est installé aux Tuileries," *Le Petit Journal* May 17, 1927; and L'Imagier, "Claude Monet au Musée de l'Orangerie," *L'Oeuvre* May 17, 1927.

279　Jacques-Emile Blanche, "En me promenant aux Tuileries," *L'Art vivant* Sept. 1927: 695–6.

280　Eugenio d'Ors, *La Vie de Goya* (Paris: Gallimard, 1928), 179, as quoted in Hoog, *Les "Nymphéas" de Claude Monet*, 77.

281　Hoog, *Les "Nymphéas" de Claude Monet*, 77.

282　Maurice Denis, Preface to M. Storez, *L'Architecture et l'art décoratif en France après la guerre (comment prépare leur renaissance)* (Paris, 1918), as quoted in Silver, *Esprit de Corps*, 197.

283　André Masson, "Monet le fondateur," *Verve* 7, no. 27–8 (Dec. 1952), 68–70.

OCEANIC SENSATIONS

I would like to thank Hughes Vilhem for his invaluable advice during my research in Paris.

1　It was this belated restoration that inaugurated the publication of Robert Gordon and Charles F. Stuckey's important two-part article "Blossoms and Blunders: Monet and the State," *Art in America* (Jan.–Feb. 1979): 102–17; and Stuckey, part II, Ibid. (Sept. 1979): 109–25. I would like to thank Robert Gordon for his additional clarifications in a long conversation in January 1998.

2　Theodor Adorno, "Valéry's Proust Museum," *Prisms* (Cambridge, M.A.: MIT Press, 1990), 175.

3　See Gordon and Stuckey, "Blossoms and Blunders"; Robert Gordon and Andrew Forge, *Monet* (New York: Abrams, 1983), 224–59; and Michel Hoog, *Les Nymphéas de Claude Monet au Musée de l'Orangerie* (Paris: Réunion des Musées Nationaux, 1984).

4　The publication that refers to this correspondence is a book by one of Monet's heirs, Jean-Pierre Hoschedé:

Claude Monet ce mal connu, 2 vols. (Geneva: Pierre Cailler, 1960), vol. 2.

5　Georges Clemenceau, *The Water Lilies* (New York: Doubleday, 1930) originally published in French as *Claude Monet, les Nymphéas* (Paris: Plon, 1928).

6　Correspondence of the Monet-Hoschedé donation to the Jeu de Paume, Archives du Louvre, File B.8 [hereafter AL, File B.8]. Whether Michel Monet managed to avert this is unclear.

7　Rosalind Krauss, "Photography's Discursive Spaces," *Art Journal* 42 (winter 1982), repr. *The Contest of Meaning: Critical Histories of Photography*, ed. Richard Bolton (Cambridge, M.A.: MIT, 1992), 288.

8　Clement Greenberg, "The Later Monet," *Artnews Annual* 26, 1957, reprinted in *Modernism with a Vengeance, 1957–1969*, vol. 4 of *Clement Greenberg: The Collected Essays and Criticism*, ed. John O'Brian (Chicago: University of Chicago Press, 1993), 3–11.

9　Walter Benjamin, "The Work of Art in the Age of Mechanical Reproduction," in *Illuminations: Walter Benjamin Essays and Reflexions*, ed. Hannah Arendt (New York: Schocken Books, 1969), 224–5.

10　Pierre Olmer, "Le Musée Claude Monet à l'Orangerie des Tuileries," *L'Architecture* 40, no. 6 (June 15, 1927): 183–6; and Alexandre Benoît, "Alexandre Benoit reflechit" (1931) repr. Hoog, *Les Nymphéas de Claude Monet*, 46.

11　Louis Gillet, *Trois variations sur Claude Monet* (Paris: Plon, 1927). Part III, "5 Décembre 1926: Sur la terrasse du bord de l'eau," devoted to the Water Lilies, was based on two articles published in *Le Gaulois* on Dec. 5, 1926, and May 27, 1927. While Clemenceau's essay (see n. 5 above) is often cited in the Monet literature, Gillet's is not. The main exception is Steven Z. Levine in "Seascapes of the Sublime: Vernet, Monet, and the Oceanic Feeling," *New Literary History* 16, no. 2 (winter 1985): 877–400. *Monet, Narcissus, and Self-Reflection: The Modernist Myth of the Self* (Chicago: University of Chicago Press, 1994), chap. 15: "War, Water Lilies, and Death (1910–26)."

12　Gillet, *Trois Variations*, 100, 112–14.

13　On Clemenceau's role in Monet's donation, see Stuckey, "Blossoms and Blunders, Part II, 109–25.

14　Clemenceau, *Water Lilies*, 143, 146, 156–70.

15　Sigmund Freud, *Civilization and its Discontents*, ed. James Strachey (New York: Norton & Co., 1961): 11–12. On this exchange, see David. S. Werman, "Sigmund Freud and Romain Rolland," *International Review of Psychoanalysis* 4 (1977): 235–42; and *Sigmund Freud et Romain Rolland: Correspondance 1923–1936. De la sensation océanique au trouble du souvenir sur l'Acropole*, ed. Henri and Madeleine Vermorel (Paris: Presses Universitaires de France, 1993). Levine, "Seascapes of the Sublime," and *Monet, Narcissus, and Self-Reflection*, also discusses, although in different and mostly ahistorical terms, the link between Gillet and Freud in regard to the oceanic sensation.

16　Rolland wrote a biography of Mahatma Gandhi in 1924, and *La Vie de Ramakrishna* as well as *La Vie de Vivekananda et l'Evangile*, published as a single volume in English as *The Prophets of the New India* (New York: Boni, 1930). See David J. Fisher, *Romain Rolland and the Politics of Intellectual Engagement* (Berkeley: University of California Press, 1988).

17　The degree to which this oceanic sensation – which in Rolland's thought is oriented toward "the great mother", "the great goddess of unity," and "maternal nostalgia" – is repressed rather than rejected by Freud (as the all-engulfing feminine principle, the Id, the flood, as opposed to the primacy of the Father and the Oedipal Principle in his theories about the formation of the Ego), constitutes another major point of divergence that might be applied to the Gillet/Clemenceau polarity as well. See Vermorel, *Sigmund Freud et Romain Rolland*, 320–24; and Klaus Theweleit, *Women floods bodies history*, vol 1 of *Male Fantasies* (Minneapolis: University of Minnesota Press, 1987).

18　Gillet, *Trois Variations*, 104–5.

19　See Kenneth E. Silver, *Esprit de Corps: The Art of the Parisian Avant-Garde and the First World War, 1914–1925* (Princeton N.J.: Princeton University Press, 1989), 210–18.

20　André Lhote, Review of Monet's show, *La Nouvelle Revue française*, 1921: 810; and *Traité du paysage* (Paris: Floury, 1946). On the role of landscape painting after the First World War, see Romy Golan, *Modernity and Nostalgia: Art and Politics in France between the Wars* (New Haven and London: Yale University Press, 1995).

21　See John Patrick Tuer Bury, *France, The Unsure Peace: From Versailles to the Depression* (New York: American Heritage Press, 1972), 105.

22　See Sigmund Freud, "The Uncanny" (1919) and "Beyond the Pleasure Principle" (1920); and Cathy Caruth, *Unclaimed Experience: Trauma, Narrative, History* (Baltimore: Johns Hopkins University Press, 1998).

23　Georges Limbour, *Exposition André Masson* (Paris: Galerie Simon, 1929). See Golan, "The landscape of the trenches," in *Modernity and Nostalgia*, 11–17.

24　Although he does not link it to the trauma of the First World War, the link between the *Grandes Décorations* and death is discussed at length by Levine in "Seascapes of the sublime," and *Monet, Narcissus, and Self-Reflection*.

25　On this phenomenon in French historiography see Pierre Nora, "Between Memory and History: *Les Lieux de mémoire*," *Representations* 26 (spring 1989): 7–25.

26　Aloïs Riegl, "The Modern Cult of Monuments: Its Character and Origin," originally written in 1903, was first published in 1928. It was recently translated in *Oppositions* (fall 1992): 21–51.

27　The stipulations of the contract appeared in *Le Bulletin de l'art ancien et moderne*, no. 668, July 15 1922: 63. See Stuckey, "Blossoms and Blunders, Part I": 103.

28　Paul Jamot, *Claude Monet: Exposition rétrospective* (Paris: Musée de L'Orangerie, 1931), 8, 13, 22, 24.

29　Benoît, "Benoît réflechit", 46.

30　Albert Flament, "Rétrospective," *La Revue de Paris* (1931): 475–77.

31　AL, File B.8.

32　For an account of its construction see Isabelle Gournay, *The New Trocadéro/Le Nouveau Trocadéro* (Paris: Mardaga, 1985).

33　This project was finally realized, without the Grandes Décorations, as the last stage of the building campaign of the Grand Louvre in 1997.

34　See Blandine Chavanne and Christiane Guttinger, "La Peinture décorative" and the entries on individual pavilions in *Paris 1937: Cinquantenaire de l'Exposition des Arts et Techniques de la Vie Moderne* (Paris: Institut Français d'Architecture, 1987), 364–91.

35　In "Arts et littératures dans la société contemporaine," *Encyclopédie française*, vol. 16, ed. Pierre Abraham (Paris: Librairie Larousse, 1935), 1670.2–1670.5.

36　Louis Chéronnet, "Au pied du mur," *Europe*, no. 161 (May 1936): 116–24.

37　Fernand Léger, "The Wall, the Architect, the Painter" (1933) in *Fernand Léger: Functions of Painting*, ed. Edward Fry (New York: Thames and Hudson, 1973), 91–9: in the same volume, see also "Mural Painting and Easel Painting" (1950), and "Mural Painting" (1952). And see Ruth K. Meyer, "Fernand Léger's Mural Paintings, 1922-1955," Ph.D dissertation, University of Minnesota, 1980.

38　See Jean Badovici, "Peinture murale ou peinture spatiale," *L'Architecture d'aujourd'hui* (March 1937): 75–8.

39　One of great bones of contention in the mural debate, irrespective of the political and aesthetic positions of the protagonists, was the dichotomy of Mediterraneanism – that is the south versus the north. It was the Mediterranean, according to the Italian Fascists, that was the true home of the human, solar tradition of painted architecture, a lineage that went all the way back, we are repeatedly told, from the Renaissance fresco and the Byzantine mosaic to cave painting. It is significant in this respect that the cave paintings of the Jebel Uweinat in the Lybian desert (where Ladislaus de

Almasy left his beloved in *The English Patient*), were discovered in 1933 under Mussolini's auspices on Italian colonial territory. Mario Sironi, Mussolini's favorite and most vocal artist, called *ad nauseam* during the 1930s for a revival of the *Latin* grandeur of the mural against the Puritan architectural severity of the Protestant North, the land of the de-humanized Machine Aesthetic of the Werkbund and the Bauhaus. Sironi also identified this North (France included), from the invention of oil painting to the triumph of the nineteenth-century Paris Salon, with a base, mercantile, obsession with easel painting. The contradiction inherent here between the northeners' love of the white or glass wall and their infatuation with paintings is only one of the many paradoxes engendered by this kind of purely ideological reasoning. See Mario Sironi, *Scritti editi e inediti* ed. Ettore Camesasca (Milan: Feltrinelli, 1980). These issues will be discussed in detail in my forthcoming book *Mural Effects in European Art, 1928–1958.*

40 Le Corbusier, "Peinture, sculpture, et architecture rationaliste," in *Le Corbusier-Savina* (Paris: Philippe Sers, 1984), 12–21.

41 See, for instance, Philippe Diole, "On demande des murs," *Beaux-Arts*, no. 102 (Dec. 14, 1934): 1; Louis Chéronnet, "L'Art mural," *L'Intransigeant* (June 8, 1935): 4; Yvanohé Rambosson, "Quelle place aura l'art mural en 1937?" *Comoedia* (June 15, 1935): 7; Jean-Marc Champagne, "La Vie des arts: avec Fernand Léger," *Marianne* (Oct. 13, 1937): 8.

42 Jean Gallotti, "La Renaissance de la fresque et du décor," *L'Illustration*, no. 4928 (Aug. 14, 1937): n.p.

43 Chavanne and Guttinger, "La Peinture décorative," *Cinquantenaire*, 364.

44 See n. 9 above.

45 See François Robichon, "Le Panorama, spectacle de l'histoire," *Le Mouvement social*, no. 131 (April–June 1985): 65–86.

46. See Dora Pérez-Tibi, *Dufy* (New York: Abrams, 1989), 250–75. Had they been moved to the Musée d'Art Moderne, the *Grandes Décorations* would have been housed today in the same space as Dufy's *Fée Electricité*, and with the other great artist to have been overlooked at the time of the 1937 Fair, Henri Matisse, whose second version of *La Danse* of 1933 (based on the one at the Barnes Foundation in Merion) was installed, after endless delays, in 1977. See Jack Flam, "Histoire et metamorphose d'un projet," in *Autour d'un chef d'oeuvre de Matisse: les trois versions de la Danse Barnes (1930–1933)*, (Paris: Musée National d'Art Moderne, 1994.)

47 AL, File B.8. See also *Choix des relevés des peintures murales de la collection des Monuments Historiques* (Paris: Musée des Arts et Monuments Français, 1945).

48 See Emily Braun, "Gleanings of Gold: Sironi's Mosaic in the Palazzo dell'Informazione," in *Racemi d'oro: il mosaico di Sironi nel Palazzo dell'Informazione*, Emily Braun ed. (Milan: Immobiliare Metanopoli, 1992).

49 The paintings, which have been discussed in the recent Pollock literature (e.g. Steven Neifeh and Gregory White Smith, *Jackson Pollock: An American Saga*, New York: Harper Perennial, 1991), were often titled by friends and by art critics such as Clement Greenberg and Harold Rosenberg.

50 AL, File B.8; see letters dated July 12, 22, 26, 1949; August 1, 12, 1949; June 13, 21, 1950; October 29, 1952. Archives du Louvre.

51 "Jeanne et Paul Facchetti entretien avec Daniel Abadie, March 26 1981," in *Jackson Pollock* (Paris: Musée National d'Art Moderne, Centre Georges Pompidou, 1982), 297.

52 Masson, "Monet le fondateur," *Verve* 7 (1952): 68, repr. *Hommage à Claude Monet (1840–1926)* (Paris: Grand Palais, 1980).

53 *Tapisseries inédites executées dans les ateliers Tabard à Aubusson* (Paris: Galerie Louise René, 1958), n.p.

54 See Jean Lurçat, "Révolte contre le tableau de chevalet," *Formes et Couleurs*, no. 6 (1943) n. p.; *Tapisserie française* (1947); and Jean Cassou, *Tapisserie française du Moyen Age*

a nos jours (Paris: Musée National d'Art Moderne, Paris, 1946); and *La Tapisserie française et les maîtres cartonniers,* Ibid, 1958.

55 Germain Bazin, "L'Homme et la tapisserie," in Jean Lurçat et al., *La Tapisserie française: Muraille de laine* (Paris: P. Tisne), 7, 9.

56 Flament, "Rétrospective": 276.

THE MONET REVIVAL

My thanks to Nicole Michel, a student at Massachusetts Institute of Technology, who assisted with the research for this essay, and to Margaret Werth and Paul Tucker for numerous valuable suggestions and criticisms.

1 The three different exhibitions of Monet's work organized in 1957 by museums in St. Louis, Minneapolis, Chicago, and Boston were the first by American museums since 1927, when Boston organized a memorial exhibition for the artist. In the intervening period there had been three significant exhibitions of Monet's art at New York galleries: Durand-Ruel in 1940, Wildenstein in 1945, and Knoedler in 1956.

2 Louis Finkelstein, "New Look: Abstract-Impressionism," *Art News* 55 (March. 1956): 36.

3 Thomas Hess, "Monet: Tithonus at Giverny," *Art News* 55 (Oct. 1956): 42.

4 Meyer Schapiro, for example, argued that concealed beneath the avant-gardist rhetoric of opposition between the formlessness of Impressionism and the structure of abstraction were strong continuities. In his view, the Impressionists introduced into art a modern form of vision, distinguished by casual, accidental perception and heightened subjectivity at the expense of any sense of the firmness and objectivity of the real world, which was shared by their more radical descendants, specifically Matisse. See "Matisse and Impressionism," *Androcles* 1.1 (Feb. 1932): 21–36.

5 The measure of popularity enjoyed by Monet's art presented a problem for some of the authorities seeking to reevaluate his work. See, for example, Clement Greenberg, who puzzled over how such advanced painting could have appealed to popular taste. "'American-Type' Painting," *Partisan Review* (spring 1955): 191.

6 "Public Favorites," *Time* 62 (Aug. 24, 1953): 48.

7 Monet's *Bridge at Bougival* 1870 (W.152) was acquired by the Currier Gallery in Manchester, N.H., in 1949 and quickly became a "public favorite," as *Time* reported in 1953. Other nationally publicized acquisitions of Monet's paintings included Smith College's *Seine at Bougival in the Evening*, 1870 (W.151) in 1946; the Wadsworth Atheneum's *Beach at Trouville* 1870 (W.156) in 1948; the Cleveland Museum's *Field of Corn* 1881 (W.676) and *Low Tide at Pourville* 1882 (W.716), both received by donation in 1947; the Detroit Institute of Art's *Seine at Asnières* 1873 (W.269) in 1948; the Minneapolis Institute of Art's *Seaside at Sainte-Adresse* 1864 (W.22) received by donation in 1953; and the Cleveland Museum's *Spring Flowers* 1864 (W.20) in 1953. Exceptions to this pattern were the Baltimore Museum's *Charing Cross Bridge, Reflections on the Thames* 1900 (W.1532) received by donation in 1947, and the Museum of Modern Art's *Poplars at Giverny* 1888 (W.1156) received as a promised gift in 1952, but not yet held in MoMA's possession as of this writing. Before 1945 acquisitions of late Monets by American museums were rare but not nonexistent, as indicated by the Worcester Art Museum's 1910 purchase of a *Water Lilies* (W.1733) and the Boston Museum's 1919 receipt by donation of a *Water Lilies* (W.1697).

8 In his 1957 essay for the St. Louis and Minneapolis Monet exhibition, William Seitz hypothesized that Monet was discouraged by his results in these pictures. *Claude Monet* (St. Louis and Minneapolis, 1957): 38. In the 1960 MoMA cat-

alogue he wrote. "It was not until after 1950 that they were once more deemed worthy of their creator, and understood as masterpieces with a meaning for our time as well as his." *Claude Monet, Seasons and Moments* (New York: Museum of Modern Art, 1960): 50.

9 Chrysler's collection of modern art had been exhibited at the Richmond and Philadelphia museums in 1941, and his collection of Renaissance, Baroque, and modern works would tour the country in 1956. He was rumored to have paid approximately $12,000 for the Water Lilies painting in 1950.

10 Bührle donated W.1964, W.1965, and W.1980 to the Zurich Kunsthaus; he kept W.1804 and W.1979. The conditions that motivated two Swiss art museums (Basel 1949 and Zurich 1952) to exhibit and acquire late Monets early in the revival remain to be investigated.

11 Rewald's *History of Impressionism*, which tracked the movement to 1886, was published by the Museum of Modern Art. Barr had helped to arrange funding from Durand-Ruel for Rewald's research for this book; see Alice Goldfarb Marquis, *Alfred H. Barr, Jr., Missionary for the Modern* (Chicago: Contemporary Books, 1989): 184. Goldfarb also says that Barr bought two other late Monets for private collectors at the same time as the MoMA purchase.

12 A. L. Chanin, "Art," *Nation* Dec. 24, 1955: 563. In retrospect, William Seitz called the acquisition "clairvoyant"; "The Relevance of Impressionism," *Art News* 67 (Jan. 1969): 57.

13 A large triptych shown at this exhibition was sold in parts, with one panel each going to the Nelson-Atkins Museum in Kansas City (W.1977), the St. Louis Museum (W.1976), and the Cleveland Museum (W.1975). The Museum of Modern Art (W.1932) and *Reader's Digest* (W.1892) also acquired works from the show. Private collectors who purchased works from the show or from Knoedler around the same time, included Robert Tobin (W.1863), Larry Aldrich (W.1792), G. David Thompson (W.1785), Joseph Pulitzer (W.1784), Albert Greenfield (W.1930), Putnam Dana McMillan (W.1931), and three anonymous collectors (W.1790, W.1817, and W.1827). MoMA president William A. M. Burden also acquired a late Monet from Granoff in 1958 (W.1810). See Wildenstein catalogue and *Time* magazine, Jan. 28, 1957: 79.

14 According to Hess, "Monet: Tithonus at Giverny": 42. This remark is surprising, coming as it does on the heels of the Cognacq sale of modern French paintings in Paris in 1952, which brought record prices for paintings by Cézanne, Renoir, and Degas. The Goldschmidt sale in London in 1958 was another watershed for the Impressionist market. In New York the 1957 sale of the Lurcy collection brought record prices for Monet, Renoir, and other French moderns, and some of these records were broken the next year at the Kirkeby sale, also in New York. Clearly, the heated market for late Monets developed against the background of an escalating market for Impressionist works in general. For a thorough analysis of the New York art market during this period, see A. Deirdre Robson, *Prestige, Profit, and Pleasure: The Market for Modern Art in New York in the 1940s and 1950s* (New York: Garland, 1995), especially pp. 234ff.

15 "Recent Acquisitions," *Arts* May 1957: 27; *Museum of Modern Art Bulletin* 24.4 (summer 1957): 3.

16 André Masson, "Monet le fondateur," *Verve* 7, no. 27–8 (1952): 68.

17 Greenberg, "The Later Monet," *Art News Annual* 1957 (Dec. 1956): 132, 148; "'American-Type' Painting": 190.

18 Hess, "Monet: Tithonus at Giverny": 42.

19 Undated letter from Miller to Barr in the files of the Painting and Sculpture Department, Museum of Modern Art. I am grateful to Kirk Varnedoe and Laura Rosenstock for making these files available to me.

20 Minutes of meeting of Museum Collections Committee, April 6, 1955; press release for New Acquisitions exhibition, November 30, 1955; copy for wall label dated

November 29, 1955 (later adapted for *MoMA Bulletin* 28, no. 2–4, 1961: 6–7); all in the files of the Painting and Sculpture Department, Museum of Modern Art. The circumstances leading to Barr's interest in acquiring a late Monet painting for the MoMA collection are complex. As late as July 1953, he apparently had no immediate intention of seeking a second Monet to add to MoMA's recently acquired *Poplars at Giverny, Sunrise*. In a letter he composed for MoMA president William A. M. Burden, in response to a letter from Barnett Newman, Barr quoted from a forthcoming issue of the *MoMA Bulletin* (20, no. 3–4, Summer 1953: 4): "The Museum has long needed a typical impressionist landscape. This fine Monet fills this need and at the same time responds to the revival of interest in the artist's later work on the part of younger painters here and abroad." Barr was probably referring to Masson's essay as well as to Newman's own letter. In his response to Newman Barr went on to say that MoMA would now seek works by important Impressionists unrepresented in its collections, such as Renoir, Pissarro, and Degas. He cited MoMA's recent change in its collection policy – the museum had decided to retain in perpetuity a collection of modern masterpieces instead of circulating older works out of the collection – as one factor influencing the museum's current attitude toward Impressionist acquisitions. (Alfred Barr papers, microfilm reel 2178.) His intention to build the later nineteenth-century collection was described in *MoMA Bulletin* 22, no. 4 (summer 1955), and he mentions specifically Monet, "whose late work has recently taken on a new significance." Another stimulus for Barr's interest in Monet's *Water Lilies* may have been a collaborative project of 1955, when MoMA sent to the Orangerie an exhibition of nineteenth-century French paintings from American collections. One of the earliest appearances of the term "abstract impressionism" is in Elaine de Kooning, "Subject: What, How or Who?" *Art News* April 1955: 62.

21 *Life* Dec. 2, 1957: 94; *Time* Jan. 30, 1956: 70–71; *Art News Annual* 26 (1957): 138–9. The painting helped generate the interest motivating other articles on Monet's late work in the national press, even when the MoMA painting was not specifically reproduced. See, for example, *Vogue* July 1955: 64–9; *Reader's Digest* April 1957: 186–8; *Look* Nov. 11, 1958: 100–101.

22 Letter dated Feb. 9, 1956, in the Painting and Sculpture Department files, Museum of Modern Art.

23 *Newsweek* April 28, 1958: 84; *New York Times* April 16, 1958: 30; *Life* April 28, 1958: 56.

24 Many are contained in the Alfred Barr papers, Archives of American Art, microfilm reels 2183 and 2184.

25 The fire killed an electrician, Rubin Gelder, working at the museum. In addition to the Monet mural, a smaller *Water Lilies* painting was also destroyed (W.1813). Newspaper reports gave the price paid for the mural as $30,000; at the time of the fire its value had increased to $100,000, the amount of the insurance payment. See the *New York Times* articles, April 16, 17, 19, 1958. The fact that the new triptych required about 800 hours of conservation work was reported in the *New York Times* (Nov. 2, 1959: 33). Besides being dry, brittle, and dirty, the panels had been damaged by shrapnel during the Second World War.

26 Letter from William A. M. Burden (composed by Barr) to Newman, July 15, 1953. Alfred Barr Papers, Archives of American Art, microfilm reel 2178. Along with Newman, the younger painters Barr had in mind probably included Seitz and Masson as well as the emerging Abstract Impressionists discussed below.

27 From *Barnett Newman: Selected Writings and Interviews*, ed. John P. O'Neill (Berkeley: University of California Press, 1992): 38–40, 80–83. Newman also contrasted the "voluptuous" art of Western Europe with the intellectual art he and his associates produced, and he repudiated Europeans' commitment to the reality of sensation and to beauty instead of to sublimity. See Ibid.: 147, 173.

28 See, for example, William Rubin, "Jackson Pollock and the Modern Tradition," part II, *Artforum* March 1967: 37, n. 18. "Newman was the first of the New York painters to speak of rejecting Cézanne as 'my father,' insisting on Monet and Pissarro as the true revolutionaries in whom he had more interest. While not arguing his own direct descent from Impressionism (or that of any of his contemporaries), Newman's emphasis on Monet was important in generating the Monet revival." Rubin does not give a source for this statement, nor can I locate one. If Newman did say or write something to this effect, it is, as I have proposed, contradicted by many of his other statements. In 1951 Newman wrote that "Cézanne was a complete Impressionist. When will someone with eyes examine his work and see this?" See *Barnett Newman: Selected Writings and Interviews*: 122. William Seitz quotes the first half of Rubin's note in "The Relevance of Impressionism": 58. In *The New York School* (New York: Harper and Row, 1978), Irving Sandler discounted Rubin's assertion. "The first generation [of Abstract Expressionists] in its germinal period was indifferent or antipathetic to Impressionism." See pp. 52 and 58, n. 23.

29 See, for example, Howard Devree, "Modern Pioneer: Monet Wrought a Magic in Color and Light," *New York Times*, Oct. 14, 1956, section 2: 11; John Richardson, "Monet," *Studio* Oct. 1957: 99–100, 128.

30 Greenberg, "The Later Monet," p. 195.

31 Seitz, "Monet and Abstract Painting," *Art Journal* 16.1 (1956): 45; and *Claude Monet* (1957): 39.

32 Greenberg's disagreement with both Seitz and Barr concerning the nature of Monet's significance is clearly seen in their different treatments of Kandinsky. For Seitz and Barr, Kandinsky was an important intermediary between Monet and the Abstract Expressionists; for Greenberg, he represented a failure whose example was best resisted. See Greenberg, "The Role of Nature in Modern Painting," *Partisan Review* Jan. 1949: 78, 81. Greenberg's extensive rewriting of this essay in 1959 for inclusion in his book *Art and Culture* (Boston: Beacon Press, 1961) is a good illustration of the changes in his account of modernist art history provoked by his reconsideration of Monet's late work. The revised essay provides a considerably more complex treatment of the lessons of late Impressionism for progressive abstraction and its relation to nature.

33 Seitz, "Monet and Abstract Painting": 40, 42–4.

34 The dissertation was published posthumously: *Abstract Expressionist Painting in America* (Cambridge: Harvard University Press, 1983).

35 Seitz, "Monet and Abstract Painting": 34–46; Dore Ashton, "Modern Problems; Educators, Museum Officials, Critics Discuss Controversial Issues," *New York Times* Feb. 5, 1956, section 2: 15.

36 *Claude Monet: Seasons and Moments*: 6.

37 Ibid.: 52.

38 Seitz, "Monet and Abstract Painting," 46; *Claude Monet: Seasons and Moments*, 7; *Claude Monet* (New York: Abrams, 1960): 158.

39 Seitz's Monet was also at odds with the one presented in Masson's essay, who, Masson insisted, was not a theologian. "Monet le fondateur": 68.

40 MoMA's support or non-support of the Abstract Expressionists has been a controversial issue since the 1950s. See the editorials by Thomas Hess in *Art News* chiding MoMA for neglecting the leading New York School artists: Nov. 1954: 17, and summer 1957: 27. Barr responded to Hess, and Hess replied, in *Art News* Sept. 1957: 6, 56–8. See also Michael Kimmelman, "Revisiting the Revisionists: The Modern, Its Critics, and the Cold War," and Lynn Zelevansky, "Dorothy Miller's 'Americans,'" both in *Studies in Modern Art #4: The Museum of Modern Art at Mid-Century* (New York: Museum of Modern Art, 1994): 50ff., 90ff. My own view is that MoMA's ambivalence did not prevent it from using Abstract Expressionism to promote U.S. cultural diplomacy during the cold war. MoMA

tested all sorts of "national styles" for their diplomatic value abroad and used them simultaneously.

41 "Monet: The eye is magic," *Art News* 59 (April 1960): 27–8.

42 Seitz was one of three men whose photographs of Monet's favorite locations were being published and exhibited in the U.S. at this time. See John Rewald, "Monet, Solid Builder of Impressions," *Art News* Oct. 1–14, 1943: 23–5; Alexander Liberman, "Monet," *Vogue* July 1955: 65–6, 106 ff.; John Canaday, "Monet's Eye and the Camera's Eye," *New York Times Magazine* March 6, 1960: 32–3. Canaday reproduces Seitz's photographs. Seitz wrote to Barr that "I have looked out from more places that Monet looked out than anybody else has." Undated letter, probably late 1957 or early 1958, in the files of the Department of Painting and Sculpture, Museum of Modern Art. Monet was not the only modern artist to receive this kind of treatment; Rewald had also traced Cézanne's steps in this way. In Monet's case the phenomenon has many motivations: the appeal of his locations as tourist destinations, the dimension of the religious pilgrimage following the footsteps of the master, but it also tells us something about the wish and need to compare Monet's painting with some "real" source.

43 "Monet and Abstract Painting," 37–8. The emphasis is Seitz's.

44 Hess, "Monet: Tithonus at Giverny," 53.

45 *Mainstreams of Modern Art* (New York: Simon and Schuster, 1959): 189–90.

46 De Kooning, "Subject: What, How or Who?": 62.

47 The critical momentum of Abstract Impressionism in the 1950s was such that it drew in some reluctant participants – such as Guston, who was ambivalent about Impressionism and doubted that his paintings bore any significant relation to Monet.

48 Finkelstein, "New Look: Abstract-Impressionism," 36–9, 66–8.

49 Ibid.: 68.

50 Rubin, "The New York School – Then and Now," part I, *Art International* 2 (March./April 1958): 24. A year earlier Sonya Rudikoff had noted that the word on Abstract Expressionism was that it could not last, and that there was a widespread expectation that something would happen, perhaps "the much heralded return to nature." "Tangible Abstract Art," *Partisan Review* Spring 1957: 275. Seitz too had noted a new tendency toward "more lyrical and naturalist forms of abstraction" in recent art, and this led him to argue that Monet's relevance was greatest for these emerging artists. "Monet and Abstract Painting": 35. On the academicization of the New York School, see Sandler, *New York School*: 278–89; and Bradford Collins, "Clement Greenberg and the Search for Abstract Expressionism's Successor: A Study in the Manipulation of Avant-Garde Consciousness," *Arts* May 1987: 36. It is worth noting that Greenberg attributed special importance to Still's art because "it shows abstract painting a way out of its own academicism." "'American-Type' Painting," 192.

51 Arthur Schlesinger, Jr., "The Crisis of American Masculinity," *Esquire* Nov. 1958: 63–5, cited in Cécile Whiting, *A Taste for Pop* (New York: Cambridge University Press, 1997). Whiting analyzes the gendered terms of contemporary discussions of crises in art and culture; see pp. 128ff.

52 Heron, "The Americans at the Tate Gallery," *Arts* March 1956: 16. There was by this time a long tradition of criticism portraying the Impressionist style as feminine. Some early examples are cited in Kathleen Adler and Tamar Garb, *Berthe Morisot* (Oxford: Phaidon, 1987): 64.

53 Just two months before Finkelstein's essay appeared in *Art News*, the same publication featured an article by editor Thomas Hess surveying recent directions in American painting. Hess wrote, "I found no signs of a revived interest in Monet, which I had been led to expect." The article includes a profile of Hyde Solomon describing his work as a marriage of impressionism and abstraction, which presumably makes him an exception to Hess's rule. See Hess,

"U.S. Painting: Some Recent Directions," *Art News Annual* 1956 (Dec. 1955): 93, 194.

54 "Old Master's Modern Heirs," *Life* Dec. 2, 1957: 94–9. Among the artists featured in *Life* were Hyde Solomon, Sam Francis, and Jean-Paul Riopelle.

55 "Women Artists in Ascendance," *Life* May 13, 1957: 74–7. The magazine's very brief presentations of four of the five artists profiled (Helen Frankenthaler, Blaine, Mitchell, and Jane Wilson; the exception is Grace Hartigan) highlighted the reference to nature in their paintings. As a prominent female artist in this decade, Frankenthaler was usually treated in these terms, although her work was rarely associated with Monet and Impressionism.

56 Dorothy Seiberling, "Baffling U.S. Art: What It Is About," *Life* Nov. 9, 1959: 68–80, and "The Varied Art of Four Pioneers," *Life* Nov. 16, 1959: 74-86.

57 The Monet revival participated in a broad resurgence of artistic interest in nature; one important indication of this wider interest was the Whitney Museum's 1958 exhibition *Nature in Abstraction*, organized by John I. H. Baur.

58 Douglas T. Miller and Marion Nowak, *The Fifties: The Way We Really Were* (Garden City, N.Y.: Doubleday, 1975): 71.

59 "Month in Review," *Arts* Feb. 1956: 46–8.

60 Steinberg, *Other Criteria* (New York: Oxford, 1972): 85. Steinberg's essay on Monet is reprinted in this volume.

61 For a discussion of the politics of Abstract Expressionism's exploration of self, see my *Reframing Abstract Expressionism: Subjectivity and Painting in the 1940s* (New Haven and London: Yale University Press, 1993).

62 Hess attributes the term to Harold Rosenberg in "Monet: Tithonus at Giverny": 42; Greenberg, "The Later Monet": 132.

Select Bibliography

For the most complete record of the literature on Claude Monet, see Daniel Wildenstein, *Claude Monet: Biographie et catalogue raisonné*, Lausanne (Vol. I, 1840–81 [1974]; Vol. II, 1882–6 [1979]; Vol. III, 1887–98 [1979]; Vol. IV, 1899–1926 [1985]; Vol. V, additions to previous volumes, drawings, pastels, index [1991], reprinted in four volumes and published by Taschen-Institut Wildenstein, Paris 1997.

For recent studies of Claude Monet, see:

Robert Gordon and Andrew Forge, *Monet*, New York: Abrams, 1983
John House, *Monet: Nature into Art*, New Haven and London: Yale University Press, 1986
Virginia Spate, *Claude Monet: Life and Work*, New York: Abrams, 1992
Steven Z. Levine, *Monet, Narcissism, and Self-Reflection*, Chicago: University of Chicago Press, 1994
Paul Hayes Tucker, *Claude Monet: Life and Art*, New Haven and London: Yale University Press, 1995
Charles F. Stuckey, *Claude Monet 1840–1926*, exh. cat., Chicago: Art Institute of Chicago, 1995

For recent studies of specific relevant areas, see:

Charles S. Moffett et al., *Monet's Years at Giverny*, exh. cat., New York: Metropolitan Museum of Art, 1979
Jacqueline and Maurice Guillard et al., *Claude Monet au temps de Giverny*, exh. cat., Paris: Centre Culturel du Marais, 1983

Christan Geelhaar, et al., *Claude Monet: Nymphéas: Impression-Vision*, exh. cat., Basel: Kunstmuseum, 1986
Philippe Piguet, *Monet et Venise*, Paris: Herscher, 1986
Michel Hoog, *The Nymphéas of Claude Monet at the Orangerie*, Paris Réunion des Musées Nationaux, 1987
Grace Seiberling, *Monet in London*, exh. cat., Atlanta: High Museum of Art, 1989
Paul Hayes Tucker, *Monet in the '90s*, exh. cat., Boston: Museum of Fine Arts, 1989; London: Royal Academy of Arts, 1990
Joachim Pissaro, *Monet and the Mediterranean*, exh. cat., Fort Worth: Kimbell Art Museum, 1997
Pierre Georgel et al., *Monet: le cycle des "Nymphéas"*, exh. cat., Paris: Musée de l'Orangerie des Tuileries, forthcoming

There is no recent, comprehensive bibliography of Impressionism and Post-Impressionism; but see the most recent editions of John Rewald, *History of Impressionism*, London and New York: Thames and Hudson, 1973, and *History of Post-Impressionism*, London and New York: Thames and Hudson, 1978. For an informative review of the context of Monet's work created after 1912, see Kenneth E. Silver, *Esprit de Corps: The Art of the Parisian Avant-Garde and the First World War, 1914–1925*, Princeton, N.J.: Princeton University Press, 1989.

Photographic Credits

Index